MASTER DRAWINGS

from the

SMITH COLLEGE MUSEUM *of* ART

———

ANN H. SIEVERS

with LINDA MUEHLIG *and* NANCY RICH

with Contributions by

KRISTEN ERICKSON *and* EDWARD J. NYGREN

HUDSON HILLS PRESS · NEW YORK

in association with the Smith College Museum of Art

Northampton, Massachusetts

First Edition

© 2000 by the Smith College Museum of Art.

All rights reserved under International and Pan-American Copyright Conventions.

Published in the United States by Hudson Hills Press, Inc.,
1133 Broadway, Suite 1301, New York, NY 10010–8001.

Distributed in the United States, its territories and possessions, and Canada
by National Book Network.

Editor and Publisher: Paul Anbinder

Manuscript editor: Fronia W. Simpson

Proofreader: Lydia Edwards

Indexer: Gisela Knight

Designer: Howard I. Gralla

Composition: Angela Taormina

Manufactured in Japan by Dai Nippon Printing Company.

Library of Congress Cataloguing-in-Publication Data

Smith College. Museum of Art.
 Master drawings from the Smith College Museum of Art /
 Ann H. Sievers with Linda Muehlig and Nancy Rich with contributions
 by Kristen Erickson and Edward Nygren. — 1st ed.
 p. cm.
 "In association with the Smith College Museum of Art,
 Northampton, Massachusetts."
 Includes bibliographical references and index.
 ISBN: 1-55595-183-x (cloth : alk. paper)
 1. Drawing, European—Catalogues. 2. Drawing, American—Catalogues.
 3. Drawing—Massachusetts—Northampton—Catalogues. 4. Smith College.
 Museum of art—Catalogues. I. Sievers, Ann H. II. Muehlig, Linda D.
 III. Rich, Nancy. IV. Title.

NE625 .S57 2000
741.94'074'74423—dc21
 00-40909

CONTENTS

ACKNOWLEDGMENTS

THE DEBTS of gratitude that one incurs in the course of preparing a catalogue of this nature are legion, each one a testimony to the abundant goodwill and generosity of colleagues and friends. It is a pleasure to acknowledge their contributions here.

First and foremost, I would like to thank my co-authors, all current or former staff members of the Smith College Museum of Art: Linda Muehlig, Associate Curator of Painting and Sculpture; Nancy Rich, who began writing her entries as Assistant Curator of Prints, Drawings and Photographs, and completed them as the museum's first Curator of Education; Edward J. Nygren, former Director of the Smith College Museum of Art and current Director, Art Division, The Huntington Library, Art Collections and Botanical Gardens, San Marino, California; and Kristen Erickson, former intern and curatorial assistant, who completed her entries from New York's Museum of Modern Art. I am extremely grateful to them for their scholarship and their dedicated work on this project.

The authors join me in thanking the many individuals who have shared their expertise and provided advice, assistance, and encouragement over the course of this project. We are especially grateful to our colleagues who read and commented on early drafts of catalogue entries: Sue Welsh Reed, Suzanne Folds McCullagh, Carol Clark, Diane DeGrazia, Colin Eisler, Linda Konheim Kramer, and William W. Robinson. Busy scholars all, they were willing to take time and trouble to forward our project.

Particularly generous in her contributions was Craigen Bowen, Philip and Lyn Straus Conservator for Works on Paper at the Straus Center for Conservation and Technical Studies, Harvard University. Having surveyed and conserved many of Smith's drawings in years past, she examined them anew for this catalogue, identifying media, tenaciously pursuing the best method for recording even the most elusive of watermarks, and helpfully discussing questions of drawing media and technique.

Each major project undertaken at the Smith College Museum of Art affects virtually every member of the museum's small staff. This catalogue is no exception, and I am deeply grateful to all my colleagues for their help and encouragement. Museum director Suzannah Fabing devoted unflagging energy to ensure the forward momentum and completion of the catalogue. Former interim director Charles Parkhurst also supported the project, as did his predecessor Edward J. Nygren, who backed the initial proposal and encouraged plans for an associated exhibition. Former print room assistants Hyde Meissner, Claire Golda Dienes, and Gwen Allen skillfully performed a variety of administrative tasks in support of the catalogue and assisted with bibliographic and provenance research. Current curatorial assistant and print room supervisor Alona Horn ensured that the activities of the study room and the collections management work of the print, drawing and photograph department proceeded smoothly and efficiently, allowing me to focus attention on final preparation of the catalogue manuscript. For his many contributions to examination and discussion of the drawings' paper and media, I am very grateful to David Dempsey, the museum's preparator/conservator.

A succession of curatorial interns have made significant contributions to catalogue research. Corinna Jaudes ably assisted Linda Muehlig, summer intern Ute Schmidt helped verify German references, and Gretchen Fox provided enthusiastic and talented research assistance on several of the drawings early in the project. In the later stages of catalogue preparation, Claire Renkin not only provided superb research assistance, but also took responsibility for gathering comparative photographs and securing the necessary copyright permissions. Nancy Noble, summer curatorial assistant, verified bibliographic records and tracked down information on exhibition dates with characteristic skill and dispatch. Research on exhibition histories was facilitated by museum archivist Michael Goodison and registrar Louise Laplante. Stefne Lynch efficiently coordinated the extensive new color photography of the drawings undertaken by Stephen Petegorsky, whose patience and high standards are much appreciated.

The late Elizabeth P. Richardson, a gifted editor and admired friend, helped clarify early drafts of the entries. After Liz's death, editor Fronia W. Simpson, equally skillful and always encouraging, saw the manu-

script through final preparations. We have been fortunate indeed to have had the benefit of her talents. It has also been a great pleasure to work with Paul Anbinder, President of Hudson Hills Press, who deserves our thanks for producing this beautiful book so sensitively designed by Howard I. Gralla.

Research for this catalogue would not have been possible without the resources of many libraries and the expertise and unstinting assistance of their staffs. At Smith we have been extremely lucky to have had resourceful and enthusiastic assistance from art librarian Barbara Polowy and her predecessor Amanda Bowen, who continued to provide generous help after assuming her new position at the Harvard University Fine Arts Library. Among the always helpful staff of Hillyer Art Library at Smith we must particularly acknowledge the assistance of former staffer Laura Graveline and that of Taeko Brooks, whose patience and graciousness are boundless. Thanks are also due to the college's interlibrary loan staff, particularly Christine Ryan and Naomi Sturtevant. We are also extremely grateful to the libraries at Harvard University and the Boston Museum of Fine Arts, as well as to the Watson Library at the Metropolitan Museum of Art, the Getty Center Library, the Frick Art Reference Library, the National Fine Arts Library at the Victoria and Albert Museum, London, the British Library, and the Biblioteca Hertziana, Rome.

We have been graciously received by colleagues in drawings collections here and abroad, we have benefited from the visits to Smith of scholars who have shared their thoughts on our drawings, and we have received generous and helpful responses to our many specific requests for opinions and information. Numerous individuals have assisted us in verifying the provenance and exhibition histories of our drawings and have helped us obtain photographs, and performed other services, large and small. We gratefully acknowledge Alex Reid & Lefevre Ltd, Christiane Andersson, Aquavella Contemporary Art, Inc., Colin B. Bailey, Joseph Baillio, Jonathan Bass, Peter Blank, James Bergquist, Mària van Berge-Gerbaud, Suzanne Boorsch, Mark Brady, Sylvie Brame, Bernard H. Breslauer, Etienne Bréton, Stephanie Buck, William T. Cartwright, Sonia Cavicchioli, Leslie Chang, Hugo Chapman, Miles Chappell, Alvin L. Clark, Jr., Simon Cobley, Marjorie Cohn, Peter Dreyer, Lorenz Eitner, John Elderfield, Marianne Feilchenfeldt, Craig Felton, Susan Foister, Galerie Jan Krugier, Kate Garmeson, Margaret Glover, Marguerite Goldschmidt, Antony Griffiths, William M. Griswold, Wanda de Guébriant, Jane Gunther, Monique Hageman, Mark Henderson, Martin Hugelshofer-Sigrist, Philip Johnson, Will Johnston, Joop M. Joosten, Fritz Koreny, E.W. Kornfeld, Suzanne Folds McCullagh, Michiel van der Mast, David Mitchinson, Emmanuel Moatti, Mark Morford, Christian M. Nebehay, Stephen Ongpin, Nicholas Penny, Annamaria Petrioli Tofani, Marianne Roland Michel, Joe Roberts, Cristiana Romalli, E. Bruce Robertson, Stella Rudolph, Béatrice Salmon, Werner Schade, Scott Schaefer, Carrie Schweiger, Carol Selle, Susan L. Siegfried, Larry Silver, Marc Simpson, Regina Soria, Emmanuel Starcky, Gerald G. Stiebel, John L. Sullivan, Martha Tedeschi, Eugene and Clare Thaw, Barbara Thompson, Nicholas Turner, Lora Urbanelli, Scott Wilcox, Eunice Williams, Alan Wintermute, Linda Zatlin, and Pascal Zuber.

The National Endowment for the Arts provided generous support in the form of two grants, the first for the research and writing of the catalogue, the second for its publication. Additional funds were supplied by the Kunstadter Fund and the Tryon Associates of the Smith College Museum of Art.

Ann H. Sievers
Associate Curator of Prints, Drawings and Photographs

INTRODUCTION

TRUE TO THE INTENT of Sophia Smith's 1870 will, which envisioned an institution that would instruct women in fields of learning including "[t]he Useful and Fine Arts," the trustees of Smith College, in their prospectus of 1872, asserted that "more time will be devoted than in other colleges to aesthetical study, to the principles on which the fine arts are founded, to the art of drawing and the science of perspective, to the examination of the great models of painting and statuary," noting opportunities for advanced work in "Aesthetic Culture," including drawing and painting.[1] Not only did the college's first academic building include an art gallery, the significance of which the first president, L. Clark Seelye, emphasized in his inaugural address of 14 July 1875, but by the close of the college's first academic year Seelye was ready to begin forming an art collection.[2] Just a year later (May 1877), an extensive article on Smith College in *Scribner's Monthly* included an engraving of a "View in the Art Gallery" that shows the progress he had made.[3] The author asserts that

> the art gallery, even unfinished, would delight the eye of an artist. This gallery is divided into alcoves by an ingenious arrangement of gothic screens, which are covered with several hundred autotype copies [photographic reproductions] of representative paintings of the Italian, Flemish, Dutch, German, and Spanish schools. The ends of these screens are finished to form effective backgrounds for casts representing noted statues. There are also oil copies of celebrated paintings of the different schools. The art lecture-room has its walls covered with illustrations of the French school, and an adjoining room is to be devoted to the English school of art.[4]

Although instruction in the practice of drawing was a cornerstone of art studies at Smith from the start, there appears to have been no corresponding commitment in the early years of the college to building a collection of drawings. A succession of artists, including James Wells Champney (from 1877–79), John Niemeyer of Yale University (1881–86), and Dwight W. Tryon (1886–1923), taught drawing and painting to undergraduates and to special students in the college's associated Art School (established 1877 and integrated into the college in 1903). In accord with standard art instruction of the day, students learned by copying from paintings and sculpture by the great masters — hence the collection of casts and other reproductions that constituted the gallery's first displays. By 1879, however, Seelye was able to purchase original art, inaugurating — with the acquisition of twenty-seven paintings — his innovative plan to form a collection of paintings by living American artists.[5] When Seelye wrote in his annual report to the trustees for 1885–86 that the art collections of Smith College were "now among the most important in the country,"[6] they already included paintings by Thomas Eakins, John La Farge, Winslow Homer, and others and were housed in the gallery of a new art building erected in 1881–82 with a gift from the Northampton businessman Winthrop Hillyer. The college had also just acquired its first drawings, a large group of original designs for illustrations in the *Century* (successor to *Scribner's Monthly*) and *St. Nicholas* (a monthly magazine "for boys and girls").[7] These hung "neatly framed" in one room of the gallery for the art reception held two days before commencement in 1886 (at which the editor of the *Century*, Richard Watson Gilder, read an original poem to the graduating class). Among other works of art on view were two watercolors purchased that year.[8]

Judging from the pattern of acquisitions in this and subsequent years, Seelye seems never to have developed a specific interest in collecting drawings, but rather to have bought some few works on paper that could — and would — have been considered "paintings" at the time, such as watercolors or pastels (now classified as "drawings" in today's Smith College Museum of Art). Perhaps because of the sizable group of drawings already donated, he felt little need to expand acquisitions in this area. In these years only a handful of other watercolors and pastels were received as gifts.[9]

The appointment of Alfred Vance Churchill in 1905 to the college's new chair in the History and Interpretation of Art resulted in an important new direction for the Smith collections. Because of

Churchill's interest in European art, he found the existing collections inadequate for his teaching, the photographic reproductions and plaster casts "mere shadows and substitutes for reality."[10] Placed in charge of the Hillyer Art Gallery, Churchill sought ways of expanding the range of original art presented. The first loan exhibition, a group of Rembrandt van Rijn's prints borrowed from the Frederick Keppel Gallery in New York (1911), prompted student members of the Studio Club and their friends to purchase a fourth-state impression of *The Three Crosses* from the show as a gift to the college. This marked the start of Churchill's efforts to build a print collection, and it seems to have prompted other donations of prints in the following years.[11] But Churchill's opportunity to make his greatest impact on the collection came in 1919, when he was appointed director of the newly named Smith College Museum of Art and charged by the trustees with the task of formulating a collecting policy. His proposal for "concentration" on Western art of the "modern" era (beginning at the French Revolution), with a "distribution" of high-quality works from other periods, has guided the museum to this day.[12] Drawing up a "List of names representing the Indispensable Links in the Development of Modern Art (c. 1793–1900)," Churchill began his search for acquisitions.[13] His initial five-month buying trip to Europe did not result in a single drawing purchase, however, nor did he add a drawing to the collection for the next few years.[14] Although drawings were not neglected in special exhibitions, they appear to have received more attention in the latter years of Churchill's tenure.

Dwight W. Tryon's pledge to build a new art gallery must have done much to support Churchill's efforts. When the Tryon Gallery was completed in 1926, it featured a Print Room on the lower floor to display that rapidly growing collection, which now included recently acquired works by Eugène Delacroix and Théodore Gericault, a selection of English prints, and a sizable representation of the French Société des Aquafortistes, the bequest of Tryon's patron Charles Lang Freer (1920).[15] That same year Churchill purchased a red chalk figure drawing by Pierre Puvis de Chavannes, and shortly thereafter (1927) a portrait drawing and sheet of studies (1929) attributed to Gericault, both of which featured in Churchill's Gericault exhibition (4–25 April), the first in America dedicated to the artist. That same year, arranging to borrow some drawings by Jean-Auguste-Dominique Ingres, he stated that "we are hoping to acquire one for the museum."[16] A drawing by Pierre-Paul Prud'hon came as a gift in 1931.

A painter himself, with a strong belief in the potential of even fragmentary works by great artists to reveal their creator's mind, Churchill made a point of seeking out unfinished works such as the large canvas by Gustave Courbet, *The Preparation of the Dead Girl* (then called *The Preparation of the Bride)*. It was left to his successor, Jere Abbott, to extend the collection to include not only paintings but related drawings as well.

Jere Abbott (director 1932–46) came to Smith after serving as the founding associate director of the Museum of Modern Art in New York. Often remembered for his acquisition of important School of Paris paintings and the inauguration of Smith's photography collection (1933), Abbott's purchases of drawings were not numerous, but they were often significant. The first major drawing he bought (1934) was a study for *The Daughter of Jephthah* (cat. 33), the large unfinished canvas by Edgar Degas that he had acquired the previous year. His next important purchase was the Ingres double portrait of the architects Leclère and Provost (1937; cat. 30). The following year he bought the two Georges Seurat crayon studies for *Sunday Afternoon on the Island of La Grande Jatte* that had been on loan to the museum (cats. 41, 42); they joined an oil study for the same painting acquired four years earlier. All these drawings supported the concentration plan, representing artists singled out in Churchill's list of "Indispensable" artists as especially significant. In 1939 Abbott made his most important contribution to the "distribution" plan by purchasing the late-fifteenth-century silverpoint *Portrait of a Young Man* attributed to Dieric Bouts (cat. 1). Other drawings chosen by Jere Abbott — his own Paul Klee *Goat* (which figured in an exhibition at Smith in 1932 and again in 1959; cat. 62) and the Charles Burchfield watercolor *Freight Cars* (cat. 57), his wedding gift to Alfred and Marga Barr — eventually came to the museum as gifts in the 1970s.

Several noteworthy sixteenth- and seventeenth-century Italian drawings, including the Domenico Campagnola *Landscape with Farmyard* (cat. 6) and the Lodovico Cigoli *Saint Catherine* (then attributed to Bartholomaeus Spranger; cat. 11), were purchased by Frederick Hartt, the historian of Italian Renaissance art who served as acting director in 1946–47. His successor, Edgar Schenk, whose tenure at Smith was almost as brief (1947–49), did not purchase a single drawing.

Under the leadership of the museum's next director, the distinguished architectural historian Henry-Russell Hitchcock (1949–55), the drawings collection received renewed attention. He was assisted by Mary Bartlett Cowdrey, a scholar of American art. Noting his two immediate predecessors' departure from Churchill's concentration plan, Hitchcock stated his determination to return to the focus on modern art. But because so many key French artists were represented in the collection already, he proposed devoting his energies to extending the concentration to modern art from other countries.[17] Among the outstanding English works he purchased were drawings by Paul Nash (cat. 59) and Henry Moore (cat. 65), the latter chosen at the artist's studio. Other drawing acquisitions included American works: Maurice Prendergast's *South Boston Pier* (purchased in 1950; cat. 51), Barnett Newman's untitled ink drawing (a 1952 gift from the architect Philip Johnson; cat. 67), and Elihu Vedder's large crayon drawing (a gift in 1955; cat. 45). Not only did prints receive renewed attention, being highlighted in exhibitions and given two renovated study galleries (one in 1950–51, a second in 1951–52), but for the first time a gallery was designated (informally) for drawings except when it was needed for special exhibitions. Hitchcock's first annual report records that thirty to forty drawings were framed (or reframed) and shown there during the year.[18] Exhibitions also helped bring donations (e.g., Charles Goodspeed, a lender to Churchill's John Ruskin exhibition [1949–50], gave twenty-eight Ruskin sketches and watercolors). Wider recognition of the high quality of the college's drawings had already begun to come in the form of frequent loan requests, in particular for the Ingres, Bouts, Degas, and Seurat drawings. Smith's drawings received further attention when a selection was included in an exhibition of forty-five paintings and drawings from the collection held at Knoedler Galleries, New York (1953). Another exhibition, at Boston's Institute of Contemporary Art, highlighted forty-four major works from the Smith College collection, several of which were drawings (including the recently acquired Moore and Prendergast sheets). At this time the museum also increasingly benefited from the loyalty and generosity of Smith alumnae art collectors, their families and friends. One notable instance of this support was the gift of twenty-six English watercolors and drawings from the children of Mrs. Thomas Lamont (among them the Thomas Gainsborough, Paul Sandby, and Thomas Rowlandson drawings in this catalogue; cats. 26, 22, and 28).

The advent of Robert O. Parks as director (1955–61) brought the museum its greatest advocate and connoisseur of drawings. Although he did not neglect other aspects of the collection (acquiring, for example, the major expressionist painting *Dodo and Her Brother* by Ernst Ludwig Kirchner, among other noteworthy works), drawings are among his most important acquisitions. An exhibition in the fall of 1956 (14 Sept.–5 Oct.), *Five Drawings by Jacques-Louis David,* was the source of two purchases that academic year. The following season Parks recorded as his major purchase from budgeted funds a drawing by Fra Bartolommeo (cat. 2).[19] Among the works acquired with gifts of funds, the *Study of Drapery* by Matthias Grünewald was especially significant (cat. 3), achieved after nerve-wracking negotiations. It remains the only drawing by this rare Renaissance master in an American collection. Parks's acquisitions were often supported by Smith alumnae Caroline and Adeline Wing, who provided financial resources, and by the advice of such collectors as Philip Hofer and Janos Scholz (whose Italian drawings were shown at Smith in 1958).

In the spring of 1958 (22 May–30 June), Parks mounted the "first comprehensive exhibition" of the sixty-six "most important European drawings" in the collection, several of them purchased that very year, and followed this with a similar show of British drawings and watercolors (1–19 Dec. 1958). Drawings by Francesco Guardi, Rosso Fiorentino, Federico Barocci, Théodore Gericault, and Käthe Kollwitz (a sheet featured in a 1958 exhibition of her work) all entered the collection through Parks's efforts (cats. 23, 5, 7, 31, and 53).

After a brief interregnum overseen by Hamish Miles (acting director) and Patricia Milne-Henderson (acting assistant director), Charles Chetham assumed the leadership of the museum. In the course of his twenty-five years as director (1962–88) numerous drawings came to the museum through purchase and gift. His own interest in Dutch art is reflected in several important acquisitions, among them Piet Mondrian's *Chrysanthemum* (purchased 1963; cat. 60) and Jan Toorop's *View of Castle Doorwerth, near Arnhem* (purchased 1986; cat. 56). *Orphan Man with Walking Stick,* an 1886 portrait by Vincent van Gogh

(cat. 38), whose early drawings had been the subject of Chetham's dissertation, was acquired at auction, fulfilling at last Churchill's goal of representing this important artist at Smith. Fittingly, a second *Orphan Man* joined the collection through a generous gift some years later (1996; cat. 39). Other Northern European drawings of note purchased by Chetham include Spranger's *Mars and Venus* (cat. 10) and Adolph von Menzel's *Bearded Man with a Glass* (cat. 46).

Despite a decline in the museum's purchasing power, fine drawings were still within its reach, and a succession of noteworthy acquisitions enhanced the collection. Henri de Toulouse-Lautrec's portrait of Henri-Gabriel Ibels (cat. 49) was the focus of a special exhibition. Henri Fantin-Latour's *Commemoration* (the gift of Mina Kirstein Curtiss in 1965; cat. 43) featured in Chetham's Fantin-Latour exhibition.

With the construction of a new Fine Arts Center in 1969–72, Chetham oversaw the greatest increase in the size of the museum's galleries to date, as well as a substantial increase in the museum's staff. His plans for the new building reflected his belief in the importance of the museum in educating undergraduates and young museum professionals. The building was equipped with a large print study room, as well as a gallery suited to special exhibitions of works on paper. Elizabeth Mongan became the first curator to oversee the works on paper collection in its new home, succeeded by Colles Baxter, Christine Swenson, and the present writer. Along with continuing purchases (e.g., the composition studies by Jean Michel Moreau le jeune acquired by Mongan; cats. 24, 25), numerous gifts of drawings were made in these years. The bequest of Sigmund and Maxine Kunstadter brought drawings by such American artists as Mark Tobey (cat. 68), while the 1984 bequest of Selma Erving, who had donated her important collection of nineteenth- and early-twentieth-century European prints and *livres d'artiste* in the 1970s, brought drawings by Marc Chagall (cat. 54), Pierre-Auguste Renoir (cat. 37), Odilon Redon (cat. 47), and others. Many other gifts of note are also included in the present catalogue.

The drawings collection has continued to prosper under subsequent directors. The renewed emphasis on contemporary art that characterized the two-year tenure of Edward J. Nygren (1988–91) is reflected in the works acquired with the aid of a National Endowment for the Arts grant to purchase drawings by living American artists. The brilliant Benedetto Luti pastel of 1712 (cat. 16) was also bought at this time. During the eighteen-month interim directorship of Charles Parkhurst a second study for *The Daughter of Jephthah* was purchased (cat. 34). A third study (cat. 35) entered the collection as a gift under the current director, Suzannah Fabing, who came to Smith in 1993. Acquisitions of drawings have been steady in recent years, but none has been more surprising than the discovery of a long-lost study by Lodovico Cigoli in a rare book auction in Northampton (cat. 9).

The present catalogue highlights a selection of the finest drawings in the collection of the Smith College Museum of Art, beginning chronologically with the silverpoint portrait attributed to Dieric Bouts and ending at the mid-twentieth century. As the catalogue goes to press the museum will be starting another major renovation and expansion; when it is published we will have entered a new millennium. It is our hope that this volume will stand as a tribute to the many discriminating individuals who shaped the drawings collection of the Smith College Museum of Art and a challenge to those who will guide the collection in the future.

Ann H. Sievers
Associate Curator of Prints, Drawings and Photographs

1. Seelye 1923, p. 13.

2. On the inaugural address, see Seelye 1923, p. 29. For his recommendation regarding the art collection, see his 1870 Report to the Trustees (College Archives).

3. *Scribner's* 1877, p. 14.

4. Ibid., p. 9.

5. Report to the Trustees, 1879 (College Archives).

6. Report to the Trustees, 1886 (College Archives).

7. According to Seelye this gift was "a token of their interest in the artistic work of the College and in recognition of the fact that Dr. J. G. Holland — one of the original founders of that periodical — wrote his first published poem while in the service of Judge Dewey, whose homestead occupied the site of the Hillyer Art Gallery." Seeley 1923, p. 69. Holland, the editor of *Scribner's Monthly* from 1870 to 1881 (with Richard Watson Gilder as managing editor, until the magazine left C. Scribner's Sons in 1881, becoming the *Century,* with Gilder as editor), was a close friend of Seelye, whose wife was cousin to his own wife (Rhees 1929, pp. 76–82). Gilder's wife, Helena de Kay Gilder, was a painter and founder (with Wyatt Eaton, Walter Shirlaw, and Augustus St. Gaudens) of the American Art Association (later the Society of American Artists).

8. See the article in the *Springfield (Mass.) Republican,* 22 June 1886. The watercolors were "purchased from the exhibition of English works in Boston." The article notes "over 100" drawings were in the Century Company's gift. College records from this time are sparse; the early accession books record 75 drawings, but as these books were compiled long after the acquisition, the original number of drawings in the gift is uncertain. None of these works remained in the collection.

9. E.g., a James Wells Champney pastel after a painting by Raphael (given by the artist).

10. Churchill's Annual Report for 1920 (College Archives).

11. Kimball 1922.

12. A brief statement of the plan was published in Churchill 1923. A more complete account is found in Churchill 1932. See also SCMA 1986, pp. 23–24.

13. SCMA Archives. "Sheet I — Painting" is the only part of the list that remains. Churchill underlined the names of artists he felt were of the highest significance for the collection.

14. Within a year of becoming director of the Smith College Museum of Art, Churchill launched publication of the museum's *Bulletin.* Exhibitions and acquisitions become easier to track after this date. Churchill also introduced better record-keeping procedures, accessioning objects acquired previously.

15. Churchill 1927, p. 139.

16. Letter of 25 Oct. to Josef Strasky (SCMA Archives).

17. Henry-Russell Hitchcock, Annual Report to the Trustees for 1949–50, pp. 12–13 (SCMA Archives).

18. Henry-Russell Hitchcock, Annual Report to the Trustees for 1949–50, p. 16 (SCMA Archives).

19. Annual Report for 1956–57 (SCMA Archives).

A NOTE ON THE CATALOGUE

Arrangement of Entries

Catalogue entries are arranged chronologically by date of drawing. Titles are given in English, followed where appropriate by the title in its original language. The date assigned each work is based on a combination of documentary and stylistic evidence discussed in the associated essay. The following conventions have been used:

1840	executed in 1840
c. 1840	executed sometime around 1840
1840/1860	begun in 1840, finished in 1860
1840–60	executed sometime between 1840 and 1860
c. 1840–60	executed sometime around the period 1840 to 1860

Medium

The principal instrument and medium are given first, followed by others in order of importance. Descriptions of papers used (weight, texture, and color) are based on *The Print Council of America Paper Sample Book: A Practical Guide to the Description of Paper* by Elizabeth Lunning and Roy Perkinson (1996). Papers are of medium weight and are slightly textured unless otherwise indicated. Paper colors are given as they appear today, but if it can be determined that the paper was originally a substantially different color, this is indicated. If a drawing is adhered ("laid down") to a mount, the mount is described and its dimensions given if they differ from those of the drawing.

Watermarks

Watermarks are described in each entry with reference to standard watermark dictionaries where possible. For Beta-radiographs, X-radiographs, or other reproductions of the watermarks on drawings in this catalogue, see Watermarks, an appendix to this volume.

Size

Measurements are of the sheet, height before width, unless otherwise specified. Dimensions are given both in millimeters and inches. If the drawing is shaped irregularly this is indicated, and maximum measurements are given.

Inscriptions

Inscriptions are assumed to be in a hand other than the artist's unless so indicated (e.g., "signed" and "dated" denote the artist's hand). Location, instrument, and medium of inscriptions are described.

Provenance

The provenance is given chronologically, and wherever possible dates of ownership are included. Each owner is separated from the next by a semicolon; "to" indicating the direct passage of a drawing from the previous owner. Dealers and art galleries are distinguished from private individuals by curly brackets ({ }) to signal their usual role in transfers of drawings by sale from one owner to another. It has not been possible in every instance, however, to establish whether a dealer or gallery owned a drawing or was acting as

agent for another individual; in some cases drawings belonged to a dealer's private collection. Collector's marks are noted with reference to Lugt or Lugt Suppl (see Literature).

Literature and Exhibitions

All bibliographic citations are given in shortened form in the literature and exhibition histories for each catalogue entry as well as in the notes. Full citations are found in the lists at the back of this volume. Short references for exhibitions usually consist of the city of the organizing venue with inclusive dates of the exhibition. Citations under Exhibitions in the catalogue entries are for all exhibitions in which the drawing is known to have been shown. Citations under Literature in the catalogue entries refer to sources in which the drawing is reproduced or discussed, including catalogues for exhibitions that did not show the drawing. Short references for sources other than exhibitions usually consist of the author's surname and the year of publication.

Illustrations

No drawing is reproduced larger than actual size.

Authors

KE	Kristen Erickson
LM	Linda Muehlig
EJN	Edward J. Nygren
NR	Nancy Rich
AHS	Ann H. Sievers

THE CATALOGUE

DIERIC BOUTS (ATTRIBUTED TO)

Active in Leuven (Louvain) by 1457[1]–1475 Leuven

1 *Portrait of a Young Man*, late 1460s–70s

Silverpoint on ivory prepared paper. Several later touches in graphite (three light lines at jaw, others on proper right arm, and at proper left shoulder, where the surface of the drawing was abraded); laid down on a mount (stiff card)

Watermark: None visible[2]

Sheet: 139 × 107 mm (5⁷⁄₁₆ × 4¼ in.); mount: 210 × 170 mm (8¼ × 6¹¹⁄₁₆ in.)

Inscribed recto, at left, in graphite: *180;* inscribed on recto of mount below drawing, at center, in pen and brown ink: *Andrea di Mantegna* [this inscription canceled in graphite]; inscribed on verso of mount, at center, in graphite: *Either by Van Eyck or someone of his school, & has some / resemblance to the Portrait called of Hans Memmelink / 1464 - sold in Rogers's sale, which is by Dirck Sturb an*[d; the final letter cut by the trimmed edge of the mount] / *whose pictures (2 are at the Palace at the Hague) wer*[e; final letter off edge of mount] / *attributed to Memmelink;*[3] in a different hand, lower center, in graphite: *Rogier van der Weyden the elder;*[4] and lower left corner, in graphite: *val*[?]

PROVENANCE Rev. Dr. Henry Wellesley (1791–1866), Oxford; to his estate (sale, London, Sotheby's, 25 June 1866 and thirteen days following, fourth day, no. 709, as Hans Hemelinck [Memling], *His Own Portrait,* pen washed, on prepared paper), to "Whitehead" for £21;[5] Frederick Locker-Lampson (Frederick Locker prior to 1885; 1821–1895), London and Rowfant, Sussex by 1886;[6] presumably to his widow, Hannah Jane Lampson (d. 1915);[7] to Godfrey Locker-Lampson, P.C. (1875–1946), their son (sale, London, Christie's, 20 Dec. 1918, no. 142, as Hans Memling);[8] to {P. & D. Colnaghi, London}, for £682.10, purchased in half-shares with {M. Knoedler and Co.}, Colnaghi stock no. A1786;[9] to Henry Oppenheimer (1859–1932), London, 4 Jan. 1919 for £750.15;[10] to his estate (sale, London, Christie's 10–14 [10, 13, 14] July 1936, second day, no. 221, pl. 56, as Bouts), for £4000;[11] to {P. & D. Colnaghi, London} probably as agent for Ludwig Rosenthal, Bern (afterward called L. V. [Lewis Valentine] Randall [1893–1972], Montreal);[12] {Schaeffer Galleries, Inc., New York}; sold to SCMA in 1939

LITERATURE Locker-Lampson 1886, p. 225 (as Hans Memling. Ascribed to); Vasari Society 1921, no. 11, entry by A. E. P[opham] (as Memling, *Portrait of a Man),* pl. 11; Conway 1921, p. 245 (as Memling workshop); Popham 1926, p. 8 and pl. 17, catalogued p. 24 (as Dirk Bouts); Holmes 1936, repr. p. 116 (as Bouts), men-

tioned on p. 118 (in "The Drawings" by W. A. M.); Schöne 1938, pp. 5, 7, 120, no. 7, pl. 19; *Springfield Republican* 1939, repr.; Vorenkamp 1939a, pp. 3–10, frontispiece and fig. 2 (detail); Vorenkamp 1939b, pp. 9, 18–19, repr. p. 9; Vorenkamp 1939c, pp. 287–88, repr., p. 280; *Smith AlumQ* 1939, p. 26, repr. p. 27; Watson 1940, repr. p. 467 (no credit line to SCMA); *ArtD* 1940, mentioned p. 20; SCMA 1941, p. 11, repr. p. 38; Shoolman and Slatkin 1942, pl. 348; de Tolnay 1943, p. 58, no. 152, repr.; Tietze 1947, no. 4, repr.; Mongan 1949, entry (by Agnes Mongan) on p. 14, repr. on opp. page; Held 1953, repr. p. 12; Panofsky 1953, vol. 1, note 316[5] (as follower of Dirc Bouts), vol. 2, pl. 267, no. 423; Faison 1958, mentioned and repr. p. 138; Vorenkamp 1958, pp. 1–7, repr. on cover; Guitar 1959, p. 114, repr. p. 113; Schaeffer 1961, no. 26, repr.; Moskowitz 1962, no. 465, color repr. (text by Egbert Haverkamp-Begemann); Eisler 1963, p. 12, pl. 7; Chetham 1965, repr. p. 74; *Flemish . . . Art* 1965, p. 212, repr. (as Bouts?); Friedlaender 1968, Addenda no. 117, pl. 51; Chetham 1969, p. 774; AFA 1970–72, [p. xiii], fig. 15; Meder-Ames 1978, vol. 1, p. 73, vol. 2, pl. 28; Fromme 1981, p. 67; Chetham 1982, mentioned p. 26, repr. p. 36; Faison 1982, pp. 248–49, fig. 170; Prevenier and Blockmans 1986, fig. 251 (as Dirk Bouts or one of his pupils); SCMA 1986, no. 197, repr. color pl. p. 41; Panofsky 1991 (as Follower of Dirc Bouts); Kuretsky in The Hague/San Francisco 1990–91, p. 87, fig. 9; de Patoul and Van Schoute 1994, p. 120, repr. p. 388 (as Bouts [ou imitateur]); Harbison 1995, p. 71, fig. 43 (as attributed, c. 1460); New York 1998–99, p. 207, fig. 75; Ainsworth 1998, pp. 9–10, fig. 4

EXHIBITIONS London 1927, no. 504 (as Hans Memling); London 1927 (Memorial), no. 504 (as Hans Memling); San Francisco 1940, no. 409, repr. p. 100; San Francisco 1941, mentioned in introduction (unpaginated), no. 9, repr. p. 54; Montreal 1944, no. 1; Cambridge 1941; Cambridge 1948–49, no. 5; Rotterdam/Paris/Brussels 1948–49 (Paris and Brussels venues only), no. 14, pl. V (Paris), no. 13, pl. V (Brussels); Philadelphia 1950–51, no. 11, repr. (as Bouts); Worcester 1951–52, no. 4, repr.; New York 1953a, no. 33; Montreal 1953, no. 1 repr.; Brussels/Delft 1957–58, no. 32, repr. (as Bouts, not before 1467); Northampton 1958a, no. 6; Bruges/Detroit 1960–61, no. 58, repr. (entry by Lucy Ninane, "very close to Bouts"; Detroit venue only); Chicago 1961, no. 26, repr.; Cambridge 1967b; Northampton 1979b, no. 3; Northampton 1982a; Northampton 1983a, no. 30, repr.; Northampton 1984b, no. 1

Purchased, Drayton Hillyer Fund
1939:3

One of the most celebrated early Netherlandish portrait drawings, this work is among the most significant in the SCMA collection, as Northern drawings of this period and quality are quite rare. The drawing is executed on a paper prepared with an ivory-colored ground. For metalpoint drawings a ground was commonly made of powdered bones or lead white mixed with a binder of gumwater (water with gum arabic) or size and applied in several coats to the paper. In this drawing the lines left by the metalpoint of the stylus have oxidized to the medium-

brown tone characteristic of silverpoint.[13] Examination under the microscope reveals that the drawing is almost entirely original. As noted by Robert O. Parks in 1958, at three places on the shoulder and sleeve the drawing has been strengthened with touches of graphite. These are the only marks that can be attributed to a later hand.[14]

First published as a work by Hans Memling,[15] the drawing was still listed under his name in the Vasari Society's (1921) publication of drawings from the Oppenheimer collection, although A. E. Popham's entry

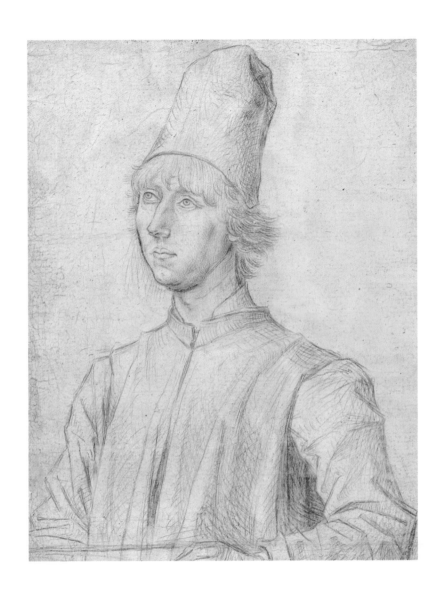

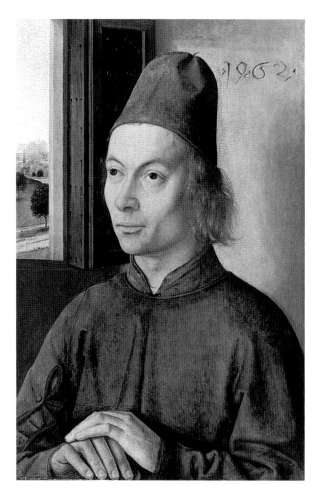

Fig. 1. Dieric Bouts, *Portrait of a Man*, 1462. Oil on oak panel, 31.5 × 20.5 cm (12⅜ × 8⅛ in.). The National Gallery, London, Wynn Ellis Bequest, 1876. Photo: © The National Gallery

noted the similarity to the dated (1462) *Portrait of a Man* by Dieric Bouts in the National Gallery, London (fig. 1).[16] A few years later (1926) Popham reattributed the silverpoint to Bouts "without any complete conviction," suggesting that it might also be by an anonymous Bruges artist under Bouts's influence.[17] Since then the drawing has generally been given to Bouts, although scholars still debate whether it is by his own hand, a close associate, or a follower.

Dieric Bouts is said by the biographer Karel van Mander (1604) to have been born in Haarlem, in the Northern Netherlands.[18] He is first documented in Leuven (Louvain), where he spent the remainder of his career, in 1457. Although he is thought to have moved there some years earlier, possibly between 1444 and 1448 (he married the daughter of a wealthy Leuven citizen, probably by 1447 or 1448),[19] it is unclear whether he spent the years between his marriage and 1457 in Leuven. In fact, Bouts's training and early career remain the subject of speculation. His later life in Leuven was distinguished by two major works for which substantial documentation exists. Bouts made his will in April 1475 and is believed to have died a few weeks later.

Attributions of works to Bouts are based on stylistic comparison with his two documented works. The first, the triptych of the Last Supper, was commissioned by the Confraternity of the Holy Sacrament for the church of Saint Peter at Leuven in 1464 and was finished in 1467, the final payment being made in 1468.[20] The second was a major commission from the city of Leuven, a series of large panels for the town hall depicting the Justice of Emperor Otto. Bouts received this commission in 1468: one panel, *The Judgment of God,* was finished in 1473; another, *The Decapitation of the Count,* remained incomplete at the artist's death in 1475.[21]

Since Popham's observations in 1921, the SCMA silverpoint has been related to the National Gallery's *Portrait of a Man,* which is unanimously attributed to Bouts and bears the date of 1462.[22] Wolfgang Schöne (1938) considered the drawing to be undoubtedly autograph and of the same period as the National Gallery portrait, but of a different subject, probably a study for a painting.[23] This opinion was shared by Alphons Vorenkamp. The attribution was also accepted by Charles de Tolnay, Hans Tietze, Agnes Mongan, and Karel Boon, although they disagreed about the drawing's date of execution.[24] Whereas de Tolnay, like Schöne and Vorenkamp, dated it about 1462, Tietze dated it about 1462–70, Mongan placed it about 1470, around the time Bouts painted *The Justice of Emperor Otto,* and Boon dated it to the late 1460s because of the subject's tall hat, a fashion he notes was not worn until about 1467.[25]

Erwin Panofsky also considered the drawing to be later than the National Gallery painting of 1462 on the basis of the young man's hairstyle and tall hat, dating the silverpoint to about 1470. Moreover, he interpreted it as the artist's self-portrait, a reading of the drawing that dates back as far as the 1866 Wellesley collection sale catalogue.[26] Panofsky could not, however, attribute the drawing to Bouts, as the artist would have been substantially older than the subject of the SCMA drawing; Panofsky therefore believed the silverpoint to have been executed by a close follower. Most scholars do not consider the silverpoint to be a self-portrait. The bust-length portrait in three-quarter profile is a common formula in the work of early Netherlandish portraitists such as Jan van Eyck and Rogier van der Weyden, and the SCMA silverpoint reveals a debt to these masters.

Arguments for dating the drawing no earlier than the late 1460s are persuasive. Although stylistic comparison to Bouts's paintings seems to place the silverpoint securely within his orbit, certainty regarding the attribution is more elusive. Studies of Northern Renaissance drawings have come increasingly to consider the evidence for an artist's style and working methods offered by underdrawings, made visible through infrared reflectography of paintings. Unfortunately these investigations have not resulted to date in a definitive attribution for the SCMA portrait.[27] As has been noted repeatedly in the literature, however, the SCMA silverpoint is the only drawing that can be plausibly argued to be by Bouts.

AHS

1. No documents have been found to verify either the place or date of Bouts's birth. He is thought to have been born in Haarlem (see below for discussion). Hand and Wolff 1986 accept c. 1415–20 as the probable date of his birth; Leuven 1998 places it c. 1410.

2. The drawing was examined for a watermark at the Straus Center for Conservation and Technical Studies, Harvard University, in 1990 to see if any physical evidence could be found that might lend support to a particular dating or attribution. Various X-ray techniques were used, but no watermark could be found (see letter from Craigen Bowen to the author, 20 March 1990, SCMA curatorial files).

3. This refers to the painting in the National Gallery, London, *Portrait of a Man* dated 1462 (not 1464), formerly in the collection of Samuel Rogers, London (sold London, Christie's, 2 May 1856, lot 599). See Davies 1968, no. 943. On the confusion of Dieric Bouts with the artist Hubrecht Stuerbout, reflected here in the attribution to "Dirck Sturb," see Goffin 1907, p. 44, and Jacob Wise, "Distinguishing between Bouts and Stuerbout as Official City Painters," pp. 19–33 in Leuven 1998.

4. The National Gallery's *Portrait of a Man* has sometimes been identified with a 1462 painting, called a self-portrait by Rogier van der Weyden, seen by Marcantonio Michiel in Venice in 1531 (in the collection of Zuan Ram). See Davies 1968, no. 943.

5. Catalogue in FARL annotated in ink with price: "£21." A sale cat. in the Getty Center Library (original owner of the cat. not indicated) gives the buyer as "Whitehead."

6. Frederick Locker purchased a drawing attributed to Titian (*The Miracle of the Infant Child, Made to Speak by Saint Anthony of Padua in Defence of His Mother's Honor*) from the Wellesley sale. The drawing, now in the Frits Lugt Collection, Fondation Custodia, Paris (inv. 1502, Byam Shaw 1983, no. 228, repr.) is inscribed in Locker's hand: *Frederick Locker / Bought at Dr. Wellesley's Sale. July 1866.* Although the transaction is undocumented, it is likely Locker purchased the Bouts directly from "Whitehead," the buyer at the Wellesley sale, as Locker was also the next recorded owner of another drawing in the Lugt collection (by Domenico Campagnola; inv. 1503, Byam Shaw 1983, no. 232, repr.) that was purchased at the Wellesley sale by "Whitehead."

7. Mrs. Locker-Lampson is recorded as the owner of another drawing reproduced in facsimile by the Vasari Society 1909–10.

8. From Godfrey Locker-Lampson according to Lugt (see also annotation in FARL catalogue). According to an annotated catalogue from R. W. Lloyd, Esq., in the Getty Center Library, lot 142 was purchased for £650 (but see below).

9. According to Stephen Ongpin of Colnaghi, who reads the firm's price code for this purchase as £682.10 (letter to the author, 19 Sept. 1996, SCMA curatorial files).

10. Ibid. The annotated copy of the catalogue inscribed *G. K. W.* in the Getty Center Library incorrectly records the purchase price as £715.

11. According to the annotated sale catalogue in the Getty Center Library "ex libris R.W. Lloyd," which also contains a newspaper clipping from the day following the sale (14 July), reporting "£4,200 for a Dirk Bouts Drawing," "the highest price of the afternoon," and according to which the drawing was purchased by Colnaghi; the article also reports that "This drawing . . . cost Mr. Oppenheimer £715 in 1919."

12. Colnaghi's records show the firm was probably acting as agent for Rosenthal, as they purchased the drawing for a hammer price of 4,000 guineas and sold the drawing to Rosenthal on 15 July 1936 for 4,200 guineas, the amount probably reflecting the buyer's premium. Ongpin letter (see note 9).

13. On the technique of silverpoint, see Cennini, p. 17.

14. See Vorenkamp 1958, p. 7 note 14. Recent examination of the drawing under the microscope has confirmed Parks's observations. As he points out, Boon's suggestion that the pupils of the eyes were drawn by a later hand (Bruges/Detroit 1960–61, no. 58) is unfounded; the lines of the eyes are drawn in the same metalpoint as the rest of the drawing.

15. This attribution dates at least as far back as the Wellesley sale (1866) and is repeated in the catalogue of the Locker-Lampson collection, as well as in the sale catalogue of 1918. As Vorenkamp (1939a, p. 3) points out, this attribution may have been arrived at by analogy with the National Gallery painting, which was also once attributed to Memling. The date of the anonymous inscription on the verso of the drawing's mount is unknown. The mount has clearly been cut down, and, as the inscription is virtually complete, it must have been written after the mount was first trimmed.

16. Vasari Society 1921, no. 11.

17. Popham 1926, p. 8.

18. Van Mander 1604/1994–, vol. 2, fol. 206v.

19. This date has been calculated based on a document regarding the artist's eldest son, also named Dieric. See Wolff 1989.

20. Painted on panel; it is still in the church of Saint Peter, Leuven.

21. Both panels are now in the Musées Royaux des Beaux-Arts, Brussels. A painting of the Last Judgment was commissioned at the same time by the city of Leuven and was completed by the time of Bouts's death. The two paintings, the *Fall of the Damned into Hell* and the *Ascension of the Saved into Heaven,* both in the Musée des Beaux-Arts, Lille, are usually identifed as the wings of this work; the central panel is lost.

22. The attribution to Bouts was made by Crowe and Cavalcaselle in 1857, and has been accepted since that time.

23. Schöne 1938, p. 88.

24. See Vorenkamp 1939a; de Tolnay 1943, p. 130; Tietze 1947, p. 8; Mongan 1949, p. 14; and Boon in Brussels/Delft 1957–58, no. 32.

25. Brussels/Delft 1957–58, no. 32. Boon cites as his authority the costume specialist F. W. S. van Thienen.

26. Panofsky 1953, vol 1., note 316[5]. In the Wellesley sale catalogue the drawing is described as Memling, "his own portrait"; in the Locker-Lampson catalogue of 1886, the drawing is "ascribed to Memling, portrait of a man" and says that it is "said to be by" (a typographical error for "of"?) the artist himself.

27. Virtually no underdrawing is visible in the figure in the National Gallery's *Portrait of a Man* (letter to Kristen Erickson from Dr. Susan Foister, 13 May 1996, in SCMA curatorial files). See also J. R. J. van Asperen de Boer, "Observations on Underdrawing and the Creative Process in Some Dirk Bouts Paintings," pp. 259–66 in Leuven 1998 (for infrared reflectographs of the *Justice of Emperor Otto* panels, see. p. 577 fig. 2, p. 578 figs. 3 and 4, and p. 579 figs. 5–7).

BACCIO DELLA PORTA (CALLED FRA BARTOLOMMEO)
Florence 1472–1517 Florence

2 *View of the Ospizio di Santa Maria Maddalena at Caldine; View of a Farmhouse*, c. 1508

Pen and brown ink on cream antique laid paper; laid down on album sheet

Sheet: 281 × 215 mm (11 × 8⁷⁄₁₆ in.); mount: 411 × 276 mm (16³⁄₁₆ × 10⁷⁄₈ in.)

Watermark: A fruit, very close to Briquet 7386 (Florence 1507)

PROVENANCE Probably among the drawings bequeathed by the artist to Fra Paolino da Pistoia (c. 1490–1547), monastery of San Marco, Florence; possibly given or bequeathed to Suor Plautilla Nelli (1523–1588), convent of Santa Caterina da Siena in Piazza San Marco, Florence (which she entered in 1537); possibly to the convent of Santa Caterina da Siena, Florence; Francesco Maria Nicolò Gabburri (1676–1742), Florence, after 1722 (as by Andrea del Sarto), in an album apparently assembled by Gabburri in 1730;[1] to his heirs; to Mr. Kent,[2] apparently an art dealer living in Rome in the 1740s–50s, who sold the album in London; to a collector in England by 1768;[3] an Irish collector in 1925 (sale, London, Sotheby's, 20 Nov. 1957, no. 8, repr.; to {P. & D. Colnaghi, London} as agent for SCMA

LITERATURE Gronau 1957, no. 8, pl. 15; *ArtQ* 1958, listed p. 91; Kennedy 1959, pp. 1–12, figs. 1 and 2 (detail); SCMA 1986, no. 202, repr. (as c. 1512–16); Fischer 1989, pp. 310, 313 note 34, fig. 15; Rotterdam 1990–92, pp. 375–77, 383 note 23, 386, and 390, under no. 110, fig. 258; New York 1994a, under no. 17

EXHIBITIONS Northampton 1958a, no. 2; Northampton 1979b, no. 2; Northampton 1982c; Northampton 1984b, no. 2; Northampton 1987b, no. 10

Purchased
1957:59

This drawing once formed part of an important album of landscape drawings by Fra Bartolommeo that was dismembered and dispersed at auction in 1957. Of over one hundred such drawings listed in the inventory of the artist's studio at the time of his death, only about a dozen pen and ink landscape drawings by the artist were known until the rediscovery of this album, which contained forty-one sheets holding sixty landscape drawings.[4] The addition of so many drawings to his oeuvre sparked a reassessment of Fra Bartolommeo as a draughtsman and has led to a number of discoveries regarding his working methods.

The landscape album was assembled (apparently in 1730) by the Florentine connoisseur and collector Cavaliere Francesco Maria Nicolò Gabburri, who was also responsible for compiling the two important volumes of Fra Bartolommeo figure drawings now in Rotterdam (Museum Boijmans-van Beuningen).[5] However, it is clear from the landscape album's title page, which, like its frontispiece, was drawn in 1730 by Rinaldo Botti (1650/60–1740) especially for the album, that Gabburri believed the drawings to have been made by Andrea del Sarto.[6] As Chris Fischer notes in discussing the provenance of Gabburri's albums, it is surprising that the collector should have been mistaken in his attribution if he acquired the drawings from the same source from which he acquired the sheets in the Rotterdam albums. The latter drawings had passed at Fra Bartolommeo's death from his workshop in the monastery of San Marco, Florence, to his heir and fellow painter Fra Paolino da Pistoia (c. 1490–1547), who gave or bequeathed them to his own pupil, the painter and Dominican nun Suor Plautilla Nelli (1523–1588), resident at the convent of Santa Caterina da Siena in Piazza San Marco, Florence.

After Suor Plautilla's death the drawings remained in the convent, where Gabburri discovered them.[7] Although this has always been considered the provenance of the landscape album's drawings as well, Fischer has more recently suggested that these sheets may have been purchased by Gabburri from a different source, and that they may have been among the drawings that left Fra Bartolommeo's workshop sometime between the inventory following the artist's death in October 1517 and Lorenzo di Credi's appraisal of the drawings "and other implements" given to Fra Paolino.[8]

The landscape album's individual sheets, a number of which have drawings on both recto and verso, were mounted so that both sides were visible, an unusual practice for the time but one used by Gabburri in the Rotterdam albums as well.[9] The SCMA drawing, like the other landscapes, was executed in pen and brown ink. Although only the recto of this sheet was used by the artist, it nonetheless bears two discrete drawings, which are oriented in opposite directions. The larger drawing depicts a substantial building with an arcade, the other a farmhouse.

The SCMA drawing was one of only two from the album whose subjects were known in 1957, when Carmen Gronau published Dr. Hannah Kiehl's identification of the arcaded building as the monastery of Santa Maria Maddalena in the Mugnone Valley (as seen from the south).[10] Built between 1464 and 1482, this monastery was an *ospizio* (hospice), one of several not far from Florence that belonged to the convent of San Marco and offered hospitality to traveling friars.[11] It also served as a summer retreat and a home for elderly or infirm friars. As Fischer notes, Fra Bartolommeo's travels suggest that he would have been a frequent guest at this *ospizio*,

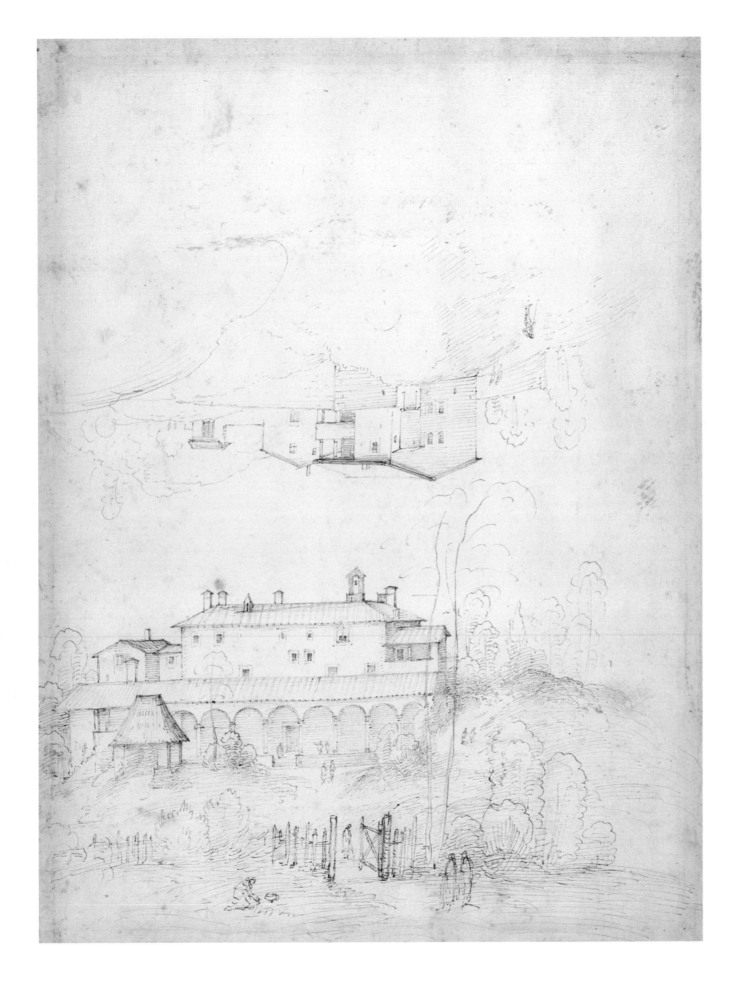

which stood near the village of Le Caldine on the Via Faentina, one of the main roads leading from Florence to the northeast.[12]

Baccio della Porta trained with the Florentine painter Cosimo Rosselli from about 1483/84 until about 1490/91, when he left this workshop to establish a partnership with Mariotto Albertinelli, also a pupil of Rosselli. Deeply influenced by Girolamo Savonarola, the charismatic preacher who became prior of San Marco in Florence in 1491 and exercised great power in the city until he was tried and burned as a heretic in 1498, Baccio had already spent considerable time at the monastery of San Marco when he decided to become a Dominican monk. In 1500 he began his novitiate at San Domenico in Prato, taking his first vows as a friar in 1501 and settling permanently at San Marco after completing his education in 1504. He soon resumed painting, and subsequent years brought many important commissions to his workshop at San Marco.

Like several other landscape drawings by Fra Bartolommeo, the SCMA sheet was used for two different compositions, an economical use of his paper that the artist seems to have intended from the outset.[13] Both compositions appear to have been drawn from nature, and that depicting Santa Maria Maddalena is easily recognized as the *ospizio*. As has been demonstrated clearly by Fischer, however, some landscape drawings were composed by Fra Bartolommeo in the studio on the basis of other drawings done from nature. This is the case with a different view of the same *ospizio*, which was combined with an imaginary setting of large rocks in a drawing in the Albertina (fig. 1).[14] It is based on a lost drawing of Santa Maria Maddalena from the northeast that is known from three copies in the Uffizi, a drawing that seems to have been similar in feel to the SCMA sheet and was probably drawn from nature (although not necessarily with strict topographical accuracy).[15] The second drawing on the SCMA sheet, which depicts a farmhouse, is simpler and even more spontaneous and compares with farmhouses in drawings such as the *Landscape with Farm Buildings* in the Ashmolean.[16]

The dating of Fra Bartolommeo's landscape drawings remains somewhat uncertain. Carmen Gronau pointed out that the chimney pots in some of the town views in the album suggest a relationship to the Frate's trip to Venice in 1508.[17] Other drawings have also been placed with some certainty in the early years of the century.[18] But whereas Fischer believes the group of landscape drawings was executed between 1495 and 1508, Charles Ellis is of the opinion that Fra Bartolommeo made such drawings throughout his career.[19] Although watermarks on some sheets from the album (including the SCMA drawing) also appear in documents dated 1507 and 1508, they provide evidence only for an approximate dating of the drawings.[20]

Fra Bartolommeo could have visited the *ospizio* of Santa Maria Maddalena on a number of occasions and seems to have spent considerable time there after he

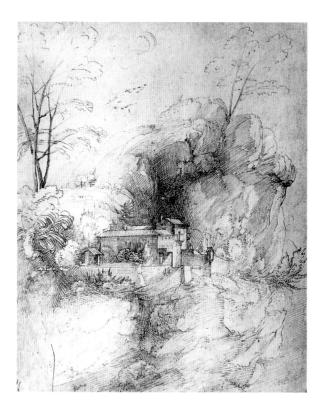

Fig. 1. Fra Bartolommeo, *Landscape*. Pen and brown ink, 260 × 209 mm (10¼ × 8¼ in.). Graphische Sammlung Albertina, Vienna, inv. 270

returned to Florence from Rome in 1514, painting several frescoes in its buildings, including a *Noli me tangere* (dated 1516) in a small chapel that was erected in the garden. The SCMA drawing evidently precedes the building of this chapel, which was constructed on the site where a kneeling monk is depicted in Fra Bartolommeo's drawing.[21] Ruth Kennedy's proposal of a date about 1508 is persuasive, especially given the drawing's resemblance to another sheet from the album now in Cleveland, the only one of these drawings that has been connected with a painting by the Frate himself.[22] Cleveland's *Farm on the Slope of a Hill*, which is very close to the farmhouse depicted in the background of Fra Bartolommeo's *God the Father, Saint Catherine of Siena, and Saint Mary Magdalen* (signed and dated 1509), exhibits a similar handling of the pen strokes that describe buildings, foliage, and fence to those in the SCMA drawing.

AHS

1. See Chris Fischer in Rotterdam 1990–92, pp. 13–14. The title page of the album (*Raccolta di Paesi e Vedute dal Vero di mano d'Andrea del Sarto*) is signed and dated: *Rinaldo Botti 1730*. Gabburri's coat of arms appears on the frontispiece, also drawn by Botti. Both drawings are in the Frits Lugt Collection, Fondation Custodia, Paris (see Rotterdam 1990–92, figs. 248 [frontispiece] and 249). In 1722, when Gabburri compiled a catalogue of his drawings, no sheets by Fra Bartolommeo or Andrea del Sarto were listed. For

a full discussion of the provenance of the landscape album and of the two albums of Fra Bartolommeo figure drawings in Rotterdam, see Rotterdam 1990–92, pp. 12ff.

2. Not the architect William Kent, as sometimes stated (see Fischer 1989, p. 302 and note 15).

3. Three of the drawings were copied by Robert Surtees, an amateur from Durham, in drawings dated 1768 (see Fischer 1989, p. 302, figs. 3 and 4).

4. See Fischer 1989, p. 301 note 3, and Rotterdam 1990–92, p. 12.

5. These two volumes appear to have been assembled at the very end of 1529 (Rotterdam 1990–92, p. 14).

6. For reasons why he might have assigned the landscapes to Andrea even if he did acquire them from the convent of Santa Caterina, see Gronau 1957, p. iv. See also Fischer in Rotterdam 1990–92, p. 375. He points out that the Rotterdam volumes contain almost exclusively chalk drawings, which he concludes must have constituted the separate sheets listed in the inventory after the Frate's death, whereas the pen and ink drawings (those the landscape album included) probably derived from sketchbooks, 12 of which are listed in the inventory of his workshop (Rotterdam 1990–92, p. 18). The Rotterdam albums also contain some drawings by other artists that were preserved with Fra Bartolommeo's workshop, some of them attributable to Albertinelli, Sogliani, and Fra Paolino da Pistoia, the Frate's heir (Rotterdam 1990–92, pp. 20–21).

7. On this provenance, see Fischer in Rotterdam 1990–92, who corrects and amplifies the provenance as given by earlier writers. Gabburri had apparently found the drawings by following the information given by Giorgio Vasari in his life of Fra Bartolommeo. On the date of his purchase, see Rotterdam 1990–92, pp. 13–14.

8. Fischer notes that 66 of the separate landscape drawings listed in the former document (which was also drawn up by Lorenzo di Credi) are missing from the latter (Rotterdam 1990–92, pp. 12–13). See also Gronau 1957, p. iv, who notes that Gabburri, in his life of Fra Bartolommeo, gives the number of drawings in his possession as 600, but reduces that number to 500 in the life of the artist that appeared in volume 3 of Filippo Baldinucci's *Notizie de' professori del disegno da Cimabue in qua,* which he helped edit (published 1728). She thinks Gabburri may have been led by the inscription on one of the landscape drawings to attribute the lot to Andrea del Sarto.

9. Fischer in Rotterdam 1990–92, pp. 19 and 375.

10. A number of others have been identified since then, especially by Fischer 1989.

11. Two others owned by San Marco, the Madonna del Lecceto near Lastra a Signa and Santa Maria del Sasso at Bibbiena, also appear in drawings by Fra Bartolommeo. The former is depicted in a drawing in the Pierpont Morgan Library (Rotterdam 1990–92, no. 112 recto and verso, repr.; the two views probably done between 1498 and 1504 according to Fischer), the latter in two

drawings in the Albertina (Rotterdam 1990–92, nos. 108 and 109, both repr.; Fischer dates both between 1507 and 1512) and a drawing in the Ashmolean Museum, Oxford (Rotterdam 1990–92, fig. 251).

12. On the *ospizio,* see Gronau 1957, Fischer 1989, and Rotterdam 1990–92.

13. For examples similar to the SCMA sheet, see Rotterdam 1990–92, p. 383 note 23. Fischer believes the two drawings once owned by Mariette and now in the Albertina (one of Santa Maria del Sasso, the other of a nearby farmhouse) were also originally on one sheet but were divided by Mariette (see Rotterdam 1990–92, nos. 108 and 109, both color repr.). The latter drawing has inserted in it (probably also by Mariette) a small drawing of a capital from the *ospizio* of Santa Maria Maddalena.

14. See Fischer 1989, p. 315 and fig. 19, and Rotterdam 1990–92, no. 110, color repr.

15. See Ellis 1990, p. 7 and p. 16 note 29. On the Uffizi copies (inv. 48P, 964P, and 966P), see Fischer 1989, fig. 20 (Uff. 48P) and p. 340 note 45; see also Rotterdam 1990–92, fig. 255 (Uff. 48P) and p. 389 note 33. Other examples of paired drawings, one from life, the other drawn in the studio, are cited by Fischer in Rotterdam 1990–92, nos. 165 and 166, and Ellis 1990.

16. See Fischer 1989, fig. 39.

17. Gronau 1957, p. v. The artist departed from Florence in March or April 1508 and returned in June or July the same year. Other documented trips took the Frate to Rome at the beginning of 1514 and back to Florence in the summer, and to Ferrara in May 1516. He also presumably went to Lucca in 1509–10 in connection with his painting of *The Virgin and Child with Saints Stephen and John the Baptist* for Lucca cathedral, although this trip is undocumented (see chronologies in Florence 1986–87 and Rotterdam 1990–92).

18. See, e.g., a landscape in the Metropolitan Museum of Art that appears to be worked up from a drawing in the Louvre, which is based in turn on the landscape background in Dürer's engraving *Hercules at the Crossroads* of c. 1498–99 (which was copied by Fra Bartolommeo in another drawing at the Louvre). See Fischer 1989, figs. 12–14. See also the landscape in Cleveland mentioned below.

19. Rotterdam 1990–92, p. 375, and Ellis 1990, p. 12.

20. One watermark (a fruit), which Briquet found on a document from Florence dated 1507, appears on sheets 7, 8 (SCMA drawing), 12, 17, and 20 of the album. The other (a flower, Briquet 6664), which Briquet found on a Florentine document of 1508, appears on sheets 13, 15, 24, and 32 (see Gronau 1957). As Fischer cautions, however, Briquet's dates are the dates of the documents, not necessarily the dates the papers were made (p. 75 note 8).

21. Fischer 1989, p. 313.

22. See Rotterdam 1990–92, p. 319, for other echoes of the motif in works by the Frate's associates. See also New York 1994a, p. 21, under no. 17 (entry by William M. Griswold).

MATHIS GOTHART NITHART (CALLED GRÜNEWALD), COMMONLY KNOWN AS MATTHIAS GRÜNEWALD[1]

Wurzburg c. 1475/c. 1480–1528 Halle

3 *Study of Drapery*, c. 1508–15

Black chalk on cream antique laid paper; losses at upper and lower left corners made up

Watermark: None

131 × 181 mm (5⅛ × 7⅛ in.)

Inscribed recto, lower right, in graphite (by a later hand): *A. Durer;* inscribed verso, upper left, in graphite(?): *89,* and lower left, in graphite: *Grunewald*

PROVENANCE Luigi Grassi (d. c. 1937, according to Lugt), Florence (Lugt Suppl. 1171b, lower right recto); to Frits Lugt (1884–1970), Maartensdijk (near Utrecht) and Paris, in 9 Nov. 1923[2] (sale, London, Sotheby's, 13 May 1924, as from the "G. L. Collection," no. 89, repr. opp. p. 7); to {P. & D. Colnaghi, London} for £76, stock no. 4231,[3] as agent for Henry Oppenheimer (1859–1932), London (to Oppenheimer on 27 May 1924 for £76);[4] to his estate (sale, London, Christie's, 10–14 [10, 13, 14] July 1936, third day, no. 377, pl. 86); to "Eisemann," probably {Heinrich Eisemann (1890–1972), London}, for £388.10.0;[5] Ludwig Rosenthal (1893–1972), Bern (afterward called L. V. [Lewis Valentine] Randall [1893–1972], Montreal) before 1940;[6] {Schaeffer Galleries, New York};[7] LeRoy M. Backus (1879–1948), Seattle, before 1940; to his estate (his widow), his son, Manson F. Backus III, executor;[8] to {Schaeffer Galleries, New York}, as agent, 1948–49; Major Eric H. L. Sexton (b. 1902), New Canaan, Conn., by 1953 (Lugt Suppl 2769c, lower left verso);[9] to {Schaeffer Galleries, New York}, as agent;[10] sold to SCMA in 1958

LITERATURE Friedlaender 1926, p. 14, repr. p. 8; Friedlaender 1927, no. 1, pl. 1; Fuerstein 1930, p. 138, no. 1, pl. 64; Burkhard 1936, no. 24, pl. 82, mentioned p. 70; Zülch 1938, no. 6, fig. 173; Tietze 1947, p. 66, no. 33, repr. p. 67; Schoenberger 1948, no. 13, repr. (as on yellow-brown paper); New York 1948b, no. 20 (as *Study for a Crouching Figure;* represented in exhibition by a photograph, according to annotated copy of cat. in FARL; the drawing was in Cambridge 1948–49); Mongan 1949, p. 46 (entry by Agnes Mongan), repr. on opp. p.; Behling 1955, no. 4; Jacobi 1956, p. 24 note 101, pp. 26–30, p. 27 note 124, p. 113; Meier 1957, no. 7, repr.; Pevsner and Meier 1958, mentioned p. 26, no. 7, repr. p. 31, fig. 7; *SCMA Bull* 1958, fig. 13; Guitar 1959, p. 114; *ArtQ* 1959, listed p. 220, repr. p. 236; Weixlgärtner 1962, p. 42, no. 6, repr.; Hütt 1968, p. 93, fig. 74 (as *An Apostle for Transfiguration*); Chetham 1969, pp. 774–75, repr. p. 775; Ruhmer 1970, pp. 22, 80, no. 3, pl. 3; AFA 1970–72, [p. xiv], fig. 21; Bianconi 1972, no. 42; Baumgart 1974, no. 18, repr.; *Drawings 1977*; Behling 1981, p. 11; Fromme 1981, p. 67; Faison 1982, p. 249, fig. 170; Fraenger 1983, repr. p. 86; SCMA 1986, no. 200, repr.; Reichenauer 1992, p. 202

EXHIBITIONS San Francisco 1940, no. 51, repr.; San Francisco 1941, no. 450; New York 1941, no. 24; Portland 1946;[11] Cambridge 1948–49, no. 19 (as black crayon); Montreal 1953, no. 88, repr. (as *Garment Study for the Transfiguration*); Northampton 1958a, no. 34 (as about 1512, presumed study for the lost *Transfiguration*); Newark 1960, no. 14, repr.; Chicago 1961, no. 30; Los Angeles 1976, no. 177, repr. p. 161; Northampton 1979b, no. 8; Northampton 1984b, no. 4

Purchased with an anonymous gift in honor of the class of 1898
1958:3

From the time it first appeared on the art market in 1924, this drapery study has been universally accepted as a work of Matthias Grünewald. The only Grünewald drawing in America, the SCMA sheet is among a relatively small number of drawings by this master that have survived; fewer than forty are generally accepted as autograph. It is clear, however, that Grünewald's drawings were collected and greatly appreciated in his lifetime, and that many more drawings originally existed than have come down to us. A number of drawings ascribed to Grünewald are listed in the inventories of sixteenth-century collections, and the seventeenth-century French traveler Balthasar de Monconys recorded in his diary (1663–64) that he had seen in the collection of Abraham Schelkens in Frankfurt a volume of drawings by Grünewald.[12] This was the same album known to Joachim von Sandrart, Grünewald's first biographer, who had studied it in Frankfurt some fifty years earlier when it was in the collection of the painter Philipp Uffenbach.[13] Most of the drawings for which we have early notices cannot be traced past the seventeenth cen-

tury, however, and nothing is known of the SCMA drawing's provenance prior to its ownership by Luigi Grassi in the early 1920s. Like several other autograph drawings, it bears a later, handwritten attribution to Grünewald's exact contemporary, Albrecht Dürer (1471–1528).[14]

The SCMA drawing is a study of voluminous drapery beneath whose folds are barely discernible the knees and legs of a seated or recumbent figure whose feet are totally concealed by the flowing hem of the garment. Eberhard Ruhmer's suggestion that Grünewald may have drawn on occasion from a lay figure may be supported by the appearance of the SCMA sheet, a carefully rendered drawing without pentimenti. It has been noted, however, that Grünewald drawings in general exhibit relatively few pentimenti.[15]

The drawing is executed in black chalk, which appears to have been stumped or rubbed in areas of shadow to blend the individual strokes of the medium. The chalk is of a rather greyish tone and of a medium hardness, sharpened to a point to render delicate contour lines (e.g., the hem of the garment) and used with a blunter tip to

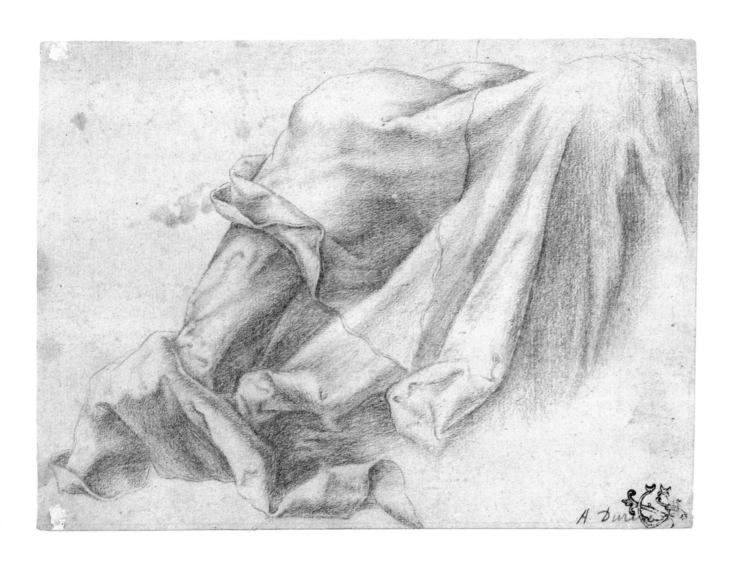

shade the deep troughs of the drapery folds. Although over the years the drawing's surface may have been somewhat rubbed overall, it still preserves a great delicacy and impressive three-dimensionality. On the evidence of the surviving drawings, black chalk was Grünewald's preferred medium throughout his life. Whereas Dürer favored pen and ink for figure and drapery studies, modeling forms with precisely ordered linear hatchings, Grünewald applied the more atmospheric medium of chalk in a less systematic way.[16]

Since 1927, when Max Friedlaender published the SCMA drawing as a probable study for Grünewald's lost Frankfurt *Transfiguration* (1511), most scholars have considered it a preparatory drawing for one of the three apostles who traditionally appear in this subject. The Gospels of Matthew (17:1–9), Mark (9:2–9), and Luke (9:28–36) recount how Peter, James, and John accompanied Jesus to "a high mountain," where he was transfigured in their presence, his face shining like the sun and his clothing transformed to dazzling white.

Grünewald's painting *The Transfiguration* is cited in von Sandrart's biography as being in the Dominican church in Frankfurt.[17] A document of 1511–12, which mentions Grünewald's work there, has enabled scholars to date the painting although evidence for its appearance is limited.[18] Von Sandrart describes it in 1675 as a "watercolor" painting showing "in the forefront a wondrous fair cloud, wherein appear Moses and Elijah, as well as the apostles kneeling on the ground."[19] In 1679 he mentions it again, noting, "Also at the foot of the mountain, the apostles in a very ecstasy of fear."[20]

Two studies in the Print Room, Dresden, both executed in black chalk heightened with white, have convincingly been associated with Grünewald's *Transfiguration.* One, representing a falling man seen from the side, has usually been identified as Peter because of his tonsure, while the other, a falling man seen from the back, has been tentatively identified as James.[21] In both cases these figures appear agitated, gripped by a strong emotion, and conform to von Sandrart's description of "kneeling" apostles "in a very ecstasy of fear."[22] The textual sources for depictions of the apostles' attitude were Mark, who notes their emotion, and Luke, who describes them as "heavy with sleep." The latter gave rise to a tradition of depicting the apostles as sleeping or as reclining, but awake and dazzled by their vision of Christ.[23] An early misreading of the SCMA study as representing a "kneeling" or "crouching" figure facing right, "the head... omitted, or... completely covered by the cloak," could logically connect the figure's pose and attitude with that of the Dresden figures, who conform to Mark's description of the apostles as "sore afraid."[24] However, the SCMA study is for the draped legs of a seated figure facing left in a static pose that is difficult to reconcile with the agitation of Grünewald's *Transfiguration.*[25]

Chronological classification of Grünewald's drawings has proved difficult and remains controversial, as few sheets can be shown conclusively to be for known, dated

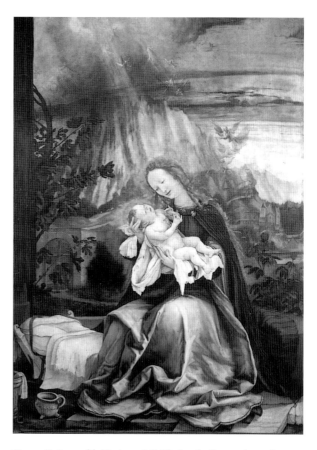

Fig. 1. Grünewald, *Virgin and Child,* detail of central panel from the Isenheim altarpiece, 1516. Oil on panel, 265 × 304 cm (104⅜ × 119⅝ in.). Musée d'Unterlinden, Colmar. Photo: O. Zimmermann

paintings.[26] Most scholars have dated the SCMA drapery study to 1511 on the basis of its presumed connection to the Frankfurt *Transfiguration.* The only dissenting voices are Eberhard Ruhmer and Fritz Baumgart, who nonetheless disagree as to a more likely date for the sheet. Whereas Ruhmer dates it on stylistic grounds "much earlier" than *The Transfiguration* (but does not propose a specific year), Baumgart prefers a later dating (also on stylistic grounds), placing it between 1512 and 1519.[27]

Perhaps the most likely explanation of the Smith College sheet is as an independent study, which could serve as a model for a variety of paintings. It may well be an early drawing to which Grünewald returned for inspiration. As Ruhmer notes, the SCMA drawing appears to have been used, with some modifications, for the draperies of the seated Virgin in the panel of the Madonna and Child in the Isenheim altarpiece, which was finished by 1516 (fig. 1).

AHS

1. Concerning Grünewald's original name, see Behling 1981, p. 89, postface, no. 2.

2. According to Byam Shaw 1983 (note 4 under no. 193), Lugt acquired from Grassi on 9 Nov. 1923 a group of over 500 draw-

ings, of which he retained 37, exchanging 52 with the Albertina that year, and selling the remainder 13 May 1924 at Sotheby's, London, nos. 48–154, described as from the "G. L." [Luigi Grassi] collection.

3. According to annotated sale catalogue, unillustrated version, in the Watson Library, Metropolitan Museum of Art; see also Lugt Suppl under 1171b for mention of the drawing and the sale price ("Etude de draperie par Grunewald £76").

4. According to Stephen Ongpin of Colnaghi (letter to the author, 19 Sept. 1995, SCMA curatorial files), the firm must have been acting as agent for Oppenheimer, as the drawing was sold to him on 27 May for the same price paid for the drawing at auction.

5. According to annotated sale catalogue at Getty Library, "ex libris R. W. Lloyd"; for 370 guineas to "Eisemann" according to annotated catalogue in Getty "ex libris Clifford Duits."

6. Information from Schaeffer Galleries, New York, in SCMA curatorial files (see also San Francisco 1940, no. 51).

7. Schaeffer Galleries and Julius H. Weitzner, New York, according to Janos Scholz (note in SCMA curatorial files, unconfirmed).

8. Information from Schaeffer Galleries in SCMA curatorial files; Mrs. Leroy M. Backus is recorded as the lender to Cambridge 1948–49.

9. See Lugt Suppl 2769c for mention of the Grünewald drawing.

10. See correspondence in SCMA curatorial files.

11. According to Montreal 1953, no. 88. The Portland Art Museum has no checklist of the exhibition and has not been able to confirm this drawing was included (letter from Barbara Anderson to the author, 18 July 1994, SCMA curatorial files).

12. See Schoenberger 1948, p. 9.

13. Joachim von Sandrart in his *Teutsche Akademie* (see Schoenberger 1948, pp. 9–10, and Ruhmer 1970, p. 26.) According to von Sandrart, Philipp Uffenbach acquired the drawings after the death of the painter Grimmer (Adam or Hans), his former master, who had been a pupil of Grünewald and had obtained from that master's widow a number of magnificent sketches mostly in black chalk. After Uffenbach's death, his widow sold all the drawings, which had been collected into a book, to Abraham Schelkens of Frankfurt. On the identity of "Grimmer" and the reliability of this account, see Ruhmer 1970, p. 49 note 1. Ruhmer notes that the fate of the album after Schelkens's death in 1684 is not known. According to Pevsner and Meier 1958 (p. 26), it can be assumed that this album originally contained the drawings that Friedlaender discovered in the Savigny collection.

14. Some sheets accepted as Grünewald bear false (later) Dürer monograms. See, e.g., the Stockholm *Head of a Man* with a monogram and inscription: *Albert Durer* (Ruhmer 1970, no. XXXVII, pl. 42), and *Portrait of a Smiling Woman* (Musée du Louvre, inv. 18588) with a false monogram (see Paris 1991–92, no. 124, repr.; Ruhmer 1970, no. XVII, pl. 21).

15. Ruhmer 1970, p. 18.

16. Compare, e.g., Dürer's drapery studies for the Jacob Heller altarpiece: *Study of Drapery for a Seated Christ,* brush, pen, black ink, black ink wash, white heightening on green prepared paper (Musée du Louvre, inv. 18597; see Paris 1991–92, no. 51, repr.), or *Drapery Study* (for God the Father), Albertina, Vienna, inv. 3.117,D.89 (IEF 1984–85b, no. 6, color repr.). The Heller altarpiece was commissioned c. 1503 for the Saint Thomas chapel of the Dominican church in Frankfurt. Dürer's *Assumption and Coronation of the Virgin* for the central panel of this triptych was executed 1508–9. See also drapery studies for the mantle of the Virgin (Musée des Beaux-Arts, Lyon).

17. Von Sandrart (reprinted in Schoenberger 1948, p. 54).

18. See Schoenberger 1948, Sources, no. 1 (p. 51).

19. Von Sandrart, *Teutsche Academie,* part 1 (Nuremberg, 1675); quoted in Ruhmer 1970, p. 81.

20. Von Sandrart, *Teutsche Academie,* part 2 (Nuremberg, 1769); quoted in Ruhmer 1970, p. 81.

21. See Ruhmer 1970, nos. VI and V, pls. 7 and 6. Both were in the collection of Gottfried Winckler, Leipzig, in the early nineteenth century; his sale in 1815 included 11 drawings attributed to Grünewald. For the drawings' identification with specific apostles, see Burkhard 1936 and Schoenberger 1948, nos. 15 and 14, repr.

22. While Grünewald may have made changes in the final painting, these studies, as Ruhmer points out, cannot be "stock" drawings, but must be for a specific composition (1970, p. 22).

23. Sometimes in the "sleeping apostle" type, Peter has already awakened and shields his face from the radiance of the cloud.

24. Friedlaender 1927, no. 1; Zülch 1938, no. 6; Schoenberger 1948, no. 13.

25. Fuerstein 1930, no. 1; Burkhard 1936, no. 24; Ruhmer 1970, no. 3. Only Ruhmer and Baumgart (no. 18) remove it from association with the Dresden studies and do so on stylistic grounds. Unlike the Dresden drawings, which are heightened with white, the SCMA sheet is drawn in black chalk only. Other drawings that have been associated by most scholars with *The Transfiguration* are executed in black chalk with white heightening. See Burkhard 1936 (pl. 83) for the drawing of a kneeling man who looks upward and points (Berlin Kupferstichkabinett). In 1953 three related drawings were discovered in the Glock Bible (for a discussion of this group, see Ruhmer 1970, under no. 5).

26. See Pevsner and Meier 1958, pp. 26–27.

27. Ruhmer 1970, no. 3, and Baumgart 1974, no. 18.

4 *The Beheading of Saint John the Baptist,* c. 1516–20
Verso: *Fragmentary sketch (a figure?)*

Pen and brown ink on beige antique laid paper

Verso: Black chalk

Watermark: Fragmentary (visible along right edge), a star above a circle

216 × 158 mm (8½ × 6¼ in.)

Inscribed recto, on bodice of woman second from left, in pen and brown ink: *WR;* inscribed recto, on ledge at far right in pen and a different (lighter) brown ink: *L*

PROVENANCE Matzenauer, Vienna (collector's mark not in Lugt, lower left corner, verso, stamped in blue ink, MATZENAUER in an oval); possibly Adalbert, baron von Lanna (1836–1909), Prague (unconfirmed);[1] {Gustav Nebehay (1881–1935)}, Berlin (unconfirmed);[2] Dr. Tobias Christ (1888–1946), Basel, by 1938; to {Dr. Willi Raeber, Basel}; sold to SCMA (as School of A. Altdorfer, c. 1510) in 1957

LITERATURE Becker 1938, no. 83 (as School of Altdorfer, 1515 or later); Kurth 1938, pp. 5, 7, pl. 9; Winzinger 1952, mentioned under no. 143 (as in collection of Tobias Christ); *ArtQ* 1957b, repr. p. 472 (as Anonymous, Danube School, around 1510); *SCMA Bull* 1958, repr. no. 15 (as School of Albrecht Altdorfer or Danube School); Oettinger 1959, pp. 102–3 and 103 note 2; Packpfeiffer 1978, pp. 73–74 (as in Basel); Torriti 1981, mentioned under no. 517 (as formerly Tobias Christ collection); Paris 1984a, mentioned under pl. 248 (no. 164), entry by Bodo Brinkmann (no attribution given); SCMA 1986, no. 201, repr. (as Erhard Altdorfer or school, c. 1512–14); Berlin 1988, mentioned under nos. 26 and 191 (no attribution given)

EXHIBITIONS Northampton 1958a, no. 1 (as School of Albrecht Altdorfer); New Haven 1969–70, no. 66, pl. 17 (entry by Helen Manner); Northampton 1979b, no. 9 (as Erhard Altdorfer or school)

Purchased

1957:31

This drawing represents the beheading of John the Baptist, the ascetic preacher and forerunner of Christ, whose "voice crying aloud in the wilderness" prophesied the coming of the Savior. The story of John's imprisonment and death is recounted in the Gospel of Mark (6:17–28). Herod Antipas (son of Herod the Great) had imprisoned John for preaching against Herod's marriage to Herodias, the wife of his brother Philip. Herod was able to resist Herodias's urging that he kill John until, at a banquet celebrating his birthday, Herod's stepdaughter Salome performed a dance so pleasing to him that he promised her anything she asked. Prompted by her mother, Salome requested the Baptist's head. An executioner beheaded John in prison, giving the head to Salome on a charger, which she presented to Herodias.

The SCMA *Beheading of John the Baptist* takes place in a townscape just outside a massive gateway. The executioner, dressed in early-sixteenth-century German military costume, places the severed head of the Baptist on a charger held by the lavishly dressed Salome, who is accompanied by two female companions.

The compositional motifs used in the SCMA drawing derive from works associated with Albrecht (c. 1480–1538) and Erhard (c. 1485–1562) Altdorfer, the figure group from one source, the architecture and landscape setting from another.[3] Few documents exist regarding the early careers of these brothers. Albrecht Altdorfer is believed to have been born about 1480, possibly in Regensburg, and it is thought that Erhard was probably born within a few years of that time. The stylistic similarity of their first known works suggests that they remained in close contact throughout their early artistic development. In

1505 Albrecht acquired citizenship in Regensburg, where he pursued a successful career until his death in 1538. By 1512 Erhard had left the Danube region to work in Schwerin for Duke Heinrich von Mecklenburg, whom he served until the duke's death in 1552, after which he served his successor, Johann Albrecht, until 1561 as illustrator, chief court painter, and court architect.[4]

The figure composition of the SCMA drawing is closely related to a painting of the *Beheading of John the Baptist* known in three versions (Vienna, Siena, and Padua).[5] The stance and gesture of the executioner in these paintings are almost identical to those of the executioner in the SCMA drawing, as are the relative positions of Salome and her attendants. Despite some variation in details, the costumes of the figures are also analogous. The painting in Vienna's Gemäldegalerie is generally considered to be the best of the three known versions (fig. 1). Currently catalogued as "after Altdorfer," it was formerly attributed to the Historia Master, an artist named for his work on the pen and watercolor illustrations to the *Historia Friderici et Maximiliani,* a life history of Holy Roman Emperor Friedrich III and his son, Emperor Maximilian I, that was written for the edification of Maximilian's nephew Charles, who became Emperor Charles V.[6] Although Hans Mielke returned these illustrations convincingly to Albrecht Altdorfer himself, he expressed some hesitation about assigning the Vienna painting to Albrecht's hand. He considered the painting's conception to be Albrecht's, however, rejecting Karl Oettinger's suggestion that Erhard Altdorfer was its originator.[7] Comparing the painting to Albrecht's Bremen *Birth of Christ,* from 1507,

4 Recto

Fig. 1. After Albrecht Altdorfer, *The Beheading of John the Baptist.*
Oil on panel, 31 × 24 cm (12¼ × 9½ in.). Gemäldegalerie,
Kunsthistorisches Museum, Vienna, inv. GG A 133

Mielke dates the genesis of the *Beheading's* design to the
same period.[8]

Although a stone wall with an arched gateway appears
behind Salome and her companions in all three versions
of the painting, it is oriented quite differently from that
in the SCMA drawing. Certain aspects of the drawing's
composition — the stance of the executioner and the
large stone arch — may ultimately derive from Albrecht
Dürer's (1471–1528) *Bearing of the Cross* from his *Large
Woodcut Passion,* one of the first seven prints made for
this series (in 1497–99).[9] Scholars agree, however, that the
more immediate source for the architecture and land-
scape setting of the SCMA *Beheading of the Baptist* is the
drawing *Woman with Entourage* in Dessau (fig. 2).[10] This
sheet, which depicts an elaborately dressed woman on
horseback riding out from an arched gateway accompa-
nied by a troop of armed soldiers, is unanimously con-
sidered to be the earliest surviving version of a composi-
tion of which there are three known copies.[11] As Hanna
Becker first noted, the author of Smith's *Beheading of
John the Baptist* adapted the architecture and landscape
with only minor changes from the Dessau drawing,
adding the split tree and the stone parapet that stands
behind the figures.[12] Hans Mielke, who attributes the
Dessau drawing to Albrecht, dates it about 1508, compar-
ing it with Albrecht's *Woman with a Falcon,* whose fine-
line technique bears a close resemblance to that of *Venus
and Cupid,* a drawing signed with Albrecht's monogram
and dated 1508.[13]

Fig. 2. After Albrecht Altdorfer, *Woman with Entourage.* Pen
and black ink, heightened with white on brown prepared paper,
162 × 156 mm (6⅜ × 6⅛ in.). Anhaltische Gemäldegalerie
Dessau, inv. B II/15

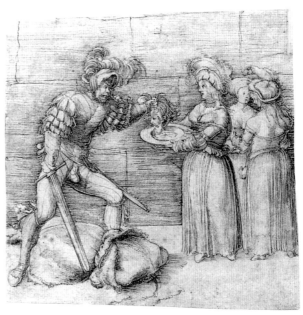

Fig. 3. Erhard Altdorfer, *Beheading of John the Baptist.*
Pen and black ink, 109 × 113 mm (4⁵⁄₁₆ × 4⁷⁄₁₆ in.). Museen
der Stadt Regensburg, inv. G 1935/107. Photo: Presse- und
Informationsstelle der Stadt Regensburg-Bilddokumentation,
© Museen der Stadt Regensburg

4 Verso

Two drawings associated with Erhard Altdorfer appear to have used the figure group depicted in the Vienna painting, adapting it for distinctly different settings. In a *Beheading of John the Baptist* at Regensburg given to Erhard by all modern scholars (fig. 3), the figure composition is reversed: the executioner, seen from the front, stands at left, straddling the body of John as he places the head on Salome's charger while two female attendants look on.[14] The figures in the *Beheading of John the Baptist* in Berlin are closer to the Vienna composition and, therefore, to the SCMA drawing, although in the Berlin sheet the middle woman has been moved to the right of the composition.[15] Stylistically, however, the SCMA *Beheading of the Baptist* differs from both the autograph sheet (which Mielke dates c. 1511) and the Berlin drawing (which Mielke and others attribute to Erhard's circle).[16] All recent writers have noted that disparities in the handling of the pen line militate against an attribution of the SCMA drawing to either Albrecht or Erhard Altdorfer; most place it in Albrecht's or Erhard's circle.[17]

Despite the use of motifs from the Altdorfer compositions discussed above, the style of the drawing seems more closely linked to the manner of Jorg Breu the Elder.[18] Breu was born about 1475, probably in Augsburg, where he became well known as a designer of woodcuts

and glass paintings. After training with Ulrich Apt the Elder and spending the years 1481 to 1502 as a journeyman in Austria, in 1502 he was a master in Augsburg, where he made his first dated woodcut in 1504. Along with Albrecht Dürer, Lucas Cranach the Elder (1472–1553), Hans Baldung Grien (1484/85–1545), Hans Burgkmair (1473–1531), and Albrecht Altdorfer, Jorg Breu contributed drawings to the *Prayer Book of Emperor Maximilian*.[19] He is thought to have visited Italy in 1508 and in 1514–15 and was in Baden and Strasburg in 1522. He died in Augsburg in 1537.

Comparison of the SCMA *Beheading of John the Baptist* with the series of drawings for glass paintings that Breu designed for doors in a hunting lodge of Maximilian I (1516) reveals striking similarities.[20] Although the glass designs are somewhat simpler in shading and detail than the SCMA sheet, the same morphology is present in the figures' facial types. The hunting scenes are especially rich in analogies, for example in the craggy faces of older men, in the technique of drawing eyes, in the stocky body type, and muscular calves of the figures' legs. Similar too is the method of shading with parallel curved strokes — a technique associated with preparatory drawings for woodcuts. Facial types and the manner of describing clothing reflect the influence of such printmakers as Hans Burgkmair and Lucas Cranach. Although the handling of

the pen is less fluid than his own, these resemblances are sufficiently close to suggest an artist in Breu's immediate circle as the author of the SCMA drawing. Unfortunately, the fragmentary sketch on the verso is too faint to suggest an attribution for either side of the sheet.

In the Smith *Beheading of John the Baptist* the executioner wears intricately patterned slit clothing of a type that mercenaries had appropriated from wealthy burghers in Southern Germany, with whom it was fashionable between 1500 and 1520.[21] Depictions of soldiers became common in the work of Swiss and South German artists at the beginning of the sixteenth century,[22] and the executioner's costume in the Smith drawing resembles that of various knights depicted in prints associated with Emperor Maximilian I. This garb lends him a somewhat higher status than that of the Landsknechts who were commonly depicted in this role.[23]

Salome can be identified as the young woman holding a salver and wearing the most elaborate clothing, including a large plumed hat. These garments are similar in type to those worn by the woman on horseback in the Dessau drawing, a figure that has been variously identified as a gentlewoman or a camp follower. The latter interpretation may, in fact, shed light on the SCMA *Beheading of John the Baptist*. While Salome might be expected to wear an elaborate gown and jewelry to signify her status as stepdaughter of Herod, the individual items she wears — large plumed hat, off-the-shoulder dress, multiple heavy necklaces — were often employed by South German and Swiss artists to denote prostitutes.[24] Examples of this abound in contemporary prints. See, for example, Urs Graf's (c. 1485–1527/28) woodcut *Two Mercenaries, Whore, and Death,* in which the whore is dressed in a low-cut dress and wears a large plumed hat and heavy jewelry.[25] An earlier example in which lavish personal adornment is associated with temptation and immorality — and one certainly known throughout South Germany in the early sixteeenth century — is Dürer's woodcut from the *Apocalypse* (1496–98) depicting the Babylonian Whore. The story of Salome's role in Herodias's revenge on John the Baptist often appears in this period either in single prints or as one in a series of prints devoted to examples of the fatal power of women over men.[26] Salome is thus depicted in the *Beheading of John the Baptist* in a manner that makes both her seductive power and immoral nature abundantly clear.

AHS

1. According to Willi Raeber, who places the collection in Vienna rather than Prague. Because the drawing neither bears von Lanna's collector's mark nor is listed in any of his sales, this provenance is unconfirmed.

2. Also according to Raeber. Nebehay's collector's mark (G. N., not in Lugt) does not appear on this drawing, nor does the drawing appear in Nebehay's catalogue (letter from his son, Prof. Christian Nebehay, to the author, 20 May 1996, SCMA curatorial files).

3. Becker 1938, no. 83 (p. 125).

4. See Juergens 1931, pp. 12–21. Only a few signed works by Erhard exist, including the engraving *Lady with a Peacock Shield* (dated 1506); an undated etching of a mountain landscape; a tripartite woodcut *Tournament* (dated 1512); and 3 of the 85 woodcuts illustrating the *Lübeck Bible* (completed in 1534).

5. From the von Lanna collection (see Kunst Mus Vienna 1991, p. 23 and pl. 583); Pinacoteca, Siena (but said to be in Florence in most of the Altdorfer literature): panel, 51 × 41 cm, Spannocchi gift (see Torriti 1981, no. 517, figs. 301–2; attributed by Voss 1907 [p. 196] to the Historia Master); the Padua painting (current whereabouts unknown) is cited and reproduced by Kurth 1938, p. 5, pl. 8.

6. Campbell Dodgson (1924, p. 94) and Peter Halm (1930, pp. 60–61) attributed the illustrations to Albrecht Altdorfer. Mielke returned them to his oeuvre, disputing the existence of the artist identified as the Historia Master by intervening scholars (Berlin 1988, no. 30). According to Butts 1988 the mistaken dating of these illustrations to c. 1515 rather than c. 1508 (based on a misinterpretation of the text) had contributed to their removal from Altdorfer's oeuvre.

7. Berlin 1988, p. 300, under no. 191. See Oettinger 1959, pp. 102ff., pl. 17, who is followed by Helen Manner in New Haven 1969–70, no. 66. Packpfeiffer 1978 does not list the Vienna painting in her catalogue of Erhard's works.

8. On this painting, see Winzinger 1975. The Gemäldegalerie catalogue (Kunst Mus Vienna 1991, p. 23, pl. 583) lists the Vienna painting as executed c. 1508 after a c. 1506 painting by Albrecht ("or Erhard?").

9. As noted by Helen Manner in New Haven 1969–70, no. 66. These prints were sold as single sheets until 1510, when Dürer made four more woodcuts for the series. A title page was made the following year, Latin verses were printed on the back of the woodcuts, and the complete set was published with the title *Passio domini nostri Jesu.* See Boston 1971–72, p. 64 and nos. 52, repr., and 53, repr., where the *Bearing of the Cross* is dated 1498–99. The gateway in Hans Schäufelein's woodcut *Bearing of the Cross* (c. 1507; Geisberg 1974, vol. 3, no. 1041, repr.), which is flanked by a rectangular window placed high in the wall to the right, is even closer to the SCMA drawing and its model (see below).

10. On a paper prepared with a red-brown ground. Becker 1938, no. 25, considered this drawing the only one of the four known versions to be by Albrecht's own hand. She dated it to 1510, based on the style of the landscape, or somewhat earlier, given the type of Landsknecht and the artist's method of making lines.

11. One is in Berlin, Staatliche Museen Preussischer Kulturbesitz, Kupferstichkabinett, inv. 82, black ink, white heightening on olive-ground prepared paper, 208 × 157 mm. See Winzinger 1952, no. 135, and Mielke in Berlin 1988, no. 26, repr. The drawing is inscribed with a date at the upper right that has been partially trimmed from the sheet at the top, and has been variously read as 1510 (Becker 1938, no. 86) or 1516. Mielke catalogues it as a 1516 copy by an unknown hand of the c. 1508 drawing by Albrecht Altdorfer in Dessau. Baldass (1938, p. 125) and Oettinger (1959) related it to the work of the Historia Master, to whom it was attributed by Winzinger (1952). On the copy of the drawing in a private collection in the U.S.A. *(Woman with Entourage,* pen with white highlights on paper prepared with a reddish brown ground, 190 × 142 mm, formerly prince of Liechtenstein, Vienna), see Becker 1938, no. 182, and New Haven 1969–70, no. 74, pl. 18. Helen Manner (New Haven 1969–70) gives this drawing to a follower of the Historia Master, possibly to Nikolaus Kirberger, on the basis of its similarity to a drawing in the Albertina of Saint John the Baptist initialed *NK* and dated 1519 (Nikolaus Kirberger's name

appears in an old annotation on the verso of the sheet). For the copy of *Woman with Entourage* formerly in London, Northwick Park, collection of Captain E. G. Spencer Churchill (pen and black ink on paper prepared with a green ground, 207 × 161 mm), see Becker 1938, no. 191 (here she reads the date as 1516), and Vasari Society 1920, no. 10, repr. Campbell Dodgson's entry for the Vasari Society lists the drawing as by Albrecht Altdorfer, although he expresses some doubts, citing the superiority of the Berlin drawing. He says the date on this drawing looks like 1510, retouched (1516), and also notes a much later copy at Oxford, dated 1608 and signed *IS*.

12. Becker 1938, no. 83 (p. 125).

13. Berlin 1988, no. 27, repr. This drawing, previously given to Albrecht Altdorfer, had been attributed to the Historia Master by Oettinger in 1959. Both *Woman with a Falcon* and *Woman with Entourage* may reflect the influence of Dürer's *Knight on Horseback and Lansquenet,* from c. 1497, specifically in the pose of the horse, the dog that runs alongside, and, more loosely, the position of the attendant who follows the woman with a falcon. See New Haven 1969–70, under no. 66; Winzinger 1952, under no. 143; and Mielke in Berlin 1988, no. 27, repr.

14. Museen der Stadt, inv. G 1935/107, black ink, 109 × 113 mm. Fragment of a watermark (noted but undescribed by Mielke). Ascribed by early scholars to Albrecht on the basis of the fine-line technique (cf. also the *Banquet* drawing in Berlin of 1506, Berlin 1988, no. 176), Baldass 1938 was the first to propose Erhard as the author. This attribution was reconfirmed by Mielke (Berlin 1988, no. 177). Mielke cites Stange's (1964, p. 88, pls. 139, 141) convincing comparison with the unsigned altar of Gutenstetten from 1511. He also compares the drawing with the Braunschweig drawing *Saint Sebastian* (Berlin 1988, no. 182, repr.).

15. Kupferstichkabinett, Staatliche Museen Preussischer Kulturbesitz, inv. 4475, black ink over black chalk, 219 × 185 mm (see Berlin 1988, no. 191, repr.). Kurth (1938, p. 7) argued that the figure composition, like that of the three paintings and the SCMA drawing, probably descends from Albrecht Altdorfer. See also Benesch and Auer 1957, pp. 39–41 (cited by Mielke).

16. Mielke thinks Stange's suggestion of Nikolaus Kirberger (Stange 1964, p. 86, pl. 131) not very convincing, as he considers the 1519 Kirberger drawing cited by Stange (1964, pl. 130; Albertina 1933, no. 226, repr.) to be a late reflection of Altdorfer's composition. See also Bock 1921, vol. 1, p. 95, inv. 4475, vol. 2, pl. 132, who dates the drawing c. 1510 and attributes it to Erhard; Becker 1938, no. 96, places it c. 1520, closely related to Erhard Altdorfer. See also Kurth 1938, p. 7, pl. 10; Packpfeiffer 1978, pp. 73ff.

17. Becker classed the SCMA sheet under ascribed drawings, copies, and drawings by near followers of Altdorfer as "School of Altdorfer, 1515 or later?" When published after its acquisition by SCMA, it was listed as Anonymous Danube school, c. 1510; Oettinger (1959) suggests it dates from c. 1514 and is after a composition originated by Erhard Altdorfer. Manner, in New Haven 1969–70, attributes it to the School of Erhard and dates it c. 1512–14 based on comparison to Erhard's drawing *Two Landsknechts* of 1513 (New Haven 1969–70, no. 65, pl. 18) and to the figures in the woodcut *Tournament* of 1512 or 1513. She also notes similarities to landscape details in the drawing *Sea Landscape* (Winzinger 1952, no. 146) and the woodcut *Joshua* (New Haven 1969–70, no. 68, pl. 17), as well as to Erhard's woodcuts for the *Lübeck Bible.* Mielke (in Berlin 1988, p. 60, under no. 26) notes that the drawing has been associated with Erhard but does not discuss the attribution further. Scholars have been more or less in agreement in dating the SCMA drawing between 1510 and 1515.

18. I would like to thank Larry Silver for suggesting Breu's name in connection with this drawing (in conversation with the author, winter of 1994).

19. On these drawings, see Mielke in Berlin 1988.

20. On the drawings for Maximilian, see Dornhofer 1897.

21. Moxey 1989, p. 72.

22. See ibid., p. 67.

23. See ibid., p. 72.

24. See Andersson 1978, pp. 28–29.

25. On her lap she holds a small dog (a pet associated with prostitutes in the art of this period) that can, perhaps, be related to the dogs that appear in the SCMA drawing and the related paintings. Reproduced in Moxey 1989, fig. 4.15. See also Washington 1990–91, no. 121, repr., Daniel Hopfer, *Soldier Embracing a Woman,* etching c. 1520(?). According to H. Diane Russell, this woman's off-the-shoulder dress and her flowing hair indicate that she is a prostitute. Note also the dog that eats from a table in the background.

26. See Washington 1990–91, no. 88, repr., Hans Baldung Grien, *Salome,* woodcut, c. 1511–12. Salome is shown three-quarter-length, holding the head of John on a platter. Note her low-cut dress, elaborate gathered sleeves, and necklaces.

GIOVANNI BATTISTA DEI ROSSI (CALLED ROSSO FIORENTINO)
Florence 1495–1540 Fontainebleau

5 *The Martyrdom of Saints Marcus and Marcellinus*, c. 1537

Red chalk over black chalk, squared with a stylus, on moderately thick, cream antique laid paper; laid down on cream laid paper

Watermark: None visible

Sheet: 238 × 209 mm (9⅜ × 8¼ in.); mount: 240 × 210 mm (9⁷⁄₁₆ × 8⁵⁄₁₆ in.)

Inscribed on verso of mount, upper right corner, in blue ink: *Dessin de Daniele Volterra Italie XVIᵉ* / *Descente de Croix 10*; along upper edge at center, in black ink: *M Angelo B t;* at upper right edge, in black ink: *Daniele Volterra;* upper left, in black chalk: *77.1;* upper left, in ballpoint pen: *3:500* / *s* [illegible]; upper right, in blue fountain pen, crossed out in graphite: *HC;* at upper center, in graphite, enclosed within a rectangle: *No 36* [changed from *35*, the *5* erased and a *6* written in its place], the whole crossed out in graphite; upper left, in graphite: *M;* lower center, in black chalk: *23;* and lower center, in black chalk: *MAngelo Bᵗⁱ*.

PROVENANCE Dumarteau collection, Dijon (unconfirmed);[1] {Walter Hugelshofer (1899–1987), Zurich}; to {F. Kleinberger & Co., Inc., New York}, May 1958, stock no. 1534 (as by Francesco Primaticcio);[2] sold to SCMA in 1959 (as *Scene of a Martyrdom* by Francesco Primaticcio)

LITERATURE Parks 1960, no. 16, repr. (as Francesco Primaticcio[?], *Martyrdom of Saints Cosmas and Damian*); Prache 1961, pp. 1–9, fig. 1 (as *Martyrdom of Saints Cosmas and Damien* by Francesco Primaticcio); McAllister-Johnson 1966, p. 255, fig. 12 (as *Martyrdom of Saints Cosmas and Damian* by Francesco Primaticcio); Béguin 1969, p. 151 note 32 (as by Rosso in his Italian period); Pillsbury 1973, p. 35; Carroll 1975, pp. 22, 25, fig. 7; Carroll 1978, pp. 25, 31, 34, fig. 8; Franklin 1988, pp. 325 and 326, no. 98; SCMA 1986, no. 204, repr. (as 1535–36); Volterra 1994, p. 85, repr. p. 33; Joannides 1996, pp. 138–39, fig. 111

EXHIBITIONS Cambridge 1962, pp. iv–v and no. 29 (as Francesco Primaticcio[?], *Martyrdom of Saints Cosmas and Damian*, 1540–50); Sarasota 1967 (as by Primaticcio); Providence 1973, no. 62, repr. (entry by Richard Campbell); Northampton 1979b, no. 13; Washington 1987–88, pp. 11, 31, 32, 308, 312, 313, 314, 316, no. 98, color repr.; Northampton 1982a; Northampton 1984b, no. 5; Northampton 1987b, no. 18

Purchased with the gift of Mrs. Stanley Keith (Helen M. Shedd, class of 1905)
1959:32

Rosso Fiorentino, whose inventiveness and skill as a draughtsman were recognized and celebrated by his contemporaries, seems to have secured his last and most important position — painter to the French king François Iᵉʳ — on the basis of a drawing. The famous *Mars and Venus,* which is thought to have been sent to François from Venice by Pietro Aretino, appears to have obtained for Rosso the wealth and security that until then had eluded him.[3]

Born and trained in Florence, Rosso established a career in Rome between 1524 and 1527, when the Sack of Rome forced him to flee the city, and went to Venice after several years working in Perugia, Borgo San Sepolcro, Città di Castello, Pieve Santo Stefano, and Arezzo. Called by François Iᵉʳ to France, Rosso arrived there by November 1530, when the first payments to him for work at the château of Fontainebleau are recorded.[4] He was occupied with a variety of projects for the king at Fontainebleau and with commissions for other members of the French nobility until his death in November 1540.[5]

In view of what we know of Rosso's dedication to drawing and the documented numbers of sheets extant in the sixteenth century, lamentably few drawings by his hand survive. From his entire career fewer than sixty drawings are unanimously considered by scholars to be autograph. The SCMA *Martyrdom of Saints Marcus and Marcellinus,* which can be dated on stylistic grounds to Rosso's French years, is therefore a work of particular importance.

The drawing was acquired by the SCMA as a work of Francesco Primaticcio (1504–1570). It was published with this attribution in 1961 by Anne Prache, who nevertheless recognized its resemblance to Rosso's work, citing the approach to composition, the manner of depicting light and shade and delineating contours, the use of hatching, and the proportions of its figures.[6] Erwin Panofsky had already privately questioned the attribution to Primaticcio in 1959, and in 1968 J. Q. van Regteren Altena suggested that the drawing might in fact be by Rosso.[7] Sylvie Béguin was the the first to publish the opinion that the SCMA sheet should be assigned to Rosso.[8] This attribution was confirmed by Eugene Carroll, and the drawing has been accepted as Rosso's work since 1973.[9]

Formerly identified as the martyrdom of Saints Cosmas and Damien, the subject was correctly identified by Carroll as the martyrdom of the brothers Marcus and Marcellinus, who had been converted to Christianity by Saint Sebastian.[10] Their story is recounted in the *Golden Legend* of Jacobus de Voragine as part of the history of Saint Sebastian. As Carroll has noted, many of the details in Rosso's image are explained by this source.[11] Saint Sebastian, a native of Narbonne in Gaul and the son of noble parents, commanded a company of the Praetorian Guard, although secretly a Christian. When Marcus and Marcellinus, two young men of noble family, also soldiers and Christians, were condemned for their faith and were implored by their families to recant and save themselves, they were exhorted by Sebastian to die rather than renounce Christianity, and went joyfully to their

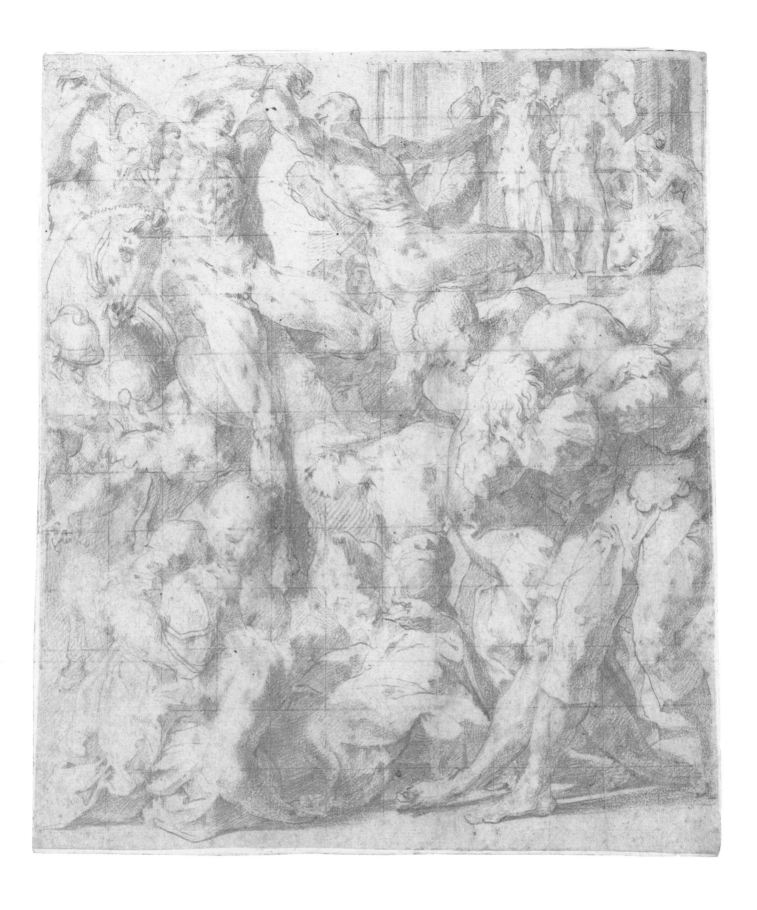

martyrdom. In Rosso's drawing, the parents, wives, and children of Marcus and Marcellinus mourn in an agonized tangle at the foot of the gibbets, while the saints submit to their deaths, being run through with lances. The small scene at the upper right is identified by Carroll as Saint Sebastian (dressed as a Roman soldier) preaching to and blessing the family of Nicostratus, in whose house the saints had been imprisoned. As Carroll observes, the brothers' joy in achieving martyrdom for their faith is contrasted to the mourning of their family.

The drawing is executed in a refined technique in which delicate black chalk outlines are combined with red chalk, sharpened to a point and employed to clarify and accent contours and to model the figures with extremely delicate parallel hatching. Rosso's evenness of touch contributes to the difficulty in reading the individual figures, who are entwined in a shallow space, and whose fractured and faceted surfaces add to the complexity of the composition. Rosso's use of red and black chalk has its origins in his Florentine work, in which he uses black chalk for a light preliminary outline drawing over which the composition is elaborated in red chalk. Rosso further developed this technique during his years in Rome, where black and red chalk were combined in a number of drawings datable to this period (e.g., the *Gods in Niches,* c. 1526).[12] In the SCMA drawing, the artist's use of these media is at its most refined; the black chalk serves not simply as an underdrawing but accents and defines the contours of the figures. An analogous approach is seen in Rosso's *Saint Jerome* (dated to 1531–32 by Carroll).[13] The SCMA *Marcus and Marcellinus* is squared with a stylus, presumably for enlargement. The stylus was also used for this purpose in Rosso's *Profile Head of a Woman* (Fogg Art Museum, Cambridge, Mass.), a black chalk drawing that seems to have been inspired by Michelangelo's (1475–1564) *teste divine* (divine heads).[14] In neither case, however, do related drawings exist that would help to clarify Rosso's working methods in developing the finished work of art.

The dating of Rosso's drawings is based almost entirely on stylistic analysis and comparison with his paintings. Only one securely dated painting exists from Rosso's French period, the damaged *Pietà* now in the Louvre.[15] Despite documented payments to Rosso for his work at Fontainebleau, the exact sequence of his work there remains unknown. Béguin considered the SCMA drawing likely to be from Rosso's Roman period because of its compositional similarity to his drawing *Saint Roch Distributing His Inheritance,* a drawing that Carroll concurs in placing within Rosso's Roman years (dating it to 1524).[16] While recognizing the echoes of this drawing in the *Marcus and Marcellinus,* Carroll nevertheless considers the SCMA drawing to date from some years later, around — and probably after — *The Enlightenment of François Ier* fresco in the Galerie François Ier at Fontainebleau; he therefore dates the drawing to 1537.[17] Although Carroll's attempts to assign precise dates to Rosso's drawings may remain open to discussion, comparison of the *Marcus and Marcellinus* to other late drawings places it convincingly within Rosso's French period.[18] This dating is further supported by a copy of the SCMA drawing in Frankfurt, identified by David Franklin as by "a seventeenth-century northern artist," which, like the SCMA sheet, has French inscriptions on the verso.[19]

The abiding influence of Michelangelo on Rosso's art, noted by many scholars, is abundantly evident in the SCMA drawing.[20] The most obvious reflection of Michelangelo's work is the figure of the saint at the left, which recalls the pose of Haman from the Sistine Ceiling.[21] As Franklin points out, if Carroll's dating of the SCMA drawing to 1537 is correct, Rosso's firsthand experience of the Sistine Ceiling would have occurred a full decade earlier. The renewed interest in Michelangelo that Carroll perceives in Rosso's art after 1535, for example in the fresco *The Enlightenment of François Ier,* Carroll traces to the arrival in France of drawings by Michelangelo that complemented those Antonio Mini had brought in 1532.[22] Paul Joannides has observed that Michelangelo may have influenced Rosso's interpretation of the gibbets as trees in the SCMA drawing (as well as his use of a similar motif in the nudes flanking *The Education of Achilles* in the Galerie François Ier) through figure studies for a lost *Martyrdom of the Ten Thousand.*[23] Also present in the SCMA *Marcus and Marcellinus,* however, are echoes — if not exact quotations — from Rosso's own earlier work, including his 1521 *Deposition from the Cross* in Volterra (the male figure with face in hands at lower right of the drawing).

The squaring of the SCMA drawing indicates that the design was to be transferred to a different scale, probably in preparation for a considerably larger work such as a painting, although no record of such a finished work is known.[24] The drawing's subject matter suggests that it was made in connection with a religious commission — Carroll postulates a cycle of paintings about Saint Sebastian.[25] Rosso was made a canon of the Sainte-Chapelle in 1532 and of Notre-Dame in 1538, but Vasari's remarks on his projects for these churches are too vague to give any hint as to the subjects. While documentary evidence suggests that Rosso executed work for the tribunes of Notre-Dame, as Béguin points out, this could have been sculpture, fresco, or easel painting.[26] Alternatively, Rosso's *Marcus and Marcellinus* might have been commissioned by a patron such as Cardinal Jean de Lorraine (1498–1550), an intimate of François Ier and wealthy patron of the arts, for whom Rosso had executed the *Ornamental Panel Illustrating Petrarch's First Vision on the Death of Laura* (c. 1534).[27] The cardinal was named by François Ier at the end of 1536 (and confirmed by the pope in January 1537) as abbot of Saint-Médard in Soissons. Although he held this position only briefly, relinquishing it at the end of October 1539, the cardinal's connection to Saint-Médard may offer a tantalizing clue to the origin of the SCMA drawing.[28] Saint-Médard, a royal abbey renowned for its many important relics, counted among its treasures remains not only of Saint

Sebastian but also of Saints Marcus and Marcellinus.[29] In the absence of further evidence, however, the association of Rosso's drawing with Jean de Lorraine or Saint-Médard must remain conjectural.

AHS

1. According to an inscription on the former mat (see note in Robert O. Parks's hand in SCMA curatorial files). The name is also given as Dumarteau in Kleinberger stock records (Paintings Department, The Metropolitan Museum of Art, New York) and on the invoice to SCMA (22 Dec. 1958), but as Demarteau in a letter of 18 Sept. 1958 from Harry G. Sperling (of Kleinberger) to Robert O. Parks in SCMA curatorial files.

2. According to Kleinberger stock records. Hugelshofer was an art historian, collector, and dealer.

3. Adhémar 1954. For a recent discussion of the evidence see Carroll in Washington 1987–88, no. 57, color repr.

4. Carroll in Washington 1987–88, p. 35 note 84. That Rosso had been invited by the king is indicated by the letters patent he received.

5. According to Vasari, Rosso committed suicide (Vasari/Milanesi, vol. 5, p. 173). He died on Sunday, 14 Nov. 1540.

6. Prache 1961, pp. 4–5, who cites the concurrence of Charles Sterling and Janos Scholz in the attribution. She sees in the drawing the strong influence of Rosso, and dates it to 1532–40, or very shortly after Rosso's death and before midcentury. Primaticcio probably arrived in France shortly after 23 March 1532 (see Washington 1987–88, p. 200 note 16).

7. Letter from Panofsky to Robert O. Parks, 19 Feb. 1959, and memo of 18 April 1968 regarding the visit of J. Q. van Regteren Altena to SCMA (SCMA curatorial files).

8. Béguin 1969, note 32.

9. Providence 1973, no. 62.

10. The former identification of the subject was made by Panofsky in 1959 (letter in SCMA curatorial files). Carroll's correction was first published in Providence 1973, no. 62.

11. Washington 1987–88, no. 98. See Voragine 1993, pp. 97–100.

12. Ibid., nos. 19–20, repr. (20 in color).

13. Ibid., no. 63, color repr. Carroll once questioned this sheet, but now accepts it as autograph.

14. Washington 1987–88, no. 46, color repr. Carroll dates this drawing to 1527 on the basis of its resemblance to figures in Rosso's painting *The Dead Christ* (Museum of Fine Arts, Boston) and in the prints *Pluto and Proserpina* (from the *Loves of the Gods*) and the *Romans and Sabines* (1527).

15. Musée du Louvre, inv. 594.

16. Washington 1987–88, no. 7, repr.

17. Ibid., no. 98.

18. Compare, e.g., the *Saint Jerome* (see note 13).

19. Inv. z425. See Franklin 1988, p. 326 (under no. 98).

20. The influence was recognized in two earlier attributions recorded on the verso of the drawing, namely, to Michelangelo himself and to his follower Daniele da Volterra (c. 1509–1566).

21. Noted also by Richard Campbell (Providence 1973, no. 62), Carroll (Washington 1987–88, no. 98), and others.

22. See Washington 1987–88, no. 98 and p. 31. Carroll also notes that c. 1538 Rosso copied Michelangelo's *Leda* (which went to France in 1532).

23. Joannides 1996, p. 138 (where he assigns the SCMA drawing to Rosso's Roman period). Joannides (1994) proposes that a number of Michelangelo studies datable to the first decade of the sixteenth century can best be explained as preparatory for a *Martyrdom of the Ten Thousand*. Some of these figures and figure groups could have been known to Rosso through original drawings or copies by other artists, among them Alonso Berruguete (1486–1561), whose drawing of nude men crucified to trees is in the Real Academia di San Fernando, Madrid (Joannides 1994, fig. 5). A copy in the Musée du Louvre, Paris (pen and ink, 329 × 117 mm, inv. 858; Joannides 1994, p. 12, fig. 23) of a Michelangelo drawing for the *Martyrdom of the Ten Thousand* is widely attributed to Rosso (Joannides 1996, pp. 32–33).

24. Although many of Rosso's Roman drawings were made expressly for prints, the French prints based on his drawings all seem to have been made after his death in 1540. Not only is there no print after this drawing, but the squaring suggests that it was preparatory for a larger work.

25. Washington 1987–88, p. 308. See also Carroll's comments on Rosso's Saint Roch cycle, of which the *Saint Roch Distributing His Inheritance* is the only remaining autograph drawing (ibid., p. 70).

26. Béguin 1989, p. 829 note 7.

27. The date according to Carroll in Washington 1987–88 (no. 67, color repr.), who suggests it may have been intended for a tapestry.

28. Defente 1996, p. 172. On the cardinal's patronage, see Collignon 1910, who notes (pp. 148–49) the considerable time he spent in Paris at the residence (*hôtel*) maintained for the abbots of Cluny (another of the many benefices he held). For another work by Rosso (probably from the early 1530s) with a possible connection to Jean de Lorraine, see Béguin 1990.

29. Defente 1996, pp. 61–62.

DOMENICO CAMPAGNOLA
Venice(?) c. 1500–1564 Padua[1]

6 *Landscape with Farmyard*, 1550s

Pen and brown ink over traces of black chalk, incised, the composition bordered by a ruled framing line in pen and brown ink, on cream antique laid paper

Watermark: Crown and star (close to Briquet 4834 and 4854, but without the countermark; these marks dated by Briquet from the 1550s to 1570s)

Sheet: 254 × 399 mm (10 × 15¹¹⁄₁₆ in.); image: 245 × 390 mm (9⅝ × 15¼ in.)

Inscribed recto, lower right corner, in pen and brown ink: *J33;* inscribed verso, along lower edge, in graphite: *Titian.— An extensive Landscape with Farm-house & Cattle / pen & bistre frm Sir P. Lely's collection.—;* and verso, lower left corner, in graphite: *y* [?]

PROVENANCE Sir Peter Lely [b. Pieter van der Faes] (1618–1680), London (Lugt 2092, lower right corner recto);[2] to his estate (presumably in the sale, London, 11 April 1688 and seven days following, or London, 15 Nov. 1694 and days following);[3] unknown collector, tentatively identified by Lugt as Hendrik Gevers (1715–1761), Rotterdam (Lugt 1121, lower right corner recto);[4] {Durlacher Bros., New York} before Nov. 1946; sold to SCMA in 1946

LITERATURE None

EXHIBITIONS Northampton 1958a, no. 8 (as *Country Scene*); Northampton 1982c (as *Country Scene*); Northampton 1987b, no. 11 (as *Country Scene*)

Purchased
1946:13-3

Although Domenico Campagnola was well known as a landscape draughtsman in his own lifetime, by the seventeenth century his work was often mistaken for that of his more famous contemporary, Titian (c. 1485–1576). This confusion, which may be ascribed in part to the difficult problems of connoisseurship that still vex scholars of Venetian drawings, also reflects Titian's renown as a designer of landscape compositions and the resulting tendency on the part of collectors to credit such drawings to him.

Born of a German father, Domenico was adopted — perhaps in childhood — by the painter and engraver Giulio Campagnola (c. 1482–c. 1518), whose name he took and who provided his earliest instruction in art, including the technique of engraving. That the young artist was deeply influenced by Titian is reflected in his earliest drawings as well as in his earliest dated works, engravings and woodcuts from 1517.[5] Although tradition has it that Domenico worked with Titian in Padua in 1511, he is not documented in that city until 1523.[6] He lived the rest of his life in Padua as a successful painter and draughtsman. His drawings in particular seem to have served as models for other artists whose work has yet to be convincingly distinguished from Domenico's own, although he is not thought to have had a workshop, properly speaking.[7]

Domenico appears to have produced many landscape drawings as finished works of art for sale to collectors. The taste for Campagnola landscapes is documented by the Venetian writer and connoisseur Marcantonio Michiel, who, as early as 1537, records seeing pen and ink landscape drawings by Domenico in a Paduan collection.[8]

The SCMA drawing is composed of elements typical of the mature Campagnolesque landscape, which combines rustic buildings, vestiges of antique ruins, a few figures, and a view beyond a meandering river to a distant town and mountain peaks. In the farmyard at the left foreground of this example, a woman draws water from a well, surrounded by cattle, roosters, and geese, while a man constructs or repairs a barrel. While it is far from a bird's-eye view, the scene is nonetheless presented from a sufficiently high vantage point to emphasize the depth of the composition and the recession into a vast and varied terrain.

Despite the progress made since Hans Tietze and Erica Tietze-Conrat's work on Domenico's drawings, including important attributions by Konrad Oberhuber and Elisabetta Saccomani's work toward a chronology, the landscape drawings have yet to undergo systematic study.[9] The SCMA sheet most closely resembles drawings that have generally been regarded as late, that is, from the 1540s or later. Comparison may be made, for example, with the figures and animals in a landscape in the Pierpont Morgan Library, or with the trees, weeds, and background buildings in the *Dives and Lazarus* in the same collection, while a similar treatment of animal physiognomy is found in a landscape in the Metropolitan Museum.[10]

The SCMA sheet is drawn in pen and ink entirely in a linear mode consonant with printmakers' conventions for delineating objects and modeling forms; the parallel and cross-hatching are handled in a manner that appears particularly close to Domenico's woodcuts. The pen line ranges from strong and wide in the foreground to light and delicate in the distant mountains, an effect that was probably achieved by employing quill pens cut to points of different widths. Close examination also reveals the indentations of a stylus that has been used to trace the contours of the drawing for transfer to another surface.

Although Domenico himself never made a print from this drawing, a later etching does exist (fig. 1). Published

Fig. 1. Flemish seventeenth-century, after Domenico Campagnola, *Landscape with Farmyard*. Etching, plate 250 × 380 mm (9⅞ × 15 in.). Collection Frits Lugt, Fondation Custodia, Institut Néerlandais, Paris, inv. 7260/5

in Antwerp in the seventeenth century, some seventy to one hundred years after the drawing was created, it attests to the significance of Venetian landscapes in the North. This print, which reverses the original drawing, is one of a numbered series of etchings after Titianesque/Campagnolesque landscape drawings, each of which has been given a moralizing inscription in Latin. The suite of twenty-four landscapes, known from a complete set in the Lugt collection (Fondation Custodia, Paris), was published by the Antwerp painter and art dealer Herman de Neyt (d. 1642), whose name appears on the first print of the series.[11] The second print bears the inscription *Titianus invenit,* suggesting that the subjects in the suite were believed at the time they were etched to have been invented by Titian.[12] All the drawings that have been identified to date as models for these prints, however, are by Campagnola or his school.[13] Although Pierre-Jean Mariette attributed the prints to Nicolas van Uden (1595–1672), scholars now give them to an anonymous Netherlandish artist.[14]

By the seventeenth century, Titian/Campagnola landscape drawings could be found in private collections across Europe.[15] Karel van Mander in his treatise on painting, *Het Schilderboeck* (1604), had particularly recommended Titian's woodcuts as models for Northern artists, singling out from the few Italians who painted landscapes "the very gifted Titian, whose woodcuts may instruct us."[16] That both original Venetian landscape drawings and prints and their Netherlandish reproductions were collected in Peter Paul Rubens's (1577–1640) circle is well documented.

As Robert C. Cafritz points out, the series of etchings published by De Neyt is particularly interesting for its Latin verse inscriptions, which shed light on the "literary and classical resonance Venetian landscapes possessed in the minds of Rubens's contemporaries."[17] All twenty-four prints bear moralizing proverbs in dactyllic verse that extol the virtues of rural life, one led in harmony with nature. The inscription on the etching after SCMA's drawing translates as: "When he [the husband] goes ahead, and the wife follows the husband in working, / The wealth of the household becomes great quickly, and each grows rich."[18]

Although the verse seems based on Virgilian prototypes such as the *Eclogues,* its language is not close enough to classical writing to indicate an antique origin. Rather, these proverbs seem to be contemporary with the prints, probably composed specifically to complement them.[19] They seem designed to cast moralizing sentiments in language that would lend them the weight of classical authority.

Although De Neyt's death in 1642 provides a *terminus ante quem* for the publication of these prints, it is likely that at least some — and possibly all of them — had been completed by the 1630s.[20] That at least two of the images were known to Rubens is reflected in two landscape paintings from this decade, *Shepherds and Shepherdesses in a Rainbow Landscape,* of the mid-1630s, which combines the foreground of a Domenico woodcut with the background of *Landscape with Pilgrims* (Fondation Custodia, inv. 7620/6), and *Farm at Sunset* of 1638, which incorporates the building from *Landscape with Mill* (Fondation

Custodia, inv. 7620/7).[21] The borrowed elements in both these paintings, however, correspond in direction, not to the prints, but to the drawings from which the etchings were copied, indicating that the drawings themselves might have been known to Rubens.[22]

The incised contours of *Landscape with Farmyard* reveal that De Neyt's printmaker had the use of the Smith drawing in the preparation of the etching plates and therefore that the drawing had reached the North by the time the print was made.[23] Might this drawing — and the other twenty-three sheets published by De Neyt — have been accessible to the printmaker in one or more Antwerp collections? Although no trace of these drawings has been discovered in seventeenth-century inventories, it is tempting to think that they may have been together in Antwerp in these years, perhaps in the hands of Rubens himself or someone in his circle.

AHS

1. See Colpi 1942–54 for documents. For a concise review of some key documents regarding his life, see Oberhuber in Washington 1973, p. 414 note 1.

2. Lely spent most of his career in England. Although the precise date of his arrival is unknown, it seems to have been in the early 1640s (1641 according to his early biographer Richard Graham, 1643 according to early biographies published in Holland; see Millar in London 1978–79, p. 9). It is thought that Lely began to collect art in the late 1640s; in the 1650s he met (and painted) the collector Everhard Jabach, and by the 1660s he had formed his own impressive collection, including drawings acquired from the collections of the earl of Arundel and Nicolas Lanier (London 1978–79, p. 24).

3. According to Lely's executor, Roger North: "I got a stamp, P.L., and with a little printing ink I stamped every individual paper, and not only that, but having digested them into books and parcels, such as we called portfolios, and marked the portfolios alphabetically AA, AB, &c, then Aa, Ab, &c then Ca, Cb, Cc, &c, so consuming four alphabets, I marked on every carton and drawing the letter of the book and number of the paper in the book, so that if they had all been shuffled together, I could have separated them again into perfect order as at first: and then I made lists of each book, and described every print and drawing, with its mark and number, the particulars of all which were near ten thousand" (quoted in Lugt under no. 2092). North's lists are unfortunately lost. The inscription *J33* on the SCMA drawing presents a single, not a double, letter before the number. It is worth noting in this connection that drawings at Christ Church, Oxford, which come from Lely's collection, bear on the verso of their old mounts numbers that correspond to the executor marks as described by North, i.e., with double letters (see Byam Shaw 1976, nos. 723–26, 729).

4. Lugt proposes that the amateur named Gevers, to whom this mark was attributed in 1844 by Joseph Maberly, was most likely the burgomaster of Rotterdam, Hendrik Gevers. This identification remains speculative, however.

5. On the attribution to Campagnola of drawings formerly given to Titian, see Oberhuber in Washington 1973, pp. 414–16. Oberhuber notes as well the equally strong early influence of the older Palma Vecchio (c. 1480–1528).

6. Saccomani 1978, p. 111 note 19. See also Oberhuber in Washington 1973, p. 414 note 1.

7. See Paris 1993, p. 566, under no. 214 (entry by W. R. Rearick).

8. Michiel says of the works he saw in the collection of Marco Mantua-Benavides that "i paesi in tele grandi a guazzo e gli altri in fogli a penna sono di man de Domenigo Campagnola" ("the large landscapes on canvas and the others in pen on paper are by the hand of Domenico Campagnola"). Quoted in translation by Tietze and Tietze-Conrat 1944, p. 123, and in Italian in Tietze and Tietze-Conrat 1939, p. 313. See also Saccomani 1978, p. 110 note 17.

9. See Tietze and Tietze-Conrat 1944, Oberhuber in Washington 1973, and Saccomani 1978, 1979, 1980.

10. Pierpont Morgan Library, inv. IV, 66 (ex coll. Peter Lely) and IV, 63; The Metropolitan Museum of Art, inv. 1972.118.243 (Bequest of Walter C. Baker).

11. *H. de Neyt excudit*. The Lugt prints, inv. 7620/1–24, are in a volume in the Fondation Custodia, Institut Néerlandais, Paris. Also contained in this album are Cornelis Cort's (c. 1533–1578) engravings after paintings and drawings by Titian and Valentin Lefebre's etchings, published in Venice in 1682, after Venetian landscape designs, many of which bear ascriptions to Titian but are now given mostly to Domenico Campagnola. On De Neyt, see Denucé 1932, who prints the inventory taken after his death. On his series of prints see Meijer in Florence/Paris 1976, nos. 22, repr. (7620/11) and 23, repr. (7620/18); Catelli Isola in Rome 1976–77 (impressions in the collection of the Gabinetto Nazionale delle Stampe), nos. 114, repr. (F.N. 1559 [35273] F. Pio-vol. 11, *Paesaggio con vita agreste*, the etching after the SCMA drawing, this impression trimmed of its Latin inscription) and 115, repr. (F.N. 1542 [35256] F. Pio-vol. 11, the print numbered "12"); Chiari 1982 (impressions in the Museo Correr), nos. 130–35, all repr. (Vol. st. E 53/28, 33, 38, 32, 40, and 29).

12. The Lugt volume, which contains a total of 46 prints and seems to have been bound late in the seventeenth century (probably in France), is titled *Paysages de Titien* (see Florence/Paris 1976, p. 33, under no. 22). The volume in Rome's Gabinetto Nazionale delle Stampe that derives from the collection of Nicola Pio (d. after 1724), the seventeenth-century Roman collector, is titled *Il Dicontro Ritratto e di Titiano Vecellio Famosissimo, e Divino Pittore. Le di Ivi opere si vedono dalle stampe del p.nte Libro....* (See Catelli Isola in Rome 1976–77. On the albums of the Fondo Pio, see Simonetta Prosperi Valenti Rodinò, "Notizie storiche sulle collezioni Corsini e Pio del Gabinetto Nazionale delle Stampe," pp. 14–25, in Rome 1976–77). The six De Neyt prints from the Museo Correr are in a volume titled *Raccolta di paesetti italiani. Album di 50 tavole tratte da disegni e pitture di Tiziano da vari incisori* (Chiari 1982, nos. 130–35, repr.).

13. Nine drawings have been identified in the previous literature. Meijer (Florence/Paris 1976, p. 34, under no. 22) identified the drawing for print no. 11 as Christ Church, inv. 0315 (but mistakenly gave the number of the Fondation Custodia print as 7620:1); and that for print no. 18 as Christ Church, inv. 0318 (see Byam Shaw 1976, no. 725, pl. 426, no. 723, pl. 421). He also cited drawings at Christ Church (no. 0312, for print no. 12; see Byam Shaw 1976, no. 729, not repr.), at Chatsworth (Devonshire Collection, inv. 264; see Jaffé 1994, no. 754, repr., for print no. 20); the Biblioteca Reale in Turin (inv. 15962, see Bertini 1958, no. 76; a copy of the original in the Metropolitan Museum of Art, inv. 1972.118.243 for print no. 19); the Louvre (inv. 5582, coll. Jabach, for print no. 21). Chiari (1982) records a drawing at Chatsworth (Devonshire Collection, inv. 911; see Jaffé 1994, no. 759, color repr.) for print no. 3. Cafritz in Washington 1988–89 (p. 128 note 13) notes Vergara's (1982, p. 57 note 96) identification of a drawing from the collection of Janos Scholz (Washington 1973, no. 94, repr.) for print no. 7. A tenth drawing, for print no. 15, is in the National Gallery of Art,

Washington, D.C., Rosenwald Collection (Washington 1978, p. 43, repr.). We can now add the SCMA drawing to this list (for print no. 5).

14. For the attribution to Nicolas van Uden, see Mariette 1969, pp. 291–92, who says that the second print in the series (which bears the inscription *Titianus invenit)* was finished by S. A. Bolswaert (1586–1659). Meijer (in Florence / Paris 1976, nos. 22 and 23) attributes the prints to an anonymous seventeenth-century Flemish artist; Catelli Isola (in Rome 1976–77, nos. 114 and 125) to an anonymous Fleming of the end of the sixteenth century. Chiari (1982, no. 135) notes Mariette's attribution but simply lists the prints under the publisher's name. Regarding Nicolas van Uden, see also Julian Stock in Venice 1980, no. 14, repr., a drawing in the Courtauld, and 14bis, repr., an etching after that drawing by Van Uden (Bartsch, vol. 5, no. 54; *Illustrated Bartsch,* vol. 6 [1980], no. 054).

15. The popularity of Venetian landscape designs in the late seventeenth and eighteenth centuries is also attested by Valentin Lefebre's *Opera Selectoria . . . ,* published in Venice in 1682, with later reprints. Antonio Maria Zanetti (1771, p. 534) remarks on the difficulty of finding the good first edition and notes that some plates have since been reworked, while impressions from others are impossible to find.

16. See Cafritz in Washington 1988–89, p. 116. Titian's woodcuts were not only widely diffused during his lifetime but were also used by seventeenth-century Northern artists. Peter Dreyer notes two landscape drawings in the Staatliche Museen Preussischer Kulturbesitz, Kupferstichkabinett, Berlin, one attributed to Jan Lievens (1607–1674), the other by Nicolas van Uden, that incorporate elements from the woodcut after Titian's *Saint Jerome in the Wilderness* (Dreyer 1985, p. 767 and figs. 34–36).

17. According to Cafritz in Washington 1988–89, p. 116, the use of Venetian landscape was tied to the desire to impart a classical and literary dimension to the Northern landscape tradition (see pp. 115–16).

18. I am grateful to Mark Morford for this translation. Perhaps there is an echo here of the reworking of Horace's *Second Epode* ("Beatus ille") by a Dutch poet called Ryckius (who is otherwise unknown) that appears on the title page of a set of prints designed by Abraham Bloemaert (1564–1651) and engraved by Boetius A. Bolswert (1580–1633) in 1614 (Hollstein 2: nos. 564–89): "When his wife happily takes her part in the work, most happy is he and in the highest measure blessed" (see Vergara 1982, pp. 158–59).

19. Neither prints by Domenico Campagnola nor those after Titian that are roughly contemporary with his designs are accompanied by explanatory inscriptions. Compare, however, the very popular prints on the subject of the Four Seasons by Jan (1550–1600) and Raphael (1561–1628) Sadeler after Bassano, which were executed in Venice between 1598 and 1600. Similar Latin inscriptions are found on other prints published in Antwerp after Italian models.

20. Further evidence that De Neyt was publishing prints in the 1630s is a print by Cornelis Galle I (1576–1650) of the Four Fathers of the Church dedicated by De Neyt to Willem van Hamme, and inscribed *P. Paulus Rubens inventor.* The print appears to have been made after the version of the painting owned by De Neyt and identified in the inventory after his death as being by Rubens (but now attributed to Jacob Jordaens [1593–1678] in execution and Rubens in conception). The painting is dated by R. A. d'Hulst to c. 1630 (see Antwerp 1993, p. 142, under no. A40).

21. See Cafritz in Washington 1988–89, p. 116, figs. 106 and 121 and figs. 108 and 109. Cafritz cites the prints formerly in the Graphische Sammlung, Munich (now lost), reproduced by Kieser 1931 and Vergara 1982, one of which (Kieser fig. 1 and Vergara fig. 31) is in reverse to the print in the Fondation Custodia (inv. 7620 / 6), and therefore in the same direction as the original drawing and the motif used in Rubens's painting. This print appears to be a copy of the etching from the De Neyt series and cannot be entirely ruled out as Rubens's source.

22. See Cafritz in Washington 1988–89, p. 116 note 13, and figs. 106 and 121 and 108 and 109.

23. I am grateful to Dan Bridgman for his help in using the computer to verify this correspondence between the contours of drawing and print. See also the drawing at Christ Church (inv. 0318) that was used for print no. 18 in De Neyt's series and which, according to Byam Shaw, is incised for transfer (Byam Shaw 1976, no. 723, repr.).

FEDERICO BAROCCI
Urbino 1535?[1]–1612 Urbino

7 *Head of a Young Woman*, study for the painting *Madonna del Gatto*, c. 1574

Black, red, and white chalks, with pink, ochre, and brown chalks [pastels?],[2] stumped, on grey antique laid paper (faded from blue); reinforced with blue paper and laid down on thin, off-white board

Watermark: None visible

330 × 246 mm (12¹⁵/₁₆ × 9⅝ in.)

Inscribed on verso of mount, in graphite: *11517 / bree/guhs*[?]

PROVENANCE {C.A. Mincieux (d. c. 1930), Geneva}; to his widow;[3] to sale, Geneva, Nicolas Rauch, sale no. 36, 13–15 June 1960, first day of sale, no. 9, as *Portrait de femme,* repr. p. 4; to {Hans Maximilian Calmann (1899–1982), London} for 8,200 Swiss francs;[4] sold to SCMA in 1960

LITERATURE *ArtQ* 1960b, p. 400; *SCMA Bull* 1961, no. 13, repr. p. 24 (as *Head of a Woman*); Olsen 1962, pp. 158–59, under no. 26; Florence 1975, pp. 40–41, under no. 29; Emiliani 1985, vol. 1, fig. 172, vol. 2, listed p. 441, no. 172; SCMA 1986, no. 207, repr. (as *Head of a Woman,* c. 1574); Halasa 1993, pp. 91–92, fig. 12; New York 1994a, p. 55, under no. 21

EXHIBITIONS Cleveland/New Haven 1978, no. 28; Northampton 1979b, no. 29; Northampton 1982a; Northampton 1984b, no. 8; Northampton 1987b, no. 21

Purchased
1960:99

This sensitively drawn head of a young woman by Federico Barocci has been described by Edmund Pillsbury as "among the finest and best preserved pastel studies by the artist."[5] It has been associated by all writers with Barocci's *Madonna del Gatto* (fig. 1), a painting that corresponds to the description by the artist's biographer Pietro Bellori of a work painted for Count Antonio Brancaleoni di Piobbico: "Barocci also painted another small piece, the Virgin seated in a room with the Christ child at her breast. She draws the Child's attention to a cat which is about to jump up at a swallow held up with a string by the young St. John. Behind, Joseph leans with his hand on a small table and pushes himself forward to watch."[6] Harald Olsen was the first to relate the SCMA drawing to the head of the Virgin in the *Madonna del Gatto,* which he dates to about 1573–74 on the basis of style. Giovanna Gaeta Bertelà also dates the painting about 1574,[7] while Andrea Emiliani prefers a slightly later dating of about 1574–75. The print after the *Madonna del Gatto* by Cornelis Cort (c. 1533–1578), dated 1577, provides a firm *terminus ante quem* for the painting, which was recorded as being in the casa Cesari, Perugia, in the eighteenth century and was already in England by 1807.[8]

The SCMA *Head of a Young Woman* is drawn in a technique for which Barocci is renowned. In its use of colored chalks on a medium-toned, blue paper (now faded to grey), the drawing approximates a painting in its coloristic and atmospheric effects. It served the artist as a preliminary study in which the tonal relationships of the painting might be worked out. Such drawings became highly valued by collectors in the following century, as they could be easily appreciated as works of art in their own right, but the evidence suggests that Barocci retained them during his lifetime for use in the studio. As recognized by Robert O. Parks, and noted in Pillsbury's discussion of the drawing, the SCMA sheet was reused by Barocci for the head of a woman in the *Martyrdom of San Vitale* (Pinacoteca di Brera, Milan) of 1580–83.[9] When the

drawings entered the hands of collectors in the seventeenth century, they may have been mounted initially in albums, but certainly by the eighteenth century, when pastel drawings had attained great popularity as independent works of art, many must have been displayed in frames. Their long-term exposure to light accounts for the fading of most of the colored papers on which Barocci's chalk drawings were executed.

Over a light outline sketch in black chalk, Barocci added colored chalks or pastels, using red to define the

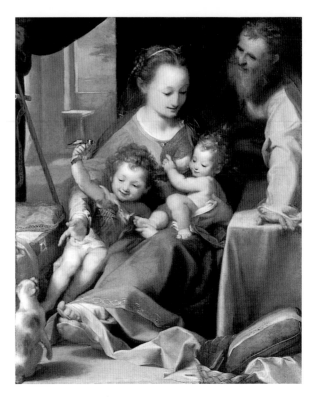

Fig. 1. Federico Barocci, *Madonna del Gatto.* Oil on canvas, 112.7 × 92.7 cm (44⅜ × 36½ in.). The National Gallery, London, inv. 29. Photo: © The National Gallery, London

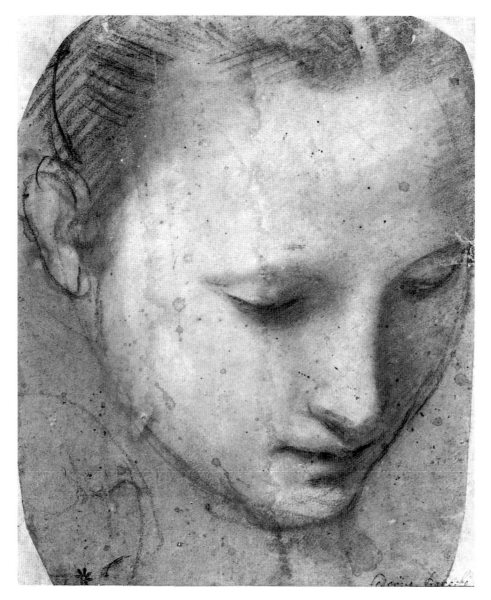

Fig. 2 .Federico Barocci, *Head of a Woman Looking down to the Right, and Slight Sketch of the Same Head,*
study for the *Madonna del Gatto.* Black chalk and pastel on discolored blue paper, 222 × 185 mm
(8¾ × 7¼ in.). The Royal Collection, inv. RL 5230, © Her Majesty Queen Elizabeth II

mouth, eyes, and nose, ochre and brown for the hair, white and pink (or light red) for the flesh. A softer black was used to rework the hair, the forehead curls being added in red chalk. Parallel strokes of black chalk shading in the background were rubbed for a soft, atmospheric effect.

Bellori's statement that Barocci learned to work in this medium from pastels by Correggio (c. 1489–1534) that had been brought to Urbino from Parma was generally accepted for many years, although no pastels from Correggio's hand have been identified. As Diane DeGrazia has observed, not only are there no surviving pastels by Correggio, but there are none by his closest followers. Noting that Barocci's earliest securely attributed pastel seems to date to the 1560s, as do those of Jacopo Bassano

(c. 1510/18–1592), DeGrazia postulates that Barocci may have learned the use of pastel in Venice.[10] Pillsbury had also suggested Bassano as a possible influence on Barocci's adoption of this medium, but W. R. Rearick believes Barocci and Bassano to have developed the use of colored chalks independently, although along partially parallel lines.[11] This view is supported by Thomas McGrath's analysis of earlier Central Italian examples by artists (especially Raphael [1483–1520]) whose work was known to Barocci.

Barocci executed many preparatory drawings for the *Madonna del Gatto,* most of them preserved today in Florence and Berlin. Olsen listed thirty drawings for this painting, five of which he identified as studies for the Virgin's head.[12] Gaeta Bertelà's consideration of the

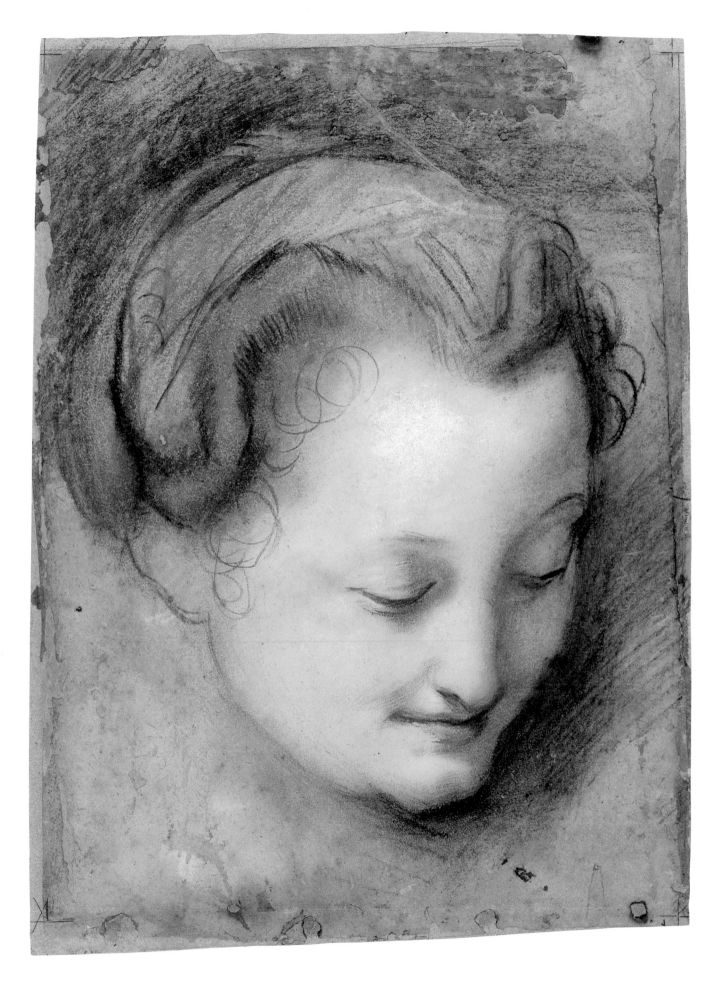

preparatory drawings for the *Madonna del Gatto* led her to outline the following sequence for these five drawings: first, a drawing in the Royal Library, Windsor Castle (fig. 2), followed by studies in the Louvre (inv. 2866) and the Uffizi (inv. 9319S and 11475F recto, which she considers the penultimate study), and finally the SCMA sheet. She places a drawing in Dijon (inv. 1750) among the early drawings of this subject.[13] Pillsbury added to this group another drawing at Windsor (inv. 5229). The exact progression is not certain, however. In both the Louvre sheet and Uffizi 11475F the neck is twisted and the head inclined in a position ultimately rejected by the artist. A development can be traced most persuasively from Windsor 5230 to Uffizi 9319S to the SCMA drawing, as Barocci refined the position of the left brow and right ear, the length of the nose, and the contours of cheek and chin.

A *Study of the Head of a Young Woman, Looking down to the Right,* identified as a study for the woman holding a child at the lower left of the *Madonna del Popolo* (1574–77; Uffizi), displays a similar facial type to the SCMA head and is executed in similar media.[14] Despite the obvious idealization of both this and the SCMA head, the strong resemblance of certain facial features — chin, nose, and mouth — suggests that they originated from the same model. Similar also is Barocci's treatment of the hair, which is drawn back from the forehead and temples in a tight roll. Comparison may also be made to another *Head of a Young Woman* (Yale University Art Gallery, inv. 1973.141), probably a study for the girl who kneels just to the right of the woman with a child in *Madonna del Popolo*.[15] In this drawing, however, the obvious pentimenti and Barocci's investigation of an alternative idea for the eyes in an auxiliary study on the same sheet suggest that it represents an earlier stage in his working process. Barocci's head studies in colored chalks were probably done in the final stages of preparation for a painting, possibly after the artist had already begun to paint.[16] The SCMA *Head of a Young Woman*, which is among the most highly finished of all Barocci's colored chalk heads, may well belong to a very advanced stage of the artist's preparation for the *Madonna del Gatto*.

AHS

1. On Barocci's birthdate, and the various opinions from Pietro Bellori on, see Olsen 1962, pp. 20–21 note 2.

2. See Burns 1994 for a discussion of when fabricated chalks or pastels began to be used. Although it is difficult — often impossible — to differentiate between natural chalks and fabricated pastels with the naked eye, she believes that Barocci may have used some fabricated colored media. See also McGrath 1998, pp. 3–4.

3. According to Janos Scholz, following the death of Mincieux c. 1930, the contents of his shop remained with his widow until Rauch retrieved them for sale. Frits Lugt recognized the quality of the Barocci head and tried to secure it from the Rauch sale for his own collection (letter from Scholz to Robert O. Parks, 23 Aug. 1960, SCMA curatorial files).

4. According to a priced and annotated sale catalogue at SCMA.

5. Cleveland/New Haven 1978, no. 28, repr. Pillsbury (note 2) notes that Harald Olsen, who had never actually seen the drawing, was probably led to qualify his acceptance of it by the misleading description in the Rauch sales catalogue of 1960: "Dessin à la pierre noir et au pastel, légères reprises du pastel probablement au XVIIIe siècle." The head itself was untouched, although extensive losses from the surrounding sheet had been restored, perhaps in the eighteenth century.

6. "Per questo signore dipinse un altro scherzo, la Vergine sedente in una camera col Bambino in seno, a cui addita un gatto, che si lancia ad una Rondinella tenuta da San Giovannino legata in alto col filo, e dietro si appoggia San Giuseppe con la mano ad un tavolino, e si fa avanti per vedere." English translation from Cleveland/New Haven 1978, p. 23. Olsen, Pillsbury, Gaeta Bertelà, and Emiliani all connect the SCMA drawing with this painting.

7. She places it after the series of portraits in the Uffizi done for Francesco Maria II della Rovere (see Bologna 1975, no. 60) and Barocci's self-portrait (Bologna 1975, no. 61).

8. For further information regarding the painting's provenance, see Emiliani and Gould 1975, pp. 10–12 note 29.

9. See undated note in Robert O. Parks's handwriting in SCMA curatorial files. See also Cleveland/New Haven 1978, no. 28.

10. See Diane DeGrazia in Washington 1984a, p 37.

11. Rearick 1993, p. 4, and McGrath 1998.

12. Olsen 1962, pp. 158–59. He also notes the painting's close relationship to the painting *Rest on the Flight into Egypt* and suggests that several studies listed for that painting might actually be for the *Madonna del Gatto* (esp. Uff. inv. 11555 verso).

13. Florence 1975, no. 29.

14. In New York/London 1988, no. 5, repr. According to this catalogue, in black, red, white pastel, yellow and brown chalks on grey-blue paper, 320 × 250 mm. The drawing is from the Skippe collection and was published by Olsen 1962, p. 168. The painting was intended for the church of Santa Maria della Pieve at Arezzo and is now in the Uffizi. Barocci received the commission for this painting in 1574; the contract was negotiated and a first payment issued in June of the following year, and by February 1576 he reported that he had finished all the drawings ("tutti li disegni") and had almost finished the cartoon. The painting itself was not completed until April 1577.

15. Cleveland/New Haven 1978, no. 28.

16. Ibid.

JACQUES (JACOB) SAVERY
Courtrai (Kortrijk) c. 1565–1603 Amsterdam

8 Mountain Landscape with Four Travelers, 1590s

Pen and light brown ink over faint black chalk underdrawing on white antique laid paper; traces of a ruled line in black ink visible at edges

Watermark: None

140 × 189 mm (5½ × 7⁷⁄₁₆ in.)

Inscribed recto, lower left corner, in light brown ink: *P BRVEGEL 1560*; inscribed verso, in graphite: *Brueghel 1560 / le vieux (?) no / — / 48191 / 6731*

PROVENANCE {Otto Wertheimer (1896–1972), Basel (Galerie Les Tourettes)} (as by Pieter Bruegel the Elder); sold to SCMA in 1958 (as by Pieter Bruegel the Elder)

LITERATURE *ArtN* 1959, p. 37 (as by Pieter Bruegel); *Museum News* 1959, p. 4 (as by Pieter Bruegel); *GBA* 1960 (listed, as by Pieter Bruegel); Parks 1960, no. 22, repr. (as by Pieter Bruegel the Elder); de Tolnay 1960, pp. 17–18, fig. 10 (as by Pieter Bruegel the

Elder); Müntz 1961, Appendix (by Luke Herrmann) no. 3, repr. (as by Pieter Bruegel the Elder); Morse 1979, listed p. 32 (as by Pieter Bruegel the Elder); Liess 1979–80, p. 12, no. E12; Liess 1982, pp. 93, 105, repr. p. 157 (as by Pieter Bruegel the Elder); SCMA 1986, no. 206, repr. (as by Pieter Bruegel the Elder); Mielke 1996, no. A22, repr. p. 84

EXHIBITIONS New York 1959a, no. 23, pl. XXIII (as by Pieter Bruegel; entry by Leonard Slatkes); Chicago 1961, no. 27 (as by Pieter Bruegel); Los Angeles 1961, no. 105, repr. p. 67 (as by Pieter Bruegel); Northampton 1979b, no. 26 (as by Pieter Bruegel); Northampton 1982c (as by Pieter Breugel); Northampton 1984b, no. 3 (as by Pieter Bruegel); Northampton 1986c (as by Pieter Breugel); Northampton 1994, no. 8

Purchased
1958:39

This drawing, formerly attributed to Pieter Bruegel the Elder (c. 1525/30–1569), belongs to a group of small landscapes that have been convincingly reattributed to Jacques Savery.[1] Unpublished in 1958 when it was purchased by SCMA, the drawing was accepted as autograph by Charles de Tolnay, who related it to the fifteen sheets that he had grouped in his catalogue raisonné of Bruegel's drawings under the heading "Small Landscapes."[2] All but one of these drawings are inscribed with Bruegel's name and bear dates ranging from 1559 to 1561. Both de Tolnay and Ludwig Müntz believed the majority of these inscriptions to be authentic.[3] Thus they and other scholars discussed the drawings in the context of works that Bruegel produced after his return to Antwerp from Italy, where he had gone shortly after joining the Antwerp painters' guild in late 1551 or early 1552. Bruegel remained in Italy until 1554, when he returned to Antwerp, and began work on drawings for prints published at Aux Quatre Vents, the firm established in 1548 by Hieronymous Cock (c. 1510/20–1570). Among these prints are large landscape compositions drawn in the studio but inspired by drawings presumably made from nature during Bruegel's passages across the Alps. The small landscape sheets dated 1559–61, which range in subject from imaginary mountain peaks to village scenes, were thought to introduce a new phase in Bruegel's investigation of landscape.

The group of Small Landscapes is stylistically very closely related to a number of larger drawings. Among these are *The Blind*, three views of Amsterdam's city walls and gates, and several village scenes, most of which are dated 1562 and inscribed with Bruegel's name.[4] Like those of the Small Landscapes, most of the signatures and dates are in the same ink as the images and seem to

be original to the drawings. Although individual sheets had been questioned, most of them retained their attributions to Bruegel until 1985, when Hans Mielke reconsidered the entire group and concluded that if some of these works could convincingly be removed from Bruegel's oeuvre, the others must also be withdrawn. Mielke persuasively argued that all these sheets should be assigned to Jacques Savery.[5]

The Savery brothers were born in Courtrai, Jacques (or Jacob) about 1565, and Roelandt in 1576. Jacques studied with Hans Bol (1534–1593), who was renowned for his watercolor paintings on canvas and for his miniatures in gouache on vellum. This training probably occurred in Antwerp, the Savery family, like Bol himself, having fled their home because of political and religious unrest in the Southern Netherlands.[6] Making his way north, Jacques Savery spent some time in Haarlem (where he is documented in 1585 and where he joined the guild in 1587) but settled finally in Amsterdam, where he became a citizen in 1591. It is thought that his pupil and younger brother Roelandt accompanied him to Amsterdam.

Jacques Savery's drawing style is known from signed drawings, including dated sheets ranging from the mid-1580s to 1603, the year of his death. As has often been remarked, after the initial strong influence of Hans Bol, Savery's work in the 1590s reflects a study of Pieter Bruegel the Elder. William W. Robinson has noted that a large watercolor *Kermis* in the Victoria and Albert Museum, which is signed and dated 1598, is based on two prints of village fairs designed by Bruegel almost forty years earlier.[7] Also in 1598 Jacques de Gheyn II (1565–1629) engraved a village scene after one of the pen and ink drawings inscribed with Bruegel's name, but now given convincingly to Savery.[8] It therefore seems logical, as

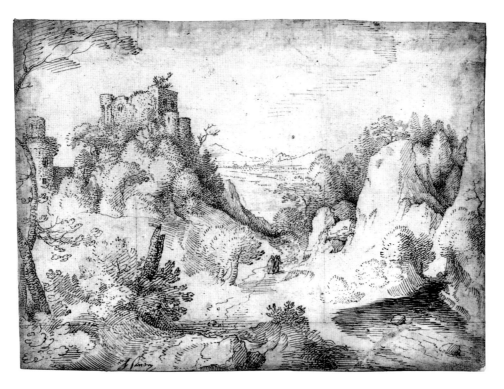

Fig. 1. Jacques Savery, *Landscape with a Castle*. Pen and brown ink. The Pierpont Morgan Library, New York, inv. 1985.101. Photo: David A. Loggie

Robinson proposes, to date the entire group of "Bruegel" sheets to the late 1590s. Whether Savery executed these drawings as deliberate forgeries, as Mielke maintained, or as exercises in virtuosity "in the manner of" a famous predecessor, as Robinson suggests, he succeeded in creating works that have been greatly admired.

Like other sheets in de Tolnay's Small Landscape group, the SCMA landscape is drawn in light brown ink, probably bistre, in the most delicate of pen strokes. Its resemblance to signed drawings by Jacques Savery is striking, and there is every reason to reassign this drawing to him. Savery's signed *Landscape with a Castle* in the Pierpont Morgan Library (fig. 1), rendered in a similar pale golden-brown ink, shows the same technique for describing the road with a series of looping, zigzag lines.[9] The small travelers present in both drawings also exhibit marked similarities in treatment.[10] Foliage is denoted by quick flicks of the pen; the distant landscape is handled with the same conventions as in the SCMA sheet, including the vertical, parallel hatching used to shade the rocky peaks, as well as the hatching style used in the foreground rocks. These characteristic touches are also present in the signed and dated (1603) drawing *A Ruined Circular Bastion and Bridge,* in which the dissolution of form into a flickering series of dots, loops, and touches of the pen is taken even further.[11]

AHS

1. Mielke 1985–86, pp. 76–81. See also the discussions in Washington/New York 1986–87, nos. 97–100 (entries by William W. Robinson). Mielke 1996 catalogued the SCMA drawing as by Jacques Savery.

2. On the "Small Landscapes," see de Tolnay 1952, nos. 24–38. De Tolnay believed that the drawings were not from a sketchbook, because their formats differ (de Tolnay 1952, p. 61). In addition to the fifteen sheets catalogued in de Tolnay 1952, Wertheimer cited a drawing sold by him to Count Seilern (now Courtauld Institute; Seilern 1969, no. 316?), and the SCMA sheet (letter to Robert O. Parks, 8 July 1958, SCMA curatorial files).

3. SCMA's *Mountain Landscape with Travelers,* dated 1560, was described by de Tolnay (1960, pp. 17–18) as a development of a motif found in de Tolnay 1952, no. 25, dated 1559 (Akademie der bildenden Künste, Kupferstichkabinett, Vienna) and a herald of de Tolnay 1952, no. 30 (Staatliche Museen Preussischer Kulturbesitz, Kupferstichkabinett, Berlin). Müntz died in 1957 before his study of Bruegel's drawings was published, but he too considered the group to be important in Bruegel's oeuvre. The SCMA sheet was listed by Luke Hermann in the appendix of works discovered since 1957 (Müntz 1961).

4. *The Blind,* Staatliche Museen Preussischer Kulturbesitz, Kupferstichkabinett, Berlin; *Walls, Towers, and Gates of Amsterdam* (2 drawings), Museum of Fine Arts, Boston, and Musée des Beaux-Arts et d'Archéologie, Besançon; *Farmhouses by Stream,* Herzog Anton Ulrich-Museum, Braunschweig. See discussion in Washington/New York 1986–87, nos. 98, repr. (the Boston drawing) and 99, repr. (the Berlin drawing). See also the drawings discussed in Mielke 1985–86, e.g., *Landscape with Two Peasants*

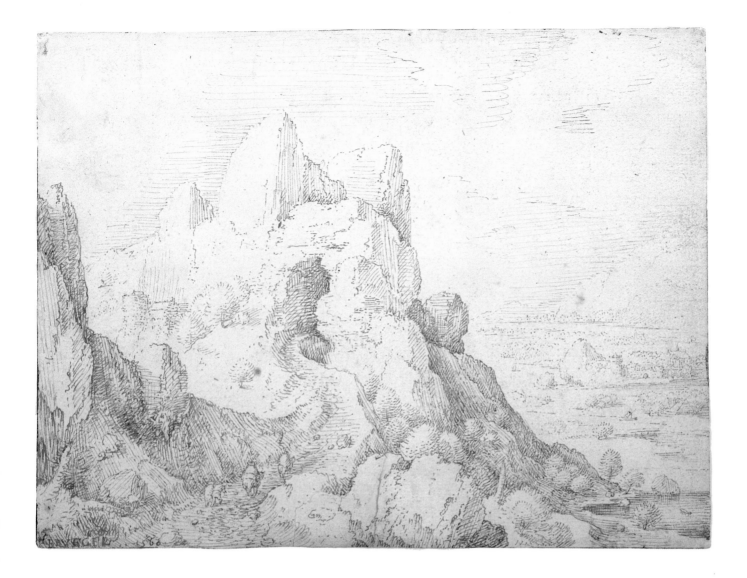

and a Dog, Courtauld Institute, London, Count Antoine Seilern Collection (see Seilern 1969, no. 317, repr.). For two recent additions to this group, see the sale, Amsterdam, Sotheby's, 15 Nov. 1995, nos. 25, repr., and 26, repr.

5. Mielke 1985–86, pp. 76–81. De Tolnay (1952) recognized that the small drawings represented a markedly different conception of landscape from the large landscape series and even expressed doubt as to the authenticity of individual sheets in the group. He also noted the strong interest in ruins and castles in these drawings (p. 24) and remarked on the delicacy of line and the use of a network of small strokes and dots that seem almost to dissolve form. All these characteristics can be seen in signed Savery drawings. Karel Boon noted that the watermark appearing on the mount of a small landscape in the Frits Lugt collection also appears on the Besançon drawings of Amsterdam (it is actually on the mounts, not the drawings themselves), which had been questioned since 1935 and which he connected with Jacques Savery without, however, reattributing the Lugt drawing to him (Florence/Paris 1980–81, no. 43).

6. After Malines was occupied by the Spanish in 1572, Bol established himself in Antwerp, joining the painters' guild in 1574 and becoming a citizen the following year. In 1584 he fled again, making his way to the Northern Netherlands, where he eventually settled in Amsterdam in 1591.

7. Washington/New York 1986–87, pp. 258–59, fig. 2.

8. The drawing is in the Kupferstichkabinett, Berlin (see Müntz 1961, no. 38, pl. 37).

9. See Washington/New York 1986–87, p. 252, fig. 1.

10. Compare also the travelers in *Landscape with a Castle* in the Musée des Beaux-Arts et d'Archéologie, Besançon (Müntz 1961, no. 43, pl. 42).

11. Frits Lugt Collection, Fondation Custodia, Institut Néerlandais, Paris, inv. 484A (Washington/New York 1986–87, no. 100, repr.). Prints by Jacques Savery show similar stylistic features. See, e.g., *Deerhunt* (dated 1602 in the plate; Hollstein 7) and the drawing on which it is based (Berlin 1975, no. 216, pl. 244).

LODOVICO CARDI (CALLED IL CIGOLI)
Castelvecchio di Cigoli (near San Miniato al Tedesco, Pisa) 1559–1613 Rome

9 *Reclining Male Figure,* 1593, study for the painting *The Dream of Jacob* (1593)
Verso: *Reclining Male Figure,* 1593, study for the same painting

Red chalk on white antique laid paper

Verso: Pen and brown (probably iron gall) ink

Watermark: None

243 × 373 mm (9⁹⁄₁₆ × 14¹¹⁄₁₆ in.)

Inscribed verso, at center of upper edge in pen and brown ink, in the hand of Giovanni Battista Cardi: *di man di Lodovico Cigoli;* at upper edge, immediately to the right of Cardi's inscription, in pen and brown ink, in the hand of William Gibson: *6.2* (his price code for 15 shillings)[1]

PROVENANCE Probably among the drawings bequeathed by the artist to his nephews (Giovanni Battista Cardi, b. c. 1592; Cosimo, d. 1631; and Francesco, date of will, 1667) in 1613; Sir Peter Lely [b. Pieter van der Faes] (1618–1680), London (Lugt 2092, lower right corner, recto); to his estate (possibly in sale, London, 11 April 1688 and following days or London, 15 Nov. 1694 and following days); possibly to William Gibson (c. 1644–1702);[2] probably to Jonathan Richardson, Sr. (1665–1745), London (Lugt 2183, lower right corner, recto); possibly to his heirs and in his sale, London, directed by Cock, 22 Jan. and following days 1747 (1746 old style); Sir Joshua Reynolds (1723–1792) (Lugt 2364, lower right corner, recto); to his heirs; anonymous owner; to {Richard Oinonen}, sale, Oinonen Book Auctions, Northampton, Mass., 12 Nov. 1996, lot 182; sold to SCMA in 1996

LITERATURE *GBA* 1998, no. 190, repr. (recto)

EXHIBITION Northampton 1997 (recto and verso)

Purchased, Ruth and Clarence Kennedy Fund, Diane Allen Nixon, Class of 1957, Fund, Josephine A. Stein, class of 1927, Fund 1996:23

Cigoli was a prolific and inventive draughtsman for whom drawing was a fundamental creative activity. His diligence in the study of anatomy and perspective, and his dedication to drawing as a means of preparing for painting were remarked on by his early biographers: "Disegno senza termine o misura" (He drew without end or moderation), according to Filippo Baldinucci (1625–1695), the Florentine connoisseur, collector, and scholar.[3] Over five hundred drawings by Cigoli are preserved in the Uffizi, the principal repository of his drawings.

Lodovico Cardi was born in Tuscany at Castelvecchio di Cigoli, from which his nickname is derived. Cigoli's first biographer, his nephew Giovanni Battista Cardi, records that the talented youth was placed at about age thirteen in the Florentine studio of the painter Alessandro Allori (1535–1607), where he began his study of anatomy. In the 1580s he trained with the architect Bernardo Buontalenti (1531–1608) and with the painter Santi di Tito (1536–1603), who was leading Florentine art away from mannerist complexity toward a new naturalism and clarity of expression. Cigoli's work with these artists brought him into contact with the ruling Medici family and other important patrons, and by the early 1590s Cigoli had established himself as an independent artist.

This drawing, which was discovered mounted in a book in 1996, preserves two studies for the figure of Jacob in Cigoli's painting *The Dream of Jacob,* now in the Musée des Beaux-Arts, Nancy (fig. 1).[4] Although multiple versions of this composition are known, the Nancy canvas is the only signed and dated one: Cigoli's monogram and the date appear on the rock at lower right. Unfortunately, it is no longer possible to make out the final digit of this date, which has been variously read — most often as 1593 or 1598—with individual scholars justifying their reading on stylistic grounds. Most scholars accept the 1593 dating proposed by the Musée des Beaux-Arts and accepted by Miles Chappell.

Fig. 1. Cigoli, *The Dream of Jacob,* 1593. Oil on canvas, 173 × 134 cm (68⅛ × 52¾ in.). Musée des Beaux-Arts, Nancy, inv. 16. Photo: G. Mangin

9 Recto

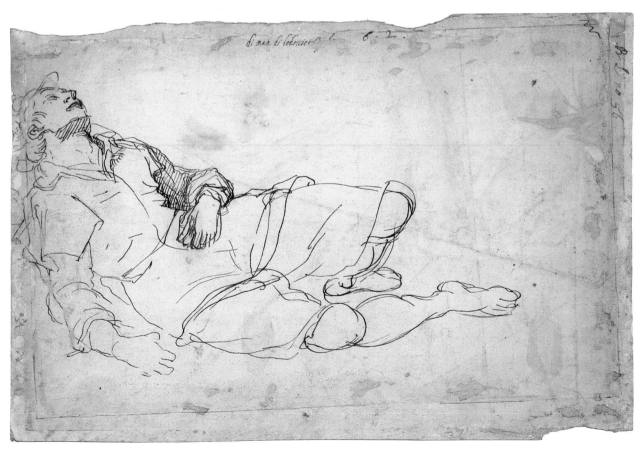

9 Verso

Fig. 2. Cigoli, *Young Man Asleep; Study of His Right Hand.* Black and red chalks with white heightening on blue paper, 264 × 412 mm (10⅜ × 16¼ in.). Paris, Musée du Louvre, Département des Arts Graphiques, inv. 11864. Photo: © RMN

In the story of Jacob's dream, told in the book of Genesis (28:10–22), God's promise of land to the Israelites is renewed. The third of the great Hebrew patriarchs, Jacob was the son of Isaac and the slightly younger twin of Esau, whom he cheated of their father's blessing, securing authority over their tribe for himself. Fleeing his brother's wrath, Jacob set out for the home of his maternal uncle Laban in Mesopotamia. As he slept at the side of the road, a pile of rocks for his pillow, Jacob dreamed of a ladder reaching to heaven. As angels ascended and descended, God addressed Jacob from atop the ladder saying: "I am the Lord God of Abraham thy father, and the God of Isaac: the land whereon thou liest, to thee will I give it, and to thy seed." Awakening, Jacob took the stones that had pillowed his head and constructed a pillar, which he anointed with oil, calling the site "Bethel" (the House of God).

The two drawings on the SCMA sheet, both preparatory for the figure of Jacob, are studies of significantly different kinds. The recto drawing is a red chalk study from life of a reclining, lightly bearded young man, probably an assistant *(garzone)* posed in the studio. The background, only lightly indicated, suggests a support against which he leans. Except for his footwear, which resembles theatrical costuming *all'antica,* he wears contemporary dress — a short jacket and breeches. The warm red chalk, which can be blended to atmospheric effect, allowed Cigoli to study the play of light on the volumes of the figure.

In contrast, the verso study is in pen and brown ink, a medium well adapted to rapid sketching and Cigoli's preferred medium for setting out preliminary ideas for entire compositions or individual figures. It is a free and fluid sketch executed directly from his imagination, in which he explores certain details of the figure, whose basic pose he had studied in earlier drawings. Here Cigoli indicates features of the costume that will appear in the final painting (the capped sleeves of Jacob's tunic, the cut of his pantaloons) and makes adjustments to the position of Jacob's left hand.

The rediscovery of SCMA's sheet brings the number of drawings that can be associated with Cigoli's *Dream of Jacob* to nine (seven sheets, two of them with drawings recto and verso). Establishing their sequence and dating, however, is complicated by the existence of multiple versions of the painting whose interrelationships remain uncertain. Miles Chappell has convincingly shown that one variant composition can be assigned to Cigoli (in conception if not necessarily in execution) on the basis of drawings.[5] Two of these sheets hold studies for the figure of Jacob. The Louvre's drawing (in black and red chalks with white heightening on blue paper; fig. 2) corresponds closely to this variant.[6] Jacob is drawn as a full-faced, beardless youth who wears a rustic costume that has slipped from his right shoulder — a white blouse under a tunic styled vaguely *all'antica* that drapes over his thighs and is held with a shoulder clasp. The position of his arms and hands is studied several times in a double-sided sheet in the Uffizi executed in the same medium on blue paper.[7] Like the Louvre drawing, these appear to be studies from a live model (as suggested by the figure's contemporary clothing). As Chappell proposes, the variant composition to which these drawings relate is probably earlier than the Nancy version.[8]

Two nearly identical composition drawings with blue wash (one in the Gabinetto Nazionale della Grafica in

Fig. 3. Cigoli, *The Dream of Jacob.* Pen and brown ink, brush and blue wash, 230 × 180 mm (9¹⁄₁₆ × 7⅛ in.). Uffizi, Gabinetto Disegni e Stampe, inv. 8906F. Photo: Soprintendenza per i beni artistici e storici, gabinetto fotografico, Florence

Rome, the other in the Uffizi, fig. 3)[9] are closely related to the Nancy painting, where Jacob's ladder recedes diagonally toward the upper right corner of the composition. These drawings still represent Jacob as a beardless youth who wears generic "ancient" costume with full sleeves and what appears to be a long tunic; but here his left arm is extended along his leg.[10]

Between the two composition drawings and the Nancy painting, Cigoli transformed Jacob into a somewhat older, bearded figure. A red chalk drawing of a reclining nude may be crucial to understanding this change (fig. 4).[11] A study from life, the drawing has long been associated with *The Dream of Jacob,* as the position of the figure is so near to that used in the painting. However, as marks on the red chalk figure's hands clearly suggest the stigmata, it may have been created instead as a study for the dead Christ. The use of this figure as the basis for Jacob would have been a perfectly logical choice iconographically, as it would underline the theological significance of the subject. Jacob was taught by the Church as a prefigurative "type" of Christ, and his dream was interpreted in the Renaissance as prefiguring Christ's promise to Nathaniel (John 1:51): "Hereafter ye shall see Heaven open and the angels of God ascending and descending upon the Son of Man."

Fig. 4. Cigoli, *Reclining Male Nude.* Red chalk, 280 × 393 mm (11 × 15½ in.). Uffizi, Gabinetto Disegni e Stampe, inv. 8987F.
Photo: Soprintendenza per i beni artistici e storici, gabinetto fotografico, Florence

The SCMA studies for Jacob, both of which are closer in detail to Cigoli's final solution for the Nancy painting, are the latest in the sequence of known drawings for this work. The sheet almost certainly remained in Cigoli's studio for his lifetime, passing at his death to his nephews, who were his sole heirs; it bears an inscription in the hand of Giovanni Battista Cardi identifying it as an autograph work by the master.[12] By the late seventeenth century the drawing had gone to England, where it can be traced from the collection of the painter Sir Peter Lely through a succession of important British collections up until the end of the eighteenth century. When rediscovered in 1996, it was inlaid in Charles Rogers's publication *A Collection of Prints in Imitation of Drawings*.[13] The sheet had been mounted along all four edges into a window created by excising from one page a print after a drawing by Baccio Bandinelli (1493–1560), so that Cigoli's pen and ink study, with its inscription *di man di Lodovico Cigoli*, would fall on the recto while the red chalk drawing would be visible on the verso of the page. The careful preservation of the print's engraved inscription identifying the owner of the Bandinelli drawing as Sir Joshua Reynolds suggests that whoever mounted the drawing was well aware that it had belonged to the famous collector, whose mark is stamped at the lower right corner of the red chalk study. The fact that the Cigoli was the single drawing inlaid into this volume suggests, however, that the owner who placed it there was probably not a significant collector of drawings.[14]

AHS

1. I am grateful to Nicholas Turner for identifying this inscription. For the meaning of the price code, see Popham 1967, no. 81.

2. William Gibson, a miniature painter, was a major buyer at the sale of Lely's drawings. He marked the drawings he owned with price codes for the benefit of his widow, from whom the portrait painter and collector Jonathan Richardson, Sr., purchased many drawings in 1703.

3. Quoted in Contini 1991, p. 115.

4. Contini 1991, no. 10, color repr. (as 1598).

5. Florence 1992, under no. 20. Safarik (1990) cites two paintings, formerly attributed to Domenico Fetti, that he considered likely to be or to reflect a painting by Cigoli. One of these, reproduced by Alberto Riccoboni in Venice 1947 (featuring paintings from [unidentified] private collections), is the work discussed by Chappell (fig. 20c).

6. See Viatte 1988, no. 141, repr. Once attributed to Barocci, the drawing was returned to Cigoli by Jacob Bean, who connected it with the painting in Nancy.

7. *Studies for Jacob,* black and red chalk, white heightening, on blue paper, 270 × 220 mm, Uffizi, inv. 9038F (see Florence 1992, no. 21 recto and verso, both repr.). Formerly attributed to

Giovanni da San Giovanni (Giovanni Mannozzi, 1592–1636), the drawing was identified as a study for Jacob by Annamaria Petrioli Tofani (1979, p. 79, under no. 37). The position of the left hand (on the recto) corresponds fairly closely with that of the hand in the Louvre drawing, although the right hand and arm are positioned differently. The second study on the page, a further investigation of the left hand's position, moves it closer to the position of the painting, with the thumb slightly extended. A third drawing, in brush and blue wash, depicts an angel that is virtually identical to the one nearest earth in the painting (Uffizi, inv. 964F; see Faranda 1986, no. 29b, repr.).

8. Florence 1992, under no. 20. Raphael's ceiling in the Vatican's Stanza d'Eliodoro is sometimes cited as a precedent for the Nancy painting, as is his sixth arcade of the Vatican *logge,* which has more in common with this variant, where Jacob's ladder rises vertically from the center of the composition. Cigoli could have known Raphael's composition from the chiaroscuro woodcut traditionally attributed to Ugo da Carpi (see *Illustrated Bartsch,* vol. 48, no. 5 [25], repr.).

9. Gabinetto Nazionale della Grafica, inv. F.C. 130625 (Rome 1977, no. 46, color repr.); Uffizi, inv. 8906F (Florence 1992, no. 20, repr.).

10. The Uffizi drawing moves Jacob closer to the picture plane, making him somewhat more prominent, as he is in the painting, supporting Miles Chappell's suggestion that this is the later of the two drawings. (Cf. Anna Forlani, in San Miniato 1959, who identified the Rome drawing as the modello for the Nancy painting and Simonetta Prosperi Valenti Rodinò, in Rome 1977, who thinks it is the more complete version.)

11. *Study for Jacob,* Uffizi, inv. 8987F (Faranda 1986, no. 29a, repr.). A. Bucci in San Miniato 1959, p. 76, listed this drawing (with the composition study and the angel) in connection with the Nancy painting.

12. That it remained in the studio is also suggested by the fact that echoes of the figure are to be found among Cigoli's late works in Rome.

13. A connoisseur and collector, the friend of Horace Walpole, Sir Joshua Reynolds, Arthur Pond, and other prominent men of his day, Rogers inherited in 1740 from his mentor William Townson a library and art collection that would form the basis for his own considerable collections, which came to include many prints and drawings. For his 1778 publication, *A Collection of Prints in Imitation of Drawings,* Rogers engaged a number of printmakers to reproduce drawings from major British collections (including his own). The two-volume publication (which included the prints, plus his own critical commentary) was printed by J. Nichols and sold by J. Boydell. The volume in which the SCMA drawing was mounted is an edition without commentary, printed by Joseph Kay.

14. The framing line drawn in pencil around the edge of the sheet and the various points at which the paper is skinned on the verso suggest that the drawing had been mounted to (and removed from) one or more supports before being inserted in the Rogers book. These would presumably include Lely, Richardson, and Reynolds mounts.

BARTHOLOMAEUS SPRANGER
Antwerp 1546–1611 Prague

10 *Mars and Venus*, 1597

Pen and dark brown ink with brush and grey wash, heightened with lead white, the composition bordered by a ruled framing line in pen and dark brown ink on moderately textured, cream antique laid paper. An oval patch inset above date at upper left, inpainted with gray wash and parallel hatching

Watermark: None

Sheet: 258 × 210 mm (10 3/16 × 8 1/4 in.); image (including framing line): 252 × 203 mm (9 15/16 × 8 in.)

Dated below window at upper left, in pen and dark brown ink: *1597*

Inscribed verso, upper left corner, in graphite: *7* (circled); upper right corner, in graphite: *42*

PROVENANCE Deiker collection, Braunfels, by 1930;[1] {Lucien Goldschmidt (d. 1992), New York}, by 1963;[2] sold to SCMA in 1963

LITERATURE Oberhuber 1958, p. 92, no. Z11; Reznicek 1961, vol. 1, p. 155 and no. 41, pl. XIV; Oberhuber 1970, p. 221, fig. 13, p. 222 note 23; Stuttgart 1979–80, vol. 2, p. 189; SCMA 1986, no. 210, repr.; Los Angeles 1988–89, fig. 127a; Frankfurt 2000, under no. 9, fig. 1.

EXHIBITIONS Kassel 1930–31, no. 215; Poughkeepsie 1970, no. 89, pl. 3; Northampton 1978a, no. 99, repr.; Northampton 1979b, no. 15 (as c. 1577); Northampton 1982a; Princeton 1982, no. 49, repr. and frontispiece; Northampton 1984b, no. 7; Northampton 1986b; Amherst 1990b, no. 22; Northampton 1994, no. 5

Purchased
1963:52

Smith's *Mars and Venus* is one of two nearly identical drawings, the other a sheet preserved in the Städelsches Kunstinstitut, Frankfurt am Main (fig. 1). Both are accepted as authentic by Konrad Oberhuber and Thomas DaCosta Kaufmann.[3] Kaufmann points out that while the Frankfurt drawing has a "stronger sense of individual form and expression," the execution of the Smith sheet displays a freedom of handling that would suggest an autograph repetition rather than a copy by another hand.[4] As both scholars have observed, Spranger is known to have repeated drawings as well as paintings.[5]

More debate has surrounded the dating of the SCMA *Mars and Venus*, which once bore an inscription at the upper left reading, *B. Sprangers Inventor 1597*, which is visible in an early photograph of the drawing.[6] Although the date remains, the rest of the inscription was removed sometime between the drawing's exhibition in Kassel (1930–31) and its acquisition by Lucien Goldschmidt. The catalogue of the Kassel exhibition describes the inscription as "later," which may account for its removal by a subsequent owner. The authenticity of inscription and date was also questioned by Oberhuber before he had personally examined the Smith College drawing and before he became aware of the Frankfurt version, which is dated 1596.[7] After observing firsthand that the date on the SCMA sheet is in the same ink used for the drawing, he came to accept both the date and the vanished inscription as authentic.[8] As Kaufmann notes, the inscription describing Spranger as inventor of the composition is entirely appropriate for an autograph second version of a drawing.[9]

The Northampton and Frankfurt *Mars and Venus* drawings have been discussed by all scholars in relation to a print of the same subject by Hendrick Goltzius (1558–1617). This engraving, inscribed *BSpranger Inventor*

HGoltzius sculptor, is dated 1588 and presents a rather different composition, in which Mars leans back against the bed on which Venus reclines in his embrace.[10] As no corresponding drawing by Spranger has been found, the sheet that served Goltzius as directly preparatory for his print is assumed to have been lost. Oberhuber saw the Frankfurt and Smith drawings as autograph replicas of a lost earlier variant of this subject which he dated to about 1577 or somewhat later.[11] E. K. J. Reznicek also proposed dating the composition before Spranger settled in Prague in 1580.[12]

Kaufmann, however, dissents, noting that arguments for dating the original composition prior to 1580 rest on the assumption that Goltzius must have worked from drawings given to him by Karel van Mander (and that Van Mander had received them from Spranger about 1577)[13] and on comparison of the composition to prints such as Goltzius's *Vulcan and Mars*, previously dated to about 1575–80, but now datable to about 1585 along with other compositions for which Goltzius must have received drawings by Spranger (including *Feast of the Gods*, dated 1587).[14] Comparing the drawing style and figure types in the Frankfurt-Northampton *Mars and Venus* to Spranger drawings and paintings of the 1590s, Kaufmann persuasively argues that the invention of the composition is not much earlier than 1597.[15] It therefore seems likely that the 1596 Frankfurt drawing represents Spranger's initial version of this particular *Mars and Venus* and, consequently, that the Frankfurt-Northampton composition is properly seen as a reprise of the subject treated in the lost drawing used for Goltzius's print of 1588.[16]

The original purpose of the drawings remains an open question, however. Before Oberhuber knew the Frankfurt *Mars and Venus,* he had suggested that the SCMA sheet was intended for a print.[17] But as Kaufmann points out,

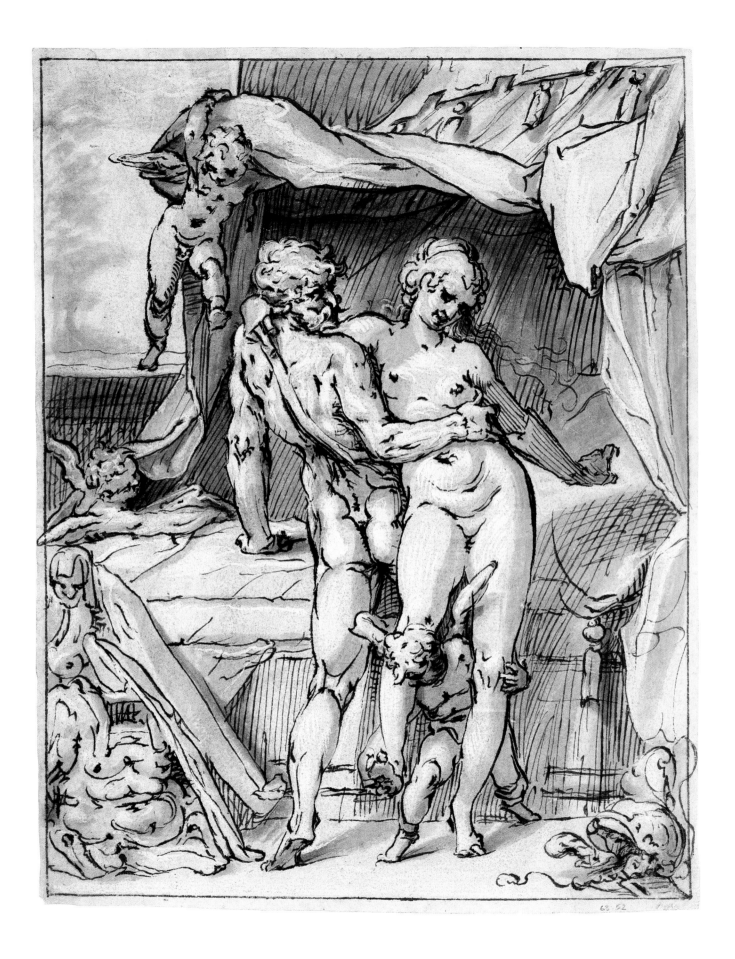

58 BARTHOLOMAEUS SPRANGER

Fig. 1. Bartholomaeus Spranger, *Mars and Venus*, 1596.
Pen and black ink, some strokes in brown ink, with brush
and grey wash heightened with white on prepared paper,
250 × 203 mm (9⅞ × 8 in.). Städelsches Kunstinstitut Frankfurt,
inv. 14458

Cardinal Alessandro Farnese and Pope Pius V until he moved to Vienna to serve Maximilian II in the fall of 1575. Scholars have detected in *Mars and Venus* echoes of Raphael (1483–1520) (*Psyche Carried by Amoretti,* in the Loggia di Psiche at the Farnesina), Michelangelo (1475–1564) (the standing soldier seen from behind in an engraving by Agostino Veneziano [1490–1540] [Bartsch 423]), and Rosso (heads of male gods, such as those in prints by Giovanni Jacopo Caraglio [c. 1505–1565]).[19] A source of erotic imagery with which Spranger undoubtedly was also familiar is the print series *The Loves of the Gods* (1527) engraved by Caraglio after drawings by Perino del Vaga (1500/1501–1597) and Rosso.[20]

Spranger, who had gone to Prague probably in the fall of 1580, was named court painter to Rudolf II (r. 1576–1612) in January 1581, joined the painters' guild three years later, and was awarded a title of nobility in 1588. Except for a visit to Antwerp, Amsterdam, and Haarlem in 1602, Spranger remained at the Rudolphine court in Prague for the rest of his career. Many of his mythological works from the 1580s and 1590s feature erotically entwined couples similar to that in *Mars and Venus* and reflect the continuing popularity of these subjects with Europe's princely patrons even after the repressive edicts of the Council of Trent.[21] Smith's *Mars and Venus* is a particularly successful example of the elegant art that Spranger created at the court of Rudolf II.

AHS

the Smith drawing, as a second version, is more likely to have been made for presentation as a gift or possibly for sale.

The subject of the drawing is the illicit affair between Mars, the god of war, and Venus, goddess of love and wife of the lame god Vulcan. The story of this adultery, its discovery by Vulcan, and the revenge he crafts, is told by Homer in the *Odyssey.*[18] Helios, observing the lovers together, informed the cuckolded husband, who forged a cunning net in which the couple were trapped at their next tryst and displayed to the amusement of the gods. But unlike the version of this story engraved by Goltzius in 1588, in which the outcome is foreshadowed by the figure of Helios in the sky outside the window, Spranger's focus in the Frankfurt and Northampton drawings is solely on the erotic intertwining of the lovers. Putti assist the couple: two pull back the sheets and bed hangings, while a third playfully tips Venus backward toward the bed.

The *Mars and Venus* draws on Italian sources that would have been familiar to Spranger from his Roman sojourn as well as from prints. After early art training in his native Antwerp, Spranger had left home in 1565, traveling to Paris, Lyon, Milan, and Parma, and arriving in Rome the following year, where he established a workshop. Over the next nine years Spranger worked for

1. According to Walther Kramm Luthmer in Kassel 1930–31, the Deiker collection was formed by a family of painters, Friedrich Deiker (1792–1843) and his sons Johannes (1822–1895) and Carl Friedrich (1836–1892), who was the most involved in collecting.

2. According to whom it "disappeared from view" after the Kassel exhibition (letter to Charles Chetham, 30 March 1963, SCMA curatorial files).

3. See Kaufmann in Princeton 1982, no. 49.

4. Ibid.

5. See, for example, the *Amor* drawings in Erlangen and in Nuremberg (Germanisches Nationalmuseum, inv. HZ28) cited by Oberhuber 1970, p. 221.

6. See the reproduction in Reznicek 1961, vol. 1, pl. XIV (Foto Marburg N. M. 2653).

7. The date, 1596, is visible at the lower right of the drawing, on the bed frame just to the left of Mars's helmet.

8. Oberhuber 1970, p. 222.

9. Princeton 1982, p. 141. See also the inscription on the drawing *Juno, Jupiter, and Mercury,* c. 1585 (Fogg Art Museum, inv. 1983.142), which reads, *B. Spranger antvers inventor.*

10. Bartsch 276 (Strauss 1977, no. 262, repr.), Hirschmann 1976, no. 321.

11. Oberhuber's opinion is followed by the authors of Poughkeepsie 1970 (Thomas J. McCormick and Wolfgang Stechow) and Northampton 1978a (Wendy Steadman Sheard). Whereas Oberhuber had dated this hypothetical version of the subject to c. 1577 in his doctoral dissertation (1958), by 1970 he had concluded it was probably somewhat later.

12. Reznicek 1961, vol. 1, p. 155.

13. In his Life of Hendrik Goltzius (fol. 284 recto) in book IV of his *Schilder-boeck* (Haarlem, 1604), Van Mander takes credit for having introduced Goltzius to the drawings of Spranger, "which he proceeded to follow closely" (see Melion 1990, p. 481 note 1). Spranger had moved to Vienna to the court of Maximilian II in the fall of 1575, and after Maximilian's death in 1576 he worked with Karel van Mander on a triumphal arch for an entry of Rudolf II into Vienna in July 1577.

14. For further discussion of the dating of these Goltzius prints, see Princeton 1982. Spranger's drawing for *Feast of the Gods* is in the Rijksmuseum, Amsterdam, inv. A2339.

15. Princeton 1982, p. 142. He cites, for example, the drawing *Hercules and Omphale* (Národni Galerie, Grafická Sbírka, Prague, inv. K.42835, signed and dated 1599) and the painting *Venus and Adonis* (Kunsthistorisches Museum, Vienna, inv. 2526, datable to the mid-1590s). He does not mention the date on the Frankfurt drawing *Mars and Venus*.

16. See Kaufmann in Princeton 1982. See also Lucas Kilian's engraving after a lost Spranger painting *Hercules and Antaeus*. Bruce Davis points out that although the print is dated 1610, Spranger's painting is likely to have been created in the 1580s or 1590s. Davis notes that the figure of Hercules is especially close to the Mars in SCMA's drawing (Los Angeles 1988–89, no. 127, repr.). In the Frankfurt-Northampton *Mars and Venus* Spranger seems to have looked back to his earlier treatment of the subject for the window, bed hangings, and helpful putti.

17. There are no signs that this drawing was ever used for transfer.

18. Book 8, lines 266–367, where the tale is told at the court of Alkinoos.

19. On Raphael, see Oberhuber 1958, p. 92, and Sheard in Northampton 1978a, no. 99; on Michelangelo, see Oberhuber 1958, p. 92; and on Rosso, see Sheard in Northampton 1978a, no. 99.

20. See *Illustrated Bartsch*, vol. 77, nos. 9–23, repr., and vol. 78 (commentary), .009–.023.

21. See Kaufmann 1985 for a full discussion of this tradition and a refutation of previous scholars' interpretation of Rudolf's erotic art as a reflection only of his personal sexual tastes. Jan Muller (1571–1628), who became printmaker to the imperial court in 1597, was one of several artists working in Prague who spread Spranger's inventions through prints. See, e.g., his engraving *Venus and Mercury* (Hollstein 63; *Illustrated Bartsch*, vol. 4, no. 68, repr.), which Oberhuber dates to c. 1601 (see discussion in Princeton 1982, pp. 142–43), after Spranger's drawing now in the Yale University Art Gallery (inv. 1974.38), in pen and brown ink with grey wash, heightened with white.

LODOVICO CARDI (CALLED IL CIGOLI)

Castelvecchio di Cigoli (near San Miniato al Tedesco, Pisa) 1559–1613 Rome

11 *Saint Catherine of Alexandria, c. 1600*
Verso: *Saint Catherine of Alexandria, c. 1600*

Pen and brown (probably iron gall) ink with brush and brown and blue washes, over black chalk, squared for transfer in red chalk, the squares numbered across the top in pen and brown ink, and down the left side in red chalk, the marginal sketch executed entirely in pen and brown ink, on white antique laid paper

Verso: pen and brown (probably iron gall) ink

Watermark: None

Sheet (irregular): 248 × 210 mm (9¾ × 8¼ in.)

PROVENANCE {Durlacher Bros., New York} before Nov. 1946 (as by Bartolomaeus Spranger);[1] sold to SCMA (as by Bartolomaeus Spranger) in 1946

LITERATURE Kennedy 1947, pp. 35–36, fig. 20 (recto) (as by Bartolomaeus Spranger); Chappell 1981, p. 78, fig. 66a (recto) (as *St. Catherine Seated with Attributes*) and (verso) (as *St. Catherine with an Angel*); Florence 1992, discussed p. 105, under no. 61, listed p. 230

EXHIBITIONS New York 1946; Northampton 1958a, no. 21 (as Flemish, late XVI century, or Austrian, XVII century); Northampton 1987b, no. 19; Northampton 1997 (recto)

Purchased
1946:136

When this drawing was acquired it was attributed to Bartholomaeus Spranger. The correct attribution, proposed by Philip Pouncey in 1958, was confirmed by Jacob Bean, who recognized the drawing as entirely characteristic of Cigoli's work.[2]

Drawings on both recto and verso represent Saint Catherine of Alexandria, whose story is recounted at length in *The Golden Legend,* the twelfth-century compendium of lives of the saints by Jacobus de Voragine.[3] A young Christian virgin of royal blood, Catherine went to Alexandria, where the Emperor Maximinus had summoned his people to make sacrifice to pagan idols. Refusing to sacrifice, Catherine expounded the true faith, confounding Maximinus with her arguments. He summoned all his best orators to debate her, but when Catherine eloquently refuted the philosophers, converting them and many others to Christianity, Maximinus put them to death. Catherine was condemned to be torn apart by spiked wheels, but the device was miraculously shattered before it could harm her. Her martyrdom was ultimately accomplished by beheading as a voice from heaven cried "Come my beloved, my spouse," and her body was carried by angels to Mount Sinai.

On the recto of the drawing Catherine is seated before an arched niche with her emblem, the broken, spiked wheel at her side. She holds the palm branch that signifies her martyrdom. Proceeding on the basis of a free sketch drawn lightly in black chalk, Cigoli used pen and ink to limn the architectural setting as well as the figure and attributes of the saint. Characteristically, he applied his washes, both blue and brown, over the fresh ink of these pen lines, causing them to blur slightly.[4] It is clear that in this drawing Cigoli was still deliberating the final form of his composition. After drawing the saint and her architectural niche, and modeling both with washes, Cigoli again resorted to black chalk to sketch in

the barely visible form of an angel at the top of the sheet. The idea introduced here — of an angel who swoops down from heaven to bestow the crown of martyrdom upon Catherine — is taken up in the small sketch at the lower right of the sheet. Drawn with a finer pen point, this rapid sketch considers the position of the hovering angel and changes the direction of the saint's gaze from an oblique downward angle (presumably toward the viewer) to one directed upward toward the angel. Cigoli's practice of working out compositions by trying alternative ideas in small sketches around the edge of the sheet is well documented by many other drawings, for example a study of the Resurrection for an altarpiece of 1591 in the Pinacoteca of Arezzo.[5] On the verso of that sheet, individual figure poses are worked out in a variety of sketches. This method is also seen in a sheet of studies for a *Madonna and Child and Saints,* which probably dates from about 1593.[6]

The composition drawn in ink on the recto of the SCMA sheet was traced on the verso, where the form of the angel was then freely drawn in approximately the same position in which it had been sketched on the recto. Although the recto drawing is squared for transfer, no further works related to it are known.

When Miles Chappell first discussed the SCMA drawing in 1981, he did not associate it with a known painting, but suggested that its compositional ideas might have been reflected in several works by Cigoli that are documented by written sources but otherwise unknown.[7] More recently, however, Chappell has proposed that the SCMA sheet, along with *The Mystic Marriage of Saint Catherine* in the Pierpont Morgan Library, constitute studies for the tondo of Cigoli's San Gaggio altarpiece.[8] This altarpiece, with its large painting *Saint Catherine Disputing with the Doctors* and the tondo above representing the Mystic Marriage of the saint, was particularly

11 Verso

11 Recto

praised for its beauty and grace by the artist's biographers Giovanni Battista Cardi and Filippo Baldinucci.[9] It was created for the main altar of the church of Santa Caterina d'Alessandria in the convent of the Agostiniane Eremitane at San Gaggio, near Florence, commissioned by Senatore Bartolommeo di Bernardo Corsini, a descendant of the founder of the church and convent. He also engaged Cigoli as architect for renovations to the church.[10]

There is general agreement among scholars that the San Gaggio altarpiece dates from about 1603, although it is neither signed nor dated.[11] Cigoli's architectural work at the church and convent seems to have been finished by that year, as the date 1603 appears along with Corsini's name carved over the arch leading to the nuns' choir of the church. Even if the execution of the paintings extended beyond this date, they were doubtless finished before April 1604 when Cigoli arrived in Rome, where he lived and worked for the rest of his life, with the exception of two visits to Florence.

Although the Morgan Library drawing corresponds in subject to the San Gaggio altarpiece tondo, like the SCMA sheet it is rectangular in format. Thus, if one or both are preparatory for that painting, they must predate Cigoli's final plan for the architectural design of the altarpiece. But whereas the *Mystic Marriage*'s composition could be adapted for use in a small tondo (as Chappell observes), it seems more likely that the SCMA *Saint Catherine* was always intended for a larger, rectangular painting — not least because it is carefully circumscribed by a rectangular framing line drawn by the artist himself. Cigoli's care in defining the format of his compositions is apparent in many other drawings, including the *Resurrection* mentioned above, where his concern for the figures' relationship to the edge of the composition is manifest in the way he adjusts the framing lines in the large study on the drawing's recto as well as in the related verso sketch.

Cigoli may have considered more than one subject before settling on *Saint Catherine Disputing with the Doctors* for the main canvas of his San Gaggio altarpiece. In fact, a drawing in Munich of Saint Catherine Refusing to Adore the Pagan Gods has been suggested by Anna Matteoli as an alternative idea for this painting.[12] But although the Smith drawing is stylistically consonant with the San Gaggio studies, it presents a devotional image of the saint rather than the more complex narrative subject appropriate for a major altarpiece. It therefore remains most likely to have been preparatory for a lost or unfinished devotional painting.

AHS

1. Exhibited in the *Tenth Annual Exhibition of Old Master Drawings*, 5–30 Nov. 1946.

2. Ruth Kennedy published it in 1947 as by Spranger (contrary to Chappell 1981, who credits her with the Cigoli attribution). See letters from Pouncey to Robert O. Parks of 29 April and 30 Aug. 1958, and the letter from Bean to Parks of 26 Jan. 1959 (SCMA curatorial files).

3. Voragine 1993.

4. Compare the use of blue wash over brown ink lines in the drawing *Daniel in the Lions' Den,* Corsini Collection, Gabinetto Nazionale delle Stampe, Rome, inv. FC 130624 (ASI 1993, no. 19, color repr.).

5. Yale University Art Gallery, inv. 1973.67. See New Haven 1974, no. 42 recto and verso (repr. front and back covers). Note also the way the bottom framing line of the drawing is marked off as if for squaring.

6. See New Haven 1974, no. 43 verso.

7. He lists as possibilities the *Saint Catherine of Siena in Contemplation,* cited in 1677 as in the Giugni collection in Florence (although the SCMA drawing is clearly Catherine of Alexandria); the *Saint Catherine,* recorded in 1657 on the high altar in the church of Santa Caterina, Faenza; and a *Saint Catherine* that was identified by subject only when it was exhibited in Florence in 1705 (Chappell 1981, pp. 78–79).

8. Florence 1992, under no. 51.

9. Cardi 1628, 1 recto–5 verso in Matteoli 1980, pp. 17–37; Baldinucci 1702, pp. 28–29; in Matteoli 1980, pp. 51–93.

10. On Cigoli's architectural work in San Gaggio, see Luciano Berti in San Miniato 1959, pp. 176–78; on the altarpiece specifically, see p. 177. See also Matteoli 1980, under nos. 52, 53, and 132, esp. p. 297.

11. Mario Bucci in San Miniato 1959. Charles Carman examined the painting and found no date or signature, contrary to what Bucci reports; Carman (1974) agrees with the dating on the basis of its similarity to the *Adoration of the Shepherds* (now in the deposit of the Museum of San Matteo in Pisa), which is signed and dated 1602. Matteoli 1980 dates the altarpiece c. 1603–4 on the basis of style (Matteoli, nos. 52, 53).

12. Staatliche Graphische Sammlung, inv. no. 7984 (Matteoli 1980, under nos. 52, 53).

JAN VAN GOYEN
Leiden 1596–1656 The Hague

12 *A Castle by a River*, 1650
Verso: *The Church of Nieder Elten*, 1650

Black chalk with brush and grey wash on moderately textured cream antique paper
Verso: Black chalk with brush and grey wash

Watermark: None

96 × 158 mm (3¹³⁄₁₆ × 6¼ in.)

Inscribed recto, upper right corner, in pen and brown ink: *29*

Gift of Mr. and Mrs. David F. Seiferheld (Helene Danforth Coler, class of 1943)
1963:44

13 *Views of Elterberg*,[1] 1650
Verso: *The Church of Nieder Elten*, 1650

Black chalk with brush and grey wash on moderately textured cream antique laid paper
Verso: Black chalk with brush and grey wash; an accidental spot of wash just above landscape at right

Watermark: Fragmentary, in upper left corner, coat of arms of Lorraine (Beck 1972, p. 337, fig. 48)

96 × 158 mm (3¹³⁄₁₆ × 6¼ in.)

Inscribed recto, upper right corner, in pen and brown ink: *30*

PROVENANCE (for cats. 12, 13) Possibly Andrew Geddes, A.R.A (1783–1844), London; possibly to his heirs and in sale, London, Christie's, 8–14 April 1845, second day of sale, no. 361;[2] Johnson Neale, London;[3] to T. Mark Hovell, F.R.C.S., London; sale, London, Sotheby's, 3 July 1918, no. 124; to {P. & D. Colnaghi [& Obach], London} for £610, Colnaghi stock no. A1700;[4] to Frederik Muller and Co., perhaps as agent for Anton Wilhelmus Mari Mensing (1866–1936), 15 Aug. 1918, for £800;[5] to A. W. M.

Mensing's heirs, sale, Amsterdam, Frederik Muller, 27–29 April 1937 (first day of sale?), no. 218, to "Hirschmann"; A. Mayer, The Hague and New York; Dr. Karl Lilienfeld, New York, 1957;[6] C. F. Louis de Wild, New York; to {Helene C. Seiferheld, New York} in 1960;[7] gift to SCMA in 1963

LITERATURE Morse 1979, listed p. 150; Beck 1972, nos. 847/29 (*A Castle by a River*) and 847/30 (*Views of Elterberg*); Paris 1986, repr. (*Views of Elterberg*); Sutton 1986, mentioned p. 209; Leiden 1996–97, fig. 98, under no. 34, (*Views of Elterberg*)

EXHIBITIONS Allentown 1965, no. 28, repr. p. 25 (*A Castle by a River*) and no. 29, repr. p. 25 (*Views of Elterberg*); Northampton 1976 (*Views of Elterberg*); Northampton 1979b, no. 24 (*Views of Elterberg*); Northampton 1982c (*Views of Elterberg*)

Gift of Mr. and Mrs. David F. Seiferheld (Helene Danforth Coler, class of 1943)
1963:43

Jan van Goyen was a prolific draughtsman whose sketches and finished drawings alike masterfully convey the topography and atmosphere of the Dutch landscape in the seventeenth century. Born in Leiden, he received his first training in that city, and after a brief trip to France about 1615, studied in Haarlem (c. 1617) with the landscape painter Esaias van de Velde (1587–1630), who was one of the most important contributors to the development of a new landscape style in the early seventeenth century. Van de Velde, with other Haarlem painters, had moved away from the prevailing mode of representing bird's-eye views of a vast, imaginary terrain toward prospects characterized by a low horizon and enormous sky. His series of small etched scenes around Haarlem, published before 1618, had a great influence on the spread of this approach, which featured specific, identifiable views that appeared to have been drawn directly from nature. Van Goyen's period of study with Van de

Velde was crucial to his development as a landscape painter and draftsman. Although he settled in The Hague, where he lived from 1631 on, Van Goyen continued to travel throughout the Low Countries. His trips are well documented in his drawings, especially in the sketchbooks, a number of which survive at least in part.

The earliest of these sketchbook sheets are preserved in the British Museum, in an album incorporating pages from various sketchbooks datable to about 1627–35,[8] and in the Albertina, which holds loose sheets from a sketchbook that scholars date to about 1630.[9] The only sketchbook that is entirely intact and original, however, is preserved in the Bredius Collection, The Hague. Although on stylistic grounds Hans Ulrich Beck dated this sketchbook to a range of five years (1644–49), Edwin Buijsen has argued that Van Goyen's incorporation of one of the last sketches in the volume into a painting of 1644 shows that he had already filled most of the book within a few

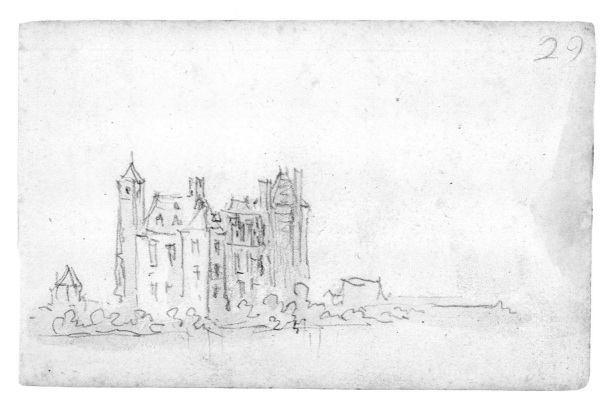

12 Recto

12 Verso

months of beginning to use it. Buijsen believes the artist returned to the sketchbook in the 1650s, filling in the blank pages at the end of the book.[10] A sketchbook in Dresden dates from an extended trip Van Goyen made to Antwerp and Brussels about 1648, returning through the province of Zeeland.[11] Another, a volume that was dispersed in the twentieth century, was used by Van Goyen in 1650 and 1651. This sketchbook is the source of both SCMA sheets.[12]

The early provenance of the 1650–51 sketchbook is obscure. The first notice of it dates to the nineteenth century — as early as 1845 if it was indeed the sketchbook owned by Andrew Geddes, but certainly to the last decade of the century, when it was lent to the Mauritshuis in The Hague.[13] The sketchbook was first published by Campbell Dodgson in 1918, when it was in the possession of T. Mark Hovell in London.[14] Dodgson convincingly attributed the sketches to Van Goyen, a conclusion that Cornelis Hofstede de Groot and Abraham Bredius, who knew the sketchbook when it was in The Hague, had reached independently.[15]

When Dodgson studied the sketchbook it consisted of 179 leaves kept loose within a parchment cover, the whole measuring 105 × 160 mm with a thickness of about 40 mm.[16] He noted that the numbers inscribed in ink in the upper corner of each sheet were erratic, some being omitted and others repeated (the highest was 290), and he concluded that although some sheets had undoubtedly been removed, the original book was not very much larger than the 179 known sheets. In 1937, when the sketchbook was sold from the collection of the late art dealer Anton W. M. Mensing, the individual sheets had been mounted in mats, although they were sold as a unit.[17] They remained together until 1957, when the dealer Karl Lilienfeld acquired them and began to sell the sheets individually.

Leaf number 1 of the sketchbook, which shows two men gazing at a rainbow, is dated *Den 7 Juni 1650*.[18] On the basis of the places depicted on the subsequent pages, it can be established that Van Goyen carried it on a trip along the Rhine, a journey that led him past Arnhem, Emmerich, Cleves, Nijmegen, and Tiel. Following his custom with other sketchbooks, after his return home to The Hague he filled up the remaining pages with sketches made on shorter, day trips, including a visit to Amsterdam, during which he recorded the damage caused by the breaching of Saint Anthony's dike near Houtewael (5 March 1651).[19]

The drawings in the sketchbook of 1650–51 are freely executed in black chalk, sometimes touched with grey wash. They are more loosely drawn than earlier sketches and capture the essence of the landscape with a minimum of detail. Having begun to use black chalk for his landscape drawings in 1626 following the example of Esaias van de Velde, Van Goyen came to adopt it as his primary medium for drawings after 1630.[20] It was a medium particularly well adapted for use in the drawings from life with which he filled his sketchbooks.

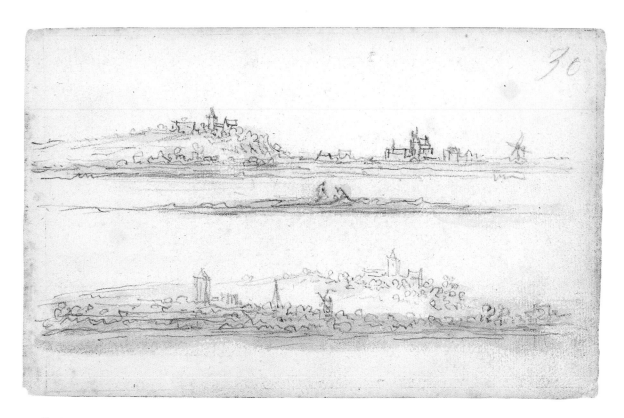

13 Recto

13 Verso

The castle on a riverbank represented in SCMA's drawing (leaf 29) is also depicted on leaves 27 and 28 of the sketchbook.[21] The view in the SCMA sketch was taken from across the river, while that on the previous page (leaf 28) presents the castle as seen from its landward side. In both drawings the building is set low on the sheet, creating the impression of a vast sky, an effect common in Van Goyen's paintings. Although no related drawings of the unidentified castle are known, evidence for an earlier trip to the site is provided by a signed and dated (1647) painting made from a vantage point slightly

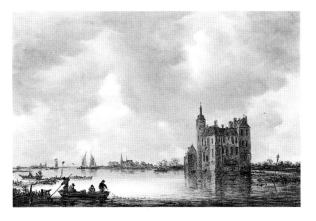

Fig. 1. Jan van Goyen, *Castle by a River*, 1647. Oil on panel, 36.5 × 56 cm (14⅜ × 22 in.). Photo: Courtesy Galerie Sanct Lucas, Vienna

to the right of that in the SCMA sketch (fig. 1).[22] Other paintings from the mid-1640s also confirm Van Goyen's familiarity with this stretch of the Rhine, including Elterberg, which is depicted in a painting dated 1645.[23]

The second SCMA sheet from the sketchbook, the leaf numbered 30, presents two views of Elterberg. It is divided horizontally with the panoramas depicted one above the other, a technique Van Goyen had already used in his sketchbook in the Bredius Collection (for example, in leaves 18 and 21, each with two bird's-eye views of the environs of Haarlem).[24] Beginning in the mid-1640s Van Goyen painted a number of panoramic landscapes, and Buijsen has noted that the later sketchbooks often show a methodical approach to recording this type of view.[25]

The SCMA *Views of Elterberg* present panoramas looking across the Rhine. The upper sketch, which includes a small portion of the near riverbank, shows the abbey of Hoch Elten on the hill, with village and windmill on the plain to the right; it continues at left onto the verso of leaf 29 with the church at Nieder Elten. The lower sketch, made from a position farther to the west, shows Nieder Elten more clearly, with the abbey of Hoch Elten on the hill at right. In these sketches Van Goyen's use of grey wash to produce atmospheric effects is particularly successful. He uses long, sometimes broad, strokes of grey wash in two tones, darker for the foreground and lighter for the background, to convey the optical effect of distance. Similar use of dark and light can also be observed in his paintings.

As Beck has shown, a number of the sketches from Van Goyen's sketchbook of 1650–51 were used by the artist as the basis for larger, more finished drawings that were probably intended for sale to collectors. These drawings, almost always executed in black chalk with grey washes, are commonly dated and signed with the artist's monogram. Created in the studio, they reveal the care with which Van Goyen structured his finished compositions. *View across the Rhine toward Elten* (signed and dated 1651),[26] identified by Beck as having been developed from the upper sketch in the SCMA drawing, transforms the sketch's summary indication of two figures on the near bank into a more elaborate repoussoir, consisting of two people in a boat, a dog, and a group of three figures.[27]

Although, as often noted, Van Goyen appears to have devoted more energy to drawing than to painting during the years 1651–53, Beck also records several paintings of Elterberg as seen from the opposite riverbank. Two paintings signed and dated 1652 and 1653 respectively depict a panorama extending from Nieder Elten (at right) to Tolhuis (at left), while a third composition, of which there is a copy in the Rijksmuseum, also shows the hill and abbey of Hoch Elten.[28] The latter is particularly close to the panorama at the top of Smith's sketchbook leaf 30, but all undoubtedly benefited from the detailed studies of the area that Van Goyen recorded in this and other sheets from the 1650–51 sketchbook.[29] The verso of leaf 30 holds a tiny sketch that continues the panoramic view on leaf 31, which appears in turn to have provided a source for another painting of Elterberg.[30]

AHS

1. Van Goyen refers to the area encompassing Nieder Elten and the adjacent hill and abbey of Hoch Elten as "Elteren Berch" (translated as "Elterberg"). See Dodgson 1918, p. 234 note 1.

2. According to Campbell Dodgson (1935, p. 284), the sketchbook of 179 pages he had described in 1918 (see Dodgson 1918, p. 234, on the sketchbook's provenance) is probably identical with the one containing 181 leaves that belonged to A. Geddes, A.R.A., and was included in his sale at Christie's, April 1845, lot 361. This provenance is unconfirmed.

3. Purchased by him "on the Continent" according to Dodgson (1918, p. 234), who notes that an inscription in the book in Neale's handwriting attributes it to Paulus Potter (1625–1654).

4. See *Burl* 1918, confirmed by Stephen Ongpin, Colnaghi, London (letter to the author 19 Sept. 1995, SCMA curatorial files).

5. According to Ongpin letter cited in note 4.

6. The date according to Zafran in Atlanta 1985, nos. 41a and b.

7. The date according to C. F. Louis de Wild (letter to Charles Chetham, 25 April 1963, SCMA curatorial files). The SCMA drawings were part of a larger group from the sketchbook purchased by Mrs. Seiferheld, who operated the Helene C. Seiferheld Gallery, New York.

8. This group consists of 182 black chalk drawings. See Beck 1972, no. 844, and Buijsen 1993, vol. 1, p. 11. Buijsen also cites a col-

lection of 67 sketches from the same period (formerly coll. General G. C. Morgan), all from a single sketchbook that was taken apart and sold in 1978.

9. Also black chalk drawings. See Beck 1972, no. 843 (1630), and Buijsen 1993 (c. 1630).

10. This sketchbook is also in black chalk. See Beck 1972, no. 845 (1644–49), and Buijsen 1993. Van Regteren Altena, however, thought the final sketch was made in 1645 at the latest (Buijsen 1993, vol. 1, pp. 17–18).

11. Also black chalk. This sketchbook has been altered. See Beck 1972, no. 846 (1648), and Buijsen 1993, vol. 1, pp. 11–12 (c. 1648).

12. See Beck 1972, no. 847, and Buijsen 1993, vol. 1, p. 12.

13. Dodgson 1918, p. 240, and *Burl* 1918. The sketchbook is mentioned in "Verslagen omtrent i Ryksversamelingen van Geschiedenis en Kunst," 18 (1895), p. 64.

14. Eight of the sketchbook pages were reproduced in this article.

15. On De Groot and Bredius, see *Burl* 1918. As Buijsen points out (1993, vol. 1, p. 20), the acceptance of Impressionism opened the way for the appreciation of Van Goyen's work. Important exhibitions were organized by the dealer Charles Sedelmayer in 1873 and by the firm of Frederik Muller & Co. in 1903 at the Stedelijk Museum in Amsterdam.

16. He also noted that the cover bore the inventory number 200 in faded ink.

17. According to the sale catalogue there were "190 esquisses." For drawings that had been removed from the sketchbook before 1918, see Beck 1972, p. 286.

18. Beck 1972, no. 847/1.

19. See Beck 1972, no. 847/166-84, and Beck 1966.

20. See Beck 1972, pp. 52 and 54. By 1647 Van Goyen was commonly adding grey washes to his black chalk drawings.

21. Beck 1972, nos. 847/27 and 847/28, repr.

22. Beck 1973, no. 684, repr. The painting was with the Galerie Sanct Lucas, Vienna, in 1972.

23. Leiden 1996–97, no. 34, repr., and no. 35, repr.

24. See Buijsen 1993, vol. 2. Van Goyen also used a single sheet for two panoramas in a number of the pages from the Dresden sketchbook (c. 1648); see Beck 1972, no. 846.

25. Buijsen (1993) notes that Van Goyen's individual sketches often proceed in a clockwise direction from his chosen vantage point.

26. Beck 1972, no. 248, repr. The drawing is in black chalk with grey wash and measures 114 × 200 mm; it was in the collection of Klaus E. Momm, Bremen, in 1967.

27. Comparison of these two works also justifies Buijsen's observation that even in his sketches from life, Van Goyen often chose vantage points that would align the features of the landscape into a compositional scheme he favored in his finished works (Buijsen 1993, vol. 1, p. 14).

28. See Beck 1973, nos. 320, 321, and 323a, Copy I.

29. See Beck 1972, nos. 847/56, 57, 58, 59, 62, 63, 64, 65, 66. Leaf 63 shows the abbey with ruins at the top of the hill from below and close-up; leaf 64 is a panorama across a plain; 65 is a view of Elterberg from Tolhuis; 66 shows the church of Nieder Elten; 56 shows Elterberg with the abbey; 57–59 depict Elterberg with the abbey on a hill (with trees in the foreground).

30. Beck 1973, no. 322a.

JAN LIEVENS THE ELDER (ATTRIBUTED TO)
Leiden 1607–1674 Amsterdam

14 Road with Trees and a Horse-Drawn Wagon near a Village, late 1660s(?)

Pen, brush and brown ink with brown wash on cream antique laid paper; laid down on heavy wove paper, the mount trimmed to the drawing

Watermark: None visible

243 × 387 mm (9⁹⁄₁₆ × 15¼ in.)

Inscribed recto, lower left, in graphite (in a later hand): *J Lievens;* lower right, in dark brown ink: *WE* [William Esdaile collector's mark, Lugt 2617]; inscribed on verso of mount, lower left, in pen and dark brown ink, in Esdaile's hand: *WE P62* [a *55* crossed out and the *62* written above it] *N 207. sold in 1818. / WE 900 b;* at center, in graphite: *13;* in hand of William Esdaile at bottom center in dark brown ink: *Lievens*

PROVENANCE William Esdaile (1758–1837), London (Lugt 2617, collector's mark recto at lower right corner, and collector's marks and inscription verso of mount at lower left); possibly to his heirs, perhaps in sale, London, Christie's, 18–25 June 1840, possibly fifth day of sale, lot 1057 or 1059; "Docteur X" (according to Rauch sale catalogue); Julian G. Lousada (c. 1874–1945), London, by 1926; to his heirs (sale, London, Christie's, 7 March 1947, no. 32, for £36.15 to "Gernsheim");[1] sale, Geneva, Nicolas Rauch, sale no. 36, 13–15 June 1960, no. 244, repr.; to Janos Scholz as agent for SCMA

LITERATURE Schneider 1932, p. 245, no. Z382 (as *Weg bei einem Dorf unter Baumen [Road near a Village among Trees]*); *Art and Auction* 1960a, repr. p. 836; *Art and Auction* 1960b, p. 192 under results of sales, no. 244; Parks 1960, p. 26, no. 40, repr.; Schneider-Ekkhart 1973, p. 376, no. Z382; Sumowski 1979–, vol. 7, pp. 3794–95, no. 1704x, repr.; SCMA 1986, no. 214, repr.; Sutton 1986, mentioned p. 209

EXHIBITIONS London 1926;[2] Northampton 1979b, no. 25; Northampton 1982c (as *Landscape with a Road*); Northampton 1986c

Purchased
1960:91

After studying with the painter Joris van Schooten (1587–1651) in his native town of Leiden (c. 1615), Jan Lievens became a pupil of Pieter Lastman (1583–1633) in Amsterdam about 1619–21, as did Rembrandt (1606–1669) a few years later (c. 1624–25). Lievens and Rembrandt worked closely together in Leiden from 1625 until 1631, when Rembrandt moved to Amsterdam. Lievens spent the years 1632–35 in England, where he came in contact with the Flemish painter and portraitist Anthony van Dyck (1599–1641). After returning to the Low Countries, Lievens lived in Antwerp from 1635 to 1644, and later in Amsterdam, with periods spent in The Hague and Leiden.

The drawings for which Lievens is best known are his portraits, usually drawn in black chalk, and his landscapes, most of which are drawn with a reed pen. These landscapes constitute the majority of Lievens's surviving drawings, but unlike the portraits, which often are signed with his monogram and dated or inscribed with the name of the sitter, the landscapes are neither signed nor dated.[3] As Lievens's draughtsmanship does not vary substantially in these sheets, it is difficult to establish a chronology based on stylistic evidence. Attempts to trace a development in the landscape drawings are further complicated by questions of attribution, particularly as regards the work of his eldest son, whose style seems to have been remarkably similar to Lievens's own.[4]

It would appear, however, that most of Lievens's landscape drawings were executed in the 1650s and 1660s. Scholars have been able to date certain sheets approximately based on a variety of external evidence. Among these are a drawing of the Roomhuis in The Hague, a town where Lievens worked between 1654 and 1658,[5] a group of drawings on papers with watermarks datable to the 1660s,[6] and garden scenes in which the costume of the female figures can be dated to the 1670s.[7]

Certain stylistic features have been remarked in all the drawings that are unanimously given to Lievens. Chief among these is the way the artist describes the play of light through foliage by using contrasting tones of brown ink and pen lines that vary greatly in width. Most of Lievens's landscape drawings were probably created in the studio as finished works of art intended for sale, and a few of them were executed on vellum.[8]

Although the SCMA's *Road with Trees and a Horse-Drawn Wagon near a Village* is catalogued as autograph by both Hans Schneider and Werner Sumowski, its attribution has been questioned by Jan Białostocki as well as by Christopher White, who suggested it might be by Lievens's eldest son, Jan Andries.[9] Christened in Antwerp in 1644, Jan was already working as an assistant to his father in 1666.[10] Only two signed drawings by him are known, both in the British Museum, which are very close to his father's style.[11] A drawing of a woodland scene with figures in the Museum Boijmans-van Beuningen, Rotterdam, whose mount bears an old attribution to Jan Andries, is closely related to a sheet in the Pierpont Morgan Library, New York, which shows the same group of trees, but with a different group of figures. While some writers ascribe the Rotterdam sheet to Lievens the Elder, Jeroan Giltaij proposes that it is a copy by Jan Andries of his father's original in New York.[12] He cites in particular the contrast between the Morgan Library drawing's powerful and direct approach and the Rotterdam sheet's more refined and decorative quality.

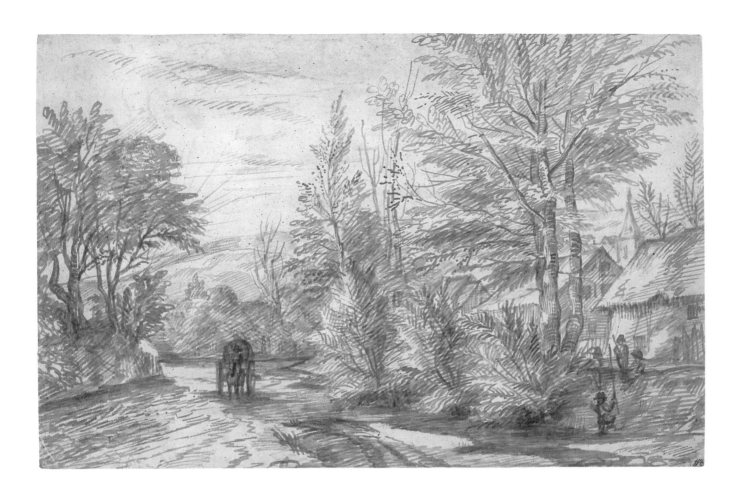

The SCMA drawing might also be described as more evenly handled and decorative in approach than the drawings universally given to Jan the Elder. More telling, perhaps, is the awkwardness of the figures at right, in contrast to a drawing such as *Wooded Landscape with Fisherman* in the Teylers Museum, Haarlem, where the figure, although schematic, is nonetheless convincing in its proportion and pose.[13] A drawing with similarly awkward figures is *Landscape with Cart* in the Museum Boijmans-van Beuningen, which Giltaij attributes to Jan Lievens the Elder, but which has been questioned by others.[14] A firm conclusion as to the authorship of Smith's *Road with Trees and a Horse-Drawn Wagon near a Village* must await further study.

AHS

1. According to an annotated sale catalogue at Christie's, London.

2. According to sale catalogue, London, Christie's, 7 March 1947. A note in the SCMA curatorial files (in the hand of Robert O. Parks), records a photograph of the SCMA drawing in FARL annotated: *ex: Burl. Fine Arts Club, London, summer 1926, Lent by J. G. Lousada, London. Photo taken at exhibition, 1926 (783:1).*

3. With the exception of the portrait drawings, the single known dated drawing by Jan Lievens the Elder is a sheet depicting Saint Jerome in a landscape that bears Lievens's monogram and the date 1665. See Schneider 1932, no. Z12, as well as Braunschweig 1979, no. 80, repr. Although many of the landscape drawings, the SCMA sheet among them, bear inscriptions identifying Lievens as their author, all these inscriptions are considered to be later.

4. See Sumowski 1979–, vol. 7, p. 3711, and Schneider-Ekkart 1932, pp. 279–83. 288.

5. In the Frits Lugt Collection, Fondation Custodia, Institut Néerlandais, Paris (Schneider 1932, no. Z146).

6. Although Lievens may have used some japanese papers, many of the sheets described as "japanese" or "oriental" in the literature are of European origin (e.g., Cambridge 1991–92, nos. 65 and 66, both repr., which bear watermarks similar to Churchill 423, discovered on a document of 1664).

7. See Ekkart in Braunschweig 1979, nos. 91–92, both repr.

8. The studio drawings were probably based on sketches from nature, fewer of which survive. See, e.g., Sumowski 1673x, repr. (Metropolitan Museum of Art, New York, inv. 61.137), based on Sumowski 1672x, repr. (Dresden, Kupferstichkabinett, inv. C143). For a drawing on vellum, see note 13, below.

9. Notes in the museum's curatorial files record the opinions of Białostocki, expressed on a visit in 1965 ("the attribution is questionable"), and of Christopher White, from a visit of 1972 ("fine, but by the son").

10. Schneider 1932, p. 279.

11. See Hind 1915–32, vol. 1, p. 89, no. 1, fig. LVII, and vol. 4, p. 141, Add. 2, fig. LXXII.

12. Museum Boijmans-van Beuningen, inv. MB 198, Schneider 1932, no. Z317. See Giltaij 1988, no. 109, repr., and Braunschweig 1979, no. 72, where the Rotterdam drawing is accepted as by Jan the Elder and dated c. 1660. Another version of the composition is in the Kunsthalle, Hamburg (Schneider 1932, no. Z298). On the Morgan Library drawing, see Schneider 1932, no. Z309, and Poughkeepsie 1976, no. 29 repr.

13. Inv. 8 (see Braunschweig 1979, no. 90, repr., which Ekkart dates to c. 1667–68).

14. See Giltaij 1988, no. 106. The drawing is in pen and brown ink with brown wash, 195 × 300 mm (inv. MB 196). On the basis of an inscription on the verso of the backing *(Decker)*, an attribution to the landscape painter Cornelis Decker (act. 1640–d. 1678) or perhaps David Decker (act. 1645–51), who was in contact with Lievens, has been proposed.

CARLO MARATTI
Camerano [Ancona] 1625–1713 Rome

15 *Religion Adored by the Four Parts of the World,* late 1670s–early 1680s

Pen and brown ink with brush and brown wash over black and red chalks, heightened with (lead?) white, on antique laid paper toned brown

Watermark: None

273 × 198 mm (10¾ × 7¹³⁄₁₆ in.)

Inscribed verso, at center, in black chalk: *3;* lower right, in graphite: *Pale Green 14*

PROVENANCE Unidentified collector (Lugt 712, lower left recto, "marque ancienne"); Richard Houlditch (d. 1736), London (Lugt 2214, lower right recto); possibly to his heirs and in his sale, London, Langford, 12 Feb. 1760 and following days;[1] Sir Joshua Reynolds (1723–1792), London (Lugt 2364, lower left corner recto); to his heirs;[2] Sir Thomas Lawrence (1769–1830), London (Lugt 2445, lower left recto); probably to {Samuel Woodburn (1786–1853), London} (see Lugt 2584); Mr. and Mrs. Arthur (1897–1970) Wiesenberger, New York; gift to SCMA (as by Pietro da Cortona) in 1959

LITERATURE None

EXHIBITIONS Northampton 1974b (as Tuscan or Roman, mid-seventeenth century, *The Four Continents before the Virgin*); Northampton 1989–90, no. 17

Gift of Mr. and Mrs. Arthur Wiesenberger
1959:199

After entering the SCMA collection with an attribution to Pietro da Cortona, this drawing was classified as "Tuscan or Roman, mid-seventeenth century" in 1978, when it was seen by John Gere. He correctly attributed it to Carlo Maratti, confirming his attribution with reference to a print after the drawing by Pietro Aquila (act. 1675–d. 1692) in the collection of the British Museum (fig. 1).[3] This etching, which follows the SCMA drawing closely, is inscribed in the plate with the names of both the etcher *(P. Aq.a sculp.)* and inventor of the composition *(Carolus Maratus Inv.)*; it is untitled and bears no other inscriptions.[4]

The subject of the composition, Religion Adored by the Four Parts of the World, is described by Karl Heinrich von Heinecken in his catalogue of Aquila's prints (1778) and by Charles Le Blanc (1854) as *Triumph of the Christian Religion.*[5] The allegorical figure of Religion, seated among clouds that partially obscure the columns flanking an arched opening behind her, gestures toward Heaven and gazes down on figures who personify the Four Parts of the World. Maratti's depiction of these allegorical figures follows the general outlines for their appearance given by Cesare Ripa in his *Iconologia,* which served as a standard handbook of allegorical representations for Maratti and his contemporaries.[6]

America is easily recognizable as the seminude standing figure holding a bow, who wears a skirt of feathers; her quiver of arrows is strapped to her back, and an elaborate feather headdress covers her hair. Africa, seated immediately below, her arm around a lion, is the only Part of the World accompanied here by one of the symbolic animals Ripa assigns her. Except for a coral necklace and a drapery that covers her lap and left leg, she is nude, signifying her lack of riches. Her headdress is made from the head of an elephant, as seen in ancient medals (coins) of the Emperor Hadrian, in reference (according to Ripa) to the African use of these animals in war. Asia kneels in the right foreground, offering up with her right hand a burning pot of incense symbolizing the many precious spices her lands produce. Crowned with a garland of flowers to indicate that she provides not only the necessities of life but also many luxuries, Asia is richly robed and holds branches of aromatic herbs in her left hand. For Europe

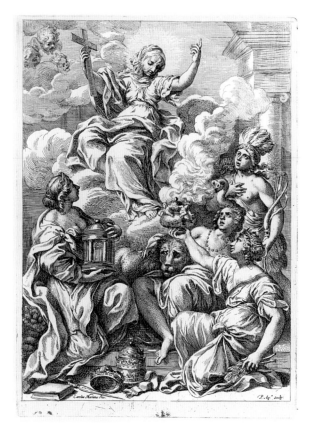

Fig. 1. Pietro Aquila, after Carlo Maratti, *Religion Adored by the Four Parts of the World.* Etching, 265 × 198 mm (10⅞ × 7¹³⁄₁₆ in.). The British Museum. Photo: © The British Museum

is reserved the entire left side of the composition, as is appropriate for the Part of the World that, according to Ripa, surpasses all the others. Depicted as a richly dressed woman who wears a crown signifying her pre-eminence, Europe is seated on a cornucopia filled with the fruits of her fertile lands. She grasps a small temple — here shown as a Bramantesque *tempietto* — as a sign of her devotion to the true faith.[7] At her feet lie symbols of her secular and religious supremacy — the scepter, crown, and papal tiara — as well as a book symbolizing her literary superiority.

The figure on which the Four Parts of the World fix their adoring gaze corresponds to Ripa's description of Religion, whose face is veiled because Saint Paul says that we see God "per speculum in aenigmate" (through a glass, darkly), and because religion is preserved in mysteries, rites, and ceremonies.

A preliminary drawing for this composition among the Maratti drawings at Düsseldorf (fig. 2) represents an earlier stage of the design,[8] which already includes the architectural setting and the pyramidal figure composition; here, however, the standing figure is clearly Asia, who holds her incense pot extended before her with both hands, while the two figures below her are not yet differentiated by their attributes. Other differences include the cross — here a crucifix — and the pose of Europe.

The SCMA drawing's high degree of finish and its close correspondence to Aquila's print indicate that it was the final model from which the printmaker worked. There is no sign, however, that this drawing was used to transfer the design to the plate, and the fact that Aquila's print is in the same direction suggests that an intermediate stage, such as a tracing, was employed.

Maratti's own printmaking activity was confined to his early career, although he clearly recognized the value of prints in recording and communicating his work.[9] Stella Rudolph notes that several French engravers worked for the artist in the 1650s and cites evidence that from 1679 Maratti showed a new interest in the production of prints after his paintings and drawings.[10] Although Aquila's etching after *Religion Adored by the Four Parts of the World* is undated, there is reason to place it after the mid-1670s, when Aquila seems to have worked after a number of drawings by Maratti that had been prepared specifically for print projects.[11] One of these is the *Homage to Raphael* that immediately follows the title page to the series of prints after Raphael's Vatican Loggia frescoes published by Giovanni Giacomo de Rossi in 1675.[12] Maratti's drawing, which presents a bust of Raphael in a niche surmounting an inscribed tablet and surrounded by allegorical figures of Fame, Painting, Sculpture, and Architecture, was originally in the collection of Queen Christina of Sweden, to whom de Rossi's suite was dedicated.[13] Its figure types and general handling are very similar to those in the SCMA drawing.

Even closer in style and technique to the SCMA sheet is *Faith and Justice Enthroned* (J. Paul Getty Museum, Los Angeles), a drawing engraved in reverse at the upper left

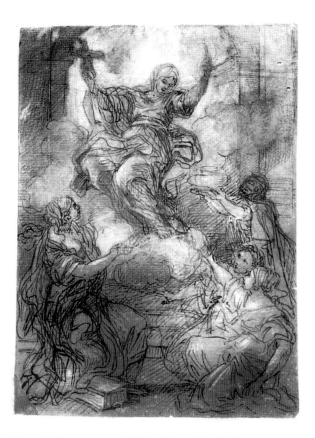

Fig. 2. Carlo Maratti, study for *Religion Adored by the Four Parts of the World*. Pen and ink, red chalk and white heightening, 270 × 198 mm (10⅝ × 7¹³⁄₁₆ in.). Kunstmuseum Düsseldorf, Graphische Sammlung, inv. FP 11999. Photo: © Landesbildstelle Rheinland and Kunstmuseum Düsseldorf

of the map of Rome by G. B. Falda, printed by de Rossi in 1676.[14] Diane DeGrazia has remarked on the sculptural use of white heightening in the Getty drawing and has noted that the morphology of the figures shows the influence of Annibale Carracci (1560–1609), characteristics that can also be observed in the SCMA drawing.[15] Also worth noting is the *tempietto* held by Faith, which is virtually identical to that held by Europe in the Smith sheet.

The dating of *Religion Adored by the Four Parts of the World* to the late 1670s or early 1680s is also supported by comparison with Maratti's treatment of a similar theme in his designs for the great hall of the Palazzo Altieri in Rome. Commissioned to decorate the ceiling vault of this room, which was among the major renovations to the Altieri family palace undertaken during the reign of Pope Clement X Altieri (r. 1670–76), Maratti received payments for his work from 1674 to 1677.[16] His fresco *The Triumph of Clemency,* an allegorical tribute to the Altieri pontiff, was the only part of the decoration to be completed. We know, however, from Pietro Bellori's Life of Maratti that the artist planned to expand the decorative scheme into the spandrels beneath the vault and that he was supplied with a program by Bellori himself.[17] In addition to the figures representing Religion, Faith, Divine

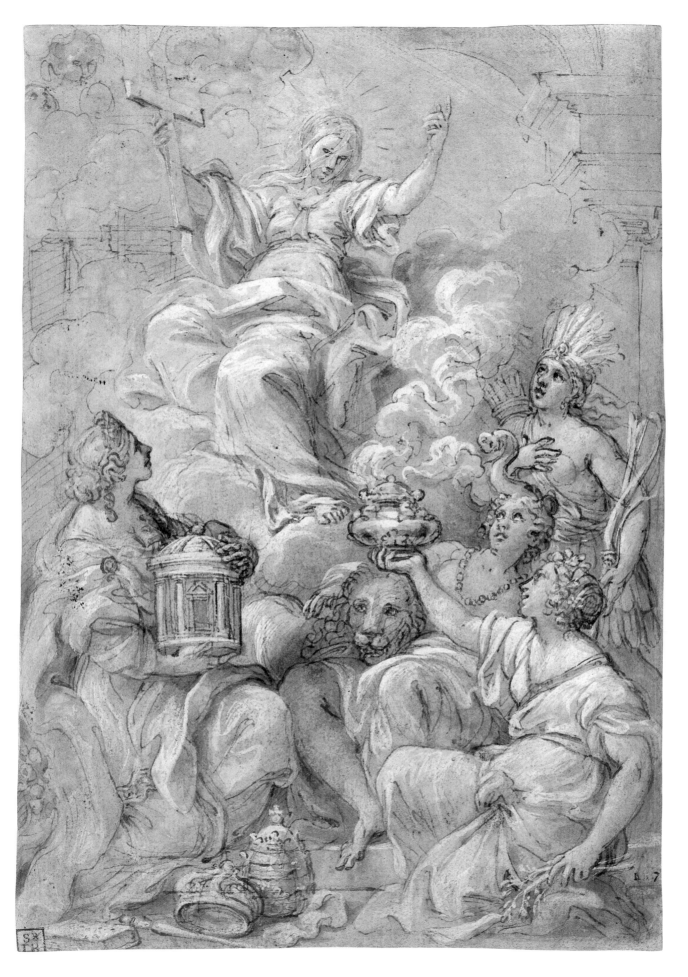

Wisdom, and Evangelical Truth, planned for spaces above the end walls, allegorical figures of Sacred and Christian Rome, Peace, and Virtue Crowned by Honor were to occupy the three spandrels between the windows on the courtyard side of the hall, opposite figures of Europe, Asia, Africa, and America.[18]

A number of Maratti's drawings for the Altieri spandrels survive, and comparison of the studies for the Four Parts of the World with the SCMA's *Religion Adored* reveals a close relationship between them.[19] Perhaps the most instructive comparison is with a sketch in the Accademia di San Fernando, Madrid, for the spandrel depicting Asia and America. Jennifer Montagu suggests this sketch may be Maratti's second idea for the composition, which would have followed the more finished study (Denison University, Granville, Ohio), in which Asia is seated with America standing behind her.[20] Their positions are reversed in the Madrid sheet, and Asia holds up her pot of incense with both arms extended, a pose resembling Maratti's first idea for the figure of Asia in *Religion Adored by the Four Parts of the World,* although it is viewed from a different angle. This idea is abandoned in the more finished spandrel study in the collection of Carel Vosmaer, as it is in the final version of *Religion Adored.*[21] It seems likely that the SCMA drawing was created shortly after Maratti's development of his Altieri spandrel designs — perhaps after the Altieri project was abandoned — when he was free to rework his ideas in a new composition.

The purpose for which *Religion Adored by the Four Parts of the World* was made has yet to be identified. Although Eduard Kolloff states that Aquila's print was the title page for a Roman thesis, there is no clear evidence to support this assertion.[22] The modest size of both drawing and print, and their lack of a characteristic cartouche or tablet for an inscription suggest instead that the design was intended for a book, perhaps for a frontispiece.[23] It is tempting to speculate that the impetus for *Religion Adored* may have come from a member of the Altieri family, but any such suggestion must await further evidence.

AHS

1. The drawing cannot be identified in the sale catalogue, which does not describe individual sheets.

2. The drawings were stamped after his death, the most valuable sheets being marked on the recto.

3. Letter to Colles Baxter, 20 July 1978 (SCMA curatorial files).

4. A space reserved at the bottom of the plate might originally have been intended for a text. This space is visible in the impression of the print in the British Museum; all other impressions that I have seen have been trimmed to the image. The fact that early cataloguers of Aquila's prints do not record such an inscription — and that they give different titles for the print — suggests that an inscription was never added.

5. Edward Kolloff in Meyer 1878 assigned the correct title (*Pietro Aquila*), section B, no. 31). See Heinecken 1778–90, vol. 1 (1778), p. 428 *(Le Triomphe de la Religion chrétienne)*, and Le Blanc 1854, vol. 1, p. 53, no. 29 *(Triomphe de la Religion chrétienne, 265 ×*

198), who describes it in detail: "La Religion, assise sur des nues; au dessous sont les 4 parties du Monde, L'Europe tenant un temple, l'Asie brulant de l'encens, l'Afrique appuyé sur un lion, et l'Amérique avec un arc."

6. First published in Rome in 1593, the *Iconologia* was initially a modest, unillustrated quarto booklet, which described one hundred allegorical subjects. By the time of the third edition (Rome, 1603), it was illustrated and had been considerably enlarged. On the various editions and translations of the *Iconologia,* see Erna Mandowsky, in Ripa 1603/1970.

7. In the 1603 edition of Ripa, Religion's temple is similarly depicted as a *tempietto* (see Ripa 1603/1970).

8. Schaar no. 448, in Harris and Schaar 1967.

9. On Maratti's prints, see Pavia 1977–78. On his association with other printmakers and his activity as publisher of prints after his work, see Rudolph 1978.

10. By 1695 Maratti was employing Robert Audenaerd full-time and was regulating sales of his prints (Rudolph 1978, p. 197).

11. Rudolph 1978, p. 194, cites a series of six prints on the Life of the Blessed Toribio, which she suggests were made to be given out at the pontifical mass celebrating his beatification (28 June 1679 in Saint Peter's). Kolloff (in Meyer 1878) lists, in addition to the *Homage to Raphael* (see section B. [*Blätter nach verschiedenen Meistern*], nos. 1–17; see also note 12, below), and the *Toribio* series (B. 29a), *Three Geniuses Holding the Papal Tiara and the Keys* (B. 31a), for a 1675 chronological chart(?) with portraits of the popes, and *Pope Sylvester and Emperor Constantine with the First Basilica of Saint Peters* (B. 32), the title page for *Descrizione fatta della Chiesa antica moderna di S. Pietro con misure più principali e relazione di pittura, scultura et architettura* by Carlo Padre Dio (Rome, 1673). While all these projects seem to have been initiated by others, Maratti himself is known to have commissioned work from Aquila. Luisa Erba points out that the dedicatory inscription to Giovanni Pietro Bellori on Aquila's print after Maratti's *Angelo custode* indicates that Maratti himself commissioned the print (in Pavia 1977–78, p. 93).

12. *Imagines Veteris ac Novi Testamenti a Raphaele Sanctio urbinate in Vaticani Palatii Xystis mira picturae elegantia expressae. Jo. Jacobi de Rubeis cura ac sumptibus delineatae, incisae, ac typis editae.* Fifteen of the fifty-two prints in the series were executed by Pietro Aquila.

13. Paris 1971b, no. 72, repr., *Hommage à Raphael,* pen and bistre wash with white heightening, 310 × 380 mm, private collection.

14. Goldner 1988, no. 23, repr.

15. In ibid., no. 23.

16. See Schiavo [1964].

17. See Montagu 1978. She discovered a manuscript in the Vatican that preserves Bellori's original program.

18. Montagu 1978 points out that Bellori's original program included a figure of Time for a spandrel on the courtyard wall, in the mistaken belief that there were four spandrels on each long side of the great hall. This figure could simply be dropped from the program, but two Parts of the World had to be combined in a single spandrel on the opposite wall.

19. On the spandrel drawings, see Feinblatt 1979 (where many of the drawings are reproduced).

20. See ibid., figs. 20, 21.

21. For the Vosmaer study, see Amsterdam 1989, no. 2, repr., color repr. p. 23.

22. Kolloff, in Meyer 1878, *Pietro Aquila,* B. 31.

23. The SCMA drawing measures 273 × 198 mm, and the print 265 × 198 mm. The Düsseldorf drawing is also virtually identical in size, 270 × 198 mm.

BENEDETTO LUTI
Florence 1666–1724 Rome

16 *Head of an Apostle*, 1712

Pastels on moderately textured grey antique laid paper, laid down on a heavier off-white board, the top and bottom edges of the paper wrapped around the mount

Watermark: None visible

410 × 335 mm (18⅛ × 13³⁄₁₆ in.)

Inscribed on verso of mount, upper right corner, in graphite: *9;* signed and dated on original wooden frame backing, upper center, in pen and dark brown ink: *Roma 1712 / Benedetto Luti fece*

PROVENANCE Sale, New York, Sotheby's, 14 January 1987, no. 126, repr.; to {Thos. Agnew & Sons Ltd, London, and David Tunick, New York}, Agnew stock no. CM0148;[1] sold to SCMA by Thos. Agnew & Sons in 1989

LITERATURE *GBA* 1991, no. 234, repr.

EXHIBITIONS London 1989, no. 34, color repr.; Northampton 1992a

Purchased, the Beatrice Oenslager Chace, class of 1928, Fund 1989:33

This brilliant pastel is one of a series that had remained together in matching eighteenth-century frames until 1987, when it was sold at auction in New York and dispersed to private and public collections in this country and abroad.[2] The twelve *Apostles* rank among the most handsome creations of the artist, who produced many such highly finished pastels for collectors and for the commercial art market.

Benedetto Luti was born in Florence, where he trained in the workshop of Antonio Domenico Gabbiani (1652–1726). Edgar Peters Bowron, in an important article on Luti's pastels, has shown the artist's initial exposure to the technique of drawing in colored chalks and pastels to date from his youth in Florence, and to have been encouraged by the enthusiasm for such drawings at the court of Cosimo III de' Medici, grand duke of Tuscany (d. 1723).[3] Before becoming grand duke, Cosimo had traveled extensively through Europe, acquiring works of art to fill lacunae in the family holdings and enlarging the collection of artists' self-portraits begun by his uncle Cardinal Leopoldo de' Medici (1617–1675).[4] In 1670 he visited Robert Nanteuil's (1623–1678) studio in Paris, acquiring a self-portrait and several other pastels. After returning to Florence, Cosimo dispatched the young Domenico Tempesti (1655–1737) to study in Nanteuil's studio. Tempesti executed portraits of the Medici court and taught pastel technique to other Florentine artists following his return home in 1679.[5] Luti would also have had access to the colored chalk heads by Federico Barocci (1535?–1612) that were among the Medici collections in the Palazzo Pitti in the 1680s and that were greatly admired at the Florentine court.

Luti's early training in pastel bore fruit in his Roman years. In 1689 or 1690 he went to Rome as the protégé of a Pisan nobleman, Cavaliere Giovanni Niccolò Berzighelli, but maintained close ties with Florence, receiving the continuing patronage and support of Cosimo III and Prince (later Grand Duke) Ferdinando. In addition to his activities as an artist, Luti rapidly became one of the principal dealers and agents in the Roman art market, as well as a collector of drawings in his own right. He was received into Rome's Accademia di San Luca in 1695[6] and became its *princeps* twenty-five years later. Luti's activities as painter, dealer, and collector placed him in a perfect position to market his own pastels.

Luti seems to have produced pastel drawings intermittently throughout his career. His earliest dated heads in pastel are from 1703 and 1704.[7] Although Luti is known to have made some extremely fine portraits, it seems the majority of his drawings in this medium were ideal heads.[8] In choosing to draw ideal types he may have had in mind the example of Barocci or of Correggio (c. 1489–1534), whose strong influence on Luti's work was cited by his contemporaries.[9] But as Bowron suggests, the naturalism and immediacy of these works may indicate that they originated from life drawings that were then worked up and repeated.

The pastel *Head of an Apostle* at Smith preserves the fresh color and rich surface of Luti's best work in this medium. Applied to a grey paper of a moderate weight and visible tooth, the pastel is handled with a virtuoso technique. The brilliant effect of Luti's pastels is due in large part to the artist's method of combining the even surface and *sfumato* achieved by using the stump to blend his pastels, with individual strokes of color that remain undisturbed and animate the surface. In the SCMA *Apostle,* Luti has used unblended strokes of red (in the ear and along the nose), ochre (in the hair on the head), and black (in the hair and beard), with dark brown and white (on the yellow robe). This approach was greatly facilitated by the availability in Rome of improved pastels about 1700.[10]

The presence of autograph inscriptions on the back of the original mounts of drawings such as the *Head of a Bearded Man* in the Julius Held collection suggests that Luti's pastels were mounted by the artist himself, or at least under his supervision.[11] In the case of the *Apostles,* where Luti's signature and date appear on the wooden

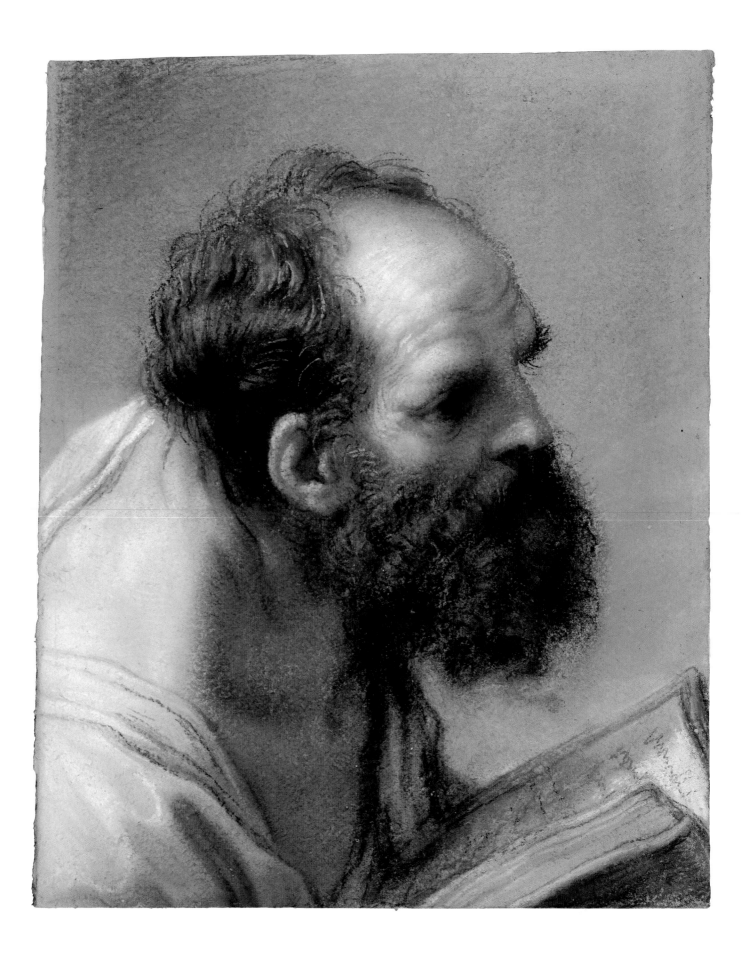

frame backings of several heads in the series, including the SCMA pastel, we can conclude that the suite was framed in Luti's shop or to his order.

Although Luti probably produced many single or pendant ideal heads for the commercial art market, it is perhaps more likely that this series of twelve *Apostles* was undertaken as a commission. Given the subject matter, one might postulate a clerical patron, but although it is known that Luti numbered among his patrons prominent churchmen, including Cardinal Pietro Ottoboni (1667–1740) and the electoral archbishop of Mainz, Lothar Franz von Schonbron (from whom he accepted commissions in 1712), the identity of the original owner of the *Apostles* remains unknown.

It is worth noting, however, that Luti was among the prominent artists who contributed to the suite of tondo paintings representing Christ, the Madonna, and the Apostles that Cardinal Ottoboni submitted in 1713 to the annual exhibition commemorating the translation of the Santa Casa di Loreto held under the auspices of the Pio Sodalizio dei Piceni in the cloister of San Salvatore in Lauro.[12] Luti's painting of Saint Paul is lost, but the surviving tondi by other artists represent bust-length figures of Apostles holding books or other attributes.[13] Although no direct connection can be made between Ottoboni's paintings and Luti's series of pastels, their close correspondence in date and subject raises interesting questions about the popularity and influence of such suites in Rome in the early eighteenth century.

AHS

1. See the photograph showing the pastel at David Tunick, New York, in *Art and Auction* 1993, p. 18.

2. Another head in this series was with Agnew's (London 1989, no. 35; Sotheby's, New York, 14 Jan. 1987, no. 130, repr.). Two pastels purchased by Ian Woodner have since been sold; one is now in the Los Angeles County Museum of Art (Sotheby's no. 122, repr.). Others are in the Spencer Museum of Art, University of Kansas (inv. 1991.25; Sotheby's no. 121) and the Philbrook Art Institute, Tulsa (inv. 1993.12; Sotheby's no. 120, repr.).

3. Bowron 1980. Although Dowley 1962 acknowledged the many pastel heads or portraits attributed to Luti, he did not discuss them, noting only that despite the unresolved problems of dating them, it seems probable that the pastels were executed over a long period of time (p. 233).

4. Among the works he acquired were paintings by Rembrandt, Rubens, and Peter Lely. Cosimo also contributed to the reorganization of the family collections (see Chiarini 1983, esp. p. 328).

5. One of his pupils was Giovanna Fratellini (1666–1731), like Luti a student of Gabbiani (Bowron 1980, p. 443).

6. Luti's reception piece for the Accademia was a *Saint Benedict*, now lost (see Dowley 1962, p. 223 note 40).

7. Inscribed on a pair of pastel heads in the Royal Collection at Fredensberg Castle near Copenhagen (provenance unrecorded), these are the earliest recorded dates for Luti's independent pastels (Bowron 1980, p. 444).

8. The portraits include *Portrait of a Man* (1718) at the Victoria and Albert Museum, as well as Luti's self-portrait in the Louvre (inv. 1218), executed for Nicola Pio (Bowron 1980, figs. 13 and 1).

9. According to Stefano Bottari, Luti's collection of drawings contained 14,000 sheets, including a portfolio of 259 drawings by Correggio and Raphael (Bowron 1980, p. 444). On Luti's collecting, see also Dowley 1962, pp. 225–26, and p. 225 note 46).

10. See Bowron 1980, p. 447 note 6.

11. The Held drawing is signed in pen and brown ink on the verso of the original mount: *Roma 1715 / Il cavaliere Benedetto Luti fece–*. (see Laura Giles in Williamstown 1979–80, no. 22, repr.). Compare also the careful mounting of other pastels that bear Luti's signature on their mounts, e.g., the Holkham Hall heads (Bowron 1980, p. 444) as well as the self-portrait owned by Nicola Pio (Bowron 1980, fig. 1; see also Clark 1967, p. 13, no. 25).

12. On the artists and the subjects they painted, see Pietrangeli 1980, pp. 399–400.

13. Carlo Pietrangeli (1980) identified three related canvases among the paintings in the storerooms of the Pinacoteca Vaticana, Rome. The tondi measure 50 cm in diameter and represent Saint Thaddeus (repr. p. 401) by Antonio Creccolini (1675–c. 1736), Saint Simon (repr. p. 402) by Luigi Garzi, and Saint Peter (repr. p. 404) by Francesco Trevisani (1656–1746). If Cardinal Ottoboni owned Luti's pastel Apostles, this is not recorded in the inventory of 1740 (which lists more than a dozen other Luti pastels). However, the Cardinal's heirs had already sold many works of art to cover his debts (letter to the author from Edward J. Olszewski, 16 Nov. 1998, in SCMA curatorial files).

GIUSEPPE GALLI BIBIENA (ATTRIBUTED TO)
Parma 1695–1757 Berlin

17 A Monumental Stair Hall
Verso: *Two Arches Supported by Composite Columns and Pilasters*

Pen and dark brown ink with brush and grey wash over black chalk, the drawing bordered by a ruled framing line in pen and dark brown ink on cream antique laid paper

Verso: Pen and dark brown ink over black chalk, the drawing bordered at top, bottom, and left side by ruled lines in pen and dark brown ink

Watermark: None

292 × 193 mm (11½ × 7⁹⁄₁₆ in.)

Inscribed recto, lower right corner, in pen and dark brown ink: *M* [or *11*]; inscribed verso, upper right, in pen and dark brown ink: *nessner*[?]

PROVENANCE {Yvonne ffrench (1901–1989), London} by late 1965; sold to SCMA as *Architectural Perspective* in 1966

LITERATURE None

EXHIBITIONS Northampton 1978–79, no. 19 (as *Architectural Drawing*); Northampton 1984b, no. 9

Purchased
1966:5

The history of baroque theatre design in Europe is largely a history of the Bibiena family of architects and theatre designers. Ferdinando (1657–1743) and Francesco (1659–1739), the founders of this artistic dynasty that dominated stage design in Europe for a century, were the sons of the painter Giovan Maria Galli (1625–1665), who had trained in the shop of Francesco Albani (1578–1660) in Bologna.[1]

Ferdinando turned to architecture and theatrical engineering after training as a painter and devoted more than twenty years to the design of theatre sets and wall paintings at the court of Ranuccio II Farnese, duke of Parma. His first commission outside of Italy took him to Barcelona in 1708 to oversee the wedding festivities for the pretender Charles III of Spain. Four years later this same Hapsburg patron, who had become Emperor Charles VI, summoned Ferdinando to Vienna, where he and his second son, Giuseppe (1695–1757), became scenographers and architects to the court.[2]

Ferdinando's brother Francesco had already gone to Vienna in 1700, constructing a theatre for Emperor Leopoldo I,[3] and this city remained a center of Bibiena family activity from which individual members went forth to spread the family style. The Bibienas nevertheless retained close ties to the city of Bologna, and several members of the family were named to important positions at the Accademia Clementina (founded in 1710).[4]

Ferdinando's four sons, Alessandro (1686–1748), Giuseppe, Antonio (1697–?1774), and Giovanni Maria the Younger (1700–?1777), who followed him into the family workshop, as did Francesco's son Giovanni Carlo Sicinio (1713?–1760), were instrumental in spreading the family style throughout Europe. Alessandro spent most of his career at the court of Mannheim, in South Germany;[5] Giuseppe, often collaborating with his father, passed most of his working life at the Austrian and German courts;[6] Antonio built or renovated theatres in Italy,

Austria, and Germany;[7] Giovanni Maria worked in Prague; and Giovanni Carlo was called to work at the Portuguese court of King Joseph I from about 1752 to 1760.[8] Giuseppe's son, Carlo (1721–1787), the third generation of Bibiena architects and scenographers, worked for Catherine II in Russia as well as for Gustav II in Sweden.

The work of the Bibiena family encompassed the architectural design of theatre buildings and other permanent structures, the creation of temporary sets for theatrical performances, and the design of many ephemeral structures erected in conjunction with court festivities and ceremonies. Their designs are preserved not only in the many finished drawings and preliminary studies that were handed down in the family workshops or retained by their noble patrons but also in prints contained in the festival books issued as souvenirs of court celebrations and in the volumes published by Ferdinando and Giuseppe Bibiena. Ferdinando's *Varie opere di Prospetiva* (Bologna, c. 1708) and *L'Architettura civile* (Parma, 1711, with a second edition at Bologna, 1731–32) and Giuseppe's *Architetture e Prospettive* (Augsburg, 1740–47) did much to spread the family's influence.[9]

In *L'Architettura civile,* published just before he left Parma for Vienna, Ferdinando claims to have invented the "veduta per angolo," an innovation of paramount importance to baroque scene design, and of which he is considered to be the foremost practitioner, if not the actual inventor.[10] The "veduta per angolo" offered a striking contrast to the perspective scheme used in Renaissance stage design, which relied on a single vanishing point located on a central axis along which buildings appeared to recede in a series of planes set parallel to the proscenium.[11] The new approach established a variety of vanishing points along multiple planes and featured buildings seen at a forty-five-degree angle. A structure's corner might seem to protrude directly toward the audience or, conversely, the space might recede to a sharp

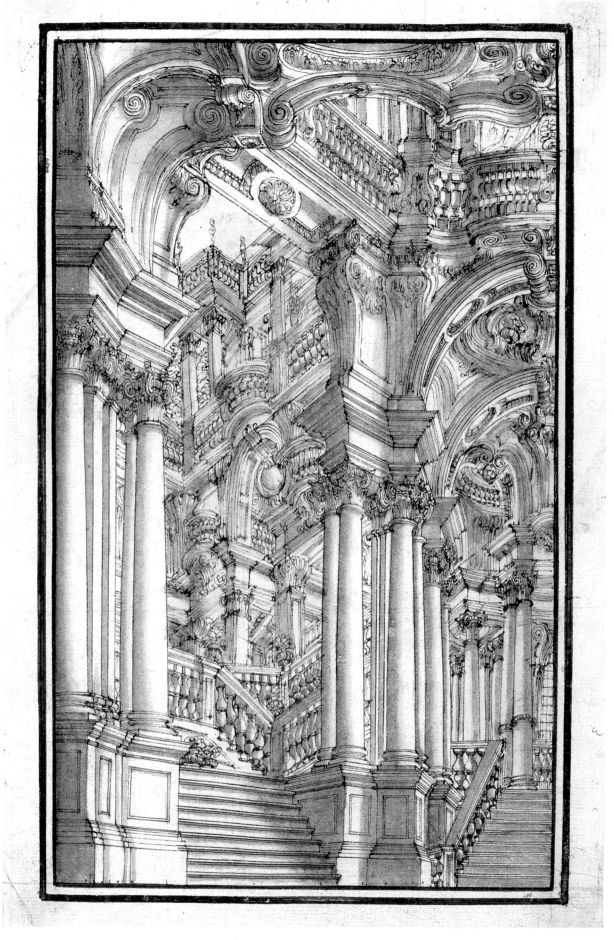

17 Recto

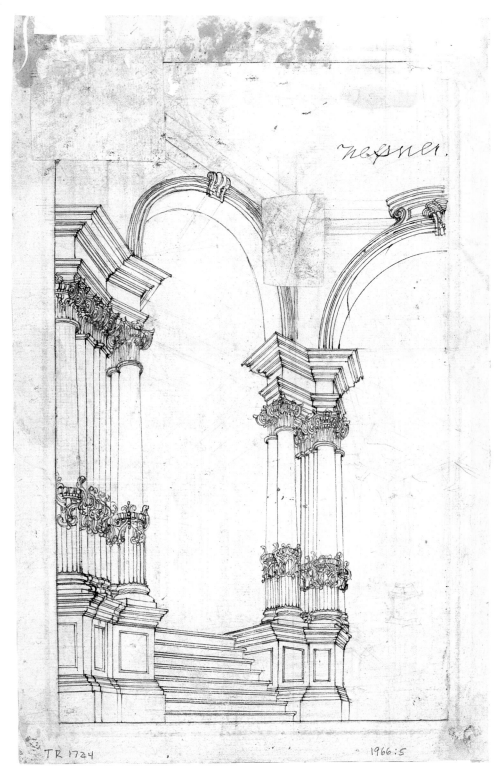

17 Verso

conjunction of diagonals — creating ground plans that A. Hyatt Mayor has likened to the prow of a ship facing the spectators or to the corner of a room whose walls extend to embrace the audience.[12] These plans could also be combined to intersect in an X. The result was stage design of a remarkable new complexity and dynamism, capable of creating the illusion of vast and grandiose spaces.

The drawing *Monumental Stair Hall* in the SCMA, which was acquired as a work of Giuseppe Galli Bibiena, is a characteristic example of the Bibiennesque architectural "veduta per angolo." The highly finished recto drawing is a view of an elaborate hall with staircases that lead through arched openings to a courtyard with numerous balconies and terraces. The verso drawing, abandoned when the line drawing was only partially complete,

explores a variation on the design of the arches and columns in the foreground of the recto. Both compositions are oriented in the same direction and were drawn independently, neither having been traced from the other, although the steps and column pedestals in each are virtually identical. The verso drawing is limited to the arched openings supported by paired columns and pilasters standing on high pedestals, with only a few steps drawn in between the columns at left. Overlaying the verso drawing are two rectangular patches, made from paper of a coarser texture than the main sheet. The larger patch, applied to the upper left corner (verso), allowed a change or correction to the drawing on the recto. A portion of the main sheet was carefully cut away at the upper right to reveal the blank patch, which was then drawn in pen by the artist in dark brown ink that appears identical to that employed in the rest of the drawing. The grey wash, which shows no disjunction between the main sheet and the correction, seems to have been applied to the entire drawing after the correction was drawn. Although the smaller patch on the drawing's verso may have been applied preparatory to another contemplated change, that alteration was never made.[13]

It has proven extremely difficult to assign drawings to the various members of the Bibiena family on the basis of individual style. Their conscious development of a family manner and their frequent close collaboration on projects seriously complicate this enterprise.[14] To date, the drawings of Ferdinando and Giuseppe have been the most clearly differentiated by scholars, and most attributions that have found general acceptance have been made on the basis of autograph inscriptions or on the drawings' close relationship to plates in L'Architettura civile or Architetture e Prospettive.[15] Albums of drawings from Giuseppe's workshop also survive, and although all these volumes include sheets by other hands, most of the drawings are considered to be by Giuseppe.[16] Although the SCMA drawing cannot be definitively attributed at this time, it bears a distinct resemblance to drawings generally given to Giuseppe Bibiena, especially in the handling of medium and the style of drawing capitals, balustrades, and volutes.

AHS

1. The Galli family came originally from Florence. Giovan Maria, whose father had served as *podestà* of the Tuscan hill town of Bibiena, added "da Bibiena" to the family name to distinguish himself from another artist named Giovanni Galli. See Beaumont in ASI 1990–91a, p. 12.

2. Ferdinando was accompanied by his two eldest sons, Alessandro and Giuseppe. Their first stay in Vienna lasted seven years.

3. This structure was already finished in 1704, according to the date inscribed in a cartouche over the *palco reale,* or royal box (ASI 1990–91a, p. 13).

4. Francesco was a professor and director of the Faculty of Architecture and was succeeded by his son, Giovanni Carlo Sicinio, who had also studied there. Giuseppe was *aggregato all'Istituto* (adjunct) from 1721 and was named director in 1725. This was an honorary position (he remained in Vienna), but according to the historian of the Accademia Clementina, Giuseppe's father promised to fulfill the duties of the office (Venice 1970, p. 56, under no. 69). Giuseppe returned many times to Bologna, establishing his wife and four of his sons there when he left Vienna for Dresden.

5. He entered into the service of Carlo Filippo in 1717 and built the Jesuit church and college (1733–56), the opera house (1737–42), and the right wing of the palace.

6. He worked with his father in Vienna as court scenographer to Charles VI and was architect of the court theatre at Bayreuth.

7. He also worked with his father on sets for the Teatro Malvezzi in Bologna in 1721.

8. He did designs for the Royal Opera Theatre (Real Opera do Tejo), the first of its kind built in Lisbon. This theatre was destroyed in the earthquake of 1755 only seven months after its completion.

9. The full titles of these volumes are L'architettura civile preparata sú la geometria, e ridotta alle prospettive. Considerazioni pratiche di Ferdinando Galli Bibiena cittadino bolognese Architetto primario, capo mastro maggiore, e pittore di camera, e feste di teatro della Maestà di Carlo III. il monarca delle Spagne dissegnate, e descritte in cinque parti. In Parma Per Paolo Monti MCDCCXI [MDCCXI]; Varie opere di Prospetiva inventate da Ferdinando Galli d.º il Bibiena Bolognese Pittore et Architetto dell'A: SS.ma del Sig.re Duca di Parma Raccolte da Pietro Abbati e intagliate da Carlo Antonio Buffagnotti. Le diede alla luce e stampò Giacomo Camillo Mercati in Bologna (c. 1708 according to Venice 1970, p. 20, under no. 15); Architetture, e Prospettive dedicate alla Maesta di Carlo sesto Imperador de'Romani da Giuseppe Galli Bibiena, suo primo Ingegner teatrale ed Architetto, inventore delle medesime Augustae sotto la Direzione di Andrea Pfeffel MDCCXL (1740–47 according to Venice 1970, p. 62, under no. 77).

10. On the introduction of the "veduta per angolo," see Hyatt Mayor 1964 and Muraro and Polvoledo in Venice 1970. Ferdinando dedicated L'Architettura civile to Charles VI in 1711 but had clearly been at work on it for some time (Venice 1970, p. 3).

11. See, for example, Sebastiano Serlio's *scena comica* and *scena tragica,* both repr. in Frommel 1998, p. 54.

12. Hyatt Mayor 1964, p. vi.

13. Although a patch might also be used to reinforce a weak spot on a drawing, there is no evidence it served that purpose here. The area of the recto that is backed by the small patch is just above the balustrade to the left and just beyond the large volute above the paired columns at the center of the sheet.

14. For example, Giuseppe frequently assisted his father, and his documented work shows the strong influence of his uncle Francesco. Giuseppe was assisted by his son Carlo in the court theatre at Bayreuth (1748), which refers to Francesco's Hoftheater in Vienna.

15. For drawings with inscriptions by Ferdinando, see Venice 1970, nos. 18, repr., and 23, repr.

16. These albums are at Harvard (Houghton Library), Philadelphia 1968, no. 28, at the Nationalbibliothek, Vienna, and with Wildenstein, New York. See Venice 1970, p. 16.

GIOVANNI BATTISTA (GIAMBATTISTA) TIEPOLO
Venice 1696–1770 Madrid

18 *Angelica and Medoro* (formerly *Rinaldo and Armida*), early 1740s

Pen and bistre with brush and bistre wash over black chalk on white antique laid paper

Watermark: None

424 × 292 mm (16¹¹⁄₁₆ × 11½ in.)

Inscribed verso, lower center, in graphite: 2 [circled]

PROVENANCE Emile Pierre Victor Calando (1872–1953), Paris (Lugt 837 [his father's collector's mark] lower left recto and lower left verso;[1] see Lugt Suppl. 426b), sale, Paris, Hôtel Drouot, 17–18 March 1927, second day, no. 237, repr. opp. p. 28 (as *Venus and Adonis*), 11,000 francs;[2] Ernest II (1871–1955), duke of Saxe-Altenburg;[3] {Charles E. Slatkin Galleries, New York} by 1956; sold to SCMA (as *Rinaldo and Armida*) in 1960

LITERATURE Parks 1960, no. 35, repr. (as *Rinaldo and Armida*, c. 1757–59); GBA 1961, p. 39, no. 118, repr.; Lee 1961, repr. p. 11; Hill 1966, p. 62, fig. 21; New York 1975–76, mentioned under no. 40 (as *Rinaldo and Armida*); Morse 1979, listed p. 256 (as *Rinaldo and Armida*); SCMA 1986, no. 219, repr. (as *Rinaldo and Armida*, c. 1740–50); Cambridge/New York 1996–97, p. 156, (under no. 56), fig. 1 (as *Rinaldo and Armida*)

EXHIBITIONS New York 1956b, no. 20 (as *Rinaldo and Armida*); Wellesley/New York 1960, no. 58, pl. 27 (as *Rinaldo and Armida*); Northampton 1960 (as *Rinaldo and Armida*); Chicago 1961, no. 36 (as *Rinaldo and Armida*); Princeton 1961 (as *Rinaldo and Armida*); Baltimore 1963–64 (as *Rinaldo and Armida*); Northampton 1973–74 (as *Rinaldo and Armida*); Birmingham/Springfield 1978, no. 52 (as *Rinaldo and Armida*); Northampton 1979b, no. 31 (as *Rinaldo and Armida*); Northampton 1982a (as *Rinaldo and Armida*); Northampton 1984b, no. 11 (as *Rinaldo and Armida*); Northampton 1988, no. 8 (as *Rinaldo and Armida*)

Purchased in honor of Clarence Kennedy with funds given by Mr. and Mrs. Edwin Land
1960:43

Since the time this drawing was with the Slatkin Galleries, it has been titled *Rinaldo and Armida,* an identification argued by Rensselaer Lee in a long article on the sheet published shortly after its acquisition by the SCMA.[4] Drawn from Torquato Tasso's epic poem *Gerusalemme Liberata,* published in 1581, the story of Rinaldo and Armida takes place during the Christian crusades to capture Jerusalem from the Muslims. The pagan witch Armida, beautiful niece of the king of Damascus, sets out to distract the crusaders from their goal and ultimately to destroy them. Despite her sworn enmity, however, Armida falls in love with Rinaldo, the hero on whom depends the capture of Jerusalem. Equally enchanted by Armida, Rinaldo is spirited away to her palace in the Fortunate Isles, where the couple while away the hours in lovemaking until the crusaders Carlo and Ubaldo arrive to rescue Rinaldo, recalling him to his Christian duty. The crucial passage for representations of the lovers' idyll is canto 16, stanzas 17–23, which describe the way Rinaldo reclines in Armida's lap as she sits on the grass.[5] Rinaldo holds up a looking glass into which Armida gazes as her lover in turn stares into her eyes and extolls her beauty.[6]

An alternative identification of the couple as the lovers Angelica and Medoro was considered by Lee and rejected. The story of these two lovers is told in Ludovico Ariosto's poem *Orlando Furioso,* first published in 1516, followed by a revised and enlarged version in 1532.[7] Angelica, the beautiful and willful princess of Cathay, has eluded a succession of noble would-be lovers, including Orlando, who has gone mad with unrequited love. She discovers Medoro, a young Moorish soldier, wounded on a battlefield outside Paris, where pagan forces have attacked the Christian defenders of the city. Staunching Medoro's wounds, Angelica falls in love with him. The two marry and before returning to Cathay pass a joyful honeymoon during which they wander about the countryside carving their names on rocks and trees in testimony to their love.[8]

Lee's identification of the subject as Rinaldo and Armida rests on two main points: first, the position and attitude of the lovers; and second, the interpretation of a particular calligraphic passage in the drawing as the mirror Rinaldo holds up to Armida. That this passage is not a mirror, but rather a knot or burl in the tree trunk is clear on examination of the drawing and comparison with sheets that contain trees with similarly handled knots.[9] The male figure in the SCMA drawing clearly holds a knife and therefore should be identified as Medoro, who carved his lover's name on trees. Lee's observation that the position of the figures reflects depictions of Rinaldo and Armida is correct, but as he himself notes, Tiepolo did not always follow current models in his representations of Angelica and Medoro. It is hardly surprising, therefore, that he might adopt an arrangement commonly associated with Tasso's amorous couple in a depiction of the lovers from Ariosto.[10]

The medium and technique employed by Tiepolo in the SCMA's drawing are entirely characteristic of his wash drawings.[11] His chosen paper was a fine, brilliantly white sheet, heavily sized and with a fairly hard surface that preserved a crisp pen line and retained the clarity and sharp edges of the wash passages. Tiepolo began from an extremely loose sketch in black chalk in which he lay out alternative possibilities for his figures. Clearly

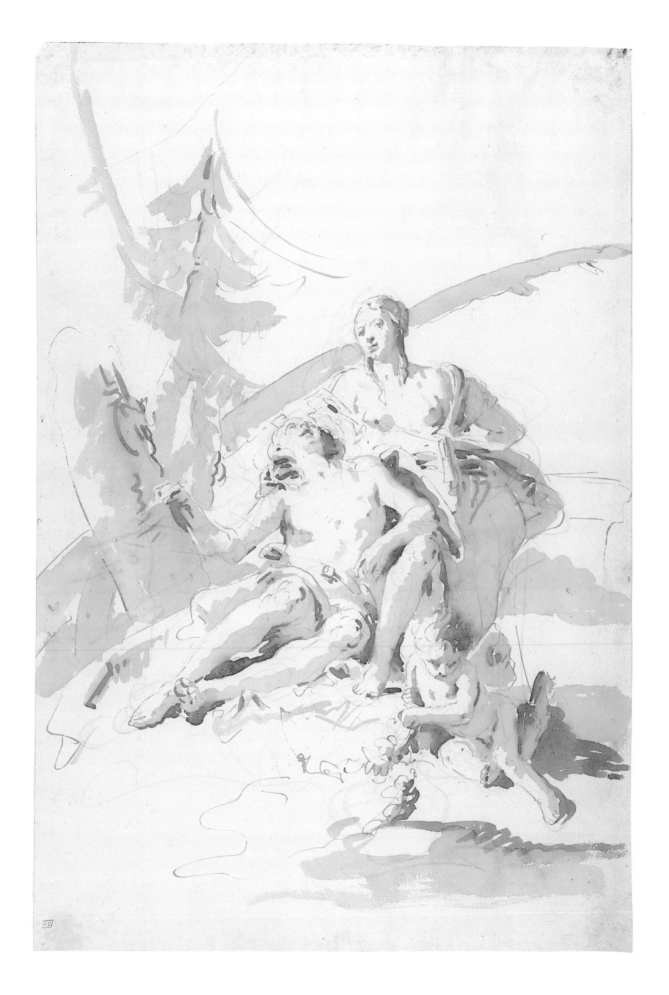

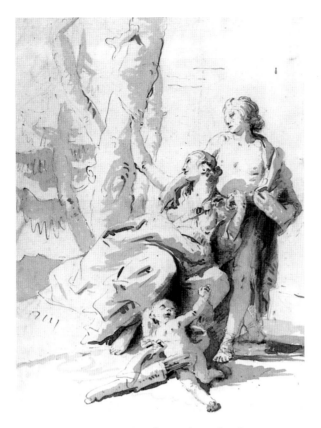 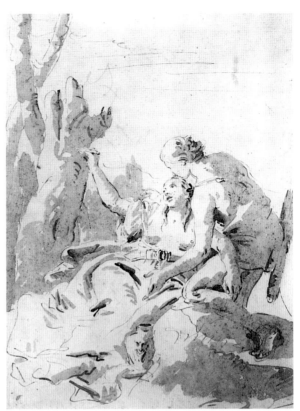

Fig. 1. Giovanni Battista Tiepolo, *Angelica and Medoro.*
Pen and brown ink, brush and brown wash over black chalk,
384 × 286 mm (15⅛ × 11¼ in.). Thaw Collection, The Pierpont
Morgan Library, New York. Photo: Schecter Lee

Fig. 2. Giovanni Battista Tiepolo, *Angelica and Medoro,*
c. 1745. Pen and brown ink, brush and brown wash over black
chalk, 357 × 259 mm (14¹/₁₆ × 10³/₁₆ in.). National Gallery
of Art, Washington, Rosenwald Collection, inv. 1943.3.8112.
Photo: © Board of Trustees, National Gallery of Art

visible in the SCMA sheet are alternatives for Medoro's
right hand, which holds the knife, as well as variant ideas
for Angelica's left arm and the positions of both figures'
heads. Over this loose sketch he used a quill pen and ink
applied with a light, fluid touch to define the drawing's
contours concisely. Wash was then applied over the pen
lines in two discrete values. Loading his brush with pig-
ment (to produce the darker tone), Tiepolo first accented
the drawing at points where he desired shadows (for
example, around Medoro's limbs and in the folds of
Angelica's draperies) or wanted emphasis or composi-
tional balance (as in Cupid's hair). Then, in his character-
istically rapid technique, he applied a medium-toned
wash over the darker passages, which are sometimes
wiped of the still-wet pigment at their center (as in
Cupid's hair). In combination with the bright white
paper, this technique produces a remarkable luminosity.

After training first with Gregorio Lazzarini (1655–1730)
and then with Marcantonio Franceschini (1648–1729),
Giambattista Tiepolo became a member of the Venetian
painters' guild (or *fraglia*) in 1717. The first of many ma-
jor commissions that would take him to work outside
Venice came in 1726, when he was asked to decorate a
chapel in the duomo at Udine. He left Venice again for
Milan a few years later, writing to Count Giuseppe Casati

in April 1731 to say that at the end of that month or early
the following one he would go to Milan to finish the dec-
orations of the Archinto palace (destroyed in 1943) and
begin those for Casati. In 1732 he was back in Venice for a
short time, but in the autumn of that year he went to
Bergamo to fresco the Colleoni chapel, where he was
employed again in the autumn of the following year.

These projects were followed by paintings at the villa
of Count Niccolò Loschi at Biron, near Vicenza, as well
as work for Padua and Rovetta (Bergamo). In the sum-
mer of 1737 he was back in Milan, executing a painting in
the church of Saint Ambrose. Tiepolo's third and final
stay in Milan dates to 1740, when he was invited to fresco
the ceiling of the main hall in the Palazzo Clerici.

Lee related the SCMA sheet to Tiepolo's drawings for
the Palazzo Clerici, citing, for example, the Metropolitan
Museum's *Prudence and a River God,* which was used for
both the Clerici ceiling and the ceiling of the Scuola del
Carmine (1739–44).[12] A number of other sheets that can
be stylistically associated with the Clerici drawings also
bear similarities to the SCMA *Angelica and Medoro,* which
Lee dates "not much earlier, and . . . no later than" 1745.[13]
It is not directly related to any work in another medium
but seems instead to have been conceived as an indepen-
dant work of art. Tiepolo's use of a similar golden ink in

stylistically related drawings supports dating the SCMA sheet to the period in or just following Tiepolo's last work in Lombardy.

The drawings to which the SCMA sheet is most closely related, however, are the *Angelica and Medoro* now in the Thaw collection (fig. 1) and a drawing of the same subject in the National Gallery of Art, Washington (fig. 2).[14] These two works are particularly close to each other in the position of their figures as well as in their facial types and expressions. Neither is dated, but Andrew Robison's proposal of about 1745 for the National Gallery sheet seems plausible for both.[15] As the SCMA's *Angelica and Medoro* is rather closer to the Palazzo Clerici studies in style it may be slightly earlier than the Thaw and National Gallery drawings, but like those sheets it is one of many works by Giambattista on the theme of Ariosto's lovers.[16]

AHS

1. The son of Emile Louis Dominique Calando (1840–1898), he adopted his father's collector's mark (see Lugt 837).

2. According to a priced sale catalogue (The Metropolitan Museum of Art, New York) and an article from an unidentified newspaper of 19 March, taped to the inside cover of a copy of the sale catalogue stamped "Fine Arts Division, Topeka Public Library, Topeka Kansas" (Getty Research Institute).

3. Unverified information from the Slatkin Galleries.

4. Lee 1961.

5. "... egli e in grembo a la donna, essa a l'erbetta.... Sovra lui pende; ed ei nel grembo molle le posa il capo, e 'l volto al volto attolle" (... he is in his lady's lap, she on the lawn. . . . She bends above him and he lays his head in her soft lap and lifts his face to hers). Tasso 1987, p. 342, canto 16, stanzas 17 and 18.

6. "...ella del vetro a se fa specchio, ed egli / gli occhi di lei sereni a se fa spegli. / l'uno di serviru, l'altra d'impero / si gloria, ella in se stessa ed egli in lei.... [Rinaldo tells Armida:] Non più specchio ritrar si dolce imago, / ne in picciol vetro e un paradiso accolto: / speccio t'e degno il cielo, e ne le stelle / puoi riguardar le tue sembianze belle" (From the lover's side hung down [strange armor] a crystal mirror shining and clear. He rose, and held it up for her between his hands, the chosen vessel for the mysteries of Love. He with enkindled, she with laughing eyes, in varying objects gaze at one object only: she makes herself a mirror out of glass, and he makes himself mirrors of her limpid eyes.... So sweet an image mirror cannot copy, nor in a little glass a paradise be comprised: the heavens are the mirror worthy of you, and in the stars you can see your lovely semblance). Tasso 1987, p. 343, canto 16, stanzas 20 and 22.

7. Their story is recounted in canto 19, stanzas 1–41.

8. "e più d'un mese poi stero a diletto / i duo tranquilli amanti a ricrearsi. / [and] Fra piacer tanti, ovunque un arbor dritto / vedesse ombrare o fonte o rivo puro, / v'avea spillo o coltel subito

fitto: / cosi, se v'era alcun sasso men duro: / et era fuori in mille luoghi scritto, / e cosi in casa in altretanti il muro, / Angelica e Medoro, in varii modi / legati insieme di diversi nodi" (and the tranquil lovers passed more than a month there in pleasurable enjoyment. . . . Amid so many pleasures, whenever she saw a tree which afforded shade to a spring or limpid stream, she would hasten to carve it with a knife or pin; she did the same to any rock unless it was too hard. A thousand times out of doors, and another thousand indoors, all over the walls, Angelica's and Medoro's names were inscribed, bound together in various ways with different knots). Ariosto 1974, p. 220, canto 19, stanzas 34 and 36.

9. Also compare Giambattista's drawings of Rinaldo and Armida, where the mirror is always very clearly indicated, as in his drawings for sculpture associated with the Villa Cordellina, Knox 1960, nos. 74, repr., and 75, repr.

10. Lee recognized that the sheet's underdrawing shows the male figure holding a knife (with arm extended) but concluded that Tiepolo confused his texts, initially including the motif from Ariosto, but later substituting a mirror without correcting the position of the hand.

11. These materials and methods were thoroughly investigated and described by Marjorie Cohn in Cambridge 1970, p. 211–21.

12. Lee 1961. He feels the SCMA drawing to be freer and therefore a bit later.

13. Lee 1961. Other drawings that are closely related in style and technique are Metropolitan Museum of Art, *Justice and Peace*, inv. 37.165.22; *Female Figure with Standing Cupid*, inv. 37.165.24; *River God, Boy with Fish*, inv. 37.165.30; Pierpont Morgan Library, inv. *Chronos and Cupid*, for Palazzo Clerici, inv. IV.125; *Three Female Figures, Two with Wings*, for Palazzo Clerici, inv. IV.129; *Figure Seen from Below*, inv. 1983.50; *Warrior with Scimitar and Another Figure*, inv. 1983.51.

14. In 1960 both the SCMA and Thaw drawings were with the Slatkin Gallery, which considered them pendants and therefore as necessarily representing different and complementary subjects. Beyond general similarities of technique and size and a partially shared provenance, however, there is no compelling evidence to support this.

15. Washington 1978, p. 75, repr.

16. In October 1743 Tiepolo was working on the ceiling of the Villa Cordellina at Montecchio Maggiore near Vicenza. Drawings of paired figures preserved in the Victoria and Albert Museum, London, suggest his involvement with the villa's garden sculpture as well. Two sculptural groups in the gardens appear to reflect these designs, which include a *Rinaldo and Armida* as well as an *Angelica and Medoro*. Seven studies of paired sculptural figures are catalogued by Knox (1960, nos. 74–80). In regard to Tiepolo's repetitions of a subject, see Knox's comments on the Orloff album, in which a group of thirty-three drawings, all virtually identical in size (about 410 × 280 mm) and similar in style and subject matter, include seven variations on the theme of the Madonna and Child with Saints, five of the Annunciation, two of the Holy Family, six of the Flight into Egypt, etc. He dates the earliest to c. 1725 and latest to c. 1732 (Knox 1961).

CHARLES-JOSEPH NATOIRE
Nîmes 1700–1777 Castel Gandolfo

19 *A Faun Carrying a Basket of Grapes*, 1747, study for the painting *The Triumph of Bacchus* (1747)

Red chalk heightened with white chalk on brown antique laid paper; laid down on off-white card (the sheet trimmed down after mounting)

Watermark: None visible

366 × 235 mm (14⁷⁄₁₆ × 9¼ in.)

Inscribed recto, lower left in red chalk: *c natoire;* inscribed on verso of mount, at center, in graphite: *92;* at lower center, in graphite: *37[?] = 24;* at upper right, in graphite: *$20;* at lower right, in graphite: *K49[?]* or *K99[?];* at upper right in graphite in Philip Hofer's hand: *Bot of P Proute / 1951 for 5000 fr. = $15–;* and at upper left corner, very faintly, in graphite (erased?): *30[?]*

PROVENANCE Unidentified collector (collector's mark, not in Lugt, lower right verso, stamped in blue-green ink, an elaborate shield with wings at top); {Paul Prouté, Paris}; to Philip Hofer (1898–1984), Cambridge, Mass., in 1951; gift to SCMA in 1951

LITERATURE Rosenberg 1972, p. 14, fig. 9; Troyes 1977, p. 90, under no. 56; SCMA 1986, no. 218, repr. (as c. 1747)

EXHIBITIONS Northampton 1958a, no. 48 (as *A Satyr*); Toronto 1972–73, no. 97, pl. 91; Northampton 1979b, no. 30; Northampton 1982a; Northampton 1988, no. 9; Northampton 1988–89

Gift of Philip Hofer
1951:270

Charles-Joseph Natoire was the son of the sculptor and architect Florent Natoire (b. 1667), who came originally from Nancy. After presumably receiving his earliest training from his father, Charles was sent to Paris to study with Louis Galloche (1670–1761), painter to the king. About 1719 he entered the atelier of François Le Moyne (1688–1735) along with François Boucher (1703–1779), who was to remain his friend and rival. Having won the Grand Prix de Rome in 1721, Natoire arrived at the Académie de France in Rome as a *pensionnaire* in 1723, remaining until 1729. The years following his return to France were marked by great success as a painter of major commissions for the king and members of the royal court, and he became a member of the Académie Royale in 1734. Named in 1751 as Jean-François de Troy's (1679–1752) successor as director of the Académie de France in Rome, he returned to Italy in October of that year. Although at first he continued to work on large decorative projects, he later gave up this type of work and turned mainly to landscape. After his retirement in mid-1775, Natoire spent the rest of his life in Italy.

The SCMA's *Faun Carrying a Basket of Grapes* is one of a number of figure studies drawn by Natoire in preparation for his painting *Triumph of Bacchus* (fig. 1), now preserved in the Louvre.[1] The *Triumph of Bacchus* was painted for a *concours* (competition) announced in February 1747 by the new *directeur général des Bâtiments du Roi,* Le Normand de Tournehem, who had decided to "encourage emulation in what was regarded as the highest branch of painting, and to provide economic support for it by guaranteeing the purchase of all the entries by the Crown for installation in the royal palaces."[2] The participants in the competition were to be ten history painters whose names had been supplied by the *premier peintre du roi,* Charles-Antoine Coypel (1694–1752):[3] Charles Natoire, François Boucher, Pierre-Jacques Cazes (1676–

1754), Hyacinthe Collin de Vermont (1693–1761), Jacques Dumont, called Dumont le Romain (1701–1781), Louis Galloche, Sébastien Leclerc (1676–1763), Jean-Baptiste Marie Pierre (1713–1789), Jean Restout the Younger (1692–1763), and Carle Vanloo (1705–1765).[4] Etienne Jeaurat (1699–1789) also submitted a painting, bringing the total number of competitors to eleven.[5] Although Le Normand de Tournehem may have hoped this *concours* would reinvigorate history painting by encouraging the depiction of new subjects, Natoire, like many of the competitors, chose to paint a traditional mythological theme.[6]

Natoire's entry presents several episodes in the legend of Bacchus, god of wine. His treatment of the theme has been described by Pierre Rosenberg as "altogether

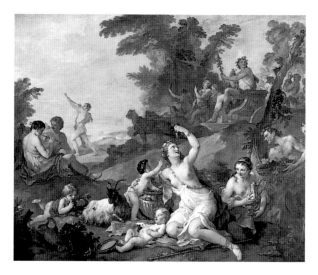

Fig. 1. Charles-Joseph Natoire, *Triumph of Bacchus,* 1747. Oil on canvas, 162 × 195 cm (63¾ × 76¾ in.). Musée du Louvre, Paris, inv. 6854. Photo: © RMN–H. Ldwandowski

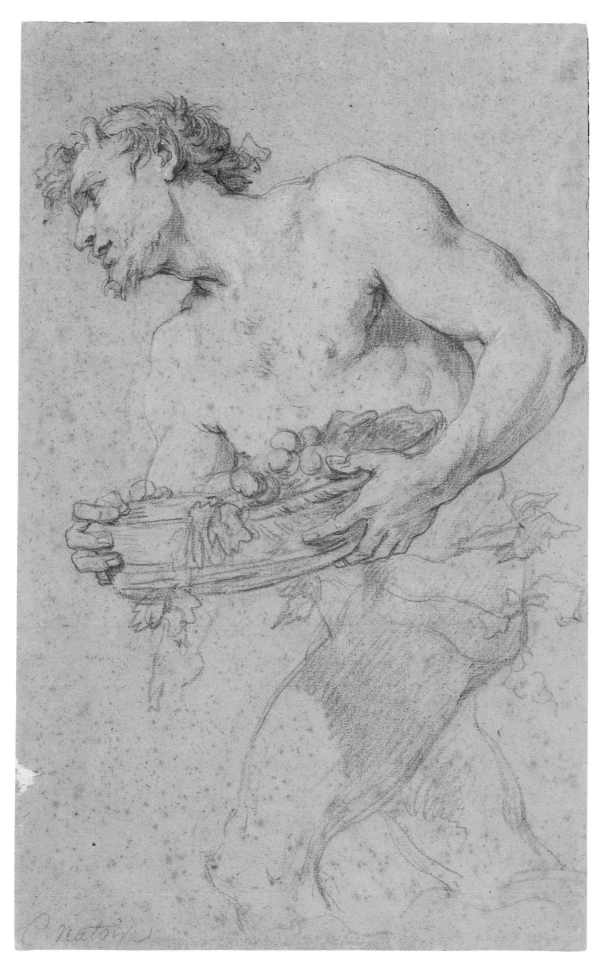

galante," and indeed its palette and composition reflect mid-eighteenth-century fashions in decorative painting.[7] Natoire's painting was exhibited with the other entries in the Salon held in August 1747 in the Galerie d'Apollon at Versailles and was purchased for 1,500 livres by Louis XV for the château de La Muette.

Drawing played an important role in Natoire's working process. His method of developing a painting commonly involved a variety of *premières pensées* (first ideas) and composition studies, as well as life drawings from the model, including careful studies of poses and details of figures. The SCMA sheet, in red chalk with subtle white chalk heightening on brown paper, is a superb example of Natoire's individual figure studies. It represents a faun holding a basket of grapes, a figure who can be seen at the far right of the 1747 painting. In the drawing the artist's attention is devoted to the figure's upper body; his legs are more lightly sketched and Natoire has not bothered to model them with shading or highlights. Slight pentimenti are visible in the faun's profile (specifically in his forehead, nose, and lips), as well as in his neck, left hand (especially the thumb), and left arm (above the elbow). Barely visible are traces of an erased line indicating an earlier idea for placing the right arm farther forward. The subtle touches of white chalk that suggest the play of light across the faun's face and torso work together with Natoire's primary drawing medium, a warm red chalk, and the intermediate tone of the colored paper to convey a fully modeled form. This type of chalk drawing is typical of the artist's figure studies, which, as Lise Duclaux notes, are often on colored paper, generally beige or blue. In these studies Natoire often combined red and black chalks with white heightening (usually white chalk rather than gouache).[8]

Studies for a number of other figures in *The Triumph of Bacchus* are known. A chalk drawing for the man who sounds a horn to herald Bacchus's arrival is preserved in the Musée Atget, Montpellier.[9] This figure appears in the left background of the painting, but his pose is substantially altered from that presented in the drawing, which sets the figure in a landscape background. A nude study for the central female figure in the painting was probably drawn from a studio model.[10] Another female figure is the subject of a drawing in the Louvre.[11] Identified by Rosenberg as a "first idea" for the woman holding a jug at the far right of the painting, this drawing represents a seated woman nursing two infants. The infants have disappeared in the painting, although the figure's pose remains very much the same. Bacchus is treated in a red chalk drawing sold at Sotheby's in 1982.[12] This drawing,

identified by Rosenberg as a study for the 1747 painting,[13] shows the figure of Bacchus in the pose adopted for the painting. At the bottom of the sheet is an auxiliary study of Bacchus's head, in which his gaze is directed slightly down and to his right, in contrast to that depicted in the full-figure study.

AHS

1. Collection of Louis XV.

2. Quoted by Colin Bailey in Paris/Philadelphia/Fort Worth 1991–92 under no. 47.

3. Le Normand de Tournehem, uncle of Madame de Pompadour, had been appointed in 1745. On 20 Jan. 1747 he named Coypel to the post of *premier peintre,* which had been vacant for ten years. See Locquin 1912, p. 3.

4. Boucher's entry, *L'Enlèvement d'Europe,* is in the Louvre; Cazes's *L'Enlèvement d'Europe* is lost; Collin de Vermont's *Pyrrhus enfant reconnu par Glaucus* and Dumont le Romain's *Mucius Scaevola* are in the Musée des Beaux-Arts et d'Archéologie, Besançon; Galloche's *Coriolan* is in the Musée d'Orléans; Leclerc's *Moise sauvé des eaux* is lost; Pierre's *Aurore quittant Tithon* is in the Musée de Poitiers; Restout's *Alexandre et son médecin Philippe* is in the Musée d'Amiens; Vanloo's *Silène nourricier et compagnon de Bacchus* is in the Musée des Beaux-Arts, Nancy.

5. Jeaurat's *Diogène brisant son écuelle* is in the palais de Fontainebleau.

6. See the discussion in Paris/Philadelphia/Fort Worth 1991–92 under no. 47. Although the format of the paintings originally was to have been six feet wide and four high (a standard format), the dimensions were reset to the unusual format of five feet high and six wide. The original decision to award six prizes was also changed to include awards for all eleven competitors.

7. Toronto 1972–73, under no. 97.

8. Duclaux [1992], p. 7. She notes that Natoire's composition studies are executed in pen and wash.

9. It is inscribed with initials recto, lower right corner: *CN;* at lower left: *Natoire fecit;* at lower center: *faune;* and at lower right: *Charles Natoire.*

10. Rosenberg 1972, fig. 10; in the Bronfman collection, Montreal, according to Toronto 1972–73, under no. 97.

11. Coll. Orsay, inv. 31425 (mentioned by Rosenberg in Toronto 1972–73 under no. 97). *Femme assise à mi-corps, allaittant un enfant,* black and red chalks, grey wash, white heightening on blue paper, 420 × 283 mm (Duclaux [1992], no. 27, repr. and color repr. on cover).

12. Sale, New York, Sotheby's, 30 April 1982, no. 41, repr. (as *Studies of Bacchus,* red chalk on grey laid paper, laid down, 433 × 274 mm), from the estate of Christian Humann, New York. This drawing had previously appeared in a sale at Sotheby's, London, 22 July 1965, no. 125, repr., and was with Farber and Maison, London, in 1969.

13. Toronto 1972–73, under no. 97.

JEAN-HONORÉ FRAGONARD
Grasse 1732–1806 Paris

20 *Venus in a Chariot*, 1750–53

Black and red chalks with touches of blue and white chalks on dark beige antique laid paper; laid down on cream card faced with blue laid paper

Watermark: None visible on drawing. On the blue paper of mount: *C;* on the off-white card of mount: words [illegible]

Sheet: 165 × 228 mm (6½ × 9 in.); mount: 246 × 301 mm (9¹¹⁄₁₆ × 11⅞ in.)

Inscribed recto, lower left, in pen and dark brown ink: *h. fragonard;* inscribed on verso of mount, upper right corner (along right side) in pen and dark brown ink: *2 10 passepartout or;* inscribed verso of mount, lower left, in pen and dark brown ink: *1# 3#;* in lower right corner, in graphite: *Exp. Fragonard, Berne 1953, nr. 128 / étude pour le tableau de la vente Mühlbacher / Paris 1907, nr. 21. / Ba[?]nor 198;* faint handwriting visible overall on verso of mount (accounts?), in graphite, beneath all other inscriptions

PROVENANCE Private collection, Paris (Mühlbacher?, see Washington/Cambridge 1978–79), by 1954; {Mathias Komor (b. 1909), New York} (Lugt 1882a, verso of mount, lower left corner); to Reyna Lander McGowen (d. 1989);[1] by inheritance to her husband, Edward McGowen; gift to SCMA in 1992

LITERATURE Cailleux 1960, p. iv note 35; Ananoff 1961–70, vol. 1, no. 401, fig. 151 (as *Venus offrant des couronnes*), and vol. 2, p. 310; Cuzin 1988, p. 137 note 2; GBA 1993, listed p. 94.

EXHIBITIONS Bern 1954, no. 128 (as *Venus offrant des couronnes*); Washington/Cambridge 1978–79, no. 1, repr.

Gift of her family in memory of Reyna Lander McGowen, class of 1953
1992:29

Jean-Honoré Fragonard was born in 1732 in the Provençal town of Grasse, son of a glove maker who moved his family to Paris, most probably when Jean-Honoré was about six years old.[2] Although Fragonard's early years in Paris are undocumented, his grandson Théophile reported that he trained first with Jean-Siméon Chardin (1699–1779) for a period of six months, and then with François Boucher (1703–1770), whose style had a much more significant influence on him.[3] Despite his lack of academic training, Fragonard, like Boucher before him, entered the competition for the Prix de Rome, winning the Grand Prix de Peinture on 26 August 1752 with his painting *Jeroboam Sacrificing to the Idols*.[4] The following May (30 May 1753), Fragonard entered the Ecole Royale des Elèves Protégés, a school that had been founded in 1749 with the purpose of preparing the prospective *pensionnaires* of the Académie de France in Rome for their studies in Italy.[5] Directed by the painter Carle Vanloo (1705–1765), the school offered its pupils instruction in history and geography as well as practice in drawing and visits to the principal monuments of Paris and its environs. After three years there, Fragonard left for Rome to take up his studies at the Académie de France (housed at that time in the Palazzo Mancini, on the Corso), arriving shortly before 22 December 1756. For the next four years Fragonard pursued his training in Rome, returning to Paris on 26 September 1761 after an extended trip in the company of the Abbé de Saint-Non.[6]

Since it was first published in 1954, the SCMA's *Venus in a Chariot* has been related to a small oval oil sketch, *Venus Offering Crowns*, formerly in the Mühlbacher collection.[7] Alexandre Ananoff, believing the Smith drawing to be a possible first idea *(première pensée)* for this oil sketch, assigned it the same title, even though no floral crowns appear in the drawing, which depicts Venus as reclining casually in her chariot.[8]

The oil sketch has, in turn, been associated with one of the overdoors purchased by the comtesse du Barry (1743–1793), mistress of Louis XV, for the château de Louveciennes, which the king had given her in 1769. Madame du Barry not only restored and redecorated the old château but commissioned a new building, the Pavillon Neuf, from Claude Nicolas Ledoux (1736–1806). Constructed in nine months, it was inaugurated with great ceremony on 2 September 1771.[9] To decorate the château, the comtesse du Barry purchased from the painter François-Hubert Drouais (1727–1775), on 21 June 1770, for the sum of 1,200 livres, four overdoors by Fragonard, *The Graces, Cupid Setting the Universe Ablaze, Venus and Cupid,* and *Night*.[10]

The overdoor *Venus and Cupid*, now in the National Gallery of Ireland, Dublin, depicts the goddess of love in her chariot, drawn through the clouds by doves as she holds out floral crowns she has received from Cupid, who reclines alongside her outstretched leg.[11] Venus's pose is virtually identical in the smaller oil sketch of the subject, where she also offers a floral crown extended in her right hand. Pierre Rosenberg traces the inspiration for this motif to the figure of a young girl at the right of Pietro da Cortona's (1596–1669) *Minerva Wresting Adolescence from the Arms of Venus,* in the Palazzo Pitti, Florence, which Fragonard copied on his return trip from Rome to France in 1761.[12] Neither the oil sketch nor the overdoor *Venus and Cupid* is securely dated, however. In fact, considerable controversy has surrounded the dating of Fragonard's Louveciennes overdoors. While some scholars believe they were painted expressly for the comtesse du Barry shortly before 1770, it has also been

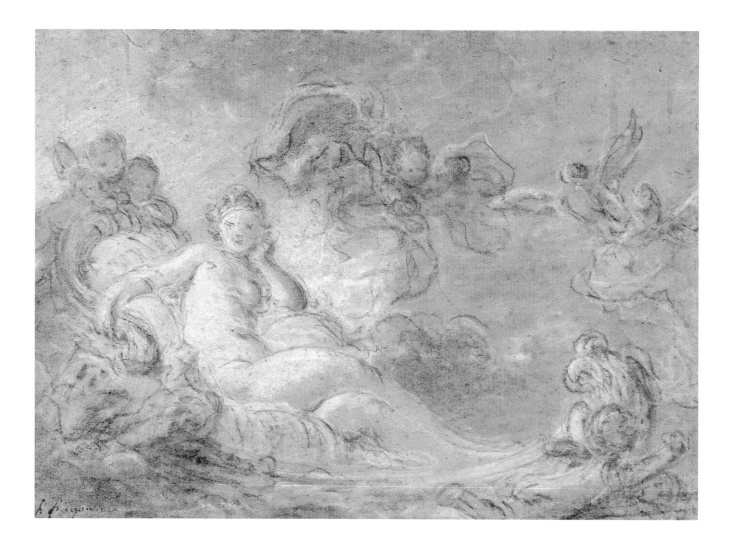

suggested that they might predate Fragonard's first trip to Rome in 1756.[13] Rosenberg points out that beginning in 1765 Fragonard secured many commissions for decorative schemes, only one of which was completed, and suggests that the Louveciennes overdoors could be the remnants of earlier, unfinished projects that were assembled and completed for Madame du Barry.[14]

The influence of Boucher, evident in both paintings of *Venus Offering Crowns,* is nowhere more apparent than in the SCMA drawing of *Venus in Her Chariot.* For stylistic reasons, Eunice Williams places it among Fragonard's earliest known drawings, executed while he was very much under Boucher's influence and perhaps while he was still in Boucher's studio, that is, between 1750 and 1753.[15] Although this dating is offered tentatively, she argues convincingly that the draughtsmanship of the SCMA sheet not only reflects a close study of Boucher, but also reveals a lack of systematic training. As Fragonard is unlikely to have received formal training in figure drawing until he entered the Ecole des Elèves Protégés, an early date for the drawing seems plausible. Although the drawing shares a general compositional similarity with the oil sketch and overdoor, and also shares with the

oil sketch the particular detail of the cupid seen from the rear at lower right, there are a number of significant differences between the SCMA drawing and the paintings. As Williams notes, these include the absence of crowns in the SCMA drawing as well as the informal pose of Venus, who reclines casually in a chariot that "resembles an upholstered armchair, such as a *bergère* in the Louis XV style." The abundance of cupids, who lean on the chariot back and disport themselves in the clouds above, is another striking difference between the drawing and the more restrained composition of the paintings.

Two small oil sketches cited by Williams for their similarity in style and handling to the SCMA drawing lend additional support to an early dating for the SCMA's *Venus in a Chariot. War* and *Peace* depict cupids playing with attributes appropriate to their respective subjects.[16] *Peace* includes a chariot that is virtually identical to that in the SCMA drawing. Both these sketches belonged to Charles Natoire, director of the Académie de France in Rome during Fragonard's years there. It is likely that they were painted by Fragonard in Rome, that is, between 1756 and 1761, and were acquired by Natoire directly from the artist.[17]

Although Fragonard made many drawings in black or red chalk alone, the Smith sheet is unusual in its combination of the two chalks with pastel. Williams notes that in the Smith sheet Fragonard used the touches of blue and white to decoratively enrich a drawing that is essentially constructed in black and red chalk.[18]

AHS

1. Purchased by her from Mathias Komor before her marriage, according to her sister Elinor Lander Horwitz (conversation with the author, 27 Feb. 1992).

2. Paris/New York 1987–88, p. 32.

3. On Fragonard's biographers and accounts of his early training, see ibid., esp. pp. 31–39.

4. Ibid., no. 8, color repr.

5. See Courajod 1874/1994 for a history of the school.

6. The itinerary is recorded in Saint-Non's journal (see Rosenberg and Bréjon de Lavergnée 1986). The companions made many drawings recording the works of art seen on this trip.

7. Bern 1954, no. 128. The oil sketch measures 32 × 40 cm (see Wildenstein 1960, no. 295, pl. 50). It appeared in the Mühlbacher sale, Paris, 1907, no. 21, as *Venus et l'amour* or *Le Jour,* and in the sale in Paris, 19 May 1913 as *Venus offrant les couronnes.* The oil sketch is also illustrated and discussed by Cailleux 1960, fig. 11, who proposes that it is a portrait of Marie-Catherine Colombe (therefore c. 1769–70), although noting (note 35) that the related SCMA drawing is too generalized to be considered a portrait.

8. Ananoff 1961–70, vol. 1, no. 401, fig. 151. Ananoff's catalogue is organized thematically; he does not propose a date for either the drawing or the oil sketch.

9. See the drawing by Moreau le jeune, Paris, Musée du Louvre, Département des Arts Graphiques, inv. 31360.

10. Paris/New York 1987–88, pp. 319–25 and nos. 152 and 153, repr. On the overdoors, see Wilhelm 1956. See also Wildenstein 1960, nos. 297–300. Madame du Barry also commissioned from Fragonard a new suite of paintings for the salon of the Pavillon Neuf, which are preserved in the Frick Collection, New York. Although the four main canvases may have been briefly in place at Louveciennes, they did not remain for long, reportedly because of a dispute between the artist and the patron over the price of the works, but possibly because of Madame du Barry's preference for the fashionable, new neoclassical style. Although the precise date of the commission is not known, Fragonard was at work on them in 1771. For a full discussion, see Paris/New York 1987–88, pp. 319–25.

11. Marianne Roland-Michel published a smaller (probably cut down) version of this painting in Paris 1987, no. 73. She considers it to be autograph and dates it for stylistic reasons between 1767 and 1769.

12. See the black chalk drawing in the British Museum, London, inv. 1936.5.9.20 (Paris/New York 1987–88, no. 47, repr.). Fragonard and Saint-Non were in Florence 17 April–5 May 1761 (see Paris/New York 1987–88, p. 69, and Rosenberg and Bréjon de Lavergnée 1986).

13. See Wilhelm 1956 and Toulon 1985–86, where this suggestion is discussed with regard to the overdoor *Cupid Setting the Universe Ablaze* (Wildenstein 1960, no. 298), now at Toulon.

14. Paris/New York 1987–88, p. 328.

15. See Washington/Cambridge 1978–79, no. 1.

16. *War* (Wildenstein 1960, no. 79, fig. 55; private collection, Paris) and *Peace* (Wildenstein 1960, no. 80, fig. 56; private collection, Paris) are oil on canvas and measure 38 × 46 cm.

17. See the Natoire collection sale catalogue (1778), annotated with drawings by Gabriel de Saint-Aubin (Bibliothèque Nationale, Paris). Paris/New York 1987–88, p. 63, fig. 2, shows two of Natoire's four paintings by Fragonard to have been the oil sketches *War* (p. 63, fig. 4), and *Peace* (p. 63, fig. 5). See also Wildenstein 1960, nos. 79, fig. 55, and 80, fig. 56.

18. Washington/Cambridge 1978–79, no. 1.

FRANÇOIS BOUCHER
Paris 1703–1770 Paris

21 *Juno Inducing Aeolus to Loose the Storm on Aeneas*, 1753 or later

Pen and brown ink with brush and brown and blue washes on antique laid paper toned a medium brown; laid down to a lightweight card

242 × 335 mm (9½ × 13¼ in.)

Watermark: None visible

Inscribed on verso of mount, upper left, in graphite: *Natoire ou Servandony;* lower right, in graphite: *Natoir ou Servandony*[1]

PROVENANCE Jacques Mathey (1883–1973), Paris;[2] Messieurs Cailleux, Paris (collector's mark, not in Lugt, lower left corner recto, stamped in black ink, C..x in oval)[3] by 1964; to {H. Schickman Gallery, New York}, in 1973 (as *Juno and Aeuleus,* stock no. D1891); sold to SCMA in 1975

LITERATURE Ananoff and Wildenstein 1976, 674/6 (as "dans le commerce parisien en 1964"), fig. 1756; New York 1981, mentioned under no. 59 (but not identified as being at SCMA); SCMA 1986, no. 222, repr. (as c. 1769); New York 1986–87, mentioned under nos. 84–85 (p. 319, Drawings: *Juno Asking Aeolus to Release the Winds,* no. 1) but not identified as being at SCMA; Sotheby's, London, 4 July 1994, mentioned under no. 105 (but not identified as being at SCMA); Cambridge 1998–2000, under no. 61 note 7; Christie's, New York, 28 Jan. 1999, mentioned under no. 134.

EXHIBITIONS Paris 1964; Northampton 1979b, no. 49; Springfield 1984; Northampton 1985b, no. 14; Northampton 1986b; Northampton 1988, no. 22; Northampton 1988–89

Purchased with funds from the Theodore T. and Hilda Rose Foundation, Linda C. Rose, class of 1963, President
1975:26-1

François Boucher was born in Paris in 1703, the son of Nicolas Boucher (1671–1743), a master decorative painter in the Académie de Saint-Luc, from whom he probably received his earliest instruction in art. Following a brief period of study with François Lemoyne (1688–1737), Boucher won the Prix de Rome in 1723 but was unable to take up his scholarship until 1728. After his return to France in late 1731, Boucher began to receive major commissions and was received into the Académie Royale in January 1734. As his fame grew, so did the number of royal commissions he obtained; in addition to paintings, he produced designs for tapestries, porcelain, and theatre sets. Named *premier peintre du roi* in August 1765, Boucher continued to work up until the last year of his life, dying in May 1770.[4]

Juno Inducing Aeolus to Loose the Storm derives its subject from Virgil's *Aeneid.* The drawing depicts the vengeful goddess Juno's attempt to prevent Aeneas, who had escaped by sea after the sack of Troy, from reaching Latium, where he was destined to found the great city of Rome. Juno, who had taken the side of the Greeks in the Trojan War and had heard that a future race of Trojan blood would one day topple her beloved Carthage (she was the principal goddess of that city), was the implacable enemy of Aeneas, the son of her rival, Venus, and the Trojan shepherd Anchises. She persuaded the god Aeolus, controller of the winds, to unloose them on Aeneas and his companions on the high sea off Sicily, smashing his fleet against the rocks. Only the intervention of Neptune enabled Aeneas to come safely ashore near Carthage (*Aeneid,* book 1, 50–86).

At the upper left of the drawing, Juno, holding a scepter in her right hand, gestures with her left to the most beautiful of her attendant nymphs, Deiopea, whom she promises to Aeolus in return for his assistance. Behind her is her emblematic peacock as well as cupids who hover above her chariot. The figure to Juno's right can be identified as Iris, the winged goddess whom Juno often dispatches as her messenger (Iris's rainbow appears to be indicated by the arched form on which Deiopea sits). Aeolus, grasping his scepter, draws back the stone to release the Winds that he keeps captive under the mountain. The winged Winds, with puffed cheeks and clenched fists, burst forth from the cavern to create a tempest on the high sea, represented by the group of Nereids at lower left.

The Smith College sheet is one of several drawings that bear a thematic and compositional relationship to Boucher's only known painting on the subject of Juno and Aeolus, a large vertical canvas executed in 1769 for a room in the Hôtel Bergeret de Frouville, Paris.[5] As Alastair Laing has recognized, however, the drawings represent an earlier, independent treatment of the subject that may have preceded Boucher's painting by as much as two decades.

The first known stage in Boucher's development of the horizontal composition used in the SCMA sheet is represented by two nearly identical drawings, one in red chalk, the other in black, which are now in private collections.[6] The general disposition of figures is similar, and although Aeolus is seated, his body rotated toward Juno, the attitude of the goddess and her attendants is already fairly close to the SCMA drawing. No figures can be clearly identified as Nereids, although the sketchy forms behind a Wind at the lower right may constitute the embryonic expression of these figures.

The figure of Aeolus received Boucher's attention in an *académie* (a nude study) that alters the position of his

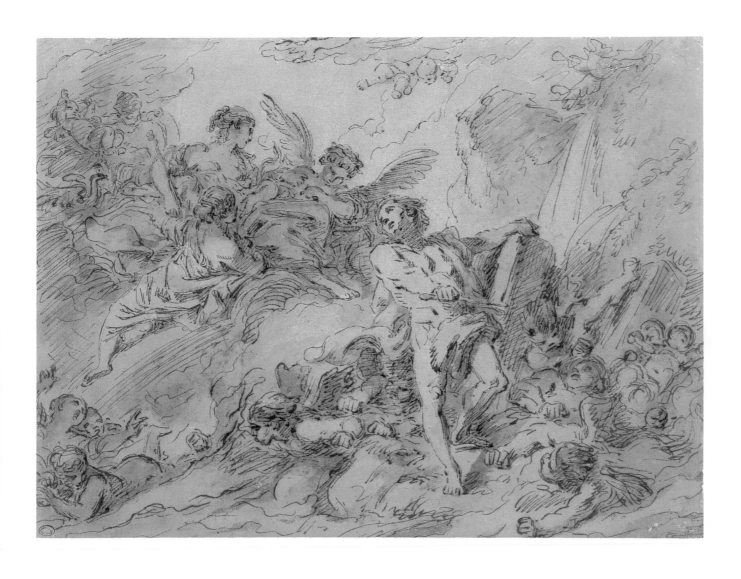

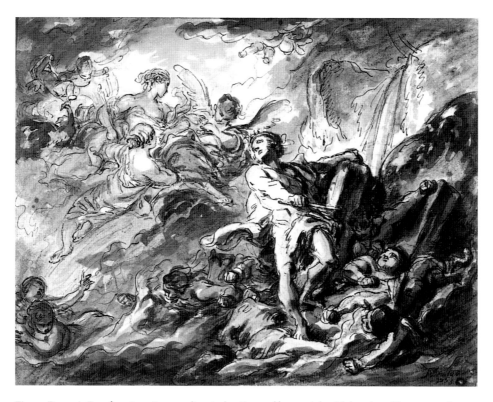

Fig. 1. François Boucher, *Juno Commanding Aeolus*. Pen and brown ink with brush and brown wash over black chalk, 260 × 347 mm (10¼ × 13¹¹⁄₁₆ in.). Courtesy of the Fogg Art Museum, Harvard University Art Museums, Loan from the Collection of Jeffrey E. Horvitz. Photo: Photographic Services, © President and Fellows of Harvard College

legs and torso while retaining the general arrangement of his arms, the left outstretched, the right extended across his body.[7] This study seems to have led directly to another composition drawing (private collection) in which Boucher made further adjustments to the position of Aeolus's left leg.[8] Evidently Boucher continued to be dissatisfied with Aeolus's pose, for he returned to the problem in a black and white chalk study in which he made a substantial revision that was retained in his final drawings.[9] Here Aeolus stands, facing away from Juno, his left foot poised on a large rock, although he continues to gaze at the goddess over his right shoulder as he did in the immediately preceding studies.

The final sheets in the sequence are two highly finished drawings of the full composition, one in the Jeffrey E. Horvitz collection, the other the Smith College drawing under discussion.[10] The Horvitz drawing, which is signed and dated, is executed in pen and brown ink with brush and three tones of brown wash over a sketch in black chalk. Its vigorous black chalk underdrawing indicates that it preceded the SCMA *Juno and Aeolus,* whose pen line is more precise and dry and which appears to lack underdrawing entirely. Nevertheless, comparison of the two drawings suggests that Smith's *Juno and Aeolus* is an autograph replica of the Horvitz sheet. Not only

does it exhibit a number of slight differences in individual figures,[11] but the handling of pen and wash and the conventions used to indicate such elements as the hands and heads of subsidiary figures appear to be entirely characteristic of Boucher.

The date on the Horvitz drawing has been read by Laing as 1753, a date that accords with scholarly opinion on the probable date of the first chalk composition studies.[12] If the inscription is read as 1763, the drawing would instead be a reprise and further development of a composition first explored in the previous decade.

Although the previous composition and figure studies of *Juno and Aeolus* may well have been preparatory for a work in another medium, it is probable that the Horvitz drawing was made as an independent work of art, as Laing asserts.[13] The drawing's mount retains the blind stamp of the mount maker Glomy (Lugt 1119), and it would appear to be this drawing that figured in the 1769 sale of the collection of Claude Philippe Cayeux (1688– 1769), Paris.[14] If, as seems likely, the Horvitz sheet was presented or sold to a collector by Boucher, the SCMA drawing could be plausibly explained as a replica made by the artist for his own use.[15]

AHS

1. Giovanni Niccolo Servandoni (1695–1766) was a pupil of Giovanni Paolo Panini (1691/92–1765). He moved to Paris in 1724 and became *premier peintre décorateur de l'Académie Royale de Musique.*

2. Information from Marianne Roland-Michel, Galerie Cailleux, Paris (letter to the author, 17 June 1996, SCMA curatorial files).

3. For identification of this mark, see Bean and Turcic 1986, no. 269 (Hubert Robert, *Figures among Ruins,* The Metropolitan Museum of Art, inv. 67.129).

4. See New York 1986–87 for a detailed chronology.

5. *Juno Asking Aeolus to Release the Winds,* oil on canvas, signed and dated 1769, Kimbell Art Museum, Fort Worth, Foundation Acquisition, inv. AP 72.7. On the full suite of six paintings, see Alastair Laing in New York 1986–87, nos. 84–85, color repr. and p. 319. Three of the other paintings are at the Kimbell Art Museum: *Venus at Vulcan's Forge, Mercury Confiding the Infant Bacchus to the Nymphs of Nysa,* and *Boreas Abducting Oreithyia,* Foundation Acquisitions, inv. AP 72.8, AP 72.9, and AP 72.10, respectively (see Kimbell 1972, pp. 101–7, all repr., and Ananoff and Wildenstein 1976, nos. 674–77). Two canvases are in the J. Paul Getty Museum, Los Angeles: *Aurora and Cephalus,* inv. 71.PA.55, and *Venus on the Waters,* inv. 71.PA.54 (Ananoff and Wildenstein 1976, no. 670, fig. 1751 [as *Venus and Endymion*], and no. 671, fig. 1752).

6. The red chalk drawing measures 255 × 325 mm (sale, Paris, Hôtel Drouot, 29 Oct. 1980, no. 67, repr.). The black chalk drawing measures 226 × 293 mm (formerly A. Mos collection, sale, Amsterdam, R. W. P. de Vries, 2 Nov. 1928, no. 117, pl. XII). Neither is catalogued in Ananoff. See Laing in Cambridge 1998–2000, under no. 61, and fig. 2 (the red chalk drawing). See also Laing in New York 1986–87, under nos. 84–85.

7. Laing in Cambridge 1998–2000, p. 228 (under no. 60), fig. 2 and p. 230 (under no. 61).

8. Ibid., p. 230 (under no. 61), fig. 3.

9. In the sale, London, Sotheby's, 7 July 1999, no. 134, repr.

10. Cambridge 1998–2000, no. 61, color repr.

11. E.g., the position of the front Nereid at lower left.

12. Cambridge 1998–2000, p. 130.

13. Ibid. He refutes suggestions that the earlier chalk studies could have been for a tapestry (as their compositions are not intended for reversal).

14. On the probable provenance of the Horvitz drawing, see Cambridge 1998–2000, no. 61 (Provenance) and n. 2. It is not always possible to definitively identify the drawings cited in early sales, however, and one or more of these references may be to the SCMA rather than the Horvitz drawing.

15. This composition undoubtedly served as the starting point for Boucher's 1769 painting, which repeats the pose of Aeolus, revising the position of his right arm.

PAUL SANDBY
Nottingham 1730–1809 London

22 *Remains of King John's Palace, Eltham, 1780–82*[1]

Brush and watercolor, with pen and black ink, over traces of graphite on antique laid paper, mounted on laid card

Watermark: Strasburg Lily, similar to Heawood 1743 (1767); mount: Whatman

Sheet: 278 × 431 mm (10¹⁵⁄₁₆ × 17 in.); mount: 305 × 441 mm (12 × 17⅜ in.)

Inscribed recto, across bottom of mount, in graphite: *Remains of King John's Palace at Eltham Kent;* in another hand verso of mount, lower left, in black crayon: *F22/NPU*

PROVENANCE Possibly artist's sale, London, Christie's, 2–4 May 1811, first day, no. 19, 37, or 38; {Walker's Galleries, Ltd., London}, by 1934; to Mrs. Thomas W. Lamont (1872–1952), New York;

to her children (Thomas S. Lamont [1899–1967], New York; Dr. Austin Lamont [1905–1969], Philadelphia; Corliss Lamont [1902–1995], New York; Eleanor Lamont Cunningham [1910–1961], Smith class of 1932, West Hartford, Conn.); gift to SCMA in 1953

LITERATURE Priestly 1965, p. 1343, fig. 3

EXHIBITIONS London 1934c, no. 94; Northampton 1953 (as *Remains of Eltham Palace*); Northampton 1958c, no. 69; Northampton 1979b, no. 69; Northampton 1983b

Gift of the children of Mrs. Thomas W. Lamont (Florence Haskell Corliss, class of 1893)
1953:31

Called "the father of modern landscape painting in water-colours"[2] at the time of his death, Paul Sandby was one of the leading landscape painters of a generation that included Richard Wilson (1713–1782) and Thomas Gainsborough (1727–1788). Born in Nottingham toward the end of 1730, Sandby spent most of his life in London after moving there in the late 1740s to become a draughtsman for the Board of Ordnance, a post previously held by his older brother Thomas (1723–1798), an artist and architect. With his brother, Paul was a founding member of the Society of Artists in 1761 and of the Royal Academy in 1768, in which year he was appointed chief drawing master of the Royal Military College at Woolwich, a position he held until his retirement in 1797. He died in London on 8 November 1809.

Although Sandby is perhaps best known for his topographical watercolors like this depiction of King John's

Palace in Kent, he also executed oils and was the first successful publisher of aquatint prints in England. In the early 1780s, when this work was painted, he was at the height of his powers and reputation. A frequent exhibitor at the Royal Academy, he had in 1775 published his first series of Welsh views, which was followed by numerous other prints mostly after his own designs. One print, issued in 1782,[3] reproduces the present watercolor with the addition of figures in the right foreground (fig. 1). Sandby occasionally mounted his finished drawings on a backing sheet, decorated with a wash border, as in SCMA's watercolor.

In the greater London area on the south side of the Thames and farther east, Eltham is only two miles from Woolwich, where Sandby was serving as drawing master when he executed this view. Existing drawings and watercolors of the locale, several of which are preserved in the

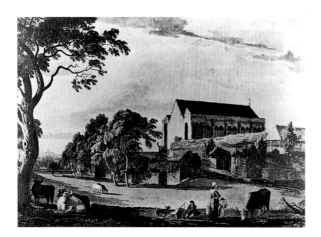

Fig. 1. After Paul Sandby, *Remains of King John's Palace,* 1782. Aquatint. Photo: Stephen Petegorsky

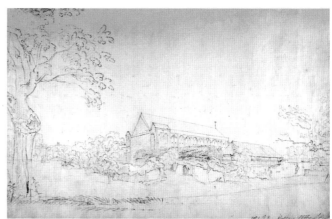

Fig. 2 Paul Sandby, *King John's Palace, Eltham.* Graphite, 318 × 501 mm (12½ × 19¾ in.). The British Museum, inv. 1867-12-14-102. Photo: © The British Museum

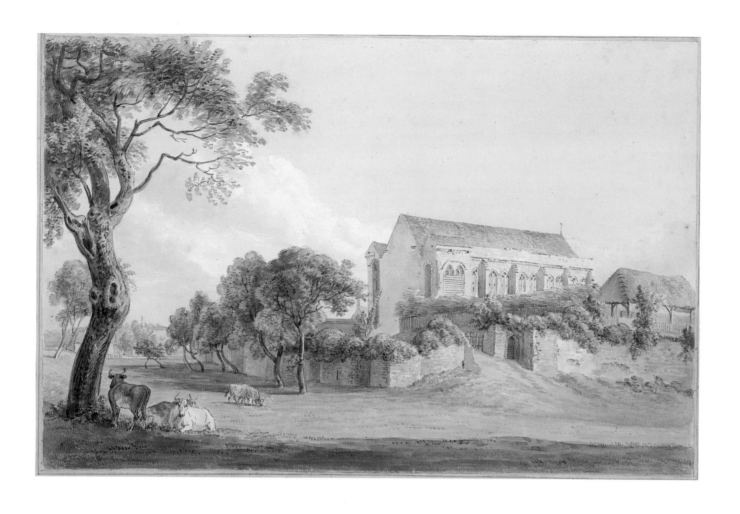

British Museum (fig. 2),[4] document his interest in the area. In the SCMA drawing Sandby focuses on the ruins of the banqueting hall as seen from the southwest.[5] In his day, when using ancient structures for such purposes was not uncommon, the hall functioned as a barn. The presence of the cattle in the composition undoubtedly refers to that contemporary use of the site.

The manor at Eltham became a royal residence in 1311 on the death of Antony Bek, bishop of Durham. It was one of several palaces on the outskirts of London enjoyed by the king as retreats from the city. The great hall, begun in 1475 during the reign of Edward IV, was probably completed by the time of his death eight years later. The palace continued to be visited by monarchs until Henry VIII and the acquisition of Hampton Court. In 1629 Charles I granted the manor to his queen, Henrietta Maria, and Anthony van Dyck (1599–1641) had apartments there. The palace was seriously damaged during the Civil War. A hundred years later, the banqueting hall was virtually all that remained of the elaborate complex.

The origin of the designation "King John's Palace" is unknown, but several explanations have been offered.[6] The name could refer to John of Eltham, brother of Edward III, who was born in the palace and served as regent when the king was absent from England. It has also been suggested that it alludes to the French monarch Jean II (Jean le Bon), who was Edward's prisoner there for several years.

Other artists have treated the site (Thomas Girtin [1775–1802] and J. M. W. Turner [1775–1851] painted it at the end of the eighteenth century), but the number of surviving depictions by Sandby suggests that Eltham had a special appeal for him. Close to Woolwich, the ruins were certainly convenient; they also suited the contemporary taste for picturesque and antiquarian subjects. The composition emphasizes this association. With a large tree framing the left side and leading the eye toward the building in the right middle distance, the scene recalls numerous works by Claude Lorrain (1600–1682) and his eighteenth-century British followers, such as George Lambert (1700–1765) and Richard Wilson, among whom Sandby must be numbered.

Like many of his contemporaries, Sandby frequently painted ruins, which served as romantic symbols of the transient nature of life but were also enjoyed for their picturesqueness. In *Remains of King John's Palace,* cattle graze amid the splendid remnants of a former haunt of royalty. Bathed by the warm sun, the pastoral scene speaks of past glories and present pleasures, of the continuity of nature and the onslaught of time. But this particular subject may also have embodied a commentary on current events. Painted in the wake of the antipapist Gordon Riots of 1780 and during the American War for Independence, the depiction of a once magnificent royal palace could well have been a reflection, conscious or not, on the destructiveness of war.

EJN

1. Priestley 1965, p. 1343, suggests a date of 1782; see also note 4 below.

2. *London Review* 1809, p. 400.

3. Brook 1960, pl. VI.

4. One pencil drawing (1867-12-14-101) is almost identical to the print and therefore close in composition to SCMA's watercolor. It is slightly larger, measuring 329 × 505 mm (12^{15}/₁₆ × 19⅞ in.). A second view of the palace (fig. 2) was taken from approximately the same angle but farther away (1867-12-14-102). Another of the pencil drawings (1867-12-14-96) is dated 1780. Priestly 1965, p. 1342, states that there are fourteen surviving views of the area by Sandby in various media.

5. Priestly 1965, fig. 3, identifies the orientation of the view.

6. Brook 1960, App. A.

FRANCESCO GUARDI
Venice 1712–1793 Venice

23 Study of a Crowd, 1770s

Pen and brown ink with brush and brown wash over traces of black chalk, the figures at center shaded in black chalk (applied prior to the wash) on cream antique laid paper; traces of an old vertical fold slightly to the left of center

Watermark: Fragmentary, at right of top edge: unidentified

78 × 289 mm (3¹⁄₁₆ × 11⅜ in.)

PROVENANCE {Richard Ederheimer (b. c. 1885), New York} (his sale, New York, Anderson Galleries, no. 1415, 9 April 1919, no. 166/6);[1] to Seymour de Ricci (1881–1942), Paris; G. H. Clark, New York;[2] possibly Janos Scholz (1903–1993), New York;[3] {Mathias Komor (b. 1909), New York} (Lugt 1882a, upper left verso);[4] sold to SCMA in 1958

LITERATURE GBA 1960, p. 38, no. 131, repr. (as *Macchiette*); Guitar 1959, p. 114; Byam Shaw 1959, figs. 6 and 7 (as *Spectators at a Ceremony*); Venice 1962, under no. 93; Morse 1979, listed p. 160

EXHIBITIONS Northampton 1959, no. 41 (as *Study of Figures*); Sarasota 1967; Allentown 1971; Northampton 1979b, no. 36; Northampton 1988, no. 6

Purchased with the gift of Adeline F. Wing, class of 1898, and Caroline Wing, class of 1896
1958:40

This spirited drawing of a Venetian crowd belongs to a genre of rapid sketches by Guardi for anonymous figure groups, or *macchiette,* that capture the essential elements of pose and dress in a lively, almost caricatural way. As James Byam Shaw was the first to observe, this particular drawing is related to the series of twelve paintings by Guardi depicting ceremonies and festivals of the Doge (*Le Feste Ducali* or *Le Solennità Dogali*), a series that ultimately derives from a suite of drawings by Canaletto (Antonio Canale, 1697–1768) that had been engraved by Giovanni Battista Brustolon (1712–1796).[5] The SCMA sheet is related to the third composition in the print series, *The Doge Crowned on the Scala dei Giganti of the Ducal Palace* (fig. 1), and depicts the crowd that stands at the foot and slightly to the left of the monumental staircase.[6]

Although Brustolon's prints are inscribed with the legend *Antonio Canal pinxit,* it is generally agreed that they are based, not on paintings, but on a series of large ink and wash drawings by Canaletto, ten of which are still preserved.[7] The drawings were found in a bookseller's in Venice by Sir Richard Colt Hoare in 1789.[8] In this latter year the dealer Giovanni Maria Sasso mentions Hoare's acquisition of the drawings in a letter to Sir Abraham Hume, with whom he was in frequent correspondence regarding the Venetian art market.[9] All ten drawings remained with the Hoare family at Stourhead in Wiltshire, where they hung surrounding the library fireplace, until their dispersal at public auction in 1883.[10]

This series of drawings constitutes what seems to have been Canaletto's last major commission, although there is no direct documentary evidence regarding his employment on the project, which seems to have been a typical de luxe publishing venture of eighteenth-century Venice. The impetus for the commission is generally considered to have been the election of Doge Alvise IV Giovanni Mocenigo (elected 19 April 1763, died 1778), whose arms are present in Canaletto's depiction of *Giovedi*

Grasso and appear to be original to the drawing.[11] The large drawings were used as models for a series of comparably sized prints (executed in a combination of etching and engraving), each bearing a descriptive title in Latin and the notations *Antonius Canal pinxit* and *Jo. Bap. Brustolon inc.* The publisher, whose name is also prominently engraved on the prints, was Ludovico Furlanetto, proprietor of a store for books and prints on Ponte dei Baretteri, a short distance down the Mercería dell'Orologio to the north of the Piazza San Marco. In March 1766 he announced the forthcoming suite of eight prints, at which time it was possible to subscribe to the series for a discounted price to be paid in installments *(a rate).*[12]

Responses must have been encouraging, for several months later he requested and was granted (on 6 August 1766) a publishing privilege for an additional four plates, bringing the full series to twelve.[13] Only one-third of the prints had been completed, however, when Furlanetto issued a revised subscription invitation dated 6 August 1768.[14] According to Dario Succi, the suite was probably not finished before 1773–75; the earliest mention of the completed series is in 1779.[15]

As for the date of Canaletto's drawings, most scholars have assigned them to late 1765–66 based on the mistaken belief that eight of Brustolon's prints were already on sale in April of the latter year.[16] But while the artist may well have executed the better part of the series shortly after receiving the commission, it is now clear that a longer period of development cannot be ruled out.

The drawings are virtually the same size as the prints, whose compositions are oriented in the same direction. This lack of image reversal, as well as the absence of any marks on the drawings that might indicate their direct transfer to the plate, would suggest that an intermediate drawing or tracing was used by the printmaker.

The Canaletto drawing for *The Coronation of the Doge on the Scala dei Giganti,* the composition to which the

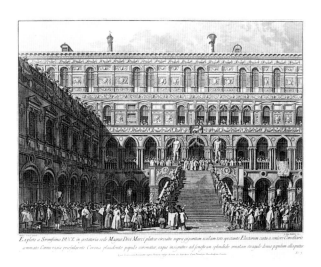

Fig. 1. Giovanni Battista Brustolon, after Canaletto, *The Doge Crowned on the Scala dei Giganti of the Ducal Palace.* Etching and engraving, 440 × 561 mm (17⅜ × 22⅛ in.). The Metropolitan Museum of Art, The Elisha Whittelsey Fund, 1961, inv. 61.532.3. Photo: Photograph and Slide Library, The Metropolitan Museum of Art, New York

SCMA drawing is related, is an imposing sheet (385 × 553 mm) executed in pen and brown ink with grey wash. The Latin inscription on the corresponding print describes the bestowing of the *cornu,* the traditional ducal crown, on the newly elected doge.[17] The SCMA drawing, in which Guardi excerpts a group of figures standing at the foot of the Scala dei Giganti, differs in some details from both Canaletto's original drawing and Brustolon's print, which follows its model closely. Take, for example,

the two figures at the right of the SCMA sheet, who correspond to the prominent figures at the foot of the staircase who gesture toward the coronation above. Their hands, clearly delineated by both Canaletto and Brustolon, are eliminated in Guardi's drawing. (A similar omission can be noted in the small figure next to them.) Guardi has preserved the direction of the light source, however, making the shadows on the figures similar to those in the print. Guardi's painting *The Doge Crowned on the Scala dei Giganti,* preserved in the Louvre (fig. 2), corresponds to the SCMA drawing in specific details, for example in omitting the hands of the two figures at the foot of the staircase.

Rapidly drawn in pen and ink over a quick chalk sketch on very fine, thin paper, the drawing bears an interesting relationship to other *macchiette* that can be associated with Guardi's paintings of the *Feste Ducali.* As Byam Shaw observed, the group of figures represented in the SCMA sketch is repeated more loosely and with modifications in a drawing in the Musée Départemental des Vosges, Epinal (inv. 30380.C). A similar pair related to Brustolon print number one *(The Newly Elected Doge Presented to the People in San Marco)* is represented by drawings in the Corcoran Gallery of Art, Washington, D.C., and the Museo Correr, Venice. Byam Shaw proposed that the drawings at Epinal and Venice are later versions of the SCMA and Washington sheets that appear to have been drawn "with his eye on the model." Whether these models were Brustolon's prints or Guardi's own paintings (a possibility Byam Shaw raises) has not been determined.[18]

The relationship of Guardi's paintings to the Brustolon prints and their models is complex and has been much discussed. Most scholars are in agreement that Guardi

based his compositions on the prints, although some hesitate to rule out Canaletto's drawings themselves as his source.[19] When the Guardi paintings differ from the Canaletto drawings they are always closer to Brustolon's engravings, however, indicating that he used the prints even though he often altered the proportions of buildings and changed details. Scholarly opinion on the dating of Guardi's paintings has varied. Most recently, Margherita Azzi Visentini has suggested that the series was probably begun shortly after the appearance of Brustolon's first prints, but, like Morassi and Terisio Pignatti, she believes that the execution of the paintings extended over some years. She proposes a span of about a decade (that is, from about 1766 to 1776), agreeing with Morassi that the

latest subjects painted include feminine fashions that appeared between 1770 and 1775.[20] Pignatti dates the entire series somewhat later, beginning about 1770 with those subjects that most closely preserve Canaletto's compositions.[21] Given Succi's revised dating of Brustolon's prints, it seems most convincing to assign Guardi's paintings and their related *macchiette* to the decade of the 1770s whether the drawings are considered to be preparatory to or based on the canvases.

The source of Guardi's commission for the twelve paintings of the Feste Ducali remains unknown. All twelve were already in Paris, in the collection of barone di Pestre de Seneffe, a Belgian citizen, when they were confiscated by the French government on 26 May 1797.[22]

AHS

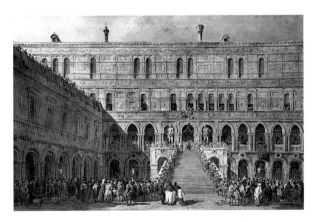

Fig. 2. Francesco Guardi, *The Doge Crowned on the Scala dei Giganti of the Ducal Palace*. Oil on canvas, 66 × 100 cm (26 × 39⅜ in.). Musée du Louvre, Paris, inv. 323. Photo: © RMN–Gérard Blot

1. The SCMA drawing was one of eight on seven sheets sold as a group. See Lugt 1711 for mention of this group, sold for $3,500. An annotated sale catalogue (photocopy in SCMA curatorial files) records the buyer's name.

2. According to an inscription on the former mat (recorded in a note in SCMA curatorial files), but unconfirmed.

3. In a letter of 24 May 1960 to Robert O. Parks (in SCMA curatorial files), Janos Scholz refers to SCMA's drawing as "(ex-Scholz)." A note in Parks's hand records Scholz's statement that he sold some Ederheimer Guardis to a Swiss collector.

4. A note in SCMA curatorial files records this dealer's stamp, inscribed in ink: Q523, on the back of the former mat.

5. According to Moschini [1924], Brustolon was trained in the workshop of Giuseppe Wagner (1706–1786), a printmaker and publisher who in 1739 established a flourishing business in Venice that employed numerous professional engravers. On Brustolon, see Gorizia / Venice 1983.

6. The *Twelve Ducal Ceremonies and Festivals* (Constable and Links 1989, vol. 2, nos. 630–41) are as follows: 1. *The Newly Elected Doge Presented to the People in San Marco;* 2. *The Doge Carried round the Piazza San Marco;* 3. *The Doge Crowned on the Scala dei Giganti of the Ducal Palace;* 4. *The Doge Returns Thanks in the Sala del Maggior Consiglio;* 5. *The Doge in the Bucintoro Departing for the Porta di Lido on Ascension Day;* 6. *The Doge in the Bucintoro Leaving San Nicolo;* 7. *The Doge Attends the Giovedi Grasso Festival in the Piazzetta;* 8. *The Annual Visit of the Doge to Santa Maria della Salute;* 9. *Procession on Corpus Christi Day in the Piazza di San Marco;* 10. *Visit of the Doge to San Zaccaria on Easter Day;* 11. *Reception by the Doge of Foreign Ambassadors in the Sala del Collegio;* 12. *The Doge Entertains Foreign Ambassadors at a Banquet.*

7. The inscription seems to be simply a misleading reference to the highly finished wash drawings. Although occasionally attempts are made to relate paintings to these prints, no autograph series by Canaletto exists, and there are other cases in which the term *pinxit* appears on an engraving for which there seems to have been no painting (New York 1989–90, p. 347).

8. Ibid. No record exists of the drawings for the final two prints in the series, and it would seem that they were already lost at the time Hoare acquired the others. (As Alessandro Bettagno suggests, they may have been separated from the group already, or destroyed in the printmaking process.) He notes that perhaps drawings were never completed for these final subjects.

9. This letter, dated 11 Feb. 1789, is preserved at the National Gallery, London (Constable and Links 1989, vol. 2, p. 527). It is quoted in New York 1989–90, p. 347: "Capito poi costi il cav. Hoare e fui occupato con lui a girar Venezia ed altro non prese costi che n. 10 disegni squisiti di Canaletto che sono belli quanto quadri" (Then I was with cav. Hoare and was busy with him traveling around Venice, and he bought nothing there but ten exquisite drawings by Canaletto that are as beautiful as paintings).

10. Constable and Links 1989, vol. 2, p. 527, and Venice 1982, p. 51, in which the drawings' placement is shown in a watercolor preserved at Stourhead. See Constable and Links 1989, vol. 2, p. 527, and New York 1989–90, pp. 347–48 regarding the drawings' dispersal. Drawings are preserved at the British Museum (for Brustolon nos. 2, 4, 5, 10); in a private collection, Wiltshire, in 1982 (for Brustolon, nos. 1 and 3); in the collection of the earl of Rosebury, in 1982 (for Brustolon nos. 7 and 8); in the Ratjen Foundation, Vaduz (for Brustolon no. 9); and in the National Gallery of Art, Washington, D.C. (for Brustolon no. 6).

11. Visentini in Venice 1993, p. 179. See also Morassi 1984, vol. 1, p. 354, and Venice 1982, under no. 83, and New York 1989–90, p. 348.

12. See Gallo 1941, pp. 38–41.

13. Dario Succi in Gorizia/Venice 1983, p. 58.

14. Ibid., p. 59. The invitation, which was discovered in the suite of prints at the Libreria Marciana, Venice, does not name the four finished prints.

15. In the catalogue of prints Furlanetto appended to his request to the Reformatori dello Studio di Padova for an exclusive privilege, prompted by the alleged plagiarism of Teodoro Viero, another Venetian publisher (ibid., pp. 59–60). Brustolon's *Feste Ducali* seem to have enjoyed substantial success, as they were republished by Viero and later by Giuseppe Battagia (also of Venice).

16. See, e.g., Bettagno in Venice 1982, p. 51, who takes the mention of Furlanetto's subscription announcement by the Venetian chronicler Pietro Gradenigo *(Notatori,* April 1766) as evidence that the first prints were already on sale.

17. The inscription on the print reads, *Expleto a Serenissimo DUCE in gestatoria dede Magnae Divi Marci platae circuitu supra gigantum scalam toto spectante Electorum coetu a seniore Consiliario gemmato Cornu regia praefulgente Corona plaudente populo coronatur, eoque insignitus ad fenestram splendido ornatum stagulo denuo populum alloquitur.*

18. Byam Shaw 1959, pp. 16–17, figs. 10 (Epinal) and 11 (Corcoran). He also notes a very freely drawn sketch in the Museum Boijmans-van Beuningen, Rotterdam, relating to Brustolon 5 *(The Doge in the Bucintoro Departing for the Porta di Lido on Ascension Day).* See Morassi 1975, no. 203, fig. 210, for the Epinal drawing, which he dates to 1770–80 (without noting the relationship to Brustolon 3 or the SCMA drawing). For the Museo Correr drawing, see Morassi 1975, no. 202, fig. 209, "late period" (again with no reference to the Brustolon print or Corcoran drawing). For the Boijmans-van Beuningen drawing, see Morassi 1975, no. 207, fig. 206, which he associates with the painting after Brustolon 5. Morassi does not catalogue either the SCMA or the Corcoran drawing.

19. See Morassi 1984, vol. 2, p. 354, *Le Solennità Dogali,* nos. 243–54. For other proposals concerning the connection between prints, paintings, and drawings, see the discussion in Constable and Links 1989, vol. 2, pp. 526–27. Another instance of Guardi's executing a painting by working after a print, in this case an engraving by Antonio Visentini (1688–1782) after Canaletto (a picture in the collection of Joseph Smith), is cited by Byam Shaw [1951], p. 34 and p. 34 note 2; it is a view of the entrance to Canareggio, which Byam Shaw dates to the 1770s.

20. Venice 1993, p. 179 (under no. 65). Morassi (1984, vol. 2, p. 254) notes certain details of women's costumes, the latest of which date to 1770–75 if not later (p. 175). A similar observation was made by Byam Shaw ([1951], p. 37 note 5), who dates the paintings as late as 1780, noting that although Guardi retains the Mocenigo arms in one of the paintings, another, *The Reception by the Doge of Foreign Ambassadors in the Sala del Collegio,* shows a lady in the extreme right foreground with a coiffeur of the 1780s, a detail that does not appear in the Brustolon print that was used as a model.

21. Pignatti 1975, p. 63.

22. See Morassi 1984 (vol. 2, p. 354). A second series of paintings was in the collection of a Mr. Ingram, who lived in the Palazzo Mignanelli, Venice, in the late eighteenth and early nineteenth century and was a friend of Guardi. (For the subsequent provenance, see Constable and Links 1989, vol. 2, under no. 330.) Seven are known from what probably was originally a set of twelve; they bear a traditional attribution to Giuseppe Borsato (1771–1849) and also derive from the Brustolon prints, which they follow wherever they differ from the Canaletto drawings. One of these paintings (collection of Mrs. Langton Douglas) is based on Brustolon 3, *The Coronation of the Doge on the Scala dei Giganti.*

JEAN-MICHEL MOREAU LE JEUNE
Paris 1741–1814 Paris

24 *The Royal Banquet (Le Festin Royal)*, 1782, study for the print (1782/1789)

Pen and black ink with brush and grey ink wash over graphite on cream antique laid paper; laid down on a sheet of cream antique laid paper, the drawing bordered by a ruled line in pen and black ink

Watermark: Fragmentary, coat of arms with horn, D. & C. Blauw, similar to Churchill 329 (not dated)

Watermark on mount: Strasburg lily with date 1797 and initials

Sheet: 273 × 262 mm (10¾ × 10⁵⁄₁₆ in.); image: 272 × 262 mm (10¹¹⁄₁₆ × 10⁵⁄₁₆ in.); mount: 332 × 303 mm (13¹⁄₁₆ × 11⅞ in.)

Signed and dated recto, lower right, in pen and black ink: *J. M. Moreau le jeune 1782.*

1973:13-2

25 *The Masked Ball (Le Bal Masqué)*, 1782, study for the print (1782/1789)
Verso: *Male Figure with Arm Raised*

Pen and black ink with brush and grey ink wash over graphite on moderately thick and moderately textured cream antique laid paper

Verso: Graphite

Watermark: Fragmentary, a coat of arms, similar to Heawood 3268 (D. & C. Blauw)

Sheet: 337 × 307 mm (13¼ × 12¹⁄₁₆ in.); image: 275 × 262 mm (10¹³⁄₁₆ × 10⁵⁄₁₆ in.)

PROVENANCE (for cats. 24, 25) Baron Nathaniel Mayer de Rothschild (1840–1915), Vienna, before 1903; by inheritance to Baron Alphonse Mayer de Rothschild (1878–1942), Vienna; to his widow, Baroness Clarice de Rothschild (Clarice Sebag-Montefiore, b. 1894), New York; to her estate; to {Rosenberg & Stiebel} as agents; to {Marianne (Mrs. Walter) Feilchenfeldt}, Zurich (her private collection); sold to SCMA in 1973

LITERATURE Rothschild 1903, no. 68 (both drawings listed under this number along with drawings for *L'Arrivée de la Reine* and *Le Feu d'artifice*); SCMA 1986, nos. 225, repr. *(Bal Masqué)*, color repr. p. 39, and 226, repr. *(Le Festin Royal)*

EXHIBITIONS Providence 1979, no. 57, repr. *(Le Festin Royal)* and no. 58, repr. *(Le Bal Masqué)*, the latter discussed under no. 59; Northampton 1973–74 (both); Northampton 1974a (both); Northampton 1975a, nos. 87 *(Le Bal Masqué)*, 88 *(Le Festin Royal)*; Northampton 1978b, (both); Northampton 1979b, nos. 51 *(Le Festin Royal)*, 52 *(Le Bal Masqué)*; Northampton 1984b, no. 10 *(Le Bal Masqué)*; Northampton 1985a (both); Northampton 1985b, nos. 12 *(Le Bal Masqué)*, 13 *(Le Festin Royal)*; Northampton 1988, no. 2 *(Le Festin Royal)*; Northampton 1988–89 (both)

1973:13-1

These drawings were made in preparation for two in the series of four prints commemorating the lavish festivities sponsored by the City of Paris in 1782 to celebrate the birth of an heir to King Louis XVI and Marie Antoinette. The Dauphin's arrival on 22 October 1781 had been anxiously awaited, and although "impromptu" fireworks had been staged at Versailles when the delivery was announced, a grander public acknowledgment of this event was desired.[1] The first large Parisian fête since the royal wedding of 1770, it would also prove to be the last great royal festivity of the ancien régime.

The Corporation of the City of Paris, led by the officials of the Petit Bureau de la Ville, undertook the organization of the festivities in consultation with the king.[2] They chose to use a traditional site for such celebrations, the Hôtel de Ville (the City Hall) in the place de Grève, but deemed it necessary to build a large temporary wing on the early-seventeenth-century building to provide the proper setting.[3] This addition, constructed in under two months, was designed by Pierre-Louis Moreau-Desproux

(1727/36–1793), the *maître des bâtiments de la ville de Paris,* who was also responsible for the decor of the related celebrations, including the elaborate fireworks display set up along the Seine directly across the place de Grève from the temporary wing. Preparations for the fête (including everything from ball tickets to police deployment and carriage parking) were overseen by the members of the Petit Bureau de la Ville: the *prévôt des marchands de Paris* (the head of the municipal government), the four *échevins* (the aldermen), the *procureur du roi et de la ville* (an attorney), the *greffier* (the registrar of documents), and the *receveur* (the tax collector).[4]

The two days of festivities began on Monday, 21 January 1782. After visiting the churches of Notre Dame and Sainte-Geneviève to give thanks for the Dauphin's birth, the queen proceeded in her carriage through the streets of the city to the Hôtel de Ville, where she was greeted by Monsieur de Cosse, *gouverneur de Paris,* and by Lefebvre de Caumartin, the *prévôt des marchands.* Delayed by the press of spectators thronging the streets,

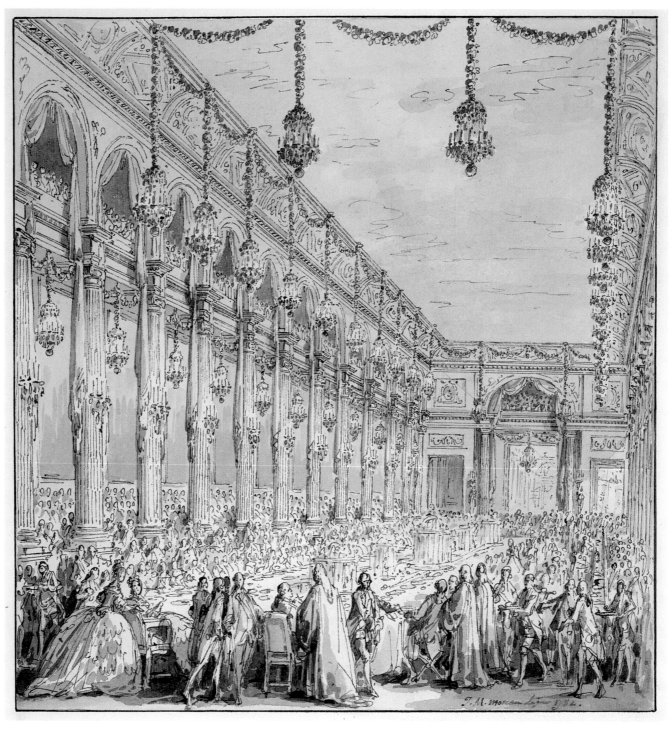

24 Recto

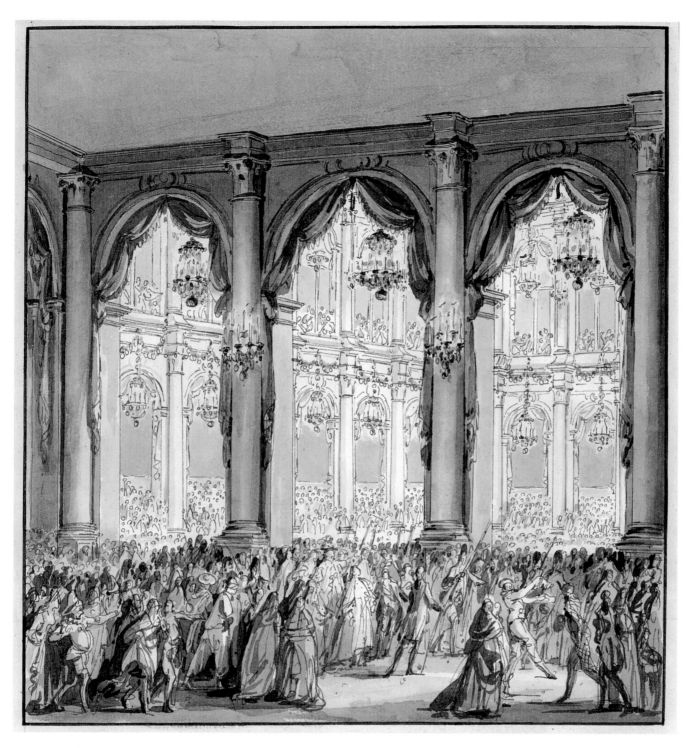

25 Recto

25 Verso

Louis XVI joined the queen several hours later, and the royal couple showed themselves to the crowd from the loge on the facade of the temporary wing before returning inside for a royal banquet held in the long *galerie.* They then adjourned to a games room until dark, when they took their places in the loge to watch the fireworks. This *feu d'artifice,* set on a platform extending out over the Seine, represented the Temple of Hymen, with fountains and colonnades, and figures representing France joyfully receiving the Dauphin.[5] On Wednesday, 23 January, after little more than a day of interim preparations, a great masked ball was presented in the Hôtel de Ville's courtyard, which had been supplied with a temporary roof for the occasion. Although the king and queen were not expected, their appearance at the ball after dining at the home of the comte d'Artois delighted the huge crowd and capped the evening's excitement.[6]

Later that year the officials of the Petit Bureau determined to commemorate these festivities with a suite of four prints.[7] The artist they chose was Jean-Michel Moreau le jeune, the *dessinateur et graveur du cabinet du roi.* Called "le jeune" (the younger) to distinguish him from his elder brother, also an artist, Moreau had trained in the studio of Louis Joseph le Lorrain (1715–1759), with whom he worked on theatre decoration in St. Petersburg from 1758 to 1760. After returning to Paris, Moreau established his reputation as a book illustrator and in 1770 assumed his first post with the French court, as draughtsman for the *menus plaisirs du roi.*[8]

Moreau le jeune wrote the members of the Petit Bureau on 13 August 1782 accepting their invitation to execute four prints depicting the arrival of the queen at the Hôtel de Ville, the fireworks in the place de Grève, the royal banquet, and the masked ball, and attaching sketches of each subject.[9] He agreed to execute four large drawings based on these sketches that would be the same size as the prospective prints, that is, the *Arrivée de la Reine* and the *Feu d'Artifice* would be 8 × 27 *pouces* (216 × 729 mm), while the other two would be the same height and approximately half the width.

At a meeting of 22 August attended by Moreau, the *prévôt des marchands,* the *procureur,* and the *échevins,* Moreau's sketches were approved and a contract drawn up. Moreau undertook to execute the full-scale drawings and to engrave the prints himself, supplying the plates and covering any expenses related to their preparation.

He agreed to deliver the plates within twenty months from the date of the contract (that is, by the end of April 1784) and to supervise their printing.[10] Moreau would receive twenty-five impressions of each print and he promised to make other prints representing the celebrations if requested. His compensation of 40,000 livres was to be paid in six installments of 5,000 livres during the course of the work (beginning from the completion of the first drawing), with 10,000 livres to be paid when the work was finished and approved, plus a 5,000-livre bonus if it was completed on time. The contract was signed by all parties, and four sketches were similarly signed and appended to the document.[11]

Moreau had completed all four of the large drawings by the middle of 1783, when they were exhibited at the Paris Salon.[12] But although he may also have begun work on the plates by then, Moreau not only failed to deliver them by the deadline (April 1784) but had still not completed them over three years later.[13] The prints were finally delivered in January 1789, and in March the Bureau officially recorded their receipt and ordered payment of the remaining money to Moreau, including his bonus.[14]

The two drawings in the SCMA, both signed and dated 1782, are from a set of four small preparatory drawings for the prints that seem to have remained together until the mid–twentieth century, when they were dispersed from the Rothschild collection. The current whereabouts of the drawings for the *Arrivée de la Reine* and the *Feu d'Artifice* are unknown.[15]

The *Festin Royal* as depicted by Moreau corresponds in detail to contemporary descriptions of the banquet published in the *Mercure de France* (the newspaper of the court).[16] Moreau-Desproux's long *galerie,* which he decorated with gilding and simulated colored marbles and lapis, is hung with chandeliers and garlands of fresh flowers, and the table, set with seventy-eight places, is adorned by a centerpiece of classical temples. Members of the court watch from loges at left, and guests also circulate through the room to watch the king, queen, and highest members of the court dine, while servers bring dishes from a long table set up along the right side of the room. Louis XVI and Marie Antoinette are seated in the foreground, in armchairs at the head of the table, attended by the *prévôt des marchands* and the *échevins.* Although difficult to identify individually, the prominence of the *prévôt* and *échevins* reflects not only their key role in arranging this particular fête but also the long-standing tradition in which the Corporation of the City of Paris commissioned group portraits of the *prévôt* and *échevins* in the context of court festivities.[17]

Le Bal Masqué depicts the royal couple at the center of the composition as they make their way through the throng in the Hôtel de Ville. The excitement of the crowd that surges around them is vividly conveyed. The king and queen are surrounded by their attendants and guards and preceded by figures in the costume of the Italian commedia dell'arte, a Pierrot (or Gilles) who appears to have spontaneously taken on the job of announcing their

Fig. 1. Moreau le jeune, *Le Festin Royal*. Etching and engraving, 522 × 385 mm (20⁹⁄₁₆ × 15¹⁄₁₆ in.). The Metropolitan Museum of Art, Gift of Georgiana W. Sargent in memory of John Osborne Sargent, 1924, inv. 24.63.1043. Photo: Photograph and Slide Library, The Metropolitan Museum of Art, New York

arrival, and a Harlequin in motley who steps forward from the right.[18]

Both drawings are executed in a spirited style in which the main focus is on the architectural setting and the disposition of the most important figures; the crowds are indicated in a rapid shorthand manner. After drawing the architecture and main figures lightly in graphite, Moreau completed the composition in pen and ink, using washes to set out the patterns of light and dark that he would employ in the final print.

Between these modestly scaled preliminary drawings and the final, full-scale studies for his prints, Moreau decided on several changes that he retained in the final prints.[19] In *Le Festin Royal* (fig. 1) the final composition is higher in proportion to its width, conforming to the size stipulated by the contract. The configuration of chandeliers is slightly changed, and the number of bays in the arcade at left is reduced. Several of the foreground figures are repositioned slightly. In *Le Bal Masqué* (fig. 2) Moreau has eliminated some foreground figures to make the king and queen more prominent; he has moved the potbellied Polichinelle farther to the right and has given the figure dressed as Gilles a longer jacket. Moreau has also made the ballroom seen through the arches appear larger; he has changed certain architectural details (for

Fig. 2. Moreau le jeune. *Le Bal Masqué*. Etching and engraving, plate: 523 × 398 mm (20¹¹⁄₁₆ × 15¹¹⁄₁₆ in.). Museum of Art, Rhode Island School of Design, Gift of Murray S. Danforth, Jr., inv. 50.3.3

example, substituting Ionic capitals for Corinthian in the vestibule), as well as the proportions of the overall composition as he did in *Le Festin Royal*. All four full-scale drawings are oriented in the same direction as the final prints, suggesting that an intermediate stage, such as a tracing, was employed to transfer the final design to the etching plates.

The drawings that Moreau and the officials of the Petit Bureau signed and attached to their contract were executed on tracing paper and drawn entirely in outline (figs. 3 and 4). Comparison with the SCMA studies reveals that the contract drawings were traced directly from them. Not only are the Smith *Festin Royal* and *Bal Masqué* almost identical in size and format to the contract drawings, but they correspond in the details of their compositions. The SCMA wash drawings would therefore be the drawings Moreau prepared for the approval of the Petit Bureau and then retained for his own use in working up the full-scale drawings for his suite of prints.

Another view of *Le Festin Royal* exists in an unfinished drawing by Moreau formerly in the Gallice collection.[20] Its relationship to the suite of prints is unclear, however. The composition is horizontal, taken from a vantage point on the courtyard side of the room looking toward the loges under the arcade. Once Moreau knew the proposed sizes for the prints desired by the Petit Bureau it is unlikely that he would have chosen to pursue a composition in this format for their project. The Gallice drawing may represent instead a first idea for an independent work to be executed in his capacity as *dessinateur et graveur du cabinet du roi*. Another drawing relating to the festivi-

Fig. 3. Moreau le jeune, *Le Festin Royal*. Pen and black ink on tracing paper. Musée de l'Histoire de France, Centre Historique des Archives Nationales à Paris, inv. K 1017, no. 306-4. Photo: Centre Historique des Archives Nationales

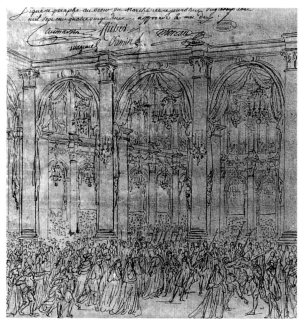

Fig. 4. Moreau le jeune, *Le Bal Masqué*. Pen and black ink on tracing paper. Musée de l'Histoire de France, Centre Historique des Archives Nationales à Paris, inv. K 1017, no. 306-6. Photo: Centre Historique des Archives Nationales

ties of 21 January may also reflect Moreau's recording of these important royal celebrations which he would have attended so that they might be "drawn from life" as duly noted in the inscriptions on the suite of prints he executed for the City of Paris.[21]

On the verso of *Le Bal Masqué* is a faint sketch of a male figure posed as a classical orator addressing a crowd (of soldiers?) from a podium. Although its purpose is unknown (it is larger than most of Moreau's drawings for book illustrations), it is possibly related to the studies of theatrical costumes drawn by the artist in the 1780s.[22]

AHS

1. Dauphin Louis-Joseph-Xavier-François (1781–1789) was the second child born to the royal couple, whose firstborn was a daughter.

2. By a fifteenth-century ordinance that remained legally in force until 1789, Paris was governed in principle by the Corps de Ville de Paris, headed by the Bureau de la Ville, which consisted of the Petit Bureau and the Grand Bureau (composed of the Petit Bureau and the 24 town councillors). Among the administrative tasks turned over to them by the king were the upkeep of bridges, quays, and fountains, and the control of festivities and celebrations (Mousnier 1984, pp. 579ff.).

3. The Hôtel de Ville (completed in 1628) housed the headquarters of the Bureau de la Ville.

4. Under Louis XVI the *prévôt des marchands* (provost of merchants) was an appointee of the king. The *échevins,* appointed by the king from among the senior city councillors, formed (with the mayor) the executive committee of the municipality. Both positions conferred nobility on the officeholder (Mousnier 1984, pp. 584 and 752). In 1781 the *procureur* was appointed by the *prévôt* (ibid., p. 581). On the other positions, see ibid., pp. 580, 761.

5. This was a reprise (with appropriate revisions) of the *feu d'artifice* that Moreau-Desproux had designed for the royal wedding in 1770.

6. Although 13,000 tickets had been distributed, many more people managed to gain admittance on the night of the ball.

7. See Bapst 1889. On the prints see Mahérault 1880, nos. 71 *(Arrivée),* 72 *(Bal),* 78 *(Festin),* and 79 *(Feu),* and Bocher 1882, nos. 200 *(Bal),* 201 *(Festin),* 202 *(Arrivée),* and 203 *(Feu).*

8. The *menus plaisirs* were entrusted with organizing the festivities of the royal court.

9. Archives Nationales, Paris, K1017 no. 48 (hereafter abbreviated as Archives).

10. Paper was to be supplied and printing expenses were to be covered by the Corps de Ville de Paris.

11. Archives K1017 no. 306-1 (see also the draft document no. 305). It is signed by Caumartin, Richet, Jamin, Maginel, and Moreau. The titles of the drawings, as given in document no. 306-2 are *L'arrivée de la Reine a l'hotel de Ville* (K1017 no. 306-5), *Le feu d'artifice dans la Place audevant led. hotel* (K1017 no. 306-3), *Le festin Royal* (K1017 no. 306-4), and *Le Bal Masqué* (K1017 no. 306-6). These drawings have been removed from the archives and are now preserved in the Musée de l'Histoire de France, Paris. For *L'Arrivée de la Reine,* see Gruber 1972, fig. 72, and p. 200; for *Le Feu d'Artifice,* see ibid., fig. 68 and pp. 198–99; *Le Festin Royal* and *L'Arrivée de la Reine* were exhibited in Paris 1975, no. 103.

12. The Salon *livret* (booklet) lists them in the section on *gravures* (prints), p. 57, no. 306: "Quatre Dessins des Fêtes de la Ville, à l'occasion de la Naissance de Mgnr LE DAUPHIN. Le premier, l'arrivée de la Reine à l'Hôtel de Ville. Le second, le Feu d'Artifice. Ces deux dessins ont 27 pouces de long sui [*sic*] 17 de haut. Le troisieme, le Repas donné par la Ville à leurs Majestés. Le quatrieme, le Bal Masqué." On the full-size drawings, see note 19, below. At the Salon of 1783 Moreau exhibited two other drawings relating to the birth of the Dauphin *(livret no. 311).*

13. On 6 Aug. 1787, in a temporizing reply to a stern letter from the *prévôt,* Moreau attempted to mollify the gentlemen of the Petit Bureau by promising to show them the very first proofs to be pulled from his plates (Archives K1018 no. 158). Asked to appear before the *procureur du roi* on 6 Oct. 1787, Moreau wrote again, requesting an extension of his deadline until Jan. 1788; he was granted an extension until April (Archives K1018 no. 21-4).

14. Bapst 1889, pp. 135–36. Moreau's plates are in the Chalcographie du Louvre (Angoulvent 1933, nos. 4044–47; the *Festin* is no. 4045, the *Bal* is no. 4047). Exhibited Paris 1985, nos. 103A *(Bal)* and 104A *(Festin).*

15. All four drawings were among the works of art that Baroness Clarice brought to New York from Austria after World War II. Two sold at auction in Bern, Gutekunst & Klipstein, 21–22 June 1949, second part, no. 642, pl. 24 *(L'Arrivée),* and no. 643, pl. 25 *(Le Feu d'Artifice),* for 2,900 Swiss francs to art historian and dealer Dr. Walter Hugelshofer (1899–1987). See letters to the author from Gerald G. Stiebel, 2 May 1996, and Eberhard Kornfeld, 9 April 1996, in SCMA curatorial files.

16. Although it has been stated that the room was open to the sky (New York 1966, p. 95), documents refer clearly to the ceiling of the room.

17. For royal entries or receptions the *prévôt* wore a cassock of red satin, under a judge's gown, worn open, in the colors of the town, half red and half tan, and a cap of the same with a broad gold band and tassel; the *échevins* wore a velvet gown half red and half tan with long, heavy sleeves and a cap with gold edging; the *procureur du roi* wore a gown of red velvet; and the town councillors wore mantles with long satin sleeves (Mousnier 1984, p. 584). For drawings attributed to François de Troy (1645–1730) of a *prévôt* and *échevins* in their ceremonial garb, see London 1991, nos. 19 and 20, both repr.

18. At left is Polichinelle (Pulcinella), wearing a ruff, with a humpback and large belly. On the Italian comedy in France, see Duchartre 1966, pp. 114–18.

19. The four full-size drawings are signed and dated 1783, and are described by Bocher (1882, p. 693), as "grands dessins in-folio, à la plume, rehaussés d'aquarelle." Despite the provision in the contract stipulating that the drawings and prints were to be delivered to the City of Paris, the drawings remained with the artist and descended in the family of his daughter.

20. Wash with heightening, 395 × 530 mm. Paris, Galerie Charpentier, Gallice sale, 25 May 1934, no. 30, repr. (called a "première idée"). According to this catalogue, the drawing is from the collection de la Herche, Beauvais, and was in the Decourcelle sale (for which, see Paris, Galerie Georges Petit, Collection Pierre Decourcelle, 29–30 May 1911, second day of sale, no. 134, attributed to Jean-Michel Moreau le jeune, *Festin Royal,* 39 × 52 cm).

21. This drawing, formerly in the Goncourt collection, has not been located and its authorship cannot be confirmed. The *Passage de Marie Antoinette, place Louis XV, à l'occasion de la naissance du Dauphin,* "dessin lavé à l'aquarelle sur trait de plume, 0,45 × 1,05," was sold in Paris, Hôtel Drouot, Collection Goncourt, 15–17 Feb. 1897, second day of sale, no. 196, as Moreau le jeune(?), repr. in heliogravure between pp. 94 and 95.

22. Mahérault 1880, p. 509, lists a number of these studies.

THOMAS GAINSBOROUGH
Sudbury 1727–1788 London

26 *Wooded Landscape with Figures, Country Cart and Cottage*,[1] mid-1780s

Black chalk with stumping and brush and grey wash on cream wove paper

Watermark: None

273 × 371 mm (10¾ × 14⅝ in.)

PROVENANCE Possibly Dr. Thomas Monro (1759–1833), London;[2] Francis Wheatley (1747–1801), London (according to Ipswich 1927); Alexander Pope (1763–1835), London (per label on frame backing: A. Pope, artist and actor); Walter Sichel (1855–1933) by 1927 (sale, London, Sotheby's, 25 Oct. 1933, no. 300); to {G. Douglas Thomson, Palser Gallery, London} for £41; to Mrs. Thomas W. Lamont (1872–1952), New York, in 1934; to her children (Thomas S. Lamont [1899–1967], New York; Dr. Austin Lamont [1905–1969], Philadelphia; Corliss Lamont [1902–1995], New York; Eleanor Lamont Cunningham [1910–1961], Smith class of 1932, West Hartford, Conn.); gift to SCMA in 1953

LITERATURE Fell 1934, p. 202, repr. (as *Study for "The Market Cart"*); Woodall 1939, pp. 69–71, 141, no. 450, pl. 90 (as *Study for "The Market Cart"*); Guitar 1959, p. 114, repr. (as *Study for "The Market Cart"*); Parks 1960, no. 32, repr.; Hayes 1971, vol. 1, no. 644 (as *Wooded Landscape with Figures, Country Cart, and Cottage*); Clarke 1973, p. 932; Morse 1979, p. 134 (as *Study for "The Market Cart"*); SCMA 1986, no. 227, repr. (as *Study for "The Market Cart"*); Egerton 1998, pp. 130–31, fig. 2 (partly used for *The Market Cart*)

EXHIBITIONS Ipswich 1927, no. 174 (as *The Market Cart*); London 1934a, no. 28 (as *The Market Cart*); Birmingham 1934, no. 63, repr.; London 1934b, no. 33, repr.; Northampton 1953; Northampton 1958c, no. 26; Chicago 1961, no. 29, repr.; Santa Barbara 1964, no. 19, repr.; Providence 1975a, no. 68, repr.; Northampton 1979b, no. 68; Northampton 1982c; Northampton 1983b; Northampton 1986c

Gift of the children of Mrs. Thomas W. Lamont (Florence Haskell Corliss, class of 1893)

1953:28

Thomas Gainsborough, one of the leading artists of his day and a founding member in 1768 of the Royal Academy, was born in Sudbury, Suffolk. He studied in London in the early 1740s with the French émigré artist and master of the Rococo, Hubert François Gravelot (1699–1773). Returning to his native Suffolk in 1748, Gainsborough remained there for more than a decade painting portraits and landscapes. In 1759 he moved from Ipswich to Bath and fifteen years later settled permanently in London, having established himself as a fashionable painter. Although perhaps best known for his elegant portrayals of the landed gentry and aristocracy, he delighted in creating landscapes. While still at Bath he wrote to his friend and future biographer, William Jackson, that he was sick of portraits and wanted to retire to some village where he could paint landscapes and enjoy the end of life in peace and quiet.[3]

In his 1798 biography of the artist, *Character of Gainsborough*, William Jackson remarked: "If I were to rest his reputation upon one point, it should be on his Drawings."[4] Gainsborough has been called a "compulsive draftsman,"[5] who drew for the sheer pleasure of it as well as out of a need to express himself. Of the 1,000 or so drawings he is said to have created, 878, including more than 700 landscapes, are recorded in John Hayes's catalogue raisonné.[6] Few of those made after his removal from Ipswich, even fully realized compositional studies like Smith's, were sold. They were given to friends and patrons or kept by the artist, perhaps for future reference. According to a contemporary, Gainsborough "could never be prevailed upon to receive money for those effusions of his genius."[7]

Early in his career, when he was influenced by the Dutch landscape painters of the seventeenth century, Gainsborough made many direct studies from nature of specific elements such as trees and plants. The landscape drawings created in Bath and London, however, tended to be more generalized, reflecting his awareness of the seventeenth-century Franco-Italian masters of the classical landscape, Claude Lorrain (1600–1682) and Gaspar Dughet, called Poussin (1615–1675), then so admired by the British cognoscenti. Gainsborough's drawings occasionally served as preliminary ideas for painting compositions, but many were products of his imagination created as separate entities for their own sake. This is particularly true of landscape compositions executed late in his life.

Described as "among the most beautiful works of art on paper ever produced by an Englishman,"[8] Gainsborough's depictions of nature are generally not literal transcriptions of actual scenes but lyrical interpretations of the countryside in which time and life seem almost to stand still. The present work exemplifies this quality. It is among Gainsborough's many depictions of country folk traveling to and from market, a theme first explored by the artist in the 1740s and that engaged his attention throughout his life. Because of the central group and the massing of trees, this drawing has long been identified as a study for *The Market Cart* (1786; National Gallery, London).[9] It varies significantly from the painting (fig. 1), however, particularly in its orientation (the painting is vertical) as well as in details: the cottage on the right bank does not appear in the oil, and several figures are added to the foreground on both sides of the composition. While undoubtedly related to the

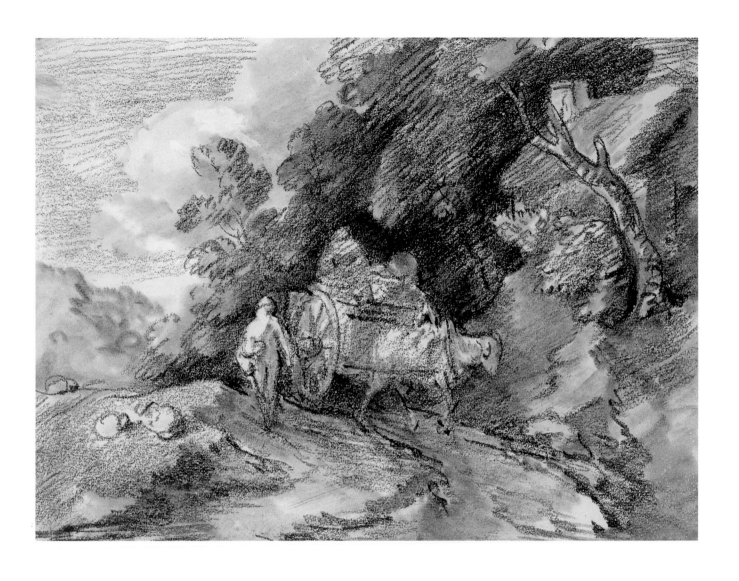

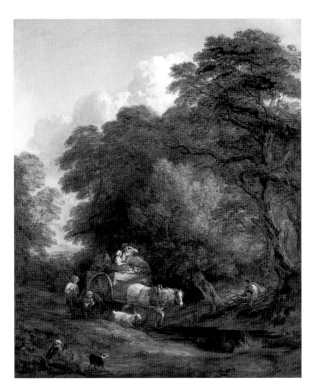

Fig. 1. Thomas Gainsborough, *The Market Cart*, 1786. Oil on canvas, 184 × 153 cm (72½ × 60¼ in.). The National Gallery, London, inv. NG 80. Photo: © The National Gallery, London

National Gallery picture, the SCMA drawing seems as much a variation on a favorite theme as a study for that particular painting.

Although not a depiction of any specific locale, the mountainous scenery in this work as well as in other drawings from the mid-1780s may well be a visual allusion to Gainsborough's trips to the West Country and Lake District early in the decade. Like many drawings of the period, it is a monochromatic design. The quick application of the wash suggests a certain spontaneity in its creation even as the hatching lines in the sky and landscape give a rhythmic unity to the composition. The rak-

ing light, which bathes the central group and casts shadows over the terrain, establishes the time as sunset. Silhouetted against the blackness of the trees, the figures are caught at the end of the day on the crest of a hill as they slowly make their way down the road.

Gainsborough's affecting portrayal of peasants moving homeward after a long day at the market invests a commonplace event with poetic grace and solemnity. The people, like the landscape itself, are generalized and undifferentiated. The grey wash and black chalk contribute to the lugubriousness of the scene as the figures emerge from the darkness and advance with measured pace toward the viewer. A palpable sense of quietude and melancholy pervades this image, reflecting perhaps the artist's own desire at the end of his life to retire from society.[10]

EJN

1. The present descriptive title was devised by John Hayes for his catalogue raisonné of Gainsborough's drawings (Hayes 1971, no. 644). The work was identified as a study for *The Market Cart* (1786, National Gallery, London). See Woodall 1939, p. 141, no. 450, who describes it as "A horse and cart being driven along a road past a cottage among trees r.; a man walking by the side of it."

2. According to Woodall 1939, p. 141, no. 450. Additional information on the provenance is provided in Hayes 1971, no. 644.

3. Woodall 1961, p. 115. The letter bears a date of 4 June (no year).

4. Quoted in Hayes 1971, p. 9.

5. IEF 1983–84, p. 1.

6. Hayes 1971, p. 105. Hayes knew the location of about 730 landscape drawings, but since then additional works have come to light.

7. Quoted in Hayes 1971, p. 93.

8. Robert Wark, quoted in IEF 1983, p. 1.

9. Woodall 1939, no. 450. Woodall (p. 70) states that Smith's drawing is "by no means identical with the picture" but feels "it is clearly a study leading up to that composition."

10. Pointon 1979 discusses Gainsborough's landscapes in terms of their connections with the concept of retreat from the city and with the pastoral poetry of the time.

JACQUES-LOUIS DAVID
Paris 1748–1825 Brussels

27 *Mother and Child at the Feet of Tatius,* c. 1795–96, study for the painting *The Sabine Women (Les Sabines,* dated 1799)

Graphite, squared in graphite, on cream laid paper; traces of a ruled line in graphite at right edge

Watermark: None

133 × 168 mm (5¼ × 6⅝ in.)

Inscribed verso, at center, in graphite: *3*

PROVENANCE The artist until his death (1825); to his sons Eugène (see Lugt 839) and Jules (see Lugt 1437), sale, Paris, 17 April 1826 and following days, not specifically identified in the catalogue of the sale (part of an album later dismantled?);[1] L. J. A. Coutan (d. 1830), Paris; to his widow, Mme Coutan (née Hauguet, d. 1838), Paris; to her brother, Ferdinand Hauguet (d. 1860), Paris; to his son, Maurice-Jacques-Albert Hauguet (d. 1883), Antibes; to his widow, Mme Hauguet (née Marie-Thérèse Schubert, d. 1883), Antibes; to her father, Jean Schubert, and her sister, Mme Gustave Milliet (née H. Schubert) (see Lugt 464, no mark on SCMA drawing), sale [Coutan-Hauguet], Paris,

Hôtel Drouot, 16–17 Dec. 1889, no. 104 ("Sous un même cadre, cinq croquis. Hersilie aux pieds de Tatius. Etude pour le *Léonidas,* etc.") to "Picquenet" for 32 francs;[2] private collector; to {Jacques Seligmann & Co., New York} before 1956;[3] sold to SCMA in 1956

LITERATURE Parks 1957, repr. p. 74; *ArtQ* 1957a, listed p. 96; *SCMA Bull* 1958, p. 62; Parks 1960, repr. p. 41; Bloomington 1968, p. 18; Morse 1979, listed p. 96; Noël 1989, repr. p. 55; Paris/Versailles 1989–90, mentioned under no. 148; Lajer-Burcharth 1999, p. 142, fig. 72

EXHIBITIONS Northampton 1956, no. 7;[4] Northampton 1958a, no. 17; Toronto 1972–73, no. 40, pl. 134 (as *A Woman Holding a Child and Kneeling at the Feet of a Soldier,* black chalk, squared); Northampton 1979b, no. 56; Northampton 1985a; Northampton 1988, no. 21; Northampton 1988–89

Purchased
1956:46

This small but powerful drawing is a study for one of the foreground figures in Jacques-Louis David's painting *The Sabine Women (Les Sabines),* a work conceived during his incarceration in the Luxembourg prison in 1794 and completed in the autumn of 1799 (fig. 1). Executed independently of any commission, *The Sabine Women* was exhibited to the public by David in the Salle de l'Ancienne Académie d'Architecture at the Louvre from December 1799 until May 1805. The public was charged an admission fee and received with their entrance ticket a *livret* (booklet) containing David's explanation of the painting.[5]

The subject he chose to depict was quite rare in contrast to an earlier episode from legendary Roman history, the rape of the Sabine women, a subject that had been popular with artists for centuries. Whereas the rape depicts the young men of Rome abducting the unmarried Sabine women in furtherance of their leader Romulus's plan to ensure the growth of Rome's population,[6] David's canvas takes up the equally dramatic moment when the Sabine women, now Roman wives and mothers, successfully intervene between their husbands and the Sabine army that has attacked Rome in revenge. A complex composition of many figures, the painting's sense is clearly and economically conveyed in the action of Hersilia, wife of Romulus, who stands, arms outstretched, between her husband and her father, Tatius, leader of the Sabine warriors.

Of the ancient sources for this story, David's primary inspiration was Plutarch's *Life of Romulus,* cited in the explanatory *livret.* Although this is the most detailed account, the story is also told in Livy (1.12) and in Ovid's

Fasti (book 3).[7] An eighteenth-century source on which David may also have drawn was Charles Rollin's *Histoire romane.*[8]

David began work on drawings for *The Sabine Women* during the difficult period of his imprisonment following the fall of Robespierre. Arrested on 2 August 1794 (15 Thermidor in the Revolutionary calendar), only a few days after Robespierre's execution, David was kept at first in the *maison d'arrêt* of the Hôtel des Fermes, where he was allowed to have his paints. The first surviving composition sketch for *The Sabine Women* was executed

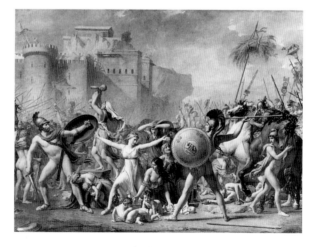

Fig. 1. Jacques-Louis David, *The Sabine Women,* 1799. Oil on canvas, 386 × 520 cm (152 × 204¾ in.). Musée du Louvre, Paris, inv. 1691. Photo: © RMN

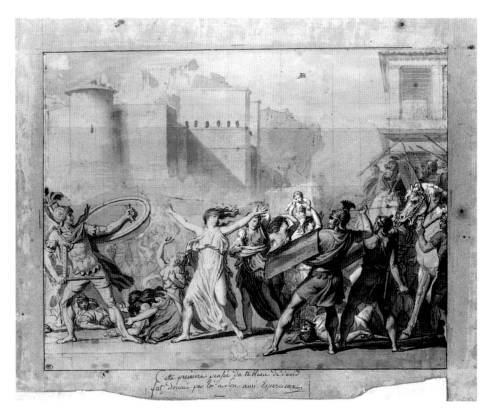

Fig. 2. Jacques-Louis David, *première pensée* for *The Sabine Women*. Black chalk, pen and black ink, brush and grey wash, heightened with white on toned paper, 256 × 359 mm (10⅛ × 14⅛ in.). Musée du Louvre, Département des Arts Graphiques, inv. RF 5200. Photo: © RMN

after he was transferred to the Luxembourg prison in September.[9] Although freed in December, his occupation with other works seems to have kept David from turning seriously to *The Sabine Women* until after his liberation from a second imprisonment (28 May–3 Aug. 1795).

David's pupil Pierre Maximilien Delafontaine (1774–1860) reported that in 1795 David was preparing *The Sabine Women* and employed him in library research (i.e., in studying prints at the Bibliothèque Nationale) and in work on the large drawing that served to transfer the composition to the canvas.[10] David began painting in the spring of 1796, and when Etienne-Jean Delécluze (1781–1863) entered his studio around October of that year, the composition was entirely outlined on the canvas *(ébauché)*, and some portions, including the kneeling woman, the figure studied in the SCMA drawing, were already painted.[11]

David drew inspiration from a wide variety of visual sources, including the antique, sixteenth- and seventeenth-century paintings, and works by his contemporaries. These he progressively assimilated and adapted through rough sketches and more detailed drawings of figure groups and individual figures. David's composition drawings for *The Sabine Women* show evidence of having been repeatedly reworked, with pieces of paper cut out and pasted down to form the basis for revisions. David's process of eliminating superfluous figures and refining the poses of the remaining figures to clarify the meaning of his canvas continued through the last stages of preparation.

In the surviving *première pensée* (first idea) for the painting the general lines of the composition are already laid out, with the Sabine warriors at the left, the Romans at the right, the Sabine women at center, and the ramparts of Rome visible in the background (fig. 2).[12] The woman who kneels at the feet of Tatius is already present, although her pose differs considerably from that in the SCMA drawing, as it does from the figure in the final painting. She is clothed and her body is more upright. In addition, she holds her baby before her, her arms outstretched in supplication; her unbound hair streams over her shoulders and falls in a curtain behind her face.

Several of David's sketchbooks preserve drawings of individual figures or of figure groups relating to *The Sabine Women*. The book containing the largest number of these sketches[13] includes a rapid sketch of Hersilia with several companions on the verso of the final sheet (fig. 3). At the left is a Sabine woman prostrate at the feet of a warrior (indicated by a single leg), an idea for the figure represented in the SCMA drawing. In this sketch she kneels, her torso bent almost to the ground, her head just above the warrior's foot; she does not hold a child, and pentimenti suggest that David was primarily concerned with establishing the posture of the kneeling figure.

Fig. 3. Jacques-Louis David, study of Hersilia for *The Sabine Women*. Graphite or black chalk, 176 × 136 mm (6¹⁵⁄₁₆ × 5⅛ in.). Musée du Louvre, Département des Arts Graphiques, inv. RF 9137-62v. Photo: © RMN

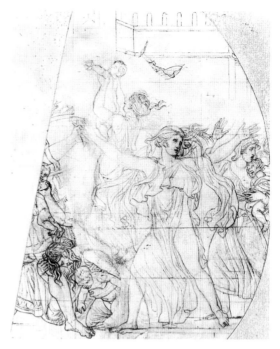

Fig. 4. Jacques-Louis David, study of Hersilia for *The Sabine Women*. Black chalk, touched with pen, squared in black chalk, 303 × 218 mm (11¹⁵⁄₁₆ × 8⅝ in.). Musée des Beaux-Arts, Lille, inv. 3494

The SCMA drawing appears to have been executed after the *première pensée* and the Hersilia sketch but before the larger, more developed study for Hersilia preserved in the Musée des Beaux-Arts, Lille, which also includes the kneeling woman (fig. 4).[14] In the SCMA study the figures are drawn entirely nude, a practice David commonly used to clarify the pose and structure of his figures, as in his nude studies for *The Oath of the Tennis Court*.[15] In the SCMA drawing, the woman rests her weight on her extended right arm while she clasps her baby in her left.

A number of pentimenti are visible in the SCMA drawing, including a faintly drawn arc just above the woman's head. This first thought, which would have focused her gaze toward the warrior's leg, was rejected in favor of lowering her head so that she looks toward the ground. Numerous other pentimenti attest to David's efforts to find the best position for the woman's weight-bearing arm and to establish the position of the child's arms and legs. The woman's left calf and foot, originally drawn as if receding at a sharper (about 45-degree) angle, were also repositioned more nearly parallel to the picture plane. Most of the drawing's contours have been repeatedly redrawn and refined.

The Lille drawing introduces a significant change in David's conception of the kneeling woman's relationship to Tatius. She now clasps his leg with her right hand, as she does in the final painting. Her head is no longer turned slightly away, as in the SCMA drawing, but is in strict profile in front of Tatius's knee, and the entire figure group of mother, child, and warrior is more compact.[16] This figure is one of many that seems to have evolved from David's study of works by other artists. One source for David's composition of *The Sabine Women* may have been the version painted by his contemporary François-André Vincent (1746–1816). Shown in the Salon of 1781, it included the motif of a woman holding the leg of a warrior although the woman's pose is distinctly

different.[17] A great number of Raphaelesque motifs are present in the Louvre sketchbook discussed above — most drawn from prints accessible to David in the Bibliothèque Nationale — and it is worth noting that the prints after Raphael's *Massacre of the Innocents* contain a kneeling woman holding a baby that may have sparked David's imagination as he searched for ideas for his *Sabine Women*.[18]

Fig. 5. Jacques-Louis David, compositional study for *The Sabine Women*. Pen, black and brown ink over black chalk, with brush and grey wash and white heightening, 476 × 636 mm (18¾ × 25¹⁄₁₆ in.). Musée du Louvre, Département des Arts Graphiques, inv. 26.183. Photo: © RMN

The figures of mother, child, and soldier in the Lille study are included with few changes in what appears to be David's final composition study for *The Sabine Women,* which is preserved in the Louvre (fig. 5).[19] Like the first composition drawing, this sheet has had separate pieces of paper pasted on it for corrections, one of them containing the figures of Tatius, Hersilia, and the Sabines in the center of the composition. Although several of the figures in the Lille study were eliminated in the final composition drawing, the kneeling woman at Tatius's feet differs only slightly.

<div style="text-align: right">AHS</div>

1. This drawing is not marked with the paraphes of David's sons.

2. According to a priced and annotated copy of the sale catalogue in the Getty Center Library.

3. When this drawing was acquired by Jacques Seligmann from a private collector, it was matted and framed together with four other drawings. These other drawings were marked with the paraphes of David's sons. The largest drawing, mounted at the center of the group, was marked with the Coutan stamp (Lugt 464), indicating that all five drawings had been together in the Coutan-Hauguet sale (letter of 10 April 1965 from Betty Morrison Childs of the Jacques Seligmann Gallery to student Martha McManus; in SCMA curatorial files). Hence the group had remained intact from the time of its appearance in the Coutan-Hauguet sale until it was dispersed by the Seligmann Gallery.

4. The exhibition featured the five sheets that were mounted together (see note 2). In addition to the SCMA drawing they included: *Warrior and Kneeling Woman,* black crayon, 171 × 102 mm (6¾ × 4 in.), now SCMA 1956:45; *Two Groups of Men Fleeing to the Left,* graphite, 241 × 191 mm (9½ × 7½ in.), the largest sheet, the drawing with the Coutan stamp; *Three Men Fleeing to the Left,* graphite and black ink, squared, 127 × 165 mm (5 × 6½ in.); and *Two Men Blowing Horns,* graphite, 171 × 102 mm (6¾ × 4 in.).

5. The painting was also exhibited in the Salon of 1808, no. 146. On the history of this painting (now in the Louvre, Paris, inv. 3691), see Schnapper in Paris/Versailles 1989–90, pp. 323–38.

6. Romulus had arranged a festival, inviting the inhabitants of neighboring settlements to attend with their wives and children.

At a signal, the young men of Rome carried off the Sabine women.

7. Schnapper in Paris/Versailles 1989–90, p. 323. See also Livy 1:9 and 1:13, Plutarch 2:14 and 2:19, and Ovid 3:199–228.

8. Rollin 1823.

9. This is the drawing later given to his pupil (see note 12). Arlette Serullaz (in Paris/Versailles 1989–90, p. 340) suggests that a sketch preceded this, perhaps the "première pensée" that appeared in the April 1826 estate sale under no. 43.

10. See Schnapper in Paris/Versailles 1989–90, p. 324.

11. Delécluze reported that "les personnages de Tatius et de la femme à genoux, et exposant ses enfants, avaient déjà été repeints." Quoted by Schnapper in Paris/Versailles 1989–90, p. 325.

12. This drawing, made while the artist was in the Luxembourg prison, was presented on 3 Jan. 1799 to his friend, the sculptor Espercieux (1757–1840).

13. A *carnet* (sketchbook) in the Louvre, RF 9137 (see Paris/Versailles 1989–90, no. 148), with drawings in graphite or black chalk. Of the 62 pages in this sketchbook, over half (about 35) contain studies relating to *The Sabine Women,* usually on recto and verso. Some are direct studies for the painting; others are copies from antique sources or more recent masters and reveal the models David consulted.

14. Inv. W. 3494 (see Paris/Versailles 1989–90, no. 153, repr.).

15. See, e.g., the drawings exhibited in Paris/Versailles 1989–90, fig. 13 or nos. 105, repr., and 109, repr.

16. Although the child is held in a similar way, in the Lille sheet she is clasped more tightly to the body of her mother, whose right knee is visible left of the baby.

17. Rosenblum 1962, p. 161. Vincent's painting was shown the same year David exhibited his *Belisarius* (Louvre, Paris, inv. 3694). Schnapper traces the motif of the woman holding the warrior's leg to Poussin's *Rape of the Sabines,* now in the Metropolitan Museum of Art (Paris/Versailles, 1989–90, p. 323).

18. See Serullaz in Paris/Versailles 1989–90, under no. 148. For the *Massacre of the Innocents,* see Lawrence/Chapel Hill 1981–82, nos. 21, repr., and 26, repr.

19. See Paris/Versailles 1989–90, no. 152, repr. This drawing was formerly in the collection of Jean-Auguste-Dominique Ingres (1780–1867), who, according to Henry Lapauze 1911 (p. 286), received it from Mme Coutan.

THOMAS ROWLANDSON
London 1756–1827 London

28 *Knaresborough, Yorkshire*, 1802 (3?)

Brush and watercolor with pen and red ink and graphite on smooth cream wove paper

Watermark: None

246 × 381 mm (9⅝ × 15 in.)

Signed and dated recto, lower right, in brown watercolor: *Rowlandson 1802* [3?]

PROVENANCE Desmond Coke (1879–1931), London (sale, London, Christie's, 22 Nov. 1929, no. 11); to {Walker Galleries, Ltd., London}; to Mrs. Thomas W. Lamont (1872–1952), in 1934; to her children (Thomas S. Lamont [1899–1967], New York; Dr. Austin Lamont [1905–1969], Philadelphia; Corliss Lamont [1902–1995], New York; Eleanor Lamont Cunningham [1910–1961], Smith class of 1932, West Hartford, Conn.); gift to SCMA in 1953

LITERATURE Roe 1947, p. 34; Parks 1960, no. 43, repr.; SCMA 1986, no. 230, repr.

EXHIBITIONS London 1930, no. 126; London 1934c, no. 86 (as *Knaresborough, York.*, 1802); Northampton 1953; Northampton 1958c, no. 48; Cambridge 1960, no. 33; Phoenix 1961–62, no. 8; Minneapolis 1962, no. 104; Northampton 1979b, no. 71; Northampton 1983b; ASI 1990, no. 77, repr.

Gift of the children of Mrs. Thomas W. Lamont (Florence Haskell Corliss, class of 1993)
1953:26

Born in London on 14 July 1756, Rowlandson began studying at the Royal Academy in 1772. He is the quintessential urban artist who satirized the weaknesses of human nature and the foibles of his age. Among his own vices were a love of high living and of gambling, subjects treated frequently in his work, which led to his squandering a small inheritance. Although he often visited the Continent and traveled extensively around Britain, most of his time was spent in London. For the last three decades of his life he occupied a house in James Street, Adelphi, where he died on 21 April 1827, apparently having suffered a stroke some two years earlier.

Rowlandson has been described by John Hayes as "one of the greatest of all English draftsmen, at his best unsurpassed as a master of supple, flowing, and expressive line, adept and fluent in the use of wash and watercolor."[1] He was also extraordinarily prolific. In the course of his life Rowlandson produced thousands of prints, drawings, and watercolors as well as illustrations for a host of books. Starting in the late 1790s, he worked for the famous print publisher Rudolph Ackermann. His subject matter was diverse, but he often turned out variations on the same theme over the course of several years and frequently made more than one version of a particular composition.

Best known for his humorous and often bawdy depictions of high and low life, Rowlandson was also a deft portrayer of the English countryside. His was the age of the picturesque, when middle-class men and women traveled around Britain to see the natural beauty spots and visit ruins. The Reverend William Gilpin and others had promoted this pastime through numerous books describing tours to various parts of the country. Ever one to see the humor in a situation, Rowlandson caricatured Gilpin in a series of volumes recounting the travels of one Dr. Syntax, like his model a clergyman.

Knaresborough, Yorkshire dates from the first decade of the nineteenth century, a period during which Rowlandson executed many landscapes. While clearly displaying the artist's familiarity with the theories of the picturesque through its jagged rocks, winding river, and rustic houses, the composition also exhibits the fluency of Rowlandson's line and the subtlety of his coloring.[2] Another, slightly smaller, watercolor from about the same time depicts the World's End Inn on the left and the bridge but from a different viewpoint (fig. 1).

Knaresborough is in North Yorkshire, about fifteen miles west of York and about the same distance north of Leeds. Considered one of the most picturesque towns in the region, it was described in 1831 as "delightfully situate on the north-eastern bank of the river Nidd, which runs in a most romantic valley or glen, below precipitous

Fig. 1. Thomas Rowlandson, *The Bridge at Knaresborough, Yorkshire*, 1807. Brush and watercolor, 241 × 336 mm (9½ × 13¼ in.). Victoria & Albert Museum, London [D794]. Photo: © The Board of Trustees of the Victoria & Albert Museum

rocks."[3] When Rowlandson painted it, Knaresborough had a romantic past as well as romantic scenery to attract tourists. A royalist stronghold during the Civil War, the town had the remains of a fourteenth-century castle as well as a natural wonder, the Dropping Well, from which limewater dripped and petrified objects coming in contact with it. But it also had been the site in the mid-eighteenth century of the famous murder by the scholar Eugene Aram, which was always mentioned in contemporary commentaries on the town.

In this and the other view of Knaresborough, Rowlandson has chosen to capture the picturesque nature of the locale rather than the bustling quality of a market town. Two bridges span the Nidd and lead into Knaresborough. The one depicted is the low bridge near Grimbald Crag, seen on the right, a distinguishing feature of the area and the site of the Chapel of Our Lady. On the left bank, just beyond the bridge near the turn of the river, was the Dropping Well. The cave where Aram buried his victim would also have been on the left but behind the point from which this view was taken. The high bridge of medieval origin spans the river valley farther upstream and leads more directly into the town.

Although it is hardly a topographical rendering of the site, Rowlandson portrayed here the part of Knaresborough most closely associated with its natural attractions and infamous history. The grouping of houses along Abbey Road (Waterside) provides an extension of the crag itself, moving the mass ever closer to the river. Although the bulging forms and irregular lines of the buildings speak of human activity, this rendering gives the viewer no sense of Knaresborough as a prosperous town of considerable size. Instead, the cluster of thatched cottages, the dirt road, and the dense vegetation on the opposite bank convey a rugged and rustic impression, emphasizing the picturesqueness of the region.

EJN

1. ASI 1990, p. 11.
2. Wark 1975, p. 12.
3. Allen 1831, p. 395.

NICOLAS-ANDRÉ MONSIAU
Paris 1754–1837 Paris

29 Aspasia Conversing with the Most Illustrious Men of Athens
(Aspasie s'entretenant avec les hommes les plus illustres d'Athènes), c. 1806

Brush and grey wash over pen and grey ink on white laid paper; laid down on a white card faced with blue paper

Watermark: None visible

Sheet: 169 × 243 mm (6¹¹⁄₁₆ × 9⅝ in.); mount: 259 × 334 mm (10⅛ × 13⅛ in.)

Inscribed on mount recto, below lower left edge of drawing, in pen and dark brown ink: *Monsiau*; inscribed on verso of mount at upper left in graphite: *17*; at upper right in graphite: *325 × 25ᵐᵃ*; at lower right in graphite: *Socrate et Alcibiade chez Aspasie*

PROVENANCE Private collection, Paris; to {David and Constance Yates, New York}; sold to SCMA in 1986

LITERATURE None

EXHIBITIONS Northampton 1988, no. 20; Northampton 1988–89; Northampton 1989, no. 32; Northampton 1992b, no. 1

Purchased with funds given in memory of Mimi Norcross Fisher, class of 1959, by her family and friends
1986:6

A Parisian artist who trained in the studio of Jean-François-Pierre Peyron (1744–1814), Monsiau was elected to the Académie Royale de Peinture et de Sculpture in 1789. Between 1787, when he first exhibited as an *agréé,* and 1833 he regularly contributed paintings and drawings to the Salon.[1] One of two paintings by which he was represented in the Salon of 1806 was *Aspasia Conversing with the Most Illustrious Men of Athens,* a canvas now preserved in the museum at Chambéry (fig. 1).[2] According to the brief description published in the Salon *livret* (booklet), this painting shows Aspasia, who was much admired for her eloquence, surrounded by the soldiers, philosophers, men of letters, and artists who frequented her home.[3] The highly finished drawing in the SCMA corresponds in virtually all details to this painting.

Monsiau's composition depicts one of the most renowned women of ancient Greece. Aspasia, born of a Milesian family, was a courtesan in Athens who became the mistress of Pericles, living with him after he had divorced his wife (c. 445 B.C.) until his death in 429 B.C. A woman of keen intellect, she taught rhetoric and conversed with Socrates, a distinction for which she is remembered by his followers, including Plato.[4]

A significantly expanded discussion of Monsiau's painting appears in C. P. Landon's *Annales des Musées* (1833), where it is reproduced in a line engraving by Charles Normand.[5] Landon identifies several of the figures: Pericles leans on the back of Aspasia's chair; Socrates, seated across the table from Aspasia, turns to address a comment to Alcibiades, standing behind him; the young Xenophon stands at Alcibiades' side; and the painter Parrhasius wears the gold wreath he had arrogantly assumed as the self-proclaimed "king of painters." The remaining figures named in the 1806 Salon *livret* — Sophocles, Euripides, Phidias, Plato, and Isocrates — are not individually distinguished by Landon.

Landon asserts that Monsiau's intention was to create a pendant to his popular canvas *Molière Reading "Tartuffe" at* the Home of Ninon de Lenclos, exhibited at the Salon of 1802, which showed the playwright and the famous courtesan surrounded by the most celebrated writers of the time.[6] The seventeenth-century female protagonist of the earlier painting would thus be paired with one from antiquity.[7]

In taking up the theme of Aspasia and her admirers, Monsiau returned for inspiration to his two earlier compositions depicting Aspasia with Socrates and Alcibiades. Monsiau's first treatment of the subject, a painting exhibited at the Salon of 1798 (no. 312)[8] was revised in a canvas of 1801, now in the Pushkin Museum, Moscow (fig. 2), which bears a closer compositional relationship to his painting of 1806.[9] The artist seems to have drawn on the 1801 painting for the position of the figures and certain details of the setting of his 1806 canvas, such as the floor pattern and the placement of a bust on a pedestal standing immediately behind Aspasia.

The popularity among artists of paintings based on morally edifying themes from antiquity — and perhaps to some degree the specific interest in Socrates — was greatly enhanced by the success of Jacques-Louis David (1748–1825), who had shown his *Death of Socrates* in the Salon of 1787 (no. 119) to wide acclaim. That same year Monsiau's teacher, Peyron, also exhibited a *Death of Socrates* (no. 154), an oil sketch for a painting commissioned by the king that he showed two years later (Salon of 1789, no. 112) along with two small sketches, one of which also dealt with this subject.[10] Peyron had previously treated the relationship between Socrates and Alcibiades, his pupil, in *Socrates Detaching Alcibiades from the Charms of Volupté,* a painting exhibited in the Salon of 1785 (no. 179).

In addition to his own compositions of 1798 and 1801, Monsiau might have had in mind as he began work on his 1806 painting a bistre drawing by François-Philibert Vincent (a student of David; b. 1768, active 1799–1812) of Socrates giving lessons to Alcibiades and the young men of Athens exhibited in the Salon of 1801 (no. 714).[11]

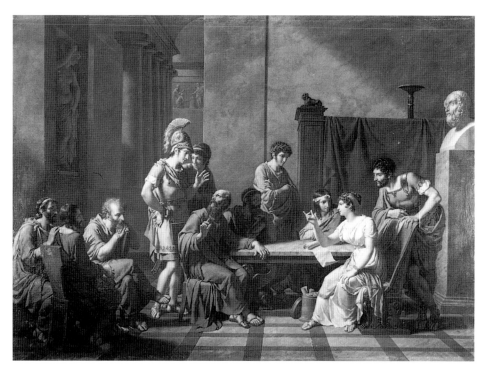

Fig. 1. Monsiau, *Aspasia Conversing with the Most Illustrious Men of Athens,* 1806. Oil on canvas, 106.5 × 146.5 cm (41⅞ × 57⅝ in.). Musée du Louvre, Paris, Département des Peintures, inv. RF 185, on deposit at Chambéry. Photo: © RMN

Like most painters of his day, Monsiau often submitted drawings to the annual Salon. In many cases these seem to have been highly finished composition studies for his paintings.[12] In the instances where both works are known, the drawings exhibit some differences from the paintings, which would suggest they precede the final, painted composition. The precise relationship between drawing and painting is not always clear, however. Monsiau's painting *Zeuxis Choosing His Models from the Most Beautiful Girls of Croton* (Salon of 1798, no. 311) was exhibited together with a drawing of the same subject (no. 313, described as a "drawing after the Zeuxis painting"). A large drawing of Zeuxis choosing his models that was on the London art market in 1981 may be the drawing exhibited at the Salon.[13] Notwithstanding the *livret* description, it is significantly different from Monsiau's painting. Its resemblance to François-André Vincent's painting of the same subject (Louvre, inv. 8453), exhibited at the Salon of 1789, suggests that it is a working stage between Monsiau's initial model and his final solution.[14] The SCMA drawing of Aspasia, however, is virtually identical in composition and detail to the finished painting, and this correspondence, along with the drawing's lack of pentimenti, raises the question of whether it might not be an autograph replica of the painting rather than a preparatory drawing.

Of other known drawings by Monsiau, the closest in composition and approach to the SCMA sheet is *Fulvia Exposing the Catiline Conspiracy to Cicero.*[15] This drawing is undated, but we know that in the 1822 Salon Monsiau exhibited a painting of this title (no. 956). In both drawings Monsiau has used the compositional device of placing figures around a table in the foreground, while a corridor leads into the background at the left. He has decorated both rooms with a statue in a niche and a bas-relief inset high into the corridor wall and has depicted furnishings (e.g., the lamps and the tables, which have

Fig. 2. Monsiau, *Aspasia Conversing with Socrates and Alcibiades,* 1801. Oil on canvas, 65 × 81 cm (25⅝ × 31⅞ in.). Pushkin State Museum of Fine Arts, Moscow, inv. 1248

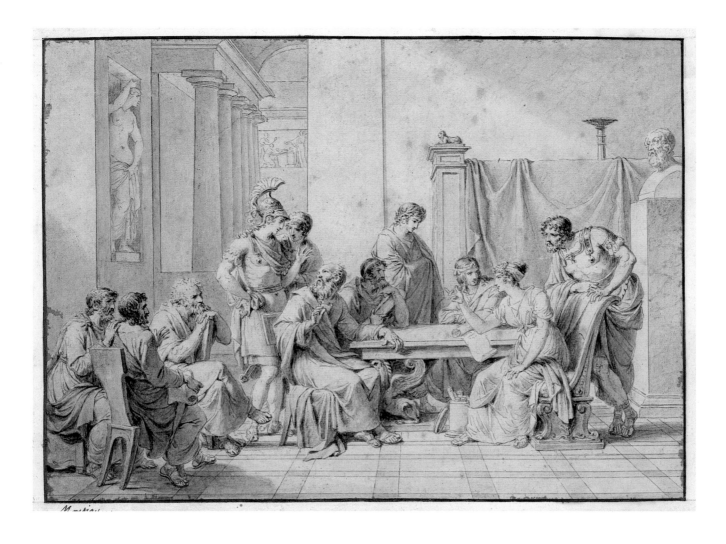

griffin or sphinxlike bases) that reflect contemporary interest in archaeological discoveries. Noteworthy in Smith's *Aspasia Conversing* is the bust at right, which is clearly based on an ancient bust of the blind Homer. Like the face of Socrates, it is modeled on sculptural types that could have been known to Monsiau either from engravings or in the original (in Paris, or in Rome, where he worked from 1776 to 1780).[16]

AHS

1. For biographical information on Monsiau, see the "Notice sur la vie et les ouvrages de M. Monsiau" published at the beginning of the catalogue to his posthumous sale, Paris, Palais de l'Institut, Bataillard C.P. [*commissaire priseur*] 30 Aug.–1 Sept. 1837.

2. Oil on canvas, 1.065 × 1.465 m, signed and dated at lower right: *Monsiau / Faciebat anno / MDCCCVI.* Owned by the Musée du Louvre, it was the gift of Mme Jules de Saux in 1877 (RF 185). See also Aubert 1985, no. 19. Aubert mistakenly identifies Monsiau's 1801 painting in the Pushkin Museum (see note 9) as the one exhibited in 1798.

3. See Paris Salon 1806, no. 391. The writer names her visitors (although he does not identify individual figures in the painting) as Pericles, Socrates, Alcibiades, Plato, Xenophon, Sophocles, Phidias, Euripides, Parrhasius, and Isocrates.

4. For example in the *Menexenus,* a dialogue in which Socrates calls Aspasia his master in rhetoric and recites a funeral oration he attributes to her. On Aspasia, see the *Oxford Class Dict.* Although she was accused by some Athenians of exerting undue influence on Pericles, these accusations seem to have been motivated by political opposition to Pericles and he successfully defended her.

5. Landon 1833, pp. 70–71, pl. 39. On the line engraver Normand, see Beraldi, vol. 10, pp. 217–21. On Normand, see Beraldi, vol. 10, pp. 217–21.

6. The *livret* for the Salon of 1802 names them: "Le grand Cornéille, Racine, Lafontaine, le maréchal de Vivone, Boileau, Chapelle, Lully, Th. Corneille, Mansard, Quinault, Baron, le grand Condé, Saint Evremont, la Bruyère, Mignard, Girardon, le duc de la Rochefoucault." Paris Salon 1802, no. 210. Reproduced in a print by Anselin, which was exhibited in the Salon of 1814 (no. 1230), the painting is now at the Comédie Française, Paris. The first version of Tartuffe (1664), a play in three acts, was denounced as an attack on religion. Forbidden to perform the play publicly, Molière (1622–1673) and his troupe performed it privately for some of the most prominent people of his day.

7. Mademoiselle Anne (Ninon) de Lenclos (1616–1706), lover and confidante of many distinguished men of her day, presided over a celebrated salon. Molière is said to have consulted her on all his plays.

8. *Socrate et Alcibiade chez Aspasie,* oil on canvas, 96 × 127 cm, Riom (Puy-de-Dôme), Musée Mandet (inv. 866.17.2), gift of vicomte Auguste de Plancy in 1866. On deposit at the Hôtel de Ville, Riom. Reproduced in the catalogue of the sale, Christie's, Monaco, 20 June 1992, under no. 244 (a closely related drawing, repr.), fig. 1 (erroneously as at Clermont-Ferrand). See Paris Salon 1798, no. 312.

9. *Socrate et Alcibiade chez Aspasie,* oil on canvas, 65 × 81 cm, signed and dated at lower left: *Monsiau 1801.*

10. Monsiau's Salon entry in 1789 (no. 193) was a painting of Agis, king of Sparta, a subject drawn from Plutarch. Two years later, in 1791, a print after Peyron's *Death of Socrates* was exhibited at the Salon (no. 438).

11. I have been unable to locate this drawing and so cannot say whether it influenced the composition of Monsiau's work or is simply an example of a related subject.

12. He is known, for example, to have exhibited a painting of the death of Phocion in 1787 (no. 231) and a bistre drawing, *The Death of Phocion,* in 1791 (no. 415).

13. The drawing is in pen and brown ink with brush and brown and grey wash, heightened with white; it measures 400 × 504 mm. See London 1981, no. 65, repr., according to which the painting's whereabouts are unknown. According to London 1987, it was this drawing, not the painting, as stated in London 1981, that was engraved by Brion, who misidentified the subject as Apelles.

14. See London 1987, no. 30. See also Rosenblum 1969, p. 22 note 62; see Paris/Detroit/New York 1974–75, p. 554, private collection, Bordeaux. Vincent's painting was exhibited at the Salon of 1789 and again in that of 1791 along with a print after the painting.

15. Pen and *encre de chine* wash, 225 × 265 mm (Paris 1971a, no. 62, repr.).

16. Portraits of Homer and Socrates are known to have been in Paris by this time. Monsiau owned bronze busts of Tiberius and Vecellius (no. 101 in his posthumous sale; see note 1, above) as well as volumes of prints after ancient sculptures and bas reliefs (e.g., nos. 80 and 81 in his sale).

JEAN-AUGUSTE-DOMINIQUE INGRES
Montauban 1780–1867 Paris

30 *The Architects Achille Leclère and Jean-Louis Provost*, 1812

Hard graphite on smooth beige wove paper (a thin tissue) mounted on a cream wove backing sheet

Watermark on backing sheet: J. Whatman, Turkey Mills 1807

313 × 242 mm (12¼ × 9½ in.)

Signed and dated recto, lower right, in graphite: *Ingres D.*^{vit} *a rome / 1812*

PROVENANCE Probably Achille Leclère (1785–1853), Paris, to his heirs; Maurice Delestre (sale, M[aurice] D[elestre], Paris, Hôtel Drouot, 14 Dec. 1936, no. 71), for 22,500 francs;[1] to {Herbert Bier (co-owned with Paul Cassirer and Vitale Bloch [1900–1975])};[2] sold to SCMA by Vitale Bloch, London, in 1937

LITERATURE Delaborde 1870, no. 347 (reference to the print after the drawing); Blanc 1870, p. 245 (reference to the print); Courboin 1895, no. 10154 (reference to a copy after the print in graphite by an unknown hand in the collection of Alfred Armand in the Bibliothèque Nationale, Paris); Lapauze 1901, p. 267 (reference to the print); Lapauze 1911, repr. p. 124 (the print); Marmottan 1922, p. 126; Angoulvent 1933; SCMA 1937, p. 41, repr. p. 129; *Smith AlumQ* 1937, p. 59, repr.; *ArtN* 1937, p. 17, repr.; Abbott 1938, pp. 7–9, fig. 2; Hitchcock 1938, p. 9; *Parnassus* 1939, repr. p. 40; Lane 1940, p. 7; Goldwater 1940, p. 84; Mongan 1947, no. 4, repr.; Huyghe and Jaccottet 1948, p. 173, repr. p. 15; Shoolman and Slatkin 1950, pl. 63 and facing text on p. 112; Alazard 1950, p. 51; *SCMA Bull* 1951, pp. 18–19; Fitzsimmons 1953a, p. 14, repr. p. 1; Hamilton and Hitchcock 1953, pp. xiv, xvi, xxii–xxiii, no. 4, repr.; Faison 1958, pp. 138–39, repr. p. 138; Bouchot-Saupique 1958, p. [7]; Huyghe 1961, repr. p. 295; Raoul 1962, fig. 2; Hill 1966, p. 51, fig. 14; Pincus-Witten 1967, p. 46; George 1967, repr. p. 51; Chaet 1970, p. 173, fig. 173 (as *Portrait of Leclerc and Provost*); AFA 1970–72, [p. xiii], fig. 14; Naef 1977–80, vol. 1, chap. 37 (pp. 317–22), fig. 1; vol. 4, no. 89, repr.; Chaet 1978, p. 162, fig. 162 (as *Portrait of Leclerc and Provost*); SCMA 1986, no. 232, repr.; Christie's, New York, 22 May 1997, mentioned under no. 18, fig. 1

EXHIBITIONS Springfield 1939–40, no. 46, repr.; San Francisco 1947, no. 5, repr.; New York 1953, no. 19; Andover 1954, no. 14; Northampton 1958a, no. 39; ICMoMA 1958–59, Rotterdam no. 128, pl. 96, Paris no. 128, pl. 104, New York no. 128, pl. 96; Chicago 1961, no. 32; Minneapolis 1962, no. 63; South Hadley 1966, no. 24; Cambridge 1967a, no. 23, repr.; Paris 1967–68, no. 58, repr.; Austin 1977, Ingres drawings checklist, no. 3; Ithaca 1978; Northampton 1979b, no. 89; Northampton 1982a; Northampton 1983a, no. 35; Northampton 1984b, no. 12; Northampton 1985b; Northampton 1985d; Northampton 1992b, no. 3

Purchased, Drayton Hillyer Fund
1937:5-1

Ingres's double portrait of the young architects Achille Leclère and Jean-Louis Provost, executed when both subjects were pensioners at the French Academy in Rome, is one of the most renowned and widely published drawings in the collection of the Smith College Museum of Art. Before its acquisition in 1937 the drawing was known in the literature only from a print by Louise Girard and an anonymous drawing after the print.[3]

Ingres had been in Rome for some six years when he drew the double portrait of Leclère and Provost. Having won the Grand Prix de Peinture in 1801 (for his *Ambassadors of Agamemnon*, Ecole des Beaux-Arts, Paris), he arrived in Rome on 11 October 1806 and stayed until 1820, returning to Paris only after an additional four years in Florence.[4] Ingres, whose skill as a portraitist was already known to his friends in Paris, must have rapidly achieved a reputation for his portrait drawings among his contemporaries in Rome. The first one he is known to have made there, executed within a month of his arrival, had been promised to its subject, the architect Jean-François-Julien Ménager, before either artist left Paris. This portrait, intended by Menager for his parents, was delivered to them in France on 12 November 1806 by a student returning from Italy.[5] That same year Ingres drew the portrait of the landscape painter Thomas-Charles Naudet (1773–1810).[6] Like so many of the subsequent *portraits dessinés* Ingres made during his first stay in Rome,

these drawings depict the artist's friends and acquaintances at the French Academy, where young artists worked together companionably, drawing the same ancient and modern sites, and exchanging examples of their work.[7] A number of them also brought home portraits drawn by Ingres.

The SCMA *Portrait of Leclère and Provost* is dated 1812 and, as suggested by Hans Naef, may have been made to celebrate the reunion in Rome of these two friends and former pupils of Charles Percier (1764–1838).[8] It was in 1812 that Provost began his term as pensioner at the Académie de France, and Leclère, who had preceded him as a recipient of the Prix de Rome, returned to the city after travels in Tuscany.

Ingres's drawing of the two young architects presents Leclère (aged 27) on the left and Provost (aged 31) on the right. His sympathetic portrayal of two markedly different characters has made this drawing justifiably celebrated. Leclère's pose is the more assertive — he stands erect and turns slightly toward the viewer as he holds a book or portfolio under his arm and gazes out and slightly to the viewer's left. Provost, his torso turned away from us, looks back over his shoulder, his gaze focused in the direction opposite to that of his companion. Ingres describes his subjects' clothing with simple but eloquent contour lines and minimal shading, devoting most of his attention to his sitters' heads. These are modeled in hard

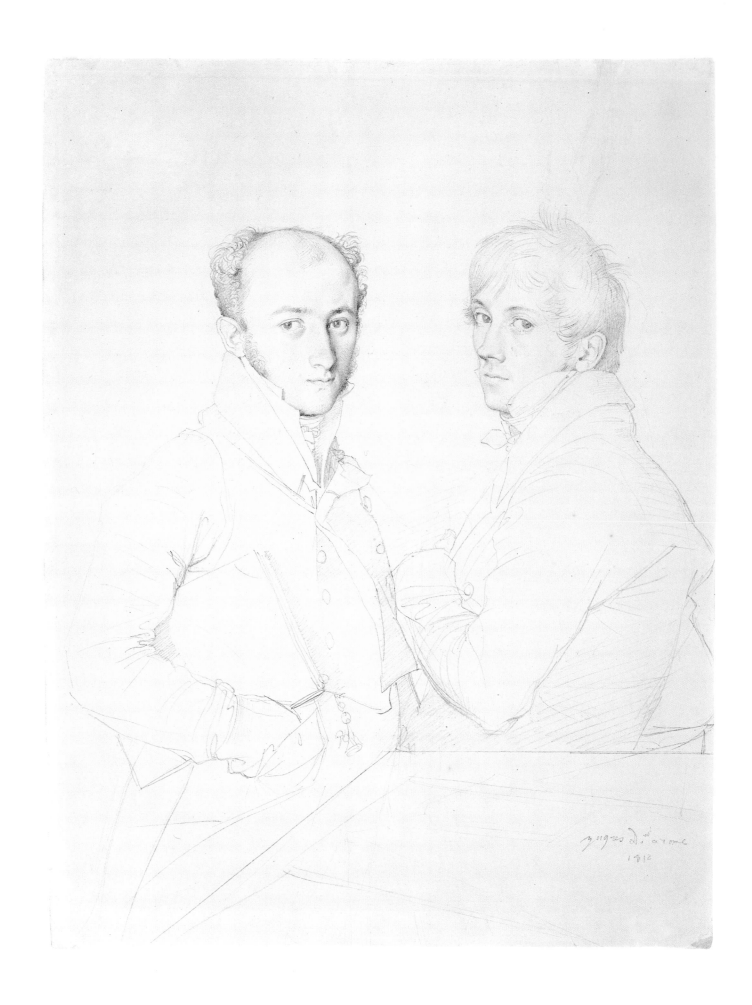

128 JEAN-AUGUSTE-DOMINIQUE INGRES

graphite with a delicate web of parallel hatching that approaches stippling at some points and describes subtle variations in texture and tone. Leclère's face receives the greatest emphasis, having the most carefully modulated surfaces as well as the highest contrast of light and dark. Ingres's sensitive description of the contrasting features of these two young men is nowhere more striking than in his treatment of their hair. The crisp curls at the side and back of Leclère's balding head, his curly sideburns, and the remaining wisps of hair visible at his crown are set against the straighter, thicker hair of Provost.

Achille-François-René Leclère was born in Paris in 1785, the son of an architect. According to his biographer Adolphe Lance, at age sixteen (that is, in 1801) the young man presented himself for admission to the studio of the architect Charles Percier. Percier, who had worked in partnership with Pierre-François-Léonard Fontaine (1762–1853) for some years, had begun to devote himself increasingly to the instruction of students, and several Prix de Rome winners of the early nineteenth century came from his studio. Leclère won numerous medals in the Parisian architectural *concours* (competitions), earning the first prize in 1807 for the design of "public baths for a great capital." He departed Paris for Rome in November 1808 along with a companion, the architect Mazoie (later known for his work on the ruins of Pompeii), arriving at the Académie de France (at Villa Medici) on 12 December. After a year of study at Rome, he traveled to Naples in 1810 and through Tuscany in 1811, returning to Rome in 1812, where he worked on a project for the restoration of the Pantheon that brought him a measure of fame among his associates. Two years later, he returned to Paris, arriving there on 7 March 1814.

Like Leclère, Jean-Louis Provost was a pupil of Percier. Born in Paris in 1781, he won the second prize in architecture in 1806 and the first prize in 1811 for a "palace for the University." The following year he arrived in Rome to take up his studies at the Académie de France. During his stay he designed a restoration of the Temple of Jupiter (1815). His life is not as well documented as that of his friend Leclère, and he seems to have enjoyed limited professional success, although like Leclère he was named chevalier of the Légion d'honneur (1838). There are no records of his date of death, although the sculptor David d'Angers (1788–1856), who had won the Prix de Rome the same year as Provost, left an account in his notebooks of the funeral of his friend. Inspired by this event (which seems to have occurred no later than 1846) to imagine a funerary monument to Provost, David contemplated symbolizing his friend's life by a truncated column, one rising no farther than its base.[9]

In the Paris Salon of 1850, Louise Girard exhibited a print after the SCMA drawing inscribed *À M*ʳ. *A. Leclère / ses eleves et ses amis.*[10] Mme Louise Girard (née Bathilde in 1787), wife of the engraver François Girard (b. 1787), was a miniature painter and printmaker, who debuted at the Salon of 1824. In addition to reproductive prints after artists such as Raphael (1483–1520; *La Saint Vierge*) and

Sassoferrato (1609–1685; *Ave Maria)*, she made original prints, such as *Gloria in Excelsis Deo,* which were printed and published by her husband.[11] Her print titled *Les Deux Frères,* after a painting by Paul Delaroche (published by Rittner & Goupil), is a very delicate piece in a stipple technique similar to that used in her print of Leclère and Provost.[12]

The exact circumstances under which this print was made are not known, although its inscription indicates that it was intended as a tribute to Leclère, who had become a devoted teacher of architecture in the years since his return to Paris. The drawing must have been available to Louise Girard when she made her print, and there is reason to believe it was originally owned by Achille Leclère. His interest in preserving the memory of his associates at the Académie de France is documented by an album in the Fogg Art Museum that contains drawings by many of these friends and once held another sheet by Ingres.[13] The fact that Ingres executed a second portrait of Provost in 1813, just one year after the SCMA double portrait, might also suggest that Leclère owned the SCMA drawing.[14] Although the double portrait does not appear in the sale of Leclère's collection following his death in 1863 (which did include the Fogg album and an Ingres drawing of the Sistine Chapel), it may have been retained by his sister, to whom he was very close and who became his heir.

AHS

1. See also the letter from Gaston Delestre, his grandson, to Robert O. Parks, 13 Feb. 1959 (in SCMA curatorial files).

2. According to a letter from Vitale Bloch to Robert O. Parks of 1 Oct. 1957 (in SCMA curatorial files). A memorandum of 14 March 1958 records the information conveyed "verbally to" June Marie Fink that Bier purchased the drawing, Bloch bought a share the same day, and Cassirer purchased a share shortly afterward (in SCMA curatorial files).

3. Girard's print is preserved in several states at the Bibliothèque Nationale (see note 10, below). The drawing after the print is in the Bibliothèque Nationale, collection Alfred Armand (see Courboin 1895, no. 10154).

4. On the organization of the Prix de Rome competition in the years 1797–1863, see Philippe Grunchec in IEF 1984–85a, pp. 25–27.

5. See Naef 1967, no. 1, pl. 1. The drawing is dated 1806.

6. Museum of Art, Rhode Island School of Design, inv. 29.087. Naudet had arrived at the French Academy in Oct. 1806 to make illustrations for a prospective *Voyage pittoresque.* See Providence 1975b, no. 42, repr.

7. See Mongan 1980.

8. Naef 1977–80, vol. 1, chap. 37, p. 317.

9. On Provost, see Bauchal 1887. For David d'Anger's notebook, see Bruel 1958, vol. 2, pp. 240–41. On the question of Provost's date of death, see Naef 1977–80, vol. 1, p. 322 note 1. Agnes Mongan noted that Frits Lugt records (under Lugt 22) that Alfred Armand (see note 3 above), the architect of major railroad stations (the Gare Saint-Lazare and stations at Saint-Cloud, Saint-Germain, etc.), was a pupil of Provost and Leclère (letter to Charles Chetham of 14 March 1968, SCMA curatorial files).

10. The Salon *livret* lists it as no. 3778, "Portraits de MM. A. Leclerc [*sic*] et Prevot [*sic*], d'après Ingres" by Girard (Mme B.),

15, rue de Condé. The print is a "stipple engraving." It is inscribed in the plate, within the image at lower left: *Mme Girard Sct Paris / 1850;* within the image at lower right: *Ingres D.el a Rome / 1812;* and below the image at lower center: *À M^r. A. Leclère / ses eleves et ses amis.* The copperplate is in the collection of the SCMA (1937:5-2; purchased, Drayton Hillyer Fund) and was acquired from Vitale Bloch at the same time as the drawing. An impression of the print on *chine appliqué* was in the sale, New York, Sotheby's, 6–7 March 1986, no. 276.

11. Inscribed: *A Paris chez F. Girard, Graveur, Editeur, Rue Mignon St. André-des-arts, No 5.* On these printmakers, see Béraldi, vol. 7, pp. 145–50 (the print after SCMA's drawing listed, p. 149).

12. The print is inscribed *Rittner & Goupil, 15 Boulevard Montmartre.* An impression of this print is preserved in an album in the Bibliothèque Nationale. The page on which it is mounted is marked "1836."

13. This drawing was removed by a former owner of the album. See Mongan 1980, p. 10.

14. For the 1813 portrait of Provost, see Naef 1977–80, vol. 1, no. 94, repr. Sold in New York, Christie's, 22 May 1997, no. 18, repr., it is now in a private collection, New York.

THÉODORE GERICAULT
Rouen 1791–1824 Paris

31 Landscape with Stormy Sky, c. 1817
Verso: Buildings and Trees (View of Montmartre) (with additional sketches of a horse's hoof and ear), 1815–16

Pen and brown ink, with brush and transparent and opaque watercolor (gouache, combined with an unidentified vehicle), over graphite on cream wove paper

Verso: Graphite, pen and brown ink, with touches of watercolor

Watermark: None

214 × 286 mm (8⁷⁄₁₆ × 11¼ in.)

PROVENANCE Purchased from the artist by L.-J.-A. Coutan (d. 1830), Paris; to his widow, Mme Coutan (née Hauguet, d. 1838), Paris; to her brother, Ferdinand Hauguet (d. 1860), Paris; to his son, Maurice-Jacques-Albert Hauguet (d. 1883), Antibes; to his widow, Mme Hauguet (née Marie Thérèse Schubert, d. 1883), Antibes; to her father, Jean Schubert, and her sister Mme Gustave Milliet (née H. Schubert), but not included in the sale [Coutan-Hauguet], Paris, Hôtel Drouot, 16–17 Dec. 1889 (Lugt 464, recto at lower right and lower left corner of image, extending into bor-der); private collection, Paris; {Wildenstein & Co., New York}, 1948; sold to SCMA in 1960

LITERATURE Berger 1952, pp. 47, 68–69, no. 30, pl. 30; Berger 1955, pp. 48–49, 76, no. 30, pl. 30 (as Italian Landscape, 1816–17); Gaudibert 1953, p. 87; Eitner 1953, p. 81; Eitner 1954, p. 168; Sele Arte, p. 41, repr.; Arts 1956, p. 54; Parks 1960, no. 56 (recto), repr., and no. 57 (verso), repr.; GBA 1961, p. 45, repr.; Busch 1967, p. 184, note 19; SCMA 1986, no. 231, repr. (recto); Bazin 1987–94, vol. 4, nos. 1147 (recto) and 1148 (verso), repr., discussed pp. 17, 68

EXHIBITIONS New York 1949b, no. 62; Winterthur (Switz.) 1953, no. 149; New York 1955, no. 138; New York 1956a, no. 55; New York 1959b, no. 2; Ann Arbor 1965, no. 27, repr.; Sarasota 1967; College Park 1977–78, p. 44, no. 63, repr. p. 2; Northampton 1977; Northampton 1979b, no. 100; Northampton 1982b; Williamstown 1984, no. 79, repr.; Northampton 1992b, no. 16

Purchased
1960:92

One of three drawings by Théodore Gericault owned by the Smith College Museum, this sheet is a palimpsest of ink and graphite sketches and a more finished drawing that may have resulted from as many as four different occasions when the artist used this sketchbook page.[1] The most finished drawing in watercolor and gouache (combined in some areas with an unidentified agent that creates a glossy sheen) is an imaginary scene of buildings poised on mountainous ground and silhouetted against a stormy sky with a painted margin of blue watercolor. Under this is a rapid and apparently unrelated pen sketch extending below the clouds in the gouache drawing toward the turrets of the architecture. On the reverse of the sheet is a pen and ink drawing of buildings and trees, which shows staining through the paper from media on the reverse of the sheet. Below this is a pencil sketch, some of which is clearly related to the pen and ink drawing, but there are additional slight pencil sketches of a horse's hoof and backturned ear in the upper right as well as very faint pencil markings of what may have been the beginnings of a landscape.

The issues presented by this drawing concern its date, or dates, of execution and the identification of the site, not of the gouache drawing, which appears to be an invented scene, but of the pen and ink sketch of domestic architecture on the reverse of the sheet. Central to the discussion of chronology is the relation of the sheet to Gericault's stay in Italy from September 1816 to September 1817, a trip planned and undertaken by the young artist despite his failure to win the Prix de Rome competition. A student of the neoclassicist Pierre-Narcisse Guérin (1744–1833), Gericault had broken away from the Davidian manner to paint dramatic military and Napoleonic subjects, including the Charging Chasseur (1812, Louvre, Paris) and the Wounded Cuirassier (1814, Louvre, Paris), both shown but disappointingly received at the Paris Salon. Prior to his voyage to study and work in Italy, Gericault turned to classical subjects, and, as Lorenz Eitner has pointed out, drawing "played the dominant role in his struggle to conjure a vital new style" from antique sources.[2]

When Landscape with Stormy Sky was being considered for acquisition by the museum in 1960, Eitner associated the sheet with a group of drawings of landscapes in a wash and gouache technique over ink and pencil, which he dated about 1814–16.[3] In Germain Bazin's catalogue raisonné of Gericault's work, most of the drawings Eitner originally associated with the SCMA sheet (B. 1147, 1148 verso) are grouped together, including Italian Landscape with a verso pencil sketch of two horses (B. 1146, 1339 verso; figs. 1, 2) and cloud studies from the Musée Bonnat, Bayonne (B. 1149–54, rectos and versos).[4] With the exception of the gouache skyline drawing View of Montmartre (B. 1710; fig. 3), which he dates after Gericault's return from Italy, Bazin ascribed the SCMA sheet and related drawings to Gericault's Italian trip in

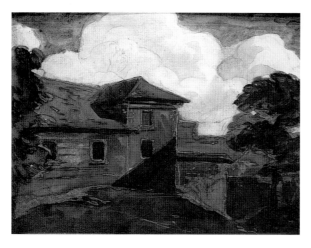

Fig. 1. Théodore Gericault, *Italian Landscape* (B. 1146), reidentified as *View of Montmartre*, c. 1817–20. Brush and gouache on parchment, 165 × 216 mm (6½ × 8½ in.). Private collection. Photo: Courtesy of Wildenstein & Co., Inc.

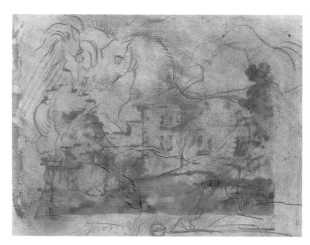

Fig. 2. Théodore Gericault, *Horses* (B. 1139), c. 1817. Brush and gouache on parchment, 165 × 216 mm (6½ × 8½ in.). Private collection. Photo: Courtesy of Wildenstein & Co., Inc.

1816–17.[5] This date accords with Klaus Berger's dating of the SCMA sheet, which he titled *Italian Landscape* in the first known published reference to the drawing.[6]

During the year spent in Rome and Florence, with a voyage to Naples and Paestum in the spring of 1817, Gericault made drawings after Michelangelo (1475–1564) and other Renaissance and baroque painters, scenes of Italian street life treated in a monumental style, and carefully rendered sketches of classical monuments. *Landscape with Stormy Sky* and at least one of its related drawings may be seen in relation to paintings from Gericault's Italian period, if not specifically as studies then in terms of pictorial likeness. Bazin considers the pencil sketch of two horses (B. 1339) on the verso of *Italian Landscape* (B. 1146) to be related to Gericault's depictions

of the race of the riderless horses (the Mossa), an annual race, or stampede, in the Corso in Rome, which Gericault witnessed during Carnival in mid-February 1817. Bazin also mentions the SCMA sheet in that regard: "On this sheet (cat. 1339 [*Italian Landscape*]), the artist has drawn horses from life, undoubtedly for the *Mossa,* but the verso also has sketches of horses underlying a landscape in a quickly worked gouache (cat. 1146), which resembles another gouache (cat. 1147 [SCMA]), under which one can distinguish the same type of sketch."[7]

Gericault made numerous studies of rearing horses and their grooms for a series of paintings of the Mossa, most of which concentrate on the explosive energy of the animals at the start of the race.[8] Despite its very fragmentary pencil sketches of a horse's hoof and ear, the

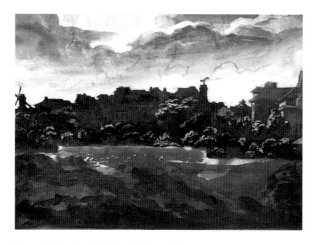

Fig. 3. Théodore Gericault, *View of Montmartre* (B. 1710), c. 1816–20. Brush and brown wash, watercolor, and gouache with traces of black crayon, 187 × 264 mm (7⅜ × 10⅜ in.). Private collection. Photo: Courtesy Galerie Jan Krugier, Geneva

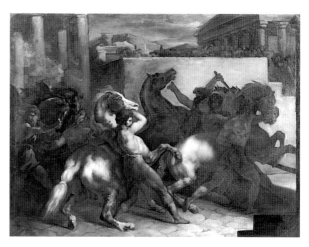

Fig. 4. Théodore Gericault, *Race of the Riderless Horses, 1817.* Oil on paper mounted on canvas, 45 × 60 cm (17¾ × 23⅝ in.). Musée du Louvre, Département des Peintures, inv. RF 2042. Photo: © RMN

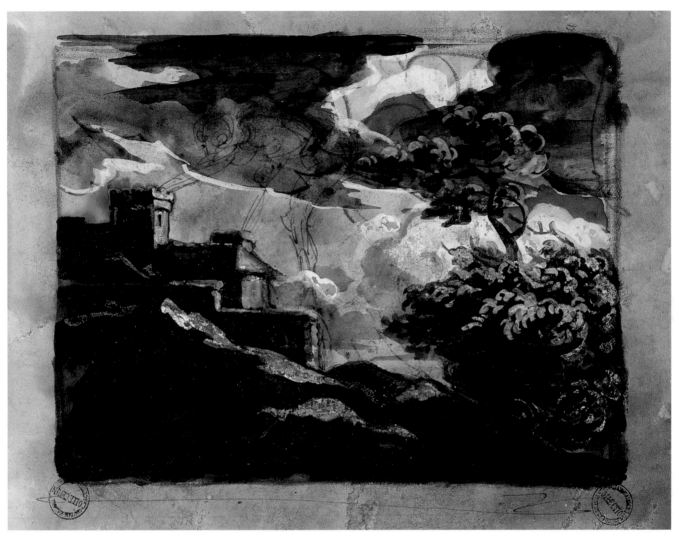

31 Recto

relationship of the SCMA sheet to the race of the riderless horses has less to do with the protagonists of the race than its setting: the composition of *Landscape with Stormy Sky* is almost exactly repeated in the background vignette of architecture in a mountainous landscape in the Louvre's *Race of the Riderless Horses (La Mossa)* of 1817 (fig. 4). The SCMA sheet and another drawing (B. 1149) may also be associated in a more general way with the background landscape vignette in the Musée de Rouen's *Horse Held by Slaves* (B. 1373). The intent of these drawings and the painted vignettes is not to record an actual site recognizable to the viewer but rather to evoke mood and setting. However, while the painted vignettes recede as backdrops for the drama of men restraining powerful horses, landscape is advanced as the subject of the drawings and, in the SCMA sheet in particular, becomes a theater of stormy skies, swirling clouds, and wind-blown trees.

If *Landscape with Stormy Sky* is indeed related to the background vignette in the Louvre's *Race of the Riderless Horses,* it follows that the drawing preceded the painting, possibly as a study, and further, that the gouache drawing would have been completed while Gericault was in Italy. The pen and ink sketch on the reverse of the SCMA sheet presents a different story. Unlike the imaginary scene of *Landscape with Stormy Sky,* the specificity of the ink sketch of domestic architecture and trees on the verso of the SCMA sheet indicates that it was drawn from an actual site. In 1960 Eitner first suggested that SCMA's verso ink sketch represented the courtyard of the artist's residence on the rue des Martyrs in Montmartre, where Gericault lived from 1813 until his death. Montmartre appears as the subject of a number of the artist's drawings, including the watercolor and gouache *View of Montmartre* (B. 1710) and a pen and ink sketch in the Ecole des Beaux-Arts, Paris (B. 755), which shows the same skyline view.[9]

Eitner's early suggestion that the SCMA ink sketch represents Montmartre was recently reinforced by his comparison of an etching after Charles Regnier's (1811–1862) 1837 drawing of Gericault's house published in A. P. Martial's *Ancien Paris* (fig. 5)[10] to the SCMA ink sketch and to the gouache drawing published by Berger and Bazin as *Italian Landscape* (B. 1146). The buildings in the SCMA sketch, whether or not they represent the artist's home at 23, rue des Martyrs,[11] do accord with the general architecture of the print after Regnier's drawing.[12] While Bazin considers *Italian Landscape* an imaginary scene, Eitner points out that it almost exactly repeats the architecture as well as the angle of view in the etching. Based on this, a strong case can be made to reidentify this drawing as Montmartre rather than an entirely invented scene.[13]

If *Landscape with Stormy Sky* was completed in Italy, the question remains whether, as Eitner suggests, the ink sketch was completed in 1815–16 before Gericault's departure from Paris or after his return. In this case, the physical relation on the sheet of the sketch to the

Fig. 5. A. P. Martial, after [Charles] Regnier, *Gericault's House in Montmartre*. Etching, from A. P. Martial, *Ancien Paris* (Paris, 1866). Photo: Courtesy of Peter Blank, Stanford Art & Architecture Library

gouache may provide some insight. The SCMA sheet is taken from a sketchbook whose binding remnants are visible at the top edge of the pen and ink sketch (and at the right edge of the gouache and watercolor drawing). Prior to removal from the book, the pen and ink sketch would have occupied the recto side of the folio and the imaginary landscape the verso. When the sketchbook was in use, it is logical to assume that the recto side of the page would have been completed before its reverse. Because of the significant staining of the media of *Landscape with Stormy Sky* through the paper, it is also reasonable to conclude that the ink sketch was done first, when the sheet was fresh, and that the sketchbook sheet was used later for the more materially complex drawing.[14] Eitner agrees that the ink sketch was probably executed first and occupies what should be considered the recto of the sheet.[15]

It may therefore be proposed that the SCMA sheet dates within a two-year span: the ink sketch, drawn first in 1815–16 before the trip to Italy, and the gouache drawing *Landscape with Stormy Sky,* executed in Italy in 1817 in

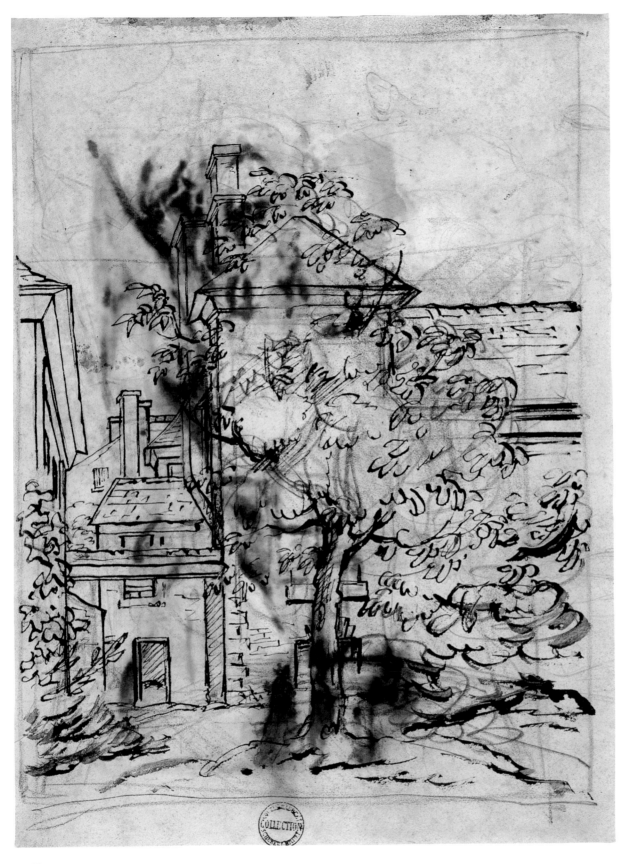

31 Verso

connection with the artist's studies and paintings on the theme of the race of the riderless horses.[16] However, the ultimate key to understanding the SCMA sheet in relation to Gericault's other gouache and watercolor landscapes may lie in further research to reconstruct the sketchbook and the drawings that once belonged to it. The SCMA sheet was once a part of the prestigious group of Gericault drawings owned by the collector L.-J.-A. Coutan, who amassed a collection that included works by David (cat. 27), Ingres (1780–1867), Antoine-Jean Gros (1771–1835), Anne-Louis Girodet-Trioson (1767–1824), Alexandre Gabriel Decamps (1803–1860), Richard Parkes Bonington (1801–1828), Horace Vernet (1789–1863), and others. As Eitner first suggested in 1960, a number of the many Gericault drawings that share the Coutan-Hauguet provenance may have come from the same dismembered sketchbook, including the SCMA double-sided drawing and the *Italian Landscape* (B. 1146), whose sheet dimensions match.[17]

LM

1. The other drawings by Gericault owned by the museum are ink sketches. One contains fragmentary drawings of heads, arms and legs, a crowned head of Bacchus, a profile of Hercules, and a seated figure seen from the rear (1929:11-1; Bazin 1987–94 [hereafter abbreviated as B.], no. 470); the other is a double-sided drawing, with a mounted officer and a sketch possibly for Hercules and Anteus on the recto of the page (1941:6-1; B. 855) and a sketch of a horse's forelegs on the verso (B. 856).

2. Eitner 1983, p. 89.

3. Letter of 20 June 1960, from Lorenz Eitner to Robert O. Parks (SCMA curatorial files). Eitner lists as related drawings "one in the Ackerman coll., another in the coll. of P. A. Hendricks . . . Johannesburg, South Africa (140 × 210 mm), representing a villa amidst tall trees, stormy sky; a mountainous landscape in the Musée Bonnat . . . , cloud studies, also at Bayonne."

4. The landscape drawing that Eitner described in his letter of 20 June 1960 to Parks as a villa amid tall trees (and whose dimensions he gives as 140 × 210 mm) may be the drawing catalogued by Bazin (1987–94) under no. 1155 as "auteur inconnu."

5. Gary Tinterow has more recently dated the *View of Montmartre* (B. 1710) after Gericault's return from Italy (Tinterow 1990–91, pp. 41–42). In his discussion of the *View of Montmartre* sheet (no. 4), Tinterow dates the verso drawing of a Lapith battling a centaur, copied after Montfaucon's *Antiquité expliquée et représentée en figures* (1719), no later than 1815–16, but puts forward the opinion that the gouache drawing of Montmartre dates after the artist's return from Italy in 1817 and may date from as late as 1820. He relates the portentous mood of the gouache drawing to the Musée Bonnat cloud drawings, which Philippe Grunchec identifies as studies for the *Raft of the Medusa* from 1818–19 (in IEF 1985–86, under no. 64, *Sailboat on a Raging Sea,* which Grunchec also associates with the *Raft of the Medusa).*

6. Berger 1952, pp. 68–69, no. 30, pl. 30.

7. Bazin 1987–94, vol. 4, p. 68: "Sur la feuille (cat. 1339) l'artiste a tracé des chevaux pris sur le vif, sans doute pour la *Mossa,* mais il a recouvert le verso qui lui aussi portait des croquis de chevaux par un paysage à la gouache enlevé à la diable (cat. 1146) semblable d'ailleurs à un autre paysage également à la gouache (cat. 1147 [SCMA]) sous lequel on distingue le même type de croquis."

8. See Eitner 1983, pp. 117–34, and Whitney 1997, pp. 89–155, for a description of the race and Gericault's treatment of this theme.

9. See also B. 220, 755, and 1709. As Eitner points out in a letter to the author, 9 Nov. 1995 (SCMA curatorial files), B. 755 is a view of Montmartre, which is incorrectly catalogued by Bazin as *Vue de Belleville(?).* Eitner considers the small pen and ink wash sketch of Montmartre (B. 200) from the Zoubaloff sketchbook (Louvre) to provide a firm dating point of 1815 for a group of Montmartre drawings, including SCMA's ink sketch, and B. 755, 1709, 1710, 1146, as well as drawings from the Musée Bonnat, Bayonne (B. 1149 [1150 verso], 1151 [1152 verso], and 1153 [1154 verso]).

10. Martial 1866, vol. 1, no. 35. The caption below the etching reads, in part, *dessin par Regnier 1837* (drawing by Regnier); at the lower right are the initials *AM.* Adolphe Martial (pseudonym of Adolphe-Théodore-Jules Potemont, 1828–1883) apparently made the etching after an original drawing of Gericault's house by Regnier (presumably Charles Regnier). The author is grateful to Bernard Barryte, Associate Director and Chief Curator, Iris & B. Gerald Cantor Center for Visual Arts at Stanford University, for examining the print in the copy of *Ancien Paris* held by Stanford's art history library.

11. In the caption for Martial's etching (after Regnier's drawing) of Gericault's house in *Ancien Paris* (fig. 5, see note 10), the artist's residence is given in the caption as 21, rue des Martyrs. Bazin (1987–94, vol. 1, "Domiciles et Résidences," pp. 165–69) gives the address as 23, rue des Martyrs at the time Gericault and his father lived there. He explains the changes from the old to new numbering system effected between 1847 and 1851, when the former 21 and 23, rue des Martyrs were together redesignated 21. Therefore, when *Ancien Paris* was published in 1866, the caption for Gericault's house reflected the new street number.

12. Bazin (1987–94, vol. 4, p. 68) describes both *Italian Landscape* and *Landscape with Stormy Sky* as "works of the imagination" and notes that both gouaches are treated with the same "monumental style" he associates with Gericault's Italian period. However, he also notes that the architecture in the SCMA ink sketch "could be French."

13. Letter from Eitner to the author, 9 Nov. 1995 (SCMA curatorial files). It should be noted that Eitner maintains that both sides of the SCMA sheet date from 1815–16, before the artist's trip to Italy. He therefore presumably would not accept Bazin's identification of the pencil sketch of horses on the verso of the so-called *Italian Landscape* (B. 1146) as a study related to the race of the riderless horses. If, on the other hand, this sheet presents the same dichotomy as the SCMA sheet — that is, a side that was apparently drawn in Paris (a view of Montmartre) and the other side drawn in Italy and related to the race of the riderless horses — the presence of the sketch of a horse's head, visible in the clouds but underlying the gouache layer, adds a complicating factor. It appears to be stylistically similar to the pencil sketch of horses fighting (B. 1339) on the reverse of the sheet, and if Bazin is correct that the horses, including the partial sketch under the gouache, are associated with the Mossa, then it follows that both sides of this sheet were drawn initially in Italy, with the gouache drawing of Montmartre executed after the artist returned to Paris.

14. Other physical clues support the theory that the ink sketch was executed before the gouache landscape. Craigen Bowen, conservator at the Center for Technical Studies and Conservation, Harvard Art Museums, noted that if the sketch had been drawn after the gouache had been completed, the deformation lines of the ink sketch, which are visible on the opposite side of the sheet, would show loss, transfer, or fracture of the gouache medium

from the pressure of the stylus (examination of the drawing at SCMA, 25 April 1996, with SCMA staff members Ann Sievers and David Dempsey). There is no evidence of loss or damage along these lines.

15. Letter from Eitner to the author, 9 Nov. 1995.

16. In the author's opinion dating the SCMA sheet ink sketch to 1815–16 and the gouache drawing to c. 1817 presents the strongest of several plausible explanations. It is also possible, as Eitner suggests, that both sides of the drawings were executed in 1815–16 before Gericault's trip to Italy, in which case the relation of the gouache *Landscape with Stormy Sky* to the race of the riderless horses would be weakened if not discounted entirely. Alternatively, both sides of the SCMA sheet or the gouache draw-ing alone might be seen to date after the Italian trip (again discounting a relation to the race of the riderless horses), in which case the sheet would be more closely associated with Tinterow's dating of the *View of Montmartre* gouache and Philippe Grunchec's dating of the Musée Bonnat cloud studies.

17. In contrast, the sheet dimensions of *View of Montmartre* (B. 1710) are smaller (187 × 264 mm) compared with the dimensions of the SCMA sheet (214 × 286 mm) and *Italian Landscape,* indicating that this drawing came from a different notebook or that the sheet was trimmed. However, like SCMA's sheet, *View of Montmartre* is a double-sided drawing whose recto and verso apparently date from different years (see note 5 above).

LOUIS-LÉOPOLD BOILLY
La Bassé 1761–1845 Paris

32 *The Happy Family (Le Bon Ménage),* study for the painting *L'Heureuse Famille,* c. 1829–30

Black and white chalks, with stumping, on tan wove paper

Watermark: None

242 × 278 mm (9½ × 10¹⁵⁄₁₆ in.)

Inscriptions: None

PROVENANCE Possibly in anonymous sale, Paris, C.P. [*commissaire priseur*] Ridel, 20–21 April 1846, no. 101; possibly in sale (Général Ribourt), Paris, C.P. Tual, 25–26 March 1895, no. 11(?); C. Bernard (collector's mark, not in Lugt, blind-stamped on former mat at lower right, according to memo in SCMA curatorial files);

{Helene C. Seiferheld, New York}, by 1960; {Nathan Chaikan, New York}; sold to SCMA in 1961

LITERATURE Harrisse 1898, p. 177, no. 1086; *ArtQ* 1961, p. 399, repr.; *ArtJ* 1961–62, p. 124; Meder/Ames 1978, vol. 2, p. 214, no. 221, repr.; to be included in Etienne Bréton and Pascal Zuber, *Catalogue Louis-Léopold Boilly,* Paris (catalogue raisonné, in progress)

EXHIBITIONS New York 1960, no. 74; Northampton 1979b, no. 90; Northampton 1988–89; Northampton 1992b, no. 15

Purchased
1961:84

Louis-Léopold Boilly was a prolific portraitist and observer of late-eighteenth- and early-nineteenth-century Paris whose social panoramas of life on and off the streets of the city were painted in a highly refined style with a miniaturist's eye for detail. An accomplished trompe-l'oeil and still-life artist trained in Arras in northern France, Boilly began working in Paris after his arrival in 1785 as a painter of gallant subjects — small paintings of amorous encounters for private patrons. His ability to adapt to a society of radically changing tastes and politics was demonstrated by his willingness to transform and tailor his subject matter to the scenes of modern life he painted to appeal to the post-Revolutionary public. While his Salon paintings of the urban spectacle of the boulevards established his reputation, his portrait production, estimated at 4,500 to 5,000 paintings, provided a reliable income. Genre subjects and scenes of domestic life such as the Smith College drawing, *The Happy Family,* increasingly engaged Boilly's attention in the last stages of his career.[1]

The Happy Family is a late work, dating near the beginning of Boilly's retirement, which was marked by the sale of the contents of his studio and private collection in 1829. The Smith College drawing is one of at least two known preparatory studies for Boilly's painting of the same title, last recorded in 1984 in a private collection in France (fig. 1). There is a closely related oil sketch (fig. 2) and possibly another pen and ink sketch, whose present

Fig. 1. Louis-Léopold Boilly, *The Happy Family,* c. 1829–30. Oil on canvas, 27 × 33 cm (10⅝ × 13 in.). Private collection. Photo: Courtesy of Etienne Bréton and Pascal Zuber

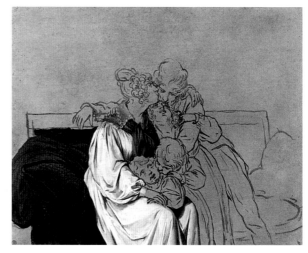

Fig. 2. Louis-Léopold Boilly, study for *The Happy Family,* c. 1829–30. Oil on paper, 235 × 304 mm (9¼ × 11¹⁵⁄₁₆ in.). Photo: Courtesy of Emmanuel Moatti

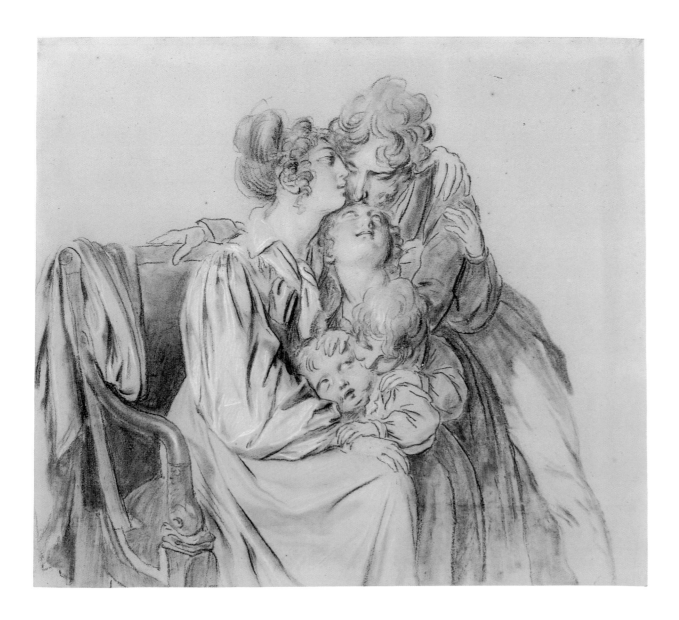

whereabouts are unknown.[2] While a number of Boilly's genre works were conceived as pendants, such as *Première Dent* and *Dernière Dent* of about 1826 (a humorous pairing of baby's first tooth and grandmother's last),[3] the painting for which the Smith College drawing is a study does not appear to belong to a pair. Instead, it conveys a certain mildly satiric contrast of opposites, in that mother, father, and eldest child are shown sharing a happy kiss at the top of the family (and compositional) pyramid while the middle child bites the cheek of the youngest sibling seeking escape in mother's lap.

Twice married and the father of ten children (five of whom survived), Boilly sometimes used his own children as models in his work, for example in the painted and engraved versions of *Mes Petits Soldats (My Little Soldiers)* of 1809, which depict his sons Julien, Edouard, and Alphonse from his second marriage.[4] However, most of the children in his genre paintings, and indeed most of his figures, are differentiated more according to costume and

social setting than as individuals. Like actors in a repertory company, they could be recast in a variety of ways. A striking example is Boilly's reuse of the central group in the 1812 Salon painting *Entrance to the Turkish Garden Café* (private collection, Australia), which is exactly quoted in the painting *The Marionette Performance* (Jacques Kugel, Paris) of the same year.[5] The artist has simply moved his figures — a mother and her three children watching a street boy's marionette — from an outdoor setting in the Marais district to an interior scene in a bourgeois household.[6] This trio of siblings, or a very similar combination of children of the same age, sex, and type, appears again in *The Happy Family* painted nearly two decades later. As Susan Siegfried points out, the artist developed an inventory of figures, which allowed for a "level of generality [that] invites viewers not only to identify with the characters, but also to help construct the story and project themselves into the scene."[7] Siegfried also notes that Boilly's blurring of social distinctions

served the new family ideology, in which age and gender were emphasized over class and promoted the bourgeois "type" as an image of social unity.[8]

The Smith College sheet and its related oil sketch[9] show that the artist made few major changes in the family group portrayed in the final painting but altered the furnishings instead. In the partially completed oil sketch, the settee is longer and parallel to the picture plane, there are pillows that do not appear in the Smith College drawing or in the finished painting, and the mother's scarf is red, instead of white. In SCMA's drawing, the settee is shown basically as it appears in the painting, with a drapery over the left corner, but the back support cushion lacks the crisscross pattern of the final painted version. The Smith College drawing also does not include the small table with glassware to the right of the family group that appears in the painting. Because the drawing appears to be closer than the oil sketch to the painting, not only in details of furniture and costume elements but also in the hand positions of the figures, it can be suggested that the oil sketch preceded SCMA's sheet.

In addition to the sketches and painting, Boilly also produced a lithograph of *The Happy Family,* which was published as *Le Bon Ménage* (and was thus probably the source of the secondary title by which the Smith College drawing and oil sketch are known). The lithograph, dated 1830, reverses the composition; an engraved version, possibly made after the lithograph, restores the image to its original orientation.[10] Boilly's early biographer Henry Harrisse notes that the popular or familiar title of the lithograph was *Une Fricassée de Museaux* (roughly, a "stew of mugs").[11] From 1820 to about 1830, Boilly produced lithographs on popular or satiric subjects,[12] including his well-known *Recueil de Grimaces* lithographic series published by François-Séraphim Delpech (1778–1825) from 1823 to 1828. Although *Le Bon Ménage* was produced after the series, John Hallam associates it and other separately published lithographs as a type related to the *Grimaces* and notes a specific compositional (and thematic) relationship between *Le Bon Ménage* and *Le Neuvième Mois (The Ninth Month)* of about 1823, in which a husband solicitously embraces his expectant wife.[13]

LM

1. The work of Susan L. Siegfried is the most important source of information on the artist. For Boilly's early career and transition from a painter of gallant subjects, see Siegfried 1995, esp. the chapters "Persona and Status" (pp. 1–27) and "An Artist Negotiates the French Revolution" (pp. 28–55).

2. The painting was included in the exhibition Paris 1984b, no. 34, repr. Harrisse 1898 records the painting (no. 304), the oil sketch (no. 305), the SCMA sheet (no. 1086), and another pencil and ink sketch (no. 1087). The last is titled *L'Heureux Ménage* and is mentioned with reference to the lithograph after the painting (no. 1885). It is possible, therefore, that the pen and ink sketch (no. 1087), whose whereabouts remain unknown, is a study after the painting for the lithograph. However, as Etienne Bréton, co-author of the forthcoming catalogue raisonné of the works of Boilly, has suggested in a letter to the author (12 Nov. 1996; SCMA curatorial files), Harrisse may have mistakenly catalogued the SCMA drawing twice (as nos. 1086 and 1087). This is also suggested by Harrisse's confusion in listing the provenance for nos. 1086 and 1087. Therefore, as Bréton has advised, the early history for SCMA's drawing incorporates the 1846 and 1895 sales with reservations.

3. See Lille 1988–89, nos. 48 and 49, repr.

4. Ibid., no. 39, repr.

5. See Paris 1984b, no. 26. The entry cites the traditional interpretation of the family group as the artist's second wife, two daughters, and youngest son, Adolphe, who would have been eleven in 1812, when the painting was completed.

6. Siegfried, in London/New York 1991, p. 18, figs. 3 and 11. Siegfried also discusses the use and reuse of other figures in *The Entrance to the Turkish Café,* including transpositions across societal levels.

7. Siegfried in London/New York 1991, pp. 24–25.

8. Siegfried 1995, p. 141.

9. Most recently this sketch, formerly in the Georges Danyau collection (Lugt 720), was included in the sale, New York, Sotheby's, 16 May 1996, no. 117, repr. Previously it was held by the Shepherd Gallery, New York (in 1987), and by the dealer Emmanuel Moatti, Paris (by 1993).

10. Harrisse catalogues the lithograph but not the engraving. The lithograph (Harrisse 1898, no. 1229) is reproduced in Marmottan 1913, p. 192. Both the lithograph and engraving are described in the catalogue for New York 1987 and were offered with the oil sketch (no. 40, repr.).

11. Harrisse 1898, no. 1229.

12. Lille 1988–89, p. 134.

13. Hallam 1983, pp. 130–31. Hallam notes that the lithographs *Le Deuxième Mois* (Harrisse 1898, no. 1358) and *Le Neuvième Mois* (Harrisse, no. 1359) are pendants, because both treat stages in the theme of pregnancy. He relates the lithographs to two small paintings on wood at the Museum of Art, Rhode Island School of Design, Providence. These works are catalogued in Rosenfeld 1991 as attributed to Boilly (see p. 214, P13 and P14, repr.). A charcoal drawing entitled *The Happy Wait* or *The Ninth Month,* signed and dated 1807 (15¼ × 12¾ in.), recently appeared on the art market (New York 1998, no. 17, repr.). In this highly finished drawing, the wife clasps her husband's hand over her obvious pregnancy, while the family dog rests its head on her knee. This compositional type, the prelude to the happy family group, is another motif Boilly reused and adjusted as needed.

EDGAR HILAIRE GERMAIN DEGAS
Paris 1834–1917 Paris

33 *Boy Holding a Trophy* (formerly titled *Boy Leading a Horse*), study for the painting *The Daughter of Jephthah*, c. 1859–61

Graphite on beige wove paper

Watermark: None

Sheet, irregular, trimmed: 319 × 247 mm (12⁹⁄₁₆ × 9¾ in.)

Inscribed verso, at lower center, in graphite: *a/*[?] or *2/*[?]

PROVENANCE Edmond Degas, the artist's nephew; Marcel Guérin (1873–1948), Paris;[1] sold to SCMA in 1934

LITERATURE Abbott 1934, p. 5, fig. 3; SCMA 1937, pp. 40, 131, repr.; Kennedy 1953, p. 6 note 6; Haverkamp-Begemann, Lawder, and Talbot 1964, vol. I, p. 77; SCMA 1986, no. 237, repr.

EXHIBITIONS New London 1950; New Haven 1953; Northampton 1958a, no. 18 (as *Boy Leading a Horse*); Berkeley 1960, p. 56; Bloomington 1968, no. 37; Boston 1974, no. 69; Northampton 1977; Northampton 1979b, no. 121; Northampton 1982a; Northampton 1983a, no. 34; Northampton 1984b, no. 14

Purchased, Winthrop Hillyer Fund
1934:1

34 *A Man Carrying an Urn*, study for the painting *The Daughter of Jephthah*, c. 1859–61

Graphite on cream wove paper

Watermark: None

Sheet, trimmed: 302 × 213 mm (11⅞ × 8⅜ in.)

Inscribed recto, lower right, in pencil: *Ph1913*; inscribed verso with Georges Petit catalogue photography numbers.

PROVENANCE In the artist's atelier at his death (Lugt 657, lower right recto) and in his estate sale (Lugt 658, lower right recto), Paris, Galerie Georges Petit, (Atelier Edgar Degas *Vente IV*), 2–4 July 1919, no. 119d, repr.; Jesse Shapiro, New York, by 1968;[2] to her estate (sale, New York, Sotheby's, 26 Feb. 1990, no. 11, repr.); to {Frederick J. Cummings (d. 1990), New York}; to {W. M. Brady & Co., Inc., New York}, in 1990; sold to SCMA in 1991

LITERATURE Mitchell 1937, p. 185, fig. 21; *GBA* 1993, no. 275, p. 60, repr.

EXHIBITIONS New York 1990, no. 39, repr.; Northampton 1992b, no. 4

Purchased, Beatrice Oenslager Chace, class of 1928, Fund; Diane Allen Nixon, class of 1957, Fund; and funds given in memory of Mimi Norcross Fisher, class of 1959, by her family and friends; by Jill Capobianco, class of 1986; by friends of Katherine Mosser Pediconi, class of 1918, in her memory; by Ann Nichols in honor of Janice Carlson Oresman, class of 1955; and by Marjorie L. Harth, class of 1965
1991:17

35 *Gesturing Men*, study for the painting *The Daughter of Jephthah*, c. 1859–61

Graphite on beige laid paper

Sheet, irregular: 333 × 216 mm (13⅛ × 8⁹⁄₁₆ in.)

Watermark: Three stars in a crest

Inscribed verso, center, in blue pencil: *1611*; in graphite: *44⁵ · 31⁵*

PROVENANCE In the artist's atelier at his death (Lugt 657, lower left recto) and in his estate sale, Paris, Galerie Georges Petit, (Atelier Edgar Degas, *Vente I*), 6–8 May 1918, no. 6b; Olivier Senn,

Paris (presumably); Mme Olivier Senn, Paris; {Galerie du Cirque, Paris}; {Alex. Reid & Lefevre, Ltd., London}, in 1961 (stock no. 13/16); to George S. Heyer, Jr., Austin, Texas, Sept. 1965; gift to SCMA in 1998

EXHIBITIONS London 1964, no. 77; San Antonio 1995, p. 93

Gift of George S. Heyer, Jr., in honor of Isabel Brown Wilson, class of 1953
1998: 15

The Daughter of Jephthah (La Fille de Jephté; fig. 1) is one of Edgar Degas's most ambitious paintings, in size, composition, and intent.[3] Begun in 1859 after the artist had returned from Italy, the canvas was never brought to completion. Its unfinished state reveals the young artist's struggle to reconcile a variety of influences and quotations from other masters, ranging from Andrea Mantegna (1431–1506) in the fifteenth century, to Paolo Veronese (1528–1588) in the sixteenth, to Eugène Delacroix (1798–1863) in his own.[4] This confrontation of styles set the stage for the biblical drama of Jephthah, called from exile to lead the Israelites against the Ammonites. In the story from chapter eleven in the Book of Judges, Jephthah vows to sacrifice the first from his household to greet his return if God will grant his army victory in battle. In the painting, the conflation of triumph and tragedy is played out as Jephthah, mounted on his horse among his soldiers carrying the spoils and trophies of war, turns away from his daughter, a figure in white gesturing toward him from a group of women, who already seem to mourn her fate.[5]

This grand history painting, obviously intended for the Salon, finally reached a stalemate after two years of notebook sketches, numerous individual preparatory drawings, and a small group of oil studies.[6] Although the artist may have returned to the canvas at a later time, the legless leaping dog suspended in the foreground remains as a metaphor for Degas's attempts to resolve the warring elements of composition and style and the theatrical, complex interplay of figures. The brilliant but flawed canvas remained in the artist's possession until his death and passed through several owners after the atelier sale until it was purchased by the Smith College Museum of Art in 1933.

A year after *The Daughter of Jephthah* was acquired for the collection, Jere Abbott, director of the museum from 1932 until 1946, purchased the preparatory drawing *Boy Holding a Trophy,* then known as *Boy Leading a Horse,* from

Marcel Guérin.[7] Correspondence at the time indicates that Guérin had also offered the museum other studies for purchase consideration, and a letter from Abbott to Smith College President William A. Neilson concerning the *Boy Holding a Trophy* mentions that "it might be interesting from time to time, as they become available, to acquire some of the original sketches for our painting."[8] However, almost sixty years would pass before a second preparatory drawing for *The Daughter of Jephthah, A Man Carrying an Urn,* was purchased by the museum.[9] This drawing was sold in the fourth sale (1919) of works remaining in Degas's studio, along with a number of other preparatory sketches and figural studies for the painting. A third preparatory drawing for the painting, *Gesturing Men,* was given to the museum in 1998 by a private collector.

Boy Holding a Trophy is a drawing of a youthful figure, sketched swiftly in the upper body and more carefully studied in the position and balance of the legs; in the right margin, there is a drawing of a bearded profile (possibly a study for Jephthah himself). *A Man Carrying an Urn* is a more fully delineated figural study emphasizing the weight of the burden being carried and its effect on the body. Both of these drawings represent figures that survived to be included in the final painting, where they bracket the figure of a soldier raising a palm branch, a symbol of victory and sacrifice.[10] The pose of the youth in *Boy Holding a Trophy* closely resembles the figure in the canvas. In an early compositional study (fig. 2), which arrays a complex frieze of soldiers that Degas later reduced and simplified, the figure is an adult soldier, whom Degas evidently decided to change into a more youthful figure.[11] The urn bearer seems to have undergone a similar evolution. In the compositional study, a version of the figure stands to the right of a partially clothed striding figure. Although the urn bearer's back faces the viewer, his function is indicated by his posture (back and knees

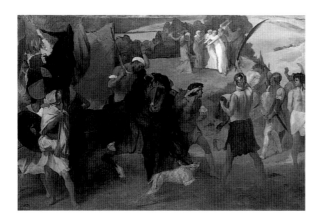

Fig. 1. Edgar Degas, *The Daughter of Jephthah,* 1859–61. Oil on canvas, 195.5 × 298.5 cm (77 × 117½ in.). Smith College Museum of Art, Purchased, Drayton Hillyer Fund, inv. 1933:9-1. Photo: David Stansbury

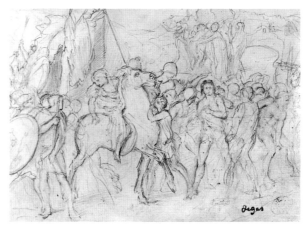

Fig. 2. Edgar Degas, composition sketch for *The Daughter of Jephthah,* c. 1859–61. Graphite, 184 × 260 mm (7¼ × 10¼ in.). Private collection. Photo: Courtesy of Wildenstein & Co., Inc.

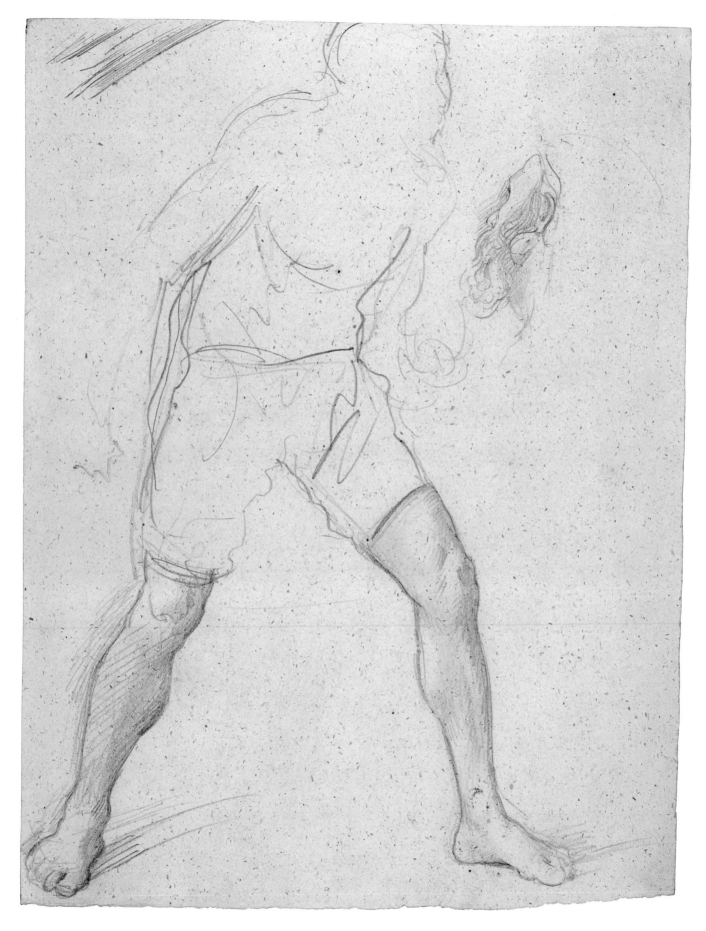

33

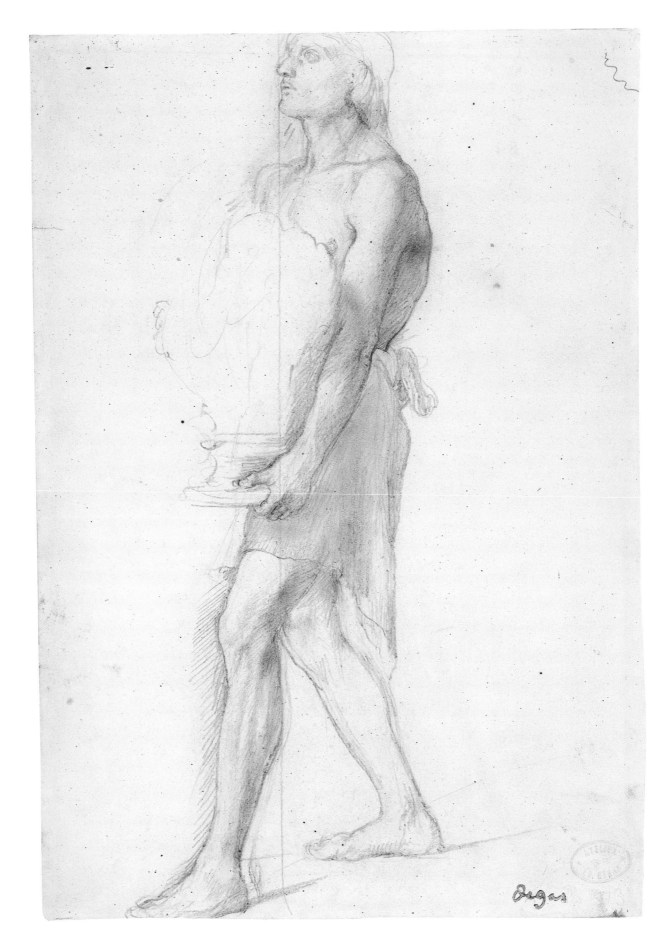

34

144 EDGAR HILAIRE GERMAIN DEGAS

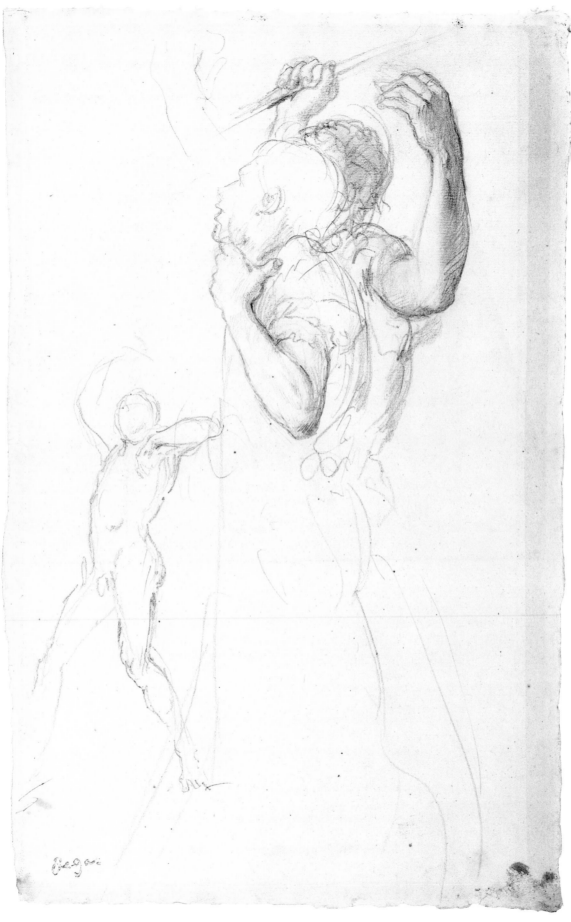

35

slightly bent, visible arm held low) and by the delicately sketched urn or amphora, whose handle, body, and neck can be discerned in outline. In the painting the urn bearer has been displaced from the foreground to the middle ground and his position in the composition has been assumed by the soldier with the palm branch.

Of the three figures in *Gesturing Men* — one a full-length, quickly sketched male nude, the others a pair of striding male figures in profile whose arm positions are carefully observed — only one of the tandem figures and a detail of the other appear to have been incorporated in the painting. The outermost figure of the pair is reflected at the extreme right of the painting in the man wearing an ochre cloak, behind the urn bearer and the bound slave. In the drawing, the figure's raised right arm is barely indicated, while Degas chose to study the left arm and hand, positioned as if to grasp an object. This decision was reversed in the painting, where only the upraised right arm is visible and the left is instead entirely covered by drapery. The left arm of his companion, fully realized and shaded in the drawing, is the only detail of this figure to appear in the canvas, where it is barely indicated by a few outline strokes. The partially sketched nude figure on the left side of the sheet may be analogous to the figure in the compositional study (fig. 2) behind and to the right of the figure that ultimately became the boy holding a trophy; however, this figure does not appear in the painting.[12]

The urn bearer and boy appear in other studies in addition to the Smith College sheets. Another drawing of the boy, with greater attention to the upper body and torso in contrast to the Smith sheet's emphasis on the boy's legs, was sold in the fourth atelier sale (no. 119a). A related drawing of the youth, holding a large trophy but facing left, studies a variety of leg positions.[13] The bearded head in profile, which appears as a separate study on the recto of the Smith sheet, seems to be related to heads in another preparatory drawing for *The Daughter of Jephthah* in the collection of the Fogg Art Museum, Harvard University.[14] A quickly sketched version of the urn bearer, closely related to the Smith College drawing, appears in notebook 16 (fig. 3).[15] In the notebook sketch and SCMA's drawing, the urn bearer is now turned more toward a three-quarter profile view rather than the rear view of the compositional sketch. In notebook 14a (p. 30) there is a careful drawing of two urns with a notation identifying the sketch as a study for "le vase que tient l'homme devant le cheval" (the vase held by the man in front of the horse) and other notations regarding color and decoration.

The Smith College drawings, like many of the sketches for the painting, reflect old-master and nineteenth-century sources. As Theodore Reff has documented, three of Degas's notebooks and parts of three others are filled with sketches, copies, and notes that pertain to the development of the canvas; Andrea Mantegna and Albrecht Dürer (1471–1528) are primary sources for the military aspects and accoutrements of the scene, but

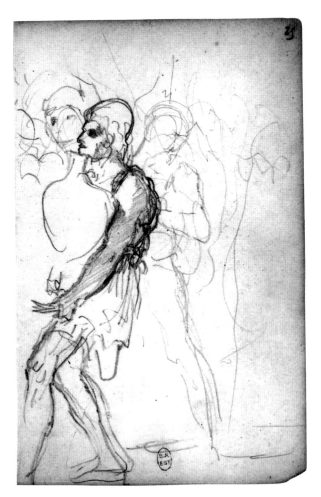

Fig. 3. Edgar Degas, *Man Carrying an Urn*, notebook 16, p. 25 (notebook in use c. 1859–60). Graphite. Bibliothèque Nationale, Paris, Carnet 27B 41909

Degas also borrowed liberally from Delacroix and other artists as well whose works are copied in the same notebooks that include studies for *The Daughter of Jephthah*.[16] A number of Degas's references are nearly direct quotations of other works, which are then modified through subsequent sketches and life studies to suit the final composition. One such quotation is the standard bearer to the left of Jephthah, copied from a print source after the eighth canvas of Mantegna's *Triumph of Caesar* (1486– c. 1492, Hampton Court, England) in notebook 15 (p. 21) and later adjusted in pose for the painting. Likewise, the Smith College drawing of the urn bearer seems to derive from Mantegna's *Triumph of Caesar*. The prominent figure of vase bearer in the fourth *Triumph* canvas, an older man who carries an immense trophy, is a possible source of influence, but the pose of another figure in the foreground of the second canvas — a man carrying a statuette (fig. 4) — is very strongly recalled in the position of the legs and left arm of Degas's urn bearer. In the case of both the Smith College and notebook drawings for the urn bearer, Degas seems to have substituted a vase for the large female statuette (which holds a jug in its right

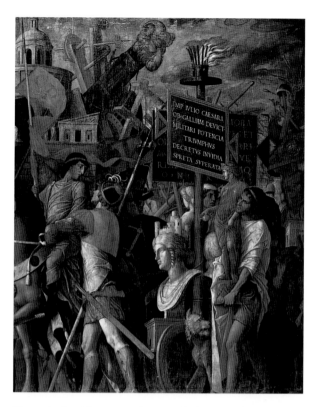

Fig. 4. Andrea Mantegna, *The Triumph of Caesar: The Triumphal Car* (detail), 1486–c. 1492. The Royal Collection, inv. RTW 2911/B, © Her Majesty Queen Elizabeth II. Photo: Rodney Todd-White & Son

Boy Holding a Trophy may be related to a fifteenth-century source, Benozzo Gozzoli's (1420–1497) *Procession of the Magi* fresco (1459, Palazzo Medici-Riccardi, Florence), which Degas copied in several drawings.[19] There is no direct match between the boy and a particular figure in the fresco itself, but there is a drawing in notebook 12 (fig. 5) that, as Reff points out, seems to be a preliminary study for *The Daughter of Jephthah* based on a loosely reworked and somewhat reinvented version of the *Procession*.[20] In this drawing the figure preceding the lead magus is a youth holding a trophy, possibly an early idea taken up again and later reworked in the Smith College sheet. A more immediate source of influence for the boy is presented by Delacroix's *Justice of Trajan* (fig. 6), another work copied by Degas in studies related to *Jephthah*. It has been pointed out that the figure restraining Jephthah's horse is based on a similar figure holding Trajan's rearing mount but reversed,[21] since the action in the Delacroix painting proceeds from right to left and in the Degas painting, from left to right. In the foreground of *The Justice of Trajan*, there is a figure of a youth, silhouetted in stark contrast against Trajan's white horse, in very much the same activated, almost crouching pose as the boy holding a trophy in the Smith College sheet, but seen from behind. Just as Degas reversed the figure

hand) being carried by the figure.[17] In contrast, Eleanor Mitchell has suggested that the drawing of the urn bearer may be a reflection of a figure in Nicolas Poussin's (1594–1665) *Rape of the Sabines* (Louvre, Paris), which Degas had also copied,[18] but Mantegna is the more likely source in this case.

Fig. 5. Edgar Degas, study for *The Daughter of Jephthah*, notebook 12, p. 93 (notebook in use 1858–June 1859). Graphite. Bibliothèque Nationale, Paris, Carnet 1865 B 37519

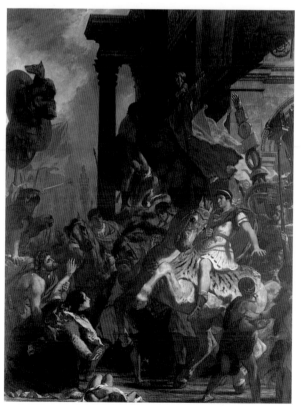

Fig. 6. Eugène Delacroix, *The Justice of Trajan*, 1840. Oil on canvas, 490 × 389 cm (193 × 153½ in.). Rouen, Musée des Beaux-Arts, inv. D.844.1. Photo: © Rouen, Musée des Beaux-Arts. Photographie Didier-Tragin/Catherine Lancien

restraining a horse in *The Justice of Trajan* to suit his own composition, he appears to have also borrowed the pose of the boy in the foreground of Delacroix's painting, but this time turning the figure from back to front in the Smith College sheet and studying this aspect of the position from a studio model posed in the same way.[22]

Gesturing Men presents a more difficult challenge. In the drawing, the paired figures seem to function as bearers of either booty or weapons, suggesting a source like a triumphal procession; however, there are no comparable figures from Mantegna's *Triumph of Caesar,* which are clearly recognizable even from Degas's more fragmentary sketches in the notebooks.[23] In the painting they hail (or react in surprise to) the sight of Jephthah's daughter and the lamenting women on the hilltop, but they do not carry arms or spoils of war.[24] In the transition from the drawing to the painting, the figure that became the man in the ochre cloak echoes the soldier raising a palm branch in the foreground, which has been identified with Degas's drawing of figures from Cesare da Sesto's (1477–1523) *Adoration of the Magi* (c. 1520, Capodimonte, Naples).[25] However, Degas also copied Leonardo da Vinci's (1452–1519) *Adoration of the Magi* (1481–82, Uffizi, Florence). Gerhard Fries associates the man in the ochre cloak with a gesturing figure that Degas picked out among many others in an abbreviated sketch made after Leonardo's unfinished masterpiece.[26] As he has noted, the figure Degas borrowed from the *Adoration* appears at the extreme right in an oil sketch, which, with certain exceptions, is close in composition to the large canvas. If the man in the ochre cloak is ultimately derived from Leonardo's *Adoration,* the paired figures as they appear in the Smith College sheet may have been a studio experiment. The second figure of the pair, who holds a rod aloft, may be based on another, as yet unidentified, source, but Degas has clearly used the Smith College sheet to study the rhyming arm positions of these two men.

The Smith College drawings and their evolution toward the canvas suggest the difficulties that finally defeated Degas's attempts to complete a picture based on so many different, and sometimes antithetical, sources, but they also reveal how Degas nearly succeeded in marshaling the disparate elements of his composition. The figures studied in these drawings eventually became key indicators in reading the narrative of the painting. In *Boy Holding a Trophy* the figure's sketchily rendered face is turned toward the viewer, but in the painting, his head is turned sharply to the left. Degas further altered the urn bearer in the final canvas by placing him on a diagonal line rather than nearly parallel to the picture plane. He walks toward the figure of the boy holding a trophy, but his head is turned in the direction of Jephthah's daughter and the group of women on the knoll. As the protagonist Jephthah closes his eyes and turns away, the boy carries the viewer's gaze toward the figure with an urn and the figure in the ochre cloak behind him, who together redirect attention to the drama taking place on the hilltop. There, the viewer "sees" with them the sight from

which Jephthah recoils: the physical and symbolic nexus of the tragedy, personified by the figure of his daughter.

LM

1. The original frame backing is inscribed in graphite (presumably in Guérin's hand): *Degas (Edgar) / Etude pour "La fille de Jephté" / provenant de son atelier, . . . n'ayant passé aux ventes; acheté à Edmond Degas son neveu* (. . . from his atelier, . . . not having passed through the sales; purchased from Edmond Degas his nephew).

2. A memorandum, dated 13 Aug. 1968 (Mira Matherny Fabian to Charles Chetham), in the SCMA curatorial files records the visit of "Mrs. Jessie [*sic*] Shapiro." The memo states that Mrs. Shapiro "said she has a drawing by Degas of the Man carrying the urn in *La Fille de Jephte*" and that she had only recently discovered "what the subject was." The memo further notes that "she seems to be a collector, knows Degas' cousin who runs art gallery in Paris, also the film maker, Renoir."

3. The literature on this painting is extensive. In addition to principal sources such as Lemoisne 1947–48 (vol. 1, no. 94), the catalogue for Paris/Ottawa/New York 1988–89 (no. 26) should be consulted for exhibition history and selected bibliography.

4. See Mitchell 1937, pp. 175–89; Reff 1963, pp. 241–51 *(La Fille de Jephté* discussed pp. 242, 242 note 12); Fries 1964, pp. 352–59 *(La Fille de Jephté* discussed pp. 354–55); Reff 1964, pp. 250–59; Reff 1965, pp. 320–21; Reff 1971, pp. 534–43 *(La Fille de Jephté* mentioned p. 537). Also see Reff 1976b, vol. 1, pp. 8, 19–21, 24, 29 note 2; notebook 12, p. 93; notebook 13, p. 58; notebook 14, pp. 2, 6, 8–10, 13, 22, 25, 30, 31, 33, 35–36, 38, 52, 80; notebook 14A, pp. 17, 18, 20–23, 30, 32; notebook 15, pp. 6, 11, 17, 18, 20–23, 30, 32; notebook 15, pp. 6, 11, 17, 18, 23, 24, 26–33, 35, 39, 40, 42; notebook 16, pp. 5, 8, 12–15, 25, 27, 29, 37, 39, 41; notebook 18, pp. 5, 6, 17, 21, 51, 59, 61, 67, 76–77, 85, 92, 94, 99, 139; notebook 19, pp. 53–57, 102A. (All references to Degas's notebooks in this article are based on Reff's numbering and pagination.)

5. Reff 1976a, pp. 153–54.

6. In Henri Loyrette's entry on Degas's copy of Mantegna's *Crucifixion* in the catalogue for Paris/Ottawa/New York 1988–89 (no. 27), he notes that the group of women surrounding Jephthah's daughter is based on Mantegna's grieving women at the foot of the cross. He revises the date of Degas's copy of the *Crucifixion* to the last quarter of 1861, when Degas is known to have reregistered as a copyist at the Louvre, and therefore extends the dates of Degas's active work on *The Daughter of Jephthah* to 1861.

7. In the painting, as well as in a number of the notebook studies, the figure that should be more properly identified as controlling or "leading" Jephthah's mount is a youth who turns toward and restrains the horse and literally leans into and against its neck and chest. This figure, dressed in blue, is not fully realized in the painting. The new title of the Smith College drawing, *Boy with a Trophy,* is based on the small trophy held in the left hand of this figure in the painting. He does not appear to lead Jephthah's horse.

8. Letters in the museum curatorial files from Marcel Guérin to Abbott and Elizabeth Payne, 23 Nov. and 26 Dec. 1933 and 30 Jan. 1934. Letter from Abbott to Neilson, 7 Dec. 1933, also in museum curatorial files.

9. The museum owns three other drawings by Degas: a sheet of studies after the Vatican Loggia frescoes (see Kennedy 1953, fig. 4), a preparatory drawing for the history painting *Semiramis*

Constructing a City (see Monnier 1978, fig. 28), and *Two Dancers* (*Vente IV*, no. 149, repr.).

10. As Theodore Reff pointed out in the lecture "Degas and the Daughter of Jephthah" presented at Smith College on 14 Dec. 1966 (transcript in SCMA curatorial files).

11. Notebook 18, p. 7 (Reff 1976b, repr.) is a compositional study that concentrates on the mounted Jephthah, a youthful figure restraining the horse, and the turning figure of an adult soldier. The relative positions of these figures are retained in the final canvas; however, the adult soldier is transformed into a boy in the Smith College drawing and in the painting.

12. Another more finished drawing (*Vente IV*, no. 118c, repr.) seems to be related in pose to this quickly sketched nude, but the figure is seen from the front, with his head downturned and his bent left arm held at chest level rather than raised above his shoulder.

13. This drawing, titled *L'Adolescent* (12 × 8½ in.), was owned by the Lefevre Gallery, London. See London 1961, no. 2, repr.

14. "Studies for *La Fille de Jephté*," graphite, 317 × 241 mm (12½ × 9½ in.), Bequest of Marian H. Phinney, 1962:28 (*Vente I*, 1918, no. 6b, repr.). The verso of this drawing contains studies of the legs and arms of the figure with a palm branch.

15. Reff 1976b, notebook 16, p. 25, repr.

16. As noted in Reff 1976b, vol. 1, p. 19.

17. The associated notebook drawing of the urn bearer (Reff 1976b, notebook 15, p. 25, repr.), however, has briefly sketched background figures that do not repeat the figures surrounding the man carrying a statue in the second canvas of the *Triumph*. Reff does not identify a source for the notebook drawing.

18. Mitchell 1937, p. 185 and figs. 2 and 21. In Poussin's painting, the figure is one of the Romans in the left foreground attempting to carry off a Sabine woman who energetically resists her captor. Given the difference in burdens, Degas's drawing of the urn bearer, if it can indeed be seen to recall the stride and general pose of the Poussin, does so in a less activated and dramatic way.

19. See Mitchell 1937, p. 182 note 2 and fig. 9; *Vente IV*, nos. 81d, 91a, b, c, repr.; and Reff 1976b, notebook 12, p. 93.

20. See Reff 1976b, notebook 12, p. 93, repr. This early sketch also includes a cropped version of the leaping dog (far right on the sheet) and the figure that restrains Jephthah's horse (at left), which appear in Degas's painting but do not seem to be directly based on or copied from figures in the *Procession of the Magi*. Unlike Degas's more faithful copies of the fresco (*Vente IV*, nos. 81d, 91a, b, c, repr.), this notebook drawing appears to be a "condensed," free version, with Degas's own interpolations. The "boy with a trophy" figure in this sketch may be a reinterpretation of the youthful figure leading Caspar's horse (which Degas copied carefully from the east wall of the fresco in no. 91c).

21. Mitchell 1937, p. 182, fig. 8.

22. *L'Adolescent*, the related drawing of the youth with the trophy facing left (see note 13), further supports the probability that Degas was experimenting with different views of this figure. It should also be noted that Ruth Wedgwood Kennedy mentioned the "beautiful youth with the windblown cloak" in Raphael's *School of Athens* (Vatican) as a possible source for the boy holding a trophy (Kennedy 1953, p. 6 note 6), but Delacroix's *Justice of Trajan* was the more likely source.

23. See, e.g., Reff 1976b, notebook 18, p. 205, repr., which includes sketches of arms, heads, and legs from a number of different figures from the *Triumph of Caesar*.

24. It is evident from the upraised arms and the direction of the open-mouthed gaze of the outermost figure of the pair in the drawing that Degas had probably intended these figures to salute Jephthah's daughter and her companions, but the inclusion of (or provision for) objects held in their hands indicate he intended them to have a double function: that is, as bearers of spoils and as a device to direct the attention of the viewer to the group of women on the hilltop.

25. Mitchell 1937, p. 184, fig. 14 (*Vente IV*, no. 86c, repr.).

26. Fries 1964, pp. 355–56, repr. p. 357. The oil sketch (private collection, Paris) is also reproduced in Reff 1976b, pl. 49, where it is dated 1860, and catalogued in Brame and Reff 1984, no. 36. In this oil sketch, the urn bearer does not appear, and the boy holding a trophy appears to be an adult soldier. The head, shoulders, and gesturing arm of this figure appear in the abbreviated study that focuses on the Virgin and the kneeling man (*Vente IV*, no. 85c, repr.; no. 85b, repr., is another compositional sketch of Leonardo's *Adoration of the Magi*).

JAMES JACQUES JOSEPH TISSOT
Nantes 1836–1902 Buillon

36 *Young Woman in a Rocking Chair,* study for the painting *The Last Evening,* c. 1873

Brush with opaque (gouache) and transparent watercolor over graphite on grey-blue wove paper

Watermark: None visible

Sheet slightly irregular, trimmed: 277 × 403 mm (10⅛ × 15⅞ in.)

Signed recto, lower left, in brown ink: *J Tissot*

PROVENANCE Robert H. Cumming (1928?–1995),[1] Marblehead, Mass.; to {Gropper Art Gallery, Cambridge, Mass.}, in 1966; sold to SCMA in 1967

LITERATURE *GBA* 1968, p. 81, no. 295, repr. (as *Etude de Mrs. Katherine Newton);* Misfeldt 1971, fig. 74a; Wentworth 1984, pp. 105,

159, pl. 85; SCMA 1986, no. 240, repr.; Wood 1986, pp. 62–63, fig. 59; New York 2000, under no. 4

EXHIBITIONS Cambridge 1966; Providence/Toronto 1968, no. 51, repr. (as *Young Lady in a Rocking Chair);* Northampton 1977; Williamstown 1978a; Northampton 1979b, no. 123; Northampton 1984b, no. 13; London/Manchester/Paris 1984–85, no. 56, fig. 59 (English ed.; see also no. 55 and exhibition brochure, checklist no. 56), no. 46 (French ed.; see also no. 45)

Purchased
1967:2

T his gouache is one of two known studies[2] for *The Last Evening* (fig. 1), one of three paintings by Tissot including *Too Early* (Guildhall Art Gallery, London) and *The Captain's Daughter* (Southampton Art Gallery and Museums) shown at the Royal Academy in 1873.[3] Anecdotal and engaging, with the high finish typical of Tissot's style, these paintings belong to a series of works painted during the artist's London period from 1872 to 1882 that take English social life as their subject matter. The student of Louis Lamothe (1822–1869) and Paul Flandrin (1811–1902), Tissot enjoyed a successful career in Paris, where he had established a reputation in the decade of the 1860s for his narrative

works and fashionable costume paintings. Although he had shown his paintings in 1862 and 1864 in London and contributed caricatures to *Vanity Fair,* Tissot's hasty flight to England in 1871 in the aftermath of the Franco-Prussian War was precipitated by the fall of the Commune and the "Bloody Week" reprisals of the Versailles government.[4] Whether he arrived in London with the intention of staying or simply to outlast the political turmoil is not clear, but he found a ready market and the opportunity to show his work soon after his arrival.[5]

Like his friend James McNeill Whistler (1834–1903), Tissot was drawn to the Thames River, in particular the

Fig. 1. James Jacques Joseph Tissot, *The Last Evening,* 1873. Oil on canvas, 72.3 × 102.8 cm (28½ × 40½ in.). Guildhall Art Gallery, Corporation of London

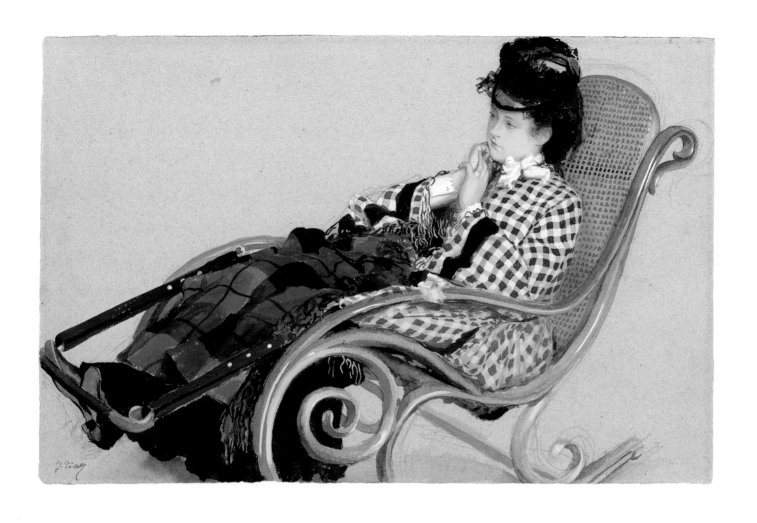

commercial area between Tower Bridge and Greenwich.[6] Tissot's many shipboard and Thames-side paintings such as *The Last Evening* and *The Captain's Daughter* combine narrative with meticulously observed nautical settings and often stage the same models and costumes against a backdrop of masts and complex rigging. *The Last Evening* is perhaps one of the best known of these works, described by Christopher Wood as a tour de force of Victorian narrative painting enlivened by Tissot's "French brilliance." Wood singles out in particular the pensive woman seated in the Thonet bentwood rocking chair, the subject of the Smith College sheet, as one of Tissot's most remarkable figures.[7]

Formerly identified as Kathleen Newton, who lived with the artist from 1876 until her death in 1882, the model for the Smith College drawing is Margaret Kennedy Freebody, who is shown in the finished painting with her brother Captain Lumley Kennedy at her side.[8] Brother and sister appear in a number of the Thames works, as do the black-and-white checked tunic with "pagoda sleeves" and red plaid shawl worn by Margaret Freebody in *The Last Evening*.[9] In the painting, they are cast as lovers about to part; behind them the ship's captain and her father consult, and a young girl listens to their conversation. The scene is ambiguous in meaning; the ship's mate cradles his lover's chair as she turns slightly away, her eyes downcast, as though distracted.[10] In the drawing, the focus of her gaze is forward, suggesting perhaps an earlier moment of exchange between the two.

The strong graphic and decorative interest of the woman's dress and her red shawl, the only spot of color against an otherwise monochromatic background, identify her as the central figure in the painting. Her importance both to the narrative and the composition may account for the degree of finish in the drawing and for Tissot's choice of gouache, his favored drawing medium in the 1870s because the polish that could be achieved approximated the effect and gloss of his oil paintings.[11] In the Smith College study, the drawing extends to the extreme top, left, and bottom edges of the sheet. While there is evidence of some trimming of the paper support, which is slightly irregular, the drawing itself does not appear to have been cropped; under magnification the brushstrokes in the hat, the footrest, and the curving struts of the chair end at or just short of the physical lim-

its of the paper.[12] Therefore, the artist has intentionally omitted the bottom portion of the chair to focus on the figure itself and to explore the decorative patterning of textile and costume against the porcelain delicacy of the model's face and hands.

LM

1. This drawing apparently belonged to the mosaic artist Robert Homer Cumming, who, in addition to his studies at the Vesper George School of Art in Boston and at Boston and Harvard Universities, attended the Académie Julian in Paris. It is possible that he acquired the watercolor while in Paris. Attempts to contact Mr. Cumming in 1993 and 1994 (prior to his death in 1995) were unsuccessful, and the early history of this work remains unknown.

2. A previously unrecorded study currently in a private U.S. collection recently came to light (New York 2000, no. 4, color repr.). The drawing (transparent and opaque watercolor and pencil on buff paper, 280 × 425 mm [11 × 16¾ in.]) shows full detail of the figure and chair but, as Bona Montagu points out, in nearly profile view rather than at an angle, as in the SCMA drawing. The head of the model is lowered, and the buff paper is allowed to show through at her brow and in the hair surrounding her face, making her appear to be almost blonde.

3. See London/Manchester/Paris 1984–85, nos. 55 and 56.

4. See Wentworth 1984, pp. 78–83, for the controversy surrounding Tissot's involvement with the Communards.

5. For a full account of Tissot's life and career, Wentworth 1984 remains the principal resource, with Misfeldt 1971, Wood 1986, and London/Manchester/Paris 1984–85.

6. Wentworth 1984, pp. 99–100; Wood 1986, p. 61.

7. Wood 1986, pp. 62–63.

8. London/Manchester/Paris 1984–85, no. 55.

9. See Krystyna Matyjaszkiewicz, in London/Manchester/Paris 1984–85, p. 73. Since the red shawl appears in many of the "departure" pictures of Kathleen Newton, the costume and almost convalescent attitude of the woman in the rocking chair may have been responsible for the misidentification of the SCMA drawing.

10. Sir Michael Levey, in London/Manchester/Paris 1984–85, p. 10.

11. London/Manchester/Paris 1984–85, no. 56.

12. Examination by Craigen Bowen, Conservator, Center for Conservation and Technical Studies, Harvard University, on 13 June 1996, confirmed that the drawing had not been cropped. There is no fracturing of the medium at the base of the sheet, as might be expected if the paper had been folded or trimmed after the drawing was executed.

PIERRE-AUGUSTE RENOIR
Limoges 1841–1919 Cagnes-sur-Mer

37 *Portrait of Léon Riesener*, 1879, study for illustration in *La Vie Moderne*, 17 April 1879

Black crayon with scratch marks on scratchboard (*papier procédé*)

Watermark: None visible

Sheet: 325 × 245 mm (12¹³⁄₁₆ × 9⅝ in.); image: 300 × 235 mm (11⅞ × 9¼ in.)

Signed verso, lower right, in crayon: *Renoir.;* inscribed verso, upper center, in graphite: *No. 1;* and in blue pencil: *1854*

PROVENANCE {Galerie Druet, Paris};[1] Selma Erving (1906–1980), West Hartford, Conn.; bequest to SCMA in 1984

LITERATURE *La Vie Moderne,* 17 April 1879 (lithograph based on original drawing); Rewald 1945, pp. 171–88, fig. 8 (Renoir's illustrations for *La Vie Moderne* discussed pp. 183–88); Viallefond 1955, no. 8 (lithograph); White 1984, p. 88; Boston 1984–85, pp. xliv–xlv, fig. 27 (lithograph)

EXHIBITIONS Northampton 1984c, no. 15; Northampton 1985–86

Bequest of Selma Erving, class of 1927
1984:10-57

Published on the title page of the 17 April 1879 issue of the literary and artistic weekly *La Vie Moderne,* Pierre Renoir's drawing of the painter Léon Riesener dates after Renoir ended his participation in the impressionist exhibitions to return to the Salon.[2] From the mid-1870s until the early 1880s, Renoir's chief source of income came from portrait commissions for such wealthy patrons as the publisher Georges Charpentier, who launched *La Vie Moderne* in 1879 with Emile Bergerat as its managing director and Renoir, among other artists, as illustrator. (Renoir's brother, Edmond, was a literary contributor to the magazine.[3]) Georges Charpentier had inherited his father's publishing firm, the Charpentier Library, and later became the publisher for Alphonse Daudet, Gustave Flaubert, the Goncourt brothers, Guy de Maupassant, and Emile Zola. His first association if not actual contact with Renoir came in 1875, when he purchased three of the artist's paintings in the famous impressionist auction of 1875, followed by commissions to the artist and decorations for the family's town house on the rue de Grenelle. Renoir's elaborately enframed medallion portrait of Riesener appeared in *La Vie Moderne* a month before his successful Salon showing of the large portrait painting *Mme Charpentier and Her Children* (1878, The Metropolitan Museum of Art, New York), a commission by Marguérite Charpentier to her "resident artist," as Renoir referred to himself. In June 1879 an exhibition of Renoir's work was held at *La Vie Moderne*'s offices on the boulevard des Italiens, the fifth in a series of exhibitions organized by the newly fledged magazine.

Renoir's portrait of the stern-faced Riesener is markedly different in aspect from Eugène Delacroix's (1798–1863) painting of the darkly handsome artist in his youth (1835, Louvre, Paris).[4] Inset in a bosky niche and supported by two bacchantes, probable references to the paintings of voluptuous nudes for which Riesener became known, Renoir's portrait was intended as an homage to the elder artist, who had died in May the previous year. In his letter to Riesener's widow, Renoir thanks her for the opportu-

nity "to do this inadequate homage to the memory of a great painter."[5] The drawing was undoubtedly commissioned by *La Vie Moderne* in connection with the two exhibitions of Riesener's work organized by his friend Fantin-Latour (1836–1904), one a retrospective held in the late artist's home at Cours La Reine and the second at the Galerie Georges Petit preceding the atelier sale at the Hôtel Drouot, events referred to in Armand Silvestre's article "Le Monde des Arts" in the same issue.[6] Expressing admiration for the artist's work, and especially for his watercolors, Silvestre asks, "Why is this artist, so complete, so sincere, and so interesting almost forgotten?" Despite numerous and generally enthusiastic notices in the press (and Edgar Degas's purchase of seventy-five drawings from the atelier sale), Silvestre's question was echoed in the introduction to the sale catalogue, in which the writer notes, "a great part of his life's work remains unknown."

Born in Paris, Léon Riesener (1808–1878) came from a line of artists: his father was the painter Henri-François Riesener (1767–1828), who studied under François-André Vincent (1746–1816) and Jacques-Louis David (1748–1825); his grandfather Jean-Henri Riesener (1743–1806) was the celebrated cabinetmaker to Louis XV and Louis XVI. However, the most illustrious artist in the family was Eugène Delacroix, Léon's first cousin, lifelong friend and a frequent visitor to the Riesener country home in Frépillon.[7] After early studies with his father and then in Baron Gros's (1771–1835) atelier, Léon Riesener made his Salon debut in 1833, where, despite later refusals, he would show fairly regularly to favorable notice by critics such as Théophile Gautier. Commissions followed for the Palais de Luxembourg (1840), the chapel of the Hospice de Charenton (1843–49), the Hôtel de Ville, and Saint Eustache (begun 1849). The religious and peasant subjects that characterized his early painting career were succeeded by portraits, landscapes, and female nudes such as the coyly erotic *Leda* (Musée des Beaux-Arts, Rouen), which was shown in both the 1841 and 1855 Salons.

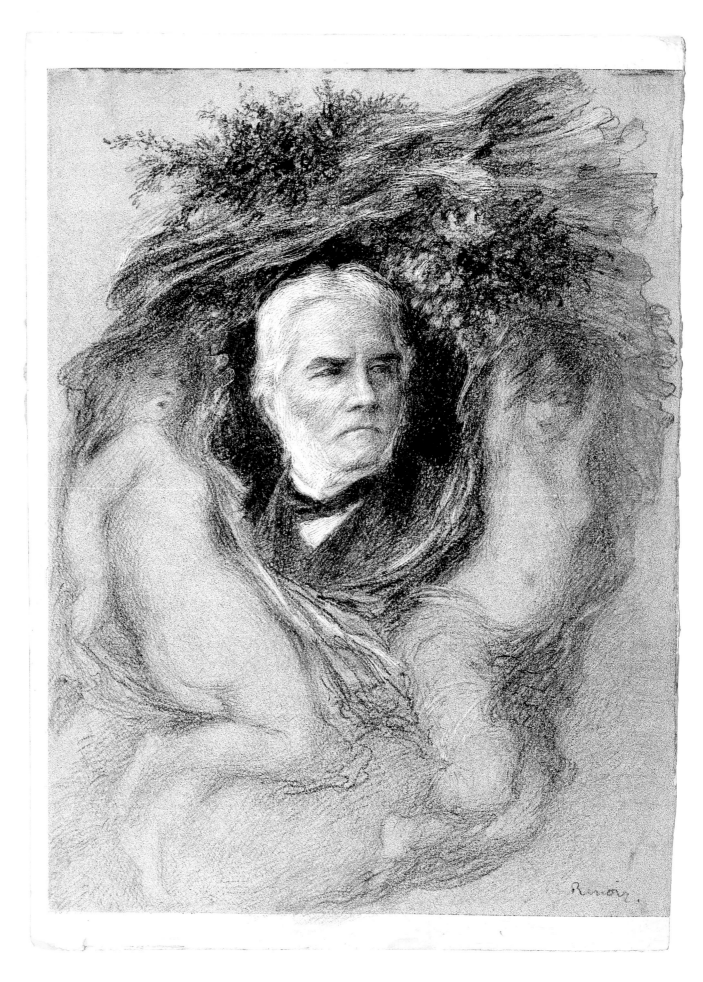

154 PIERRE-AUGUSTE RENOIR

Erigone (Louvre, Paris), another suggestively sprawled nude painted in 1855 but not shown until the 1864 Salon, predates and presages Gustave Courbet's (1819–1877) *Woman with a Parrot* of 1866 (The Metropolitan Museum of Art, New York), which adopts a similar pose and angle of view.

Renoir's portrait of Riesener, as well as his drawings of the comte de Beust and Théodore de Banville published in *La Vie Moderne,* were executed in a new drawing medium for the magazine, which employed professional illustrators and artists to translate original works of art to the printed page using refinements of the Gillot process.[8] Patented by Firmin Gillot in 1850, *gillotage,* or zincography, was a non-photographic process used for transferring an original drawing, which would have been drawn in greasy ink on lithographic paper, to a zinc plate for etching.[9] However, this process could not effectively reproduce halftones and was succeeded in the late 1870s by a new drawing medium developed by Charles Gillot that required the use of "papier procédé, or scraperboard, thick papers or cards, coated with barium oxide, that were embossed and sometimes printed with patterns that could produce a uniform gray tone."[10] A drawing made on prepared paper could then be transferred photographically to a line block and printed.[11]

The use for which Renoir's portrait of Riesener was intended and the technical demands of the transfer process account for the drawing's appearance, which in many ways mimics the look of a print. The portrait is in fact drawn on a printed surface. In this case, the top sheet of the scraperboard is patterned with minute grains of black, close in appearance to aquatint.[12] This reticulated pattern "reads" grey in the background of the drawing and in the printed illustration in *La Vie Moderne.* Tonal effects — greys and shaded areas — were thus entirely achieved in both the drawing and the periodical image through black and white. In an article published in the *Studio* in 1893, seven types of Gillot "prepared surface papers" are described, including black patterns consisting of diagonal lines (or white lines for stipple effect), straight lines, or aquatint printed on white papers, and white patterns printed on black papers. Of the black aquatint pattern that would seem to accord with the prepared paper used by Renoir for his drawing, the writer notes that it can be used "with advantage in the representation of textile fabrics," but warned that this paper "requires care in working."[13]

The *Studio* writer's cautionary note echoes Renoir's frustration fourteen years earlier in drawing on scraperboard, which required the artist to work both on and below the surface of the support. While the drawing was worked in black crayon, highlights and whites could only be created by scraping into the surface of the paper to reveal the layer of barium oxide below. Renoir felt little affinity for this reductive as opposed to additive technique, later complaining to Ambroise Vollard, "they [the publishers of *La Vie Moderne*] forced upon us . . . drawing paper . . . which requires the use of a scraper to render the whites: I have never been able to get used to it."[14] His stated discomfort with the medium is evident in the facial highlights of his drawing of Riesener, which were created by scratching a fine network of tiny lines into the *papier procédé.* The procedure in the end was much the same as drawing with crayon on a lithographic stone and scraping to create highlights[15] and produced in this case both a drawing and a published image that resembled lithographs.

The Smith College drawing, so unusual in Renoir's oeuvre, suggests the influence of Fantin-Latour, specifically with regard to his transfer lithographs on Wagnerian themes and homages to great composers. Fantin was to become "the major force . . . in fostering a lithographic revival," producing over eighty-five lithographs between 1876 and 1889, which were shown at the Salon and circulated widely through gifts to friends and colleagues.[16] Renoir's homage to Riesener was preceded three years earlier by Fantin's homage to Hector Berlioz, *The Commemoration* or *L'Anniversaire,* which was shown at the 1876 Paris Salon in both the painted and lithographed versions (see cat. 43). Like Fantin, Renoir also treated Wagnerian themes, producing his own *Tannhäuser* in 1879, overdoors commissioned by their mutual friend Dr. Emile Blanche.[17] In subject matter and style, Renoir's drawing of Léon Riesener suggests Fantin's penumbral lithographs, worked with a scraper, and cast with the dramatis personae and symbolic apparatus of fame. Fantin would also have been a further link to Riesener through their friendship, their admiration for contemporary music, and the last compliment paid by Fantin to Riesener — the posthumous exhibitions that provided the occasion for Renoir's drawing.

LM

1. A Galerie Druet sticker affixed to the back of the frame bears the stock number 3746. The frame is also stamped *BELGIUM.* The provenance records for this and other drawings in the Selma Erving collection are incomplete, but it is known that the dealer John Wyss bought works for Miss Erving at auction.

2. Renoir participated in the first three impressionist exhibitions, in 1874, 1876, and 1877. His dealer, Durand-Ruel, showed his work at the seventh impressionist exhibition in 1882.

3. For background on Renoir's relationship with the Charpentiers, see Distel 1990, pp. 140–49, and Ottawa 1997–98, nos. 31 and 32 (see Colin B. Bailey, pp. 1–5, for Renoir as a portraitist).

4. See Johnson 1981, no. 225.

5. London 1965, unpag.

6. Silvestre 1879, pp. 20–21.

7. See Johnson 1981, nos. 225 and 226. Riesener was Delacroix's first cousin, the son of Henri Riesener, who was the half brother of Delacroix's mother, and Delacroix's maternal aunt, Félicité-Longrois Riesener (c. 1786–1847). Riesener considered himself to be a younger brother to Delacroix, who helped his cousin in his career, but who also wrote of him (Johnson 1981, p. 44, quoting Delacroix's journal for Oct. 1854): "il a été un fou toute sa vie; il y a un fonds de bon sens dans son esprit, et il en a toujours manqué dans sa conduite" (He was a fool all his life; he had basic good sense, but it was always lacking in his conduct).

8. Douglas Druick and Peter Zegers in Boston 1984–85, p. xliv.

9. Gascoigne 1986, 33c and f.

10. Druick and Zegers in Boston 1984–85, p. xliv.

11. Gascoigne 1986, 33h.

12. Although Druick and Zegers (Boston 1984–85, pp. xliv–xlv) speculate that the original drawing for Renoir's cover illustration was drawn on embossed paper (which could be used to create a pebbled background as the artist rubbed his crayon across the sheet), the support for the Smith College drawing is actually a printed paper. Examined under the microscope, the pattern of the paper resembles a gelatin reticulation such as that used in collotype.

13. Chefdeville et al. 1893, pp. 65–72 (see "Prepared Surface Papers," pp. 71–72). Also see Lloyd 1980, pp. 264–68; fig. 1 reproduces the Gillot paper prepared with black aquatint lines from the 1893 *Studio* article.

14. Rewald 1945, p. 186, translating Ambroise Vollard, *En écoutant Cézanne, Degas, Renoir* (Paris, 1938), p. 194. Camille Pissarro encountered his own frustrations in working with prepared papers, writing in a letter to his eldest son, Lucien, in 1884 (quoted in Lloyd 1980, p. 266): "Le Gillotage est à la gravure ce quel les faux tapis turc sont aux vrais" (Gillotage is to engraving what imitation Turkish rugs are to the real thing).

15. Gascoigne 1986, 33h.

16. Paris/Ottawa/San Francisco 1982–83, pp. 275–81.

17. Renoir was also included in Fantin's contemporary homage to the "disciples of Manet" in the *Atelier of the Batignolles* of 1870 (Musée d'Orsay, Paris).

VINCENT VAN GOGH
Zundert 1853–1890 Auvers-sur-Oise

38 *Orphan Man with Walking Stick*, 1882

Graphite on cream wove paper

Watermark: Dambricourt Frères Hallines

485 × 260 mm (19 × 10¼ in.)

PROVENANCE C. Mouwen Jr., Breda; Hendricus Petrus Bremmer (1871–1956), The Hague, by 1928; Willem Brinkman, Schipuliden, the Netherlands, 1955; sale, New York, Sotheby's, 16 May 1984, no. 106, repr.; sold to SCMA in 1984

LITERATURE Faille 1928/1970, no. 958, repr.; Vanbeselaere 1937, p. 89, no. 958, pp. 88, 170, 409; Tralbaut 1969, repr. p. 88; Hulsker

1980/1996, no. 251, repr.; *GBA* 1985, p. 41, no. 235, repr.; SCMA 1986, no. 245, repr.

EXHIBITIONS Vlaardingen 1953, no. 4; Paris 1960, no. 86; Frankfurt 1970, no. 11; Northampton 1985–86

Purchased
1984:30

39 *Orphan Man Holding a Cup*, 1882

Graphite on cream wove paper

Watermark: Dambricourt Frères Hallines

491 × 245 mm (19⁵⁄₁₆ × 9⅝ in.)

PROVENANCE C. Mouwen, Jr., Breda; {Kunsthandel C. M. van Gogh, Amsterdam}, by September, 1908; sale, Amsterdam, Frederik Muller and Co., 18 May 1909; Hendricus Petrus Bremmer (1871–1956), The Hague, by 1928; to his heirs by 1957; {E. J. van Wisselingh & Co., Amsterdam}; to Mr. and Mrs. Chapin Riley (Mary Alexander Riley, d. 1963), Worcester, Mass., in Nov. 1958 (Chapin Riley, later of Los Angeles); gift to SCMA in 1996

LITERATURE Faille 1928/1970, no. 957, repr.; Vanbeselaere 1937, p. 89, no. 957, pp. 88, 170, 409; Hulsker 1980/1996, no. 242, repr.

EXHIBITION Amsterdam 1908, no. 105(?)

Gift of Chapin Riley in honor of Katherine Harter Alexander, class of 1902, Mary Alexander Riley, class of 1930, and Cynthia Riley Fehsenfeld Parsons, class of 1956
1996:3

The museum's pair of "orphan man" drawings, *Orphan Man with Walking Stick* and *Orphan Man Holding a Cup,* belong to Vincent van Gogh's Hague period (1881–83), shortly after he had given up his work as an evangelist and decided to set his course as an artist. Moving to Etten in 1881 to stay with his parents at his father's parsonage, Van Gogh sketched working people and the countryside, while continuing his practice of making copies after Jean-François Millet (1814–1875) and other artists. During this time he also traveled to The Hague to begin an apprenticeship with his cousin, the painter Anton Mauve (1838–1888). A rupture with his parents precipitated Van Gogh's move to The Hague in late 1881, where his relationship with Mauve gradually worsened into a final break over the senior artist's insistence that his pupil continue to draw from plaster casts. In keeping with Van Gogh's statement that he would "draw from plaster casts when . . . there are no more hands and feet of living people to be drawn,"[1] the Smith College sheets and other drawings dating from The Hague period were made from local models, including Clasina Maria Hoornik ("Sien"), who would become Van Gogh's companion, and Sien's mother and children. These unidealized portrayals of people conditioned by hard circumstance are at the same time sympathetic, a combination of unflinching eye tempered by respect that characterizes Van Gogh's drawings of the "orphan" or almshouse men.

Van Gogh opened his house to his models, writing to his brother Theo: "My ideal is gradually to work with more and more models . . . poor people to whom the studio could be a kind of harbor or refuge on winter days, or when they are out of work or in great need."[2] In the early fall of 1882, he wrote several times to Theo of his current subjects, "a few old men from the almshouse."[3] A letter on or about 1 October describes a particular individual, who wears "a large old overcoat, which gives him a curiously broad figure. . . . He has a . . . bald head — large deaf ears and white whiskers."[4] W. J. A. Visser identified this almshouse model as Jacobus Adrianus Zuyderland (Zuijderland) from the registration number on the upper right sleeve of the overcoat worn by the sitter in the profile drawing *An Almshouse Man in a Top Hat* (fig. 1) and by the lapel military cross honoring Zuyderland's service in Holland's Ten-Days' Campaign against Belgium in 1831.[5] A number of the orphan men drawings appear to represent this model, an apparent favorite of the artist's.[6] Although the registration patch and military decoration are not visible in the museum's

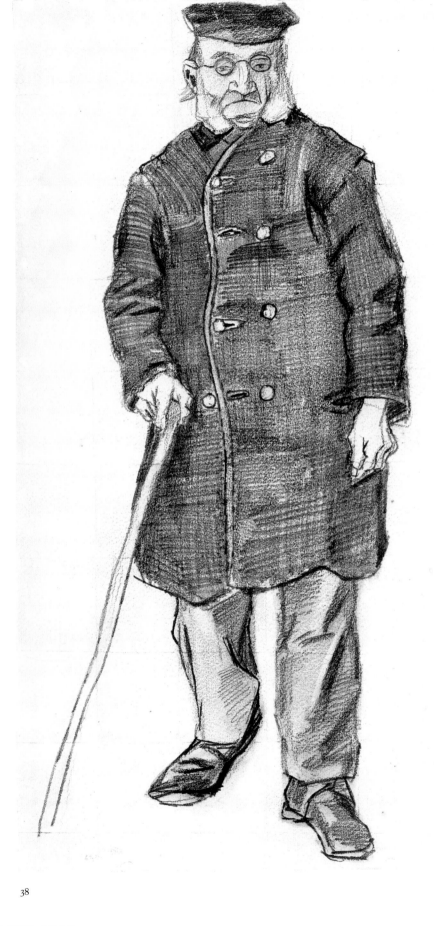

38

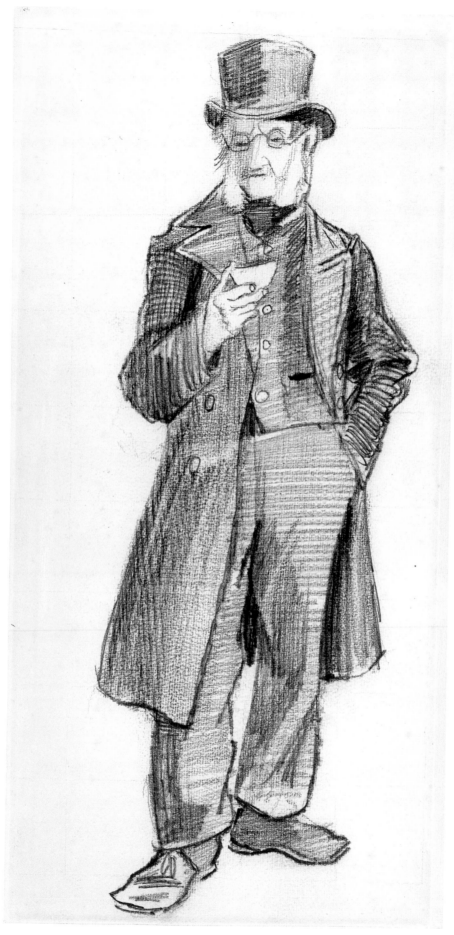

39

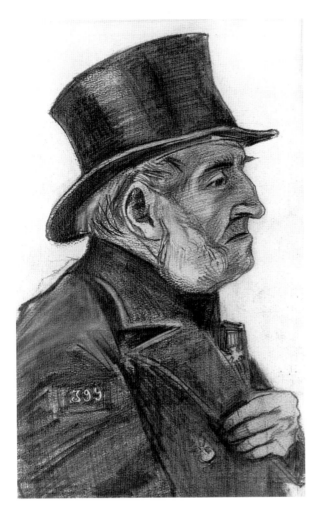

Fig. 1. Vincent van Gogh, *An Almshouse Man in a Top Hat*.
Graphite and white heightening, 400 × 245 mm (15¾ × 9⅝ in.).
Worcester Art Museum, Worcester, Massachusetts, Gift of
Mr. and Mrs. Chapin Riley, in memory of Francis Henry Taylor,
inv. 1957.153. Photo: © Worcester Art Museum

Orphan Man Holding a Cup, it is possible that this may be Zuyderland as well. If he is not the same man, like Zuyderland his top hat and overcoat identify him as one of the pensioners, or *Diaconiemannen*, from the Dutch Reformed Old Men's and Old Women's Home on the Om en Bij. In contrast, the unknown model for *Orphan Man with Walking Stick* belonged to the *Weesmannen*, or residents of the Catholic Orphanage and Old People's Home on Warmoezierstraat, who wore a cap and the letters *RCA* (for Roman Catholic Paupers) on their clothing.[7]

Van Gogh's many drawings of the almshouse men frequently isolate solitary figures, described in bold lines and dramatic contrasts of black and white, against the blank background of the drawing paper. Some of the elderly men are awkwardly posed, while others, like *Orphan Man Holding a Cup*, handle simple props — an umbrella, a cup, or a book. This individual, hand in pocket, cup raised, projects an almost jaunty air, while the figure in *Orphan Man with Walking Stick* steps forward, scowling and bespectacled, from an undescribed, featureless space.

Both SCMA sheets are drawn with carpenter's pencil on papers bearing the Dambricourt Frères watermark.[8] During his Hague years, Van Gogh preferred to work with a carpenter's pencil, which provided a heavy, thick lead.[9] According to Liesbeth Heenk, who has made a recent study of Van Gogh's drawing papers, the figure studies and drawings of heads from 1882–83 were often executed on Dambricourt Frères Hallines 1877 papers, which were strong enough to withstand the pressure of the carpenter's pencil, as well as his vigorous working methods, and to allow experimentation with other drawing media.[10] Van Gogh also regularly used milk as a fixative for his drawings: *Old Man with Walking Stick*, which has been conserved, suggests the remnants of a milk stain spread in an aureole around the figure.[11]

In style and subject matter, Van Gogh's orphan men drawings may owe less to the artists of The Hague School — Anton Mauve, the Maris brothers (Jacob, 1837–1899; Matthijs, 1839–1917; Willem, 1844–1910), J. H. Weissenbruch (1824–1903), and the painter-collector H. W. Mesdag (1831–1915) — than to the work of English social realist painters. Van Gogh had lived in England in the mid-1870s during a peak period of the illustrator's craft and was particularly influenced by Luke Fildes (1844–1927), Hubert (von) Herkomer (1849–1914), Frank Holl (1845–1888), and others whose work appeared in the *Graphic*, comparing them favorably with Millet and Jules Breton (1827–1906) for their "noble and . . . serious sentiment."[12] He would become an avid collector of prints, eventually assembling a large collection that numbered at least 2,500 examples of English, French, and American illustrations culled from periodicals alone, including the *Graphic* (the complete run of issues from 1870 to 1880), the *Illustrated London News*, and *L'Illustration*.[13] Works such as Herkomer's *Last Muster: Sunday at the Royal Chelsea Hospital*, published in the 18 February 1871 issue of the *Graphic* and later developed into a painting (Lady Lever Art Gallery, Port Sunlight [Merseyside]) shown at the Royal Academy in 1874, is often cited as a point of reference for the orphan men drawings. This painting shows an array of realistically observed old soldiers, one of whom has quietly passed away during chapel services.

As Charles Chetham has noted, Van Gogh's drawings also reflect a stylistic relationship to print illustrations in "the simplicity of outline, the strong verticals used in modelling the forms and the cross-hatching to indicate shadows."[14] In *Orphan Man Holding a Cup* the old man's sleeves are defined by spirals down their length and his trousers by parallel horizontal lines, while the haphazardly buttoned overcoat of *Old Man with Walking Stick*, created by a dense mesh of lines, is treated almost as a second portrait that carries much of the visual interest of the drawing. According to Johannes van der Wolk, Van Gogh had two purposes in drawing from the model during this time: one was to develop figures that could be incorporated into more complex compositions, the other was to explore the possibility of becoming an illustrator himself.[15] Van Gogh's letters record his plans for making

a series of thirty lithographs of "figures from the people for the people" and his hope to compile his drawings as a portfolio for future employment.[16] Several of the orphan men drawings were made into lithographs,[17] and *Orphan Man with Walking Stick* and *Orphan Man Holding a Cup* each have a lightly traced grid on the surface of the paper, evidence that the artist squared the drawings for possible transfer. However, neither of the Smith College sheets seems to have been used as the basis for a later print.

The museum's drawings share a common early provenance and were reunited in 1996 with the gift to the museum of *Orphan Man Holding a Cup* from Chapin Riley. Both were originally in the collection of C. Mouwen, Jr., of Breda and H. P. Bremmer, a gifted Dutch neo-impressionist, art historian, and critic, who owned a number of the orphan men drawings.

<div align="right">LM</div>

1. Van Gogh 1959, letter 189.

2. Van Gogh 1959, letter 278.

3. Van Gogh 1959, letters 235, 236, 238, and R14 refer to the almshouse subjects.

4. Van Gogh 1959, letter 235.

5. Visser 1973. Zuyderland is recorded in the Register of the Old People's Home, 1877–90, Archives of the Poor Relief Board of the Dutch Reformed Church of The Hague, number 133, inv. 1652, Municipal Archives, The Hague. On *An Almshouse Man in a Top Hat*, see Faille 1928/1970, no. 954, and Hulsker 1980/1996, no. 287. Hereafter these catalogue raisonné references will be abbreviated as F. and H., respectively.

6. See Hulsker 1980/1996, pp. 58–59.

7. Dr. Michiel van der Mast, Chief Curator of the Haags Historisch Museum, has kindly provided information concerning the Catholic and Dutch Reformed Old People's homes in The Hague. In a letter of 22 Dec. 1995 to the author (SCMA curatorial files), he confirmed that the Smith College drawing *Old Man with Walking Stick* represents a resident of the Catholic Orphanage and Old People's Home on Warmoezierstraat 89–91. Hulsker (1980/1996, p. 60) refers only to the existence of the Dutch Reformed Home and gives its location incorrectly as on Warmoezierstraat.

8. While the drawing medium for *Old Man with Walking Stick* had been previously published as graphite and charcoal, a technical examination under microscope at the SCMA (10 Oct. 1994) revealed only the presence of graphite.

9. Otterlo 1990, p. 30.

10. Heenk 1994, pp. 30–39.

11. As Heenk notes (1994, p. 32, fig. 3), milk fixative is clearly visible as a halo or tideline in another orphan man drawing, the *Almshouseman Drinking Coffee* (F. 976, H. 265). Examination of *Orphan Man with Walking Stick* by Craigen Bowen, Conservator, Center for Conservation and Technical Studies, Harvard University, on 25 April 1996 confirmed the presence, but not the type, of fixative used on the sheet.

12. Van Gogh 1959, letter 240.

13. See Chetham 1976, pp. 90–112, for a discussion of the influence of print periodicals on Van Gogh's work. See also Bailey 1990.

14. Chetham 1976, pp. 102, 104.

15. Otterlo 1990, pp. 65–66.

16. Otterlo 1990, p. 66, referring to letters 241 and 245 in Van Gogh 1959.

17. Two drawings, both titled *Orphan Man with Top Hat, Drinking Coffee* (F. 1682, H. 263 and F. 966a, H. 264), were the basis for the lithograph of the same title (F. 1657, H. 266). *Orphan Man with Long Overcoat and Stick* (F. 962, H. 212) is repeated as a lithograph (F. 1658, H. 256). *Old Man with His Head in His Hands* (F. 997, H. 267) became the lithograph *At Eternity's Gate* (F. 1662, H. 268).

PAUL CÉZANNE
Aix-en-Provence 1839–1906 Aix-en-Provence

40 *Village Cottages (Maisonettes)*, 1880–85
Verso: *Study of a Piece of Upholstered Furniture*

Brush with transparent and opaque watercolor (gouache) over graphite on beige wove paper

Watermark: None visible

327 × 499 mm (12⅞ × 19¹¹⁄₁₆ in.)

Inscribed verso, upper left corner, in graphite: *18;* at lower right, in graphite: *N° 2;* at center of top edge, in graphite: *50 × 32½;* and at lower right, in graphite: *65 × 68*

PROVENANCE The artist until his death; to his son Paul Cézanne, Paris; {Valentine [Dudensing] Gallery, New York} as agent, by Jan. 1937; to Charles C. Cunningham (then of Boston); bequest to SCMA in 1980

LITERATURE Rivière 1923, p. 219, repr. opp. p. 58; Venturi 1936, no. 836, repr.; Venturi 1943, pp. 9, 12, fig. 4; Rewald 1983, no. 159, repr. (see also "List of Exhibitions," pp. 469–77, for further information concerning exhibition history); SCMA 1986, no. 245, repr.

EXHIBITIONS Paris 1907, no. 2; New York 1933, no. 17(?); Paris 1935; Paris 1936, no. 121; Boston 1937; New York 1937, no. 9 (as *Maisons de Village*); San Francisco 1937, no. 39, repr.; Boston 1939, no. 146; Columbus 1939–40, no. 1 (as *Houses in Provence*); Northampton 1948; Northampton 1950, no. 7 (as *Houses in Provence*); Chicago/New York 1952, no. 32; Hartford 1957, no. 60; New York 1959a, no. 74, pl. LXXIII; New York 1963, no. 12, pl. 9; Tübingen 1982, no. 21, repr.; Northampton 1985–86; Paris/London/Philadelphia 1995–96, no. 74, repr. (Philadelphia venue only)

Bequest of Charles C. Cunningham in memory of Eleanor Lamont Cunningham, class of 1932
1980:22-1

Paul Cézanne's watercolors, from his first venture into the medium in the late 1860s, were initially associated with his paintings and then developed their own course, sometimes paralleling and later influencing his work in oils. As John Rewald has written, Cézanne's experimentation with Impressionism in the 1870s, as he turned away from the dark tonalities and dramatic themes of his early paintings, relegated watercolors to a secondary role, consisting of invented "vignettes of country life" and landscapes.[1] Cézanne's discovery of the "constructive stroke" at the end of the 1870s was a breakthrough in oils that could not be duplicated in watercolors. This had the effect of freeing him to explore the technical demands and aesthetic possibilities of watercolors, which he would come to master as one of the greatest artists ever to work in the medium.

Few of Cézanne's watercolors are signed or dated. It is therefore difficult to construct a reliable chronology based on stylistic analysis alone, which is complicated by the artist's tendency to rework motifs or ideas throughout his career and to explore different approaches at the same time in different mediums.[2] Accordingly, *Village Cottages* has been variously dated within a twenty-year period from 1872 to 1892. Georges Rivière, the earliest writer to comment on this watercolor, assigned it the latest date, listing the Smith College sheet under works created in 1892.[3] In his catalogue raisonné, Lionello Venturi attributed a date of 1879–82 to the SCMA sheet,[4] seconded by Götz Adriani, who wrote that "the severely orthogonal arrangement of the motif as well as the careful preliminary drawing are characteristic of [this] period."[5] Rewald assigned the museum's sheet to a five-year period from 1880 to 1885, noting that Venturi had

intended to adjust his own dating to an earlier five-year span from 1872 to 1877, in a planned, but unpublished revised edition of his catalogue.[6]

While Rivière's date of 1892 is stylistically too late, the meticulous pencil drawing underlying the more localized application of pigment, including both watercolor and heavier gouache, supports an earlier date, but perhaps not as early as Venturi's intended revision. The Smith College sheet does not resemble earlier, more traditionally worked watercolors such as Cézanne's portrait of the manor house at Jas de Bouffan of about 1870 (last recorded in a collection in Milan),[7] which allows little of the paper to show beneath the pigment, but it does begin to share characteristics with other architectural subjects late in the decade. Like *Une Cabane* (Courtauld Institute, London),[8] a fairly realistically rendered image of an abandoned cottage that Venturi dates about 1872–77 and Rewald dates about 1880, the Smith College sheet focuses on a horizontal band of linear architectural elements isolated in a relatively undescribed background. In *Village Houses,* the addition of gouache in the walls of the buildings adds solidity to the structure, in contrast to the transparency of the watercolors. Although the pencil drawing does include more minutely observed aspects of the buildings, for example, shutters and detailing in the windows, the composition as a whole relies on a progression of essentially abstract forms — squares and rectangles — across the page. The colors pick up and selectively isolate a few of these elements, further deconstructing the buildings and increasing the sense of the drawing's own abstract structure.

As Rewald has written, "Cézanne's watercolors of the eighties show strong linear tendencies . . . in which colors

40 Recto

40 Verso

seem to serve mainly to enhance the drawing. It appears as though he was now aiming at a great purity of line from which color is not allowed to detract. He even assigns a secondary role to color, which is applied more or less uniformly without attempts at producing similar nuances."[9] Although this may be seen to be generally reflected in the museum's sheet, Cézanne chose and applied his colors in *Village Cottages* not only to reinforce the graphite drawing but for visual, and interactive, impact: the frost blue of a window frame vibrates against the ochre of the walls of the central house, and the long, glowing strip of purple at the eaves underscores a red blush overlaid with pale cream strokes in the roof. The visual clue for the original intensity of the colors is contained in the apple greens in the tree and foliage, still bright within a mosaic of other greens that have receded, including the broad, light wash of dark green defining the foreground, which serves as a color base supporting the architecture. The familiar hues of Cézanne's palette — ochres, purples, blues, and russet reds, in addition to a range of greens — are used here with a less gestural, broken application in areas of local color. Because of the gradual darkening of the paper support and partial fading of the watercolor pigments, the whites of the gouache may have become more assertive over time.[10]

Rewald specifically groups the Smith College sheet with four other watercolors (V. 943, 945, 826, 971; R. 155–58) as examples of works from the early 1880s, explaining that while "in previous years, Cézanne had sometimes painted watercolors in which his brush faithfully followed the design of a preliminary pencil drawing . . . he had not, as he was to do in the early eighties, insisted on crisp outlines and even arabesques." Noting that this linear approach was also characteristic of paintings of this period, Rewald records that this "phase," in which drawing takes precedence over color, was short-lived, although it was to resurface later.[11]

The site of the cottages has not been identified, but it has been suggested that their red, possibly tile, roofs may imply a location in the Midi.[12] The verso of the Smith College sheet bears a sketch in watercolor, gouache, and pencil of what appears to be part of a piece of upholstered furniture. Although few conclusions can be drawn on the basis of this very incomplete drawing in blue, white, and cherry red, it may be worthwhile to note that Cézanne made a small group of watercolors and notebook drawings of chairs, tables, beds, and bolsters, which Rewald dates in the mid-1880s.[13] These may provide a *terminus ante quem* for the museum's sheet.

LM

1. Rewald 1983, p. 23 (see pp. 19–40 for a discussion of the stylistic and technical development of Cézanne's work in watercolors). Rewald 1983 and Venturi 1936 catalogue raisonné references are hereafter abbreviated as R. and V., respectively.

2. As Götz Adriani points out in Tübingen 1982, p. 15.

3. Rivière 1923, p. 219.

4. V. 836.

5. Tübingen 1982, pp. 266–67, no. 21.

6. R. 159.

7. V. 817; R. 22.

8. V. 837, R. 102.

9. Rewald 1983, pp. 26–27. Rewald lists SCMA's sheet as an example of the drawings from the 1880s that demonstrate linear qualities and use color as enhancement.

10. In 1980, after the watercolor was given to SCMA, it was examined by conservator Marjorie Cohn, of the Center for Conservation and Technical Studies, Fogg Art Museum, Harvard University. Her survey report (TL79:80.31; SCMA curatorial files) noted that the paper showed severe mat burn and discoloration from exposure to light and old mounting papers. It is therefore difficult to tell, even after treatment, how much the recto differs from its original appearance (the verso remains many shades darker, presumably because of prolonged contact with acidic mounting papers, which were stretched around a wooden frame). Cohn noted that a glue splash above the roofs on the far right may have preserved a spot of the original color of the paper. If this is correct, then Cézanne was working on a buff-colored or tan surface that was slightly paler in appearance than the sheet in its conserved condition.

11. Rewald 1983, p. 123, see under no. 155.

12. Joseph Rishel in Paris/London/Philadelphia 1995–96, no. 74.

13. R. 184–91, repr.

GEORGES PIERRE SEURAT

Paris 1859–1891 Paris

41 *Three Young Women,* study for the painting *Sunday Afternoon on the Island of La Grande Jatte,* c. 1884–85

Black conté crayon on cream laid paper

Watermark: None visible

235 × 305 mm (9¼ × 12 in.)

PROVENANCE Félix Fénéon (1861–1944), Paris, by 1905 until at least 1926; Mrs. Cornelius J. Sullivan, New York, by 1929 (on loan to SCMA 1 March 1935–30 June 1938); sold to SCMA in 1938

LITERATURE Zervos 1928, repr. p. 374; Kahn 1928, vol. 2, pl. 94; Werner 1932, repr. p. 151; Rich 1935, pp. 36, 54, pl. 19; Abbott 1939a, p. 7, repr.; Abbott 1939b, pp. 19–22, fig. 11; *SCMA* 1941, p. 12, repr. p. 40; Apollonio 1947, pl. 10; Seligman 1947, no. 7, pl. VI; Hamilton and Hitchcock 1953, pp. vi, xiv, xxiv; Hitchcock 1954, [p. 2]; Dorra and Rewald 1959, no. 138d, p. 153, repr.; Hauke 1961, vol. 2, no. 633, repr.; Herbert 1962, pp. 106–7, fig. 95; Homer 1964, pp. 125, 128, fig. 37; Chetham 1965, pp. 73–76, repr.; Russell 1965, p. 160, fig. 147; Courthion 1968, repr. p. 27; Kuh 1968, p. 70, repr.; Chetham 1969,

pp. v, vi, xiv, xxiv, no. 30, repr.; Kahn 1971, repr. p. 114; Broude 1978, p. 129, fig. 9; Sutter 1970, p. 32, repr.; Thomson 1985, p. 106, fig. 113; SCMA 1986, no. 248, repr.; Clayson 1989, p. 159, fig. 7; Zimmermann 1991, pp. 181–82, fig. 341

EXHIBITIONS Paris 1905, no. 9; Paris 1908–9, no. 191; Munich 1906–7, no. 107; Paris 1926, no. 110; New York 1929, no. 69; Springfield 1933, no. 133; Chicago 1935, no. 7, repr.; Deerfield 1944; New York 1947a, no. 4; New York 1949a, no. 47; New London 1950; Amherst 1953; New York 1953a, no. 29; Boston 1954; Chicago 1958, no. 78 and p. 23; Northampton 1958a, no. 57; IC MoMA 1958–59, no. 189, pl. 174 (Rotterdam and New York), pl. 188 (Paris); Chicago 1961, no. 33; Northampton 1979b, no. 128; Northampton 1983a, no. 39; Paris/New York 1991–92, no. 145, repr.

Purchased, Tryon Fund
1938:10-2

42 *Head of a Woman,* study for the painting *Sunday Afternoon on the Island of La Grande Jatte,* c. 1884–85

Black conté crayon on cream laid paper

Watermark: None visible

298 × 216 mm (11¾ × 8½ in.)

Inscribed verso in red crayon: *Seurat/s/344*; at lower left in graphite: *4s-36*

PROVENANCE In the artist's atelier at his death (no. 344 in the posthumous studio inventory); to his brother Emile Seurat (1846–1906); Félix Fénéon (1861–1944), Paris, by 1908; Mrs. Cornelius J. Sullivan, New York, by 1933 (on loan to SCMA 1 March 1935–9 Feb. 1938); sold to SCMA in 1938

LITERATURE Cousturier 1921, pl. 35; Cousturier 1926, pl. 57; Zervos 1928, repr. p. 368; Rich 1935, p. 53, pl. 6; Abbott 1939b, pp. 19–22, fig. 10; *SCMA* 1941, p. 12, repr. p. 41; Seligman 1947, p. 49, no. 8, repr.; Hamilton and Hitchcock 1953, pp. vi, xiv, xxiv; Faison

1958, pp. 136–37, fig. 3; Guitar 1959, repr. p. 114; Dorra and Rewald 1959, no. 138j, p. 155, repr.; Hauke 1961, vol. 2, no. 634; Hill 1966, p. 60, fig. 19; Chetham 1969, pp. v, vi, xiv, xxiv, no. 31, repr.; Courthion 1982, p. 60, fig. 142b; SCMA 1986, no. 247, repr.; Zimmermann 1991, p. 180, fig. 337

EXHIBITIONS Paris 1900 (not in exh. cat., but listed in an annotated copy belonging to Félix Fénéon); Paris 1908–9, no. 188; Paris 1920, no. 46; Springfield 1933, no. 135; Chicago 1935, no. 13; New York 1947a, no. 5; New York 1949a, no. 50, repr. on cover; New York 1953a, no. 28; Boston 1954; AFA 1956–57, no. 43 (nos. vary with catalogues for the venues); Northampton 1958a, no. 56; Chicago 1961, no. 34; Northampton 1979b, no. 125; Northampton 1983a, no. 38; Northampton 1984b, no. 17

Purchased, Tryon Fund
1938:10-1

These sheets belong to a group of twenty-seven drawings, an equal number of painted panels, and three canvases made as preparatory studies for Seurat's monumental painting *Sunday Afternoon on the Island of La Grande Jatte* (1884–86, The Art Institute of Chicago, fig. 1).[1] A scene of Sunday strollers and boating parties on the island of La Grande Jatte in the Seine west of Paris, the finished canvas transformed an impressionist theme of leisure activity into an epic, staged composition whose flickering surface is composed of a vast constellation of layered and juxtaposed dots and strokes of paint. In this canvas,

Seurat's "scientific" approach, informed by his exploration of current color and optical theories, and his solid, hieratic figures deployed across the visual field were a direct challenge to the impressionist aesthetic of an art of sensation.[2] Intended for an exhibition of the Société des Artistes Indépendants in March 1885, the canvas was reworked before it was ultimately shown at the eighth and last impressionist exhibition the following year. When *La Grande Jatte* was shown for the second time, with works by Charles Angrand (1855–1926), Henri-Edmond Cross (1856–1910), Albert Dubois-Pillet (1846–

41

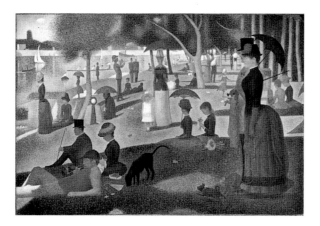

Fig. 1. Georges Seurat, *Sunday Afternoon on the Island of La Grande Jatte,* 1884–86. Oil on canvas, 207.5 × 308 cm (81¾ × 12¼ in.). The Art Institute of Chicago, Helen Birch Bartlett Memorial Collection, inv. 1926.224. Photo: © 1994, The Art Institute of Chicago. All Rights Reserved

Fig. 2. Georges Seurat, *Woman with Monkey,* 1884. Oil on panel, 24.8 × 15.9 cm (9¾ × 6¼ in.). Smith College Museum of Art, Purchased, Tryon Fund, 1934:2-1. Photo: David Stansbury

1890), Lucien Pissarro (1863–1944), and Paul Signac (1863–1935), the critic Félix Fénéon coined the term *Neo-Impressionistes* in his exhibition review to describe the practitioners of the new style.

According to Seurat's 1889 letter to Fénéon, who at one time owned both Smith College drawings, the artist began the studies for *La Grande Jatte* (and, he also claimed, work on the canvas itself) on Ascension Day, 22 May 1884. Although it may not be possible to establish an exact sequence for all the studies, according to Robert Herbert most of the painted panels were completed in the autumn of 1884.[3] The museum's panel *Woman with Monkey* (fig. 2) is a study of one of the principal figures in the composition, who appears (with her simian pet) in the final version and in other preliminary studies with a top-hatted man at the far right of the canvas.[4]

Many of the drawings came after the painted studies, as Seurat refined individual figures and groups. Herbert identifies the museum's *Three Young Women* as "a fragment of the large canvas in its first stage."[5] This drawing shows the back profile of the woman with monkey, which forms an abstract repoussoir at the left of the sheet, and two young women with a girl with the shadowy form of a carriage; at the right a parasol juts into the field of view. The drawing is a reworking of the painted panel in the Musée d'Orsay (fig. 3, H. 129, DR. 129), which does not include the seated girl but contains instead a pair of children and two reclining males in the left-hand portion of the composition, later eliminated in the final version. As Richard Thomson has pointed out, the drawing seems to have further reworkings that would suggest it was executed after the Metropolitan Museum's small version (fig. 4, H. 142, DR. 138), a painted study on canvas of the entire composition that includes most, if not all, the figures that would appear in the final version.[6] The painted study does not include the parasol

Fig. 3. Georges Seurat, study for *La Grande Jatte* (H. 129, DR. 129), 1884. Oil on panel, 16 × 25 cm (5¾ × 9⅞ in.). Musée d'Orsay, Paris, inv. RF 2828. Photo: © RMN

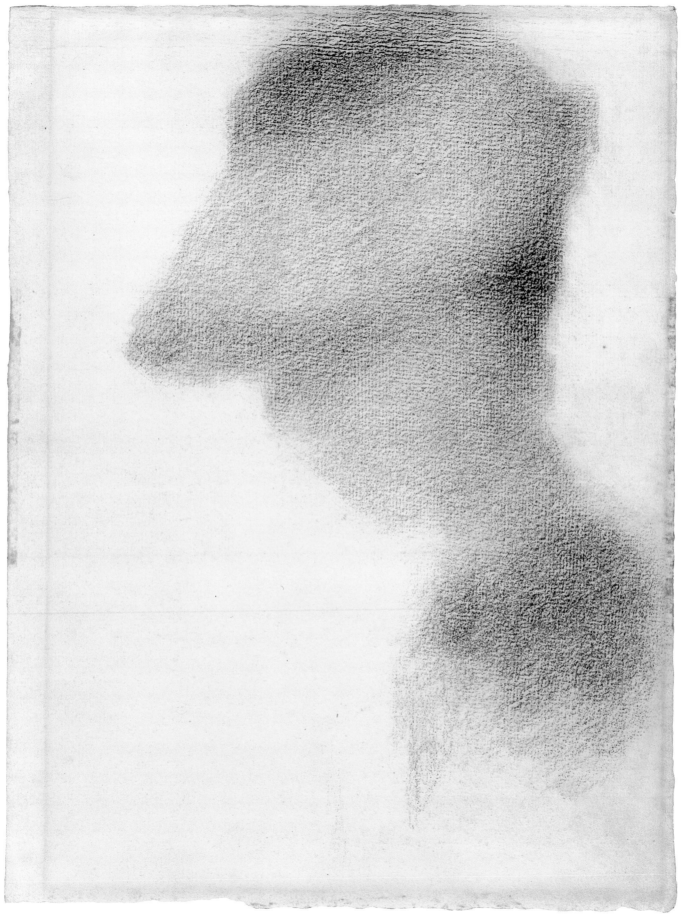

42

Fig. 4. Georges Seurat, study for *La Grande Jatte* (H. 142, DR. 138). Oil on canvas, 70.5 × 104.1 cm (27¾ × 41 in.). The Metropolitan Museum of Art, Bequest of Sam A. Lewisohn, 1951, inv. 51.112.6. Photo: All rights reserved, The Metropolitan Museum of Art

Fig. 5. Georges Seurat, *Seated Woman,* study for *La Grande Jatte* (H. 632, DR. 1381). Conté crayon, 305 × 240 mm (12 × 9⁷⁄₁₆ in.). Philadelphia Museum of Art: The Louis E. Stern Collection, inv. '63-181-180

intruding from the right in the drawing, which becomes an orange blade-shaped form tipped in from the right edge in the final painted version. In the finished canvas, the three young women occupy a visual niche formed by the bustled back of the woman with a monkey and the extended, tapering length of the walking stick held by her male companion; the parasol of the woman with a monkey tilts like a black wing above the heads of the seated trio, its point poised just above the flowered bonnet of the young woman on the group's right.

The museum's *Head of a Woman* is closely related to a drawing in the Philadelphia Museum of Art (fig. 5, H. 632, DR. 1381), which shows the head and torso of the woman silhouetted against light in the upper half of the sheet and shadow in the lower half. According to Herbert, the Philadelphia sheet was a refinement of the Metropolitan's large painted compositional study, where the woman is placed at the far left foreground between the reclining *canotier* and another seated man with a cane; the Smith College sheet is a further refinement of the nuances of tone in the woman's face and hat.[7] In the final canvas, the woman sews a white fabric, and Seurat places a still life of books and a tasseled fan at her side. Herbert has suggested that the man with a cane seated next to her may be her husband; however, Hollis Clayson, following an interpretation by T. J. Clark, believes that the three figures are strangers who "temporarily share a patch of shaded grass."[8]

It may be said in general of the drawings for *La Grande Jatte* that Seurat departs stylistically from the "haloing" and sculptural effects of studies for his first large canvas, *Une Baignade, Asnières* (1883–84, National Gallery, London), depicting male bathers relaxing on the left bank of the Seine opposite the island of La Grande Jatte (whose tree-lined shore is visible at the upper right of the canvas). In the *Baignade* drawings and in other independent drawings of the period, Seurat worked his crayon over the entire sheet, sometimes differentiating the figure from the background by providing a halo or aureole of light around the form. In the *Grande Jatte* drawings, there is a new emphasis on geometric forms and the change from the more sculptural modeling of *La Baignade* drawings to the "wafer-thin" quality of figures silhouetted against the white background of the paper.[9] William Innes Homer related the tonal effects of the drawings for *La Grande Jatte* with value contrasts in the painting, writing of *Three Young Women* that it is "close in general effect to the final painting, for in both the surface is treated as an abstract grid or mesh in which . . . modulations of luminous color or tone serve to define the subject matter." Luminosity was created by "allowing the surface of the sheet to sparkle as a result of the multitude of small white spots showing through covering crayon strokes."[10]

Homer's reference to an "abstract grid or mesh" is an apt description of the heavily textured, laid papers used by Seurat for his drawings.[11] Seurat achieved extremely subtle gradations of tone by using the texture and ridges of the paper to "catch" and separate the deposits of the conté crayon. The density of tone was determined by varying the pressure as the crayon was applied to the paper. The Smith College sheets are testament to the artist's extraordinary mastery of this technique, in which the paper itself is used as an integral part of the drawing, either to shine through and interact with the crayon strokes or to posit form itself, as it does in *Three Young Women,* where the absence of tone in the straw hat of the right-hand figure defines her bonnet against a darker backdrop of trees.[12] Tonal differences in *Head of a Woman* convey the crown and decorative band of the woman's hat; a slight darkening at the nape of her neck accords with her upswept coiffure in the painting, while the features of her delicately handled profile are undelineated but suggested under the shade of her hat brim. In both Smith College drawings, figures take on the evanescent quality of cast shadows. These ghostly, light-penetrated forms are translated in dots and strokes of color to assume weight and substance in the final painted version of *La Grande Jatte.*

LM

1. Cesar M. de Hauke (Hauke 1961; hereafter abbreviated as H.) lists thirty panels, but as Robert Herbert points out in Paris/New York 1991–92, two are not studies (H. 108 and 116), and he questions the authenticity of H. 136. Of the twenty-eight drawings listed by de Hauke, Herbert contests the authenticity of H. 623. Herbert's catalogue for Paris/New York 1991–92 as well as his earlier publication (Herbert 1962) were indispensable to this essay.

2. Seurat enumerated the theoreticians who had influenced his work in a letter of 20 June 1890, to Félix Fénéon, in which he mentions Michel-Eugène Chevreul (author of *De la loi de contraste simultané des couleurs,* 1839), Charles Blanc (author of *Grammaire des arts du dessin,* 1867, and of an 1864 essay on Eugène Delacroix), Ogden Rood (author of *Modern Chromatics,* 1879), and David Sutter (author of "Les Phénomènes de la vision," published in the review *L'Art,* 1880), in addition to the artists Delacroix and Jean-Baptiste-Camille Corot. While a discussion of their color theories is beyond the scope of this essay, an excellent basic summary, which cites primary bibliographic sources, is contained in appendices E–P of Paris/New York 1991–92. Homer 1964 remains an important source (see pp. 112–64 for a discussion of *La Grand Jatte),* as do more recent publications such as Zimmerman 1991 (see chap. 1, and for a discussion of *La Grand Jatte,* pp. 171–95).

3. Herbert in Paris/New York 1991–92, pp. 172, 179 note 4.

4. H. 137; Dorra and Rewald 1959, no. 134 (hereafter abbreviated as DR.). The painting was purchased in 1934 from Mrs. Cornelius J. Sullivan, who was also the former owner of the drawings.

5. Herbert in Paris/New York 1991–92, pp. 217–18, no. 147.

6. Thomson 1985, p. 106. Thomson (pp. 193–95) relates a drawing of the central couple of the woman with a monkey and her companion (British Museum, London; H. 664, DR. 135a) to a painted panel *A Couple* (Keynes Collection, King's College, Cambridge; H. 138, DR. 136), which he believes is based on the drawing. (Paris/New York 1991–92, nos. 137 and 138, reverses the working order, placing the drawing after the panel.) In both works, which study the placement and spatial setting of the couple against the backdrop of other figures, the group of young women with a carriage appears faintly in the background. However, it is difficult to tell whether Seurat has yet added the young girl, absent in the earlier Musée d'Orsay panel, to make the grouping of young women a trio rather than a pair. A vertical element, whether the beginnings of the figure of the girl or perhaps the continuation of a portion of the carriage, does occupy her position in both the British drawing and panel.

7. Herbert in Paris/New York 1991–92, p. 212, under no. 142.

8. Clayson 1989, p. 162. Clayson, in discussing the grouping of the woman sewing, the *canotier,* and the man with a cane, quotes Clark 1984, p. 265.

9. Herbert 1962, p. 107.

10. Homer 1964, p. 128.

11. For a description of Seurat's papers and conté crayon technique, see Herbert in Paris/New York 1991–92, pp. 34–35. Herbert states that Seurat preferred to use the Michaellet brand of Ingres paper for his drawings. No watermarks are visible on either of the two Smith College sheets; therefore, it is not possible to confirm whether Seurat used Michaellet paper as their supports.

12. Seurat achieves similar effects in the drawing *L'Enfant Blanc* (H. 631, DR. 138b), a study for the little girl in white walking hand in hand with her mother in the final canvas. In this drawing, the white of the paper provides the figure's dress, hat, and shoes.

IGNACE HENRI FANTIN-LATOUR

Grenoble 1836–1904 Buré (Normandy)

43 The Commemoration (L'Anniversaire), 1886, drawing for illustration in Le Monde Illustré, 16 October 1886

Black crayon with white heightening, the composition bordered by a ruled framing line in black crayon, on beige tracing paper *(papier calque)* mounted on beige wove card

Watermark: None visible

Image: 555 × 460 mm (21⅞ × 18³⁄₁₆ in.); sheet, irregular: 607 × 482 mm (23¹⁵⁄₁₆ × 19 in.); mount, irregular: 637 × 511 mm (25¼ × 20⅛ in.)

Inscribed by the artist (within composition): *BERLIOZ / 1803;* on scroll: *HAROLD / ROMEO / ET / JULIETTE / LA / DAMNA-TION / DE / FAUST / LES / TROYENS*

Signed and dated recto, lower left, in black crayon: *h. Fantin 1886;* partial stamp(?), lower right [indecipherable]

PROVENANCE Henri Darrasse, Paris; sale, Paris, Hôtel Drouot, 6 Dec. 1909, no. 86, for 1,200 francs; to {Galerie F. & J. Tempel-aere, Paris};[1] Mrs. Henry T. Curtiss (1896–1985), Bethel, Connecticut; gift to SCMA in 1965

LITERATURE Fantin-Latour 1911, no. 1277; *ArtQ* 1965, p. 212, repr. p. 220 (as *Hommage à Berlioz*); Paris / Ottawa / San Francisco 1982–83, p. 233 (under notes for no. 80; see also pp. 224–33, nos. 75–80, for related works)

EXHIBITIONS Ann Arbor 1962, no. 60 (as *Hommage à Berlioz*); Northampton 1966, no. 19, repr. (as *Anniversary*); Northampton 1977 (as *Hommage à Berlioz*); Northampton 1979b, no. 132 (as *Homage to Berlioz*); Northampton 1982b (as *Hommage à Berlioz*); Northampton 1987d, no. 18 (as *Homage to Berlioz*); Northampton 1992b, no. 20

Gift of Mrs. Henry T. Curtiss (Mina Kirstein, class of 1918) 1965:13

This drawing is the penultimate stage of a creative process inspired by a performance of Hector Berlioz's *Roméo et Juliette* on 5 December 1875 and Henri Fantin-Latour's decision to commemorate the composer in a painted "homage" as he had intended to do for Robert Schumann in a project that was ultimately abandoned.[2] Fantin's painting, *The Commemoration (L'Anniversaire,* F. 772; fig. 1), was completed in 1876 in time for inclusion in that year's Salon; however, its placement in the galleries reflected the jury's ambivalence toward the work, as sculpture and popular prints, rather than painting, were media more often associated with commemorative works.[3] In fact, the Smith College drawing is connected with the dedication of a sculptural monument to Berlioz by Alfred Lenoir (1850–1920). This sheet, based on but executed ten years after Fantin painted his homage to Berlioz, was drawn for reproduction in *Le Monde Illustré* (16 Oct. 1886), in an issue celebrating the inauguration of Lenoir's monument to the composer erected in the Vintimille square in Paris. A poem by Léon Valade was published with the image.[4]

A passionate Wagnerian, who postponed his marriage to Victoria Dubourg to attend the first Bayreuth festival in 1876, Fantin nurtured his interest in contemporary music at the salons of the poet Saint-Cyr de Rassac. Odilon Redon also frequented these salons, as did the artist Léon Riesener (1808–1878), Eugène Delacroix's (1798–1863) cousin (and the subject of the Renoir drawing [cat. 37] in this catalogue).[5] Although Fantin also painted portraits and floral still lifes, music was a primary source of inspiration for much of his art, which stood apart from the paintings of his impressionist peers in subject matter, style, and the dark tonalities of his palette. While his por-traits are carefully and realistically observed, his works based on musical themes are instead imaginative responses, with strong romantic undertones, to great composers and scenes from their works.

Fig. 1. Henri Fantin-Latour, *L'Anniversaire,* 1876. Oil on canvas, 220 × 170 cm (86⅝ × 66⅞ in.). Musée de Grenoble, inv. MG 1219. Photo: Musée de Grenoble

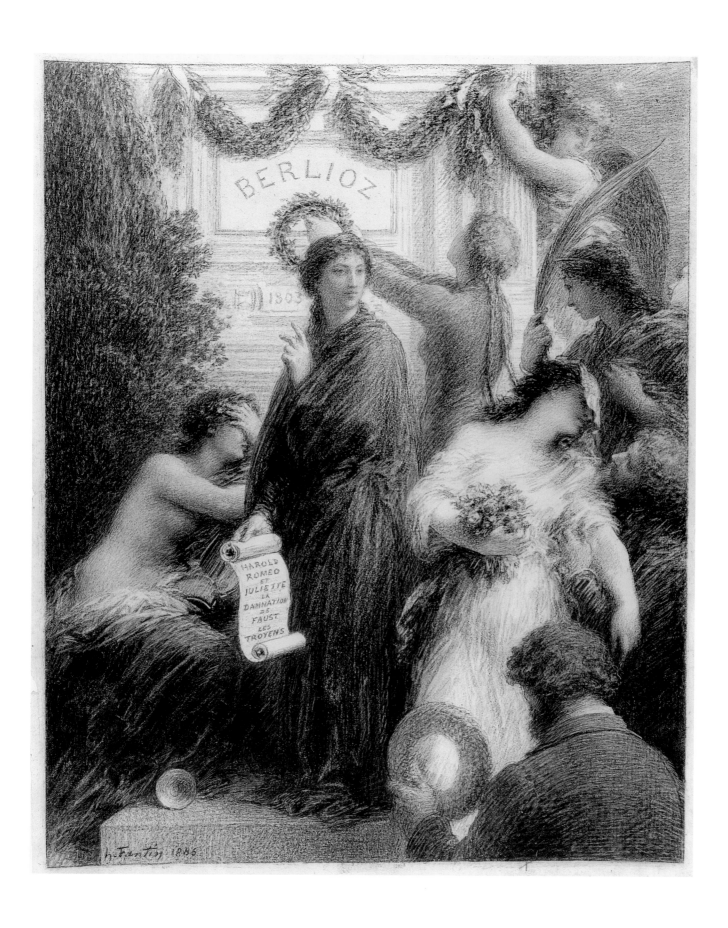

BERLIOZ

1803

HAROLD
ROMEO
ET
JULIETTE
LA
DAMNATION
DE
FAUST
LES
TROYENS

IGNACE HENRI FANTIN-LATOUR 173

Fig. 2. Henri Fantin-Latour, study for *The Commemoration (L'Anniversaire)*, 1875. Lithographic crayon on *papier calque,* 578 × 463 mm (22¾ × 18¼ in.). B. H. Breslauer collection

Fig. 3. Henri Fantin-Latour, *L'Anniversaire,* 1875. Lithograph, 623 × 503 mm (24⁹⁄₁₆ × 19¹³⁄₁₆ in.). Courtesy of the Boston Public Library, Print Department

Fantin's musical tastes centered primarily on the German composers Brahms, Schumann, and his personal icon, Wagner, who was the inspiration for one of the artist's earliest lithographs, *Tannhäuser (Tannhäuser: Venusberg,* 1862).[6] Wagner and his musical works continued as a frequent lithographic subject for the next two decades, and the composer was also the absent but honored subject of the painting *Around the Piano* of 1885 (Louvre, Paris), in which eight admirers of the master's work gather for an intimate concert. The great French romantic composer Hector Berlioz (1803–1869) was included in Fantin's personal pantheon as well. In addition to *The Commemoration* and its related works, Fantin's admiration for Berlioz resulted in a number of lithographs dedicated to the composer, in which Berlioz or his bust is crowned with laurel, or based on scenes from his operas, including fourteen lithographs illustrating Adolphe Jullien's *Hector Berlioz, sa vie et ses oeuvres,* published in 1888.[7] The lithograph *Apotheosis*[8] produced for this publication is a late reworking of the composition for *The Commemoration.*

The Commemoration was developed through various preparatory studies, including an oil sketch (F. 740) traced in a transitional drawing (fig. 2, F. 769) that was used as the basis for a black-and-white lithograph produced in 1875 (fig. 3), which reversed the composition when printed.[9] The lithograph, in turn, gave Fantin the idea to expand the format to a large-scale canvas. He used vari-ous impressions of the print, which he reworked with gouache, crayon, and other media, to refine further the composition for the painted version.[10] Fantin staged the scene as a gathering of Muses and figures from Berlioz's operas and other musical works who mourn before the composer's marble tomb (which, as Fantin noted, does not resemble the somewhat "plain" grave monument in Montmartre Cemetery). Fantin described the dramatis personae of *Commemoration* in a letter of 1876 to his friend the German artist Otto Scholderer (1834–1902).[11] The central figure is the muse Clio, who holds a scroll listing the composer's most famous works. To her right, the muse of music, holding her silent lyre, covers her eyes and weeps. To her left are Romeo and Juliet, a visual reference to the symphony that first inspired the homage; Marguerite, from the *Damnation de Faust,* places a wreath on the tomb; next to Marguerite, Dido, from *Les Troyens,* raises Virgil's golden bough; and above her an angel from *L'Enfance du Christ* garlands the monument. A "modern man" — representing the artist himself and, by extension, the audience — approaches from the foreground, bowing in respect, with a laurel wreath in hand. In contrast to Edgar Degas's more realistically observed paintings of performers onstage and musicians in the orchestra pit, Fantin constructs an entirely artificial theater of immortals symbolized by Berlioz's musical cohort of fictional heroes and heroines.

Fig. 4. Henri Fantin-Latour, *L'Anniversaire*, 1875–76. Lithograph extensively reworked with brush and wash and gouache, squared for transfer, on tinted paper, 622 × 502 mm (24⁹/₁₆ × 19¹³/₁₆ in.). Musée de Grenoble, inv. 1468. Photo: Musée de Grenoble

Fig. 5. Henri Fantin-Latour, *L'Anniversaire*, 1876. Black crayon, squared, 543 × 436 mm (21³/₈ × 17¹/₁₆ in.). Musée des Beaux-Arts, Lille, inv. 2069

The Smith College drawing is faithful in most respects to the painting, differing in small details such as the plinth or step on which Clio stands, which has been squared off in the drawing. The drawing also slightly alters the figure whose upturned face is visible behind Dido's shoulder; in the drawing this figure is repositioned so that his face is turned more in profile, thus redirecting attention back toward the tomb and the center of the composition. In the painting, Clio is detached in aspect from the activity of the mourners and seems to look beyond the temporal frame, suggesting that she alone can view the realm of immortality that has now claimed the composer. In the drawing she catches the viewer's eye (though less directly than her forthright gaze in the 1875 lithograph) and turns the focus with glance and gesture to the absent protagonist, whose name is engraved above her head.

Because the Smith College sheet was created ten years after the completion of the painting, it bears an interesting relation to the web of studies and versions in various media of *The Commemoration,* not only in the adjustments Fantin made in the composition but in the physical facts of the drawing itself, which was executed on tracing paper *(papier calque)* laid down on a heavier backing sheet.[12] Fantin's use of *papier calque* might suggest that the 1886 drawing was traced from the earlier lithograph, although the dimensions of the drawing, smaller than those of the print, argue against the use of the lithograph

as a direct, one-to-one template.[13] The Smith College sheet instead appears to be the direct descendant of two other works. Fantin reworked a lithograph in 1875–76 with brush, wash, and gouache in several colors. This sheet, in the Musée de Grenoble (fig. 4, F. 817), was squared for transfer and apparently used to make another squared drawing in 1876, in the Musée des Beaux-Arts, Lille (fig. 5, F. 818).[14] The latter, in turn, became the basis for the Smith College drawing. The sheet in Grenoble was the moment in which Fantin made the compositional decision to turn the "modern man" to face inward, as he does in the final painted version, rather than looking outside the pictorial frame, as he does in the lithograph. Among the known works associated with *The Commemoration,* the drawing in Lille is the only one whose dimensions (543 × 436 mm) are close to those of the Smith College drawing. They share the same detail of the squared plinth, which does not appear in the painting or in any of the other related works, and the figures in both correspond very closely (although Fantin may have lifted and repositioned his tracing paper slightly as he worked). It is probable that Fantin returned to the Musée de Lille drawing ten years later to trace the basic composition of SCMA's sheet and used the painting, still in his possession at that time, as a guide for details. The Smith College sheet, which is heavily worked in crayon with scraped highlights, uses techniques directly related to Fantin's work in lithography, and indeed the drawing,

while close in composition to the painting, stylistically resembles the 1875 lithograph of *The Commemoration*.

LM

1. An annotated copy of the Hôtel Drouot sale catalogue of the Darrasse collection (FARL) contains the handwritten notation "1200 Tempelaere" for no. 86, the Smith College drawing. Gustave Tempelaere was introduced to Fantin-Latour in 1887 and became his dealer. He died in 1904, the same year of Fantin's death, and was succeeded by his sons, Ferdinand and Julien, who renamed the business Galerie F. & J. Tempelaere (and were also Mme Fantin's heirs; see Paris/Ottawa/San Francisco 1982–83, pp. 17, 361). The author is grateful to Sylvie Brame of Galerie Brame & Lorenceau, Paris (publisher of a forthcoming catalogue raisonné of Fantin's paintings and pastels), for information on the Tempelaeres and for confirming that the SCMA drawing was not included in the Tempelaere gallery's 1925 exhibition of Fantin's drawings (4 Nov. 1996 telefax to the author; in SCMA curatorial files). It is therefore probable that the museum's drawing had been sold by the gallery sometime between its acquisition by the Tempelaere brothers at the 1909 Darrasse auction and the 1925 exhibition.

2. This essay is largely dependent on Douglas Druick's research published in the catalogue essays and notes for *L'Anniversaire (The Commemoration)* and its related studies in the exhibition catalogue Paris/Ottawa/San Francisco 1982–83 (nos. 75–80). Fantin-Latour 1911 is hereafter abbreviated as F.

3. Paris/Ottawa/San Francisco 1982–83, pp. 226, 230–31.

4. Ibid., p. 233 (under no. 80, "Related Works").

5. Ibid, pp. 219–22.

6. Hédiard 1906, no. 1 (hereafter abbreviated as H.).

7. Scenes from Berlioz's opera *Les Troyens*: H. 10, 22, 30, 90, 114, 116, 117, 177; from *L'Enfance du Christ*: H. 28, 36; from *Roméo et Juliette*: H. 176; and from *Sara la Baigneuse*: H. 44, 84, 99. Illustrations for Adolphe Jullien's *Hector Berlioz, sa vie et ses oeuvres* (Paris: Librairie de l'Art, 1888), which includes scenes from various operas and "visualizations" of Berlioz's *Requiem* and *Symphonie fantastique*: H. 76–89. Lithographs in which the composer or a bust of the composer is crowned with laurel: *A Berlioz (petite planche)*: H. 120; *A Berlioz (grande planche)*: H. 132; *Centenaire H. Berlioz*: H. 175.

8. H. 89.

9. See Druick in Paris/Ottawa/San Francisco 1982–83, pp. 224–26. The drawing from the B. H. Breslauer collection, reproduced here as fig. 2, is almost certainly F. 769, which was traced from the oil sketch (F. 740) and used as the basis for the lithograph (H. 7). Although the sheet dimensions of the Breslauer drawing were unavailable at the time of this publication, sight measurements of the framed drawing taken within its mat window (578 × 463 mm) fall within the sheet measurements listed for F. 769 (62 × 50 cm). Its medium and support, lithographic crayon on *papier calque*, also accord with the description of F. 769.

10. Druick in Paris/Ottawa/San Francisco 1982–83, pp. 224–33, nos. 78 and 79, which are reworked lithographs (F. 816 and 817) for *The Commemoration*.

11. Letter from Fantin to Otto Scholderer, 9 Feb. 1876, translated in ibid., pp. 224–25.

12. Examination of the drawing by Craigen Bowen, Conservator, Center for Technical Studies and Conservation, Harvard University Art Museums, on 13 June 1996 with Associate Curator Ann Sievers and Preparator/Conservator David Dempsey of the Smith College Museum's staff, revealed that Fantin-Latour made the initial tracing and then completed the drawing after the tissue was laid down on the backing board. Medium is not present in the "valleys" formed when the tissue was adhered to its backing; therefore, Fantin's crayon "skipped" as he was working.

13. Fantin also created a pastel version of *L'Anniversaire*, which was shown in the 1884 Salon. Druick (Paris/Ottawa/San Francisco 1982–83, p. 233) surmised that the pastel was drawn on top of a lithograph, since the dimensions of the pastel are identical to those of the 1875 print. This was confirmed when the Art Institute of Chicago acquired the pastel for its collection in 1998 (telefax from Suzanne Folds McCullagh, Curator of Prints and Drawings, AIC, to the author, 16 Oct. 1998, with an excerpt from the museum's acquisition proposal noting that the pastel had remained in the family of the collector Esnault-Pelterie until its recent appearance on the French art market; SCMA curatorial files).

14. Druick in Paris/Ottawa/San Francisco 1982–83, no. 79 (see "Related Works," p. 230). The sheet in Grenoble (F. 817) is squared with a numeric scale along its borders that corresponds to the metric measurements of the painting. The drawing in Lille (F. 818) is a study in crayon on tinted paper (inv. 2069, incorrectly cited on p. 230 as inv. 2068). Druick additionally cites an ink drawing (F. 815), which he describes as a tracing that was probably made from a photograph of the large-scale painting (p. 233, no. 80, under "Related Works").

PAUL CÉZANNE
Aix-en-Provence 1839–1906 Aix-en-Provence

44 *House and Barrier (La Barrière à Chantilly)*, c. 1888

Graphite, with brush and transparent and opaque watercolor (gouache) on buff wove sketchbook paper

Watermark: None

190 × 117 mm (7½ × 4⅝ in.)

Inscribed verso, in graphite: [matting notations]

PROVENANCE {Georges Bernheim, Paris}; {Bernheim-Jeune, Paris}, on 6 Oct. 1919; {Montross Gallery, New York}, 1920; Elizabeth Plummer Bliss (1864–1931), New York, 1920; to the Museum of Modern Art, New York, the Lizzie P. Bliss Bequest, 1931; sale, New York, Parke-Bernet, 11 May 1944, no. 30, repr.; to Dr. and Mrs. David M. Levy (Adele Rosenwald Levy, 1892–1960), New York; to her estate (the Adele R. Levy Fund, Inc.); gift to SCMA in 1962

LITERATURE Venturi 1936, no. 924, repr.; Cézanne 1947, unpag., repr.; Ratcliffe 1960, p. 18; Taillandier 1961, repr. p. 48; Siblík 1971, p. 36, color pl. 8; Schapiro 1973, repr. on reverse of pl. 25; Rewald 1983, no. 308, repr.; Paris/London/Philadelphia 1995–96, p. 306 note 2 (under no. 118, *The Allée at Chantilly*)

EXHIBITIONS New York 1920; Brooklyn 1926; New York 1931–32, no. 15; New York 1934, no. 14, repr.; New York 1961, p. 11, repr. p. 14; Pasadena 1967, no. 14; Northampton 1977; College Park 1977–78, p. 50, no. 26, repr.; Amherst 1979, no. 9; Tübingen 1982, no. 34, repr.; Huntington 1990, no. 20

Gift of the Adele R. Levy Fund, Inc.
1962:24

House and Barrier belongs to a period of synthesis in Cézanne's career and the stabilization of his personal life in 1886, when he came into his inheritance and also married his longtime mistress, Hortense Fiquet. As Cézanne turned definitively away from Impressionism, his art developed the strong structural and architectonic emphasis that characterize his Mont Sainte-Victoire paintings, the motif of the mid-1880s he would continue to explore until his death. The watercolors of the 1880s, whose colors reveal and amplify the structure of their underlying pencil drawing, are increasingly typified by a clarity and lightness of touch[1] that allow the paper support to add its own luminosity to the work.

House and Barrier, a view of a building facade through an allée of trees, is associated with a group of works dating from Cézanne's five-month stay in 1888 at the Hôtel Delacourt in Chantilly, north of Paris. *House and Barrier* and a second watercolor (V. 923, R. 309) are related to three oil paintings of allées in or near the village (V. 626–28).[2] The Smith College sheet is most closely related to the *Avenue at Chantilly* (V. 627), in the collection of the Toledo Museum of Art (fig. 1), which widens the view and elaborates on the watercolor's simple symmetrical architecture, with its suggestions of roof, windows, and portal, touched in blue. The second watercolor is related to the painting of a tree-lined avenue without the centrally framed element of architecture (V. 628), which John Rewald has identified as an allée in the park of the château de Chantilly.[3]

Joseph Rishel has noted a variety of influences in the Chantilly paintings, from Camille Corot (1796–1875) to Cézanne's earlier works, specifically those painted under the guidance of Camille Pissarro (1830–1903) in Pontoise and Auvers in the 1870s and the Médan and Maincy landscapes of the 1880s.[4] As Rishel points out, the Chantilly works, though rigorous in their symmetry, present a lush and verdant contrast to the sunstruck Provençal paintings that immediately preceded them. Toledo's *Avenue at Chantilly* masses dense foliage to enframe the château at the end of the allée, while the Smith College sheet builds from a platform of greens and blues in the foreground to erect an airy and open compositional structure with the strong horizontal bar of the barrier as its base. Plumes of watercolor suggest the leaves and branches of the double row of trees arching above the architectural facade. As in most of the watercolors, a pencil drawing, in this case economical markings of straight broken lines and quick, calligraphic strokes in the trees, provides the underpinning for the colors.

The Smith College sheet suggests recession into space and at the same time reinforces the two-dimensional surface of the paper. In this sense, the barrier has both a structural and psychological function, by establishing the foreground and controlling "entry" into the composition and visual access to the architectural motif beyond. As Theodore Reff has written, Cézanne avoided the effects of traditional one-point perspective by "eliminating orthogonal lines or modifying their angle of convergence, by tilting up horizontal planes to reconcile them with the picture's surface, by bringing distant forms in closer relation with those in the foreground; and he does so even when the subject contains strongly convergent elements, such as an alley of trees or a receding road." By linking vertical and horizontal planes at diminishing intervals in space, "recession without convergence" is achieved, a method he notes is particularly evident in Cézanne's views of allées and roads.[5]

The Smith College watercolor is part of the history of the early collecting of Cézanne in this country, as well as sharing connections with the newly established Museum of Modern Art. The first American owner of *House and Barrier,* Lillie (Lizzie) P. Bliss, one of the original founders

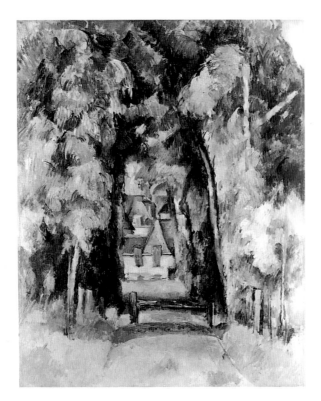

Fig. 1. Paul Cézanne, *Avenue at Chantilly*, 1888. Oil on canvas, 81.3 × 64.8 cm (32 × 25½ in.). The Toledo Museum of Art, Gift of Mr. and Mrs. William E. Levis, 1959.13

of the Modern, began collecting with the advice of the artist Arthur B. Davies (1862–1928) at the Armory Show in 1913. One of a number of signal pairings between collector and artist of the period, including the Havemeyers, who were advised by Mary Cassatt (1844–1926), Albert C. Barnes, advised by William Glackens (1870–1938) and Leo Stein, and Mrs. Montgomery Sears, who benefited from the counsel of Cassatt and Maurice Prendergast (1859–1924),[6] the Bliss-Davies friendship lasted until the artist's death in 1928. During this mutually beneficial partnership Bliss amassed a collection that included major works by the impressionists and post-impressionists, as well as the Americans Davies, Walt Kuhn (1880–1949), and the Prendergasts (Maurice and Charles, 1863–1948). The greater part of this collection was bequeathed to the Museum of Modern Art. According to Alfred Barr, Jr., in his preface to the Modern's 1934 catalogue of the Bliss collection, Cézanne dominated the "second period" of

Bliss's collecting actitivities from 1916 to 1926, succeeded in the years just prior to her death by her interest in Georges Seurat (1859–1891).[7]

According to Lionello Venturi, the museum's sheet was first shown in this country in the influential Cézanne exhibition in January 1916 at the Montross Gallery in New York as catalogue number 36 *(The Gables)*. However, both the exhibition history and provenance of the museum's watercolor were amended by Rewald to reflect the greater likelihood that Bliss saw and purchased it four years later at the same gallery.[8] The Smith College sheet was one of twenty-one Cézanne paintings and watercolors in Bliss's bequest to the Museum of Modern Art and was shown in the Modern's 1931 and 1934 memorial exhibitions of her collection. Subsequently deaccessioned and sold at Sotheby's in 1944, *House and Barrier* was acquired by Adele R. Levy, a trustee of the Museum of Modern Art and, as Bliss had been, a former vice president of the museum. The watercolor again returned to the Museum of Modern Art in 1961 for a memorial exhibition dedicated to Levy and was given the following year to the Smith College Museum of Art with a small oil on cardboard painting, *Rooftops,* by Pierre Bonnard,[9] as the gift of the Adele R. Levy Fund.

LM

1. Rewald 1983, pp. 26–31. Rewald (1983) and Venturi (1936) catalogue raisonné references are hereafter abbreviated as R. and V., respectively.

2. Joseph Rishel, in his catalogue entry for the painting *Avenue at Chantilly* (V. 627) in Paris/London/Philadelphia 1995–96, no. 118, repr., notes that a sixth work, R. 310, may belong to this group of works from Chantilly.

3. R. 309.

4. Paris/London/Philadelphia 1995–96, pp. 305–6.

5. Theodore Reff, in New York 1977–78, p. 46.

6. Rewald 1989, p. 165.

7. Alfred Barr, Jr., preface to New York 1934, pp. 6–7.

8. R. 308. Consulting the records of the Bernheim-Jeune Gallery in Paris, the sole lender of watercolors to the 1916 Montross exhibition, Rewald discovered that the Smith College sheet had not come into the possession of the Bernheim-Jeunes until 6 Oct. 1919, when the gallery purchased fifteen watercolors, including the SCMA sheet, from Georges Bernheim. He concluded that *House and Barrier* could not have been shown in New York in 1916 and removed, as well, exhibitions at Bernheim-Jeune in 1909 and 1910 from its exhibition history. Rewald concludes that the watercolor listed as *La Barrière* in the 1909 and 1910 Bernheim-Jeune exhibitions was *Entrée de Ferme* (V. 949, R. 397).

9. Dauberville and Dauberville 1965–74, no. 154.

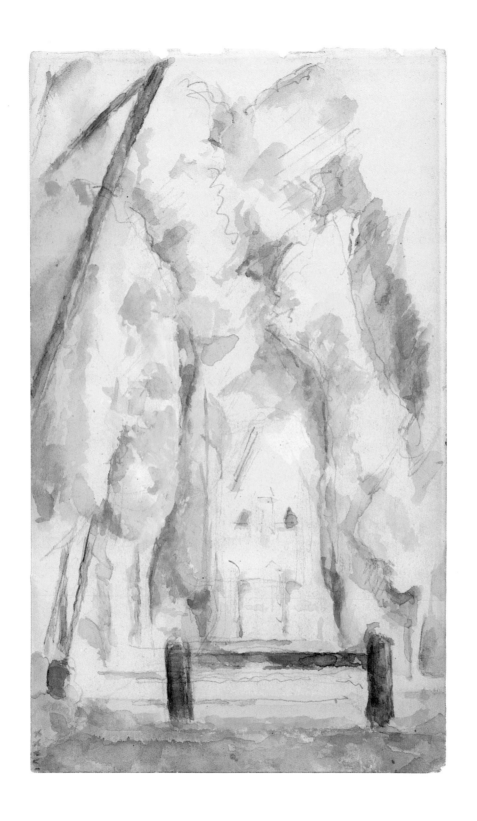

ELIHU VEDDER
New York 1836–1923 Rome

45 *Lasciate ogni speranza, voi ch'entrate* (Abandon all hope, ye who enter),[1] 1888/1898

Colored crayon, black chalk, the composition bordered by a framing line in black crayon over graphite on beige wove paper

Watermark: Vidalon-Les-Annonay ANCne MANUFre Canson & Montgolfier

442 × 546 mm (17⅜ × 21½ in.)

Signed and dated recto, lower right corner, in red and blue tempera: *1888 V Roma 98;* inscribed by the artist recto, vertically at lower left, in black crayon: *COPYRIGHT 1898 BY E. VEDDER;* titled on separate strip of paper laid down across bottom of sheet, in brown and black crayon: *LASCIATE OGNI SPERANZA, VOI CH'ENTRATE*

PROVENANCE Anita Vedder, the artist's daughter (1873–1954), Rome and Capri, Italy; bequest to the American Academy of Arts and Letters, New York, in 1954; gift to SCMA in 1955

LITERATURE Lusk 1903, p. 145, repr. p. 142; Soria 1970, no. D374 (as *A Glimpse of Hell*)

EXHIBITIONS New York 1912, no. 19; New York 1937–38, no. 186; Northampton 1974c; Northampton 1987d, no. 23

Gift of the American Academy of Arts and Letters 1955:11

Elihu Vedder, an American visionary artist who lived in Rome from 1866 until his death in 1923, was much influenced by the work of the Italian artists of the quattrocento and such artists as William Blake (1757–1827) and the Pre-Raphaelites. While he painted many Italian landscapes, the majority of his works are allegorical, drawing on classical, biblical, and literary sources. Among his best-known works are the oil paintings *The Questioner of the Sphinx* (1863), *The Cumaean Sybil* (1876), and *The Soul between Doubt and Faith* (1887),[2] as well as illustrations for Edward FitzGerald's 1884 edition of *The Rubáiyát of Omar Khayyám.*[3] Vedder was preoccupied with questions of fate, death, and the soul, executing many works on these themes, particularly after experiencing the deaths of two sons, one in 1872 in infancy and one three years later at the age of five.

The title of this drawing, *Lasciate ogni speranza, voi ch'entrate,* refers to Dante's *Inferno* (canto 3, line 9). It is the inscription on the gate to Hell through which Virgil and Dante see the figures beyond who await Charon's ferry to cross the river Acheron. The drawing depicts the faces of five women, their heads tightly massed in a fearful huddle that is framed and accentuated by the arched border of the composition. The sheet's overall tone results from blended and heavily fixed touches of grey, brown, orange, light blue, and white crayons and black chalk. The flickers of flame at botton left appear to be accompanied by a powerful wind that blows the women's hair and simple head coverings. Lit by the flames below, their faces convey consternation yet resolute stoicism. Typically, Vedder has emphasized mood rather than individualizing details in these idealized faces; his characteristic use of swiftly flowing lines creates a sense of intense emotional drama.

Vedder's choice of a Dantesque subject is not surprising, given his literary interests; he may also have been influenced by the fact that several artists whom he admired, including William Blake, Dante Gabriel Rossetti (1828–1882), and Gustave Doré (1832–1883), had translated or illustrated Dante's writings.[4] Regarding the poet's notion of Hell, Vedder observed wryly in his memoirs, *The Digressions of V:* "I notice that Dante provides a snug little place in Hell for all but himself. This idea of Hell for others may make the belief more endurable for some, — nay, even pleasant. I myself have known of people for whom some such arrangement seemed indicated."[5]

While Vedder explicitly linked the SCMA drawing to the Inferno through its inscription, the germ of his artistic concept seems to derive from his own earlier artwork rather than directly from Dante's text. The basic compositional structure of the drawing, with its compressed grouping of heads, can be related to *The Recording Angel,* one of Vedder's fifty-three illustrations for the *Rubáiyát* (1884), and his oil painting *Soul between Doubt and Faith* (1887), both of which present trios of closely positioned heads.[6] In *Love Shrinking Affrighted at the Sight of Hell* (*Rubáiyát,* stanza 78), which depicts a crowd of anguished faces, Vedder employs to dramatic effect the strategy of implying rather than showing the fearsome sight. Similar compositional ideas are present in *Faces in the Fire* (fig. 1), a painted plaster relief of 1887 that served as model for a fireback (a metal panel designed to reflect heat from the back of an open fireplace).[7] The relief depicts the closely massed heads of eight women and an angel in a vertical, rectangular format. Describing *Faces in the Fire,* Vedder wrote, "I imagined, as it was filled with a mass of heads looking out of it, that, lighted by the flames or the flickering light of the dying fire or the glow of the embers, they would seem alive and recall lost or absent friends."[8]

Vedder's oil painting *A Glimpse into Hell, or Fear* (fig. 2), now in the George F. Harding Collection of the Art Institute of Chicago, is nearly identical in composition to

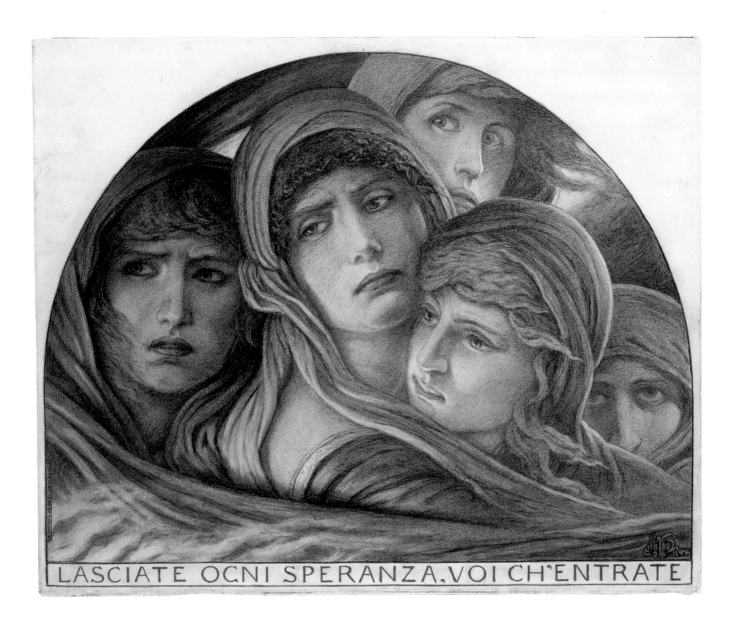

LASCIATE OGNI SPERANZA, VOI CH'ENTRATE

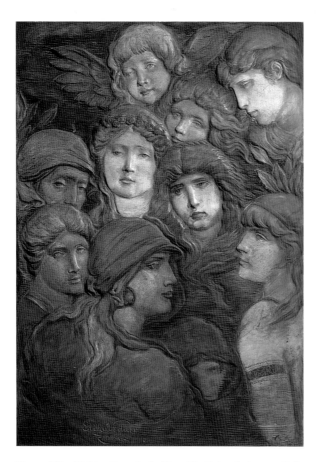

Fig. 1. Elihu Vedder, *Faces in the Fire,* 1887. Painted plaster relief, 80 × 57.7 cm (31¼ × 22¾ in.). Private collection, Evanston, Ill. Photo: Courtesy of Richard Murray, National Museum of American Art

Fig. 2. Elihu Vedder, *A Glimpse into Hell, or Fear,* 1888–98. Oil on canvas, 40 × 52.4 cm (15¾ × 20⅝ in.). The Art Institute of Chicago, George F. Harding Collection, inv. 1982.776. Photo: © The Art Institute of Chicago. All Rights Reserved

Fig. 3. Elihu Vedder, *A Glimpse into Hell,* 1898. Pastel, 127 × 162 mm (5 × 6⅜ in.). Collection of William T. Cartwright, California. Photo: John S. Sullivan

the SCMA drawing, and its dimensions are also close.[9] The oil painting is more highly colored, but its hues are related to the subdued colors in the drawing. While it was certainly Vedder's practice to make detailed sketches and colored drawings as preparation for a painting, he also often made copies of his paintings (or drawings), sometimes from memory, to sell, exhibit, or keep in his own collection. The Smith College drawing may well be a finished work of this type rather than a study for the painting.

Both works were signed by Vedder with his initial *V* and the dates *1888* and *98,* which has been taken to mean that he began work on these pieces in 1888 and completed or reworked them ten years later. Although this may be the case, a precise dating of the drawing becomes more problematic if it is indeed a copy after the finished painting. The possibility cannot be ruled out that the dates on the drawing simply record the development of the painting.

Other versions of the subject exist, including a pastel dated April 1898 (fig. 3) of the three heads that appear at the left of the SCMA drawing.[10] Regina Soria, Vedder's biographer, also reports (but does not reproduce) a small oil painting whose present location is unknown.[11] Vedder

often repeated the same or similar subject in a variety of media. Barbara White Morse cites the instance of *Soul of the Sunflower,* which appears as a sketch (1868), an oil painting (1870), a bronze fireback (1881), a ceramic tile (1887), and part of a book illustration for the *Rubáiyát* (1884).[12] While creative concerns undoubtedly played a part in this process, pragmatic considerations may well have been contributing factors. Vedder's finances were often precarious and he was quick to respond to market demands when a particular motif proved popular.

In 1898 Vedder copyrighted both the Art Institute painting and the SCMA drawing, his usual practice when completing or altering one of his originals. This procedure may have been necessitated by the fact that he often made and sold hand-colored photographs or photomechanical reproductions of his work to help cover expenses — "An honest but undignified proceeding — but

Fig. 4. Elihu Vedder, *Lasciate ogni speranza, voi ch'entrate*, c. 1898. Photomechanical reproduction of SCMA drawing at an earlier stage, 280 × 355 mm (11 × 14 in.). Courtesy of Regina Soria

very helpful," he wrote.[13] A photomechanical reproduction was made of the SCMA drawing (fig. 4), showing it at a stage just prior to its final reworking in which several minor additions were made (e.g., some wisps of hair on the figures at left and top center, and the flames at lower left).[14]

The format of the SCMA drawing and Art Institute painting raises the question of whether Vedder may at some point have thought of this image as a possible mural subject. The arched shape appears, for example, in several of his studies for murals for the World's Columbian Exposition in Chicago,[15] although it also appears in other contexts, such as oil painting and book illustration. To date, no related mural projects have been identified.

The Smith College drawing was acquired as a gift from the American Academy of Arts and Letters in 1955 along with three other works by Vedder: *Le Casacce* (study for *Near Perugia*), 1867, oil on cardboard; *Cypress Trees — Perugia, Villa Uffreduzzi*, oil on cardboard; and *Sorrow — Crown of Thorns*, crayon and colored chalk on paper.[16] These works were among a large number of paintings and drawings bequeathed to the academy by Anita Vedder, the artist's daughter, and distributed to thirty-five American museums in 1955.[17]

NR

1. The current title of this drawing derives from its inscription, but *A Glimpse into Hell, or Fear*, the title assigned by Vedder to the nearly identical oil painting now in the Art Institute of Chicago (Vedder 1910, p. 495), may represent the artist's intended title for the SCMA drawing as well. The Chicago painting is oil on canvas (rectangular with arched top, mounted on another canvas), 40 × 52.4 cm (15¾ × 20⅝ in.); dated, initialed, and inscribed at lower right, *1888 V ROMA 98*, inv. 1982.776. See Soria 1970, no. 524 (references to this catalogue hereafter abbreviated as Soria).

2. These are located, respectively, at the Museum of Fine Arts, Boston (Soria 30; Washington 1978–79, no. 50, repr.); The Detroit

Institute of Arts (Soria 298; Washington 1978–79, no. 114, repr.); and Herbert F. Johnson Museum of Art, Cornell University, Ithaca, N.Y. (Soria 434; Washington 1978–79, no. 182, repr.).

3. FitzGerald 1884.

4. Rossetti translated Dante's *Vita nuova* in the 1850s and in 1874 published some of Dante's sonnets in *Early Italian Poets*. Rossetti also painted several subjects related to the *Vita nuova*, including *Dante Drawing the Angel*, 1853; *Beata Beatrix*, 1863; and *Dante's Dream*, 1869–81. Doré's illustrated version of *The Inferno* was published in 1861. Blake executed 102 drawings for the *Divine Comedy* in 1825–27, although these were not published until after 1900.

5. Vedder 1910, p. 43.

6. *The Recording Angel* (Soria 258) appears between stanzas 76 and 77 of the *Rubáiyát* (FitzGerald 1884, unpag.). The original drawing (chalk, pencil, and ink, 1883–84) is in the collection of the National Museum of American Art, Smithsonian Institution, Washington, D.C., inv. 1978.108.39). For *The Soul between Doubt and Faith* (Soria 434), see note 2, above.

7. Soria S9; Vedder 1910, p. 498. The relief (formerly Hirschl and Adler Galleries, Inc., New York) is now in a private collection (letter to the author, 11 July 1995, from Meredith E. Ward, Hirschl and Adler Galleries, Inc.; SCMA curatorial files); see Washington 1984, no. 8, repr. Three bronze casts are known, one dated 1889 (see Detroit 1983, no. 87, entry by Michele Bogart). I am grateful to Jonathan Harding of the Century Association, New York, which formerly owned one of the firebacks, for bringing this reference to my attention.

8. Vedder 1910, p. 488.

9. See note 1.

10. This pastel, titled *Three Heads* or *A Glimpse into Hell* (not in Soria), is in the collection of William T. Cartwright, Woodland Hills, Calif., 127 × 165 mm (5 × 6⅜ in.). It is dated on the verso *April 1898* and signed lower right, *18 V 98*.

11. Soria 525 (24 × 32 cm [9½ × 12¾ in.]). Soria assigns a date of c. 1898.

12. See Morse 1974, pp. 22–23.

13. Vedder 1910, p. 494. These reproductions were variously made by Fabbri of Rome, Curtis and Cameron, and Houghton Mifflin (Soria 1970, p. 270 note 2, and p. 333).

14. This reproduction is the source of Soria's listing (Soria D375), which can now be identified as the SCMA drawing in an earlier stage. The reproduction (280 × 355 mm [11 × 14 in.]) is inscribed, lower right corner, in ink, *Elihu Vedder*, probably in the hand of the artist's daughter, Anita Vedder (letter to the author from Regina Soria, 28 Dec. 1991; SCMA curatorial files). It shows the artist's inscriptions on the drawing (at left *Copyright 1898 E. Vedder* and at lower right *1888 V ROMA 98*) in lettering that differs slightly from that currently present.

15. See, e.g., *Man's Mind* (1892, unlocated, not in Soria), *Eclipse of the Sun by the Moon* (1892, charcoal and chalk on paper, The Corcoran Gallery of Art, Washington, D.C.; not in Soria), and *Diana Passes* (1892, charcoal, pastel, and gouache on paper, Georgia Museum of Art, University of Georgia; Soria D458), figs. 244, 245, and 247 respectively in Washington 1978–79. For a discussion of Vedder's mural projects, see Murray 1979.

16. Respectively, SCMA inv. 1955:9 (Soria 12), 1955:10 (Soria 220), and 1955:12 (Soria D60).

17. Letter to the author from Nancy Johnson, archivist/librarian, American Academy and Institute of Arts and Letters, New York, 31 July 1990 (SCMA curatorial files).

ADOLPH VON MENZEL
Breslau 1815–1905 Berlin

46 *Bearded Man with a Glass*, 1890

Black chalk with stumping and graphite on moderately thick, moderately textured white wove paper

Watermark: None

125 × 203 mm (4⅞ × 8 in.)

Signed and dated recto, lower left corner, in black crayon: *A.M.* / *90*

PROVENANCE "Consul Mugden," Hamburg;[1] to {Galerie St. Etienne, New York} as agent in 1963; sold to SCMA in 1963

LITERATURE Chetham 1969, p. 775; AFA 1970–72, [p. xiv], fig. 25; SCMA 1986, no. 252, repr.

EXHIBITIONS Cambridge 1964, no. 26, repr.; Hartford 1975

Purchased with funds contributed by the Beech Corporation 1963:48

The primary drawing on this sheet depicts the half-length figure of a portly, bearded man who wears a loose, unbuttoned coat and appears to be seated, leaning slightly backward. He directs a piercing glance upward to his left, his bristling eyebrows drawn together as if in concentration, and with his right hand he holds aloft an empty goblet. Detail studies show two slightly different views of the sitter's left hand, gesturing outward, and at upper right a more shadowed version of the face. The man's right arm is crossed out at the elbow, and the second version of the face is also scribbled out.

In this drawing Menzel makes use of a soft graphite carpenter's pencil in combination with rubbing or stumping and an overlay of chalk in certain details. In areas such as the torso and arms the strokes are broad and somewhat generalized, but in the face the technique is detailed and refined. A subtle use of stumping in the brow and cheekbones conveys the play of light across the man's features and records the brief flare of emotion, allowing the sitter's mood to emerge. In the eyebrows and beard, thin, grainy strokes of black chalk applied over carpenter's pencil provide texture. Contour outlines of the head and body, where present, are lightly indicated in graphite; in places the outline disappears or is rubbed out, or is present in one detail study but not the other, as if the issue of outlining or dissolving outline was of particular concern to Menzel.

At this stage in his long and productive artistic life, after more than half a century of depicting the details of scenes around him, Menzel was legendary for his skill as a draughtsman. An unquestioned master of realism, he was noted for his ability to capture subtle nuances of pose and gesture to create a precise shade of mood. In study sketches such as the Smith College sheet, his skill in depicting the human body is apparent.

Menzel's devotion to drawing began early in life. He first studied with his father, a lithographer, who died in 1832, when Menzel was sixteen.[2] In 1833 he studied for a short time at the Berlin Academy of Art, then known for its emphasis on portraiture, perspective painting, and drawing from nature. He was largely self-taught, how-

ever, partly by inclination and partly by necessity, as he supported his family after his father's early death. By the age of twenty-five, Menzel had achieved artistic renown through his four hundred illustrations (printed as wood engravings) for Franz Kugler's *Life of Frederick the Great*,[3] a project for which he made hundreds of preparatory sketches based on careful historical research into the costumes, furniture, and architecture of the previous century.

Menzel's focus on drawing from life and his habit of making exhaustive and historically accurate preparatory drawings continued through his middle years, when his major works included a series of history paintings about the life of Frederick the Great, as well as paintings of the contemporary political and social elite of Berlin such as *Ball Supper* (1878), and the elaborately researched industrial painting *Iron Rolling Mill* (1875).[4] Through such works, Menzel became known and honored as one of the most important German realists. Frequenting the court with his ever-present sketchbooks, he was known for his insatiable appetite for drawing the scenes around him, and in his prolific output he captured many an unguarded moment in a drawing room or ballroom. He was an astute observer — almost aggressively so — but his observations stopped short of expressing judgment. As in the SCMA drawing, his tone was neutral and thus differed from that of such contemporaries as the French artist Honoré Daumier (1808–1879).[5]

From the late 1880s until his death in 1905, Menzel's work was characterized by a move toward a style and subject matter that are less timebound, chosen more for personal or aesthetic interests than for public relevance or historical significance. He entered the drawing rooms and ballrooms of Berlin's elite less and less, turning his attention instead to depicting back streets, garden walls, and fragments of landscape from his occasional travels, along with anonymous members of the bourgeoisie and lower classes whom he encountered on the streets or invited to his studio as models. Many of his studies seem to have been done to satisfy his habit of daily drawing. As August Kirstein wrote, Menzel in these late years "lived

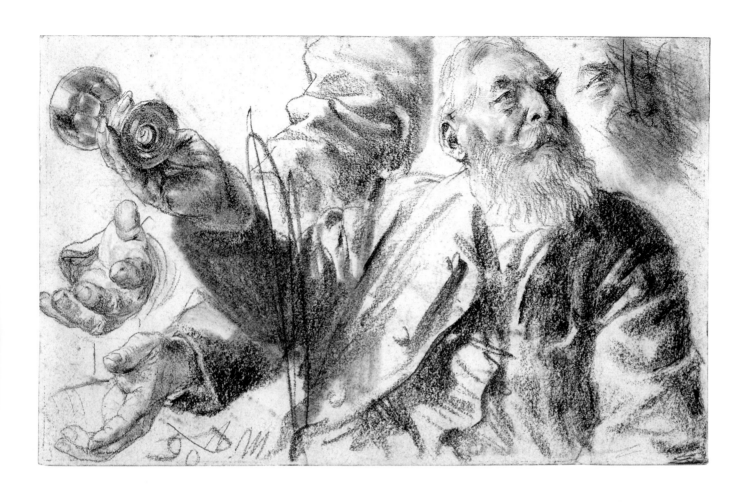

Fig. 1. Adolph Menzel, *Bearded Old Man with a Cigar, One Leg Slung over the Arm of a Chair*, 1891. Pencil, 415 × 287 mm (16⅜ × 11⁵⁄₁₆ in.). Staatliche Graphische Sammlung, Munich, inv. 36648

there on the third floor, visited only by a few intimate friends. His studio was on the fourth floor. On the landing you could see old, ugly models, the 'characters' whose heads he liked to use to exercise his skills."[6] The male figure in the Smith College drawing is probably one of these models; he appears in other drawings of this period such as *Man in Armchair* (1889) and *Bearded Old Man with a Cigar, One Leg Slung over the Arm of a Chair* (1891; fig. 1).[7]

Utilizing his pencil sketches as source materials, Menzel produced finished works in oil, gouache, ink and wash, and etching, but increasingly he focused on pencil as his medium, completing his last oil in 1892 and his last gouache in 1901. The model in the SCMA drawing was one of several candidates whom Menzel considered (and subsequently rejected) for the central figure in his highly finished ink and wash drawing *The Studio Worker* (1890),[8] but to date no finished work that utilizes the SCMA drawing has been identified.

By the late 1880s, Menzel had begun to make drawings of heads, usually of old men and women,[9] which are masterpieces of a painterly or tonal drawing technique, with their extensive use of rubbing or stumping, carpenter's pencil, and chalk. The shadows and contours of the faces seem at once to flicker, dissolve, and re-emerge in a way that suggests the world of the imagination and spirit, in contrast to the crisp-edged, anecdotal realities of Menzel's earlier work. The SCMA drawing blends elements of his earlier anecdotal style with this more impressionistic technique.

NR

1. According to the Galerie St. Etienne. This provenance remains unverified.

2. For biographical details and bibliography, see Paris/Washington/Berlin 1996–97, ASI 1990–91b, and Tschudi 1905.

3. Kugler 1840.

4. *Ball Supper* and *Iron Rolling Mill* are in the collection of Staatliche Museen zu Berlin-Preussischer Kulturbesitz, Nationalgalerie (inv. NG 985 and AI 201, respectively); reproduced as figs. 35 and 33 in Jensen 1982.

5. Françoise Forster-Hahn discusses the ambivalence that Menzel may have felt privately toward the court life he depicted (see Forster-Hahn 1978, pp. 272–75).

6. Kirstein 1919, p. 84, quoted in Cambridge (Eng.) 1984, p. 138.

7. *Herr im Sessel*, Kupferstichkabinett, Hamburger Kunsthalle (inv. 1937/17); and *Bärtiger Alter mit Zigarre, quer über einer Armlehne sitzend*, Staatliche Graphische Sammlung, Munich (inv. 36648). These drawings are reproduced as figs. 173 and 193 in Hamburg 1982.

8. See Hamburg 1982, figs. 174–77, for reproductions of *The Studio Worker* (pen and black wash over pencil) and three preparatory pencil studies; all are listed as "private collection, Hamburg."

9. See, e.g., the pencil drawing *Old Woman with a Cap* (1891) from the collection of the Kunsthalle Bremen (inv. no. 56/232), in Bremen 1981–82, no. 52, repr.

BERTRAND-JEAN, CALLED ODILON REDON
Bordeaux 1840–1916 Paris

47 *Head of a Woman in Profile*, c. 1890–95

Various charcoals and black chalk, with stumping and erasing, on cream wove paper altered to a golden tone; the paper trimmed to a framing line drawn in black chalk[1]

Watermark: BERTHOLET FRERES A WESSE

495 × 362 mm (19½ × 14¼ in.)

Signed recto, at lower center of image, in black chalk: *ODILON REDON*

PROVENANCE Andries Bonger (1861–1936), Amsterdam (possibly directly from the artist); to his widow, Françoise Bonger (d. 1976), Baroness van der Borch van Verwolde, Almen (near Zutphen), Holland; to {Jacques Seligmann & Co., New York} in 1951–52; Selma Erving (1906–1980), Hartford, Conn., by 1967; bequest to SCMA in 1984

LITERATURE Berger 1965, no. 678; *GBA* 1985, listed p. 75; SCMA 1986, no. 250, repr.; Wildenstein 1992–96, vol. 1, no. 329 (as *Profil sous l'arche*)

EXHIBITIONS New York/Cleveland 1951–52, no. 26, repr. (as *Profil à droite*); Northampton 1967, no. 49, repr. (as *Profile of a Woman*); Hanover 1973–74, no. 63, repr. (as *Head of a Woman*); Northampton 1984c, no. 22

Bequest of Selma Erving, class of 1927
1984:10-54

Odilon Redon's *noirs* (blacks), the charcoal drawings he also referred to as *mes ombres* (my shadows), occupied him for over twenty years. The first exhibitions of these drawings in Paris — in an 1881 show at the offices of the journal *La Vie Moderne* and one a year later at the newspaper *Le Gaulois*—brought him his first favorable attention as an artist. The second exhibition prompted the articles by Emile Hennequin and Joris-Karl Huysmans that helped establish his reputation as a master of bizarre fantasies. After early art studies in Bordeaux and a brief stint as a student of architecture in Paris (under pressure from his father), Redon served in the Franco-Prussian War. Following his discharge he settled in Paris, where, with a modest income from the family vineyards, he devoted himself to art. It seems to have been at this time that he seriously turned his attention to charcoal drawings, or *fusains*. At the same time he began work in lithography, publishing his first album in 1879. By then he had amassed a large number of *noirs*, created for the most part in summers spent at his family home, Peyrelebade, in the Médoc.[2]

The SCMA drawing is one of a large number of sheets by Redon showing heads of young women in profile with flowers, sometimes presented in windows or under arches.[3] The idealized female head in profile was a recurring motif in his work, variations on the theme appearing over most of his career in prints, *noirs*, and pastels. Early examples appeared in the 1880s, and it has been suggested that his marriage to Camille Falte in 1880 gave rise to this "new ideal" of "noble femininity."[4] The charcoal drawing *Profil de lumière* of 1881,[5] followed by a lithograph of the same subject in 1886, proposed one variation, in which a shaft of light seems to emanate from the profile of a helmeted figure, suggesting spiritual enlightenment, a theme echoed in the 1891 lithograph *Druidess*.[6] Redon often set his profile heads against a window; usually a windowsill or ledge separates the figure from the viewer, isolating it in an ideal or mysterious space. Like

the profile portrait itself, the use of a window as a framing device derives from Italian Renaissance portraits, which Redon would have known well from his studies at the Louvre. Another element in these works, and one that becomes increasingly common, is the association of flowers with the youthful female profile. Gloria Groom has suggested that the author Jules Michelet's use of flowers and butterflies to signify spiritual or physical "awakening" served as a source for Redon's imagery.[7] The artist sometimes reinforced the spiritual aspect of the idealized heads by setting them against an arched opening that recalls church windows. In the SCMA drawing such an opening is suggested by the shadowed arch at the right. Titles given to some of these drawings by Redon himself also underline their meaning: *Profil de jeune fille, l'intelligence* (1881; W. 157), *Le Printemps* (1883; W. 239), or *Profil de femme entourée de feuilles de lumière. La jeunesse* (1891; W. 334).[8]

Recent technical studies of Redon's *noirs* have revealed them to be drawn in a combination of black media, including charcoals, fabricated black chalk, black pastel, and black crayon.[9] Redon's procedure, visible in the SCMA drawing, was to lay down a tonal base of charcoal, from which the drawing would be worked additively, with charcoal and other black media, as well as subtractively, using kneaded bread, erasers, or the artist's hand to selectively lift the media to create the drawing's lightest passages. Here Redon has lifted broad areas across the woman's upper face as well as from the background to the right of her profile, bathing the area around her eyes in a radiant glow. In some passages he seems to have used his fingers to remove charcoal (for example, the area above the woman's head), while in others he used a pointed instrument to lift the charcoal in thin lines that suggest the figure's clothing and model the plants on the ledge. Redon's approach in this piece is characteristic of his work in the 1890s, when he adopted a more linear method of drawing. Unlike his earlier *noirs*

in which the subject was suggested to Redon by the shapes of the first charcoal passages he laid down and was then worked out in execution, this sheet seems to have been conceived before the artist began to draw.[10] The pentimenti here are few and minor. The deeper black media are used to draw the significant contours of profile and arch and then to lay in the darkest passages in the drawing, which take on a velvety surface quality. Like many other *noirs,* this drawing has been fixed on the verso; with age and the drawing's exposure to light this fixative has imparted a warm golden tone to the paper, which seems originally to have been a cream color. These effects are intentional, part of Redon's exploitation of the paper as a tonal element in his drawings, and akin to his emphasis on the chromatic qualities of his black media.[11]

This drawing belonged to one of the most important collectors of Redon's work, Andries Bonger, the man to whom the artist dedicated his writings on art, published posthumously as *A soi-même.*[12] Andries Bonger first went to Paris from his native Holland in 1879 at the age of eighteen. At the Club Hollandais he met Theo van Gogh, the art dealer who would become his brother-in-law in 1889 (marrying Bonger's younger sister Johanna).[13] This relationship not only encouraged Bonger's interest in the newest French painting but enabled him to meet the artists as well. Having met the young painter Emile Bernard (1868–1941) at the funeral of Vincent van Gogh (1853–1890) in 1890, Bonger was introduced by Bernard to Redon the following year. He became Redon's confidant and lifelong patron.[14] After Theo van Gogh's untimely death and his sister's return to Holland, Bonger also returned home and by the early 1890s had settled in Amsterdam, where he worked as an insurance agent.[15] After acquiring his first work by Redon in 1893, Bonger went on to build what has been considered the finest collection of Redon's works.[16] Although his collection grew to include Redon pastels and paintings (for example, a folding screen commissioned from the artist), at first Bonger collected the charcoal drawings, the *noirs.* For the most part these were acquired directly from the artist, as Redon generally handled his own sales rather than entrusting his work to dealers, but some were purchased on the open market as Redon's works gradually made their way from private collections into public auctions.[17] While it is likely that Bonger acquired the SCMA sheet directly from the artist, this has not been verified.[18]

Although Redon's common practice was to sign his drawings, he seldom dated them. Redon stockpiled his *noirs,* keeping them in cartons, and sometimes reworking them years after they were first created.[19] He seems to have been reluctant to part with early drawings, tending to give Bonger more recent works, which he chose himself and often sent to Holland on approval.[20] The Smith drawing has not been identified in Redon's account books or list of *noirs* but most likely dates from the years between 1890 and 1895, when Redon produced a great many of these profile heads. Ted Gott notes that Redon's

major exhibition in 1894 at Durand-Ruel gave the artist an opportunity to assess public response to his work. The most enthusiastic response was to his pastels and to the ideal heads in profile, on which numerous art critics commented favorably. Gott suggests that this prompted Redon to pursue themes of flowers and profile heads in subsequent years, making them a favorite decorative subject as he turned more and more to color.[21]

AHS

1. This framing line was probably drawn by the artist. See Harriet Stratis, in Chicago/Amsterdam/London 1994–95, p. 375. The present catalogue entry has benefited enormously from the important research undertaken for that exhibition and relies heavily on the discoveries published in the catalogue.

2. See his letter to Andries Bonger, in Levy 1987, p. 17.

3. See, e.g., Wildenstein 1992–96, vol. 1, no. 34, repr.

4. Chicago/Amsterdam/London 1994–95, p. 107.

5. Musée du Petit Palais, Paris, inv. 1235; Wildenstein 1992–96, vol. 1, no. 266, repr.

6. Enlightenment is similarly tied to reading in the drawing *The Book of Light,* 1893, National Gallery of Art, Washington, D.C. (Chicago/Amsterdam/London 1994–95, fig. 90).

7. Gloria Groom, in ibid., p. 344.

8. See Redon's account books and chronological lists (ibid., pp. 433, 450–53).

9. On Redon's technique, see Stratis in ibid.

10. For Redon's early style in his *noirs,* see Douglas Druick and Peter Kort Zeghers in Chicago/Amsterdam/London 1994–95, p. 109. On his later approach, see Stratis's remarks, pp. 364–66.

11. See Stratis in ibid.

12. *A soi-même* (Redon 1922) was drawn from the journal that Redon had kept from 1867 to 1915.

13. Hobbs 1977, p. 155; Bacou 1964, p. 398.

14. Bonger was responsible for initiating the major exhibition of Redon's work at The Hague in 1894 (Haagsche Kunstkring, May–June; 41 charcoal drawings) and was the major lender to the exhibition of 1907 at Rotterdam (Kunstsaal Rechers, Rotterdam; 17 charcoal drawings and 28 lithographs, almost all from Bonger's collection). A red chalk portrait of the collector was given by Redon to Bonger as a gift in 1904.

15. Chicago/Amsterdam/London 1994–95, p. 316.

16. Ibid., p. 244. He also collected pieces by Bernard, Van Gogh, and Paul Cézanne (1839–1906).

17. Kevin Sharp in ibid., p. 277.

18. The notebooks and lists found among the papers of André Mellerio, author of the catalogue raisonné of Redon's prints (The Art Institute of Chicago), have made it possible to date a number of drawings; some of these lists are incomplete, however. The SCMA drawing has not been identified in them.

19. Chicago/Amsterdam/London 1994–95, pp. 252, 369–71; *Cartons* are mentioned in his correspondence.

20. Ibid., p. 244. Redon even arranged for the framing of many drawings in Paris at the shop of J. Boyer (ibid., p. 375 and p. 430 note 60). Because the SCMA sheet has been trimmed to its framing line (see discussion of technique) and is no longer in its original frame, it is impossible to tell if it was among the pieces Boyer framed.

21. Melbourne 1990, pp. 106–7.

PAUL GAUGUIN
Paris 1848–1903 Fatu-Iwa, Tahiti

48 Hina (formerly Tahitian Idol), 1891–94

Pen and brown and grey ink with brush and grey wash over graphite underdrawing on tan wove paper

Watermark: None

230 × 114 mm (9¹/₁₆ × 4½ in.)

Inscribed on verso, upper left, in graphite: 55; in upper right quadrant, in graphite: Berain[?]; and faintly in graphite: 2661 [originally 2261?]

PROVENANCE Francisco Durrio (1875–1940), Paris, before July 1895 until at least 1928; {Galerie Paul Vallotton, Lausanne}; {Alex

Reid & Lefevre, Ltd., London} on 13 Dec. 1956; sold to SCMA in 1957

LITERATURE ArtQ 1957b, p. 477, repr. p. 476; SCMA Bull 1958, p. 62, fig. 37

EXHIBITIONS Basel 1928, no. 190; Berlin 1928; London 1931, no. 55; London 1957, no. 11, repr.; Northampton 1958a, no. 28; Berkeley 1960, p. 56, repr. p. 24; Northampton 1979b, no. 149

Purchased
1957:30

Before Paul Gauguin's first trip to Tahiti in 1891, the artist returned in 1888 to work in Pont-Aven in Brittany. There his paintings continued to depart from impressionist brushwork and natural motifs as he turned toward the more symbolic, imaginative, and religious themes and the definitive "flat" style of his later career. With the painter Emile Bernard (1868–1941) in Pont-Aven, Gauguin developed the principles of cloisonnism and synthetism, which emphasized line as boundary contours for pure, arbitrary colors applied in unified planes. This time was also marked by Gauguin's mounting debts as well as his growing acceptance as an avant-garde artist, a brief, but tempestuous, stay with Vincent van Gogh in Arles in the fall of 1888, and correspondence that increasingly repeated his need to escape. A trip abroad to Panama and Martinique in 1887 whetted a taste for exotic locales, and two years later Gauguin was further intrigued by the colonial displays in the Universal Exhibition of 1889, which included native peoples as part of the exhibits. At Bernard's urging, Gauguin this time chose Tahiti as his destination. In April 1891 Gauguin left Marseilles, traveling by way of the Suez Canal, Australia, and New Caledonia to arrive in the French colonial town of Papeete.

The untouched Polynesian culture Gauguin expected to encounter at the end of his journey was instead a Catholic and Protestant mission society, with an assimilated population of native inhabitants and Chinese immigrants. The Polynesian king, Pomare V, was on his death bed, and the Tahitian art Gauguin hoped to study was nowhere to be found, although sculpture from the surrounding islands was displayed in a small local museum and new carvings were offered for sale. Gauguin eventually moved to other settlements on the coast, but his artistic production from his two-year stay reflects the inspiration if not the substance of the Maori culture he had come to observe.[1] Instead, his Tahitian works were based on a syncretic combination of influences, including his study of Jacques-Antoine Moerenhout's romanticized account, Voyage aux îles du grand océan (Paris: A.

Bertrand, 1837), the arts of the Marquesas and Easter Islands, and even the sculpture of the Far East. Like many of Gauguin's Tahitian subjects that combine references to a variety of Western and non-Western art and ideas, the Smith College drawing of the Polynesian goddess Hina seems to be an artistic and cultural hybrid.

Hina appears in many works by Gauguin, and in virtually all media, from his first Tahitian subjects of 1891–93 to his masterpiece, Where Do We Come From? What Are We? Where Are We Going? (dated 1897, completed 1898, Museum of Fine Arts, Boston), in which the blue figure of the goddess presides over a complex universe of meaning and metaphor. Gauguin's knowledge of Polynesian theology was drawn in large part from his study of Moerenhout's book, which describes the creation of the universe as the union of Taaroa and Hina, who embody the generative principles of male and female, the spiritual and the material.[2] Associated with the moon, Hina is an important creation figure of legend and mythology, the exemplar of womanhood, a travel companion, and the inventor of tapa art.[3] According to Ingrid Heerman, Tahitian religion was not practiced in public at the time Gauguin was on the island, and the artist therefore had no direct, or knowledgeable, source of information concerning its rites and belief system. She surmises that he was drawn to Moerenhout's account of Hina's role as intercessor to her son Tefatou to bring life to the dead, and it is this role in the creation cycle that she believes Gauguin responded to in his artistic interpretations of the goddess.[4]

The Smith College sheet is related to a number of other works in which Hina appears as a central figure. The drawing is strikingly similar in appearance to the figure of Hina carved in relief on a wood cylinder of 1891–93 (fig. 1) and wears many of the same accoutrements.[5] In both, the masklike face is drawn from Marquesan art, while the girdle, necklace, and arm bands are derived from Hindu representations of Parvati, Siva's consort.[6] Unlike the cylinder relief, the figure in the

Fig. 1. Paul Gauguin, *Cylinder Decorated with the Figure of Hina and Two Attendants*, 1891–93. Tamanu wood with painted gilt, 37.1 × 13.4 × 10.8 cm (14⅝ × 5¼ × 4¼ in.). Hirshhorn Museum and Sculpture Garden, Smithsonian Institution, Museum Purchase with Funds Provided under the Smithsonian Institution Collection Acquisitions Program, 1981, inv. HMSG 81.1. Photo: Lee Stalsworth

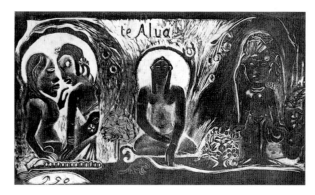

Fig. 2. Paul Gauguin, *Te Atua (The Gods)*. Woodcut on boxwood printed in black and ochre in two separate printings from the same block, slightly off-register, with touches of red (apparently printed) and green (added by hand) on ivory Japanese paper, 203 × 352 mm (8 × 14 in.). The Art Institute of Chicago. The Clarence Buckingham Collection, inv. 1948:262 recto. Photo: © The Art Institute of Chicago. All Rights Reserved

museum's drawing does not raise her arms in Parvati's gesture of giving life but adopts the pose of another sculptural version of the goddess of about 1892, a double-sided wood carving of Hina back-to-back with a figure of a woman holding an offering of flowers.[7] Hina appears in the same pose in a terra cotta vase (ca. 1893–95), which exists in three nearly identical examples and recombines the figure of Hina from the double-sided sculpture and the figures of Hina paired with Fatu (or Tefatou) from another wood cylinder (Art Gallery of Ontario, Toronto).[8]

A similar recombination of motifs from the wood sculptures is used in the woodcut *Te Atua* (fig. 2) from a suite of illustrations for Gauguin's book *Noa Noa;*[9] the figure of Hina, arms lowered in the same pose as the figure in the Smith College drawing, appears on the right side of the print. Hina also appears in the background of *Merahi Metua No Tehamana (Ancestors of Tehamana)* of 1893 (The Art Institute of Chicago), a painting of Gauguin's Tahitian mistress holding a fan and dressed in a striped mission smock. The figure of Hina to Tehamana's right and behind her on the wall is apparently a sculpture or part of a painted frieze. It closely resembles the goddess in the Hirshhorn cylinder and the Smith College sheet in pose and appearance; according to Heerman, the influence not only of Marquesan but of Hawaiian art is reflected in the proportions of her torso, arm position, and the form of the face.[10]

The museum's sheet is related to another sketch in violet ink of Hina (fig. 3), which is virtually identical in pose, attributes, and the placement of transfer lines in relation to the figure.[11] Richard Brettell relates the violet ink sketch to the painting *Mahana no atua (Day of the God,* The Art Institute of Chicago) of 1894 or to Gauguin's illustrated manuscript *Ancien Culte Mahorie,*[12] begun after the artist's return to Paris. Because of the presence of transfer lines in both ink drawings, the similarity in the pose of the figure and its unmodulated and even severe outlines, it is interesting to speculate how they might relate to the constellation of Gauguin's closely analogous depictions of the goddess in other media, in particular the wood sculptures. Whether or not the drawings may be considered preparatory studies for any specific work, the insistence on the static quality of line, as well as the hieratic frontality of these and other portrayals of the goddess, serves to reinforce the identification of the figure as an otherworldly being, specifically with its graven image as an idol. Gauguin had arrived in Tahiti with the intention of creating sculptures based on sacred indigenous art; his primitivizing style was a re-creation of what he considered lost native art forms, mediated and influenced by his knowledge of Far Eastern sculpture.[13] The Smith College sheet, if it is not a drawing for a sculp-

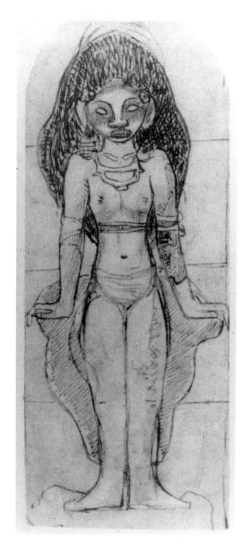

Fig. 3. Paul Gauguin, *Hina*. Pen and violet ink. Location unknown. Photo: Stephen Petegorsky

ture, is certainly a drawing of Gauguin's sculptural conception of the goddess.

The Smith College sheet and the violet ink sketch also bear a stylistic relationship to Gauguin's illustrations for the *Ancien Culte Mahorie* in the simplification of outline and spare use of cross-hatching to indicate volume. The manuscript of *Ancien Culte Mahorie* was assembled by Gauguin in Paris beginning in late 1893 from earlier notes and studies made in Tahiti. If the manuscript and wood sculptures of Hina are considered as a chronological index for the Smith College sheet, the drawing and its cognate ink sketch may be dated about 1891–94, allowing, as well, for a possible relationship to the painting *Mahana no atua*.

The Smith College drawing was formerly in the collection of Francisco (Paco) Durrio (1875–1940), a Spanish sculptor who formed part of Gauguin's social circle of younger friends and admirers after his return to France in 1893 from his first voyage to Tahiti.[14] Among the other Gauguin drawings once owned by Durrio is a sketch of Hina related in pose and attributes to the Smith College

sheet but truncated and more simplified than the SCMA drawing.[15] Christopher Gray believes that this partial sketch may be the earliest appearance of Hina in Gauguin's work.[16]

LM

1. See Ingrid Heerman, in Stuttgart 1998, pp. 147–65, on the cultural and artistic sources for Gauguin's work in Tahiti.

2. Washington/Chicago/Paris 1988–89, p. 253. Moerenhout 1837, vol. 1, pp. 563–67.

3. Heerman, in Stuttgart 1998, p. 156.

4. Ibid., pp. 156, 158.

5. For information on this cylinder, formerly in the de Monfried collection, see Washington/Chicago/Paris 1988–89, no. 139 (entry by Charles Stuckey), and Gray 1963, no. 95.

6. Washington/Chicago/Paris 1988–89, p. 253; Teilhet-Fisk 1983, p. 78; Amishai-Maisels 1985, p. 374.

7. Gray 1963, no. 97, repr.

8. See Gray 1963, no. 95, repr. (previously discussed), no. 96, repr. *(Hina and Tefatou*, also catalogued in Washington/Chicago/Paris 1988–89, no. 140, Art Gallery of Ontario), no. 105, repr. (where Hina appears on the pommel of a carved wooden cane), and no. 115, repr. *(Square Vase with Tahitian Gods*, which exists in three versions recorded by Gray at the Kunstindustrimuseet, Copenhagen, the Louvre, Paris, and a private collection, New York), for other standing, frontal representations of Hina. For the *Square Vase with Tahitian Gods*, see also Bodelson 1964, pp. 143–52, figs. 95–98, 100–106, and Washington/Chicago/Paris 1988–89, chronology, p. 294, fig. 77, where it is noted that the vase was probably executed in Ernest Chaplet's studio c. 1893–95.

9. *Te Atua* is catalogued in Guérin 1927, no. 31, and Kornfeld, Mongan, and Joachim 1988, no. 17. In Washington/Chicago/Paris 1988–89, pp. 254–55, the print is described as a sort of "trinity of Polynesian supernatural powers," with Taaroa in the central niche, Hina on the right, and Hina and Fatu on the left; see pp. 514–15 for a description of the three versions of *Noa Noa*.

10. Heerman, in Stuttgart 1998, p. 162.

11. Malingue 1946, fig. 22, described as "Femme maorie stylisée en idole," in violet ink, probably a study for *Noa Noa*. Reproduced in Washington/Chicago/Paris 1988–89, p. 364, it is credited, "Collection Galerie Charpentier."

12. Washington/Chicago/Paris 1988–89, pp. 363–65, no. 205.

13. See ibid., pp. 250–51.

14. SCMA's sheet may have a fuller exhibition history than currently recorded here. Stickers affixed to the original frame backing include: Kunsthalle Basel Ausstellung Gauguin 1928 (with notations: *190 / F. Durrio Paris*); Galerien Thannhauser (inscribed: *1285*); Paul Vallotton, Lausanne (typed inscription: *9227/GAUGUIN/Tahitienne*); 55 (handwritten *190*; above that, inscribed: *The Leicester Galleries, London*). The introduction to London 1931 notes that Durrio's entire Gauguin collection was assembled before Gauguin's departure for his second (and last) journey to the South Seas and that it was "until recently the property of the Spanish sculptor." It also notes exhibitions of the collection in "Bâle, Cologne, Bilbao and elsewhere."

15. Reproduced in Guérin 1927, p. xv, as *Idole Tahitienne*. Another drawing of Hina with Fatu (Tefatou) from the Durrio collection is reproduced on p. xvii as *Divinités maories*.

16. Gray 1963, p. 220, under no. 95; however, Vance 1986, pp. 226–27, believes the drawing is a transitional study for the figure of Hina on the cylinder now in the collection of the Hirshhorn Museum (Gray 1963, no. 95).

HENRI DE TOULOUSE-LAUTREC
Albi 1864–1901 Malromé

49 *Henri-Gabriel Ibels, Painter*, 1893, drawing for illustration in *La Plume*, 15 Jan. 1893

Brush and black ink with white heightening on beige tracing paper

Watermark: None

413 × 320 mm (16¼ × 12⅝ in.)

Signed recto, lower right, in brush and black ink: *Pour G. H. Ibels* [*sic*] / *HT* [conjoined] *Lautrec*

PROVENANCE Henri-Gabriel Ibels (1867–1936), Paris; possibly Charles Saunier (b. 1865), Paris; {Moser Gallery, New York}, 1953; sale, New York, Parke-Bernet Galleries, 22 April 1954, no. 25, repr.; to Ernest Gottlieb, New York; gift to SCMA in 1965

LITERATURE Saunier 1893, pp. 30–37, repr., p. 30 (published illus. after drawing); Coquiot 1921, p. 122; Astre 1926, p. 81; Joyant 1926–

27, p. 199; MacOrlan 1934, p. 120; Mack 1938, p. 270; La Farge 1953, p. 41, repr. p. 40; Huisman and Dortu 1964, p. 254, repr.; Adhémar 1965, p. XVIII; Dortu 1971, vol. 5, D.3.336, repr.; SCMA 1986, no. 253, repr.; Philadelphia 1989, p. 167, fig. 104; London/Paris 1991–92, p. 530, fig. 77 (published illus. after drawing); Frey 1994, p. 317

EXHIBITIONS New York 1953b; Bloomington 1968, no. 98; Montreal 1968, no. 10; New Brunswick 1985–86, no. 205, fig. 130; Worcester 1971, no. 121; Northampton 1991, no. 17

Gift of Mr. and Mrs. Ernest Gottlieb
1965:54

This sheet is one of two known drawings for the portrait of Lautrec's friend and artistic colleague Henri-Gabriel Ibels (1867–1936) published in the 15 January 1893 issue of *La Plume*. The second drawing, from the Annenberg collection, is virtually identical to the Smith College sheet but larger and worked in gouache around the head (fig. 1).[1] Although Ibels is listed by Maurice Joyant as the first owner of both drawings, the SCMA sheet is said to have belonged to Charles Saunier, author of the article on Ibels in *La Plume*.[2] If this is the case, then the museum's drawing may have been a gift from the artist-subject to the author, and in fact, the SCMA drawing seems to have been the immediate model for the published image.[3] Lautrec's portrait of his friend, which heads the article, contrasts markedly with Ibels's self-portrait, which appears at the article's end (fig. 2). In Lautrec's published version and in both studies, Ibels has a wry, self-possessed air; quick strokes define a massive, magisterial base for the portrait head, framed by a large cravat at the chin and topped off by a dark hat worn at an angle. Ibels, on the other hand, presents himself in profile view, head jutting forward, with exaggerated features, hooded eyes, and a thin beard.

By 1893 Saunier had already written reviews discussing Ibels's and Lautrec's work in the 1892 exhibitions at the Salon des Indépendants and Le Barc de Boutteville gallery. The artists had first shown together in 1891,[4] the year that Lautrec's posters for the Moulin Rouge capped the growing recognition of his work in newspaper and book illustrations with almost instant fame.[5] Their careers came to be linked not only by exhibitions such as those of the Salon des Cent held by *La Plume* at its offices from 1894 to 1900 but also by the avant-garde journals to which both contributed, including, in addition to *La*

Plume, La Revue Blanche, founded by the Natanson brothers in 1889, and *L'Escaramouche,* established by Georges Darien in 1893. The artists also shared the same subject

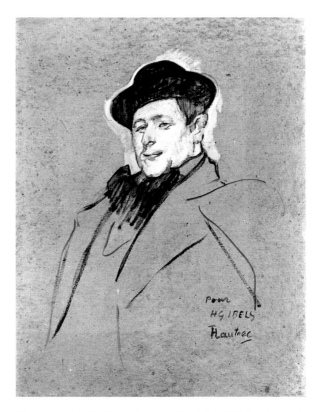

Fig. 1. Henri de Toulouse-Lautrec, *Henri-Gabriel Ibels (1867–1936)*, 1893. Brush and gouache, 521 × 394 mm (20½ × 15½ in.). The Metropolitan Museum of Art, Anticipated Bequest of Walter H. Annenberg

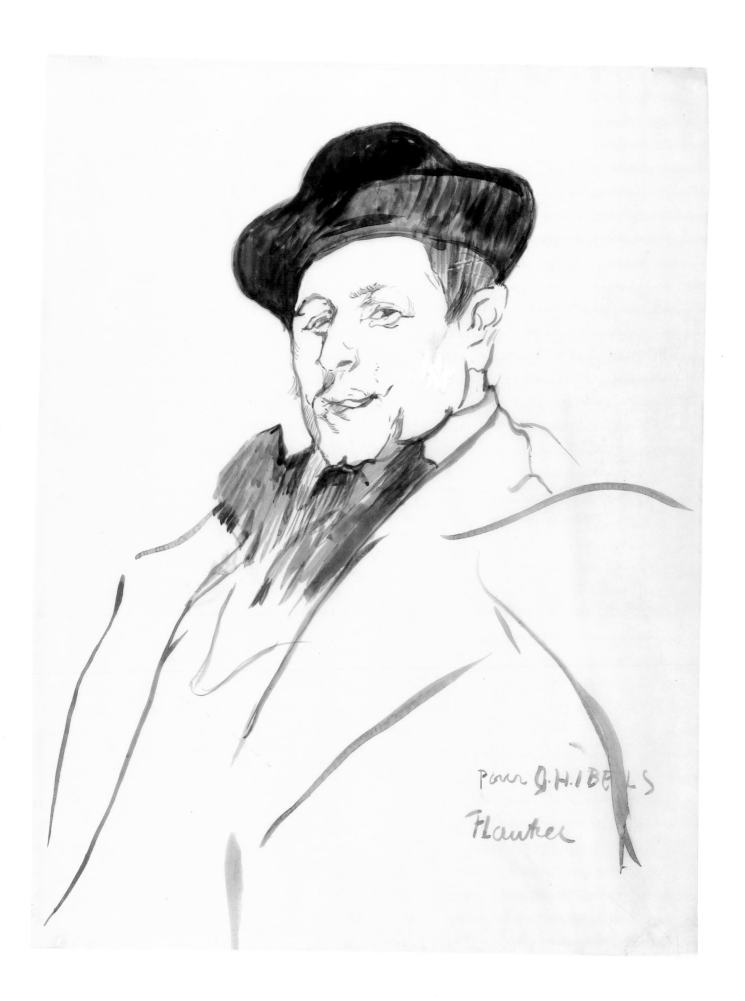

Fig. 2. Henri-Gabriel Ibels, *Self-Portrait,* published illustration from *La Plume,* 15 Jan. 1893. Photo: Stephen Petegorsky

Fig. 3. Henri de Toulouse-Lautrec, *Eldorado (Aristide Bruant),* 1892. Lithograph printed in color (poster), 146 × 98.9 cm (57½ × 38¹⁵⁄₁₆ in.). Philadelphia Museum of Art: Gift of Mr. and Mrs. R. Sturgis Ingersoll, inv. 1940-45-6. Photo: Graydon Wood, 1999

matter — the café concert, theatre, circus, and "stars" of these entertainments — and were associated through professional collaboration as well as personal ties (Lautrec was godfather to Ibels's son). By the end of 1892 they were closely affiliated,[6] and Lautrec's drawing of Ibels would mark the first published results of several projects involving both artists the following year. In March 1893 André Marty published the first album of *L'Estampe Originale* with a cover by Lautrec and work by Ibels, as well as other artists. That same year Marty published *Le Café Concert,* an album consisting of eleven black and white lithographs by Lautrec and Ibels illustrating a text by Georges Montorgueil. Ibels, the senior artist, was given the cover, and his name appeared before Lautrec's. In 1893 they also illustrated song sheets for the music publisher Georges Ondet, commissions that resulted from Ibels's gift for marketing his work and that of his friends.[7]

Although the *Café Concert* project may have prompted a stylistic exchange between Ibels and Lautrec (indeed, Ibels claimed that he had introduced Lautrec to lithographic techniques[8]), the paired portraits in *La Plume* underscore basic differences in approach. One of the

original group of Nabi painters with Paul Sérusier (1864–1927), Maurice Denis (1870–1943), Pierre Bonnard (1867–1947), and Paul Ranson (1862–1909), Ibels was known as the "Nabi journaliste" for his frequent contributions to the popular press. In his 1893 article for *La Plume,* Saunier described Ibels as "l'un des plus parfaits traducteurs de la Comédie Humaine" (one of the most perfect translators of the human condition) and declared him the probable inheritor to the tradition of illustrators represented by Honoré Daumier (1808–1879), Paul Gavarni (1804–1866), and Jean-Louis Forain (1852–1931). Ibels was also associated with the anarchist movement. His images of laborers and the working class represent a kind of leftist sociopolitical commentary more allied with that of Charles Maurin (1856–1914) and Félix Vallotton (1865–1925) than with Lautrec's portrayals of bohemian life.

Stylistically, Lautrec's drawing of Ibels has less in common with his friend's self-portrait than with his own lithographic poster, *Eldorado (Aristide Bruant)* of 1892 (fig. 3).[9] The drawing and poster share the same compositional devices and sense of dash: the framing element provided by a brimmed hat, the sweeping lines of Bruant's scarf

matched by the flaring lines of Ibels's lapel and shoulder. Interestingly, in Lautrec's portrait of Bruant for the *Café Concert* album,[10] Ibels's influence may be reflected in the heavy lines defining Bruant's torso and the almost dyspeptic portrayal of the actor. However, the framing elements are still the same as those in the Smith College sheet, as well as the cant of the head and three-quarters view.

LM

1. For a description of the drawing from the Honorable Walter H. and Leonore Annenberg collection, see Philadelphia 1989, pp. 63, 166–67, repr. (entry by Joseph J. Rishel). Because of the similarity of the Smith College and Annenberg drawings, it is sometimes difficult to distinguish between references to the two works. M. G. Dortu, for example (in 1971, vol. 2, P463), lists the 1954 Sotheby's sale as part of the Annenberg drawing's provenance; however, it was the Smith College drawing that was sold as lot 25. Likewise, Théophile Gautier's description of the portrait of Ibels (cited in Schaub-Koch 1935, p. 211) as a Pierrot "tragique de blancheur" is a probable reference to the white, almost masklike appearance of the face in the Annenberg drawing rather than the Smith College sheet.

2. Maurice Joyant (1926–27, p. 199) lists Ibels as the owner of the drawing. The museum's curatorial file on the drawing notes that when it was acquired, a sticker on the back of the frame identified Saunier as a previous owner. Dortu (1971, vol. 5, D.3.336) lists Saunier as a former owner and also notes "Mauser" and a private collector as owners, presumably references to the Moser Gallery and Ernest Gottlieb, respectively. In a letter of 15 Dec. 1965 to Smith College Museum director Charles Chetham, donor Ernest Gottlieb states that the drawing "was formerly in the collection of Charles Saunier" (SCMA curatorial files).

3. As Rishel points out in Philadelphia 1989, p. 63. The small areas of white heightening on the SCMA sheet may be taken for spot corrections in preparation for publication; if so, this provides further evidence that the museum's sheet was used for reproduction in *La Plume*.

4. Phillip Dennis Cate and Patricia Eckert Boyer in New Brunswick 1985–86, pp. 123–35 (note and entries for Ibels by Boyer).

5. New York 1985–86, p. 27.

6. New Brunswick 1985–86, p. 123.

7. Ibid., p. 124.

8. Thomson 1991, p. 250 note 17.

9. Delteil 1920, no. 344; Wittrock 1985, no. P5.

10. Delteil 1920, no. 34; Wittrock 1985, no. 4.

AUBREY BEARDSLEY
Brighton, England 1872–1898 Menton, France

50 *How Queen Guenever Made Her a Nun*, 1893, drawing for illustration in *Le Morte Darthur* (London: J. M. Dent, 1893–94)

Pen, brush, and black (India) ink over traces of graphite under-drawing on moderately thick, smooth beige wove paper; the sheet incised with a ruled line at outer edges of decorative border

Watermark: None

Sheet: 214 × 167 mm (8⁷⁄₁₆ × 6⁹⁄₁₆ in.); image (including decorative border): 213 × 166 mm (8⅜ × 6½ in.)

Inscribed verso, at center, in graphite: *No 1;* at left center, in graphite: *Full size;* and (in another hand) at lower right corner, in graphite: *FHDay* [initials conjoined]

PROVENANCE J. M. Dent & Co., London; F. Holland Day (1864–Dec. 1933), Norwood, Mass.; to his estate; to {Goodspeed's Book Shop, Boston} by 1934;[1] to Henry L. Seaver (1878–1975), Lexington, Mass.; bequest to SCMA in 1976

LITERATURE None

EXHIBITION Northampton 1986–87

Bequest of Henry L. Seaver
1976:54-385

This remarkable drawing was used as the final full-page illustration to J. M. Dent's edition of Sir Thomas Malory's *Morte Darthur,* published in twelve parts between June 1893 and November 1894.[2] Beardsley's first major commission, these illustrations effectively launched his brilliant but brief career. The young artist, already ill with the lung disease that would kill him within six years, had come to Dent's attention in the late summer of 1892 through the photographer and bookseller Frederick H. Evans.[3] Dent planned an *édition de luxe* that would rival William Morris's Kelmscott Press volumes in design while taking full advantage of recent technology to print larger editions at lower prices. Whereas Morris, who despised modern mechanical processes, printed his illustrations from hand-engraved woodblocks, Dent intended to make use of the photographic line-block process.

By the autumn of 1892 Beardsley could write jubilantly to his former headmaster at Brighton Grammar School: "The best and biggest thing I am working on at present is Malory's *Morte Darthur* (a splendid *édition de luxe*) for which I am getting £200. (Not bad for a beginning, is it?) . . . The drawings I have already done have met with real approval from all who have seen them."[4] He wrote him again in a similar vein on 9 December: "The *Morte Darthur* means a year's hard work. I've everything to do for it. Cover, initial letters, headpieces, tailpieces, in fact every stroke in the book will be from my pen. I anticipate having to do at least 400 designs all told, and I shall get £200 for them."[5] And only two months later Beardsley could boast to an old school friend: "Behold me, then, the coming man, the rage of artistic London, the admired of all schools, the besought of publishers, the subject of articles! . . . The work I have already done for Dent has simply made my name. Subscribers crowd from all parts."[6] This hyperbole notwithstanding, Beardsley had good cause for optimism. He had begun to secure other commissions for book illustrations.[7] Moreover, a

selection of his drawings, including four for the *Morte,* was to appear in the first volume of a new periodical called the *Studio,* along with a laudatory article on his work by Joseph Pennell.[8]

Dent's choice of Malory for his project was well conceived. The widespread interest in Arthurian legends — fueled by the popularity of Tennyson's *Idylls of the King* (published between 1859 and 1889) and reflected in the paintings of the Pre-Raphaelites Dante Gabriel Rossetti (1828–1882), William Holman Hunt (1827–1910), and Edward Burne-Jones (1833–1898) — promised a good market for the new book. Based on the famous edition of 1485 by the English printer and publisher William Caxton, Dent's *Morte,* with illustrations by Beardsley in "medieval manner,"[9] would be an appropriate response to Morris, the leading proponent of this style in book design, who had already produced several noteworthy volumes on Arthurian themes.[10]

The first of the *Morte Darthur*'s twelve parts appeared in June 1893 in wrappers designed by Beardsley.[11] Besides the regular edition of 1,500 copies of large octavo size, Dent issued 300 large-paper copies on Dutch handmade paper. The regular edition was designed to be bound in two volumes of six parts each.[12]

How Queen Guenever Made Her a Nun, the final full-page illustration to volume 2 of the *Morte,* was issued in part twelve, in November 1894. It appears in chapter 9 of book 21 facing page 975, but illustrates a slightly earlier passage:

And when Queen Guenever understood that King Arthur was slain, and all the noble knights, Sir Mordred and all the remnant, then the queen stole away, and fine ladies with her, and so she went to Almesbury; and there she let make herself a nun, and wore white clothes and black, and great penance she took, as ever did sinful lady in this land, and never creature could make her merry; but lived in fasting,

prayer, and alms-deeds, that all manner of people marvelled how virtuously she was changed. Now leave we Guenever in Almesbury, a nun in white clothes and black, and there abbess and ruler as reason would.[13]

Guenever's retirement to the convent is penance for her adultery with Sir Launcelot, which precipitated the conflict in which King Arthur was killed; as she confesses to her companions when Launcelot arrives by chance at Almesbury, "through our love that we have loved together is my most noble lord slain."[14] Beardsley characteristically chose to emphasize Guenever's character as adulteress and femme fatale rather than as pious penitent, enveloping her beautiful and sensuous face in the beaklike cowl of a voluminous black robe whose silhouette suggests a bird of prey. The very dominance in the drawing of this massive black shape conveys a sinister tone. Although the candelabrum behind her can be construed as a logical element in this scene, it should perhaps be interpreted in the larger context of Beardsley's art of this period, where candles figure prominently in scenes of sexual passion or enchantment. One might compare, for example, *How La Beale Isoud Nursed Sir Tristram* in the *Morte* or the drawings for Oscar Wilde's *Salome,* on which Beardsley was working concurrently in the summer of 1893.[15] The lectern over which Guenever bends also contributes subtly to this symbolism, with legs that terminate in the cloven hooves of a satyr or goat. Even the foliage that runs riot behind the wattle fence, rising flamelike to consume all but a small portion of the space, suggests the powerful nature of Guenever's illicit and ill-fated passion for Launcelot.

Beardsley's debt to William Morris's Kelmscott Press books and their illustrators, especially Burne-Jones, is evident in the drawings for the *Morte*.[16] Equally clear, however, are the differences in his style and approach, especially as his work on the *Morte* progressed. Decorative borders, which in Morris's books are densely patterned with tightly woven interlaces, Beardsley treats with broader forms more loosely twined in energetic serpentine movement. The *horror vacui* of Burne-Jones's complex line drawings is increasingly replaced in Beardsley's work by large expanses of black or white.[17] Evident in many of Beardsley's drawings, *Queen Guenever* among them, is the influence of Japanese prints, with their shallow pictorial space composed of broad overlapping forms.[18] The plants Beardsley depicts in his borders (indeed throughout his drawings) are deliberately perverse creations. Even those most like actual plants — lilies, iris — are intentionally fanciful. Many of the borders for the full- or double-page illustrations, like the flame-shaped plant forms surrounding *Guenever,* seem designed primarily to echo in their shape and movement the dominant feeling of the scene they enclose.

Although he had received praise and encouragement from Burne-Jones and was hailed as a prodigy by Pierre Puvis de Chavannes (1824–1898), Beardsley had only one year of formal training as an artist. His working method

seems to have been established early and to have continued essentially unchanged throughout his career.[19] Instead of making separate preparatory drawings for a composition, Beardsley worked out his ideas as a rough sketch in graphite directly on the final sheet. He would then ink in the drawing, sometimes disregarding his underlying sketch, the remnants of which he carefully erased after the inking was done. In the Smith College drawing, this technique is readily apparent, light graphite lines remaining visible in several areas, for example in Guenever's hand. The graphite underdrawing for Guenever's arm, body, and sleeve (visible in raking light through the black ink of her habit) suggests that this garment may have been enlarged at the inking stage. Although Beardsley must certainly have used a brush to fill in Guenever's robe, the remainder of the drawing was worked in pen, and the multiple strokes of its nib are especially evident in the black background of the border.

Few of Beardsley's drawings for the *Morte* can be dated with precision.[20] The drawings were not executed in the order of their appearance in the book, and although the publication date of each installment provides a *terminus ante quem* for its illustrations, scholars remain uncertain about the exact sequence of execution. Although the final part of the *Morte,* in which the *Guenever* appeared, was issued in November 1894, there are several reasons for suspecting that the drawing may have been made as early as the summer of 1893. A great many of the drawings for the *Morte* were completed in Beardsley's first rush of enthusiasm for the project, in the autumn of 1892 and spring of 1893, but later in the year Dent was having considerable difficulty getting the rest of the work from him.[21] Over the summer the artist was hard at work on his drawings for *Salome,* and certain stylistic similarities would suggest that *Guenever* too was made around this time. It is also worth noting that there is a shift in Beardsley's approach to the large line-block illustrations between volumes 1 and 2. Whereas all eleven illustrations to volume 1 are full-page drawings, all but the final two subjects in volume 2 are double-page compositions; and unlike volume 1 drawings, whose borders are designed to include a panel with the scene's title, those in volume 2 exclude this element entirely. The two full-page drawings, *How Sir Bedivere Cast the Sword Excalibur into the Water* and *How Queen Guenever Made Her a Nun,* may therefore date between the works for the first volume and the larger, more simplified double-page illustrations.

How Queen Guenever Made Her a Nun is arguably the most famous of Beardsley's illustrations for the *Morte,* but the original drawing seems to have disappeared from view shortly after its use for the book. One of only two full-page drawings from the *Morte* Beardsley chose to include in his *Fifty Drawings* (1897), the only collection of the artist's work to appear in his lifetime, the *Guenever* was clearly reproduced from the line-block illustration rather than the original drawing.[22] The numerous subsequent publications that reproduce this image have all relied on the line-block, and the drawing appears to have

been considered lost.[23] It now seems that this early "disappearance" can be explained by the drawing's having entered the collection of the American photographer, publisher, and aesthete F. Holland Day, a collector who was not always inclined to share his treasures.[24] Day, who may have been among those whose interest in the forthcoming *Morte* had been piqued by the *Studio,* wrote to Dent in the spring of 1893 in hopes that he might secure for his new publishing firm, Copeland and Day, the rights to publish the *Morte* in America. This proved impossible, but Dent replied cordially. Further correspondence resulted in Dent's sending Day examples of Beardsley's work.[25] Although it remains unclear exactly when or from whom Day acquired the *Guenever,* it is most likely that it came to him directly from Dent, perhaps in the summer of 1894, when he visited England. This would explain why, despite this drawing's obvious importance in Beardsley's work, it was unavailable for *Fifty Drawings* and why knowledge of its whereabouts soon became lost to Beardsley scholars.

AHS

1. Reproduced on the cover of Boston 1934.

2. For the publication history of the *Morte,* see Walker 1945 (also Weintraub 1976, pp. 44–45).

3. Beardsley, then a clerk at the Guardian Life and Fire Insurance Company in London, frequented the nearby bookshop of Jones and Evans in Queen Street, Cheapside, during his lunch hour. His talent had so impressed Evans that the bookseller sometimes accepted drawings in exchange for books. When told by his friend J. M. Dent of the search for an illustrator for the new *Morte,* Evans suggested Beardsley. Chancing by the bookshop at that moment, Beardsley was promptly set the task of providing a trial illustration for Dent's approval. (For this meeting, see especially Vallance 1898, the earliest account; Dent 1928, pp. 68–69; and Macfall 1927, pp. 58–62.) Evans, an important photographer, took what are undoubtedly the most famous portraits of Beardsley. He also formed an important collection of Beardsley drawings that included a number of the drawings for the *Morte* (see Philadelphia 1919).

4. Beardsley to E. J. Marshall [autumn 1892], in Maas, Duncan, and Good 1970, p. 34. Beardsley had recently left the insurance office on the strength of his employment by Dent.

5. Beardsley to A. W. King, 9 Dec. 1892, in Maas, Duncan, and Good 1970, p. 37. Although Beardsley gives £200 as his fee, R. A. Walker (in King 1924, note 2), referring to Beardsley's undated contract with Dent, has shown that a further £50 was promised the artist.

6. Beardsley to G. F. Scotson-Clark [c. 15 Feb. 1893], in Maas, Duncan, and Good 1970, pp. 43–44.

7. Dent had asked him to illustrate the *Bons Mots* (volumes devoted to the wit of Richard Brinsley Sheridan and others) and Beardsley was also selling drawings to the *Pall Mall Budget.*

8. Originally scheduled for February, the inaugural volume of the *Studio* did not appear until April 1893. It featured a cover by Beardsley in addition to the other drawings, including *J'ai Baisé Ta Bouche Iokanaan* (Princeton University Library; Reade 1967, color pl. 272, no. 261) inspired by Oscar Wilde's *Salome,* recently published in French. This drawing prompted John Lane and Elkin Matthews to commission Beardsley to illustrate their English edi-

tion of *Salome.* The drawings for the *Morte* included in the *Studio* were an initial letter *I; Merlin Taking the Child Arthur into His Keeping;* an ornamental border for a full page; and a frieze for a chapter heading of six men fighting on foot, three of them panoplied.

9. Letter to G. F. Scotson-Clark (see note 6).

10. E.g., *The Defense of Guenevere and Other Poems* (1858).

11. For a rejected design for the wrapper, see Reade 1967, no. 55, repr.

12. This is compared with the small editions produced by the Kelmscott Press, where the standard edition size was 300.

13. *Morte,* vol. 2, book 21, chapter 7, p. 972.

14. Ibid.

15. The contract for *Salome* was signed 8 June 1893 (Weintraub 1976, p. 56). Candles appear with the hermaphrodite herm on the title page of *Salome,* and also on the contents page. See also *Enter Herodias* and *Eyes of Herod.* Inspired by Whistler's butterfly device (according to Wilson 1983, no. 3), Beardsley's device, adopted in 1893, consisted of three vertical lines and three arrow- or heart-shaped marks; it appeared in this form on *How King Arthur Saw the Questing Beast,* the only dated drawing for the *Morte* (signed and dated within the drawing, *March 8, 1893*). One of the two *Morte* drawings executed in Beardsley's "fine-line" style, and therefore reproduced in photogravure, it was used as the frontispiece for vol. 1. On Beardsley's device, see Macfall 1927, p. 62. He cited the first use of the "Japanesque mark" as being in *The Achieving of the Sangreal,* which Beardsley had executed for Dent's approval as a trial illustration for the *Morte.* (It was used as the frontispiece for vol. 2, reproduced in photogravure.) Macfall feels sure that the mark was meant for three candles and three flames, and in a letter from Beardsley to his friend Robert Ross (of July ? 1893 according to *Princeton Lib Chron* 1955; c. Aug. 1893 according to Maas, Duncan, and Good 1970), the artist does draw his device as a group of three candles (see repr. in *Princeton Lib Chron* 1955). But interpreters who see in this mark phallic symbolism are also justified (e.g., Jussim 1981).

16. Beardsley's early drawings in particular (e.g., *The Achieving of the Sangreal*) show this influence. Burne-Jones owned a similar Beardsley drawing of Siegfried, also executed in the "fine-line" style.

17. Given these differences, incipient even in Beardsley's earliest illustrations for the *Morte,* it is no wonder that Morris disliked his work. Aymer Vallance made more than one attempt to interest Morris in Beardsley's drawings, but to no avail.

18. Whistler's art may have been an intermediate influence on Beardsley.

19. This method is discussed by Ross 1921 and others and can be confirmed by examination of the drawings themselves.

20. Only one is actually dated on the sheet (see above, note 15).

21. In September 1893 Beardsley's mother wrote his friend, Robert Ross, asking him to convince her son to complete his contract (letter of 29 Sept., published in Ross 1952). See also Benkovitz 1981, pp. 76–77, and Marillier 1920, p. 5.

22. The drawing differs from the line-block in several significant respects. For example, there are more dots in the fabric on the lectern in the original drawing than in the line-block (see especially the top of the cloth). The underside of a leaf just to the right of the stem in the leaf clump at the lower left corner, while a single piece in the drawing, is two pieces in the line-block. The top of the vertical fence pole, third from the left, has a series of short horizontal lines in the drawing, only two of which are present in the line-block. Correspondence between Beardsley and his publisher Leonard Smithers in August–September 1896 makes

apparent that an effort was made to make reproductions from the original drawings where possible, or from the original blocks or half-tones, rather than reproducing work from books. See Maas, Duncan, and Good 1970, pp. 151–52, 154, 156, 159 and ff.

23. See, e.g., Gallatin 1945, no. 302, and Reade 1967.

24. See Jussim 1981, esp. regarding Day's attitude toward his Keats collection.

25. Although Day's correspondence with Dent in June 1893 refers to Beardsley "drawings," it is by no means clear that he refers to original drawings. Among the Beardsley works Dent sent to Day, and which Day mentions in his letter, was *Merlin Taking the Child Arthur into His Keeping.* This was evidently *not* the original drawing, however, which Dent still owned when it was exhibited at the Baillie Galleries (London 1909), but may have been a proof of the line-block. In this same letter Day asks Dent to obtain for him a "proof" of the drawing for Oscar Wilde's *Salome* (presumably the drawing published in the *Studio* 1 [April 1893], p. 19). That Day did acquire original Beardsley drawings, however, is indisputable, and on the whole it is likely that he acquired his drawings for the *Morte* sometime in 1894 or very shortly thereafter. (According to Boston 1934, no. 19, a drawing for chapter 3 of book 20 was "purchased from the publisher of *Morte d'Arthur* by the previous owner in 1894.")

MAURICE BRAZIL PRENDERGAST
St. John's, Newfoundland 1858–New York 1924

51 *South Boston Pier*, 1896

Brush and watercolor and graphite on heavy white wove paper

460 × 354 mm (18¼ × 14 in.)

Watermark: None

Signed(?) recto, lower left, in pen and black ink: *Maurice B. Prendergast;* signed and dated(?) recto, lower left, in blue and mauve watercolor: *Prendergast / 1896*[1]

PROVENANCE Mr. and Mrs. J. Montgomery Sears (J. Montgomery Sears, d. 1905; Sarah Choate Sears, 1858–1935), Boston; to Mrs. J. D. (Helen) Cameron Bradley, their daughter (b. 1890), Boston and West Gouldsboro, Maine, by 1935; to {Childs Gallery, Boston} in 1950; sold to SCMA in 1950 (as *The Pier at Atlantic City*)

LITERATURE Childs 1950, repr. on cover (as *The Pier at Atlantic City*); Rhys 1952, pp. 65, 171 (as *The Pier, Atlantic City*); ArtD 1953, p. 14; Hitchcock 1954, repr. on cover; Baur et al. 1957, p. 37, repr. (as *South Boston*); *Boston Globe* 1960a, p. 37, repr.; *(Boston) City Record* 1960, p. 2, repr. on cover; *New Bedford Standard Times* 1960, p. 2, repr.; Parks 1960, no. 71, repr.; *Boston Globe* 1960b, p. 32; Russell 1969, color repr. p. 278; Bailey, Brooke, and Farrell 1970, p. 234,

color repr.; College Park 1976–77, p. 42; Williamstown 1978b, p. 19, under no. 5, repr.; New York 1979, p. 12, fig. 5; Monneret 1979, repr. p. 137; Ver Steeg and Hofstadter 1981, color repr. p. 460; Evanston 1985–88, pp. 13, 34, 92, fig. 6; SCMA 1986, no. 259, repr.; Clark, Mathews, and Owens 1990, no. 609, repr.; Peters 1991, p. 106, color repr. p. 107; Little 1996, p. 62, color repr.

EXHIBITIONS Possibly Boston 1900, no. 183;[2] possibly Buffalo 1901, no. 791;[3] possibly Charleston 1901–2, no. 32;[4] New York 1953a, no. 41; Boston 1954; South Hadley 1955, no. 35; Deerfield 1956; Amherst 1958; Boston 1960–61, no. 58, repr.; Minneapolis 1962, no. 90, pl. 42; Albuquerque 1964, no. 94, repr.; Northampton 1968, no. 37; Northampton 1974c; Salt Lake City 1976, no. 87, repr.; Northampton 1979b, no. 147; Holyoke 1982–83; Boston 1986, pp. 59–60, no. 107, repr.; Northampton 1986a, no. 3; Williamstown 1990–91, p. 14, no. 6, color repr. (New York and Williamstown venues only)

Purchased, Charles B. Hoyt Fund

1950:43

South Boston Pier dates from the period of Prendergast's first mature style, shortly after his return to Boston from a four-year stay in Europe to study art. The drawing, which was titled *The Pier at Atlantic City* when purchased by the Smith College Museum of Art, was reidentified in 1951 by SCMA curator Mary Bartlett Cowdrey. A native of New Jersey, she recognized that the scene was not Atlantic City but more likely Boston, particularly since that city was Prendergast's home in 1896. The distinctive architecture of the pier made it possible to establish the site as part of Marine Park, designed by Frederick Law Olmsted and constructed from the 1880s to about 1896 (fig. 1).[5]

Marine Park was the southern terminus of Olmsted's "Emerald Necklace" of parks intended to beautify Boston, clean up waste spaces, and provide a healthful, aesthetic antidote to the stresses of modern industrial life. The park comprised the sheltered Pleasure Bay bordered by a long crescent-shaped beachfront at City Point, in South Boston. At the northern end, fill was being dredged from Pleasure Bay to begin a causeway leading toward Castle Island, noted for the stone defense works of Fort Independence, erected after 1850 to replace Castle William, a fort dating back to colonial times.[6] Eventually the causeway with its drawbridge was to connect City Point with Castle Island, but by 1896 only a temporary wooden footbridge had been completed. This bridge was referred to as the Castle Island Bridge, South Boston Pier, or sometimes City Point Bridge.[7] Prendergast's view looks westward from the Castle Island end toward the urban structures of South Boston and shows the

pier's fashionable new electric lights, installed in 1892. The resort was immediately popular; with electric trolley cars providing easy access from downtown Boston, thousands of people visited each summer. A popular guidebook of the day touted such wholesome activities as promenading the pier, idling under the trees beside Fort Independence, enjoying the expansive maritime views, and rowing and sailing on Pleasure Bay.[8]

For Prendergast, the choice of this subject was a natural one. A resident of Boston since 1868,[9] he had early formed the habit of frequenting the city's parks and sketching outside. He had continued this practice of out-

Fig. 1. *Castle Island, Fort Independence, City Point, Boston, Mass.* Postcard. Photo: Courtesy National Park Service, Frederick Law Olmsted National Historic Site

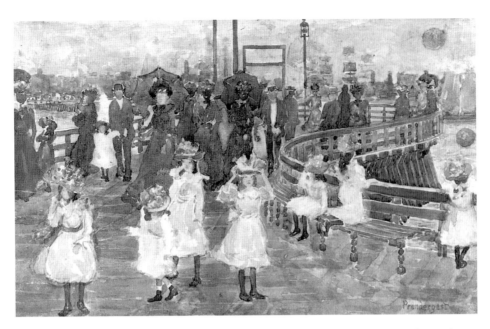

Fig. 2. Maurice Prendergast, *South Boston Pier,* c. 1895–97. Brush and watercolor over graphite with traces of white gouache, 312 × 485 mm (12¼ × 19⅛ in.). The Art Institute of Chicago. Gift of Annie Swan Coburn in memory of Olivia Shaler Swan, inv. 1948.208. Photo: © The Art Institute of Chicago. All Rights Reserved

door work during his studies in Paris at the Académies Julian and Colarossi from 1891 to 1894.[10] On his return to Boston in 1894 and until his next trip to Europe in 1898, Prendergast's primary subjects were again the people and sights in the various parks of Boston such as Marine Park in South Boston, Revere Beach, the Boston Public Garden, and Franklin Park. He created at least five other views of South Boston Pier (three watercolors, a pastel, and a monotype), with the Smith College watercolor being the only version inscribed with a date.[11] He also depicted beachfront scenes near the pier, such as women seated on benches watching sailboats in the bay.[12]

Like the impressionists, whose work he had seen, Prendergast focused on the effects of light and weather and the leisure pursuits of the middle class, emphasizing gestures and poses rather than individual faces or expressions. His interest in recording urban life linked him to such urban realists as Robert Henri (1865–1929), George Luks (1867–1933), and William Glackens (1870–1938), members of the Eight with whom his work was shown, but he did not share their interest in depicting the distress of city life.

Prendergast's handling of *South Boston Pier* is characteristic of his watercolor technique at this time. He began with a loose pencil underdrawing, then brushed in the background and added figures in the blank spaces, leaving sparkles of unpainted white paper that suggest windblown movement. The colors are clear and separate from one another — golds and russets in the foreground, splashes of primary colors in the umbrellas and dresses, accents of pale violets, olives and pinks, a delicate grey

sky. These color choices reflect in part Prendergast's interest in Japanese prints and the works of James McNeill Whistler (1834–1903), which he had seen in Europe, while his handling of paint suggests a modern or postimpressionist style. In his later works, his handling of paint was to become looser and more broken. Until about 1900, his primary media were watercolor and monotype with occasional works in oil.

The several views of South Boston Pier demonstrate Prendergast's practice of exploring compositional issues through variations on a theme. All except one of the images (CMO 608) show a landward view, and all are dominated by the strong architectural form of the bridge. In the Smith College version, the sinuous curves of the bridge are tightly positioned against horizontal bands composed of sky, pedestrians, and pier flooring. The movement from foreground to background is swift and compressed. A postcard of the structure during this period (fig. 1) shows that the pier did have such curves,[13] yet Prendergast clearly exaggerated them by his selection of viewpoint. The progression of colors from foreground to background adds to the swift compression of depth, with splashes of primary and secondary colors in the foreground, a more subdued band of blue and brown figures behind, and a dull grey and blue skyline in the distance. In the Art Institute of Chicago version (fig. 2), Prendergast similarly plays with the placement of local color to create depth, setting the young girls in bright white dresses in front of a band of adults in darker tones — brownish purples, blues, and blacks — against a light brown skyline.[14] This schematic use of linear ar-

Maurice B. Prendergast

chitectural elements and carefully placed spots of local color continued in Prendergast's Italian works from 1898 to 1899 (see, for example, *Pincian Hill, Rome,* CMO 748), but became less pronounced in later years.

The Smith College drawing is one of at least eight watercolors and four monotypes by Prendergast owned at one time by Sarah Choate Sears.[15] A watercolor artist as well as a photographer, Sears exhibited works in the Boston Art Students' Association *First Annual New Gallery Exhibition of Contemporary American Art* in 1900, and at the Pan-American Exposition in Buffalo in 1901, both of which exhibitions included a *South Boston Pier* by Prendergast. Both artists were exhibiting members not only of the Boston Art Students' Association (established in 1879) but also of the Boston Water Color Club (founded for women in 1887), which first admitted men in 1896, among them Maurice Prendergast.[16] Wife of the wealthy Bostonian Joshua Montgomery Sears, Sarah Choate Sears is said to have supported Prendergast's trip to Venice in 1898.[17] On her death in 1935, *South Boston Pier* passed to her daughter Helen (Mrs. J. D. Cameron Bradley), and in 1950 the drawing was among a group of seven Prendergast watercolors from the Bradley collection handled by the Childs Gallery.

<div align="right">NR</div>

1. These signatures could be by either the artist or his brother, Charles. According to Clark, Mathews, and Owens 1990, "Charles Prendergast sometimes inscribed 'Prendergast' on oils and watercolors by Maurice.... it is difficult to distinguish between the brothers' hands" (p. 208).

2. The checklist includes a *South Boston Pier* under "watercolors and pastels"; no dimensions or date given.

3. The checklist includes a *South Boston Pier* (watercolor); no dimensions or date given.

4. The checklist includes a *South Boston Pier* under watercolors, pastels, and monotypes; no dimensions or date given.

5. For further information about Marine Park, see the Archives, National Park Service, Frederick Law Olmsted National Historic Site, Brookline, Mass., and the Olmsted Associates Records at the Library of Congress (Series B, Job #926); Zaitzevsky 1982, pp. 91–94; and Boston Parks 1890–1900.

6. Sweetser 1885, p. 129.

7. There was also an iron pier at the southern end of the beach, whose distinctly different architecture Prendergast also depicted in *Evening on the Pier,* c. 1895–97, monotype, private collection (Clark, Mathews, and Owens 1990, no. 1683, repr.; catalogue raisonné references hereafter abbreviated as CMO).

8. Bacon 1898, p. 397.

9. For biographical details, see Chronology, in Clark, Mathews, and Owens 1990, pp. 726–29.

10. For details on Prendergast's early artistic training, see Glavin 1982.

11. These are *South Boston Pier,* watercolor (fig. 2), The Art Institute of Chicago, inv. 1948.208 (CMO 606, repr.); *South Boston Pier, Sunset,* pastel, inscribed *95* possibly by another hand, Museum of Fine Arts, Boston, inv. 63.281 (CMO 607, repr.); *South Boston Pier* and *City Point Bridge,* both watercolors in private collections (CMO 608, repr., and 610, repr.); and *Evening, South Boston Pier,* monotype, Terra Museum of American Art, Chicago, inv. 18.1982 (CMO 1684, repr.). Two works, the pastel *Sunset, Boston* (CMO 604, repr.) and the related watercolor *Sunset, South Boston Pier* (CMO 605, repr.), may or may not be accurately identified; they are difficult to fit into what is known about the physical configuration of buildings, open water, and mud flats at Marine Park in the 1890s. Neither of the two existing sketchbooks from this period, the Large Boston Public Garden Sketchbook, c. 1896–97 (CMO 1477), and the Boston Water-Color Sketchbook or Revere Beach Sketchbook, c. 1897–98 (CMO 1478), contains images related to South Boston Pier.

12. See the monotypes entitled *Marine Park* (CMO 1679, 1680, and 1681); and the oil *Castle Island,* 1915–18 (CMO 451).

13. *Castle Island, Fort Independence, City Point, Boston, Mass.,* n.d., no. 926-15 from an album dated 1914–15, Marine Park Archives (Olmsted Job #926), collection of the National Park Service, Frederick Law Olmsted National Historic Site, Brookline, Mass.

14. CMO 606. For a color reproduction of the Chicago watercolor, see Williamstown 1990–91, fig. 7.

15. Gwendolyn Owens, in Clark, Mathews, and Owens 1990, p. 50. For information on Sears, see Buck 1985.

16. For a description of these clubs, see Dominic Madormo, in Clark, Mathews, and Owens 1990, pp. 64–65.

17. College Park 1976–77, p. 38.

BERTRAND-JEAN, CALLED ODILON REDON
Bordeaux 1840–1916 Paris

52 *Oyster*, c. 1900–1910

Brush with transparent and opaque watercolor over black chalk on moderately thick cream wove paper, the sheet trimmed to a ruled line in graphite that is faintly visible at left edge

Watermark: None

228 × 140 mm (8¹⁵⁄₁₆ × 5½ in.)

Signed recto, lower right (inside edge of oyster shell), in brown watercolor: *ODILON REDON*

PROVENANCE {The New Gallery, New York}, stock no. pur. 53;[1] sold to SCMA in 1954

LITERATURE Parks 1960, p. 70, repr. (as c. 1900); Berger 1965, no. 548 (as 1912); Wildenstein 1992–96, vol. 3, no. 1302, repr.

EXHIBITIONS Washington 1956, no. 31; Northampton 1968, no. 39; Northampton 1977; Northampton 1979b, no. 150; Amherst 1979, no. 24

Purchased
1954:36

Of all Redon's work in colored media, his watercolors remain the least known. Most of them date from late in his life, after 1900, when he turned from working primarily in black to enthusiastically embrace color. Indeed, the watercolors seem to have had a somewhat more private role in his oeuvre than his work in other media. Although he discussed his *noirs*, or *fusains* (charcoal drawings), his prints, pastels, and paintings in his correspondence — and in his posthumously published writings on art — watercolor is never discussed. The mature watercolors, however, treat themes that concerned the artist throughout his career, and some, like the SCMA sheet, are complete and accomplished works of art.

In taking up watercolor about 1900, Redon was actually returning to a medium he had first explored as an art student in Bordeaux, where his parents had settled in 1840. For three years, starting at age fifteen, he studied with the watercolor painter Stanislas Gorin (active 1840s–60s). Gorin had been a student of Eugène Isabey (1803–1886), the romantic painter, whose landscape watercolors and lithographs were a lasting influence on him.[2] Gorin's greatest gift to his young pupil was to emphasize the importance of individual expression, a lesson for which Redon remained grateful his entire life. Redon debuted in the 1860 exhibition of the Société des Amis des Arts de Bordeaux as "student of M. Gorin" with two watercolor landscapes. The following year he exhibited two more, but critical response to his work was not encouraging.[3]

Redon's list of the works he presented as gifts between 1858 and 1869 reveals that of the twenty-one gifts made from 1858 to 1861 fifteen were *aquarelles* (watercolors).[4] Subsequent gifts are mostly *fusains,* or charcoal drawings. Whether the unfavorable critical response to his work provided the impetus for the change in medium is unclear, but after his early initiatives in Bordeaux in 1860 and 1861 he stopped exhibiting (and, it seems, making) watercolors. Redon's path for the next twenty or more years was firmly set in the exploration of black — in lithography and in charcoals, chalks, and pastels.

Even when he returned to watercolor about 1900, Redon seems not to have considered the medium an appropriate one for exhibition. His shows, both large and small, were limited to his prints, *noirs*, pastels, and, increasingly, his paintings. In the auction of his work, held in March 1907 to raise money to pay off his debts relating to the family home of Peyrelebade, only one of the lots is described as an *aquarelle* — and that is a copy of a watercolor by "Decamps" (presumably Alexandre-Gabriel Decamps, 1803–1860).[5] It would seem that, for the most part, Redon retained possession of his watercolors, and that they left his studio only after his death in 1916, when his widow sold large bodies of his work.[6] It is only in posthumous exhibitions, like that of April 1917 at Galerie Bernheim-Jeune, Paris, that the watercolors began to appear publicly.[7]

Oyster is a marvelously orchestrated composition, painted in a vibrant palette in which blues, browns, and greens are punctuated with ochres, oranges, and magentas. Using transparent washes combined with opaque watercolors often applied with a stiff, almost dry brush, Redon conveys the sense of mysterious forms floating in an aqueous atmosphere. The luminosity of the paler washes is complemented by allowing the cream paper to show through in some areas, for example in the aureoles of light surrounding the circular forms at the bottom of the sheet. That this is an imagined scene, however, we are never in doubt. The careful arrangement of the spiky shells above and the round, polyplike forms in the denser atmosphere below the oyster reveal this, as does the "oyster" itself, which appears opened to reveal a fleshy green interior, its shell being indicated only by the light brown corona that surrounds it.

This marine vision is related in a general way to a number of large decorative works Redon completed in the early years of the twentieth century. One might compare, for example, the folding screen designed for Olivier Sainsère in 1903 and exhibited at the 1905 Salon d'Automne (Paris), which evokes an underwater world

208 BERTRAND-JEAN, CALLED ODILON REDON

of strange flora and fauna, or the decorative panel *Beneath the Sea* that was exhibited in the 1908 Galerie Druet (Paris) show of fifty paintings and pastels.[8] Smaller works after 1905 also recapitulate an underwater theme.[9]

Oyster takes on a particular resonance, however, when seen in the context of Redon's earlier work in which the sea is identified as the cradle of life and serves as a metaphor for transformation. In the SCMA *Oyster* the modeling of the murky green flesh suggests an emerging form — almost a face — that will in time distinguish itself from the inchoate mass, an idea made explicit in a roughly contemporaneous watercolor showing a face in what appears to be an oyster shell.[10] The evolution of early life forms and form emerging from chaos are themes often treated in Redon's early work. His first album of lithographs, *Dans le rêve (In Dreams)* of 1879, contains two plates showing heads in spheres,[11] while a similar vision of heads floating in space, exhibited in 1881 as *In the Primeval Slime (Dans les boues)*, about 1880, makes the meaning clear: these are images of germination, of primitive forms at the dawn of life. Redon's knowledge of Darwin's theories has been cited as a source for these images, as has his awareness of microscopically small organisms through his friend the botanist Armand Clavaud. Contemporary journals, which illustrated microscopic forms of life, and exhibitions devoted to the findings of underwater explorations may also have provided a source of inspiration.[12] *Les Origines,* Redon's 1883 lithographic album, takes up the theme again in its frontispiece and first plate.

Redon also returned repeatedly to the theme of Oannes, the Chaldean sea god. In his first suite of prints for Flaubert's *Tentation de Saint Antoine (Temptation of Saint Anthony)*, as well as in a single lithograph (Mellerio 88), Redon follows Flaubert's description of Oannes, showing a creature with the head of a man on the body of a fish. A lithograph (Mellerio 147) from his third suite of prints for the *Tentation de Saint Antoine* quotes the words of the god: "*Oannes:* Moi, La première conscience du chaos, j'ai surgi de l'abime pour durcir la matière, pour regler les formes" (*Oannes:* I, the first consciousness of chaos, I have risen from the abyss to harden [solidify] matter, to order forms). In an oil painting of Oannes of about 1910 (Rijksmuseum Kröller-Müller, Otterlo, inv. 627-16), a human face emerges from an oval form, seemingly made from the creature's fishlike body, but less specific than earlier images. This vision of the dawn of creation in the seas from which life forms emerged bears a close thematic relationship to the SCMA drawing.

The dimensions of the SCMA sheet are modest, as is characteristic of Redon's watercolors; on average they are approximately half the size of his charcoal drawings. Like his works in other media, the watercolors are signed but not dated, and since they were not exhibited by Redon or recorded in his lists, it is difficult to date them precisely.

AHS

1. According to a paper label handwritten in black ink, affixed to the frame backing.

2. Chicago/Amsterdam/London 1994–95, p. 32.

3. See Douglas Druick and Peter Kort Zeghers in ibid., pp. 33–34, who also note that watercolor was stigmatized by its association with the amateur.

4. Ibid., p. 451. The list of early gifts was transcribed by André Mellerio from a list Redon had compiled. A number of the watercolors were presented to members of the Cercle Littéraire et Artistique in Bordeaux.

5. Paris, Hôtel Drouot, *Catalogue des tableaux, aquarelles et pastels composant la vente Odilon Redon . . .*, 11 March 1907.

6. Shortly after the artist's death in 1916, Jacques Zoubaloff purchased watercolors from Redon's widow, making a major gift at that time directly to the Petit Palais (Bacou 1956, vol. 1, pp. 219–20). In 1920 the Art Institute of Chicago bought the artist's personal holdings of lithographs and etchings from his widow (the collection that Mellerio had used as the basis for his catalogue raisonné of 1913 [Mellerio 1968]).

7. This exhibition included "paysages d'après nature, aquarelles, dessins; aquarelles et dessins 60 numéros." By the time Ari and Suzanne Redon gave the Louvre the remains of the artist's studio (some 542 pieces), only a few drawings were included that have touches of watercolor. This seems to indicate that Redon's watercolors had already left the family's hands.

8. On the Sainsère screen, see Gloria Groom in Chicago/Amsterdam/London 1994–95, p. 313, fig. 55; for the panel exhibited at Druet, see ibid., pp. 314–15.

9. See ibid., p. 314, fig. 57.

10. See New York 1958, no. 32, repr.: *Old Man in Shell,* 1900, watercolor (no measurements given), lent by Louis Macmillan. For a watercolor of fishes, see no. 33, repr.: *Fish,* 1905, watercolor, lent anonymously.

11. *Blossoming,* pl. 1 (Mellerio 1968, no. 27, repr.), and *Germination,* pl. 2 (Mellerio 28, repr.). See also Chicago/Amsterdam/London 1994–95, p. 122, figs. 2:1 and 2:2.

12. See Druick and Zeghers in ibid., p. 148.

KÄTHE KOLLWITZ

Königsberg, Germany (now Kaliningrad, Russia) 1867–1945 Moritzburg, near Dresden, Germany

53 *Arming in a Vault (Bewaffnung in einem Gewölbe)*, c. 1902, composition study for the lithograph *Arming in a Vault* (1902) and for plate IV of the print cycle *Peasants' War* (1906)

Black, burnt sienna, and light ochre chalks on heavy red-brown wove paper

Sheet, irregular: 597 × 507 mm (23½ × 20 in.)

Watermark: None

Signed recto, lower right, in black chalk: *Käthe Kollwitz;* inscribed recto, lower right, in black chalk: *Fackelfarbe / trübes Rot / Schwarzbraun* [torchlight / dark red / brownish black]

PROVENANCE Dr. Heinrich Stinnes (d. 1932), Cologne (Lugt Suppl 1376d, lower left recto) by 1932; to his estate (sale, Bern, Gutekunst und Klipstein, 20–22 June 1938, no. 571); to Archibald V. Galbraith, Northampton, Mass.; sold to SCMA in 1958

LITERATURE Parks 1960, no. 73, repr. (as *Study for Fight in the Castle Armory*)

EXHIBITIONS Northampton 1958b, no. 10, repr. frontispiece (as *Fight in the Castle Armory*); AFA 1959–60; Sarasota 1967; Northampton 1987a; Northampton 1995a

Purchased
1958:50

*A*rming in a Vault is one of seven known composition studies related to plate IV of Käthe Kollwitz's cycle of etchings *Peasants' War,* which presents a loose narrative of the German peasants' rebellion of 1522–25.[1] Laboring under severe tax burdens and intolerable working conditions, thousands of peasants and urban workers joined the upheavals set in motion by Martin Luther's demand for church reform and protested their treatment by attacking castles and monasteries. The rebellion, which had been put down by 1525, was chronicled in Wilhelm Zimmermann's *General History of the Great German Peasants' War* (Stuttgart: F. H. Köhler, 1841–42), which Kollwitz had read.

Kollwitz's interest in the theme, however, was not directly tied to her reading of Zimmermann but had emerged earlier. It reflects her long-standing sympathies with the working class, influenced by her upbringing in an educated, socialist family. She had daily contact with the working poor served by her husband, Karl Kollwitz, a physician employed by a health insurance organization for the tailors' guild in Berlin. She was also influenced by the works of Emile Zola, Maxim Gorki, Fyodor Dostoyevsky, Leo Tolstoy, Charles Dickens, and Gerhart Hauptmann, whose play *The Weavers* had inspired her first print cycle, *A Weavers' Rebellion* (1893–98). As Kollwitz noted in a letter to a friend,

> The particular prints of the Peasants' War series do not derive from any literary source. I had done the small print with the flying woman [undoubtedly the etching *Uprising,* 1899, K. 44], and the same theme occupied me for a long time. I hoped that some day I should be able to represent it, to get it out of me. At that time I read Zimmerman [*sic*] on the Peasants' War. He tells about "Black Anna" who incited the peasants. Then I did the large print on the uprising

of the peasant mob *[losbrechenden Bauernhaufen]*. This one brought me the commmission for the cycle. The rest were built around this already finished print.[2]

The "large print on the uprising" is almost certainly the etching *Outbreak (Losbruch)*, dated 1903, which was based on a 1901 drawing *(Outbreak)* inspired by the print "with the flying woman."[3] Kollwitz received the commission for *Peasants' War* in 1904 from Max Lehrs, director of the Dresden Kupferstich-Kabinett and a Kollwitz supporter, who issued the cycle of seven etchings in 1908 as a membership gift for the Association for Historical Art in Dresden. It was republished in 1921 by Emil Richter (Dresden).[4]

The cycle begins with two images of injustice to the peasants, *The Plowers* and *Raped.* The next four prints describe the peasants' response *(Whetting the Scythe, Arming in a Vault, Outbreak,* and *Battlefield).* Finally, *The Prisoners* depicts the tragic end of the revolt. Kollwitz did not develop these prints in narrative sequence, however. Indeed two of her etchings were based on lithographs — *The Plowers* (K. 60) and *Arming in a Vault* (fig. 1; K. 92) — that she had executed in 1902.[5] In her etching for plate IV of *Peasants' War* (fig. 2) she revised the composition of the lithograph *Arming in a Vault* and reversed its orientation.

The Smith College drawing, loosely sketched in black chalk on heavy reddish brown paper, depicts a large, windowless interior with a high, vaulted ceiling, in which a massive crowd of peasants bearing lances and spears swarms up a steep staircase. Touches of red and yellow chalk suggest flickering torchlight in the shadowy space. Dwarfed by the high ceiling, the crowds in the distant reaches of the room, only roughly indicated, are faceless. Toward the foreground, the lighting and the quickly increasing scale of the figures bring individuals on the staircase into focus, thrusting them into sudden and

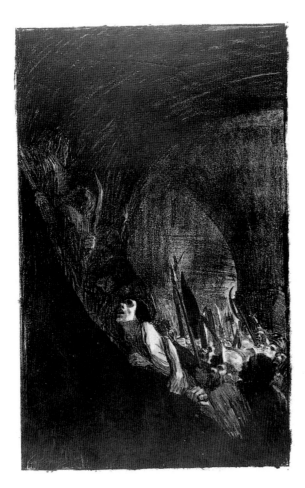

Fig. 1. Käthe Kollwitz, *Arming in a Vault,* 1902. Lithograph, 369 × 233 mm (14½ × 9³⁄₁₆ in.). British Museum, inv. 1951-5-1-72. © 2000 Artists Rights Society (ARS), New York / VG Bild-Kunst, Bonn. Photo: © British Museum

Fig. 2. Käthe Kollwitz, *Arming in a Vault,* 1906. Etching, plate: 496 × 330 mm (19⁹⁄₁₆ × 13 in.). SCMA, Purchased, inv. 1958:51. © 2000 Artists Rights Society (ARS), New York / VG Bild-Kunst, Bonn. Photo: Stephen Petegorsky

troubling prominence. The technique found in many of Kollwitz's later works, in which figures are massed together as a solid block, is already apparent here.[6]

Less finished and more tentative than the other composition studies that have been associated with the etching *Arming in a Vault,* the Smith College drawing is more closely related to the lithograph, and may be the earliest of all the studies.[7] Not only are the dimensions of the drawing's composition as sketched in by Kollwitz closer to those of the lithograph,[8] but the color of its paper suggests a link to that print. August Klipstein records rare early impressions of the lithograph printed in two or three inks on paper of various colors (the 1920 edition issued by Emil Richter featured a brown plate tone).[9] Another drawing of *Arming in a Vault* on brown paper (private collection, fig. 3), which has been assigned a date of 1902 by scholars Otto Nagel and Werner Timm, further develops the composition of the SCMA drawing.[10] In contrast, the etching was printed in cooler greys, and at least three of the other composition studies, including the only dated one (1906), are on grey paper.[11]

One of the most dramatic elements of both lithograph and etching is the seemingly endless, unstoppable surge of peasants, but this was achieved only through painstaking revisions. The SCMA drawing shows Kollwitz's efforts to shape the line of the staircase to help create this effect. A line exiting halfway up the left side of the drawing appears to mark a rejected idea for the curve of the staircase, perhaps altered to provide a swifter upward flow. A curved line at the right, outside the composition's borders, may be another attempt to work out a successful contour. In both prints, the peasants' upraised weapons point uniformly forward, a solution not yet evident in the SCMA drawing that begins to appear in the private collection drawing on brown paper. Similarly, in the prints (most markedly in the etching), the passage through which the peasants issue is constricted to concentrate the flow of bodies; the SCMA drawing features a larger opening and less differentiated lighting while the private collection drawing begins to narrow the passage.

The SCMA drawing comes from one of Kollwitz's most productive and experimental periods, in which she explored various technical issues in printmaking, including soft-ground processes, photo-etching, intaglio, and color lithographic printing, and also worked with a range of themes, refining her presentation of them into ever

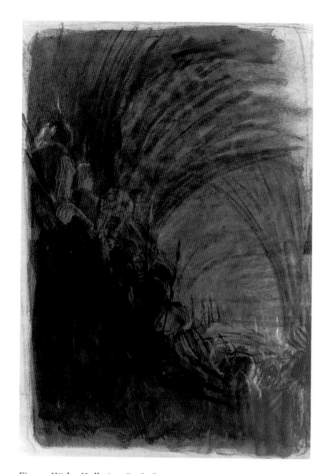

Fig. 3. Käthe Kollwitz, *Study for Arming in a Vault* (NT 213), 1902. Charcoal, graphite, and colored crayon on heavy brown paper, 448 × 330 mm (17¹¹⁄₁₆ × 13 in.). Private collection. Courtesy of the Museum of Art, Rhode Island School of Design. © 2000 Artists Rights Society (ARS), New York / VG Bild-Kunst, Bonn. Photo: Del Bogart

more insistent messages. When her first print cycle, *A Weavers' Rebellion,* was exhibited in Berlin in 1898, the jury recommended her for a gold medal, but the decision was vetoed by the Kaiser. The occasion established her reputation and resulted in an invitation to join the Berlin Secession in 1899. While Kollwitz was never regarded as an avant-garde artist, she was by this time a well-respected member of the art community. *Peasants' War* assured her status in "the front rank of German graphic artists."[12]

Kollwitz consciously simplified her work, leaving behind the detailed approach of realists such as Adolph Menzel (1815–1905), the leading artist in Berlin until his death, who was known for his historically accurate paintings based on exhaustive sketches from life. Whereas Menzel and many of his contemporaries saw their role as documentary, Kollwitz focused on creating a narrative of emotion. From the printmaker Max Klinger (1857–1920) she learned a seriousness of purpose, which is evident in *A Weavers' Rebellion* and *Peasants' War.* While she moved away from Klinger's symbolist language (echoes of which can be seen in *Raped,* plate II in *Peasants' War),* she sup-

ported his view of printmaking as a vehicle for the expression of broad, humanistic themes. During her sixty-year career, she created three other print cycles on such themes — *War* (1922–23), *Proletariat* (1925), and *Death* (1934–35) — as well as numerous single prints, posters, drawings, and sculptures. After *Peasants' War,* however, she depicted these themes using subjects from life around her rather than events from history.

A collector's mark on the Smith College drawing indicates that the sheet once belonged to Dr. Heinrich Stinnes, Cologne, one of the great early-twentieth-century collectors of modern German and other European prints and drawings, whose collection numbered some two hundred thousand sheets.[13]

NR

1. The prints are catalogued and reproduced in Klipstein 1955 (hereafter abbreviated as K.) as follows: I. *The Plowers (Die Pflüger),* 1906, K. 94; II. *Raped (Vergewaltigt),* 1907, K. 97; III. *Whetting the Scythe (Beim Dengeln),* 1905, K. 90; IV. *Arming in a Vault (Bewaffnung in einem Gewölbe),* 1906, K. 95; V. *Outbreak (Losbruch),* 1903, K. 66; VI. *Battlefield (Schlachtfeld),* 1907, K.96; VII. *The Prisoners (Die Gefangenen),* 1908, K. 98. Drawings related to *Arming in a Vault* are reproduced as figs. 213–18 in Nagel and Timm 1980 (hereafter abbreviated as NT). One of these is dated 1906 (NT fig. 215, National Gallery of Art, Washington, D.C., Rosenwald Collection). The others were assigned dates by Otto Nagel and Werner Timm as follows: NT fig. 213, 1902, private collection, on loan to the Museum of Art, Rhode Island School of Design, inv. EL 010.93.50; NT fig. 214, 1902, location unknown, in the sale, Bern, Kornfeld und Klipstein (Auction 137), 17–19 June 1970, no. 730, fig. 56, but returned to the owner, now deceased (letter to the author from Christine E. Stauffer, Galerie Kornfeld, 26 Jan. 1999; SCMA curatorial files); NT fig. 216, 1906, Käthe Kollwitz Museum, Cologne (formerly with Galerie St. Etienne, New York); and NT figs. 217 and 218, 1906, locations unknown. Timm, who has updated records of Kollwitz drawings since Nagel and Timm 1980, assigned a temporary number of 213a to the SCMA study (letter to the author 11 May 1994; SCMA curatorial files).

2. Undated letter to Arthur Bonus (1907?), in Kollwitz 1988, p. 162.

3. On the etching see note 1, above. On the drawing, see NT fig. 187.

4. Hildegard Bachert in Washington 1992, pp. 117–19 and note 6.

5. *The Plowers* was reworked in the etching K. 92 (1905) before Kollwitz made the final plate in 1906 (K. 94)

6. See, e.g., *The Parents,* 1923, plate III (K. 179) from her cycle *War (Krieg).*

7. I am grateful to Hildegard Bachert for her comments on the dating (letter to the author, 5 March 1994; SCMA curatorial files).

8. The SCMA composition is marked with chalk lines at 385 × 255 mm; the lithograph measures 369 × 233 mm and the etching 497 × 329 mm.

9. Klipstein 1955 p. 75.

10. NT fig. 213 (see note 1 above).

11. NT fig. 215 (see note 1 above).

12. Nagel 1971, p. 35.

13. See Lugt Suppl no. 1376d.

MARC CHAGALL
Vitebsk, Russia 1887–1985 Saint-Paul-de-Vence, France

54 *Over Vitebsk, c. 1914*

Pen and brown ink with brush and brown wash over graphite on smooth, light brown wove paper

Watermark: None

152 × 210 mm (6 × 8¼ in.) (slightly irregular)

Signed recto, lower right, in pen and brown ink: *chagall;* inscribed recto, lower left, in pen and brown ink: *Vitebsk*

PROVENANCE Possibly Dr. Lothar Mohrenwitz (d. by 1960), Zurich (sale, Lucerne, Galerie Fischer [catalogue 144], 24–25 Nov.

1960, no. 463, pl. VI [as *Le Ciel de Witebsk*]);[1] to Selma Erving (1906–1980), West Hartford, Conn.; bequest to SCMA in 1984

LITERATURE None

EXHIBITION Northampton 1984c, no. 13 (as *Russian Village*)

Bequest of Selma Erving, class of 1927
1984:10-5

In 1914 Marc Chagall returned to his Yiddish-speaking home town of Vitebsk, one of the oldest towns in Russia, from a four-year sojourn in Paris, where he had found a rich and stimulating environment of modern art. He had adapted many new influences into his own style — Cubism, Futurism, Orphism, Expressionism — and by the end of his Paris stay he had achieved international status as an artist, exhibiting in Paris at the Salon des Indépendants in 1912, 1913, and 1914, and in Berlin at a solo exhibition at the gallery Der Sturm in 1914. Intending to stay in Vitebsk for only three months, he rented a room across the street from the church of Saint Ilytch, pictured at the right in this drawing. World War I intervened, however, and he remained for several years in Vitebsk, taking inspiration from subjects related to his beloved town. After the 1917 Bolshevik Revolution, he was appointed commissar of art for the region of Vitebsk but encountered strong opposition from radical avant-garde artists such as Kazimir Malevich (1878–1935) and El Lissitzky (1890–1941) who felt he was too eclectic and too "objective." He left Vitebsk and moved to Moscow, finally returning to Paris in 1923 at the invitation of Ambroise Vollard, noted publisher of artists' books. Many elements of Chagall's Vitebsk work, however, reappeared in his art throughout his life, particularly his joining of subject matter from the real world with dreams and fantasies relating to his Jewish background.

The Smith College drawing is a loose contour rendering, in brown ink and brown wash over rough pencil outlines. The scene is the wintry neighborhood of the artist's lodgings, where a cart or sledge has made curving tracks in the snow in the road between a small, partially bricked house at left and the roughly outlined church of Saint Ilytch at right. At the end of the quiet, deserted street stand two peaked roofs with domes (perhaps churches surmounted with crosses), as well as other loosely sketched low buildings in the dense, helter-skelter clustering characteristic of an old town. A high wooden fence lines the left side of the street, opposite the lower and more decoratively styled fence surrounding the church

of Saint Ilytch. Into this quite ordinary setting an old man floats down from the sky, wearing a long dark overcoat and boots and bearing a large sack and walking stick. Recalling his 1914 stay in Vitebsk, Chagall said, "I painted everything my eyes lighted on. I painted at my window; never did I go walking in the street with my box of paints."[2] While the setting is one his eyes may have seen, Chagall presents a vision rather than a topographical record of the street — one in which memories and observations of real life furnish the context for a fantasy.

The drawing makes little use of shading, relying instead on perspective and scale to create a shallow space. Details are only roughly indicated; the church towers, for example, are barely delineated, and the flutings of the stonework are only partially sketched. The drawing is not distinctively cubist in style although traces of the modernist influence are present in the shallow space and in slight distortions of scale, as well as in the prominence of the abstract lines of the cart tracks. A framing line is loosely drawn around part of the image, and there are many areas of revision, where an initial idea sketched in pencil has been overridden in ink (see, for example, the outlines of the church buildings at right and the configuration of the house and fence at left). In this abbreviated jotting of creative ideas, the strokes are quick and utilitarian; although Chagall was capable of expressing mood through the quality of his line — whether fine and sensitive or heavy and rough — the line in this drawing serves the more utilitarian purpose of spontaneously recording an idea. As Jacques Lassaigne has noted, "Drawing for Chagall is not a virtuoso performance, as it is for an Ingres or a Picasso. It is not a studied discipline requiring thorough preparation. It is really the initial impulse, the rough sketch feeling for its way, the sensibility in free flow."[3]

This drawing is probably the earliest of the nine known renderings of the subject,[4] three of which are dated 1914. It is the smallest and least finished version, evidently drawn on a page from a sketchbook. Two of the works are large, finished oil paintings, one dated 1914,

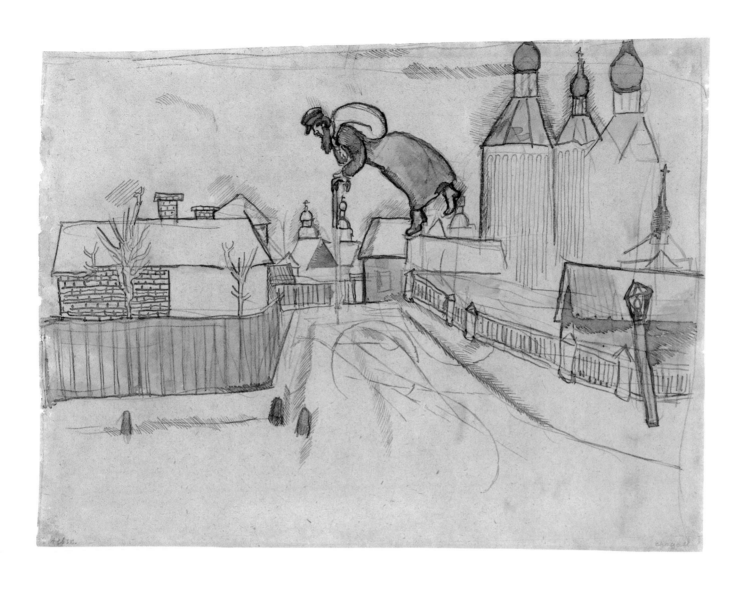

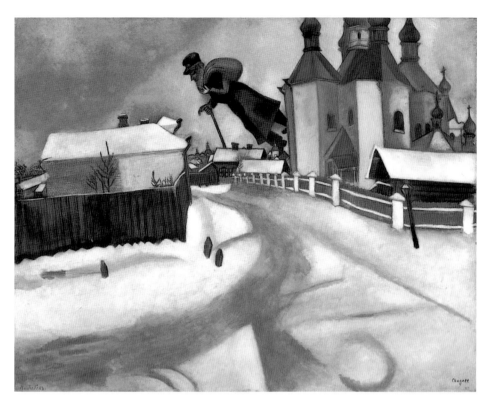

Fig. 1. Marc Chagall. *Over Vitebsk,* 1914. Oil on card mounted on canvas, 70.3 × 91 cm (27¹¹⁄₁₆ × 35⅞ in.).
Art Gallery of Ontario, Toronto. Gift of Sam and Ayala Zacks, 1970. © 2000 Artists Rights Society
(ARS) New York / ADAGP, Paris

in the collection of the Art Gallery of Ontario, Toronto
(fig. 1), and the second a revised version in a more cubist
style (1915–20), now at the Museum of Modern Art in
New York. In each version of *Over Vitebsk,* while the
compositions are blocked out in similar ways, the archi-
tectural details vary — the style of fencing changes, the
brick facing on the house may or may not be present, the
number and shape of church towers vary. It was not un-
usual for Chagall to return to the same subject with
slight variations; throughout his career he did so, espe-
cially with favorite images, sometimes to develop an
idea, but often because he liked to be surrounded by his
creations. Frequently he made a copy or another version
for himself before selling a work, or duplicated a work
for a patron.[5] With his genuine affection for Vitebsk,
despite what must have been a difficult change from the
Parisian environment, Chagall returned over and over to
his neighborhood street as a setting for other subjects, for
example in a gouache drawing of a cart horse turning the
corner *(Vitebsk, 1914),* an oil painting of a weary newspa-
per vendor (1914), and an oil painting titled *Birthday*
(1915);[6] the street appears as late as 1939 in *Snowing,*[7] long
after Chagall had left Vitebsk.

Chagall resisted specifying exact interpretations of his
symbolism. While the floating figure may refer to Chagall
himself and his recent return to his hometown, more
universal themes are also implied. The bearded figure's
extraordinary mode of arrival in Vitebsk suggests the
gracing of this ordinary town street with a touch of the
sacred, perhaps reflecting the artist's joy in returning to
his former home. The figure has been described as "the
eternal wanderer, the Jew without a country," or as
Elijah. In describing a Passover Seder from his youth,
Chagall wrote, "But where is Elijah and his white char-
iot? Is he still lingering in the courtyard to enter the
house in the guise of a sickly old man, a stooped beggar,
with a sack on his back and a cane in his hand?"[8] Isaak
Kloomok notes "the Yiddish common expression [*"Er
geht iber'n shtot"*] describing a beggar that goes from door
to door begging... literally, he walks over the city."[9]
Whatever the interpretation, the bearded man holds a
special place in Chagall's cast of characters, appearing in
many other contexts and periods of his work, for exam-
ple, in *An Old Jew,* an etching and drypoint in which the
old man is the central figure, and in *White Crucifixion*
(1938), in which the old man, eyes closed and hands
pressed together as if in prayer, leans into the flames of a
burning Torah beside a crucifix.[10] Chagall's practice of
creating variations on a theme and lifting motifs from
one context into another is consistent with his belief that
art should not be imitative of life; that is, while life fur-
nishes ideas and inspiration, art should go beyond the
recording of daily events.

NR

1. This auction was drawn primarily from the estate of Dr. Lothar Mohrenwitz, but the source of individual works was not identified. The catalogue indicates that the drawing bore a Galerie Flechtheim exhibition label (unconfirmed at this writing). This gallery, which from 1921 operated primarily in Berlin, closed in 1934.

2. Quoted in Sorlier 1979, p. 77.

3. Lassaigne 1964, p. 6.

4. The following versions are known:

1) *Study for "Over Vitebsk,"* 1914. Oil on canvas, 19.5 × 25 cm (7⅝ × 9¾ in.). Signed and dated lower right, in Cyrillic: *Chagall 1914*. Collection of Nadéjda Simina, St. Petersburg. Meyer 1964, no. 208; Frankfurt 1991, no. 69, color repr.; and Paris 1995, no. 125, color repr.

2) *Study for "Over Vitebsk,"* 1914. Watercolor and colored pencil on paper, squared for enlargement, 232 × 336 mm (9¼ × 13¼ in.). Signed and dated lower left, in Cyrillic: *Marc Chagall. Sketch for environs of city of Vitebsk 1914*. Tretyakov Gallery, Moscow, inv. P-2607 (formerly collection of Prof. A. A. Siderow, Moscow). Meyer 1964, no. 209; Frankfurt 1991, no. 68, color repr.

3) *Over Vitebsk,* 1921–22. Watercolor on cardboard, 289 × 387 mm (11⅜ × 15¼ in.). Signed and dated, lower right, in Cyrillic: *M. Chagall 1914*. Collection of Mr. and Mrs. Albert Lewin, New York. Meyer 1964, no. 333; Frankfurt 1991, no. 71, color repr.; and Paris 1995, no. 130, color repr.

4) *Over Vitebsk.* Gouache on paper, 412 × 495 mm (16¼ × 19½ in.). Signed lower right: *chagall*. Collection of Mrs. Stephen Keller, New York. Meyer 1964, no. 361.

5) *In the Sky at Witebsk.* Medium and size not given. According to Bulliet 1936, pl. 152, at Tannhauser Galleries, Berlin; location unknown. Not in Meyer.

6) *Over Vitebsk,* 1914. Oil on card mounted on canvas, 70.3 × 91 cm (27¾ × 35⅞ in.). Signed and dated lower right, *ChAgAll*, be-neath (obscured by paint) *914*. Art Gallery of Ontario, Toronto, inv. 71/85 (formerly Sam and Ayala Zacks collection). Meyer 1964, p. 233.

7) *Over Vitebsk,* 1915–20. Oil on canvas, 67 × 92.7 cm (26⅜ × 36½ in.). Signed lower left below frame edge *Russie 915-20* and lower right in ink: *Marc Chagall*. The Museum of Modern Art, New York (Lillie P. Bliss Bequest, 1949, inv. 277.49). Meyer 1964, no. 304; Frankfurt 1991, no. 70, color repr.

8) *Over Vitebsk,* c. 1914. Oil, gouache, pencil, and ink on paper, 310 × 390 mm (12¼ × 15⅜ in.). Signed lower right, *Marc chagall*. Philadelphia Museum of Art, Louis E. Stern Collection, inv. 63-181-10. Baal-Teshuva 1998, p. 79, color repr.

9) *Over Vitebsk,* c. 1925. Gouache, watercolor, and pencil on tan paper, 365 × 477 mm (14⅜ × 18¾ in.). Signed lower right, *chagall*. Sold, Sotheby's, New York, 12 Nov. 1988, no. 138, color repr. Attributed and dated by Ida Chagall.

5. See Rudenstine 1976, p. 71, for a discussion of this practice.

6. These are, respectively, *Vitebsk,* 1914, private collection, Basel. (Balingen 1987, p. 109, color repr.); *Newspaper Vendor,* 1914, Musée National d'Art Moderne, Centre Georges Pompidou, Paris, inv. AM 1984-121. (Kamensky 1989, p. 183, color repr.); and *Birthday,* 1915, oil on board, The Museum of Modern Art, New York, inv. 275.49. (London 1985, p. 87, cat. 48, color repr.)

7. Gouache on cardboard, The St. Louis Art Museum, inv. 43.42; Baal-Teshuva 1995, p. 150, repr.

8. Chagall 1960, p. 39.

9. Kloomok 1951, p. 37.

10. *An Old Jew* first appeared as pl. 13 in Chagall's portfolio of prints *Mein Leben,* published in Berlin in 1923 by Paul Cassirer (pl. 54 in San Francisco 1988). *White Crucifixion* (oil on canvas, The Art Institute of Chicago, gift of Alfred S. Alschuler, inv. 46.925) is color pl. 81, in London 1985. See London 1985, p. 19, for a discussion of the bearded figure and its appearance in other works.

JOHN MARIN
Rutherford, N.J. 1870–1953 Cape Split, Maine

55 *Tree Forms, Delaware River Country*, 1916

Brush and watercolor over graphite on heavy, textured white wove paper

Watermark: Indecipherable

Sheet: 369 × 423 mm (14½ × 16⅝ in.)

Signed and dated recto, lower right, in watercolor: *MARIN 16*; inscribed verso, along bottom edge in graphite: *Treeforms Delaware River Country* [River inserted]; at lower left, in graphite: *A-*; at center, in graphite: *Stieglitz;* at center right, in blue crayon: *12* [in a circle]; upper right, in graphite: *14;* and lower right, superimposed on collector's mark, in graphite: *19*

PROVENANCE Alfred Stieglitz (1864–1946), New York, from the artist, possibly in 1916 (collector's mark, not in Lugt, lower right verso, stamped in lavender ink *Collection/AS*); to {An American Place, New York}, by 1946; to {Downtown Gallery, New York} in 1950;[1] to Mary Virginia Carey (d. 1972), Long Beach, Calif.; to her estate; gift to SCMA in 1972

LITERATURE Reich 1970, no. 16.46, repr.

EXHIBITIONS New York 1936, no. 28; Northampton 1974c; Northampton 1987–88

Gift of the Estate of Mary Virginia Carey, M.S.S., class of 1942
1972:16-3

John Marin had a lifelong interest in depicting the natural surroundings of the countryside where he spent his summers, as well as the city environments of New York and New Jersey where he worked during the winter. During his prolific career, he painted many scenes in the Berkshires and the Adirondacks, along the coast of Maine, and, in the summer of 1916, at Echo Lake in the Kittatinny Mountains near the Delaware Water Gap in Monroe County, Pennsylvania. Arriving with his wife and two-year-old son, Marin initially found the Echo Lake country less visually stimulating than the coast of Maine, where he had spent the previous two summers, but in his typical vigorous and enthusiastic fashion, he spent much time outdoors, tramping through the woods, painting, fishing (when he had time), and getting to know the land despite mosquitoes, snakes, and mud. In a letter to his dealer, Alfred Stieglitz, Marin wrote, "Up here, it is woods and more woods smeared over the landscape. Mountains without much character? Until you find it."[2] Three weeks later he wrote:

> I just wish you could see the Delaware Valley about 3 miles from the house. On the Jersey side of the river is an immense bulwark of mountain heavily wooded. On the slope where I stand, miniature mountains jutting up, jutting up, big wild country. And in that country across the river you know there are bear, deer, all sorts of animals and snakes and there were Indians. It is a country to make you feel big.[3]

This description might have been written for just such a scene as is depicted in the Smith College drawing. Through the use of a watercolorist's vocabulary, Marin creates an impression of energy, wildness, and immensity. The work begins with a few sharp pencil strokes — verticals and horizontals at right to define the edge, diagonal slashes at left creating boundaries of tree forms, a curving line or two dividing river from trees on the opposite bank. The lines seem more like reminders of energy flows than guidelines for application of paint. A mixture of painted and blank areas, wet-brush and dry-brush passages, and separated, blended, and layered colors lies over the underdrawing. Large areas of spontaneously flowing, crusty-edged wash contrast with brush-drawn geometric elements — squares, triangles, sharp angles, parallel lines.

The composition is laid out in the three horizontal bands of a traditional landscape — foreground, middle ground, background — but beyond this basic structure, the watercolor diverges sharply from traditional representational landscape. Marin makes use of modernist techniques such as exaggeration of color, geometricizing and dematerializing of forms, and distortion of space and balance to express his feeling about nature. In the foreground lies the river, whose pale, transparent colors are greyed and muddied, yet filled with jumping shapes in horizontals, verticals, diagonals and rippling curves. The middle ground of forested hillside is alive with tilting planes of stronger colors, their angularity and shifting intensities creating a sense of agitation. Vertically connecting middle ground and foreground are subtle pairings of object and reflection: the triangular green tree and its geometric ripple, the small pink and yellow form to the left of the tree and its triangular echo in palest violet, pink, and yellow, and the broad yellow stroke at right and its faint hint below. The background of intense blue wash, with two dark strokes suggesting folds in a mountainside, surmounted by a violet suggestion of sky, presses forward, compressing the wooded hillside into a narrow zone between mountain bulwark and river. The roughly penciled border at right is overridden by the brisk yellow stroke and lighter washes of violet and green, as if the energy cannot be contained within a frame. The balance of forms tilts to the left, sustaining the sense of agitation and energy. Nowhere is there an "entry" for the viewer into the scene; the viewer simply confronts the power of the country that "makes you feel big."

In the summer of 1916 Marin felt he was breaking new ground. Writing to Stieglitz, he warned, "When I get back you mustn't look for quantity nor even quality as I am floundering along *new lines*—this is a joke, don't believe it — or development of the old, and hardly know where I am. Have done only 4 A 1's, so far."[4] His response to nature — immediate, direct, and intuitive — was strengthened over the summer. As a boy, he had found great pleasure in summer trips to the countryside. In 1916, contemplating his return to the city at the end of the summer, he wrote,

> . . . I have gotten so much of the country man in me what with these long stretches of being in comparative wild spots that I seem to have no more much feeling of the terrible. Wandering over trackless mountains, feel sort of at home. . . . I imagine . . . I'll feel rather lonesome when I get back. . . . Mountains, streams, trees and rocks are so sympathetic. Damed [*sic*] if I find most humans so.[5]

Earlier Marin had affirmed the importance of nature as a source of spiritual renewal: "Seems to me the true artist must perforce go from time to time to the elemental big forms — Sky, Sea, Mountain, Plain — and those things pertaining thereto, to sort of retrue himself up, to recharge the battery. For these big forms have everything."[6]

In 1917, the year after completing the Smith College drawing, Marin produced his most abstract works,[7] in which little in the way of recognizable subject matter remains. This venture into abstraction was no doubt fueled in part by his exposure over the years to modern artists. His study of art, which came after trying various careers, including architecture, began at the Pennsylvania Academy of the Fine Arts, Philadelphia, where he studied with Thomas Anshutz (1851–1912) from 1899 to 1901; he then briefly attended the Art Students League in New York. Although he did not respond well to formal instruction, the academy did provide him with contacts with other artists as well as encouragement to proceed with his artistic interests. Like many American artists, he went to Europe (1905–10), visiting Rome, Florence, Venice, London, Amsterdam, Bruges, Antwerp, Brussels, and Paris. He seems to have had little interest at the time in current European art developments, however, preferring instead the late-nineteenth-century work of such artists as James McNeill Whistler (1834–1903) and Pierre Bonnard (1867–1947), although he probably saw the work of Paul Cézanne (1839–1906) in the Salon d'Automne of 1907 and that of Henri Matisse (1869–1954) in the 1908 Salon d'Automne, both exhibitions in which his own work was included.[8]

In 1909 Marin was introduced to Alfred Stieglitz, who included him in a group show at his New York gallery "291" that year and mounted his first solo show in 1910. The two formed a long and close relationship, in which Stieglitz handled Marin's professional affairs, sold his paintings, and assisted him financially as needed, until Stieglitz's death in 1946. With solo exhibitions almost every year from 1910 on, Marin became a celebrated American artist, receiving extensive publicity throughout his career. Marin exhibited at the Armory Show of 1913, and through his association with "291" and its successors, The Intimate Gallery and An American Place, he saw the work of European artists such as Cézanne, Matisse, Pablo Picasso (1881–1973), Georges Braque (1882–1963), and Constantin Brancusi (1876–1957) and became acquainted with American modernists including Marsden Hartley (1877–1943), Georgia O'Keeffe (1887–1986), Max Weber (1881–1961), and Arthur Dove (1880–1946).

Marin remained unmoved by abstraction in its purest sense as an intellectual analysis of form, however. He did not continue in the abstract manner of 1917, returning instead to his selective use of abstraction to express his feelings about the "inner essence" of the landscape around him.

Marin is credited with a key role in raising the status of watercolor as an independent art form. He also produced drawings, oils, and etchings, but the majority of his large output was in watercolor. The SCMA drawing is typical of his work in this medium, which seems to have suited his need as an artist for both spontaneity of expression and direct experience with the landscape. He preferred to work out-of-doors, moving directly from idea to finished work with little underdrawing or preparatory sketching, and he placed a high value on allowing the unexpected to emerge in his painting. In his blunt and heartfelt way, he summed up his feelings in a letter to Stieglitz in 1914:

> I have from time to time in a vague sort of way planned out work ahead. But I find this wayward temper of mine will not allow me to. So that I don't know myself, I don't know my subconscious self and this sometimes scares me and surprises me and I find things cropping up I never intentionally intended. Well, maybe this keeps me from a certain set mannerism, and this is a something I detect and what forces a dislike, an unconscious dislike, of most of the modern work I have seen.
>
> Oh, it is dangerous ever, ever to work in a studio; this is of course only an opinion, take it for what it's worth and I'll do the same.[9]

NR

1. Labels appearing on the original frame backing document the drawing's presence at both An American Place and the Downtown Gallery. There is also an Alfred Stieglitz collector's mark, which has been crossed out, as well as a paper label inscribed in Stieglitz's hand: [corner torn] *Coll. / Treeforms — Delaware Country, Pa. / Water-Color by / John Marin / Never exhibited / AS*.

2. Letter to Alfred Stieglitz, from Echo Lake, 6 Sept. 1916, in Marin 1949, p. 28.

3. Letter to Alfred Stieglitz, from Echo Lake, 28 Sept. 1916, in Marin 1949, p. 31.

4. Letter to Alfred Stieglitz, from Echo Lake, 28 Sept. 1916, in Marin 1949, p. 31. "A 1's" must have designated works of the highest quality. Stieglitz evidently agreed with Marin's assessment of the summer's work as something new, and valuable as well, since when Marin sent the results of his summer's work to Stieglitz, the dealer kept *Tree Forms, Delaware River Country* and several others for his private collection rather than putting them up for sale. Dorothy Norman explains this practice as a mark of high regard: "with respect to Marin in particular — Stieglitz bought and kept together — year by year — outstanding examples of his paintings, so that the entire 'evolution' of his life work might be available for the public at large, first at Stieglitz's own galleries and later in the country's leading museums (instead of being scattered haphazard, or hidden in private collections." Marin 1949, pp. xiii–xiv.

5. Ibid, p. 31.

6. Quoted in Benson 1935, p. 107. This quotation originally appeared in Marin's article, "John Marin, by Himself," in *Creative Art* 3 (Oct. 1928), p. 35.

7. See Reich 1970, vol. 2, nos. 17.1–17.47, repr.

8. Washington 1990, p. 77.

9. Letter to Alfred Stieglitz, from West Point, Maine, 16 Sept. 1914, in Marin 1949, p. 17.

JAN THEODOOR TOOROP
Poerworedjo, Java 1858–1928 The Hague

56 *View of Castle Doorwerth, near Arnhem,* c. 1917

Black crayon on beige wove paper

Watermark: None

Sheet, irregular: 340 × 447 mm (13⅜ × 17¾ in.)

Signed recto, lower right, in black crayon: *JToorop;* titled below signature in graphite: *Doornwerth*

PROVENANCE Possibly in sale, Amsterdam, A. Mak, 15 May 1928, no. 209 (as *Le château de Doorwerth*);[1] unidentified collector (col-lector's mark, not in Lugt, lower right corner recto, blind stamp of right hand holding a hatchet, enclosed within a circle); an antique shop, New York; to {Hill-Stone Inc., New York} in 1980; sold to SCMA in 1986

EXHIBITION Northampton 1989, no. 44

Purchased
1986:29

Near Arnhem in the province of Gelderland, the Netherlands, is a thirteenth-century castle at Doorwerth (formerly Doornwerth).[2] Heavily damaged in World War II, the castle was in better condition in Jan Toorop's time. It had been bought in 1910 by General Major F. A. Hoefer, who undertook extensive restorations from 1910 to 1915. A pre–World War I photograph shows the castle much the way Toorop depicted it, with gate, drawbridge, moat, and tower (fig. 1). Toorop lived in Nijmegen near Arnhem from 1908 to 1916, when he could well have known General Major Hoefer.[3] After Toorop moved to The Hague in 1916, he returned and made sketches of several places in the neighborhood of Nijmegen. A small, signed watercolor of the castle, dated 1917, was included in an Amsterdam auction of 1926 (unfortunately not re-produced in the catalogue and not currently locatable).[4] Whether the crayon drawing was actually a study for the watercolor cannot be determined without further infor-mation, but several color notations on the SCMA draw-ing suggest that Toorop did intend to make a color ver-sion. While he did not often do drawings in preparation for paintings, a few pairs of drawings and paintings have been identified, and Toorop's correspondence with his wife makes occasional mention of such a practice.[5]

Toorop chose a vantage point on the walkway to the drawbridge, dominated by a striking tree whose arching branches fill the frame from left to right and top to bot-tom. Lozenge-shaped leaf patterns decorate the branches and the walkway. Behind the tree to the left the appara-tus for raising the drawbridge provides rigid, straight-lined contrast to the arcs of the tree branches, and the walkway with its curving fence helps to anchor the cen-tral position of the tree. Above the drawbridge, the wall of the building just above the window is marked *lucht* (sky), perhaps reminding the artist that the window should reflect the sky. The sloping roof to the right of this wall, with its dormer window, is marked *geel* (yel-low), and *lucht* appears again in a crotch of the tree. In the right-hand half of the drawing, where the architec-tural perspective is somewhat at odds with the left-hand side, the drawing remains less finished.

As a student at the Amsterdam Academy from 1880 to 1881, Toorop was trained in the close observation of nature. His line has a crisp, incisive quality, crackling with energy in its abrupt stops and starts and changes of direction, particularly noticeable in the tree branches. The limbs inscribe curves, yet the short jagged lines of which they are composed suggest brittle intensity rather than the flowing grace that marks many of Toorop's works of the 1890s. Always more comfortable with line than modeling, Toorop creates the shadowed angles and curves of the tree trunk by darkening his strokes and placing them closer together. The tree itself is darker than the architecture behind it, thus establishing it as the focal point. The slightly exaggerated expansiveness of the tree, moving from the center of the image into every corner, lends an expressive quality to the drawing.

Fig. 1. *Kasteel Doorwerth,* from A.I.J.M. Schellart, *Kastelen* (Deventer: Ankh-Hermes, 1975). Photo: Ger Dekkers

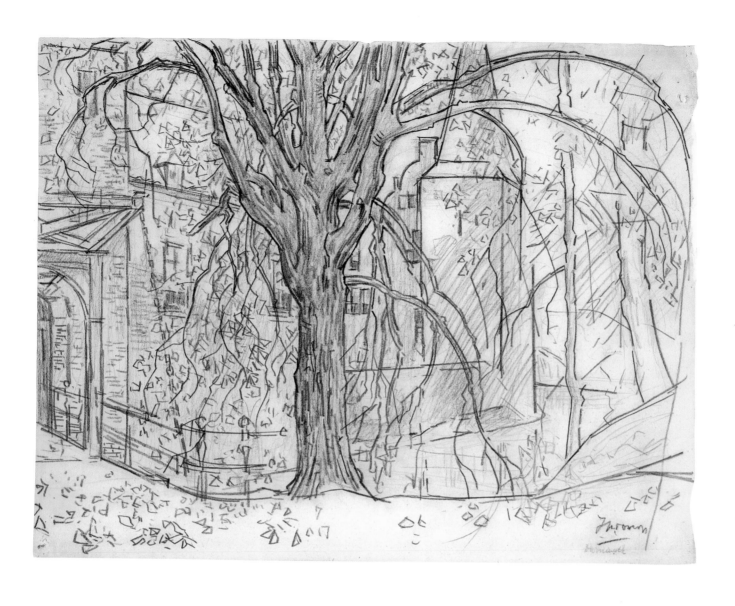

Fig. 2. Piet Mondrian, *Red Tree,* 1908. Oil on canvas, 70 × 90 cm (27½ × 39 in.). Haags Gemeentemuseum, The Hague, inv. 17-1933. © 2000 Artists Rights Society (ARS), New York / Beeldrecht, Amsterdam

Although Toorop worked in many styles, including Impressionism and Pointillism, he was regarded primarily as a symbolist artist and is best known for his symbolist works of the 1890s. He also incorporated some elements of modernism in his later work. The Toorop scholar Gerard van Wezel notes that stylistically the Smith College drawing could have been made in the same year as the watercolor of 1917.[6] Most of Toorop's works from about 1910 until his death in 1928 were drawings, in part for artistic reasons but also because physical handicaps increasingly limited his mobility and made oil painting difficult.[7] During this time, he focused primarily on portraits and landscapes and, having converted to Catholicism in 1905, on works with Christian themes, such as the design of a stained-glass window of Christ and the Twelve Apostles (1913–15) for Saint Joseph's Church in Nijmegen.[8]

Stylistically, the Smith College drawing contains both symbolist and modernist elements. Chief among its symbolist qualities is the creation of mood through stylization of forms (such as the long, drooping tree limbs) and the use of symbolic elements (such as falling leaves, often suggestive of death or transformation). Yet the symbolist qualities are considerably less pronounced than in Toorop's works of the 1890s, which were characterized by densely patterned, curvilinear forms and romantic subjects inspired by the works of the Pre-Raphaelites, Christian iconography, his childhood memories of Indonesia, and the writings of mystics and poets.[9]

Modernist influences can be seen in Toorop's efforts to use fragmented line and small broken planes in the tree, contrasted with the strong, planar surfaces of the architecture. Certain commonalities with Piet Mondrian's (1872–1944) tree series of 1908–10 (for example, *Red Tree,* fig. 2) are apparent. Like other Dutch symbolists, Toorop welcomed the movement toward abstraction. His interest had first been stimulated by his attendance at the less traditional Brussels Academy (1882–85) following his year at the Amsterdam Academy and then by his participation from 1884 to 1893 in *Les Vingt,* the Belgian group of influential avant-garde artists who promoted the works of impressionists Claude Monet (1840–1926) and Pierre-Auguste Renoir (1841–1919) as well as neo-impressionists Georges Seurat (1859–1891) and Paul Signac (1863–1935) and the symbolist Odilon Redon (1840–1916). From 1910 to 1915 Toorop organized summer exhibitions of modern French and Dutch art in Domburg, a vacation resort on the island of Walcheren in Zeeland frequented by artists such as Mondrian. In 1910 Toorop joined the Moderne Kunstkring (Modern Art Circle), which in 1911 and 1912 exhibited his work along with that of Mondrian, Paul Cézanne (1839–1906), Redon, Maurice Denis (1870–1943), Georges Braque (1882–1963), Pablo Picasso (1881–1973), and Fernand Léger (1881–1955). Toorop appreciated the cubist ideas represented in these exhibitions and spoke up in their favor at the opening in 1911, interpreting them as a spiritualized depiction of the material world and calling for common pursuit of "higher psychic expression."[10]

Let us then strive towards the highest psyche. . . .
Embody our work in a style, yet one that is extremely
simplified in straight or gently undulating, vertical or
horizontal lines. In style according with architecture!
In triangles, in the recent interesting efforts in Cubism
by the young Frenchmen. Let our work bathe in the
effects of contrasts and complementary colors, create
tone, seek architectonic mass color in large plane rela-
tions. Do all of this, yet honor pursuit of the psyche.
We must strive towards higher psychic expression —
spiritualization in the healthy, strong form.[11]

Although Toorop's drawing of the tree and castle does
not break new artistic ground, it does embody his notion
of striving for higher psychic expression. To his subject
he brings not only the expressiveness of his old symbolist
approach but also the structural restraint born of his late
years as an artist in a modernist art world.

NR

1. This drawing is listed in the sale (*Oeuvres par Jan Toorop*)
under "Diverses collections et successions." It is not reproduced
but is described as black chalk, signed and annotated *Doorwerth*,
framed and with approximately the same dimensions (345 × 450
mm) as the SCMA drawing. It remains uncertain if this sheet is
identical with the Smith College drawing. I am grateful to Gerard
van Wezel of Utrecht, who is preparing a catalogue raisonné of
Toorop's work, for drawing my attention to this listing.

2. I am grateful to J. W. Niemeijer of the Rijksmuseum,
Amsterdam, and Robert Siebelhoff, University of Toronto, for
their assistance in identifying this subject.

3. Robert Siebelhoff, letter to the author, 28 Sept. 1992, SCMA
curatorial files. For biographical information on Jan Toorop, see
Siebelhoff 1973, The Hague 1989, Paris 1977, Knipping 1948, and
Plasschaert 1925.

4. My thanks to Gerard van Wezel for informing me of these
other sketches of Nijmegen (letters to the author, 30 Jan. and
15 Feb. 1992; SCMA curatorial files). The watercolor was listed
as no. 31 in the sale (*L'Oeuvre de Jan Toorop, Diverses provenances
et successions*), Amsterdam, A. Mak, 21 Dec. 1926, described
as "Le château de Doorwerth, signée, datée et annotée 1917.
Doornwerth. Aquarelle encadrée, H. 10.5, L. 15.5."

5. Siebelhoff 1973, pp. 103–4.

6. Letter of 30 Jan. 1992.

7. The Hague 1989, p. 36.

8. Plasschaert 1925, fig. 35.

9. See, e.g., *The Three Brides* (pencil, black and colored crayon,
1893; Rijksmuseum Kröller-Müller, Otterlo, inv. 800.19, cat.
no. t47), reproduced in The Hague 1989, fig. 12.

10. See Van Adrichem 1992 for a well-researched discussion of
the introduction of modern art into Holland and the attitudes of
progressive Dutch artists including Toorop toward Cubism.

11. Jan Toorop, opening address at the Moderne Kunstkring
exhibition, Stedelijk Museum, Amsterdam, 6 Oct. 1911, reprinted
in *De Tijd*, 7 Oct. 1911; quoted in Van Adrichem 1992, p. 171 and
p. 171 note 34.

CHARLES BURCHFIELD
Ashtabula Harbor, Ohio 1893–1967 West Seneca, New York

57 *Freight Cars*, 1919

Brush with transparent and opaque watercolor on cream wove paper

Watermark: None

299 × 509 mm (11¾ × 20 in.)

Signed and dated recto, lower right, in graphite: *Chas E Burchfield — 1919—;* inscribed verso, at center, in graphite: *March 30, 1919*

PROVENANCE {Frank K. M. Rehn Galleries, New York}, as agent for the artist, between 1928 and 1929; to Jere Abbott (1897–1982), New York, in 1929; to Mr. and Mrs. Alfred H. Barr, Jr. (Alfred 1902–1981), New York, as a wedding gift (May 1930)[1]; gift to SCMA in 1970

LITERATURE Soby 1948, p. 24, repr. p. 27; SCMA 1986, no. 264, repr.

EXHIBITIONS New York 1929–30, no. 1; Northampton 1934, no. 3; Buffalo 1944, no. 18, pl. 9; Utica 1970, no. 534; Northampton 1979a; Northampton 1980, no. 32; Northampton 1983a, no. 31; Williamstown 1983, p. 42, no. 54, color repr.; Northampton 1986a, no. 9; Williamstown 1990

Gift of Mr. and Mrs. Alfred H. Barr, Jr., in honor of Jere Abbott 1970:13

Freight Cars, painted on 30 March 1919, comes from a transitional year in Charles Burchfield's early career shortly after his discharge from the army at Camp Jackson, South Carolina, in January of that year. Military service had been a very disorienting experience for him, and on his return home he found it difficult to paint. His work from 1919, done in spare hours outside of a full-time job, is marked by abrupt changes and discontinuities of style as, in his own words, he tried "desperately to get back into the intimate view of nature and her 'secrets.'"[2] He later destroyed many of his works from that year. A passage in Burchfield's journal of 22 March suggests in image-laden words the artist's dark mood at this time: "A dream — of wending along a row of hillocks running north half way between east & west; with portfolio; the way led down over a circular dam made of slippery moss-covered rocks. I started to cross, the water swirled about my feet, and it seemed as if the water leaping over the dam went down into some black subterranean passage."[3]

Burchfield's heartfelt connection with nature, evident throughout his career, began with his early years of walking and exploring the woods and farmland around the small town of Salem, Ohio, where his family moved from Ashtabula Harbor, Ohio, after his father's death in 1898. Year after year in his journal he recorded his ramblings out-of-doors and his efforts to record in his art the feelings nature inspired in him. Intimately woven into his views of the natural landscape are man-made elements — the Pennsylvania Railroad that ran through town, the factory buildings and small homes — but these are dominated by the elements of weather and light.

Freight Cars depicts a late winter scene in the back streets of the town. Two old freight cars and a telegraph pole shorn of its wires are pinned between a leaden sky and old, grimy snowdrifts before a row of nondescript houses. Pale smoke emerges from the house chimneys and one of the freight car stovepipes, the only signs of

human habitation. The drooping telegraph pole has strong expressive properties, but it is through the details of the natural elements — wintry light and snow — that the mood of the painting emerges most strongly. Prominently in the foreground Burchfield places old weeds and small rocks or perhaps trash, where these marks of late winter dominate the viewer's entry into the scene. The strongest textural point of interest is not a man-made structure but the heavy, dragging scallops of ice on the sides of the freight cars. These details provide an undercurrent of loneliness or darkness of mood. A roughening of the paint and paper texture in the sky at left draws attention to the other subtleties of tone and texture in the sky, further strengthening the power of the natural elements in this landscape to set the expressive tone. While Burchfield uses a striking array of hues — for example, blue, purple, brown, grey, pink, and green in the sky — the colors are muted and any element of sparkle in this wintry scene is suppressed.

The work is executed without a pencil underdrawing, in watercolor and gouache with broad, heavy strokes more typical of oil technique than watercolor. Whereas Burchfield worked occasionally with oils, primarily during the 1920s and 1930s,[4] he preferred the immediacy and spontaneity of watercolor. To achieve the effects he wanted, he turned in 1916 to using the stiff brushes more commonly associated with oil painting. In *Freight Cars,* the details are rendered gesturally with flicks and drags, for which the stiff brush would have been useful. The predominant technique is a layering of colors and strokes, with only occasional use of dry brush, blotting — effectively employed in the sky — and wet-on-wet technique.

During this transitional year of 1919, Burchfield produced work in diverse styles, moving among them with seemingly little order or progression as he tried to re-establish his artistic balance. Since graduating from the Cleveland School of Art in 1916, where he had studied

with Henry G. Keller (1870–1949), Frank N. Wilcox (1887–after 1962), and William J. Eastman (1881–1950), he had centered his efforts on finding graphic symbols and stylized conventions for the feelings he experienced in contact with nature. During his school years, he had found inspiration in the art of Chinese scroll paintings and Japanese prints, as well as the illustrations of Arthur Rackham (1867–1939), Ivan Bilibin (1867–1942), and Edmond Dulac (1882–1953). In 1916 and 1917 he filled sketchbook after sketchbook with outdoor studies. "Everything was first carefully drawn and outlined in pencil, then the colors filled in."[5] By 1919, although he still used pencil underdrawing from time to time, he had stopped using it as formally and often allowed spontaneity of brushwork to direct his hand. Several watercolors from that year, such as *Memory of a Dream* (painted on 15 March just two weeks before *Freight Cars*),[6] combine very broad brushstrokes, minimal detail, and mysterious settings with ambiguous spatial relationships to suggest the world of dreams. While ink and wash sketches such as *Ghost Town*[7] reflect in their linear qualities Burchfield's short-lived investigation of etching, undertaken at the suggestion of his former teacher Frank Wilcox, much of his work from 1919 was done in watercolor. It was a difficult year, and he reported that "by late spring the excesses of the late winter and early spring had left me stale and without purpose in my work.... I found myself unable to draw properly; it was as if I had to learn all over again."[8] At times, however, he felt his depression lifting, and some of his work late in 1919 (for example, *Flowerpot in Window*[9]) is more lyrical, with brighter colors and fewer linear distortions.

In *Freight Cars,* as in other works of 1919, the distortions of form are less exaggerated than in works of previous years such as *Old Barn* of 1918,[10] where the windows and doors suggest sad, almost weeping eyes and mouths, and the fields appear to writhe in sympathy. With *Freight Cars* Burchfield seems to have become more confident in his use of other artistic means to carry his emotional theme, using, for example, color and texture to call attention to the evocative wintry sky, and using the foreground to make the ugliness of late winter snow dominate the viewer's entry into the scene. Form is more solid, with the freight cars placed directly across the middle ground and the geometry of the rooftops in the background acting as foils for the expressive leaning of the telegraph pole and the scalloped ice on the cars.

While Burchfield continued to experience emotional ups and downs that year, works such as *Freight Cars* seem to have pointed the way to his next artistic phase, his style of the 1920s and 1930s, characterized by sober paintings of factories and towns in a solid and more realistic yet still highly expressive manner. In 1921 Burchfield moved to Buffalo, where he worked as a designer for a wallpaper factory, painting in his free time, until encouragement from a new dealer, Frank Rehn of New York, allowed him to quit his job in 1929 to paint full time. In the 1940s, feeling he had lost touch with the vital sense of intimacy with nature of his earlier years, he returned to landscape themes and a more calligraphic style using abstract patterning for expressive purposes.

Charles Burchfield played a significant role in developing watercolor as an independent medium in the twentieth century. His work was extensively shown, with solo exhibitions at Montross Gallery, the Frank K. M. Rehn Galleries, the Museum of Modern Art, the Fogg Art Museum, the Albright Art Gallery, and elsewhere. He also communicated his ideas through teaching summer and special courses at various institutions from 1949 to 1953. From his long career, beginning in 1915 (the year he felt he had made his first serious painting) and ending with his death in 1967, more than 1,500 works survive, testifying to his lifelong fascination with rendering the inspiration of the natural landscape.

Burchfield's work has often been interpreted as regionalism, and indeed images such as *Freight Cars* record aspects of midwestern industrial towns. But he described his aim differently: "While I feel strongly the personality of a given scene...my chief aim in painting it is the expression of a completely personal mood."[11] In 1945, looking back on his work, he wrote, "It seems to me that thru all my work there has been the romantic trend, more obvious perhaps in the early years, but never lost sight of. The difference between the periods is in the form rather than the subject matter."[12]

Jere Abbott, the founding associate director of the Museum of Modern Art in New York, purchased *Freight Cars* in 1929 and gave it as a wedding present the following year to his friend and colleague Alfred H. Barr, Jr., director of MoMA. Forty years later the Barrs presented the watercolor to SCMA in honor of Abbott, who served as the museum's director from 1932 to 1946.

NR

1. The drawing's old paper frame backing is inscribed at center, in graphite (in Abbott's hand): *To Alfred and Marga / with Love. / Jere. / 1930 / NYC;* and in another hand (A. or M. Barr?) at lower right, in graphite: *Exhibited: Museum of Modern Art / Paintings by Nineteen Living* [paper torn] / *1929 / Smith College Museum of Art, 1934 / From Frank K M Rehn Gallery 1929 / Collections: Jere Abbott 1929–1930 / A. H. B. Jr. 1930–.*

2. Charles Burchfield, "Autobiography Supplement," p. 5 of the MS written for John I. H. Baur, Whitney Museum of American Art, quoted in Baur 1982, p. 92.

3. Quoted in Townsend 1993, p. 114.

4. See Baur 1982, pp. 157–62, for a discussion of Burchfield's oil paintings.

5. Utica 1970, p. 37, quoting from Burchfield's journal.

6. Columbus 1997–98, color pl. 52 (collection of Burchfield-Penney Art Center, Buffalo State College, Buffalo, N.Y.).

7. Baur 1982, fig. 70 (in the collection of Kennedy Galleries).

8. Quoted in Tucson 1965–66, p. 25.

9. Columbus 1997–98, color pl. 8 (private collection).

10. New York 1985, fig. 25 (private collection).

11. Burchfield 1945, foreword, [p. 2].

12. Ibid.

PAUL KLEE

Münchenbuchsee, Switzerland 1879–1940 Muralto-Locarno, Switzerland

58 *Singer (Sängerin),*[1] *1919*

Brush and watercolor and oil transfer with touches of pen and black ink on cream laid paper laid down on smooth beige wove mount

Watermark: Van Gelder

Image: 193 × 200 mm (7⅝ × 7⅞ in.); mount: 225 × 232 mm (9 × 9⅛ in.)

Signed recto, lower right, in pen and black ink: *Klee;* dated and inscribed by the artist, on recto of mount, lower left, in pen and black ink: *1919 211. Sängerin;* inscribed, on recto of mount, lower left, in graphite: *S. Kl*

PROVENANCE The artist until his death (1940); to his widow, Lily Klee (1876–1946), Bern, in 1940; to Klee-Gesellschaft, Bern, in

1946; to {Buchholz Gallery (Curt Valentin), New York} in 1949 as agent; to Sigmund W. (1901–1977) and Maxine (1903–1978) Kunstadter, Chicago, in 1950; to the estate of Mrs. Sigmund W. Kunstadter; gift to SCMA in 1978

LITERATURE None

EXHIBITIONS Northampton 1984a; Northampton 1984b; Høvikodden/Paris 1985–86, no. 5, repr. (Høvikodden) and no. 8 (Paris); Northampton 1987a

Gift of the Estate of Mrs. Sigmund W. Kunstadter (Maxine Weil, class of 1924)
1978:56-108

For Klee, music was as natural a part of his life as art. The son of two musicians, Klee early became an accomplished violinist, performing in local orchestras in Munich (1898–1901) and Bern (1902–6) and in informal chamber-music groups throughout his life. He had a thorough understanding of music history and theory and wrote music criticism for newspapers.[2] Many of his works depict subjects associated with music, such as musicians, musical instruments, musical notation, and theatrical performances.[3] Connections between Klee's art and music also exist on a deeper level in the more abstract qualities of the two art forms. On one level *Singer* is about a solitary vocalist on a stage, accompanying herself on a keyboard instrument; on another level it can be seen as a musical analogy describing complex artistic and creative issues with which Klee was occupied.

Within a shallow, cubist space, this drawing depicts two musical "instruments" — human voice and keyboard — in a schematic way that reveals their inner workings. The wires and stops of the keyboard instrument, its mechanics of tone production, are prominently displayed, while arrows and symbols diagram the internal physics of the singer's voice and perhaps the mental and auditory processes involved as well. Arrows point into and out of the singer's throat, and leverlike lines in her chest seem to connect with notes emerging from the top of her head; a treble clef adorns her ear. The diaphragm — marked β'— pushes the tone upward, until it emerges from the mouth. Other mechanisms of voice production are marked a, c, and α', suggesting both the standard musical pitch notations for different octaves as well as markings on a physics diagram. The setting appears to be a stage, with curtains loosely hooked back, but the singer's nudity and look of surprise suggest that this is not a normal public performance.

Singer derives from an earlier pencil sketch (fig. 1)[4] that Klee transferred using the oil transfer process he had

developed early in 1919. This involved coating a sheet of paper with printer's ink, and when it was sufficiently dry, placing it between the original drawing and a fresh sheet, then tracing the drawing with a stylus. Klee used this

Fig. 1. Paul Klee, *The Singer,* 1919. Graphite, 280 × 215 mm (11¹/₁₆ × 8⁷/₁₆ in.). Private collection, Switzerland. © 2000 Artists Rights Society (ARS), New York / VG Bild-Kunst, Bonn

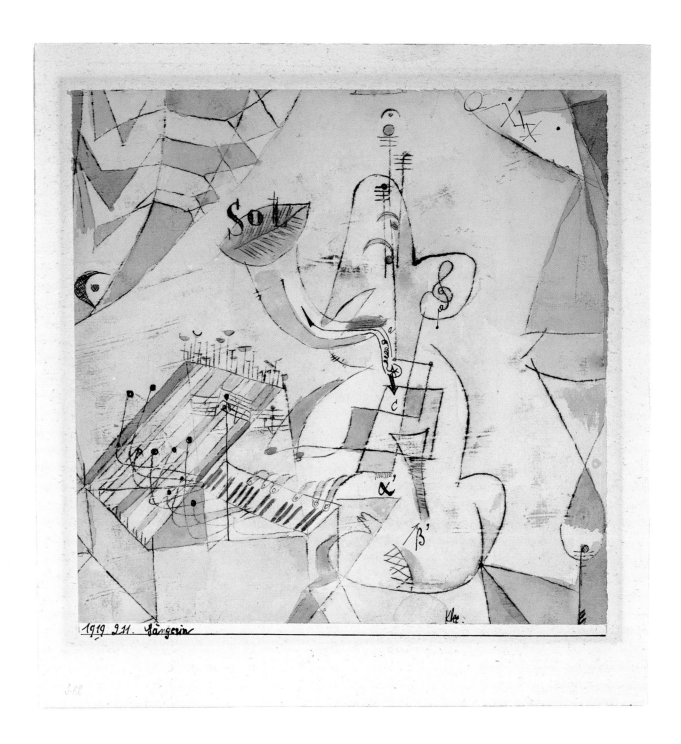

process only with simple linear drawings, without hatching or shading. The pressure of his hand often resulted in smudged or shadowy areas, and before or after the transfer (after, in the case of *Singer*), he added areas of watercolor.[5] In *Singer*'s transformation from pencil drawing to watercolor and oil transfer, Klee omitted some details and added or emphasized others. With pen and black ink, for example, he enhanced the heads and stems of the musical notes where the oil transfer was faint and added new details such as the arrows and symbols and piquant

touches of pink watercolor on the upper lip and breasts. Bars of color on the lid of the keyboard suggest sets of chords or harmonies. Klee also focused attention on the performer by cropping the composition on all four sides.

The tone of the SCMA drawing is satirical and somewhat crude. The singer's grossly exaggerated breasts gravitate toward the keyboard as if their nipples were eyes. A garter encircles her fleshy thigh, and at her nether end, a triangular burst of color suggests that a breath has passed through her diaphragm and is departing as a fart. The

original sketch is less subtle: the presence of two doglike creatures accentuates the fart, and the singer's upper lip and chin are distinctly hairy, while her head is bald.

The shape emerging from the singer's mouth like an exaggerated trumpet bell and ending with the oval form that Klee often used to depict leaves of plants is inscribed *Sol,* suggesting both the sun, the source of energy for all plant life, and sol, the fifth, or dominant, tone in the musical scale. In the preliminary sketch, Klee alludes more literally to the natural world by means of the doglike creatures, the moon, and the stars.

In 1918, the year of his discharge from the German army and the beginning of a period of concentrated, very productive work before his years of teaching at the Bauhaus (1920–31), Klee wrote a brief "Creative Credo" outlining his theory of art.[6] Beginning with his famous statement, "Art does not render the visible, but makes visible," he went on to give examples of pictorial themes, couching them in terms of biological processes:

An apple tree in blossom, the roots, the rising sap, the trunk, a cross section with annual rings, the blossom, its structure, its sexual functions, the fruit, the core and seeds. An interplay of states of growth.

A sleeping man, the circulation of his blood, the measured breathing of the lungs, the delicate function of the kidneys, in his head a world of dreams, related to the powers of fate. An interplay of functions, united in rest.[7]

Singer, created a year later, depicts such a pictorial theme, "making visible" the process of creating music. With its interweaving of physical mechanisms, inspirational sources, and forces of nature, the image presents a statement about the complexity of the creative process.

Klee often looked to music for analogies to artistic principles. Andrew Kagan notes that Klee felt called on to discern and state the underlying tectonic laws of visual art, as musical scholars had done for eighteenth-century polyphonic music.[8] Klee believed that visual art should be "absolute," that is, created and valued as non-representational or abstract in the way that music, freed of the obligation to describe human emotions or daily events, was appreciated for its abstract elements of form.[9] Line and color could be freed from their traditional descriptive roles in part by separating the functions of line and color from each other. Klee's oil transfer technique was one way of separating (and then reintegrating) the functions of line and color by the simple physical means of independently layering them. In *Singer* this is further symbolized through the image of the musician, who in a single performance masters two musical instruments — the voice, capable of singing but one note at a time, and thus producing melodic line, and the keyboard, playing multiple notes, and thus producing harmony, or the musical equivalent of color.

A more literal link between music and art in this drawing may reside in the keyboard instrument itself with the bars of color on its lid. Since the eighteenth century, inventive instrument makers in Germany, England, and elsewhere had produced "color organs," musical instruments that displayed an array of colored lights corresponding to the notes being played, creating color harmonies that corresponded to musical harmonies and intriguing performers and audiences with the possibilities of synaesthesia, the integration of music and color.[10]

Specific evidence as to the extent of Klee's knowledge of these instruments remains to be discovered. However, as a well-read individual who had a highly developed sense of the connections between art and music, Klee is likely to have been aware of these experiments, since they were widespread and well publicized in Europe and the United States. According to the musicologist Kenneth Peacock, the keyboard instrument in the Smith College drawing does not appear to be a rendering of a specific color organ in existence by 1919, although it is similar to several proposals for such instruments. It seems more likely that the drawing depicts a "fantasy" instrument of Klee's own devising.[11]

Given the complexity of the relationships "made visible" in this drawing between nature and art, music and art, and line and color, it is not surprising that Klee annotated this work *S. Kl,* an abbreviation for *Sonderklasse* (special class), his designation for works that he felt marked significant steps in his artistic development.[12] Not only did he keep this work in his possession throughout his life, but his wife, Lily, retained it until her death in 1946.

NR

1. Klee 1919, no. A211, gives the title as *Sängerin am Klavier,* while the title inscribed on the drawing itelf is *Sängerin* (as on the preparatory drawing for which see fig. 1 and note 4 below).

2. For details of Klee's background and activities in music, see Verdi 1968, pp. 81–82; Kagan 1983, pp. 20–26; Grohmann 1954, pp. 379–80.

3. See Grohmann 1954, pp. 245–48, on the large group of "theatrical pictures," including operatic, comedy, and marionette subjects, from 1921 to 1925, Klee's years at the Bauhaus in Weimar.

4. This drawing (signed, recto, upper right: *Klee 1919*) is inscribed below the image, *1919/254, Zeichnung zu dem Aquarell "Die Sängerin (1919/211) [Drawing for the Watercolor "The Singer"].* The numbers 1919.254 and 1919.211 refer to Klee 1940, where drawings and watercolors are listed separately.

5. See Glaesemer 1973, p. 260.

6. Spiller 1961, pp. 76–80. "Creative Credo" was first published in Edschmid 1920.

7. Spiller 1961, p. 79.

8. See Kagan 1983, pp. 38–93.

9. Ibid., pp. 29, 33–34.

10. The best-known nineteenth-century color instrument was Alexander Wallace Rimington's invention, patented in England in 1893 and described in *Colour Music: The Art of Mobile Colour* (Rimington 1911). Alexander Scriabin wrote a color-symphony, *Prométhée: Le Poème du feu,* in 1911, which involved projected light.

11. For a brief introduction to color organs and synaesthesia, see the article "Colour Organ," pp. 447–48, in vol. 1 of Sadie 1984; Peacock 1988; and Peacock 1991.

12. New York 1977, p. 9.

PAUL NASH
London 1889–1946 Boscombe

59 *Littlestone*, 1919–20[1]

Pen and black ink, brush and watercolor (with black ink washes?), with blue pencil and black crayon over graphite on smooth white wove paper; laid down on a smooth beige wove mount

Watermark: None

Sheet: 237 × 301 mm (9⁵⁄₁₆ × 11¹³⁄₁₆ in.); mount: 318 × 460 mm (12½ × 18⅛ in.)

Signed recto, lower right, in pen and black ink: *Paul / Nash;* inscribed on recto of mount, down left side, in graphite: *neutral / warm tint / ple mauve paling / ochre sand / ple pink / mauve / shingle / ple E r__ / grey ___*

PROVENANCE Margaret Nash, the artist's widow; to {Leicester Galleries, London}; to SCMA in 1952

LITERATURE Causey 1980, p. 115, no. 261, pl. 131

EXHIBITIONS Possibly London 1920, no. 55; Oxford 1931, no. 9; London 1952, no. 13 (as *Littlestone, Dymchurch*, 1921); Northampton 1958c, no. 42

Purchased
1952:60

Born in London on 11 May 1889, Paul Nash became one of the leading British artists of the period between the two world wars. Having studied briefly at the Slade School, he had his first one-person show at the Carfax Gallery in 1912. Two years later, with the outbreak of World War I, he enlisted in the army. Injured in the Ypres Salient and sent home in May 1917, he returned to the front in October as a war artist. He was discharged in February 1919. Later that year Nash visited Dymchurch on the coast of Kent to consult on a design project. In 1921 he and his wife, Margaret, moved there while he was recovering from a breakdown, brought on in part by his wartime experiences. They stayed in the area for four years. Nash's highly personal interpretation of landscape earned him early recognition, and he was a key figure in the surrealist movement in Britain. During World War II he served again as a war artist. He died on 11 July 1946 in a seaside town in Hampshire.

Nash's treatment of landscape was not topographical or descriptive but one that sought to get behind the particulars of a place to express its essence or spirit — its *genius loci*—through a stylized rendering of forms and a symbolic use of elements. In this respect, his artistic predecessors were William Blake (1757–1827) and Samuel Palmer (1805–1881). In his posthumously published autobiography he commented on his approach: "It was always the inner life of the subject rather than its characteristic lineaments which appealed to me. . . . The secret of a place lies there for everyone to find, though not, perhaps, to understand."[2]

The four years Nash spent in Dymchurch were very important for his development. As Andrew Causey has noted, "Of the places where Nash worked in the ten years after the war only Dymchurch on the Kent coast, with its vast length of wall built to protect Romney Marsh from flooding by the sea, touched Nash's imagination."[3] By 1925 the area no longer held any interest for the artist; however, the paintings and watercolors Nash produced of Dymchurch and the surrounding region

between his first visit in 1919 and his departure in 1925 represent an especially potent group of images. Stark and haunting, often devoid of human beings but usually showing the impact of man on his surroundings, these depictions of the shore and marshland reflect Nash's contemporary involvement with the theater and his recollection of the devastation of war.[4]

Since *Littlestone* is the product of an early visit, before Nash lived in Dymchurch,[5] it is among the first works showing his response to the area. The subject is a small town on the Kent coast, about twenty miles southwest of Dover and just below Dymchurch. At a distance from the vast breakwater in front and serving as a kind of backdrop for the scene, the town looms like a ghostly citadel over a beach studded with palings that not only protect the shore from the onslaught of the sea but, like barbed wire in a no-man's-land, impede movement across the intervening space. In this view, Littlestone seems more ephemeral than attainable.

Stopped by the lines of wooden stakes running parallel to the picture plane, the viewer is forced to look up at the distant town from a low perspective. The mauve buildings, abstracted and flattened, seem to float like a mirage above the pastel land and sea. A yellow sky streaked with purple and blue adds to the visionary quality of the image. The visual conflict between the seductive colors and the hostile stakes produces an effect similar to that found in Nash's contemporaneous images of war-torn fields, in which the rhythmic disposition of shattered tree trunks intensifies the feeling of desolation (fig. 1).[6]

In his autobiography Nash remarks on how the family garden at Iver Heath in Buckinghamshire took on an unreal beauty in certain kinds of light. "It was this 'unreality,' or rather this reality of another aspect of the accepted world, this *mystery of clarity* which was at once so elusive and so positive."[7] It is the light and its way of shaping form and heightening color that give *Littlestone* both its mystery and its beauty.

EJN

Fig. 1. Paul Nash, *We Are Making a New World,* 1918. Oil on canvas, 71.1 × 91.4 cm (18 × 36 in.). Imperial War Museum, London

1. "Margaret Nash dated the picture 1921 and 1922, but it was catalogued for the OAC [Oxford Arts Club] in 1931 as 1919" (Causey 1980, no. 261); Causey accepts the date of 1919 on stylistic grounds, but in his exhibition history he also states that the work was shown in October 1920 at the London Group. The inscription in brown pencil on the fragment of an old mat or mount preserved in the SCMA curatorial files *(Littlestone 1920 / *May be exhibited)* may have been added at the time of the London show in 1920. See Causey's remarks for a related watercolor, *The Sands* (no. 274, pl. 132).

2. Nash 1949, p. 36.

3. In London 1975, pp. 17–18.

4. Causey 1980, p. 120.

5. See note 1.

6. For example, see also *The Menin Road* (1918–19) and *Void of War* (1918), both, Imperial War Museum, London. Cardinal 1989, pp. 33–34, discusses the Dymchurch images and their relation to Nash's war experiences.

7. Nash 1949, p. 107, emphasis added.

PIET MONDRIAN (PIETER CORNELIS MONDRIAAN)
Amersfoort, the Netherlands 1872–1944 New York

60 *Chrysanthemum,* c. 1921–25
Verso: *Friedel M. Cabos-de Fries,* 1924, study for the painting
Portrait of Friedel M. Cabos-de Fries (1924)

Black and brown chalks with stumping on grey laid paper

Verso: Black chalk

Watermark: Indecipherable

629 × 384 mm (24¾ × 15⅛ in.)

PROVENANCE Gift of the artist to Wobine (Wobien?) de Sitter (1876–1958), Domburg, the Netherlands, after 1924; gift to her grandniece Eleanor Kanegis {Eleanor Kanegis Inc.}, Boston, in 1957; sold to SCMA in 1963

LITERATURE Hill 1966, pp. 27–30, fig. 9 (recto); Welsh 1966, pp. 132–35, fig. 3 (recto); Mongan 1969, pp. 229–30, fig. 5 (recto), p. 229 note 13 (verso); AFA 1970–72, [p. xv], fig. 26 (recto); Sim-mons 1977, fig. 4.14 (recto); Leslie 1980, fig. 4.2 (recto); SCMA 1986, no. 261, repr. (recto and verso); Sutton 1986, p. 209, fig. 303 (recto); Edwards 1987, fig. 4-1 (recto); Neet 1987, p. 295, fig. 17 (recto); Nilsson 1991, repr. p. 26 (recto); Shapiro 1991, repr. p. 10 (recto); Goldstein 1992, p. 204, fig. 8.4 (recto); Mondrian 1993, no. 51, repr. (recto); Joosten 1998, nos. C62, repr. (recto) and C29 (verso)

EXHIBITIONS Northampton 1963 (recto); South Hadley 1968 (recto); Hartford 1975 (recto); Northampton 1979b, no. 165 (recto); Northampton 1984a (recto); Amherst 1990a (recto); Montreal 1995, no. 279 (recto and verso), figs. 359 recto and 359 verso

Purchased
1963:51 a (recto), b (verso)

Piet Mondrian is best known for his abstract geometric grid compositions, yet a large part of his oeuvre consists of representational works — landscapes, seascapes, and more than 250 flower studies, mostly of single flowers, with chrysanthemums being the most frequently depicted species.[1] This expressive chalk drawing of a chrysanthemum, with a portrait of a young woman on the reverse, was purchased by the museum from the Boston dealer Eleanor Kanegis, to whom it had been given by her great-aunt Wobien de Sitter of Domburg, the Netherlands. De Sitter was a friend and early patron of Mondrian, who from 1908 to 1914 frequented the artists' colony and vacation resort at Domburg on the island of Walcheren in Zeeland. For reasons discussed below, it is likely that the drawing was executed in the early 1920s before Mondrian's abstract works had begun to sell, when paintings and drawings of flowers were a means of support for the artist, even though he had turned away from naturalistic studies as his artistic goal.

The chrysanthemum drawing displays its creator's intense interest in and respect for nature. Drawn in black chalk with touches of brown chalk and many areas of rubbing and alteration, each petal and leaf of the flower has been closely observed and recorded. Despite being past its prime, the chrysanthemum has a distinctly erect posture and a certain fortitude. The outlines are strong and crisp, and the transitions from one tonal value to another are sharp and distinct. Details of texture lend vigor to this dying flower; the lines forming the petals, made of deep, intense blacks and velvety dark greys, swirl and twist as if alive, and the crosshatched markings on the leaves take on a life of their own, abruptly changing direction with each change in planar facet.

The way *Chrysanthemum* is drawn reveals the hand of an artist versed in principles of abstraction. For Mondrian, a key issue was equilibrium, the balancing of vertical and horizontal forces, which he expressed in his abstract paintings by means of carefully organized relationships between squares and vertical and horizontal lines. The SCMA *Chysanthemum,* its top-heavy head poised on a slender vertical stem punctuated with horizontal leaves, achieves equilibrium, although the slightest change might alter this balance. The tendency to minimize three-dimensionality can be seen in the way Mondrian makes the leaves into intricate mosaics of facets, nearly dissolving the notion of "leaf" as an object with three-dimensionality. The flower is also portrayed without a defined setting or space; it simply floats.

Mondrian often made several versions of a flower study — a drawing and one or more paintings based on a tracing of the drawing. An oil painting in the Eugene and Clare Thaw Collection (fig. 1) repeats the Smith College drawing very closely in size, outline, and form.[2] The crosshatched leaves are translated into shades of blue, and the intense tonal values of the petals emerge as beige, pink, and rose hues set off by black outlining. A bluish white surround seems to exist not so much as background but as a matrix within which the flower is embedded in momentary balance. The bottom of the stem is extended slightly downward in a pale blue so that the flower seems to stand on a single, precarious toe. In some ways the painting, in comparison with the drawing, softens the evidence of Mondrian's abstract concerns. The planar faceting of the leaves, for example, so obvious in the chalk version, is muted in the painting; the equilibrium seems more dynamic in the black-

and-white flower with its darker, heavier head and shorter stem.

Wobien de Sitter, in a letter to her grandniece Eleanor Kanegis, describes both the chrysanthemum drawing and an earlier work:

> One is [a] little oil painting, c. 40 × 40 cm, a half-finished sketch of some white irises. It is a very old one, he gave it to me before he ever dreamt of abstract painting. The other is later, a coal drawing of a chrysanthemum. In the times when he could not yet find buyers for his abstract paintings, he made some very articulate flowers as a sort of study, very beautiful conscientious work, with the intention of fabricating cheap little watercolors after them for sale. This is one such a model-flower.[3]

Mondrian's sensitivity to the natural world, so evident in his flower studies, has often been noted and sometimes puzzled over, given his later nonrepresentational work. As a student, Mondrian had been taught in the tradition of Dutch still-life painting and in the conservative impressionistic landscape style of the Hague school at the Academy of Fine Arts in Amsterdam, which he attended from 1892 to 1897. Among his early works was a study of a single chrysanthemum, given to Queen Wilhelmina of Holland on her marriage in 1901. But his interest in representational subjects soon became a study of their underlying form. Looking back, he remarked in 1941, "I enjoyed painting flowers, not bouquets, but a single flower at a time, in order that I might better express its plastic structure."[4] As his ideas about art crystallized, he no longer considered such subjects appropriate to his true work; his change to abstraction did not, however, reflect a negative feeling toward nature. Charmion von Wiegand, who knew Mondrian in his New York days, wrote, "Years before, he said, he had come to the conclusion that art must be detached from the natural world. It was not, as had been written of him, that he did not love nature, . . . but he felt nature's multiplicity and brilliance could never be successfully transposed on canvas."[5]

The relationship of Mondrian's flower studies to his abstract work, and in particular the dating of his flower studies, has been the subject of some discussion.[6] The Smith College drawing was initially assigned a date of 1906–9, that is, before his turn toward abstraction, but a dating in the early 1920s seems to be more defensible on stylistic grounds. Mondrian's first efforts in a cubist style occurred about 1912, when he moved to Paris and saw the works of Georges Braque (1882–1963) and Pablo Picasso (1881–1973) for the first time. In his famous tree studies from 1908 to 1913, naturalistic tree forms gradually became abstract compositions. During World War I, he returned to Holland, consolidating his ideas and developing a style consisting of short horizontal and vertical lines and then of colored rectangles. He described his aesthetic credo as "Neo-plasticism," believing that art should deal with abstract form rather than representation. After helping to found the Dutch De Stijl move-

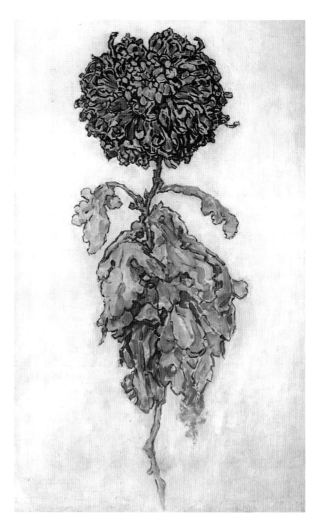

Fig. 1. Piet Mondrian, *Chrysanthemum,* 1906. Oil on canvas, 65.3 × 41.2 cm (25¾ × 16¼ in.). Eugene and Clare Thaw Collection. © 2000 Artists Rights Society (ARS), New York / Beeldrecht, Amsterdam

ment, which was based on these ideas, in 1919 he returned to Paris. In the early 1920s Mondrian began producing the canvases for which he is best known, in which only vertical and horizontal black lines, planes of pure primary colors, and planes of "non-color" (white, black, and grey) are used. In 1941, describing his turn toward abstraction, Mondrian wrote,

> Impressed by the vastness of nature, I was trying to express its expansion, rest, and unity. At the same time, I was fully aware that the visible expansion of nature is at the same time its limitation; vertical and horizontal lines are the expression of two opposing forces. . . . I recognized that the equilibrium of any particular aspect of nature rests on the equivalence of its opposites. . . . [I then became conscious] that reality is form *and* space. . . . Art has *to determine space as well as form* and to create *the equivalence of these two factors.*[7]

The Smith College *Chrysanthemum* demonstrates artistic concerns that are identifiable with this abstract period.

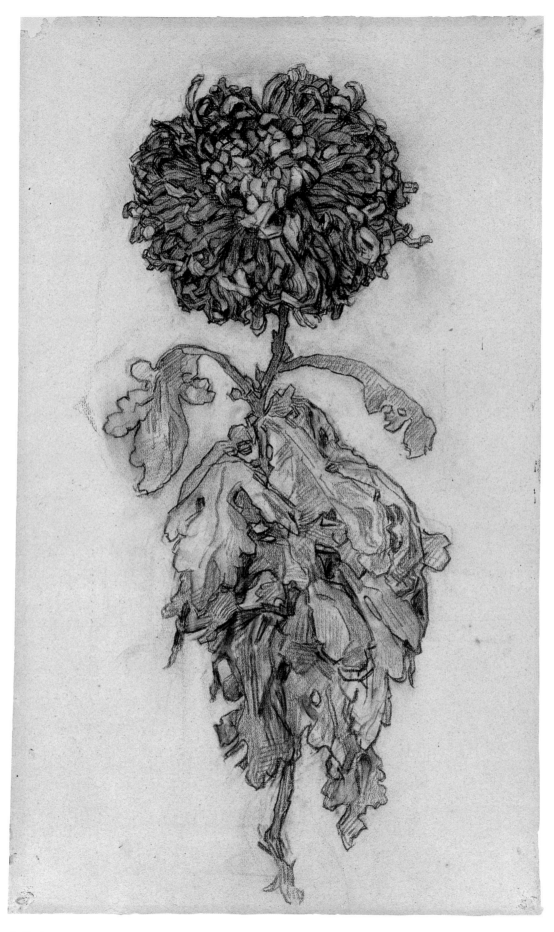

60 Recto

60 Verso

238 PIET MONDRIAN (PIETER CORNELIS MONDRIAAN)

Fig. 2. Piet Mondrian. *Portrait of Friedel M. Cabos-de Fries,*
1924. Oil on canvas, 57 × 45 cm (22½ × 17¾ in.). Private
collection. © 2000 Artists Rights Society (ARS), New York /
Beeldrecht, Amsterdam. Photo: Courtesy of Sotheby's, London

at least one portrait, that of Friedel M. Cabos-de Fries (1893–1988), for which the drawing on the verso of *Chrysanthemum* is a study (fig. 2).[10] Cabos-de Fries had met Mondrian in the early 1920s when she was on a trip to Paris with her husband, who was in the circle of the De Stijl architect J. J. P. Oud.[11] The SCMA drawing depicts a young woman wearing a loose, smocklike blouse and staring soberly at the viewer with wide-open eyes; her intensity is enhanced by strokes of softly rubbed chalk radiating about her head. In the painting, the presentation is more geometric and frontal, the fullness of the face transformed into a perfect oval above a cylindrical neck and lozenge-shaped neckline. Mondrian's correspondence documents that in November 1923 he was considering whether to undertake a portrait commission (presumably that of Cabos-de Fries).[12] In late August the following year he wrote from Paris that he was at work on the portrait of Cabos's wife "after a drawing I made here."[13] On New Year's Day 1925 Mondrian recorded his dissatisfaction with this work. "Those people of the portrait were here, and I finished that nasty job yesterday. . . . They are pleased; I'm not. Oh well, the things you have to do for money!"[14] Not long after, he wrote, "I don't make any more portraits. Cabos talked me into it at the time and he was pleased, but I find it too hard to do and I am not pleased."[15] While Mondrian did continue to do occasional flower pieces after this time, his abstract work finally began to sell, and he was at last able to turn all his efforts in that direction.

NR

The inscription of *1906* on the Thaw painting must, of course, be considered in dating the drawing, but as Agnes Mongan noted, "The artist himself is not always to be relied upon in his own dating. Many things were dated years after their creation. Some flowers drawn in the first decade were, it seems, not signed or dated until his arrival in New York in 1941. Sometimes he appears to have forgotten the exact year or the precise progression. Occasionally, he dated a finished watercolor earlier than its preparatory drawing."[8] Joop Joosten suggests that the 1906 inscription on the Thaw painting was added at the time of Mondrian's exhibition at the Valentine Gallery in January 1942:

> Mondrian brought four chrysanthemum paintings with him to New York, three of them signed and dated in his typical New York handwriting "PM 1906." . . . To me, all four paintings are done in the twenties in Paris. According to the catalogue, Mondrian must have intended to make from his first American show a kind of retrospective. Not having works with him from his pre-cubist period except the two drawings of a nude, Mondrian relied on these late-naturalistic works as quite suitable replacements.[9]

From 1921 to mid-1925 Mondrian's financial circumstances were strained, and he reluctantly turned to doing commercial work, primarily flower studies but also

1. For color images of Mondrian's flower studies, see Shapiro 1991.

2. See Joosten 1998, no. C64.

3. Undated letter, postmarked 1957 (SCMA curatorial files).

4. From his essay "Toward the True Vision of Reality" (1941), translated in Mondrian 1993, p. 341.

5. Von Wiegand 1961, p. 58.

6. See, e.g., Welsh 1966, Mongan 1969, Neet 1987, Shapiro 1991, and Blotkamp 1995, pp. 43–47.

7. "Toward the True Vision of Reality," translated in Mondrian 1993, p. 339.

8. Mongan 1969, p. 229.

9. Letter of 25 Feb. 1992, to the author (SCMA curatorial files). I am grateful to Joop Joosten for sharing his thoughts on the SCMA *Chrysanthemum* and confirming my identification of the portrait on its verso. His conclusions are published in Joosten 1998, pp. 472–73 and 481.

10. See Joosten 1998, no. C30 as well as the discussion in Welsh 1973, p. 359. This painting was in the possession of the heirs of M. F. Wibaut-de Fries and was offered (but not sold) in the sale London, Sotheby's, 29 June 1999, no. 176, color repr.

11. Letter, 5 Jan. 1992, from Robert P. Welsh to the author (SCMA curatorial files).

12. Joosten 1998, p. 472, quoting a postcard of 11 Nov. 1923 to Oud.

13. Ibid., quoting a letter of 29 Aug. 1924 to S. B. Slijper.

14. Ibid., quoting a letter of 1 Jan. 1925 to C. Van Eesteren.

15. Ibid., quoting a letter of 10 March 1925 to S. B. Slijper.

YASUO KUNIYOSHI

Okayama, Japan 1889–1953 New York

61 *Three Cows and One Calf,* 1922

Pen and dry brush with black (India) ink over graphite with scraping on cream wove paper

394 × 572 mm (15½ × 22½ in.)

Watermark: *N 1920 ENGLAND B* [Whatman]

Signed and dated recto, lower right, in pen and black ink: *YASUO KUNIYOSHI/22*

PROVENANCE Philip L. Goodwin, New York, by 1947;[1] gift to SCMA in 1953

LITERATURE SCMA 1986, no. 266, repr.; Ozawa 1991, fig. 6

EXHIBITIONS New York 1923, no. 17 (as *Three Cows with Only One Calf*); New York 1942–43 (possibly exhibited as a lithograph); New York 1948a, no. 90 (as *Three Cows and Only One Calf*); Troy 1960; Northampton 1974c; Northampton 1979b, no. 171; Northampton 1980, no. 23; Northampton 1987c; Kyoto 1989–90, no. 12, repr.; Amherst 1990a; Fort Worth 1996–97, p. 29, pl. 23

Gift of Philip L. Goodwin
1953:6

The cow was so frequent a motif in Kuniyoshi's early work that critics initially responded to the artist as a humorist. Kuniyoshi, however, attributed this affinity to his observation of the animals during the summers he spent in Ogunquit, Maine, at the rural home of his first patron, Hamilton Easter Field, as well as to the fact that, according to the traditional Japanese calendar, he (the artist) had been born in the Year of the Cow. Fascinated with the irregular shapes of the animals, he depicts them in the SCMA drawing with humor rather than sentimentality, contrasting bowed ribcages with upwardly rocketing hindquarters, supported by impossibly tiny feet. The placid stares of these animals are the more striking because of the undignified proportions of their bodies. Thin, delicate lines undulate and curve gracefully around the cows' chests and shoot abruptly along their backs, contrasting with heavy, dark tonal areas. The grasses and flowers loom larger than life, a stalk of Queen Anne's lace dwarfing the miniaturized calf. As in most of his early work, Kuniyoshi sets naturalism aside in this drawing, creating a small fantasy world. There are no shadows, and within the upwardly tilted picture plane, the objects are ambiguously positioned in relationship to one another and within space, suggesting the floating world of memory or dreams.

Like many of Kuniyoshi's drawings, *Three Cows and One Calf* was intended as an independent work of art. He viewed drawing as "an independent creation, an intimate expression almost always freer and less self-conscious. It requires infinitely more knowledge to produce a drawing, which in itself speaks as eloquently as a painting, without relying on color.... I believe in treating a drawing in the same way I do a painting."[2]

He used a variety of techniques, beginning first with the barest of outlines in pencil, followed by India ink and a fine-point pen. He then used brush and ink for areas of tone, scraping some of the inked areas to create texture or to pick out details such as the spines and wrinkled necks of the cows. His fine, calligraphic line and his effec-

tive use of contrasting elements of size, shape, and texture make this black-and-white drawing speak eloquently.

Born in Okayama, Japan, in 1889, Kuniyoshi had had no formal art training prior to his immigration to the United States in 1906, although he had studied weaving and dyeing in technical school in Japan and learned to draw by copying from sample books of traditional Japanese painting. In 1910 he enrolled for a short time at the School of the National Academy of Design in New York. Following a brief period at Robert Henri's (1865–1929) Independent School, where he was caught up in the excitement of talk about the Armory Show and Cubism, he studied at the Art Students League from 1916 to 1920 under Kenneth Hayes Miller (1876–1952).[3] He felt that he had been brought up "seeing and feeling things in the oriental way, that is in a two-dimensional way, one plane behind another going up," and that Miller taught him to "see things in depth, one behind another."[4] Both these influences can be seen in the SCMA drawing in the way the forms are placed in the composition — floating in an ambiguous space yet overlapping to create a shallow sense of depth.

Kuniyoshi was never identified with a particular school of artists. He was part of the circle of New York artists such as Alexander Brook (1898–1980), Katherine Schmidt (1896–1978), and Reginald Marsh (1898–1954), whom he had met as a student, but he did not share their interest in regionalist or realist styles. He is sometimes described as a visionary artist. The critic Henry McBride, for example, compared Kuniyoshi's style of modeling with the work of Odilon Redon (1840–1916), finding the same "short shading off of velvet blacks into shiny whites... which seems to hint that both artists read nature by flashes of lightning."[5] The "visionary" quality, however, is less apparent in early works such as *Three Cows and One Calf,* where these effects stop short of evoking a mood and remain largely decorative. After about the mid-1920s Kuniyoshi began depicting women, landscapes, and still lifes, and by the 1940s and early 1950s, his

subject matter centered on expressionistic themes of masks and carnivals, abandoned house sites, broken-down cars and furniture on empty plains, and solitary mourning figures under stormy skies. In many of his late paintings the ambiguous spatial relationships and distortions of scale found in earlier pieces are amplified and combined with a highly developed sense of color to create sharply emotional visions of sadness, isolation, and despair.[6]

Kuniyoshi continued to make finished ink drawings throughout his life, and his work in lithography and oil painting reflects his skill with pen, brush, and ink. Areas of color in his late paintings are enhanced, for example, with a linear texture that refers back to his ink drawing techniques, and his lithographs are executed with the fine line present in such early works as the SCMA drawing.

Kuniyoshi's critical reception was generally favorable throughout his life, although, like many other representational artists, he felt the difficulties of working in a critical environment that valued abstract art above all. He was one of the youngest painters included in the much-debated 1929 exhibition *Nineteen Living Americans* at the Museum of Modern Art, and in 1948 he became the first living artist presented by the Whitney Museum of American Art in a one-person show. The Charles Daniel Gallery in New York, noted for launching the careers of such modernists as John Marin (1870–1953), Marsden Hartley (1877–1943), Charles Demuth (1883–1935), and Man Ray (1890–1977), gave Kuniyoshi solo shows almost every year from 1922 until the gallery closed in 1931. *Three Cows and One Calf* was shown at the Daniel Gallery in 1923.

NR

1. Goodrich, reel N688, frame 547, quoting a letter from Goodwin dated 24 Nov. 1947. Goodwin was the architect (with Edward Durell Stone) of the Museum of Modern Art. He was also a collector of modern art and an acquaintance of the architectural historian Henry-Russell Hitchcock, director of the SCMA from 1949 to 1954.

2. Kuniyoshi, quoted in New York 1948a, p. 21.

3. For an autobiographical account, see Kuniyoshi 1945.

4. Typed transcript of notes by Lloyd Goodrich of conversation with Kuniyoshi, 6 Jan. 1948; Goodrich, reel N670, frames 62–63.

5. McBride 1924, pp. 295–96.

6. For color reproductions of works from this period, see Kyoto 1989–90.

PAUL KLEE

Münchenbuchsee, Switzerland 1879–1940 Muralto-Locarno, Switzerland

62 Goat (Bock), 1925

Brush and watercolor (some applied with atomizer) on smooth, coated paper laid down on beige wove mount[1]

Watermark: None visible

Image: 218 × 281 mm (8⅝ × 11¹/₁₆ in.); mount: 345 × 457 mm (13⅝ × 18 in.)

Signed recto, lower right, in pen and black ink: *Klee;* dated and inscribed by the artist, on recto of mount at center, in pen and black ink: *1925 "T. 8." Bock;* inscribed on recto of mount at lower left, in pen and black ink: *IV.*[2]

PROVENANCE Purchased from the artist by Jere Abbott (1897–1982) in 1926; gift to SCMA in 1976

LITERATURE *SCMA Bull* 1935, p. 16, fig. 13; Miller 1945, repr. p. 42; *ArtJ* 1977, repr. p. 341; Lynes 1981, repr. p. 56; SCMA 1986, no. 267, repr., color pl. p. 53

EXHIBITIONS New York 1930, no. 9; Northampton 1933, no. 57; Northampton 1975b, no. 36; Northampton 1979b, no. 170; Northampton 1983a, no. 36; Northampton 1984b, no. 19; Northampton 1987a; Amherst 1990a

Gift of Jere Abbott
1976:23

This watercolor dates from 1925, midway through Klee's tenure as a teacher at the Bauhaus (1920–31), around the time of the school's move from Weimar to Dessau. The Bauhaus was becoming increasingly constructivist in its aesthetic philosophy with the arrival of key faculty such as Theo van Doesburg (1883–1931), leader of the De Stijl movement, who taught at the school from 1921 to 1923; Wassily Kandinsky (1866–1944), who arrived in 1922, bringing ideas from the Russian constructivists; and the Berlin constructivist László Moholy-Nagy (1895–1946), who came in 1923. Architecture and functional design were emphasized, characterized by system and repetition. In the making of pictorial works, Bauhaus instructors stressed nonrepresentational art, undefined abstract space, and geometricized forms that often implied engineering or mechanical applications. Although Klee left the Bauhaus in 1931 in part because this approach was no longer fertile ground for his art, he nevertheless studied constructivist ideas closely and absorbed their influence into his works of the mid- to late 1920s, moving from a more cubist orientation of the 1910s and early 1920s.[3]

The goat is composed in a manner consistent with the constructivist style, with jointed plates substituting for the rounded forms of skull and haunch, cubelike sticks for legs, and dense cross-hatching that resembles wire mesh. The brown watercolor spray holds the animal's body in a shallow, indeterminate space. Despite the mechanistic presentation, the goat has a vivid personality, created by the outsized horns, startled, quizzical eyes, and exaggerated tail. The goat's expression suggests a lively, quixotic nature, perhaps with a touch of shyness or innocence, in contrast to the lustfulness associated with Pan and the goat-legged satyrs of pagan antiquity, or the sinfulness of the goats that symbolized the damned in Christian iconography. The combination of this whimsical personality with the mechanical forms of Constructivism creates a note of humor, even parody; as Richard Verdi observed, Klee's depictions of "higher animals" are frequently "more comic than cosmic in character."[4]

Klee's interest in nature was lifelong, beginning with his earliest drawings as a child, his systematic studies in his youth of animals and plants, and the grounding of his artistic work in an understanding of biological processes.[5] Animals, fish, plants, and birds are frequent subjects in Klee's work, as are the basic processes of nature — birth and decay, patterns of growth, death. With regard to depictions of animals, "Klee rarely concerns himself with nature's more unusual inventions among the higher beasts.... More often Klee's desire to reveal nature at its most typical leads him to favour ordinary domestic animals — horses, dogs, cows, and (above all) cats."[6] Goats, however, were uncommon subjects in his work.

Although the SCMA *Goat* has the appearance of a pen and ink drawing, it is executed in watercolor with a very fine brush and, in places, perhaps with a damaged brush with split hairs. Around and over the figure of the goat, which is painted in rust, brown, blue, and black, Klee has sprayed a mist of brown. The drawing's ground appears under magnification to be chalky or plasterlike, with pitting and flaking in places and occasional embedded brush hairs, indicating that it was applied by hand rather than commercially prepared.

Klee's notes for his Bauhaus lectures suggest the pictorial issues with which he was concerned at this time. In a lecture on 28 November 1921, Klee discussed the development of form: "Tension between line and line results in a plane.... The line moves and produces the plane; the plane moves and the body comes into being.... The cube is a balanced synthesis of three definite dimensions and as such the normative symbol of corporeality."[7] Elsewhere, he discussed creating form through color and tone, avoiding traditional modeling techniques that use light and shadow, color shifts, and perspective.[8]

Klee's choices of graphic technique and media in *Goat* reflect these interests. In the watercolor cross-hatching,

a technique found in other Klee drawings of this period,[9] the lines move in parallel or crisscrossed formations through space, creating planes, which then mesh with each other to convey solid form. By alternating warm and cool colors Klee creates a sense of advance and recession, using changes in density of cross-hatching to the same effect. The layer of spray, a technique Klee had begun using as early as 1919,[10] is darkest near the edges of the picture and lightest around the figure, forming an atmospheric chiaroscuro layer that places the goat within a space whose depth is impossible to measure.

Unlike many of his contemporaries, Klee did not condemn representation but rather stressed the need for sound pictorial structure regardless of subject:

> To be an abstract painter [means] to distil pure pictorial relations. . . . Pure pictorial relations: light to dark, colour to light and dark, colour to colour, long to short, broad to narrow, sharp to dull, left-right, above-below, behind-in front, circle to square to triangle. . . .

> The crucial point in evaluating such a picture is not whether dog, cat, etc. or "nothing" (which does not exist) is represented, but whether the representation makes use of means that belong to picture-making, or do not. . . .

> Thus from an abstract point of view the outcome of cat or dog is not to be condemned if it occurs along with (or in spite of) a pure use of the pictorial elements.[11]

Klee's choice of a shy, whimsical goat as the vehicle for this virtuosic display of "pure pictorial elements" contains a note of humor and perhaps a hint of private resistance to the constructivist emphasis on nonrepresentational art. He considered subject a private matter for the artist and rarely discussed it, preferring instead to talk about form.

This watercolor was purchased by Jere Abbott, founding associate director of the Museum of Modern Art in New York (and later director of SCMA), during a studio visit to the artist in 1926. In 1930 Abbott included the drawing in MoMA's solo exhibition of Klee's work, the artist's first show in a major American institution.

NR

1. In his "Oeuvrekatalog" (Klee) for 1925, Klee described the medium of this work (no. A 198), as "Aquarell (zeichnerisch-farbig) Briefpapier a) Kreidegrund b) Temperaweissgrund" (watercolor applied in a draughtsman-like manner on writing paper a) chalk ground b) white tempera ground).

2. Klee sometimes used penciled Roman numerals to indicate quality, but the precise meaning of the code is at present uncertain (New York 1977, p. 9). In 1925 Klee began an auxiliary numbering system in his "Oeuvrekatalog," a combination of letters and numbers (such as "T.8"), which the artist's son Felix Klee explained was done "at the request of art dealers who did not want buyers to know how many works Klee produced in a year" (ibid., p. 9, quoting Klee 1962, pp. 201–3).

3. For a discussion of Klee's relationship to constructivism and cubism, see Jordan 1984, esp. pp. 172–91. For general information about Klee's years at the Bauhaus, see Geelhaar 1973.

4. Verdi 1985, p. 36.

5. See Verdi 1985, pp. 1–32.

6. Verdi 1985, p. 37.

7. Quoted in Spiller 1961, p. 125.

8. See, e.g., Spiller 1961, pp. 50–53.

9. See, e.g., *Dämonie*, pen and ink, 1925, collection of the Paul-Klee-Stiftung, Kunstmuseum Bern, inv. Z577 (Glaesemer 1984, fig. 122).

10. Grohmann 1954, p. 160.

11. Quoted in Spiller 1961, pp. 72–73.

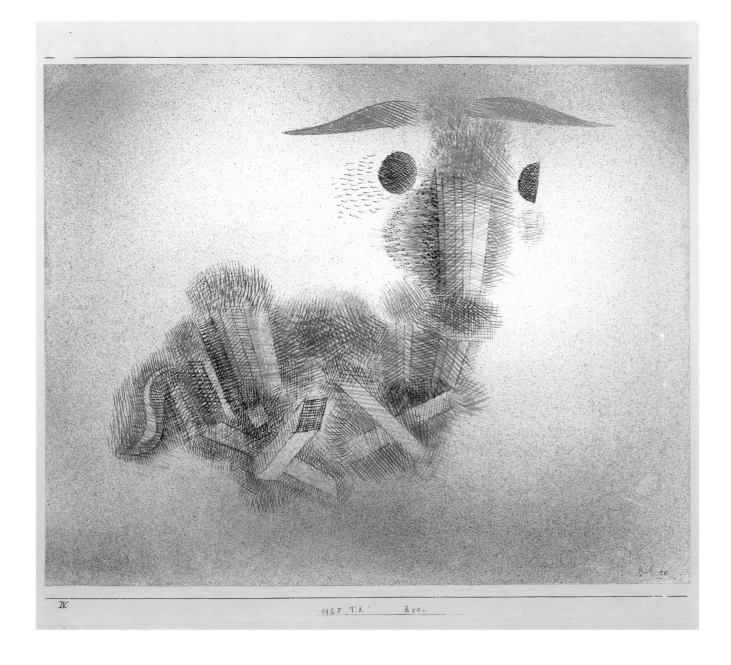

IV. 1925. T.8. Boc.

HENRI MATISSE
Cateau Cambrésis 1869–1954 Nice

63 *Still Life: Fruit and Flowers*, 1940

Graphite on beige laid paper

Watermark: Initials VM in a circle (see Watermarks)

442 × 339 mm (17⅜ × 13⅜ in.)

Signed and dated recto, lower right, in graphite: *Henri Matisse .40;* inscribed verso, lower left, in graphite: *NY 7033;* at lower center: *No. 4;* along right edge: 1¼

PROVENANCE {Buchholz Gallery, New York}, by 1947; to Elsa Detmold Holliday (1891–1991), New York, before 1955; gift to SCMA in 1963

LITERATURE None

EXHIBITIONS New York 1947b, no. 56, repr. on cover; South Hadley 1968; Northampton 1977; Northampton 1979b, no. 169; Northampton 1984b, no. 20

Gift of Mr. and Mrs. Terence Holliday (Elsa Detmold, class of 1911) in memory of Sara Evans Kent, class of 1911
1963:47

The Smith College sheet, signed and dated 1940, was drawn during a time of transition in Matisse's late career and personal circumstances. Following a serious illness that almost claimed his life in 1938, the artist moved his studio from his apartment at place Charles Félix in Nice, the city in southern France that had become his principal residence since 1917, to the Hôtel Régina in the Cimiez suburb. Within the next year, Matisse and his wife of forty-two years began the process of legal separation, which the artist finalized in Paris just as France was invaded by Germany in May 1940. He returned to his rooms in the Hôtel Régina in August. Although the American Emergency Rescue Committee offered to arrange his passage to the United States after the invasion, Matisse chose to remain in France for the duration of the war, moving to Vence in 1943 to escape Allied bombing.[1]

Against this backdrop of personal and political disruption as well as continuing health problems, Matisse maintained a remarkable concentration on his work. Drawing was a particular focus and the subject of a number of his theoretical writings from about 1937 to 1943, including "Notes of a Painter on His Drawing" of 1939.[2] In this essay, Matisse describes line drawing as "the purest and most direct translation" of emotion, which is made possible by the "simplification of the medium" itself.[3] By early 1940 he would write Pierre Bonnard (1867–1947) of an artistic crisis involving his inability to reconcile painting — color — with the spontaneity of line drawings.[4] The Smith College sheet, with its deceptively facile, quick line, belongs to this renewed period of experimentation.

The Smith College still life may be dated to the winter of 1939–40, when Matisse was working on "simplified

Fig. 1. Henri Matisse, *Still Life with a Sleeping Woman*, 1940. Oil on canvas, 81 × 100 cm (31⅞ × 39⅜ in.). National Gallery of Art, Washington, Collection of Mr. and Mrs. Paul Mellon. © 2000 Succession H. Matisse, Paris / Artists Rights Society (ARS), New York

Fig. 2. Henri Matisse, *Interior with an Etruscan Vase*, 1940. Oil on canvas, 73.7 × 108 cm (29 × 42½ in.). The Cleveland Museum of Art, Gift of the Hanna Fund, inv. 52.153. © 2000 Succession H. Matisse, Paris / Artists Rights Society (ARS), New York. Photo: © The Cleveland Museum of Art, 1996

compositions" of plants and objects in his Hôtel Régina studio.[5] During this time he painted the works to which the museum's sheet is most closely related: *Still Life with a Sleeping Woman* (fig. 1), completed on 6 January 1940; and *Interior with an Etruscan Vase* (fig. 2), completed on 13 February.[6] He also began work on *The Dream* (private collection), which was finished in September 1940. The scallop-edged table in the Smith College drawing appears in all three paintings, as well as other works from this period. The drawing shares with *Still Life with a Sleeping Woman* and *Interior* the similar motif of fruit strewn across the table's surface, which also holds large-leafed, palmlike plants set in clay pots. Unlike the paintings, there is no figure in the Smith College sheet, but the flower-filled vase in the drawing occupies a compositionally similar function. In both the drawing and *The Dream,* a beautifully abstract work related to *Still Life with a Sleeping Woman,* Matisse has tilted the table, which floats at a diagonal in *The Dream* and pushes up toward the viewer to fill virtually the entire picture plane of the drawing. This re-creation of perspective is described in "Notes of a Painter": drawings claim their own "luminous space, and the objects of which they are composed are on different planes . . . thus in perspective, *but in a perspective of feeling.*"[7]

The perforations along the left edge of the museum's sheet clearly reveal that the drawing originally belonged to a sketchbook. Although it is not by strict definition a study for a specific painting, as Wanda de Guébriant of the Matisse Archives has stated, it was Matisse's practice to develop sketches and drawings during the course of painting a canvas, changing the point of view in different variations and searching for the essential expression of his motif. She relates the Smith College sheet to similar drawings made between November 1939 and March 1940, when Matisse filled his notebooks (each consisting of ten sheets of Maillol paper) with studies of a green marble table with or without plants and sometimes including a model, shown asleep or awake.[8] Another interesting point of reference for the SCMA sheet and other tabletop still-life studies from this period is the collage canvas, *Still Life with Shell,* dated 1940 (private collection). It appears to have been fashioned as a pinboard to allow the artist to experiment with placing paper still-life elements of apples, a leaf, a pitcher, a cup and saucer, and a coffee pot. Strings stretched across the canvas marked the sides of the tabletop and, like the still-life elements, could be moved and repositioned.[9]

More generally, the museum's drawing is related to what John Elderfield has identified as a kind of serial treatment of theme and motif that prevailed in Matisse's work in the 1940s. As he has pointed out, Matisse returned to still-life drawing in 1940 after many years, and still-life subjects, especially flower and leaf motifs, would occupy him throughout the decade.[10] The Smith College drawing can therefore be seen as a prelude to the artist's *Themes and Variations* drawings of 1941–42, which consist of seventeen groups of drawings, each with its own "Theme" (a drawing in charcoal) followed by three to nineteen "Variations" (in pen or crayon). Of these, six groups explore themes and variations based on still lifes of fruits and flowers.[11]

LM

1. See the chronology in New York 1992–93, pp. 362–65.

2. See John Elderfield in London / New York 1984–85, pp. 117–18 (and the chapter "Illuminations," pp. 101–33, which discusses his late period).

3. "Notes of a Painter on His Drawing," trans. in Flam 1973, pp. 81–82.

4. Elderfield in London / New York 1984–85, p. 121, discusses Matisse's artistic difficulties in 1940 in reconciling drawing and painting, quoting the Matisse exchange with Bonnard from "Correspondance Matisse–Bonnard 1925–46," *La Nouvelle Revue Française* 18, no. 211 (1 July 1970), p. 92.

5. Elderfield in New York 1992–93, p. 364. In a letter of 14 July 1994 to the author (SCMA curatorial files), John Elderfield concurs that the SCMA drawing dates to early 1940. He also points out that the plant pot in the drawing appears in the painting *Interior with an Etruscan Vase* of the same period.

6. The exact completion dates of the paintings were supplied in a letter to the author of 9 May 1996 (SCMA curatorial files) from Wanda de Guébriant of the Matisse Archives (Les Heritiers Matisse, Paris).

7. Flam 1973, p. 81.

8. Wanda de Guébriant letter, 9 May 1996.

9. See the catalogue for New York 1997–98, p. 223 and pl. 71.

10. Elderfield in London / New York 1984–85, pp. 122–23.

11. Ibid., pp. 121 and 276 (no. 113), which lists series A, G, H, J, M, and Nbis as the thematic groups based on fruits and flowers.

ARTHUR DOVE
Canandaigua, New York 1880–1946 Centerport, New York

64 *From Trees*, 1940

Brush and transparent and opaque watercolor with pen and brush and black (India) ink on moderately textured cream wove paper

Watermark: None

127 × 178 mm (5 × 7 in.)

Signed recto, center bottom, in pen and black ink: *Dove;* titled and dated on original frame backing, in pen and black ink, in the artist's hand: *From Trees / 1940*

PROVENANCE {An American Place (Alfred Stieglitz [1864–1946]), New York}, as agent for the artist, by 1944; to Dr. Douglas Spencer (d. 1988), Piermont-on-Hudson, N.Y., in 1944; gift to SCMA in 1976

EXHIBITIONS Northampton 1979b, no. 172; Northampton 1980, no. 28; Northampton 1986a, no. 11; Northampton 1987–88

Gift of Dr. and Mrs. Douglas Spencer (Daisy Davis, class of 1924) 1976:38-2

In 1940, when Arthur Dove painted *From Trees,* he was recovering from a heart attack, complicated by the development of Bright's disease, a kidney ailment, and his activity was severely limited. Much of the time he was confined to bed, which necessitated his working in small sizes and from memory rather than from observation. Nevertheless, despite his physical limitations, it was a very productive period. As had been his custom since 1925, he sent a number of oils and watercolors that year to his dealer, Alfred Stieglitz, who exhibited them at An American Place, his New York gallery.[1]

From Trees was undoubtedly intended as a finished work, although Dove frequently based oil paintings on watercolor sketches made outdoors.[2] The title is given by the artist in his own hand on the watercolor's original frame backing. Although the round, green form suggests a tree, with a pale blue sky above, and hints of rust-colored earth below, the image is essentially abstract. The transparent watercolors are laid down without pencil underdrawing in wide, wavy-edged spirals of forest green, olive, and beige. Shiny black India ink, applied with a wide pen, is used in dots and zigzags and undulating lines that accentuate the spiral form. The strokes of gouache in tints of light blue along the edges of the spiral give a slight roundness to the forms, but for the most part the colors are applied with equal intensity and create a sense of flatness rather than the depth of a natural landscape. As Matthew Baigell has observed, Dove's work "has a clearly handmade look,"[3] and *From Trees* is no exception. The hand of the artist is especially evident in the ink markings that resemble handwriting, especially where they overlap with Dove's pen and ink signature. The silvery wood frame, made by the artist, also has a handcrafted appearance.[4] This quality and the diminutive scale give the watercolor an intimate feel and underline the impression that this work is a personal expression of something deeply felt.

Dove's strong affinity for the natural landscape developed at an early age and was an integral part of his art. Born in Canandaigua, New York, in 1880, he spent most of his childhood in Geneva, New York, on the Finger Lakes.

He studied law and art at Cornell University, graduating in 1903, and after working as an illustrator in New York City for such magazines as *Collier's* and *Century,* he felt the need for a more rural environment. From 1910 to 1933 he lived in Westport, Connecticut, supporting himself by farming, and in various other locations on Long Island Sound, including a houseboat for seven years. From 1933 to 1938 he moved back to Geneva to settle the family estate, returning to Long Island Sound (Centerport) in 1938. During his one trip to Europe in 1908–9, he spent much of his time sketching outdoors.[5]

The irregular, rounded biomorphic shapes typical of Dove's work sometimes loosely represent natural objects from the outdoors — trees, cows, boats, the moon, the sun — but he made a distinction between depicting nature and abstracting an "essence" from nature, and the latter was his goal. "We cannot express the light in nature because we have not the sun — we can only express the light we have in ourselves."[6] *From Trees* is a characteristic abstract rendering of dynamic forces and realities underlying the outward manifestations of nature. Dove conveys these unseen forces by means of abstract rhythms, patterns, and shapes. The alternating bands of light and dark in the tree form, emphasized by black ink contours, begin a spiraling motion. The tempo is accelerated by the pattern of ink dots placed progressively closer together, and by the gradually lengthening sections of zigzag. The form pushes against the confining rectangular borders and implodes back toward the center. The impression is one of power, but the positive power of nature quivering and bursting with life rather than the destructive power of, for example, lightning or storm. If the zigzags suggest energy, then the flow is from the roots of the tree upward and outward toward the very tips of its canopied branches, as if in a springtime surge.

Dove's first one-person show at Stieglitz's gallery in 1912 marked him as one of the earliest American abstractionists. His devotion to abstraction continued even when many American artists were exploring realism and working in the style of American regionalism in the 1920s and 1930s. Undoubtedly this contrary direction had

an adverse impact on Dove's public following, which was never broad, but he was respected by other artists and enjoyed the patronage of the collector Duncan Phillips for many years, as well as Stieglitz's lifelong support. From 1925 until his death in 1946, Dove's work was shown in Stieglitz's gallery every year except one. His work was also included in major group shows of modern and abstract art at the Whitney Museum of American Art in 1935 and 1946 and at the Museum of Modern Art in 1936–37 and 1939. Dove's contacts with Stieglitz's galleries as well as his own reading made him very much aware of modern art movements such as Cubism, Surrealism, and Dadaism. The source of his interest in abstraction, however, lay in his very personal connection with nature and his belief that abstraction was the best way of expressing the unseen in nature. *From Trees* exemplifies this belief and provides testimony to Dove's skill in expressing the unseen with a seeming simplicity of means. From 1940 on, Dove's work became more abstract, angular, and geometric than in the Smith College drawing, but nature and its dynamic forces continued to provide his theme.

NR

1. A paper label affixed to the original frame backing of the SCMA drawing is inscribed in pen and black ink, in Alfred Stieglitz's hand: *"An American Place"* / *509 Madison Ave. — N.Y.* / [and in the artist's hand] *From Trees–1940* / *Arthur G. Dove*. Although it seems likely that *From Trees* was exhibited at An American Place, this could not be confirmed as watercolors were not listed individually in the exhibition checklists from this time ("Arthur Dove — Exhibition Catalogues and Announcements," Archives of American Art, Smithsonian Institution, Washington, D.C., reel N70-51, frames 359–61). The long and mutually respectful relationship between Dove and Stieglitz is documented in their correspondence; see Morgan 1988.

2. For an extensive discussion of the role of watercolors in Dove's oeuvre, see Kirschner 1998.

3. Baigell 1979, p. 101.

4. Despite his illness, Dove continued to make his own frames at this time. See San Francisco 1974, p. 118, for a description.

5. For biographical information, see Morgan 1984.

6. Dove, as quoted in San Francisco 1974, p. 11.

HENRY MOORE

Castleford, Yorkshire 1898–1986 Much Hadham, Hertfordshire

65 *Ideas for Sculpture: Studies of Internal and External Forms,* 1948, study for the sculpture *Internal and External Forms,* four versions in bronze and wood (1951–54) Verso: *Sketch* (idea for sculpture), 1948

Brush with transparent and opaque watercolor (gouache), black and colored wax crayons (red and blue), black (India) ink, and grey ink on smooth beige wove paper

Verso: Graphite

Watermark: None

292 × 241 mm (11½ × 9½ in.)

Signed and dated recto, lower right, in black ink: *Moore / 48*

Inscribed verso, upper center, in blue ink: *Interior and Exterior Forms (Helmet)*; inscribed upper left, in graphite, *10* [circled] (crossed out) *38* [circled] (page numbers for sketchbook); inscribed upper center, in red wax crayon: *H m* (in different hands)

PROVENANCE {The Hanover Gallery Ltd., London} as agent for the artist;[1] sold to SCMA in 1952

LITERATURE Clark 1974, pl. 123, p. 138, repr.; Parks 1960, no. 80, repr.; Melville 1970, no. 375, repr.; Wilkinson 1977, no. 217, p. 130, repr.; Wilkinson 1979, p. 116, repr.; Lieberman 1984, p. 127

EXHIBITIONS Boston 1954; AFA 1954–56; Chapel Hill 1958, no. 108, repr.; Northampton 1958c, no. 40; Burlington 1959; Hanover 1966, no. 14; Toronto/London 1977–78, no. 217, repr. p. 130; New York 1983; Northampton 1995b, no. 6

Purchased
1952:64

Henry Moore, Britain's foremost modern sculptor, was a prolific draughtsman who valued drawing as an integral part of the sculptural process. Born in a coal-mining town in Yorkshire, Moore attended the Leeds School of Art from 1919 to 1921 and subsequently won a scholarship to the Royal Academy schools in London, where he studied sculpture from 1921 to 1923. Both institutions emphasized drawing, particularly life drawing, as an essential element in the training of a sculptor. In the 1920s and 1930s, while concentrating on carving in stone and wood, Moore came to rely on drawings as an efficient means of capturing his ideas for sculpture.[2] As he explained, "sculpture compared with drawing is a slow means of expression, and I find drawing a useful outlet for ideas which there is not time enough to realize as sculpture."[3]

Drawing provided Moore with a means of "generating ideas for sculpture, tapping oneself for the initial idea."[4] He sometimes began "with no preconceived problem to solve, with only the desire to use pencil on paper, and make lines, tones, and shapes with no conscious aim."[5] This approach echoed the "automatic" technique of the surrealists, and indeed Moore synthesized elements of Surrealism into his own work, asserting that all art "contained both abstract and surrealist elements."[6] Most of his drawings record three-dimensional sculptural ideas; drawing allowed him to sort out and develop these ideas. In the 1940s and 1950s he increasingly used a maquette as an intermediary stage between drawing and sculpture. By the mid-1950s he was sculpting maquettes in clay without preparatory sketches, and eventually he abandoned preparatory drawings altogether.[7]

The recto of this sheet is a preliminary study for the interlocking two-piece sculpture *Internal and External Forms* (1951–54, L. H. 294–297), of which there are two final versions, one in wood and one in bronze, and two

65 Verso

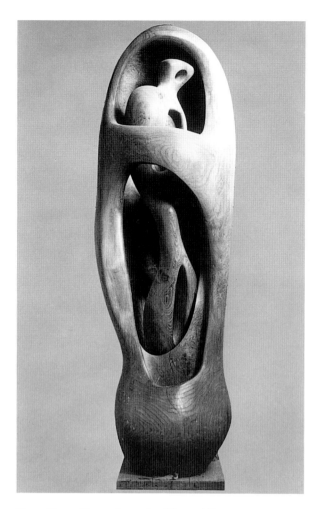

Fig. 1. Henry Moore, *Internal and External Forms*, 1953–54 (L. H. 297). Elm, 261.6 × 91.4 × 276.9 cm (103 × 36 × 109 in.). Albright-Knox Art Gallery, Buffalo, New York, Charles Clifton, James G. Forsyth, Charles W. Goodyear, Edmund Hayes, and Sherman S. Jewett Funds, 1955, inv. 55.11. Reproduced by permission of The Henry Moore Foundation

Fig. 2. Henry Moore, *Helmet Heads,* 1950 (HMF 2698). Watercolor, pen and ink, from sketchbook 1950–51. The British Museum, inv. 1975-2-26-4 (1-78). Reproduced by permission of The Henry Moore Foundation. Photo: © The British Museum

recounted in 1966: "The large wood version was started in early 1953, about a week after the tree had been cut down . . . by carving it slowly over a period of two years, and because its final form has no part more than five inches thick, it is now fully seasoned."[11] The large grain of the elm perfectly suited the scale Moore desired for his carving, and the wood version, now in the Albright-Knox Art Gallery, stands over eight feet tall (fig. 1). Of the material, Moore noted: "It was necessary for the upright carving to be in wood, which is alive and warm and gives a sense of growth. Wood is a natural and living material, unlike plaster or metal which are built up by man."[12] In 1958 he finally cast the bronze version of *Internal and External Forms* in an edition of three.

This drawing for *Internal and External Forms* was executed in meticulous layers of graphite, wax crayon, watercolor, gouache, and ink on a sketchbook page. Moore often combined a wide range of materials in his drawings and also scraped back into layers to create texture and model figures. He generally sketched out an idea with graphite, then drew his forms with plain wax or wax crayon.[13] Next, watercolor and ink washes were laid on, creating fluid, painterly effects, with the wax acting as a resist. Finally, details were delineated with thicker watercolor, gouache, and colored crayon, and last with colored pencils or pen and ink.[14] The year of this drawing's creation, 1948, marked the culmination of Moore's highly original means of conveying three-dimensionality, the "two-way sectional line," visible on each of the forms on this sheet. First attempted in 1928, this formal innovation involved drawing lines "both down the form as well as around it, without the use of light and shade modeling."[15]

Moore began exploring the concept of protective and protected forms as early as 1934, with his organic *Two Forms* (L. H. 153), a carving in Pynkado wood now in the Museum of Modern Art, New York. This idea was developed further in *Helmet* of 1939–40, a sculpture in lead, and in the subsequent series of bronze helmet heads begun in 1950.[16] The sculptural relationship between internal,

working models that were also cast in bronze.[8] The verso includes a very faint sketch for an internal-and-external form, apparently unrelated to any completed sculpture, and the annotation *Interior and Exterior Forms (Helmet).* The vertical form just left of center on the recto was developed into *Maquette for Internal and External Forms* (1951), standing seven inches tall, which led to the larger *Working Model for Internal and External Forms* (1951), standing 24½ inches tall. Numerous related studies for the internal and external forms exist, but since the SCMA sheet is among the most finished, it has been identified as the final study for the maquette.[9] Moore had originally intended his idea to be worked out in wood on a very large scale, but after searching for a year for an appropriate piece of wood without success, he decided to realize it in bronze. He began modeling the 6-foot-7-inch-high *Internal and External Forms* in plaster in 1952 and was about to send it to the foundry when he found a "magnificent," recently cut elm tree perfectly suited for carving.[10] He

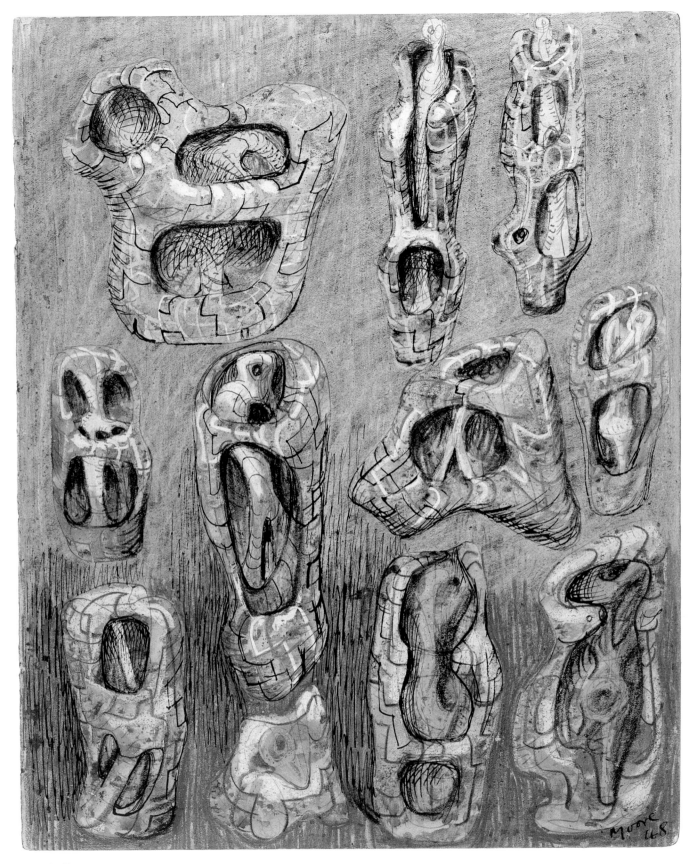

65 Recto

vulnerable forms and external, protective forms would culminate in the four versions of *Internal and External Forms,* the first complete figures on this theme. Moore described *Internal and External Forms* as "a sort of embryo being protected by an outer form, a mother and child idea, or the stamen in a flower, that is, something young and growing being protected by an outer shell."[17] A striking double-page drawing in the British Museum depicts four of the same forms that appear on the SCMA sheet adjacent to a page of helmet head studies (fig. 2). The British Museum sheet reflects the evolution of the internal-external idea from the helmet head theme.[18]

Most of Moore's sculptures originate in or relate to the human figure, but he also explored form and rhythm in bones, sea-worn rocks, weathered trees, and shells. "Shells," he wrote, "show nature's hard but hollow form (metal and sculpture) and have a wonderful completeness of single shape."[19] In a body of work known as the "transformation drawings" he altered sketches of organic objects to transform them into human or humanlike figures. He asserted that if "both abstract and human elements are welded together in a work, it must have a fuller, deeper meaning."[20] Much of his work hinges on tensions created by opposing forces and the dialogue created by two or more related abstract forms. Certain subjects and themes, including the protective outer and vulnerable inner form, the reclining figure, the seated women, and mother-and-child groups, have become hallmarks of Moore's art, since he returned to them periodically during his more than sixty years as a sculptor.

KE

1. Note in SCMA curatorial files (thought to be in Mary Bartlett Cowdrey's hand): "Selected at Moore's studio [and] Purchased through Hanover Gallery — London." The Hanover Gallery Ltd. was located at 32A St. George Street, Hanover Square, London.

2. In the early 1920s Moore executed most of his drawings for sculpture in small sketchbooks and did not intend to sell them. In the late 1920s he began working on larger presentation drawings, and by the 1930s drawings were a principal source of income for the artist.

3. Quoted in James 1966, p. 67.

4. Lund Humphries, vol. 1, p. xxxv, first published in "The Sculptor Speaks," *Listener,* 18 Aug. 1937.

5. James 1966, p. 67.

6. Henry Moore, "Notes on Sculpture," in Lund Humphries, vol. 1, p. xxxv.

7. Mitchinson 1971, p. xiv, writes: "After 1950 Moore becomes completely involved with sculpture and does very little drawing."

After 1950 the artist more often drew on single sheets of paper than in sketchbooks. I am grateful to David Mitchinson and Reinhard Rudolph of the Henry Moore Foundation, Much Hadham, Hertfordshire, for their assistance with the preparation of this essay.

8. David Mitchinson, curator of the Henry Moore Foundation, notes in a letter to the author, 30 June 1995 (SCMA curatorial files), that this drawing is recorded in the foundation archives as HMF 2408, *Page from Sketchbook 1947–49, Ideas for Internal/External Forms,* 1948. HMF numbers refer to the inventory system used by the artist's foundation. L. H. refers to *Henry Moore,* 4 vols. (London: Lund, Humphries & Co., Ltd., 1944–77). Unless otherwise noted, references herein are to L. H., vol. 2. *Maquette for Internal and External Forms* (L. H. 294) was cast in an edition of seven. *Working Model for Internal and External Forms* (L. H. 295) also was cast in an edition of seven, and examples may be found in the Museum of Art, Rhode Island School of Design, Providence (inv. 52.082, Mary B. Jackson Fund), and the Art Gallery of Ontario (Gift from the Women's Committee Fund, 1951). An example of the final bronze version of *Internal and External Forms* (L. H. 296) may be found at the Henry Moore Foundation, Much Hadham. The elmwood version (L. H. 297) is in the collection of the Albright-Knox Art Gallery, Buffalo, N.Y.

9. Wilkinson 1979, p. 116: "The maquette for No. 86 [*Working Model for Upright Internal and External Forms,* 1951] (L. H. 294) was based on a drawing of 1948 *Ideas for Sculpture: Internal and External Forms* (Fig. 101) in Smith College Museum of Art, Northampton, Mass."

10. Moore, in James 1966, p. 247.

11. Ibid.

12. Ibid.

13. Moore is believed to have used both wax and wax crayon as a resist, but without chemical analysis it is difficult to distinguish between the two media. David Mitchinson, letter to the author, 30 June 1995.

14. I am grateful to David Mitchinson for information regarding Moore's drawing technique.

15. Moore, as quoted in Toronto/London 1977–78, p. 16.

16. Private collection, L. H. 212. See Read 1966, p. 112, for a discussion of the evolution of this theme.

17. Moore, as quoted in Clark 1974, p. 114.

18. Several of the forms in the SCMA sheet are repeated in other drawings now in the Henry Moore Foundation (HMF 2540A), the Smart Gallery, University of Chicago (HMF 2604), the Albright-Knox Art Gallery, Buffalo (HMF 2540), and private collections. *Three Standing Figures,* 1948, Fogg Art Museum, Harvard University (1965:187) and *Drawings for Wood Sculpture,* 1947, HMF Collection (HMF 2693), are believed to originate in the same sketchbook as the SCMA sheet.

19. Moore, in James 1966, p. 70, as quoted in Toronto/London 1977–78, p. 24.

20. Henry Moore, "The Sculptor's Aims," quoted in L. H., vol. 1, p. xxxi. First published in *Unit One,* edited by Herbert Read (London, 1934).

WILLEM DE KOONING

Rotterdam, the Netherlands, 1904–1997 East Hampton, New York

66 *Women*, c. 1950

Graphite on cream wove paper

Watermark: None

192 × 304 mm (7%₁₆ × 12 in.)

Signed recto, center right, in blue ballpoint pen: *de Kooning;*[1] inscribed verso, upper right, in graphite: *Elaine de Kooning* / *791 B'way*

PROVENANCE Harold Diamond,[2] New York; to {B. C. Holland Gallery, Chicago}, 15 April 1961 (as *Woman, c. 1948*);[3] to {Dwan Gallery, Los Angeles}, 26 April 1961; transferred to {Dwan Gallery, New York}; to Mr. and Mrs. Richard L. Selle (Carol Osu-

chowski), Chicago, in Nov. 1967 (revised invoice dated Feb. 1968; as *Women, 1949*); gift to SCMA in 1969

LITERATURE *ArtJ* 1969–70, p. 220, repr. p. 222; Hess 1972, pp. 142–43, no. 52, repr. (incorrectly as "Collection of the Artist"); SCMA 1986, no. 273, repr.

EXHIBITIONS Northampton 1974c; Durham 1978; Northampton 1980, no. 15; Northampton 1982a; Amherst 1990a

Gift of Mrs. Richard L. Selle (Carol Osuchowski, class of 1954) 1969:46

Willem de Kooning, a pivotal figure in the abstract expressionist group, was born in Holland and immigrated to America in 1926. Settling in New York, he first earned his living as a commercial artist and house painter; in 1935 he joined the Federal Arts Project of the WPA and worked for a year as a mural painter.[4] In 1938 de Kooning met Elaine Fried (1918–1989), a young art student who later became a painter in the abstract expressionist group and an influential art critic; they married in 1943. Although he is considered one of the first American artists to commit to pure abstraction, de Kooning never renounced figuration and throughout his career remained interested in two main themes, landscape and images of women.

The SCMA drawing relates to de Kooning's well-known series of *Women* paintings of the late 1940s and early 1950s. Drawn with broad graphite strokes and sweeps of an eraser, it depicts four women — three standing and one reclining — in an ambiguous interior setting that resembles an artist's studio. Rectangular forms behind the central figure suggest an easel and canvases. Undated, like the majority of de Kooning's drawings from the late 1940s and early 1950s, the drawing is probably a preliminary study for the monumental painting *Woman I,* 1950–52 (The Museum of Modern Art, New York).[5] The central figure's frontal pose, with bent arms and clasped hands, together with the position of her breasts and her facial features are echoed in *Woman I* and in other drawings of the period, including *Woman,* 1951–52 (private collection),[6] and *Standing Woman,* 1952 (The Museum of Modern Art, New York).

In his images of women from the late 1940s and 1950s, de Kooning emphasized and exaggerated certain body parts, notably eyes, breasts, mouths, genitals, and feet; by blurring the distinction between these features he created distorted, grotesque, and sometimes comical female beings. Elongated legs and feet terminate in absurdly pointed high heels, creating a sense of instability and danger, while wild expressions suggest promiscuity or

madness. As Richard Shiff writes, "Transition, change itself, is the origin of Willem de Kooning's art and the principle he thought closest to his life . . . ambiguities pleased him."[7] Thus in the women paintings eyes and mouths are repeated in breasts and vaginas, creating sexual puns. The deliberateness of these double entendres is confirmed by the artist's assertion that "a woman has two mouths, one is the sex."[8]

In this drawing, the eyes of the figure at right peer from her torso, while her buoyant breasts have been shifted to a position lower on the body. The central figure, whose breasts sway in opposing directions, merges with the object behind her, which may be an easel. Like many of de Kooning's women, she is compartmentalized by the abstract architectural space she inhabits — what the artist called his "no environment."[9] The sheet was previously thought to depict three women, presumably because the squat woman in the right foreground and the small head in the right rear were seen as being linked; it now seems clear they are two distinct figures. Wavy lines extending horizontally underneath the small head suggest a reclining figure, while the rectangular "frame" around her hints that she might be a painting hung on the wall. The drawing was known at one time as *Cat and Woman* (a puzzling designation given that de Kooning rarely if ever depicted cats), perhaps because the short, busty figure at right was identified as feline.[10]

De Kooning developed a "complex, rhythmical flow of activity between drawing and painting,"[11] using drawings as warm-up exercises, not as studies in the traditional sense. Since he tended to draw with great freedom and rapidity, he preferred smooth papers with no resistance; papers with a rough "tooth" interfered with his intentions. He often tore up his drawings and juxtaposed the fragments to create composite works, or he collaged pieces of drawings into his paintings. A harsh critic of his own work, he sometimes scraped down paintings that appeared near completion and also destroyed a great many of them, particularly in his early years.[12] He pre-

served passages about to be destroyed through a mono-type, or oil transfer process, wherein newspaper was pressed onto paint to create an impression that could be saved for later use. While he worked on a painting, he surrounded himself with drawings, scattering them about the studio floor and tacking them to the walls.

The *Women* series of the early 1950s followed a fertile period during which de Kooning produced some of his best-known abstract works, including *Excavation, 1950* (The Art Institute of Chicago), and the black enamel *Painting, 1948* (The Museum of Modern Art, New York). From the fragmented and dynamic spaces of these abstract works emerge the smiling, gargantuan femmes fatales of the 1950s *Women* series. De Kooning's 1953 solo show *Paintings on the Theme of the Woman* at the Sidney Janis Gallery in New York prompted strong critical reactions, largely because of the shocking appearance of his female figures. The painter Jackson Pollock (1912–1956) and the critic Clement Greenberg were among those who contended that de Kooning's return to figuration represented a betrayal of the emergent abstract expressionist movement. Greenberg believed that only a break with Cubism would allow a truly American modern art movement to be formed, and for him de Kooning's *Women* series proved he was "stuck" in late Cubism. By associating de Kooning with Pablo Picasso (1881–1973), a Communist, Greenberg implied that he was both retrograde and un-American.[13]

During the 1950s, de Kooning's women were seen by many critics as icons for the all-American girl, the streetwise big-city dame, or the "new woman." Thomas Hess, one of de Kooning's most faithful supporters, initially compared *Woman I* to the passive American girl: "the girl at the noisy party who has misplaced her escort, she simply sits, is there, and smiles because that is the proper thing to do in America."[14] Hubert Crehan recognized in these paintings "the new American woman, a formidable type, who is in the avant-garde of her sex in the contemporary world."[15] His reaction, like those of many other critics, nearly all white men, reverberates with contemporary debates about the "woman problem" — the postwar question surrounding the role of women in the workplace and in the home. De Kooning's act of painting was interpreted by Sidney Geist as a violent, sexualized wrestling match with the "new woman": "In a gesture that parallels a sexual act, [de Kooning] has vented himself with violence on the canvas which is the body of this woman."[16] By 1968, Hess saw *Woman I* as a "Black Goddess: the mother who betrays the son, gets rid of the father, destroys the home."[17] James Fitzsimmons believed the artist had painted *Woman I* in "a fury of lust and hatred" and compared the act of painting to "bloody hand to hand combat."[18] Crehan teased provocatively: "Frankly he's had his hands full getting her down on canvas."[19]

The link between de Kooning's women and the woman problem was reinforced by the artist's reliance on images of women in advertisements and pinups as direct sources for his paintings. In 1950 he incorporated a smiling mouth cut from a Camel cigarette advertisement into a painting with collage entitled *Woman*.[20] The reappropriation and repetition of the mouth emphasized its sexual connotations; as de Kooning explained, "I cut out a lot of mouths. First of all, I felt everything ought to have a mouth. Maybe it was like a pun . . . maybe it's even sexual."[21] Like the popular pinups of the day, de Kooning's women are clothed but ready to reveal themselves, desirable but also threatening and unattainable.[22] In a 1953 review, Hess equates them with slick advertising images: "*Woman* and the pictures related to it should be fixed to the sides of trucks, or used as highway signs, like those more-than-beautiful girls with their eternal smiles who do not tempt, but simply point to a few words or a beer or a gadget."[23]

Readings of the *Women* series have changed with contemporary political and cultural climates, but the question of de Kooning's personal attitude toward women was raised from the first exhibition of *Woman I*. His sardonic deconstruction of woman into disjointed, exaggerated body parts and presentation of her as a fanged monster have been interpreted as evidence of misogyny. In 1968 Hess suggested that de Kooning expressed in the women paintings a deeply rooted psychological fear of his domineering mother,[24] a suggestion Elaine de Kooning seemed to confirm when she commented, "That ferocious woman he painted didn't come from living with me. It began when he was three years old."[25] Hess later qualified his earlier view and cautiously put forward a feminist interpretation of the 1950s *Women* paintings as "violent intellectual and emotional criticism, in visual form, of the contemporaneous situation of the American woman as reflected in the pin-up photograph."[26] Carol Duncan links de Kooning's use of suggestive poses and freakish expressions to a long pictorial tradition extending from ancient tribal art to modern painting and pornography. She identified the second set of teeth with which many of his women were endowed as "vagina dentata." She further positions *Woman I* with Picasso's *Demoiselles d'Avignon* as sexualized images of female bodies that actively masculinize the museum environment.[27]

De Kooning asserted that the exaggerated grins, intensity of expression, and frontal poses of his women figures originated in part in Mesopotamian idols.[28] He remarked in a March 1960 interview: "I look at them now they seem vociferous and ferocious, and I think it had to do with the idea of the idol, the oracle, and above all the hilariousness of it."[29] Ultimately, de Kooning seems to have regretted that the repulsive qualities of his 1950s *Women* had eclipsed their humorous aspect: "I wanted them to be funny and not to look sad and down-trodden . . . so I made them satiric and monstrous, like sibyls."[30]

KE

I am grateful to Allan Stone, Allan Stone Gallery, New York; Jennifer Johnson, of the Willem de Kooning Office in New York; and Jennifer Vorbach, of C&M Arts, New York, for their assistance with research for this entry.

1. The drawing appears without the signature in Hess 1972 in what is believed to be an outdated photograph. It was cut down along the top edge sometime after this photograph was taken and before its sale from the Dwan Gallery in 1968. Allan Stone (personal communication, 21 May 1996) says that de Kooning always signed his works as they were leaving the studio and that Elaine de Kooning generally titled them. It was not uncommon for de Kooning to sign along the side of a drawing, sometimes as a way of suggesting an alternative orientation of the image.

2. Harold Diamond worked for the Martha Jackson Gallery and later was a private dealer. Allan Stone (personal communication, 21 May 1996) notes that Diamond worked closely with B. C. Holland. Thomas Hess in New York 1968–69 indicates that after de Kooning moved to Long Island in 1963 and cut all ties with the Sidney Janis Gallery, he developed stronger relationships with collectors and private dealers, including Harold Diamond, "who had arrangements with Los Angeles galleries to handle and exhibit some de Koonings, and who had contacts with many New York collectors" (p. 123). Diamond also was the first to suggest to de Kooning that he sell the oil transfers from his paintings (Allan Stone, personal communication, 21 May 1996, and Washington/New York/London 1994–95, p. 175, citing Hess 1967, p. 20, and other sources).

3. Jeanne Havemeyer, former director of the B. C. Holland Gallery, has confirmed the purchase of this drawing by that gallery (personal communication, 18 March 1996).

4. De Kooning worked on several mural projects, none of which was completed. In 1936 he was forced to leave the Federal Arts Project when legislation was passed barring aliens from participation. He did not become an American citizen until 1962.

5. Minneapolis 1974–75, unpag., notes that "few drawings and pastels seem to have survived from the highly productive period of experimentation, 1945 to 1950." Dates assigned to this drawing include 1948 (letter from the previous owner, Carol Selle, to Charles Chetham, 26 March 1969, SCMA curatorial files); 1949 (Dwan Gallery receipt); and c. 1951 (Hess 1972). Allan Stone (personal communication, 21 May 1996) believes that the drawing may date to 1951 or 1952. For a comprehensive study of de Kooning's drawings, see Hess 1972. On the development of *Woman I,* see Hess 1953 and Sylvester 1995.

6. Pastel, crayon, and graphite on paper, 337 × 260 mm (13¼ × 10¼ in.), private collection; in New York 1995, no. 12, repr. See also the sale, New York, Christie's *Contemporary Art from the Collection of Ted Ashley,* 12 Nov. 1986, no. 3, repr.

7. Shiff, in Washington/New York/London 1994–95, p. 33.

8. Ibid., p. 41, quoting Bibeb, "Willem de Kooning: Ik vind dat alles een mond moet hebben en ik zet de mond waar ik will," *Vrij Nederland* (Amsterdam), 5 Oct. 1968, 3.

9. This tendency to compartmentalize his women figures is even more visible in other works of the period and is taken to an extreme in the boxlike forms of *Two Nude Figures* (Fogg Art Museum, Harvard University, Cambridge, Mass., inv. 69.1969). For a discussion of this practice, see Washington/New York/London 1994–95, p. 130.

10. The title *Cat and Woman* is given on the back of a studio photograph now in the de Kooning estate files.

11. Washington/New York/London 1994–95, p. 93.

12. Hess 1953, p. 30, relates how the artist discarded *Woman I* after working on it for a year and a half, only to have it rescued by the art historian Meyer Schapiro, who visited de Kooning a few weeks later and asked to see the abandoned painting.

13. See Greenberg 1954, p. 7, and Greenberg 1955. For an illuminating discussion of Greenberg's criticism of de Kooning, see Cateforis 1991. David Cateforis suggests that the link with Picasso set de Kooning up as un-American. David Sylvester argues that critics such as Greenberg also found it shocking that de Kooning would treat a traditional subject, a single woman, "en plein air" (Sylvester 1995, p. 222).

14. Hess 1953, p. 66.

15. Crehan 1953, p. 5.

16. Geist 1953, p. 15. See also Forge 1968, p. 246, "I can imagine a hag-ridden man regaining his wits in front of de Kooning's hilarious troupers."

17. New York 1968–69, p. 75. For a thorough discussion of Hess's evolving criticism of the *Women* paintings, see Siegel 1990.

18. Fitzsimmons 1953b, p. 8.

19. Crehan 1953, p. 4.

20. *Woman,* 1950, oil with cut and pasted paper on paper, Collection of Thomas B. Hess, jointly owned by The Metropolitan Museum of Art, New York, and the heirs of Thomas B. Hess, 1984. Marla Prather, in Washington/New York/London 1994–95, p. 81, notes that while working as a commercial designer, de Kooning drew women for Model tobacco advertisements that appeared in *Life* magazine.

21. Willem de Kooning, "Paintings as Self-Discovery," BBC interview with David Sylvester, 3 March 1960, quoted in Sylvester 1995, p. 224.

22. Hess asserts that the image of the pinup "entered the field of high art" under "the sponsorship of Willem de Kooning" in the late 1940s, in Hess and Nochlin 1972, pp. 222–37.

23. Hess 1953, p. 66.

24. New York 1968–69, p. 12.

25. Elaine de Kooning, quoted by Pepper 1983, p. 70. Allan Stone (personal communication, 21 May 1996) suggests that disagreements with Elaine prompted the *Women* series of the early 1950s.

26. Hess, in Hess and Nochlin 1972, p. 230. See Cateforis 1991, chap. 6, for a study of Hess's evolving views and of the feminist critique of the *Women* paintings. Lise Vogel challenges Hess's characterization of de Kooning as a "crypto-feminist" (Vogel 1976, p. 383).

27. Duncan 1977, p. 48, as cited in Cateforis 1991, p. 298. See also Duncan 1989 and Duncan and Wallach 1978. This concise summary of Duncan's arguments does not do justice to her exploration of the subject. The literature on de Kooning's *Women* series is too vast to address in detail here; see Cateforis 1991 for a thoughtful survey of the existing literature.

28. De Kooning 1960; reexamined in Sylvester 1995.

29. De Kooning 1960.

30. George Dickerson, unedited transcript of interview with de Kooning, 3 Sept. 1964, p. 3. Thomas B. Hess Papers, Archives of American Art, Smithsonian Institution, Washington, D.C., as quoted in Washington/New York/London 1994–95, p. 132.

BARNETT NEWMAN
New York 1905–1970 New York

67 *Untitled,*[1] 1948

Brush and black ink on heavy cream wove paper

Watermark: None

610 × 422 mm (24 × 16⅝ in.)

Signed and dated verso, lower right, in pen and black ink: *Barnett Newman — 1948;* inscribed verso, upper right, in black ink: *TOP* [above an arrow pointing up]; inscribed verso, lower right, in graphite: [framer's instructions]

PROVENANCE Philip Johnson, New York, sometime between 1948 and 1952; gift to SCMA in 1952

LITERATURE *SCMA Bull* 1953, listed p. 27; Baltimore 1979–81, "Missing Drawings," no. I; SCMA 1986, no. 274, repr. (upside down, as *Black and White*)

EXHIBITIONS Possibly exhibited at a private home, New York, in a benefit for Inez Chatfield Ferren Nicholas, c. 1950; Northampton 1974c; Northampton 1979a (as *Black and White*); Northampton 1980, no. 13 (as *Black and White*); Wilkes-Barre 1981; Amherst 1990

Gift of Philip Johnson
1952:105

Known primarily as a painter, Barnett Newman also created a body of just under ninety drawings that have the character of complete and independent works of art. They are not studies for paintings, although they explore similar issues and bear a formal relationship to his canvases. Although Newman chose to include some twenty of his drawings in exhibitions during his lifetime,[2] this body of work did not become widely known until the catalogue raisonné and related exhibition organized by Brenda Richardson in 1979.

As has been noted by Richardson and others, Newman's most prolific period as a draughtsman extended from 1944 to 1948, the years of exploration that led up to the breakthrough painting *Onement I.*[3] Recognizing this canvas to be pivotal in his development as an artist, Newman described it in an interview of 1965 as "the beginning of my present life, because from then on I had to give up any relation to nature, as seen."[4] Following this important achievement, Newman devoted himself decisively to painting, executing few drawings in subsequent years, with the single exception of 1960, when a return to drawing produced twenty-two sheets.

The SCMA drawing bears the date 1948, the year Newman painted *Onement I.* Less than a third of Newman's drawings are inscribed with dates. These were not necessarily marked at the time the drawings were made, however, but were often added to the drawings only prior to publication or exhibition.[5] Almost all the drawings that were dispersed from Newman's collection were given or sold by the artist during his lifetime.[6] Most of the drawings remained in his possession, passing after his death in 1970 to his widow, Annalee Newman, as part of his estate. She catalogued the drawings, and with the help of the artist's assistant assigned dates to those without inscriptions. The SCMA sheet is one of only two drawings inscribed 1948.[7]

Newman began his formal study of art in 1922 at age seventeen, studying at the Art Students League in New York (with Duncan Smith [1877–1934]). After graduating in 1927 from City College, where he majored in philosophy, he worked in his father's garment business, but he returned to studies at the Art Students League from 1929 to 1931 (studying with Harry Wickey [b. 1892] and John Sloan [1871–1951]) and taught art as a substitute teacher in New York high schools. At this time, he met Milton Avery (1893–1965), Adolph Gottlieb (1903–1974), and Mark Rothko (1903–1970). The biomorphic shapes that characterize Newman's drawings from the mid-1940s may reflect his study of botany and ornithology,[8] but also clearly reveal the influence of Surrealism, which European artists such as Max Ernst (1891–1976), André Masson (1896–1987), and André Breton (1896–1966) had brought to the United States. These artists and others, including Piet Mondrian (1872–1944), came to New York in the 1940s as a result of World War II and exerted a potent influence on the younger generation of American artists.

In 1943 Newman met Betty Parsons, who was operating the Wakefield Gallery, a small art gallery at the back of a bookshop. The following year he organized an exhibition for her of Pre-Columbian sculpture (for which he wrote the catalogue foreword), and two years later, when she opened her own gallery, he organized (and wrote the catalogue for) the inaugural exhibition *Northwest Coast Indian Painting.* Newman also began to exhibit his own work in group shows at the Betty Parsons Gallery, beginning in the exhibition he organized in 1947 called *The Ideographic Picture.* His first solo exhibition at the gallery (1950) was poorly received, however, as was his second in 1951.

The untitled SCMA sheet is a particularly powerful example of Newman's brush and ink drawings. It incorporates one of three motifs that appear frequently in his drawings after 1945, one that Brenda Richardson describes as "the beam," an "extended v-shape which is like the beam of a searchlight probing the sky."[9] This beam is created from the reserved white paper remaining between two swaths of black ink. After its first appearance, in a

260 BARNETT NEWMAN

drawing of 1945, this form always extends the length of the sheet from top to bottom, as in the SCMA drawing.[10] Like a number of other examples, the beam in the SCMA drawing has been achieved by masking the edges of the reserve with tape, a practice Newman may have employed first in a drawing of 1946.[11] In the SCMA sheet, the dense black curtain of ink brushed on each side of the reserve is pierced by irregular fissures between strokes of Newman's brush. Unlike earlier drawings, where his strokes had separated more distinctly into ribbons or bands of ink or where he had used a dry-brush technique to feather ink over a textured paper, the SCMA sheet presents a dense black ground that contrasts starkly with the beam and with the fissures allowed to stand within the black.[12] The beam is also centrally placed, a characteristic that Richardson sees as decisive in the move toward clarity, balance, and concentration that culminated in the painting *Onement I*.

From the irregular dimensions of his drawing sheets and the minor slices into the interior of many drawings, Richardson concludes that Newman commonly trimmed his sheets as a compositional technique.[13] This seems not to be the case, however, in the SCMA drawing, which is an imposing sheet, several inches larger than most of Newman's other drawings of the late 1940s. While there are no pinholes in the sheet to show that Newman pinned it up before painting, there are also no nicks to indicate that the sheet was later cut down. Moreover, the ink has stained all edges of the paper, indicating that none was trimmed after the drawing was completed.[14] Although one edge of the drawing is ruled in graphite on the verso, this seems more likely to have been an indication of where to trim the paper preparatory to drawing.

When Brenda Richardson published her catalogue raisonné of Newman's drawings in 1979, she was unaware of the SCMA drawing, and published as the single drawing by Newman dated 1948 an untitled brush and ink drawing in the collection of Mrs. Frances Cohen, Brooklyn, New York.[15] Richardson considered that sheet unique in its use of an unusually dense wash of black ink, but a similar sensibility is also present in the SCMA drawing. This denser covering of the drawing's ground led Jeremy Strick to suggest that the Cohen drawing may have been executed following *Onement I*.[16]

It appears that the Smith sheet is the drawing listed by Richardson under "Missing Drawings" as the one contributed by Newman to an exhibition organized in about 1950 by Jimmy Ernst and Jane Gunther for the benefit of Inez Chatfield Ferren Nicholas (once married to the artist John Ferren [1905–1970]), who had become seriously ill.

The show was held in a private home in Manhattan, and although, according to Richardson, Newman's drawing was not sold during the exhibition, it is unaccounted for in the artist's subsequent records.[17]

AHS

1. Newman titled relatively few of his drawings. Although the SCMA sheet is called *Black and White* in the museum's records and has been published under that title since its acquisition, there is no reason to think the title was assigned by the artist.

2. Richardson in Baltimore 1979–81, pp. 213–19, according to whom Newman selected about 20 different drawings for inclusion in 9 separate exhibitions, the first of which was in early 1947 at the Betty Parsons Gallery in New York.

3. Oil on canvas, 27¼ × 16¼ in.; collection of the Museum of Modern Art, New York (see Minneapolis/St. Louis/New York 1994, pl. 50).

4. Quoted by Jeremy Strick in Minneapolis/St. Louis/New York 1994 from an interview with David Sylvester in 1965. In another interview (1970) Newman says this painting was made on his birthday, 29 Jan. 1948. See O'Neill 1992, p. 305, interview with Emile de Antonio.

5. See for example, Baltimore 1979–81, nos. 44, repr., and 56, repr. Newman dated only 26 of the 83 extant drawings known to Richardson.

6. Richardson cites a single exception (see ibid., p. 33).

7. The other is Baltimore 1978–81, no. 45, repr. The other two works Richardson assigns to this year are oil paintings on paper (see nos. 53, repr., and 54, repr.).

8. Newman took courses at the Brooklyn Botanic Garden and at Cornell University, Ithaca, N.Y.

9. Baltimore 1979–81, p. 90.

10. The first appearance of the beam is in the untitled drawing, Baltimore 1979–81, no. 29, repr. For other examples, see nos. 30–33, 36–39, and 42, all repr.

11. Ibid., no. 30, signed and dated 1946. Richardson notes that Newman's first use of tape in his paintings seems to occur in this year, and suggests the influence of a Mondrian exhibition in early spring 1945 on Newman's adoption of this process.

12. Compare Baltimore 1979–81, nos. 30 and 31, or 37 and 38, all repr.

13. Ibid., p. 31.

14. The ink has stained the bottom edge of the sheet and continues onto the verso. It also stains the left edge of the drawing (leaving some marks on the verso), as well as the right. The top edge of the drawing has some staining from ink, but for the most part the ink does not go all the way across the edge.

15. Baltimore 1979–81, no. 45.

16. See Minneapolis/St. Louis/New York 1994, p. 27.

17. Baltimore 1979–81, "Missing Drawings" no. I. Richardson notes that the drawing was never photographed. Philip Johnson does not have a record of where or when he acquired the drawing but thinks he must have gotten it directly from the artist (letter of 25 June 1996 to the author, SCMA curatorial files).

MARK TOBEY
Centerville, Wisconsin, 1890–1976, Switzerland

68 *Echo*, 1954

Brush with transparent and opaque watercolor on brown paper laid down on mat board

Watermark: None

445 × 292 mm (17½ × 11½ in.)

Signed and dated recto, lower right, in red ballpoint ink: *Tobey '54*

PROVENANCE {Willard Gallery, New York}; to Sigmund W. (1901–1977) and Maxine (1903–1978) Kunstadter, Chicago, in June 1954; to the estate of Mrs. Sigmund W. Kunstadter; gift to SCMA in 1978

LITERATURE SCMA 1986, no. 276, repr.

EXHIBITIONS Chicago 1955; Paris 1961, no. 119; London 1962, no. 77; Northampton 1979a; Northampton 1980, no. 24; Northampton 1985c, no. 87; Amherst 1990a

Gift of the Estate of Mrs. Sigmund W. Kunstadter (Maxine Weil, class of 1924)
1978:56-40

Mark Tobey, best known for his delicate abstract tempera paintings on paper, strove to unite Eastern and Western cultural impulses in his art. He spent most of his life in New York and Seattle, traveling frequently in the Far East and Europe. In 1918 he discovered the Baha'i World Faith, a "universal" religion founded in Persia in 1844, promoting unity among all religions and equilibrium between science and religion as necessary for the progress of humanity. Tobey's conversion to Baha'i shaped his intellectual, spiritual, and artistic development as it initiated a long period of exploration of Asian art and philosophy. An influential but peripheral artist in the abstract expressionist movement in the 1950s, his small-scale, contemplative paintings were overshadowed by the bold, aggressive works of Jackson Pollock (1912–1956) and Willem de Kooning (1904–1997). Yet Pollock, on seeing Tobey's 1944 exhibition of "white writing" pictures at the Willard Gallery, was impressed and described Tobey as an "exception" to the rule that New York was "the only place in America where painting (in the real sense) can come thru."[1] In 1961 Tobey became the first living American to be honored with a retrospective at the Louvre; a contemporary reviewer pointed out at the time that he was "considered by prominent artists of the School of Paris, as well as by established European art dealers, to be the foremost living American painter."[2]

During his youth in Chicago, Tobey studied pastel at the School of the Art Institute of Chicago; after his move to New York in 1913 he worked as a magazine illustrator, interior designer, and portraitist. He began studying Chinese brush painting in 1922, and in 1934 he traveled through China and Japan with the British potter Bernard Leach (1887–1979), a fellow believer in Baha'i. He spent a month at a Zen monastery studying brush painting, calligraphy, meditation, and poetry, an experience that seems to have crystallized his emerging style. Despite his early interest in Asian art, most of his paintings and drawings of the 1930s and 1940s are rooted in the Western urban environment. Works such as *Broadway* (1935, The Metropolitan Museum of Art, New York) convey his interest in the dynamism of urban life, which he shared with Lyonel Feininger (1871–1956), a friend and collector of his art. Of these early works, he wrote: "No doubt I did them because I am an American painter. I cannot be indifferent to the swarming crowds, multitudes, neon signs, movie theatres, to the noises that I hate of modern cities."[3]

During the 1950s, Tobey gradually eliminated references to urban environments and began to paint mystical abstract works, such as *Echo,* which represent the coalescence of Oriental calligraphy and abstract expressionist painting. Composed of delicately interwoven lines, *Echo* is a sort of "meditative tablet"[4] inviting reflection. Spidery threads of tempera paint dance across its surface in a manner suggesting Eastern scripts or Egyptian hieroglyphs. Flecks of black ink, applied with an atomizer, add to the surface texture. Tobey generally began painting by applying a warm, purplish grey ground, over which he layered his colors, progressing from dark to light and from loose to tight brushwork. Subtle tonal gradations were achieved by washing down the surface between applications of paint with a brush or sponge. Although he generally described his medium as tempera, he probably used a mixture without egg that was similar to an opaque watercolor or gouache.[5]

In many of his elegant, kaleidoscopic drawings, Tobey translated the controlled energy of Oriental calligraphy into his own method of painting known as "white writing," an "automatic" technique that involved laying down free-flowing white lines against a dark background. Tobey explained that his aim was to explore how "structures" could be made in white: "Why did they always have to be in black? I painted them in white because I thought structures could be, should be light. What I was fundamentally interested in at the time was light."[6] Light, space, movement, and energy are the principal themes of his

work, and white signified light, which had mystical and divine relevance. He also described his "white writing" as a "performance."[7]

Like Paul Klee (1879–1940), whose work he admired, Tobey aimed to represent in his paintings and drawings mystical states of being. He shared with Klee an interest in symbols, scripts, music, and movement, and like Klee he worked on an intimate scale. Tobey attempted to "decentralize" his pictures, hoping to "penetrate perspective and bring the far near."[8] As William Seitz has noted, "Some of Tobey's apparently flat pictures, if looked at long enough, fall back above center in a domical or hemispherical vortex."[9] Each line in his paintings has "a purpose and a meaning important to the whole," and Tobey emphasized that "contemporary painting is a total conception no part of which is valid without the other."[10] He created his rhythmic paintings like musical scores, studying the relationships between all the elements of a composition.

During the 1950s Tobey explored a variety of painting techniques, many of which drew from Oriental art forms and writing. In 1957 he created a series of Japanese *sumi* (ink) drawings, using opaque black ink that was thrown and spattered in a controlled manner on paper. The SCMA owns a *sumi* drawing entitled *Space Ritual No. 4*, 1957, along with several other examples of Tobey's work. Tobey abandoned the *sumi* drawings as quickly as he had started them, declaring after two months, "I've had my fling."[11] He characterized the path of his artistic career as a "zig-zag — in and out of old cultures, seeking new horizons," and explained, "I have sought a unified world in my work and used a moveable vortex to achieve it."[12]

KE

1. Letter from Jackson Pollock to Louis Bunce, 2 June 1946, as quoted in Naifeh and Smith 1989, p. 526.

2. Watt 1961, p. 112.

3. Mark Tobey in Chevalier 1961, p. 7, as quoted in William Seitz, "Tobey's World View," in Dahl 1984, p. 18.

4. Schmied 1966, p. 34.

5. Judith S. Kays, in Stanford 1990, p. 13, states that "Although the majority of his works are labeled 'tempera,' there is considerable ambiguity concerning the types of pigment that Tobey used." Profiting from extensive discussions with Tobey's artist friends, Kays notes that he frequently combined two or more paint types in a single work. "Those interviewed agreed that Tobey used the term 'tempera' in the generic sense; because Tobey employed so many different types of pigments, often simultaneously, 'opaque watercolor' might be a more accurate appellation for the majority of Tobey's painted works." Kays also documents Tobey's method of mounting sheets at Charles Seliger's studio. "Employing a method devised by friends, the original sheet was mounted directly on composition board with wheat paste; another sheet of paper was then glued to the back of the board. Tobey felt this strengthened and prevented puckering of the tissue-thin paper" (p. 14).

6. Tobey in Davis 1974, p. 58.

7. Tobey, in Kuh 1962, p. 240.

8. Ibid., pp. 237 and 240.

9. New York/Cleveland/Chicago 1962–63, p. 31.

10. Tobey, quoted in Seattle 1970–71, unpag.

11. Tobey, letter to Ulfert Wilke, early 1958, Archives of American Art, Smithsonian Institution, Washington, D.C., as quoted in Washington 1984b, p. 66.

12. Tobey, letter to Katherine Kuh, 28 Oct. 1954, in Kuh 1962, p. 244.

WATERMARKS

cat. 2

cat. 4

cat. 6

All watermarks are reproduced at full scale except cats. 39 (reproduced at 88%), 45, and 47 (both reproduced at 80%).

cat. 13

cat. 22

cat. 24

cat. 24

cat. 25

cat. 30

cat. 35

cat. 39

cat. 45

cat. 47

cat. 58

cat. 63

cat. 63

REFERENCES

LITERATURE

Abbreviations

ArtD	*Art Digest*
ArtJ	*Art Journal*
ArtN	*Art News*
ArtQ	*Art Quarterly*
Burl	*Burlington Magazine*
FARL	Frick Art Reference Library
GBA	*Gazette des Beaux-Arts*
SCMA	Smith College Museum of Art
SCMA Bull	*Smith College Museum of Art Bulletin*
Smith AlumQ	*Smith Alumnae Quarterly*

Abbott 1934
Jere Abbott. "La Fille de Jephté." *SCMA Bull*, no. 15 (June 1934), pp. 2–7.

Abbott 1938
J[ere] A[bbott]. "A Drawing by J.-A.-D. Ingres." *SCMA Bull*, nos. 18–19 (June 1938), pp. 7–9.

Abbott 1939a
Jere Abbott. "Classics and Moderns at Smith." *ArtN* (21 Jan. 1939), pp. 7, 20.

Abbott 1939b
Jere Abbott. "Two Drawings by Seurat." *SCMA Bull*, no. 20 (June 1939), pp. 19–22.

Adhémar 1954
Jean Adhémar. "Aretino: Artistic Advisor to Francis I." *Journal of the Warburg and Courtauld Institutes* 17 (1954), pp. 311–18. First published as "L'Aretine conseilleur artistique de François I." *Mélanges Van Moe.* Paris, 1950.

Adhémar 1965
Jean Adhémar. *Toulouse-Lautrec: His Complete Lithographs and Drypoints.* New York: Harry N. Abrams, 1965.

Ainsworth 1998
Maryan Ainsworth. *Gerard David: Purity of Vision in an Age of Transition.* New York: The Metropolitan Museum of Art, 1998.

Alazard 1950
Jean Alazard. *Ingres et l'ingrisme.* Paris: Editions Albin Michel, 1950.

Albertina 1933
Graphische Sammlung Albertina. *Die Zeichnungen der deutschen Schulen bis zum Beginn des Klassizismus.* Cat. by Hans Tietze-Conrat, Otto Benesch, and Karl Garzarolli-Thurnlackh. Beschreibender Katalog der Handzeichnungen in der Graphischen Sammlung Albertina, vol. 4 (text), vol. 5 (plates). Vienna: Anton Schroll & Co., 1933.

Allen 1831
Thomas Allen. *A New and Complete History of the County of York,* vol. 3. London: I. T. Hinton, 1831.

Amishai-Maisels 1985
Ziva Amishai-Maisels. *Gauguin's Religious Themes.* Ph.D. diss., Hebrew University, 1969. New York: Garland, 1985.

Ananoff 1961–70
Alexandre Ananoff. *L'Oeuvre dessiné de Jean-Honoré Fragonard 1732–1806. Catalogue Raisonné.* 4 vols. Paris: F. de Nobele, Libraire, 1961–70.

Ananoff and Wildenstein 1976
Alexandre Ananoff with the collaboration of Daniel Wildenstein. *François Boucher.* 2 vols. Lausanne and Paris: Bibliothèque des Arts, 1976.

Andersson 1978
Christiane Andersson. *Dirnen, Krieger, Narren: Ausgewählte Zeichnungen von Urs Graf.* Basel: GS-Verlag, 1978.

Angoulvent 1933
Paul-J. Angoulvent. *La Chalcographie du Louvre: Catalogue général.* Paris: Musées nationaux, 1933.

Apollonio 1947
Umbro Apollonio. *Disegni di Seurat.* Venice: Edizioni del Cavallino, 1947.

Ariosto 1974
Ludovico Ariosto. *Orlando furioso.* An English prose translation by Guido Waldman. London, Oxford, New York: Oxford University Press, 1974.

Art and Auction 1960a
Art and Auction 4, no. 80 (31 May 1960), p. 836.

Art and Auction 1960b
Art and Auction 5, no. 91 (30 Nov. 1960), p. 192.

Art and Auction 1993
"Tunick Ups the Ante on Kornfeld." *Art and Auction* 15, no. 9 (April 1993), p. 18.

ArtD 1940
"Golden Gate Presents Magnificent Show of Old Master Drawings." *ArtD* (Golden Gate Special Number), 14, no. 18 (July 1, 1940), pp. 20–21.

ArtD 1953
"Benefit for Private Education." *ArtD* (1 April 1953), p. 14.

ArtJ 1961–62
"College Museum Notes: Smith College." *ArtJ* 21, no. 2 (Winter 1961–62), p. 124.

ArtJ 1969–70
"College Museum Notes — Acquisitions." *ArtJ* 29, no. 2 (Winter 1969–70), pp. 212–24.

ArtJ 1977
"News." *ArtJ* 36, no. 4 (Summer 1977), pp. 332–43.

ArtN 1937
"Northampton: A New Ingres Drawing and a Bonnard Landscape." *ArtN* 11, no. 11 (Dec. 1937), p. 17.

ArtN 1959
"Drawings from H. M. the Queen and Others." *ArtN* 58, no. 6 (Oct. 1959), pp. 35–36.

ArtQ 1957a
"Accessions of American and Canadian Museums, October–December 1956." *ArtQ* 20, no. 1 (Spring 1957), pp. 93–105.

ArtQ 1957b
"Accessions of American and Canadian Museums, July–September 1957." *ArtQ* 20, no. 4 (Winter 1957), pp. 469–79.

ArtQ 1958
"Accessions of American and Canadian Museums, October–December, 1957." *ArtQ* 21, no. 1 (Spring 1958), pp. 82–95.

ArtQ 1959
"Accessions of American and Canadian Museums, January–March, 1958." *ArtQ* 21, no. 2 (Summer 1959), pp. 216–30.

ArtQ 1960a
"Accessions of American and Canadian Museums." *ArtQ* 23, no. 3 (Autumn 1960), pp. 301–10.

ArtQ 1960b
"Accessions of American and Canadian Museums, July–September 1960." *ArtQ* 23, no. 4 (Winter 1960), pp. 398–407.

ArtQ 1961
"Accessions of American and Canadian Museums, July–September 1961." *ArtQ* 24, no. 4 (Winter 1961), pp. 395–412.

ArtQ 1965
"Accessions of American and Canadian Museums." *ArtQ* 28, no. 3 (1965), pp. 209–26.

Arts 1956
"In the Galleries: Drawings." *Arts* 31, no. 1 (Oct. 1956), p. 54.

Astre 1926
Achille Astre. *H. de Toulouse-Lautrec*. Paris: Editions Nilsson, 1926.

Aubert 1985
Jean Aubert. "Catalogue sommaire des peintures néo-classiques du Musée de Chambéry." *Echo des musées de Chambéry* (June 1985).

Baal-Teshuva 1995
Jacob Baal-Teshuva, ed. *Chagall: A Retrospective*. New York: Levin, 1995.

Baal-Teshuva 1998
Jacob Baal-Teshuva. *Marc Chagall 1887–1985*. Cologne: Taschen, 1998.

Bacon 1898
Edwin M. Bacon. *Walks and Rides in the Country round about Boston*. Cambridge, Mass.: Riverside Press; Boston: Appalachian Mountain Club and Houghton, Mifflin and Co., 1898.

Bacou 1964
Rosaline Bacou. "The Bonger Collection at Almen, Holland." *Apollo*, n.s., 80, no. 33 (Nov. 1964), pp. 398–401.

Baigell 1979
Matthew Baigell. *Dictionary of American Art*. New York: Harper and Row, 1979.

Bailey 1990
Martin Bailey. *Young Vincent: The Story of van Gogh's Years in England*. London: Allison & Busby, 1990.

Bailey, Brooke, and Farrell 1970
Kenneth Bailey, Elizabeth Brooke, and John J. Farrell. *The American Adventure*. San Francisco: Field Educational Publications, 1970.

Baldass 1938
Ludwig von Baldass. "Albrecht Altdorfers künstlerische Herkunft und Wirkung." *Jahrbuch der Kunsthistorischen Sammlungen in Wien*, n.s., 12 (1938), pp. 117–56.

Bapst 1889
Germain Bapst. "Quatre Gravures de Moreau le Jeune pour les fêtes de la Ville de Paris (1782)." *GBA* 31, no. 3 (1889), pp. 131–36.

Bartsch
Adam von Bartsch. *Le Peintre graveur*. 21 vols. Leipzig: J. A. Barth, 1808–54.

Illustrated Bartsch
Adam von Bartsch. *The Illustrated Bartsch*. General ed. Walter L. Strauss. New York: Abaris Books, 1978–.

Bauchal 1887
Charles Bauchal. *Nouveau Dictionnaire biographique et critique des architectes français*. Paris: André Daly fils, 1887.

Baumgart 1974
Fritz Erwin Baumgart. *Grünewald, tutti i disegni*. Florence: La Nuova Italia, 1974.

Baur 1982
John I. H. Baur. *The Inlander: Life and Work of Charles Burchfield, 1893–1967*. East Brunswick, N.J.: Associated University Presses and Cornwall Books, 1982.

Baur et al. 1957
John I. H. Baur, ed. *New Art in America: Fifty Painters of the 20th Century*. Greenwich, Conn.: New York Graphic Society, 1957.

Bazin 1987–94
Germain Bazin. *Théodore Géricault: Etude critique, documents et catalogue raisonné*. 6 vols. Paris: Bibliothèque des arts, 1987–94. Vols. 1–2 (1987); Vol. 3 (1989); Vol. 4 (1990); Vol. 5 (1992); Vol. 6 (1994).

Bean and Turčić 1986
Jacob Bean with the assistance of Lawrence Turčić. *Fifteenth–Eighteenth-Century French Drawings in the Metropolitan Museum of Art*. New York: The Metropolitan Museum of Art, 1986.

Beardsley 1897
Aubrey Beardsley. *A Book of Fifty Drawings by Aubrey Beardsley, with an Iconography by Aymer Vallance*. London: Leonard Smithers, 1897.

Beck 1966
Hans Ulrich Beck. "Jan van Goyen am Deichbruch von Houtewael (1651)." *Oud Holland* 81, no. 1 (1966), pp. 20–33.

Beck 1972 and 1973
Hans Ulrich Beck. *Jan van Goyen, 1596–1656. Ein Oeuvreverzeichnis in Zwei Bänden. Mit einem Geleitwort von Wolfgang Stechow*. 2 vols. Amsterdam: Van Galdt and Co., 1972–73. Vol. 1 (1972), *Einführung, Katalog der Handzeichnungen*; vol. 2 (1973), *Katalog der Gemälde*.

Becker 1938
Hanna L. Becker. *Die Handzeichnungen Albrecht Altdorfers.*
Münchener Beiträge zur Kunstgeschichte I. Munich: Neuer
Filser-Verlag, 1938.

Béguin 1969
Sylvie Béguin. "La Vièrge, Reine des Anges par le Primatice." *La
Revue du Louvre et des Musées de France* 19, no. 3 (1969), pp. 143–56.

Béguin 1989
Sylvie Béguin. "New Evidence for Rosso in France." *Burl* 131,
no. 1041 (Dec. 1989), pp. 828–84.

Béguin 1990
Sylvie Béguin. "Rosso Fiorentino's *St. Peter and St. Paul.*" *Print
Quarterly* 7, no. 2 (June 1990), pp. 164–67.

Behling 1955
Lottlisa Behling. *Die Handzeichnungen des Mathis Gothart Nithart
genannt Grünewald.* Weimar: Herman Bohlaus Nachfolger, 1955.

Behling 1981
Lottlisa Behling. *Matthias Grünewald.* Strasbourg: 1981.

Benesch and Auer 1957
Otto Benesch and Erwin M. Auer. *Die Historia Friderici et
Maximiliani.* Denkmäler deutscher Kunst. Berlin: Deutscher
Verein für Kunstwissenschaft, 1957.

Benkovitz 1981
Miriam J. Benkovitz. *Aubrey Beardsley. An Account of His Life.*
New York: Putnam, 1981.

Benson 1935
Emanuel Mervin Benson. *John Marin: The Man and His Work.*
Washington, D.C.: American Federation of Arts, 1935.

Béraldi
Henri Béraldi. *Les Graveurs du XIX siècle. Guide de l'Amateur
d'Estampes Modernes.* 12 vols. Paris: L. Conquet, 1885–92.

Berger 1952
Klaus Berger. *Géricault und sein Werk.* Vienna: A. Schroll, 1952.

Berger 1955
Klaus Berger. *Géricault and His Work.* Translated by Winslow
Ames. Lawrence: University of Kansas Press, 1955.

Berger 1965
Klaus Berger. *Odilon Redon: Fantasy and Colour.* Cologne: DuMont
Schauburg, 1964. Translated by Michael Bullock. New York,
Toronto, London: McGraw-Hill Book Company, 1965.

Bertini 1958
Aldo Bertini. *I disegni italiani della biblioteca reale di Torino.* Rome:
Istituto Poligrafico dello stato, Libreria dello stato, 1958.

Bianconi 1972
Piero Bianconi. *L'opera completa di Grünewald.* I Classici
dell'arte 58. Milan: Rizzoli Editore, 1972.

Blanc 1870
Charles Blanc. *Ingres, sa vie et ses ouvrages.* Paris: Vve. J. Renouard,
1870.

Blotkamp 1995
Karel Blotkamp. *Mondrian: The Art of Destruction.* New York:
Harry N. Abrams, 1995.

Bocher 1882
Emmanuel Bocher. *Les Gravures françaises du XVIIIe siècle ou cata-
logue raisonné des estampes, vignettes, eaux-fortes, pièces en couleur
au bistre et au lavis, de 1700 à 1800. Sixième fascicule: Jean-Michel
Moreau le Jeune.* Paris: Damascène Morgand et Charles Fatout,
1882.

Bock 1921
Elfried Bock, ed. *Staatliche Museen zu Berlin Kupferstichkabinett.
Die deutscher Meister: Beschreibendes Verzeichnis sämtliche
Zeichnungen.* Series editor Max J. Friedländer. 2 vols. Berlin:
Julius Bard, 1921.

Bodelsen 1964
Merete Bodelsen. *Gauguin's Ceramics: A Study in the Development
of His Art.* London: Faber and Faber, 1964.

(Boston) City Record 1960
"Fame Comes, Posthumously, to an L Street Brownie." *(Boston)
City Record* 52 (29 Oct. 1960), p. 2.

Boston Globe 1960a
"Old Boston Scenes by Hub Artist." *Boston Sunday Globe,* 23 Oct.
1960, pp. 36–37.

Boston Globe 1960b
Robert Taylor. "One Vote Cast for Prendergast." *Boston Globe,*
8 Nov. 1960, p. 32.

Boston Parks 1890–1900
City of Boston, Department of Parks. *Annual Reports of the
Board of Commissioners.* 1890 to 1900.

Bouchot-Saupique 1958
J[aqueline] Bouchot-Saupique. "Dessins français des collections
américains." *Art et Styles* 47 (1958).

Bowron 1980
Edgar Peters Bowron. "Benedetto Luti's Pastels and Colored
Chalk Drawings." *Apollo,* n.s., III, no. 220 (June 1980), pp. 440–47.

Brame and Reff 1984
Philippe Brame and Theodore Reff. *Degas et son oeuvre:
A Supplement.* New York and London: Garland, 1984.

Briquet
C. M. Briquet. *Les Filigranes: Dictionnaire historique des marques
du papier dès leur apparition vers 1282 jusqu'en 1600.* 2d ed. 4 vols.
Reprint. New York: Hacker Art Books, 1966.

Brook 1960
Roy Brook. *The Story of Eltham Palace.* London: George G.
Harrap & Co., Ltd., 1960.

Broude 1978
Norma Broude, ed. *Seurat in Perspective.* Englewood Cliffs, N.J.:
Prentice-Hall, 1978.

Bruel 1958
André Bruel, ed. *Les Carnets de David d'Anger.* Paris: Plon, 1958.

Buck 1985
Stephanie Mary Buck. "Sarah Choate Sears: Artist, Photographer,
and Art Patron." M.F.A. thesis, Syracuse University, 1985.

Buijsen 1993
Edwin Buijsen. *The Sketchbook of Jan van Goyen from the Bredius-
Kronig Collection.* Translated by Kist & Kilian, Amsterdam. 2 vols.
The Hague: The Foundation 'Bredius Genootschap,' 1993.

Bulliet 1936
C. J. Bulliet. *The Significant Moderns and Their Pictures.* New York:
Covici Friede, 1936.

Burchfield 1945
Charles Burchfield. *Charles Burchfield*. New York: American Artists Group, 1945.

Burkhard 1936
Arthur Burkhard. *Matthias Grünewald, Personality and Accomplishment*. Cambridge, Mass.: Harvard University Press, 1936.

Burl 1918
"A Dutch Sketch-Book of 1650." *Burl* 33, nos. 184–89 (July–Dec. 1918), p. 112.

Burns 1994
Thea Burns. "Chalk or Pastel? The Use of Colored Media in Early Drawings." *The Paper Conservator: The Journal of the Institute of Paper Conservation* 18 (1994), pp. 49–56.

Busch 1967
Günter Busch. "Kopien von Théodore Géricault nach alten Meistern." *Pantheon* 25 (May–June 1967), pp. 176–84.

Butts 1988
Barbara Butts. Review of *Albrecht Altdorfer: Zeichnungen, Deckfarbenmalerei, Druckgraphik* by Hans Mielke et al. *Master Drawings* 26, no. 3 (Autumn 1988), pp. 277–85.

Byam Shaw [1951]
James Byam Shaw. *The Drawings of Francesco Guardi*. London: Faber and Faber, [1951].

Byam Shaw 1959
James Byam Shaw. "A Drawing by Francesco Guardi." *SCMA Bull,* no. 39 (1959), pp. 13–19.

Byam Shaw 1976
James Byam Shaw. *Drawings by Old Masters at Christ Church, Oxford*. 2 vols. Vol. 1, Catalogue; vol. 2, Plates. Oxford: The Clarendon Press, 1976.

Byam Shaw 1983
James Byam Shaw. *The Italian Drawings of the Frits Lugt Collection*. 3 vols. Paris: Fondation Custodia, Institut Néerlandais, 1983.

Cailleux 1960
Jean Cailleux. "Fragonard as Painter of the Colombe Sisters." ("L'Art du dix-huitième siècle: Notes and Studies on Pictures and Drawings of the Eighteenth Century," advertising supplement no. 4), *Burl* 102, no. 690 (Sept. 1960), pp. i–ix.

Cardinal 1989
Roger Cardinal. *The Landscape Vision of Paul Nash*. London: Reaktion Books, 1989.

Carman 1974
C. H. Carman. "A New Painting by Cigoli: *The Mystic Marriage of St. Catherine*." *Paragone* 25, no. 291 (May 1974), pp. 73–79.

Carroll 1975
Eugene A. Carroll. "Rosso in France," pp. 17–28. In *Actes du colloque international sur l'art de Fontainebleau*, Fontainebleau and Paris, 18–20 Oct. 1972. Edited by André Chastel. Paris: Editions du Centre National de la Recherche Scientifique, 1975.

Carroll 1978
Eugene A. Carroll. "A Drawing by Rosso Fiorentino of Judith and Holofernes." *Los Angeles County Museum of Art Bulletin* 24 (1978), pp. 24–49.

Cateforis 1991
David Christos Cateforis. "Willem de Kooning's *Women* of the 1950s: A Critical History of Their Reception and Interpretation." Ph.D. diss., Stanford University, 1991.

Causey 1980
Andrew Causey. *Paul Nash*. Oxford: Clarendon Press, 1980.

Cennini
Cennino d'Andrea Cennini. *The Craftsman's Handbook: The Italian "Il Libro dell'Arte."* Translated by Daniel V. Thompson. New York: Dover Publications, 1960.

Cézanne 1947
Paul Cézanne. *Cézanne, Ten Water Colors*. New York: Pantheon, 1947.

Chaet 1970
Bernard Chaet. *The Art of Drawing*. New York: Holt, Rinehart and Winston, 1970.

Chaet 1978
Bernard Chaet. *The Art of Drawing*. 2d ed. New York: Holt, Rinehart and Winston, 1978.

Chagall 1960
Marc Chagall. *My Life*. Translated by Elisabeth Abbott. New York: Orion Press, 1960.

Chappell 1981
Miles L. Chappell. "Missing Pictures by Ludovico Cigoli: Some Problematical Works and Some Proposals in Preparation for a Catalogue." *Paragone* 32, no. 373 (March 1981), pp. 54–101.

Chefdeville et al. 1893
L. Chefdeville, D. M., L. Raven Hill, and C. J. V. "Drawings for Reproduction by Process: Outline Work and Tint Boards." *The Studio* 1 (1893), pp. 65–72.

Chetham 1965
Charles Chetham. "Seeing Past the Bookend." *Smith AlumQ,* Winter 1965, pp. 73–76.

Chetham 1969
Charles Chetham. "The Smith College Museum of Art." *Antiques* 96, no. 5 (Nov. 1969), pp. 768–75.

Chetham 1976
Charles Chetham. *The Role of Vincent van Gogh's Copies in the Development of His Art*. New York: Garland, 1976.

Chetham 1982
Charles Chetham. "The Collector's Eye: Jere Abbott, Museum Director." *Smith AlumQ,* Fall 1982, pp. 36–37.

Chevalier 1961
Denys Chevalier. "Une Journée avec Mark Tobey." *Aujourd'hui* 6, no. 33 (Oct. 1961), pp. 4–13.

Chiari 1982
Maria Agnese Chiari. *Incisioni da Tiziano. Catalogo del fondo grafico a stampa del Museo Correr*. Supplement to *Bolletino dei Musei Civici Veneziani*. Venice: Musei Civici Veneziani d'Arte e di Storia / Comune di Venezia, Assessorato alla Cultura, 1982.

Chiarini 1983
Marco Chiarini. "Il granduca Cosimo III dei Medici e il suo contributo alle collezioni fiorentine," pp. 319–29. In vol. 1 of *Gli Uffizi: quattro secoli di una galleria: atti del convegno internazionale di studi, Firenze 20–14 settembre 1982*. Edited by Paola Barocchi

and Giovanna Ragionieri. 2 vols. Florence: Leo S. Olschki Editore, 1983.

Childs 1950
"A Maurice Prendergast Watercolor." *Childs Gallery Bulletin* (Boston), April 1950, p. 1.

Churchill
W. A. Churchill. *Watermarks in Paper in Holland, England, France, etc., in the Seventeenth and Eighteenth Centuries and Their Interconnection.* Amsterdam: Menno Hertzberger & Co., 1935. Reprinted photomechanically 1965, 3d printing 1967. Meppel: Krips Reprint Co., 1967.

Churchill 1923
A[lfred] V[ance] C[hurchill]. "College Museum Policy." *Bulletin of Smith College, Hillyer Art Gallery,* 30 March 1923, unpaginated.

Churchill 1927
Alfred Vance Churchill. "The Tryon Gallery." *Smith AlumQ* 18, no. 2 (Feb. 1927).

Churchill 1932
Alfred Vance Churchill. "Our Concentration Plan." *SCMA Bull,* no. 13 (May 1932), pp. 2–22.

Clark 1967
Anthony M. Clark. "The Portraits of Artists Drawn for Nicola Pio." *Master Drawings* 5, no. 1 (Aug. 1967), pp. 3–23.

Clark 1974
Kenneth Clark. *Henry Moore Drawings.* New York: Harper & Row, 1974.

Clark 1984
T. J. Clark. *The Painting of Modern Life: Paris in the Art of Manet and His Followers.* Princeton: Princeton University Press, 1984.

Clark, Mathews, and Owens 1990
Carol Clark, Nancy Mowll Mathews, and Gwendolyn Owens. *Maurice Brazil Prendergast, Charles Prendergast: A Catalogue Raisonné.* Williamstown, Mass.: Williams College Museum of Art; Munich: Prestel, 1990.

Clarke 1973
Michael Clarke. "Gainsborough and Loutherbourg at York." York City Art Gallery *Preview,* 1973, pp. 931–35.

Clayson 1989
S. Hollis Clayson. "The Family and the Father: The *Grande Jatte* and Its Absences." *Museum Studies* (The Art Institute of Chicago) 14, no. 2 (1989), pp. 154–64.

Collignon 1910
Albert Collignon. *Le Mécénat du Cardinal Jean de Lorraine (1498–1550).* Annales de l'Est 24, fascicule no. 2. Paris and Nancy: La Faculté des lettres de l'Université de Nancy, 1910.

Colpi 1942–54
Rosita Colpi. "Domenico Campagnola (Nuove notizie biografiche e artistiche)." *Bolletino del Museo Civico di Padova* 31–43 (1942–54), pp. 81–110.

Constable and Links 1989
W. G. Constable. *Canaletto: Giovanni Antonio Canal, 1697–1768.* 2 vols., 2d ed. revised by J. G. Links, reissued with supplement and additional notes. Oxford: Clarendon Press, 1989.

Contini 1991
Roberto Contini. *Il Cigoli.* Soncino: Edizione dei Soncino, 1991.

Conway 1921
Sir Martin Conway. *The Van Eycks and Their Followers.* London: J. Murray; New York: E. P. Dutton & Co., 1921.

Coquiot 1921
Gustave Coquiot. *Lautrec ou, Quinze ans de moeurs parisiennes, 1885–1900.* 4th ed. Paris: Ollendorff, 1921.

Courajod 1874/1994
Louis Courajod. *L'Histoire de l'Ecole des Beaux-Arts au XVIIIe siècle: L'Ecole royale des élèves protégés.* Nogent-le-Roi: Librairie des Arts et Métiers-Editions, 1994. Facsimile of *Ecole Royale des Elèves protégés.* Paris: J. B. Dumoulin, 1874.

Courboin 1895
F[rançois] Courboin. *Inventaire des dessins, photographies et gravures rélatifs à l'histoire générale de l'art, legués au département des estampes de la Bibliothèque Nationale par M. A. Armand.* 2 vols. Lille: Impr. L. Danel, 1895.

Courthion 1968
Pierre Courthion. *Georges Seurat.* Translated by Norbert Guterman. New York: Harry N. Abrams, 1968.

Courthion 1982
Pierre Courthion. *Seurat. Tutti i dipinti.* Milan: Rizzoli, 1982.

Cousturier 1921
Lucie Cousturier. *Seurat.* Collection des cahiers d'aujourd'hui. Paris: G. Crès & Cie, 1921.

Cousturier 1926
Lucie Cousturier. *Seurat.* Collection des cahiers d'aujourd'hui. Paris: G. Crès & Cie, 1926.

Crehan 1953
Hubert Crehan. "A See Change: Woman Trouble." *ArtD,* no. 27 (15 April 1953), p. 5.

Crowe and Cavalcaselle 1857
Joseph Archer Crowe and G. B. Cavalcaselle. *The Early Flemish Painters. Notices of Their Lives and Works.* London: J. Murray, 1857.

Cuzin 1988
Jean-Pierre Cuzin. *Jean-Honoré Fragonard: Life and Work. Complete Catalogue of the Oil Paintings.* Translated by Anthony Zielonka (text) and Kim-Mai Mooney (cat.) of *Fragonard: Vie et oeuvre,* 1987. With some revisions and corrections. New York: Harry N. Abrams, 1988.

Dahl 1984
Arthur L. Dahl et al. *Mark Tobey: Art and Belief.* Oxford: George Ronald, 1984.

Dauberville and Dauberville 1965–74
Jean Dauberville and Henry Dauberville. *Bonnard, Catalogue raisonné de l'oeuvre peint, 1888–1905.* 4 vols. Paris: J. and H. Bernheim, 1965–74.

Davies 1968
Martin Davies. *National Gallery Catalogues: Early Netherlandish School.* 3d rev. ed. London: National Gallery, 1968.

Davis 1974
Douglas Davis. "Mark Tobey's Earthy Magic." *Newsweek* 84, no. 5 (29 July 1974), p. 58.

Defente 1996
Denis Defente. *Saint-Médard: Trésors d'une Abbaye Royale.* Soissons: Somogy Editions d'Art, 1996.

de Kooning 1960
Willem de Kooning. "Paintings as Self-Discovery," BBC interview with David Sylvester, 30 Dec. 1960. Transcript edited and published as "Content Is a Glimpse . . . ," *Location* 1, no. 1 (Spring 1963), pp. 45–53.

Delaborde 1870
Henri Delaborde. *Ingres, sa vie, ses travaux, sa doctrine, d'après les notes manuscrits et les lettres du maître.* Paris: Plon, 1870.

Delteil 1920
Loÿs Delteil. *Le Peintre-graveur illustré: Henri de Toulouse-Lautrec.* Vols. 10 and 11. Paris: Chez l'auteur, 1920.

Dent 1928
J. M. Dent. *The Memoirs of J. M. Dent, 1849–1926. With Some Additions by Hugh R. Dent.* London and Toronto: J. M. Dent and Sons, 1928.

Denucé 1932
Jean Denucé. *Inventaire von Kunstsammlungen zu Antwerpen im 16. u. 17. Jahrhundert.* Quellen zur Geschichte der Flämischen Kunst. II. Antwerp: Verlag "De Sikkel," 1932.

Distel 1990
Anne Distel. *Impressionism: The First Collectors.* Translated by Barbara Perroud-Benson. New York: Harry N. Abrams, 1990.

Dodgson 1918
Campbell Dodgson. "A Dutch Sketch-Book of 1650." *Burl* 33, nos. 178–83 (Jan.–June 1918), pp. 234–40.

Dodgson 1924
C[ampbell] D[odgson]. Review of *Albrecht Altdorfer. Studien über die Entwicklungsfaktoren im Werke des Künstlers,* by Ludwig von Baldass, and *Albrecht Altdorfer,* by Hans Tietze. *Burl* 45, no. 257 (Aug. 1924), pp. 93–94.

Dodgson 1935
Campbell Dodgson. "A Dutch Sketchbook of 1650" (letter). *Burl* 66, no. 387 (June 1935), p. 284.

Dörnhöffer 1897
Friedrich Dörnhöffer. "Ein Cyklus von Federzeichnungen mit Darstellungen von Kriegen und Jagden Maximilians I." *Jahrbuch der Kunsthistorischen Sammlungen des Allerhochsten Kaiserhauses* 18 (1897).

Dorra and Rewald 1959
Henri Dorra and John Rewald. *Seurat: L'Oeuvre peint, biographie et catalogue critique.* Paris: Les Beaux-arts, 1959.

Dortu 1971
M. G. Dortu. *Toulouse-Lautrec et son oeuvre.* 6 vols. New York: Collectors Editions, 1971.

Dowley 1962
Francis H. Dowley. "Some Drawings by Benedetto Luti." *Art Bulletin* 44, no. 3 (Sept. 1962), pp. 219–36.

Drawings 1977
Drawings of the Great Masters. Tokyo: Kodansha Ltd, 1977.

Dreyer 1985
Peter Dreyer. "A Woodcut by Titian as a Model for Netherlandish Landscape Drawings in the Kupferstichkabinett, Berlin." *Burl* 127, no. 992 (Nov. 1985), pp. 766–67.

Duchartre 1966
Pierre Louis Duchartre. *The Italian Comedy.* 1929. Translated by Randolph T. Weaver. New York: Dover Books, 1966.

Duclaux [1992]
Lise Duclaux. *Charles Natoire, 1700–1777.* Cahiers du Dessin français, no. 8. Paris: Galerie du Bayser, Editeur, [1992].

Duncan 1977
Carol Duncan. "The Esthetics of Power in Modern Erotic Art." *Heresies* 1 (Jan. 1977), pp. 46–50.

Duncan 1989
Carol Duncan. "The MoMA's Hot Mamas." *ArtJ* 48, no. 2 (Summer 1989), pp. 171–78; reprinted in Duncan, *The Aesthetics of Power.* Cambridge: Cambridge University Press, 1993.

Duncan and Wallach 1978
Carol Duncan and Alan Wallach. "MOMA: Ordeal and Triumph on 53rd Street." *Studio International* 194, no. 988 (1978), pp. 48–57.

Edschmid 1920
Kasimir Edschmid, ed. *Tribüne der Kunst und Zeit.* Berlin: Erich Reiss Verlag, 1920.

Edwards 1987
Betty Edwards. *Drawing on the Artist Within.* New York: Simon and Schuster, 1987.

Egerton 1998
Judy Egerton. *The British School.* London: National Gallery Publications, 1998.

Eisler 1963
Colin T. Eisler. *Flemish and Dutch Drawings from the Fifteenth to the Nineteenth Century. The Drawings of the Masters.* Boston and Toronto: Little, Brown and Company, 1963.

Eitner 1953
Lorenz Eitner. "Buschbesprechungen." Review of *Géricault und sein Werk,* by Klaus Berger. *Zeitschrift für Kunstgeschichte* 16 (1953), pp. 80–82.

Eitner 1954
"Letter to the Editor." *Art Bulletin* 36, no. 2 (June 1954), pp. 167–68.

Eitner 1983
Lorenz Eitner. *Géricault, His Life and Work.* London: Orbis, 1983.

Ellis 1990
Charles S. Ellis. "Two Drawings by Fra Bartolommeo." *Paragone,* Arte 41, n.s., no. 19–20 (479–81) (Jan.–March 1990), pp. 3–19.

Emiliani 1985
Andrea Emiliani. *Federico Barocci (Urbino, 1535–1612).* 2 vols. Bologna: Nuova Alfa Editoriale, 1985.

Emiliani and Gould 1975
Andrea Emiliani and Cecil Gould. *The Sixteenth-Century Italian Schools.* London: National Gallery, 1975.

Faille 1928/1970
J.-B. de la Faille. *L'Oeuvre de Vincent van Gogh, catalogue raisonné.* 4 vols. Paris and Brussels: Les Editions G. van Oest, 1928. *The Works of Vincent van Gogh: His Paintings and Drawings.* Rev. ed. Amsterdam: Meulenhoff International, 1970.

Faison 1958
S. Lane Faison, Jr. *A Guide to the Art Museums of New England.* New York: Harcourt, Brace and Company, 1958.

Faison 1982
S. Lane Faison. *The Art Museums of New England.* Rev. and expanded ed. Boston: David R. Godine, 1982.

Fantin-Latour 1911
Mme Henri Fantin-Latour. *Catalogue de l'oeuvre complet de Fantin-Latour (1849–1904)*. Paris: H. Floury, 1911.

Faranda 1986
Franco Faranda. *Ludovico Cardi detto il Cigoli*. Introduction by Renato Rolli. *I Professori del Disegno*, directed by Alessandro Marabottini, 2. Rome: De Luca, 1986.

Feinblatt 1979
Ebria Feinblatt. "A Drawing by Carlo Maratta." *Los Angeles County Museum of Art Bulletin* 25 (1979), pp. 6–23.

Fell 1934
H. Granville Fell. "Early Spring Exhibitions: At the Palser Gallery." *Connoisseur* 93, no. 391 (March 1934), pp. 201–2.

Fischer 1989
Chris Fischer. "Fra Bartolommeo's Landscape Drawings." *Mitteilungen des Kunsthistorischen Institutes in Florenz* 33, nos. 2–3 (1989), pp. 301–42.

FitzGerald 1884
Edward FitzGerald, trans. *Rubáiyát of Omar Khayyám, with an Accompaniment of Drawings by Elihu Vedder*. Boston: Houghton Mifflin, 1884.

Fitzsimmons 1953a
James Fitzsimmons. "Benefit for Private Education." *ArtD* 27, no. 13 (1 April 1953), p. 14.

Fitzsimmons 1953b
James Fitzsimmons. "Art." *Arts and Architecture* 70, no. 5 (May 1953), pp. 4, 6–10.

Flam 1973
Jack D. Flam. *Matisse on Art*. New York and London: Phaidon Press, 1973.

Flemish . . . Art 1965
Flemish and Dutch Art. Vol 3. London: George Rainbird Limited, 1965.

Forge 1968
Andrew Forge. "De Kooning's *Women*." *Studio International* 176, no. 906 (Dec. 1968), pp. 246–51.

Forster-Hahn 1978
Françoise Forster-Hahn. "Authenticity into Ambivalence: The Evolution of Menzel's Drawings." *Master Drawings* 16, no. 3 (Autumn 1978), pp. 255–83.

Fraenger 1983
Wilhelm Fraenger. *Matthias Grünewald*. Dresden: VEB Verlag der Kunst, 1983.

Franklin 1988
David Franklin. "Rosso at the National Gallery." Review of *Rosso Fiorentino. Drawings, Prints, and Decorative Arts* by Eugene A. Carroll. *Burl* 130, no. 1021 (April 1988), pp. 323–26.

Frey 1994
Julia Frey. *Toulouse-Lautrec: A Life*. New York: Viking, 1994.

Friedlaender 1926
Max J. Friedlaender. *Die Grünewald Zeichnungen der Sammlung v. Savigny*. Berlin: G. Grote Verlag, 1927.

Friedlaender 1927
Max J. Friedlaender. *Die Zeichnungen von Matthias Grünewald*. Berlin: G. Grote Verlag, 1927.

Friedlaender 1968
Max J. Friedlaender. *Dieric Bouts and Joos van Gent*. Comments and notes by Nicole Veronee-Verhager. Vol. 3 of *Early Netherlandish Painting*. Translated by Heinz Norden. Leiden: A. W. Sijthoff; Brussels: Editions de la Connaissance, 1968.

Fries 1964
Gerhard Fries. "Degas et les maîtres." *Art de France* 4 (1964), pp. 352–59.

Fromme 1981
Babbette Brandt Fromme. *Curators' Choice: An Introduction to the Art Museums of the U.S., Northeastern Edition*. New York: Crown Publishers, Inc., 1981.

Frommel 1998
Sabine Frommel. *Sebastiano Serlio architetto*. Milan: Electa, 1998.

Fuerstein 1930
Heinrich Fuerstein. *Matthias Grünewald*. Bonn: Verlag der Buchgemeinde, 1930.

Gallatin 1945
A. E. Gallatin. *Aubrey Beardsley. Catalogue of Drawings and Bibliography*. New York: The Grolier Club, 1945.

Gallo 1941
Rodolfo Gallo. *L'incisione nel '700 a Venezia e a Bassano*. Venice: Libreria Serenissima Depositaria, 1941.

Gascoigne 1986
Bamber Gascoigne. *How to Identify Prints: A Complete Guide to Manual and Mechanical Processes from Woodcut to Ink Jet*. New York: Thames and Hudson, 1986.

Gaudibert 1953
Pierre Gaudibert. "Géricault." *Europe*, no. 106 (October 1953), pp. 74–101.

GBA 1960
"La Chronique des Arts," supplement no. 1092 to *GBA* 55 (Jan. 1960), pp. 1–52.

GBA 1961
"La Chronique des Arts," supplement no. 1105 to *GBA* 57 (Feb. 1961), pp. 1–80.

GBA 1968
"La Chronique des Arts," supplement no. 1189 to *GBA* 71 (Feb. 1968).

GBA 1985
"Principales Acquisitions des musées en 1984," pp. 1–71 in "La Chronique des Arts," supplement no. 1394 to *GBA* 105 (March 1985).

GBA 1991
"Principales Acquisitions des musées en 1990," pp. 3–83 in "La Chronique des Arts," supplement no. 1466 to *GBA* 117 (March 1991).

GBA 1993
"Principales Acquisitions des musées en 1992," pp. 1–84 in "La Chronique des Arts," supplement no. 1490 to *GBA* 121 (March 1993), pp. 1–104.

GBA 1998
"Principales Acquisitions des musées en 1997," pp. 1–84 in "La Chronique des Arts," unnumbered supplement to *GBA* 131 (March 1998).

Geelhaar 1973
Christian Geelhaar. *Paul Klee and the Bauhaus*. Greenwich, Conn.: New York Graphic Society, 1973.

Geisberg 1974
Max Geisberg. *The German Single-Leaf Woodcut 1500–1550*. Revised and edited by Walter L. Strauss. 7 vols. New York: Hacker Art Books, 1974.

Geist 1953
Sidney Geist. "Work in Progress." *ArtD* 27 (1 April 1953), p. 15.

George 1967
Waldemar George. *Dessins d'Ingres*. Collection Grands Dessinateurs 3. Paris: Editions du Colombier et Albin Michel, 1967.

Giltaij 1988
Jeroen Giltaij. *The Drawings by Rembrandt and His School in the Museum Boymans-van Beuningen*. Rotterdam: Museum Boymans-van Beuningen, 1988.

Glaesemer 1973
Jürgen Glaesemer. *Paul Klee: Handzeichnungen I: Kindheit bis 1920*. Bern: Kunstmuseum Bern, 1973.

Glaesemer 1984
Jürgen Glaesemer. *Paul Klee: Handzeichnungen II, 1921–1936*. Bern: Kunstmuseum Bern, 1984.

Glavin 1982
Ellen Glavin, S.N.D. "The Boston Experience." *Art and Antiques* 5, no. 4 (July–Aug. 1982), pp. 64–71.

Goffin 1907
Arnold Goffin. *Thiéry Bouts*. Collection des Grands Artistes des Pays-Bas. Brussels: Librairie Nationale d'Art et d'Histoire, G. Van Oest & Cie, 1907.

Goldner 1988
George R. Goldner. *European Drawings. 1. Catalogue of the Collections*. With the assistance of Lee Hendrix and Gloria Williams. Malibu, Calif.: The J. Paul Getty Museum, 1988.

Goldstein 1992
Nathan Goldstein. *The Art of Responsive Drawing*. Englewood Cliffs, N.J.: Prentice-Hall, 1992.

Goldwater 1940
Robert J. Goldwater. "David and Ingres." *Art in America* 28, no. 2 (April 1940), pp. 83–84.

Goodrich
Lloyd Goodrich. *Goodrich Archives in the Whitney Museum of American Art*. Archives of American Art, Smithsonian Institution.

Gray 1963
Christopher Gray. *Sculpture and Ceramics of Paul Gauguin*. Baltimore: The Johns Hopkins University Press, 1963.

Greenberg 1954
Clement Greenberg. "Abstract and Representational." *Arts Digest* 29 (1 Nov. 1954), pp. 6–8.

Greenberg 1955
Clement Greenberg. "'American Type' Painting." *Partisan Review* 22, no. 2 (Spring 1955), pp. 179–96.

Grohmann 1954
Will Grohmann. *Paul Klee*. New York: Harry N. Abrams, 1954.

Gronau 1957
C[armen] G[ronau]. Preface in London, Sotheby's, 20 Nov. 1957, *Catalogue of Drawings of Landscapes and Trees by Fra Bartolommeo*.

Gruber 1972
Alain-Charles Gruber. *Les Grandes Fêtes et leurs décors à l'époque de Louis XVI*. Histoire des Idées et Critique Littéraire, No. 122. Geneva: Librairie Droz, 1972.

Guérin 1927
Marcel Guérin. *L'Oeuvre gravé de Gauguin*. Paris: H. Floury, 1927.

Guitar 1959
Mary Anne Guitar. "Treasures on Campus." *Mademoiselle* 49 (May 1959), pp. 112–15.

Halasa 1993
Grazyna Halasa. "Studies of the Heads by Federico Barocci in the National Museum in Poznan." *Studia Muzealne* (Museum Narodowe w Poznaniu) 17 (1993), pp. 85–94.

Hallam 1983
John Stephen Hallam. *The Genre Works of Louis Léopold Boilly*, Ph.D. diss., University of Washington, 1979. Ann Arbor: University of Michigan Microfilms, 1983.

Halm 1930
Peter Halm. *Die Landschaftes Zeichnungen des Wolfgang Huber*. *Jahrbuch der bildenden Kunst*, n.s., 7, no. 1 (1930).

Hamilton and Hitchcock 1953
George Heard Hamilton and Henry-Russell Hitchcock. *Forty French Pictures in the Smith College Museum of Art*. Northampton, Mass.: SCMA, 1953.

Hand and Wolff 1986
John O. Hand and Martha Wolff. *Early Netherlandish Painting*. Washington, D.C.: National Gallery of Art, 1986.

Harbison 1995
Craig Harbison. *The Mirror of the Artist*. London: Calmann & King, 1995.

Harris and Schaar 1967
Ann Sutherland Harris and Eckhard Schaar. *Kataloge des Kunstmuseums Düsseldorf. Handzeichnungen. Band 1. Die Handzeichnungen von Andrea Sacchi und Carlo Maratta*. Düsseldorf: Kunstmuseum der Stadt Düsseldorf, 1967.

Harrisse 1898
Henry Harrisse. *Louis Boilly. Peintre, dessinateur et lithographe*. Paris: Société de propagation des livres d'art, 1898.

Hauke 1961
César M. de Hauke. *Seurat et son oeuvre*. 2 vols. Paris: Grund, 1961.

Haverkamp-Begemann, Lawder, and Talbot 1964
Egbert Haverkamp-Begemann, Standish D. Lawder, and Charles W. Talbot, Jr. *Drawings from the Clark Art Institute: A Catalogue Raisonné of the Robert Sterling Clark Collection of European and American Drawings*. 2 vols. New Haven: Yale University Press, 1964.

Hayes 1971
John Hayes. *The Drawings of Thomas Gainsborough*. 2 vols. New Haven and London: Yale University Press, 1971. Also London: A. Zwemmer Ltd., 1970.

Heawood
Edward Heawood. *Watermarks Mainly of the Seventeenth and Eighteenth Centuries.* Monumenta Chartae papyraceae historiam illustratia 1. Hilversum: Paper Publications Society, 1950.

Hédiard 1906
Germain Hédiard. *Fantin-Latour: Catalogue de l'oeuvre litho-graphique du maître.* Paris: Libraire de l'art ancien et moderne, 1906.

Heenk 1994
Liesbeth Heenk. "Revealing Van Gogh: An Examination of His Papers." *The Paper Conservator* 18 (1994), pp. 30–39.

Heinecken 1778–90
Karl Heinrich Heinecken. *Dictionnaire des artistes, dont nous avons des estampes, avec une notice detaillée de leurs ouvrages gravés.* 4 vols. Leipzig: Jean Gottlob Immanuel Breitkopf, 1778–90.

Held 1953
Julius Held. *Flemish Painting.* New York: Harry N. Abrams, 1953.

Herbert 1962
Robert L. Herbert. *Seurat's Drawings.* New York: Shorewood, 1962.

Hess 1953
Thomas B. Hess. "De Kooning Paints a Picture." *ArtN* 52 (March 1953), pp. 30–33, 64–66.

Hess 1967
Thomas B. Hess. *De Kooning: Recent Paintings.* New York: Walker and Co. in association with M. Knoedler & Co., 1967.

Hess 1972
Thomas B. Hess. *Willem de Kooning Drawings.* Greenwich, Conn.: New York Graphic Society, 1972.

Hess and Nochlin 1972
Thomas B. Hess and Linda Nochlin, eds. *Woman as Sex Object: Studies in Erotic Art, 1730–1970. Art News Annual* 38 (1972).

Hill 1966
Edward Hill. *The Language of Drawing.* Englewood Cliffs, N.J.: Prentice-Hall, 1966.

Hind 1915–32
Arthur M. Hind. *Catalogue of Drawings by Dutch and Flemish Artists Preserved in the Department of Prints and Drawings in the British Museum.* 5 vols. London: The Trustees of the British Museum, 1915–32. Vol. 1 (1915), *Drawings by Rembrandt and His School;* vol. 4 (1931), *Dutch Drawings of the Seventeenth Century and Anonymous.*

Hirschmann 1976
Otto Hirschmann. *Verzeichnis der Graphischen Werks von Hendrik Goltzius, 1558–1617.* Leipzig, 1921. Braunschweig: Klinkhardt & Biermann, 1976.

Hitchcock 1938
H[enry]-R[ussell] H[itchcock, Jr.]. "A Note on A. Leclère." *SCMA Bull,* nos. 18–19 (June 1938), pp. 9–11.

Hitchcock 1954
Henry-Russell Hitchcock. "The Smith College Collection." *The Institute of Contemporary Art Bulletin (Boston)* 3, no. 3 (Jan.–Feb. 1954), p. [1].

Hobbs 1977
Richard Hobbs. *Odilon Redon.* Boston: New York Graphic Society, 1977.

Hollstein 1949–98
F. W. H. Hollstein. *Dutch and Flemish Etchings, Engravings, and Woodcuts, ca. 1450–1700.* 52 vols. Amsterdam: Menno Hertzberger, 1949–98.

Hollstein 1954–99
F. W. H. Hollstein. *German Engravings, Etchings, and Woodcuts, ca. 1400–1700.* 46 vols. Amsterdam: Menno Herzberger, 1954–99.

Holmes 1936
Sir Charles Holmes. "Henry Oppenheimer: A Collector and His Ways." *London Studio* 12, no. 522 (Sept. 1936), pp. 115–34.

Homer 1964
William Innes Homer. *Seurat and the Science of Painting.* Cambridge, Mass.: M.I.T. Press, 1964.

Huisman and Dortu 1964
Philippe Huisman and M. G. Dortu. *Lautrec by Lautrec.* New York: Viking Press, 1964.

Hulsker 1980/1996
Jan Hulsker. *The Complete Van Gogh: Paintings, Drawings, Sketches.* Oxford: Phaidon, 1980. *The New Complete Van Gogh: Paintings, Drawings, Sketches.* Rev. and enlarged ed. Amsterdam and Philadelphia: J. M. Meulenhoff in association with John Benjamins, 1996.

Hütt 1968
W. Hütt. *Mathias Gothart-Nithart, genannt "Grünewald": Leben und Werk im Spiegel der Forschung.* Leipzig: VEB E.A. Seemann Verlag, 1968.

Huyghe 1961
René Huyghe. *L'Art et l'homme.* Vol. 3. Paris: Librairie Larousse, 1961.

Huyghe and Jaccottet 1948
René Huyghe and Philippe Jaccottet. *Le Dessin français au XIXe siècle.* Preface by René Huyghe, biographical notes by Philippe Jaccottet. Lausanne: Editions Mermod, 1948.

Hyatt Mayor 1964
A. Hyatt Mayor (Introduction). *Architectural and Perspective Designs Dedicated to His Majesty Charles VI, Holy Roman Emperor, by Giuseppe Galli Bibiena, His Principal Theatrical Engineer and Architect, Designer of These Scenes.* Title page and illustrations from the work published under the direction of Andreas Pfeffel, 1740. New York: Dover, 1964.

Jacobi 1956
Günther Jacobi. *Kritische Studien zu der Handzeichnungen von Matthias Grünewald. Versuch einer Chronologie.* Ph.D. diss., University of Cologne, 1956.

Jaffé 1994
Michael Jaffé. *The Devonshire Collection of Italian Drawings.* 4 vols. London: Phaidon Press, Ltd., 1994. Vol. 4, *Venetian and North Italian Schools.*

James 1966
Henry Moore on Sculpture: A Collection of the Sculptor's Writings and Spoken Words. Edited by Philip James. London: McDonald, 1966.

Jensen 1982
Jens Christian Jensen. *Adolph Menzel.* Cologne: DuMont, 1982.

Joannides 1994
Paul Joannides. "Bodies in the Trees. A Mass-Martyrdom by Michelangelo." *Apollo*, n.s., 140, no. 393 (Nov. 1994), pp. 3–14.

Joannides 1996
Paul Joannides. ". . . 'non volevo pigliar questa maniera': Rosso e Michelangelo," pp. 136–39, in *Pontormo e Rosso. Atti del convegno di Empoli e Volterra Progetto Appiani di Piombino*. Edited by Roberto P. Ciardi and Antonio Natali. Venice: Giunta regionale Toscana / Marsilio Editori, 1996.

Johnson 1981
Lee Johnson. *The Paintings of Eugène Delacroix*. 4 vols. Oxford: Clarendon Press, 1981.

Joosten 1998
Joop M. Joosten. *Catalogue Raisonné of the Work of 1911–1944*. Vol. 2 of Joop M. Joosten and Robert P. Welsh, *Piet Mondrian: Catalogue Raisonné*. 3 vols. New York: Harry N. Abrams, 1998.

Jordan 1984
Jim M. Jordan. *Paul Klee and Cubism*. Princeton, N.J.: Princeton University Press, 1984.

Joyant 1926–27
Maurice Joyant. *Henri de Toulouse-Lautrec, 1864–1901*. Vol. 1, *Peintre;* vol. 2, *Dessins, estampes, affiches*. Paris: H. Floury, 1926–27.

Juergens 1931
Walther Juergens. *Erhard Altdorfer, seine Werke und seine Bedeutung für die Bibelillustrationen des 16. Jahrhunderts*. Lübeck: O. Quitzow, 1931.

Jussim 1981
Estelle Jussim. *Slave to Beauty: The Eccentric Life and Controversial Career of F. Holland Day, Photographer, Publisher, Aesthete*. Boston: David R. Godine, Publisher, 1981.

Kagan 1983
Andrew Kagan. *Paul Klee: Art and Music*. Ithaca, N.Y.: Cornell University Press, 1983.

Kahn 1928
Gustave Kahn. *Les Dessins de Georges Seurat*. 2 vols. Paris: Bernheim-Jeune, 1928.

Kahn 1971
Gustave Kahn. *The Drawings of Georges Seurat*. Translated by Stanley Appelbaum. New York: Dover Publications, 1971.

Kamensky 1989
Aleksandr Kamensky. *Chagall: The Russian Years, 1907–1922*. New York: Rizzoli, 1989.

Kaufmann 1985
Thomas DaCosta Kaufmann. "Eros et poesia: la peinture à la cour de Rudolphe II." *Revue de l'Art*, no. 69 (1985), pp. 29–46.

Kennedy 1947
Ruth Wedgwood Kennedy. "A Study Collection of Old Master Drawings." *SCMA Bull*, nos. 25–28 (July 1947), pp. 35–36.

Kennedy 1953
Ruth Wedgwood Kennedy. "Degas and Raphael." *SCMA Bull*, nos. 33–34 (1953), pp. 5–12.

Kennedy 1959
Ruth Wedgwood Kennedy. "A Landscape Drawing by Fra Bartolommeo." *SCMA Bull*, no. 39 (1959), pp. 1–12.

Kieser 1931
E[mil] Kieser. "Tizians und Spaniens Einwirkungen auf die Späteren Landschaften des Rubens." *Münchner Jahrbuch der bildenden Kunst*, n.s., 8 (1931), pp. 281–91.

Kimball 1922
E[lizabeth] K[imball]. "The Print Collection." *Bulletin of Smith College Hillyer Art Gallery*, 30 March 1922, unpaginated.

Kimbell 1972
Kimbell Art Museum: Catalogue of the Collection. Fort Worth: Kimbell Art Foundation, 1972.

King 1924
A. W. King. *An Aubrey Beardsley Lecture, with an Introduction and Notes by R. A. Walker and Some Unpublished Letters and Drawings*. London: R. A. Walker, Bedford Park, 1924.

Kirschner 1998
Melanie Kirschner. *Arthur Dove: Watercolors and Pastels*. New York: Braziller, 1998.

Kirstein 1919
Gustav Kirstein. *Das Leben Adolph Menzels*. Leipzig: E. A. Seeman, 1919.

Klee
Paul Klee. "Oeuvrekatalog." Artist's handwritten inventory, collection of the Paul-Klee-Stiftung, Kunstmuseum, Bern.

Klee 1962
Paul Klee: His Life and Work in Documents. Selected by Felix Klee, translated by Richard and Clara Winston. New York: Braziller, 1962.

Klipstein 1955
August Klipstein. *The Graphic Work of Käthe Kollwitz*. New York: Galerie St. Etienne, 1955.

Kloomok 1951
Isaac Kloomok. *Marc Chagall: His Life and Work*. New York: Philosophical Library, 1951.

Knipping 1948
John B. Knipping. *Jan Toorop*. Amsterdam: H. J. W. Becht, 1948.

Knox 1960
George Knox. *Catalogue of Tiepolo Drawings in the Victoria and Albert Museum*. London: Her Majesty's Stationery Office, 1960.

Knox 1961
George Knox. "The Orloff Album of Tiepolo Drawings." *Burl* 103, no. 699 (June 1961), pp. 269–75.

Kollwitz 1988
Käthe Kollwitz. *The Diary and Letters of Kaethe Kollwitz*. Edited by Hans Kollwitz. Translated by Richard Winston and Clara Winston. Evanston, Ill.: Northwestern University Press, 1988.

Kornfeld, Mongan, and Joachim 1988
Eberhard Kornfeld, Elizabeth Mongan, and Harold Joachim. *Paul Gauguin: Catalogue Raisonné of His Prints*. Bern: Galerie Kornfeld, 1988.

Kugler 1840
Franz Kugler. *Geschichte Friedrichs des Grossen*. Leipzig: Weber, 1840.

Kuh 1962
Katherine Kuh. *The Artist's Voice: Talks with Seventeen Artists*. New York: Harper & Row, 1962.

Kuh 1968
Katherine Kuh. "La Grande Jatte." *Saturday Review* 51, no. 15 (13 April 1968), p. 70.

Kuniyoshi 1945
Yasuo Kuniyoshi. *Yasuo Kuniyoshi*. New York: American Artists Group, 1945.

Kunst Mus Vienna 1991
Kunsthistorisches Museum Wien, Gemäldegalerie. *Die Gemäldegalerie des Kunsthistorischen Museums in Wien: Verzeichnis der Gemälde.* Vienna: C. Brandstatter, 1991.

Kurth 1938
Betty Kurth. "Zwei verschollene Werke Albrecht Altdorfers." *Die Graphischen Künste,* n.s., 3 (1938), pp. 2–7.

La Farge 1953
H[enry A.] L[a] F[arge]. "Reviews and Previews: French Paintings," review of Moser Gallery exhibition. *ArtN* 52, no. 8 (Dec. 1953), p. 40.

Lajer-Burcharth 1999
Ewa Lajer-Burcharth. *Necklines: The Art of Jacques-Louis David after the Terror.* New Haven and London: Yale University Press, 1999.

Lance 1854
Adolphe Lance. *Notice sur la vie et les travaux de M. Achille Leclère.* Paris: Bance, 1854.

Landon 1833
C. P. Landon. *Annales du Musée ou recueil complet de gravures d'après les tableaux* Vol. 2, *Ecole française moderne.* 2d, rev. and expanded ed. Paris: Pillet ainé, 1833.

Lane 1940
James W. Lane. "David and Ingres View in New York: Arrival of the Springfield Show of Two Great Neo-Classicists." *ArtN* 38, no. 14 (6 Jan. 1940), p. 7.

Lapauze 1901
Henry Lapauze. *Les Dessins de J.-A.-D. Ingres du Musée de Montauban.* Paris: Imprimerie Nationale, 1901.

Lapauze 1911
Henry Lapauze. *Ingres, sa vie et son oeuvre (1780–1867), d'après les documents inédits.* Paris: Imprimerie Georges Petit, 1911.

Lassaigne 1964
Jacques Lassaigne. *Chagall: Unpublished Drawings.* Geneva: Skira, 1964.

Le Blanc
Charles Le Blanc. *Manuel de l'amateur d'estampes.* 4 vols. Paris: P. Jannet, 1854–90.

Lee 1961
Rensselaer Wright Lee. "Giambattista Tiepolo's Drawing of Rinaldo and Armida." *SCMA Bull,* no. 41 (1961), pp. 10–22.

Lemoisne 1947–48
P. A. Lemoisne. *Degas et son oeuvre.* 4 vols. Paris: P. Brame et C. M. de Hauke, aux Arts et métiers graphiques, 1947–48.

Leslie 1980
Clare Walker Leslie. *Nature Drawing: A Tool for Learning.* Englewood Cliffs, N.J.: Prentice-Hall, 1980.

Levy 1987
Suzy Levy, ed. *Lettres inédites d'Odilon Redon à Bonger.* Paris: José Cort, 1987.

Lieberman 1984
William S. Lieberman. *The World of Henry Moore.* New York: The Metropolitan Museum of Art, 1984.

Liess 1979–80
Reinhard Liess. "Die kleinen Landschaften Pieter Bruegels d. Ä. im Lichte seines Gesamtwerkes (1. Teil)." *Kunsthistorisches Jahrbuch Graz* 15–16 (1979–80), pp. 1–117.

Liess 1982
Reinhard Liess. "Die kleinen Landschaften Pieter Bruegels d. Ä. im Lichte seines Gesamtwerkes (3. Teil)." *Kunsthistorisches Jahrbuch Graz* 18 (1982), pp. 79–165.

Little 1996
Carl Little. *Paintings of New England.* Camden, Maine: Down East Books, 1996.

Livy
Livy. *The Early History of Rome.* Books 1–5 of *The History of Rome from Its Foundation.* Translated by Aubrey de Sélincourt; introduction by R. M. Ogilvie. 1960. Harmondsworth: Penguin Books, 1973.

Lloyd 1980
Christopher Lloyd. "Camille Pissaro: Drawings or Prints?" *Master Drawings* 18, no. 3 (Autumn 1980), pp. 264–68.

Locker-Lampson 1886
Frederick Locker-Lampson. *The Rowfant Library: A Catalogue of the Printed Books, Manuscripts, Autograph Letters, Drawings, and Pictures, Collected by Frederick Locker-Lampson.* London: B. Quaritch, 1886.

Locquin 1912
Jean Locquin. *La Peinture d'histoire en France de 1747 à 1785: Etude sur l'évolution des idées artistiques dans la seconde moitié du XVIIIe siècle.* Paris: Henri Laurens, 1912.

London Review 1809
London Review and Literary Journal, 8 Nov. 1809.

Lugt
Frits Lugt. *Les Marques de collection de dessins et d'estampes.* Reproduction of the Amsterdam edition of 1921. The Hague: Martinus Nijhoff, 1956.

Lugt Suppl
Frits Lugt. *Les Marques de collection de dessins et d'estampes. Supplément.* The Hague: Martinus Nijhoff, 1956.

L. H., vol. 1, vol. 2
David Sylvester, ed. *Henry Moore.* Vol. 1, *Sculpture and Drawings, 1921–1948.* With an introduction by Herbert Read. 1944. 4th rev. ed. London: Percy Lund, Humphries & Co., Ltd., 1957. Vol. 2, *Sculpture and Drawings, 1949–1954.* With an introduction by Herbert Read. London: Percy Lund, Humphries & Co., Ltd., 1955.

Lusk 1903
Lewis Lusk. "The Later Work of Elihu Vedder." *ArtJ* 55 (1903), pp. 142–46.

Lynes 1981
Russell Lynes. "Art in Academe." *Architectural Digest* 38, no. 10 (Oct. 1981), pp. 50–58.

McAllister-Johnson 1966
W. McAllister-Johnson. "Primaticcio Revisited: Aspects of Draftsmanship in the School of Fontainebleau." *ArtQ* 29, nos. 3–4 (1966), pp. 245–68.

McBride 1924
Henry McBride. "Modern Art." *Dial* 76 (March), pp. 295–97.

McGrath 1998
Thomas McGrath. "Federico Barocci and the History of *Pastelli* in Central Italy." *Apollo*, n.s., 148, no. 441 (Nov. 1998), pp. 3–9.

MacOrlan 1934
Pierre MacOrlan. *Lautrec, peintre de la lumière froide.* Paris: Floury, 1934.

Maas, Duncan, and Good 1970
Henry Maas, J. L. Duncan, and W. G. Good, eds. *The Letters of Aubrey Beardsley.* Rutherford, Madison, Teaneck, N.J.: Fairleigh Dickenson University Press, 1970.

Macfall 1927
Haldane Macfall. *Aubrey Beardsley: The Clown, the Harlequin, the Pierrot of His Age.* New York: Simon and Schuster, 1927.

Mack 1938
Gerstle Mack. *Toulouse-Lautrec.* New York: Alfred A. Knopf, 1938.

Mahérault 1880
Marie-Joseph-François Mahérault. *L'Oeuvre de Moreau le Jeune. Catalogue raisonné et descriptif avec notes iconographiques et bibliographiques.* With a biographical notice by Emile de Najac. Paris: Adolphe Labitte, 1880.

Malingue 1946
Maurice Malingue. *Lettres de Gauguin à sa femme et à ses amis.* Paris: Editions Bernard Grasset, 1946.

Van Mander 1604/1994–
Karel van Mander. *Karel van Mander: The Lives of the Illustrious Netherlandish and German Painters, from the First Edition of the "Schilder-boeck" (1603–1604), Preceded by the Lineage, Circumstances, and Place of Birth, Life, and Works of Karel van Mander, Painter and Poet and Likewise His Death and Burial, from the Second Edition of the "Schilder-boeck" (1616–1618).* Edited by Hessel Miedema. Doornspijk: Davaco, 1994–. Vol. 1 (1994), *Text*, introduction by Hessel Miedema, translated by Michael Hoyle, Jacqueline Pennial-Boyle, and Charles Ford; vol. 2 (1995), *Commentary on Biography and Lives, fol. 196r01–211r35*, translated by Derry Cook-Radmore; vol. 3 (1996), *Lives, fol. 211r36–236v36*, translated by Derry Cook-Radmore; vol. 4 (1997), *Commentary on Lives fol. 236v37–261v44*, translated by Derry Cook-Radmore.

Mariette 1969
Pierre-Jean Mariette. *Ecoles d'Italie: Notices biographiques et catalogues des oeuvres reproduites par la gravure, XVIe–XVIIIe siècle. Les Grands Peintres, I. Editions d'études et de documents.* Paris: Les Beaux-Arts, 1969.

Marillier 1920
The Early Work of Aubrey Beardsley. With a prefatory note by H. C. Marillier. 1899. London: John Lane, The Bodley Head; New York: John Lane Company, 1920.

Marin 1949
John Marin. *The Selected Writings of John Marin.* Edited by Dorothy Norman. New York: Pellegrini and Cudahy, 1949.

Marmottan 1913
Paul Marmottan. *Le Peintre Louis Boilly (1761–1845).* Paris: H. Gateau, 1913.

Marmottan 1922
Paul Marmottan. "Sur Achille Leclere." *Bulletin de la Société de l'histoire de l'art français* 1921 (1922).

Martial 1866
A. P. Martial [Adolphe Martial Potemont]. *Ancien Paris.* Paris: Beillet [printer], 1866.

Matteoli 1980
Anna Matteoli. *Lodovico Cardi-Cigoli pittore e architetto: fonti biografiche, catalogo delle opere, documenti, bibliografia, indici analitici.* Pisa: Giardini editori e stampatori, 1980.

Meder/Ames 1978
Joseph Meder. *The Mastery of Drawing.* Translated from *Die Handzeichnung: Ihre Technik und Entwicklung.* Vienna: A. Schroll & Co., 1919. Revised by Winslow Ames. 2 vols. New York: Abaris Books, 1978.

Meier 1957
Michael Meier. *Grünewald: Das Werk des Mathis Gothardt Neithardt.* Zurich and Freiburg im Breisgau: Atlantis Verlag, 1957.

Melion 1990
Walter Melion. "Hendrik Goltzius's Project of Reproductive Engraving." *Art History* 13, no. 4 (Dec. 1990), pp. 458–87.

Mellerio 1968
André Mellerio. *Odilon Redon.* Paris: Société pour l'Etude de la Gravure Française, 1913. Reprint. New York: Da Capo Press, 1968.

Melville 1970
Robert Melville. *Henry Moore: Sculpture and Drawings, 1921–1969.* London: Thames and Hudson, 1970.

Meyer 1964
Franz Meyer. *Marc Chagall: Life and Work.* New York: Harry N. Abrams, 1964.

Meyer 1878
Julius Meyer. *Allgemeines Künstler-Lexicon.* 2 vols. Leipzig, 1878.

Mielke 1985–86
Hans Mielke. Review of *L'Epoque de Lucas de Leyde et Pierre Bruegel: Dessins des anciens Pays-Bas: Collection Frits Lugt*, by Karel Boon. *Master Drawings* 23–24, no. 1 (1985–86), pp. 75–90.

Mielke 1996
Hans Mielke. *Pieter Bruegel: Die Zeichnungen.* Turnhout: Brepols, 1996.

Miller 1945
Margaret Miller, ed., with articles by Alfred H. Barr, Jr., Julia and Lyonel Feininger, and James Johnson Sweeney. *Paul Klee: Statements by the Artist.* 2d rev. ed. New York: The Museum of Modern Art, 1945.

Milner 1992
John Milner. *Mondrian.* New York: Abbeville Press, 1992.

Misfeldt 1971
Willard Misfeldt. *James Jacques Joseph Tissot: A Bio-Critical Study.* Ph.D. diss., Washington University, 1971. Ann Arbor, Mich.: University Microfilms, 1971.

Mitchell 1937
Eleanor Mitchell. *"La Fille de Jephté par Degas: Genèse et évolution."* *GBA* 18 (Oct. 1937), pp. 175–89.

Mitchinson 1971
David Mitchinson. *Henry Moore: Unpublished Drawings.* New York: Harry N. Abrams, 1971.

Moerenhout 1837
Jacques Antoine Moerenhout. *Voyage aux îles du grand océan.* 2 vols. Paris: A. Bertrand, 1837.

Mondrian 1993
Piet Mondrian. *The New Art — The New Life: The Collected Writings of Piet Mondrian.* Edited and translated by Harry Holtzman and Martin S. James. New York: Da Capo Press, 1993.

Mongan 1947
Agnes Mongan. *Ingres, Twenty-four Drawings.* New York: Pantheon, 1947.

Mongan 1949
Agnes Mongan, ed. *One Hundred Master Drawings.* Cambridge, Mass.: Harvard University Press; London: Geoffrey Cumberlege, Oxford University Press, 1949.

Mongan 1969
Agnes Mongan. "Mondrian's Flowers." In *Miscellanea I. Q. van Regteren Altena,* pp. 228–397. Amsterdam: Scheltema and Holkema, 1969.

Mongan 1980
Agnes Mongan. "Ingres et ses jeunes compatriotes à Rome, 1806–1820." *Actes du colloque international: Ingres et son influence,* Montauban, Sept. 1980. *Bulletin,* Musée Ingres, Montauban, nos. 47–48 (1980), pp. 9–15.

Monneret 1979
Sophie Monneret. *Dictionnaire de l'impressionnisme et son époque.* Vol. 2. Paris: Editions Denoël, 1979.

Monnier 1978
Geneviève Monnier. "La Génèse d'une oeuvre de Degas, *Semiramis construisant une ville.*" *La Revue du Louvre* 28, nos. 5–6 (1978), pp. 407–26.

Montagu 1978
Jennifer Montagu. "Bellori, Maratti, and the Palazzo Altieri." *Journal of the Warburg and Courtauld Institutes* 41 (1978), pp. 334–40.

Morassi 1975
Antonio Morassi. *Tutti i disegni di Antonio, Francesco e Giacomo Guardi.* Venice: Alfieri, 1975.

Morassi 1984
Antonio Morassi. *Guardi.* 3 vols. Venice: Alfieri, Gruppo Editoriale Electra, 1984. Vols. 1–2, *I Dipinti* (orig. publ. 1975); vol. 3, *I Disegni* (orig. publ. 1973).

Morgan 1984
Ann Lee Morgan. *Arthur Dove: Life and Work, with a Catalogue Raisonné.* Newark: University of Delaware Press, 1984.

Morgan 1988
Ann Lee Morgan, ed. *Dear Stieglitz, Dear Dove.* Newark: University of Delaware Press, 1988.

Morse 1974
Barbara White Morse. "Elihu Vedder's *Soul of the Sunflower.*" *Antiques Journal* 29, no. 11 (Nov. 1974), pp. 22–23.

Morse 1979
John D. Morse. *Old Master Paintings in North America.* New York: Abbeville Press, 1979.

Moschini [1924]
G. A. Moschini. *Dell'incisione in Venezia.* Venice: Regia Accademia di Belle Arti de Venezia, [1924].

Moskowitz 1962
Ira Moskowitz, ed. *Great Drawings of All Time.* Vol. 2. *German, Flemish, and Dutch, Thirteenth through Nineteenth Century.* New York: Shorewood Publishers, 1962.

Mousnier 1979 and 1984
Roland Mousnier. *The Institutions of France under the Absolute Monarchy, 1598–1789.* Vol. 1, *Society and the State.* Paris: Presses Universitaires de France. Translated by Brian Pearce. Chicago and London: University of Chicago Press, 1979. Vol. 2, *The Organs of State and Society.* 1980. Translated by Arthur Goldhammer. Chicago and London: University of Chicago Press, 1984.

Moxey 1989
Keith Moxey. *Peasants, Warriors, and Wives: Popular Imagery in the Reformation.* Chicago and London: University of Chicago Press, 1989.

Müntz 1961
Ludwig Müntz. *Breugel: The Drawings.* Complete ed., translated and with an appendix by Luke Herrmann. London: Phaidon Press, 1961.

Museum News 1959
Museum News, 15 Feb. 1959.

Naef 1967
Hans Naef. "Eighteen Portrait Drawings by Ingres." *Master Drawings* 4, no. 3 (Feb. 1967), pp. 255–83.

Naef 1977–80
Hans Naef. *Die Bildniszeichnungen von J.-A.-D. Ingres.* 5 vols. Bern: Benteli Verlag, 1977–80.

Nagel 1971
Otto Nagel. *Käthe Kollwitz.* Greenwich, Conn.: New York Graphic Society, 1971.

Nagel and Timm 1980
Otto Nagel and Werner Timm. *Käthe Kollwitz: Die Handzeichnungen.* Stuttgart: Verlag W. Kohlhammer, 1980.

Naifeh and Smith 1989
Steven Naifeh and Gregory White Smith. *Jackson Pollock: An American Saga.* New York: Clarkson N. Potter, 1989.

Nash 1949
Paul Nash. *Outline: An Autobiography and Other Writings.* London: Faber and Faber, 1949.

Neet 1987
Jane Neet. "Mondrian's Chrysanthemums." *Bulletin of the Cleveland Museum of Art* 74, no. 7 (Sept. 1987), pp. 282–303.

New Bedford Standard Times 1960
"Maurice Prendergast: Born Too Soon." *New Bedford Sunday Standard-Times,* 11 Dec. 1960, p. 2.

Nilsson 1991
Annika Nilsson, ed. *Gen Etik.* Stockholm: Raster Förlag, 1991.

Noël 1989
Bernard Noël. *L. David*. Translated by Marie-Helene Agueros. New York: Crown Publishers, 1989.

Oberhuber 1958
Konrad Oberhuber. "Die stilistische Entwicklung im Werk Bartholomaus Sprangers." Ph.D. diss., University of Vienna (Universität Wien), 1958.

Oberhuber 1970
Konrad Oberhuber. "Anmerkungen zu Bartholomaus Spranger als Zeichner." *Umeni* 18 (1970), pp. 213–23.

Oettinger 1959
Karl Oettinger. *Altdorfer-Studien*. Erlanger Beiträge zur Sprach- und Kunstwissenschaft, 3. Nuremberg: H. Carl, 1959.

Olsen 1962
Harald Olsen. *Federico Barocci*. Copenhagen: Munksgaard, 1962.

O'Neill 1992
John P. O'Neill, ed. *Barnett Newman: Selected Writings and Interviews*. Text notes and commentary by Mollie McNickle, introduction by Richard Shiff. Berkeley: University of California Press, 1992.

Ovid
Ovid's Fasti. With an English translation by Sir James George Fraser. The Loeb Classical Library. Cambridge, Mass.: Harvard University Press; London: William Heinemann, Ltd., 1967.

Oxford Class Dict
The Oxford Classical Dictionary. Edited by N. G. L. Hammond and H. H. Scullard. 2d ed. Oxford: Clarendon Press, 1970.

Ozawa 1991
Yoshio Ozawa. *Hyoden Kuniyoshi Yasuo: Genmu to saikan*. Tokyo: Fukutake shoten, 1991.

Packpfeiffer 1978
Katharina Packpfeiffer. *Studien zu Erhard Altdorfer*. Ph.D. diss., University of Vienna, 1974. Vienna: VWGÖ, 1978.

Panofsky 1953
Erwin Panofsky. *Early Netherlandish Painting*. 2 vols. Cambridge, Mass.: Harvard University Press, 1953.

Panofsky 1991
Erwin Panofsky. *Early Netherlandish Painting*. French translation. Paris: Hazan Editeurs, 1991.

Parks 1957
Robert O. Parks. "Smith College Museum, Recent Accessions." *College Art Journal* 17, no. 1 (Fall 1957), pp. 73–75.

Parks 1960
Robert O. Parks. "Unpublished Works and Recent Acquisitions." *SCMA Bull*, no. 40 (1960), pp. 1–91.

Parnassus 1939
Parnassus 11 (Dec. 1939), p. 40.

de Patoul and Van Schoute 1994
Les Primitifs flamands et leur temps. Maryan W. Ainsworth, Bernard Bousmann, et al. under the direction of Brigitte de Patoul and Roger van Schoute. Series ed. and coordinated by Michel de Grand Ry. Louvain-la-Neuve: La Renaissance du Livre, 1994.

Peacock 1988
Kenneth Peacock. "Instruments to Perform Color-Music: Two Centuries of Technological Experimentation." *Leonardo* (Great Britain) 21, no. 4 (1988), pp. 397–406.

Peacock 1991
Kenneth Peacock. "Famous Early Color Organs." *Experimental Musical Instruments* 7, no. 2 (Sept. 1991), pp. 1, 17–20.

Pepper 1983
C. B. Pepper. "The Indomitable de Kooning." *New York Times Magazine*, 20 Nov. 1983, pp. 42–47, 66, 70, 86, 90, 94.

Peters 1991
Lisa N. Peters. *American Impressionist Masterpieces*. New York: Harkavy Press, 1991.

Petrioli Tofani 1979
Anna Maria Petrioli Tofani. Review of *Florentiner Zeichner des Frühbarock* by C. Thiem. *Prospettiva*, no. 19 (Oct. 1979), pp. 74–88.

Pevsner and Meier 1958
Nikolaus Pevsner and Michael Meier. *Grünewald*. New York: Harry N. Abrams, 1958.

Pietrangeli 1980
Carlo Pietrangeli. "Alla ricerca di une serie di dipinti Ottoboniani." *Strenna dei Romanasti* 51 (1980), pp. 395–406.

Pignatti 1975
Terisio Pignatti. "Le Feste Ducali: Canaletto, Brustolon, Guardi." *Critica d'Arte*, n.s., 40, no. 144 (1975), pp. 41–68.

Pillsbury 1973
Edmund Pillsbury. Review of *Drawings and Prints of the First Maniera 1515–1535*. *Print Collector's Newsletter* 4, no. 2 (May–June 1973), pp. 34–35.

Pincus-Witten 1967
Robert Pincus-Witten. "Ingres Centennial at the Fogg." *Artforum* 5, no. 9 (May 1967), pp. 46–48.

Plasschaert 1925
Albert C. A. Plasschaert. *Jan Toorop*. Amsterdam: J. H. de Bussy, 1925.

Plutarch
Plutarch. *The Lives of the Noble Grecians and Romans*. The Dryden Translation, ed. and rev. by Arthur Hugh Clough. Vol. 1. New York: The Modern Library, 1992. *Pericles*, pp. 201–34.

Pointon 1979
Marcia Pointon. "Gainsborough and the Landscape of Retirement." *Art History* 2, no. 4 (Dec. 1979), pp. 441–55.

Popham 1926
Arthur Ewart Popham. *Drawings of the Early Flemish School. Drawings of the Great Masters*. London: Ernest Benn, 1926.

Popham 1967
Arthur Ewart Popham. *Italian Drawings in the Department of Prints and Drawings in the British Museum. Artists Working in Parma in the Sixteenth Century*. London: Trustees of the British Museum, 1967.

Portalis and Béraldi
Roger Portalis and Henri Béraldi. *Les Graveurs du dix-huitième siècle*. Paris, 1880–82. 3 vols. New York: B. Franklin, 1970.

Prache 1961
Anne Prache. "A Drawing of the Martyrdom of Sts. Cosmas and Damian by Primaticcio." *SCMA Bull*, no. 41 (1961), pp. 1–9.

Prevenier and Blockmans 1986
Walter Prevenier and Wim Blockmans. *The Burgundian Netherlands*. Picture research by An Blockmans-Delva, foreword by Richard Vaughan. Translated by Dr. Peter King and Yvette Mead. Cambridge: Cambridge University Press, 1986.

Priestly 1965
E. J. Priestly: "Artists' Views of a Kentish Palace." *Country Life* 137, no. 3561 (3 June 1965), pp. 1342–43.

Princeton Lib Chron 1955
Princeton University Library Chronicle 16, no. 3 (Spring 1955).

Raoul 1962
Rosine Raoul. "New York Letter: The Taste for Drawings." *Apollo*, n.s., 77, no. 5 (July 1962), pp. 411–14.

Ratcliffe 1960
Robert William Ratcliffe. "Cézanne's Working Methods and Their Theoretical Background." Ph.D. diss., Courtauld Institute of Art, London, 1960.

Read 1966
Herbert Read. *Henry Moore: A Study of His Life and Work*. New York: Praeger, 1966.

Reade 1967
Brian Reade. *Aubrey Beardsley*. Introduction by John Rothenstein. New York: The Viking Press, A Studio Book, 1967.

Rearick 1993
W. R. Rearick. "Jacopo Bassano as Draftsman." *Drawing* 15, no. 1 (May–June 1993), pp. 1–7.

Redon 1922
Odilon Redon. *A soi-même. Journal (1867–1915). Notes sur la vie, l'art et les artistes*. Introduction by Jacques Morland. Paris: H. Floury, 1922.

Reff 1963
Theodore Reff. "Degas's Copies of Older Art." *Burl* 105, no. 723 (June 1963), pp. 241–51.

Reff 1964
Theodore Reff. "New Light on Degas's Copies." *Burl* 106, no. 735 (June 1964), pp. 250–59.

Reff 1965
Theodore Reff. "Addenda on Degas's Copies." *Burl* 107, no. 747 (June 1965), pp. 320–23.

Reff 1971
Theodore Reff. "Further Thoughts on Degas's Copies." *Burl* 113 (Sept. 1971), pp. 534–43.

Reff 1976a
Theodore Reff. *Degas: The Artist's Mind*. New York: The Metropolitan Museum of Art, 1976.

Reff 1976b
Theodore Reff. *The Notebooks of Edgar Degas*. 2 vols. Oxford: Clarendon Press, 1976.

Reich 1970
Sheldon Reich. *John Marin: A Stylistic Analysis and Catalogue Raisonné*. 2 vols. Tucson: University of New Mexico Press, 1970.

Reichenauer 1992
Berta Reichenauer. *Grünewald*. Thauer, Vienna, and Munich: Kulturverlag, 1992.

Rewald 1945
John Rewald. "Auguste Renoir and His Brother." *GBA*, 6th series, 27 (March 1945), pp. 171–88.

Rewald 1983
John Rewald. *Paul Cézanne: The Watercolors, A Catalogue Raisonné*. Boston: Little, Brown and Company, 1983.

Rewald 1989
John Rewald. *Cézanne and America: Dealers, Collectors, Artists, and Critics, 1891–1921*. The A. W. Mellon Lectures in the Fine Arts, 1979, The National Gallery of Art, Washington, D.C., Bollingen Series XXXV-28. Princeton, N.J.: Princeton University Press, 1989.

Reznicek 1961
Emil Karel Josef Reznicek. *Die Zeichnungen von Hendrick Goltzius mit einem beschreibenden Katalog*. Translated by Maria Simon (text) and Ingrid Jost (catalogue). 2 vols. Utrecht: Haentjens Dekker & Gumbert, 1961.

Rhees 1929
Harriet Seelye Rhees. *Laurenus Clark Seelye: First President of Smith College*. Foreword by William Allan Nielson. Boston and New York: Houghton Mifflin, 1929.

Rhys 1952
Hedley H. Rhys. "Maurice Prendergast: The Sources and Development of His Style." Ph.D. diss., Harvard University, 1952.

Rich 1935
Daniel Catton Rich. *Seurat and the Evolution of "La Grande Jatte."* Chicago: University of Chicago Press, 1935.

Rimington 1911
Alexander Wallace Rimington. *Colour Music: The Art of Mobile Colour*. New York: Stokes, 1911.

Ripa 1603/1970
Cesare Ripa. *Iconologia, overo descrittione di diverse imagini cavate dall'antichita, e di propria inventione [von] Cesare Ripa*. Rome, 1603. Introduction by Erna Mandowsky. Hildesheim and New York: G. Olms, 1970.

Rivière 1923
Georges Rivière. *Le Maître Paul Cézanne*. Paris: H. Floury, 1923.

Roe 1947
F. Gordon Roe. *Rowlandson: The Life and Art of a British Genius*. Leigh-on-Sea, Essex: F. Lewis, Publishers, 1947.

Rollin 1823
Charles Rollin. *Oeuvres complètes de Rollin*. New ed. by M. Letronne. Vol. 1. *Histoire Romaine*. Paris: Firmin Didot, 1823.

Rosenberg 1972
Pierre Rosenberg. "Dessins français du XVIIe et du XVIIIe siècle dans les collections américains." *L'Oeil*, nos. 212–213 (Aug.–Sept. 1972), p. 14.

Rosenberg and Bréjon de Lavergnée 1986
Pierre Rosenberg and Barbara Bréjon de Lavergnée. *Saint-Non, Fragonard, Panopticon Italiano: Un diario di viaggio ritrovato, 1759–1761*. Rome: Elefante, 1986.

Rosenblum 1962
Robert Rosenblum. "A New Source for David's *Sabines*." *Burl* 104, no. 709 (April 1962), pp. 158–62.

Rosenblum 1969
Robert Rosenblum. *Transformations in Late Eighteenth Century Art.* 1967. 2d printing with corrections and special preface. Princeton, N.J.: Princeton University Press, 1969.

Rosenfeld 1991
Daniel Rosenfeld. *European Painting and Sculpture, ca. 1770–1937, in the Museum of Art, Rhode Island School of Design.* Providence: Museum of Art, Rhode Island School of Design, 1991.

Ross 1952
Margery Ross, ed. *Robert Ross, Friend of Friends: Letters to Robert Ross, Art Critic and Writer, Together with Extracts from His Published Articles.* London: Cape, 1952.

Ross 1921
Robert Ross. *Aubrey Beardsley.* 1909. Revised iconography by Aymer Vallance. London: John Lane, The Bodley Head; New York: John Lane Company, 1921.

Rothschild 1903
Nathaniel Mayer de Rothschild. *Notizien über einige meiner Kunstgegenstände.* Vienna, 1903.

Rudenstine 1976
Angelica Zander Rudenstine. *The Guggenheim Museum Collection.* Vol. 1. *Paintings, 1880–1945.* New York: Solomon R. Guggenheim Foundation, 1976.

Rudolph 1978
Stella Rudolph. "The Toribio Illustrations and Some Considerations on Engravings after Carlo Maratta." *Antologia di Belle Arti* 2, nos. 7–8 (Dec. 1978), pp. 191–203.

Ruhmer 1970
Eberhard Ruhmer. *Grünewald Drawings: Complete Edition.* Translated by Anna Rose Cooper. London: Phaidon Press, 1970.

Russell 1969
Francis Russell. *The American Heritage History of the Confident Years.* New York: American Heritage, 1969.

Russell 1965
John Russell. *Seurat.* New York: F. A. Praeger, 1965.

Saccomani 1978
Elisabetta Saccomani. "Alcune proposte per il catalogo dei disegni di Domenico Campagnola." *Arte Veneta* 32 (1978), pp. 106–11.

Saccomani 1979
Elisabetta Saccomani. "Ancora su Domenico Campagnola; una questione controversa." *Arte Veneta* 33 (1979), pp. 43–49.

Saccomani 1980
Elisabetta Saccomani. "Domenico Campagnola: gli anni della maturità." *Arte Veneta* 34 (1980), pp. 63–77.

Sadie 1984
Stanley Sadie et al. *The New Grove Dictionary of Musical Instruments.* New York: Macmillan, 1984.

Safarik 1990
Eduard A. Safarik, with the collaboration of Gabriello Milantoni. *Fetti.* Milan: Electa, 1990.

Saunier 1893
Charles Saunier. "Henri-Gabriel Ibels." *La Plume,* no. 30 (Jan. 15, 1893), pp. 30–37.

Schaeffer 1961
Schaeffer Galleries. Twenty-fifth Anniversary, 1936–1961. New York: Schaeffer Galleries, 1961.

Schapiro 1973
Meyer Schapiro. *Paul Cézanne.* Paris: Nouvelles Editions Françaises, 1973.

Schaub-Koch 1935
Emile Schaub-Koch. *Psychanalyse d'un peintre moderne Henri de Toulouse-Lautrec.* Paris: Littéraire Internationale, 1935.

Schiavo [1964]
Armando Schiavo. *The Altieri Palace.* Translated by John Drummond. Rome: Italian Bankers Association, [1964].

Schmied 1966
Wieland Schmied. *Tobey.* New York: Harry N. Abrams, 1966.

Schneider 1932
Hans Schneider. *Jan Lievens, sein Leben und seine Werke.* Haarlem: De eerven F. Bohn, 1932.

Schneider-Ekkart 1973
Hans Schneider. *Jan Lievens, sein Leben und seine Werke.* Reprinted Amsterdam, 1973, with corrected captions of the illustrations and supplement by Rudolf E. O. Ekkart.

Schoenberger 1948
Guido Schoenberger, ed. *The Drawings of Mathis Gothart Nithart Called Gruenwald.* New York: H. Bittner, 1948.

Schöne 1938
Wolfgang Schöne. *Dieric Bouts und seine Schule.* Berlin and Leipzig: Verlag für Kunstwissenschaft, 1938.

SCMA 1937
SCMA Catalogue. Northampton, Mass.: SCMA, 1937.

SCMA 1941
SCMA Supplement to the Catalog of 1937. Northampton, Mass.: SCMA, 1941

SCMA 1986
Smith College Museum of Art. *A Guide to the Collections of the Smith College Museum of Art.* Northampton, Mass.: SCMA, 1986.

SCMA Bull 1935
"Loans Exhibitions." *SCMA Bull,* no. 16 (June 1935), pp. 13–16.

SCMA Bull 1951
"French Art." *SCMA Bull,* nos. 29–32 (June 1951), pp. 18–21.

SCMA Bull 1953
"American Accessions, July 1, 1951–June 30, 1953." *SCMA Bull,* nos. 33–34 (1953), pp. 25–28.

SCMA Bull 1958
"Forty-six Recent Accessions: A Portfolio of Reproductions" and "Accessions, July 1, 1956–June 30, 1958." *SCMA Bull,* no. 38 (1958), pp. 8–51 and 60–66.

SCMA Bull 1961
"Accessions." *SCMA Bull,* no. 41 (1961), pp. 23–42.

Scribner's 1877
"Smith College." *Scribner's Monthly* 14 (May 1877), pp. 9–17.

Seelye 1923
L. Clark Seelye. *The Early History of Smith College, 1871–1910.* Boston: Houghton Mifflin, 1923.

Seilern 1969
Count Antoine Seilern. *Flemish Paintings and Drawings at 56 Prince's Gate London, SW 7. Addenda.* London: Shenval Press, 1969.

Sele Arte 1954
"Géricault." *Sele Arte* 3, no. 15 (Nov.–Dec. 1954), pp. 37–45.

Seligman 1947
Germain Seligman. *The Drawings of Georges Seurat*. New York:
C. Valentin, 1947.

Shapiro 1991
David Shapiro. *Mondrian: Flowers*. New York: Harry N. Abrams,
1991.

Shoolman and Slatkin 1942
Regina Shoolman and Charles E. Slatkin. *The Enjoyment of Art in
America*. Philadelphia and New York: J. B. Lippincott, 1942.

Shoolman and Slatkin 1950
Regina Shoolman and Charles E. Slatkin. *Six Centuries of French
Master Drawings in America*. New York: Oxford University Press,
1950.

Siblík 1971
Jiří Siblík. *Paul Cézanne, Dessins*. Translated by Suzanne and
Karel Bartošek. Paris: Editions Cercle d'art, 1971.

Siebelhoff 1973
Robert Siebelhoff. "The Early Development of Jan Toorop,
1879–1892." Ph.D. diss., University of Toronto, 1973.

Siegel 1990
Eleanor Kathryn Siegel. "Willem de Kooning's *Woman* Paintings
of 1950–53." M.A. thesis, University of Texas at Austin, 1990.

Siegfried 1995
Susan L. Siegfried. *The Art of Louis-Léopold Boilly: Modern Life in
Napoleonic France.* New Haven and London: Yale University
Press, 1995.

Silvestre 1879
Armand Silvestre. "Le Monde des arts: Expositions, Musées,
Galeries, Ateliers, Ventes Célèbres, Découvertes Artistiques,
Critique d'Art." *La Vie Moderne,* 17 April 1879, pp. 20–21.

Simmons 1977
Seymour Simmons III and Marc S. A. Winer. *Drawing: The
Creative Process.* Englewood Cliffs, N.J.: Prentice-Hall, 1977.

Smith AlumQ 1939
"Recent Acquisitions of the Smith College Museum of Art."
Smith AlumQ, Nov. 1939, pp. 26–27.

Soby 1948
James Thrall Soby. *Contemporary Painters*. New York: The
Museum of Modern Art, 1948.

Soria 1970
Regina Soria. *Elihu Vedder: American Visionary Artist in Rome*.
Cranbury, N.J.: Fairleigh Dickinson University Press, 1970.

Sorlier 1979
Charles Sorlier, ed. *Chagall by Chagall*. Translated by J. Shepley.
New York: Harry N. Abrams, 1979.

Spiller 1961
Jürg Spiller, ed. *The Thinking Eye. The Notebooks of Paul Klee.*
Translated by Ralph Manheim with assistance from Dr.
Charlotte Weidler and Joyce Wittenborn. New York: George
Wittenborn; London: Lund Humphries, 1961.

Springfield Republican 1939
Springfield (Mass.) Republican, 21 May 1939.

Stange 1964
Alfred Stange. *Malerei der Donauschule*. Munich: Verlag F.
Bruckmann, 1964.

Strauss 1977
Walter L. Strauss, ed. *Hendrik Goltzius, 1558–1617: The Complete
Engravings and Woodcuts*. New York: Abaris Books, 1977.

Sumowski 1979–
Werner Sumowski. *Drawings of the Rembrandt School*. Edited
and translated by Walter L. Strauss. 10 vols. New York: Abaris
Books, 1979–.

Sutter 1970
Jean Sutter. *Les Néo-Impressionistes*. Neuchâtel: Ides et Calendes,
1970.

Sutton 1986
Peter Sutton. *A Guide to Dutch Art in America*. The Netherlands-
American Amity Trust, Inc. Grand Rapids, Mich.: Wm. B.
Eerdmans; Kampen: J. H. Kok, 1986.

Sweetser 1885
M. F. Sweetser. *King's Handbook of Boston Harbor*. 2d ed.
Cambridge, Mass.: Moses King, 1885.

Sylvester 1995
David Sylvester. "The Birth of *Woman I.*" *Burl* 137 (June 1995),
pp. 220–32.

Taillandier 1961
Yvon Taillandier. *Paul Cézanne*. Paris: Flammarion, 1961.

Tasso 1987
Torquato Tasso. *Jerusalem Delivered*. An English prose version
translated and edited by Ralph Nash. Detroit: Wayne State
University Press, 1987.

Teilhet-Fisk 1983
Jehanne Teilhet-Fisk, *Paradise Reviewed: An Interpretation of
Gauguin's Polynesian Symbolism*. Revised Ph.D. diss., University of
California at Los Angeles, 1975. Ann Arbor, Mich.: UMI Research
Press, 1983.

Thomson 1985
Richard Thomson. *Seurat*. Oxford: Phaidon, 1985.

Thomson 1991
Richard Thomson. *Toulouse-Lautrec*. New Haven: Yale University
Press, 1991.

Tietze 1947
Hans Tietze. *European Master Drawings in the United States*.
London: B. T. Batsford, Ltd.; New York: J. J. Augustin, 1947.

Tietze and Tietze-Conrat 1939
Hans Tietze and Erica Tietze-Conrat. "Domenico Campagnola's
Graphic Art, Part I." *Print Collector's Quarterly* 26 (Oct. 1939),
pp. 311–33.

Tietze and Tietze-Conrat 1944
Hans Tietze and Erica Tietze-Conrat. *The Drawings of the
Venetian Painters in the 15th and 16th Centuries*. New York: J. J.
Augustin, 1944.

Tinterow 1990–91
Gary Tinterow. "The Times of Day." *The Metropolian Museum of
Art Bulletin* (Winter 1990–91).

de Tolnay 1943
Charles de Tolnay. *History and Technique of Old Master Drawings*.
New York: Bittner, 1943. Reprint, New York: Hacker Art Books,
1972.

de Tolnay 1952
Charles de Tolnay. *The Drawings of Pieter Bruegel the Elder, with a Critical Catalogue.* Translated by Charles P. Sleeth. London: A. Zwemmer, 1952.

de Tolnay 1960
Charles de Tolnay. "Remarques sur quelques dessins de Bruegel l'ancien et sur un dessin de Bosch recemment reapparus." *Bulletin des Musées Royaux des Beaux-Arts, Bruxelles* 9, nos. 1–2 (May–June 1960), pp. 3–28.

Torriti 1981
Pietro Torriti. *La Pinacoteca Nazionale di Siena: I dipinti dal XV al XVIII secolo.* Genoa: Sagep Editrice, 1981.

Townsend 1993
J. Benjamin Townsend, ed. *Charles Burchfield's Journals: The Poetry of Place.* Albany: State University of New York Press, 1993.

Tralbaut 1969
Marc Edo Tralbaut. *Vincent van Gogh.* New York: Rizzoli, 1969.

Tschudi 1905
Hugo von Tschudi, ed. *Adolph Menzel: Abbildungen seiner Gemälde und Studien aus Grund der von der National-Galerie [Munich] im Frühjahr 1905 veranstalteten Ausstellung.* Munich: Bruckmann, 1905.

Vallance 1898
Aymer Vallance. "The Invention of Aubrey Beardsley." *Magazine of Art* 22, no. 7 (May 1898), pp. 362–69.

Van Adrichem 1992
Jan van Adrichem. "The Introduction of Modern Art in Holland: Picasso as *pars pro toto,* 1910–30." *Simiolus* 21, no. 3 (1992), pp. 162–211.

Vanbeselaere 1937
Walther Vanbeselaere. *De Hollandsche periode (1880–1885) in het werk van Vincent van Gogh (1853–1890).* Antwerp: De Sikkel, 1937.

Vance 1986
Mary Ellen Zink Vance. *Gauguin's Polynesian Pantheon as a Visual Language.* Ph.D. diss., University of California, Santa Barbara, 1983. Ann Arbor, Mich.: UMI Press, 1986.

Van Gogh 1959
Vincent van Gogh. *The Complete Letters of Vincent van Gogh.* 2d ed. 3 vols. Greenwich, Conn.: New York Graphic Society, 1959.

Vasari/Milanesi
Giorgio Vasari. *Le vite de' più eccellenti pittori, scultori, ed architettori.* New annotations and commentary by Gaetano Milanesi. 9 vols. Firenze: G. C. Sansoni, 1878.

Vasari Society 1909–10
The Vasari Society for the Reproduction of Drawings by the Old Masters. First series, part 5, 1909–10. Oxford: Oxford University Press, 1909–10.

Vasari Society 1920
The Vasari Society for the Reproduction of Drawings by the Old Masters. Second series, part 1. Oxford: Oxford University Press, 1920.

Vasari Society 1921
The Vasari Society for the Reproduction of Drawings by the Old Masters. Second series, part 2. *The Oppenheimer Collection.* Oxford: Oxford University Press, 1921.

Vedder 1910
Elihu Vedder. *The Digressions of V.* Boston: Houghton Mifflin, 1910.

Vente
Vente Atelier Edgar Degas: Catalogue des tableaux, pastels et dessins par Edgar Degas et provenant de son atelier. Paris: Galerie Georges Petit. *Vente I,* 6–8 May 1918; *Vente II,* 12–13 Dec. 1918; *Vente III,* 8–9 April 1919; *Vente IV,* 2–4 July 1919.

Venturi 1936
Lionello Venturi. *Cézanne, son art, son oeuvre.* 2 vols. Paris: Paul Rosenberg, 1936.

Venturi 1943
Lionello Venturi. *Paul Cézanne Water Colours.* Oxford: Bruno Cassirer, 1943.

Verdi 1968
Richard Verdi. "Musical Influences on the Art of Paul Klee." *Museum Studies* (The Art Institute of Chicago) 3 (1968), pp. 81–107.

Verdi 1985
Richard Verdi. *Klee and Nature.* New York: Rizzoli, 1985.

Vergara 1982
Lisa Vergara. *Rubens and the Poetics of Landscape.* New Haven and London: Yale University Press, 1982.

Ver Steeg and Hofstadter 1981
Clarence L. Ver Steeg and Richard Hofstadter. *A People and a Nation.* New York: Harper and Row, 1981.

Viallefond 1955
Geneviève Viallefond. *Le Peintre Léon Riesener, 1808–1878, sa vie, son oeuvre, avec des extraits d'un manuscrit inédit de l'artiste.* Paris: Editions A. Morancé, 1955.

Viatte 1988
Françoise Viatte. *Inventaire general des Dessins italiens, III, Dessins Toscans, XVIe–XVIIe Siècles. Musée du Louvre, Cabinet des Dessins.* Vol. 1, 1560–1640. Paris: Editions de la réunion des musées nationaux, Ministère de la culture et de la communication, 1988.

Visser 1973
W. J. A. Visser. "Vincent Van Gogh en 's-Gravenhage." *Jaarboek die Haghe,* 1973, pp. 1–125.

Vogel 1976
Lise Vogel. "Erotica, the Academy and Art Publishing: A Review of *Woman as Sex Object: Studies in Erotic Art 1730–1970.*" *ArtJ* 35 (Summer 1976), pp. 378–85.

Von Wiegand 1961
Charmion Von Wiegand. "Mondrian: A Memoir of His New York Period." *Arts Yearbook* 4 (1961), pp. 56–65.

Voragine 1993
Jacobus de Voragine. *The Golden Legend (Legenda aurea).* Translated by William Granger Ryan from the 2d ed. (1850) of the Latin text published by Th. Graesse in 1845. 2 vols. Princeton, N.J.: Princeton University Press, 1993.

Vorenkamp 1939a
Alphons P. A. Vorenkamp. "A Silverpoint by Dieric Bouts." *SCMA Bull,* no. 20 (June 1939), pp. 3–10.

Vorenkamp 1939b
Alphons P. A. Vorenkamp. "A Famous Drawing by Bouts for Northampton." *ArtN* 32, no. 36 (3 June 1939), pp. 9, 18, 19.

Vorenkamp 1939c
Alphons P. A. Vorenkamp. "Recent Acquisitions." *ArtQ* 2, no. 3 (Summer 1939), pp. 287–88. Excerpt reprinted from Vorenkamp 1939a.

Vorenkamp 1958
Reprint of Vorenkamp 1939a in *SCMA Bull*, no. 38 (1958), pp. 1–7.

Voss 1907
Hermann Voss. *Die Ursprung des Donaustils. Ein Stück Entwicklunsgeschichte deutscher Malerei.* Leipzig: K. W. Hiersmann, 1907.

Walker 1945
R. A. Walker. *Le Morte Darthur with Beardsley Illustrations: A Bibliographical Essay.* Bedford: R. A. Walker, 1945.

Wark 1975
Robert R. Wark. *Drawings by Thomas Rowlandson in the Huntington Collection.* San Marino, Calif: Huntington Library, 1975.

Watson 1940
Jane Watson. "Art in Action at San Francisco." *Magazine of Art* 33, no. 8 (Aug. 1940), pp. 462–69.

Watt 1961
Alexander Watt. "Paris Letter: Mark Tobey." *Art in America* 49, no. 4 (1961), pp. 112–14.

Weintraub 1976
Stanley Weintraub. *Aubrey Beardsley: Imp of the Perverse.* University Park: The Pennsylvania State University Press, 1976.

Weixlgärtner 1962
Arpád Weixlgärtner. *Grünewald.* Vienna and Munich: Verlag Anton Schroll, 1962.

Welsh 1966
Robert P. Welsh. "The Hortus Conclusus of Piet Mondrian." *Connoisseur* (American ed.), 161, no. 647 (Feb. 1966), pp. 132–35.

Welsh 1973
Robert P. Welsh. "The Portrait Art of Mondrian," pp. 356–60, in *Album Amicorum J. G. van Gelder.* The Hague: Martinus Nijhoff, 1973.

Wentworth 1984
Michael Wentworth. *James Tissot.* Oxford: Clarendon Press; New York: Oxford University Press, 1984.

Werner 1932
Bruno Werner. "Georges Seurat." *Die Kunst für Alle* 47, no. 5 (1932), pp. 147–51.

White 1984
Barbara Ehrlich White. *Renoir: His Life, Art, and Letters.* New York: Harry N. Abrams, 1984.

Whitney 1997
Wheelock Whitney. *Géricault in Italy.* New Haven and London: Yale University Press, 1997.

Wildenstein 1960
Georges Wildenstein. *The Paintings of Fragonard: Complete Edition.* Translated by C. W. Chilton (introductory text) and Mrs. A. L. Kitson (cat.). London: Phaidon Press, 1960.

Wildenstein 1992–96
Alec Wildenstein. *Odilon Redon. Catalogue raisonné.* 3 vols. Paris: Wildenstein Institute, 1992–96. Vol. 1 (1992), *Portraits et Figures.*

Text and research by Agnès Lecau St. Guily; documentation by Marie-Christine DeCroocq, with Sylvie Crussard and Emilie Offenstadt. Vol. 2 (1994), *Mythes et Légendes.* Text and research by Agnès Lecau St. Guily; documentation by Marie-Christine DeCroocq. Vol. 3 (1996), *Fleurs et Paysages.* Text and research by Agnès Lecau St. Guily.

Wilhelm 1956
J. Wilhelm. "Deux Dessus de portes de Fragonard provenant du château de Louveciennes." *Revue des Arts* 6, no. 4 (Dec. 1956), pp. 215–22.

Wilkinson 1977
Alan G. Wilkinson. *The Drawings of Henry Moore.* London: The Tate Gallery, 1977.

Wilkinson 1979
Alan G. Wilkinson. *The Moore Collection in the Art Gallery of Ontario.* Toronto: Art Gallery of Ontario, 1979.

Wilson 1983
Brian Wilson. *Beardsley.* 1976. Revised and enlarged ed. Oxford: Phaidon Press, 1983.

Winzinger 1952
Franz Winzinger. *Albrecht Altdorfer, Zeichnungen.* Munich, 1952.

Winzinger 1975
Franz Winzinger. *Albrecht Altdorfer: Die Gemälde: Tafelbilder, Miniaturen, Wandbilder, Bildhauerarbeiten, Werkstatt und Umkreis.* Munich: Hirmer Verlag, 1975.

Wittrock 1985
Wolfgang Wittrock. *Toulouse-Lautrec: The Complete Prints.* Edited and translated by Catherine E. Kuehn. London: P. Wilson for Sotheby's Publications, 1985.

Wolff 1989
Martha Wolff. "An Image of Compassion: Dieric Bouts's *Sorrowing Madonna.*" *Museum Studies* (The Art Institute of Chicago) 15, no. 2 (1989), pp. 112–25.

Wood 1986
Christopher Wood. *Tissot: The Life and Work of Jacques Joseph Tissot, 1836–1902.* Boston: Little, Brown, 1986.

Woodall 1939
Mary Woodall. *Gainsborough's Landscape Drawings.* London: Faber and Faber, 1939.

Zaitzevsky 1982
Cynthia Zaitzevsky. *Frederick Law Olmsted and the Boston Park System.* Cambridge, Mass.: Belknap Press of Harvard University Press, 1982.

Zanetti 1771
Antonio Maria Zanetti. *Della pittura veneziana e delle opere dei veneziani maestri.* Venice: G. Albrizzi, 1771.

Zervos 1928
Christian Zervos. "*Un Dimanche à la Grande Jatte* et la technique de Seurat." *Cahiers d'Art* 3, no. 9 (1928), pp. 361–75.

Zimmermann 1991
Michael F. Zimmermann. *Seurat and the Art Theory of His Time.* English ed. Antwerp: Fonds Mercator, 1991.

Zülch 1938
Walther K. Zülch. *Der Historische Grünewald. Mathis Gothart-Neithardt.* Munich: F. Bruckmann Verlag, 1938.

EXHIBITIONS

AFA 1954–56
Smith College Collects II. No cat. Exh. circulated by the American Federation of Arts. Wooster, Ohio, College of Wooster, 25 Nov.–15 Dec. 1954; Syracuse, N.Y, Syracuse University, 4–25 Jan. 1955; Middletown, Conn., Davison Art Center, Wesleyan University, 8 Feb.–1 March 1955; Northfield, Minn., Carleton College, 7–28 April 1955; Lincoln, Mass., DeCordova Museum, 3 July–19 Aug. 1955; Cambridge, Massachusetts Institute of Technology, 15 Sept.–5 Oct. 1955; Miami Beach, Fla., Miami Beach Art Center, 28 Nov.–15 Dec. 1955; Quincy, Ill., Quincy Art Club, 4–25 Feb. 1956; Ann Arbor, Museum of Art, University of Michigan, 8 April–29 May 1956.

AFA 1956–57
College and University Collections. Catalogues in various languages published for the venues. Exh. circulated by the American Federation of Arts. Malmö, Sweden, Malmö Radhüs, 30 June–15 July 1956; Utrecht, Holland, Utrecht Centraal Museum, 4 Aug.–9 Sept. 1956; Birmingham, England, City Art Gallery, 18 Sept.–15 Oct. 1956; Senate House, University of London, Oct. 22–27 1956; Newcastle-on-Tyne, Hatton Gallery, Kings College, University of Durham, 5–17 Nov. 1956; Brussels, Palais des Beaux-Arts, 7–31 Dec. 1956; Liège, Musée des Beaux-Arts, 12 Jan.–10 Feb. 1957; Lyons, France, Musée des Beaux-Arts, 9 March–11 April 1957; Marburg, Germany, Marburg University Museum, 8–26 May 1957; Tübingen, Germany, Tübingen University Museum, 5–30 June 1957; Besançon, France, Musée Bonnat, 8 July–1 Aug. 1957.

AFA 1959–60
Käthe Kollwitz. No cat. Exh. circulated by the American Federation of Arts. New York, Time, Inc., 1–26 Oct. 1959; Middletown, Conn., Davison Art Center, Wesleyan University, 1–22 Nov. 1959; Tulsa, Okla., Philbrook Art Center, Dec. 1959; Pensacola, Fla., Pensacola Art Center, 5–25 Jan. 1960; Louisville, The J. B. Speed Art Museum, 8–28 Feb. 1960; Charleston, Eastern Illinois University, 10–31 March 1960; Concord, N.H., St. Paul's School, 14 April–5 May 1960; Allentown, Pa., Allentown Museum of Art, 19 May–10 June 1960; Tacoma, Wash., Tacoma Art League, 4–15 Oct. 1960; Fine Arts Gallery of San Diego, 8–29 Nov. 1960.

AFA 1970–72
Nineteenth- and Twentieth-Century Paintings from the Collection of the Smith College Museum of Art. Exh. cat. by Mira Matherny Fabian, Michael Wentworth, and Charles Chetham. Exh. circulated by the American Federation of Arts. Northampton: SCMA, 1970. Washington, D.C., National Gallery of Art, 16 May–14 June 1970; The Museum of Fine Arts, Houston, 2 Aug.–13 Sept. 1970; Kansas City, William Rockhill Nelson Gallery of Art, 20 Dec. 1970–1 Feb. 1971; Richmond, Virginia Museum of Fine Arts, 28 Feb.–11 April 1971; The Toledo Museum of Art, 3 Oct.–14 Nov. 1971; Dallas Museum of Fine Arts, 12 Dec. 1971–16 Jan. 1972; Athens, Georgia Museum of Art, University of Georgia, 13 Feb.–26 March 1972; Utica, N.Y., Munson-Williams-Proctor Institute, 23 April–4 June 1972; The Cleveland Museum of Art, 10 Sept.–22 Oct. 1972.

Albuquerque 1964
Art since 1889: An Exhibition Presented in Honor of the Seventy-fifth Anniversary of the Founding of the University of New Mexico, 1889/1964. Exh. cat., foreword by Clinton Adams. Albuquerque: University of New Mexico Press, 1964. Albuquerque, Art Gallery, University of New Mexico, 20 Oct.–15 Nov. 1964.

Allentown 1965
Seventeenth-Century Painters of Haarlem, 1570–1790. Exh. cat., introduction by Richard Hirsch. Allentown, Pa., Allentown Art Museum, 2 April–13 June 1965.

Allentown 1971
The Circle of Canaletto. Exh. cat., foreword by Claus Virch. Allentown, Pa., The Allentown Art Museum, 21 Feb.–21 March 1971.

Amherst 1953
Impressionist Paintings. No cat. Amherst, Mass., Mead Art Gallery, Amherst College, 2–31 Jan. 1953.

Amherst 1958
A Synopsis of American Art II. No cat. Amherst, Mass., Jones Library, 14 Feb.–17 March 1958.

Amherst 1979
Background to Modernism: Prints and Drawings, 1899–1906. Typescript catalogue and checklist by Mark Roskill. Amherst, Mass., Mead Art Museum, Amherst College, 9 Oct.–19 Nov. 1979.

Amherst 1990a
Drawn Lines: Modern European and American Drawings. No cat. Amherst, Mass., Mead Art Gallery, Amherst College, 24 May–1 July 1990.

Amherst 1990b
Northern Travelers to Sixteenth-Century Italy. Exh. checklist by Nicola Courtright. Amherst, Mass., Mead Art Museum, Amherst College, 26 Oct.–9 Dec. 1990.

Amsterdam 1908
Vincent van Gogh Tentoonstelling. Exh. cat. Amsterdam, Kunsthandel C. M. van Gogh, Sept. 1908.

Amsterdam 1989
De verszmeling van Mr. Carel Vosmaer (1826–1888). Exh. cat. edited by Jan Frederik H. Heijbroek, cat. by F. L Bastet. 's-Gravenhage and Amsterdam: S. D. U. and Rijksprentenkabinett, Rijksmuseum, 1989. Amsterdam, Rijksmuseum, 18 March–11 June 1989.

Andover 1954
Variations . . . Three Centuries of Painting. Exh. checklist. Andover, Mass., Addison Gallery of American Art, Phillips Academy, 8 Jan.–15 Feb. 1954.

Ann Arbor 1962
A Generation of Draughtsmen. Exh. cat. by Charles Chetham and members of the Museum Seminar. Ann Arbor, The University of Michigan Museum of Art, 25 April–29 May 1962.

Ann Arbor 1965

French Watercolors, 1760–1860. Exh. cat. by P[aul L.] G[rigaut]. Ann Arbor, University of Michigan Museum of Art, 29 Sept.–24 Oct. 1965.

Antwerp 1993

Jacob Jordaens (1593–1678). Tableaux et tapisseries. Exh. cat. edited by Hans Devisscher and Nora De Poorter; cat. by Roger-Adolf d'Hulst, Nora De Poorter, and Marc Vandenden. Brussels: Réunion des Musées Nationaux and Credit Communal Belgique, 1993. Antwerp, Koninklijk Museum voor Schone Kunsten, 27 March–27 June 1993.

ASI 1990

The Art of Thomas Rowlandson. Exh. cat. by John Hayes. Exh. organized and circulated by Art Services International. Alexandria, Va.: Art Services International, 1990. New York, The Frick Collection, 6 Feb.–8 April 1990; Pittsburgh, The Frick Art Museum, 21 April–3 June 1990; The Baltimore Museum of Art, 23 June–5 Aug. 1990.

ASI 1990–91a

Eighteenth-Century Scenic and Architectural Design: Drawings by the Galli Bibiena Family from Collections in Portugal. Exh. cat. by Maria Alice Beaumont. Exh. circulated by Art Services International. Alexandria, Va.: Art Services International, 1990. Kansas City, Nelson-Atkins Museum of Art, 22 July–2 Sept. 1990; New York, Cooper-Hewitt Museum, 25 Sept. 1990–1 Jan. 1991; Dallas, Meadows Museum, Southern Methodist University, 19 Jan.–24 Feb. 1991; Pittsburgh, The Frick Art Museum, 30 March–12 May 1991; Washington, D.C., The Octagon, 25 May–7 July 1991.

ASI 1990–91b

Adolph Menzel, 1815–1905: Master Drawings from East Berlin. Exh. cat. by Peter Betthausen, Claude Keisch, Gisold Lammel, and Marie Ursula Riemann. Exh. organized and circulated by Art Services International. Alexandria, Va.: Art Services International, 1990. New York, The Frick Collection, 11 Sept.–18 Nov. 1990; The Museum of Fine Arts, Houston, 1 Dec. 1990–27 Jan. 1991; Pittsburgh, The Frick Art Museum, 16 Feb.–31 March 1991; Cambridge, Mass., Harvard University Art Museums, 27 April–23 June 1991.

ASI 1993

Three Centuries of Roman Drawings from the Villa Farnesina, Rome. Exh. cat. by Simonettta Prosperi Valenti Rodinò. Exh. organized and circulated by Art Services International. Alexandria, Va.: Art Services International, 1993. Kansas City, Nelson-Atkins Museum of Art, 17 April–6 June 1993; Sarasota, John and Mable Ringling Museum of Art, 26 June–15 Aug. 1993; Pittsburgh, The Frick Art Museum, 17 Sept.–7 Nov. 1993.

Atlanta 1985

Master Drawings from Titian to Picasso: The Curtis O. Baer Collection. Exh. cat. by Eric M. Zafran. Atlanta: High Museum of Art, 1985. Washington, D.C., National Gallery of Art, 28 July–6 Oct. 1985; Indianapolis Museum of Art, 14 Jan.–2 May 1986; Sarasota, Fla., The John and Mable Ringling Museum of Art, 27 March–11 May 1985; Atlanta, High Museum of Art, 31 May–24 Aug. 1986; Baltimore, The Walters Art Gallery, 17 Sept.–2 Nov. 1986; Frederick Wight Gallery, University of California at Los Angeles, 30 Nov. 1986–11 Jan. 1987.

Austin 1977

Eighteenth- and Nineteenth-Century French Drawings and Prints with a Selection of Drawings by J.-A.-D. Ingres. Exh. checklist.

Austin, Archer M. Huntington Gallery, University Art Museum, The University of Texas, 6 Feb.–20 March 1977.

Balingen 1987

Marc Chagall zum 100. Geburtstag: Gouachen und Aquarelle. Exh. cat. by Roland Doschka. Balingen, Switzerland: Stadthalle Balingen, 1987. No dates given.

Baltimore 1963–64

Eighteenth Century Prints and Drawings. No cat. Exh. organized by Victor Carlson.The Baltimore Museum of Art, 17 Dec. 1963–23 Feb. 1964.

Baltimore 1979–81

Barnett Newman: The Complete Drawings, 1944–1969. Exh. cat. by Brenda Richardson. Baltimore: The Baltimore Museum of Art, 1979. The Baltimore Museum of Art, 29 April–17 June 1979; The Detroit Institute of Arts, 7 Aug.–30 Sept. 1979; Chicago, Museum of Contemporary Art, 2 Nov. 1979–6 Jan. 1980; New York, The Metropolitan Museum of Art, 12 Feb.–9 April 1980; Paris, Musée National d'Art Moderne / Centre Georges Pompidou, 12 Nov. 1980–4 Jan. 1981; Cologne, Museum Ludwig, 9 Feb.–5 April 1981; Basel, Kunstmuseum, 1 May–5 July 1981.

Basel 1928

Paul Gauguin, 1848–1903. Exh. cat. Basel, Kunsthalle, July–Aug. 1928.

Berkeley 1960

Art from Ingres to Pollock: Painting and Sculpture since Neoclassicism, an Exhibition Inaugurating Alfred L. Kroeber Hall and the Galleries of the Art Department of the University of California. Exh. cat. Berkeley: University of California Press, 1960. Kroeber Hall, University of California, 6 March–3 April 1960.

Berlin 1928

Paul Gauguin, 1848–1903. Exh. cat. Berlin, Galerien Thannhauser, Oct. 1928.

Berlin 1975

Pieter Bruegel der Ältere als Zeichner. Herkunft und Nachfolge. Exh. cat. by Fedja Anzelewsky et al. Berlin: Staatliche Museen Preussischer Kulturbesitz, 1975. Kupferstichkabinett, 19 Sept.–16 Nov. 1975.

Berlin 1988

Albrecht Altdorfer: Zeichnungen, Deckfarbenmalerei, Druckgraphik. Exh. cat. by Hans Mielke, with essays by Martin Angerer and Wolfgang Pfeiffer. Berlin: Reimer, 1988. Berlin, Staatliche Museen Preussischer Kulturbesitz, Kupferstichkabinett 13 Feb.–17 April 1988; Regensburg, Museen der Stadt Regensburg, 6 May–10 July 1988.

Bern 1954

Fragonard. Exh. cat. by François Daulte, introduction by Max Huggler. Bern, Musée des Beaux-Arts, 13 June–29 Aug. 1954.

Birmingham (Engl.) 1934

Early English Watercolours by Masters of the English School. Birmingham, England, Ruskin Gallery, April 1934.

Birmingham / Springfield 1978

The Tiepolos: Painters to Princes and Prelates. Exh. cat. by Edward F. Weeks, introduction by Barry Hannegan. Birmingham, Ala.: Birmingham Museum of Art, 1978. Birmingham Museum of Art, 8 Jan.–19 Feb. 1978; Springfield, Mass., Museum of Fine Arts, 19 March–7 May 1978.

Bloomington 1968
The Academic Tradition: An Exhibition of Nineteenth-Century French Drawings. Exh. cat. by Sarah Whitfield. Bloomington, Indiana University Art Museum, 19 June–11 Aug. 1968.

Bologna 1975
Mostra di Federico Barocci (Urbino, 1535–1612). Exh. cat. by Andrea Emiliani, section on drawings by Giovanna Gaeta Bertelà. Bologna: Edizioni Alfa, 1975. Bologna, Museo Civico, 14 Sept.–16 Nov. 1975.

Boston 1900
First Annual New Gallery Exhibition of Contemporary American Art. Exh. checklist. Boston: Boston Art Students' Association, 21 Nov.–18 Dec. 1900.

Boston 1934
The Nineties in America and England. Catalogue no. 225. Boston: Goodspeed's Book Shop, 1934.

Boston 1937
Modern French Paintings from Boston Collections. No cat. Boston, Institute of Modern Art, 1937.

Boston 1939
Art in New England: Paintings, Drawings, and Prints from Private Collections in New England. Exh cat., introduction by M. A. De Wolfe Howe. Cambridge, Mass.: Harvard University Press, 1939. Boston, Museum of Fine Arts, 9 June–10 Sept. 1939.

Boston 1954
Forty-four Major Works from the Smith College Collection. No cat. or checklist. Boston, Institute of Contemporary Art, 7 Jan.–9 Feb. 1954.

Boston 1960–61
Maurice Prendergast 1859–1924. Exh. cat. by Hedley Howell Rhys; foreword by Perry T. Rathbone; cat. prepared by Peter A. Wick. Cambridge, Mass.: Harvard University Press, 1960. Boston, Museum of Fine Arts, 26 Oct.–4 Dec. 1960; Hartford, Wadsworth Atheneum, 29 Dec. 1960–5 Feb. 1961; New York, Whitney Museum of American Art, 21 Feb.–2 Apr. 1961; San Francisco, California Palace of the Legion of Honor, 22 Apr.–3 June 1961; The Cleveland Museum of Art, 20 June–30 July 1961.

Boston 1971–72
Albrecht Dürer Master Printmaker. Exh. cat. by the Department of Prints and Drawings, Museum of Fine Arts. Boston, Museum of Fine Arts, 17 Nov. 1971–16 Jan. 1972.

Boston 1974
Edgar Degas: The Reluctant Impressionist. Exh. cat. by Barbara Stern Shapiro. Boston, Museum of Fine Arts, 20 June–1 Sept. 1974.

Boston 1984–85
Edgar Degas: The Painter as Printmaker. Exh. cat. by Sue Welsh Reed and Barbara Stern Shapiro, with Clifford Ackley, Roy L. Perkinson, Douglas Druick, and Peter Zegers. Boston: Museum of Fine Arts, 1984. Boston, Museum of Fine Arts, 14 Nov. 1984–13 Jan. 1985; Philadelphia Museum of Art, 17 Feb.–14 April 1985; London, Hayward Gallery, 15 May–7 July 1985.

Boston 1986
The Bostonians: Painters of an Elegant Age, 1870–1930. Exh. cat. by Trevor J. Fairbrother, with contributions by Theodore E. Stebbins, Jr., William L. Vance, and Erica E. Hirshler. Boston: Museum of Fine Arts, 1986. Boston, Museum of Fine Arts, 11 June–14 Sept. 1986; Denver Art Museum, 25 Oct. 1986–18 Jan. 1987; Chicago, Terra Museum of American Art, 13 Mar.–10 May 1987.

Braunschweig 1979
Jan Lievens, ein Maler im Schatten Rembrandts. Exh. cat. edited by Rüdiger Klessmann; essays by Jan Białostocki, Rudolf E. O. Ekkart, and Sabine Jacob; entries by Rudolph E. O. Ekkart, Sabine Jacob, and Rüdiger Klessmann; translated by Wolfgang J. Müller, Hans Seyffert. Braunschweig, Herzog Anton Ulrich-Museum, 6 Sept.–11 Nov. 1979.

Bremen 1981–82
Adolph Menzel: Realist — Historist — Maler des Hofes: Gemälde, Gouachen, Aquarelle, Zeichnungen und Druckgraphik aus der Sammlung Georg Schäfer, Schweinfurt, und aus der Kunsthalle Bremen. Exh. cat. by Jens Christian Jensen and Jürgen Schultze. Schweinfurt, Germany: Sammlung Georg Schäfer, 1981. Kunsthalle zu Kiel, 5 April–8 June 1981; Bremer Kunsthalle, 21 June–1 Aug. 1981; Museum für Kunst und Kulturgeschichte der Stadt Lübeck, 15 Aug.–4 Oct. 1981; Altes Rathaus der Stadt Schweinfurt, 23 Oct.–29 Nov. 1981; Städtische Kunstsammlungen Augsburg, 12 Dec. 1981–31 Jan. 1982.

Brooklyn 1926
Paintings by Modern French and American Artists. No cat. Brooklyn, N.Y., The Brooklyn Institute of Arts and Sciences (now Brooklyn Museum of Art), 12 June–14 Oct. 1926.

Bruges/Detroit 1960
Flanders in the Fifteenth Century: Art and Civilization. Exh. cat. for Detroit venue, *Masterpieces of Flemish Art: Van Eyck to Bosch,* by Lucie Ninane, Jacqueline Folie, Dorothy E. Miner, Francis W. Robinson, Albert Schouteet, and Richard Kay; translated by Richard M. Stein, Frank Smolar, and Mrs. Robert Shepherd. Detroit: The Detroit Institute of Arts; Brussels: Centre National de recherches primitifs flamands, 1960. Bruges, Musée Communal des Beaux-Arts (Musée Groeninge), 26 June–11 Sept. 1960; The Detroit Institute of Arts, 18 Oct.–31 Dec. 1960.

Brussels/Delft 1957–58
Dieric Bouts. Exh. cat. edited by A. B. de Vries. Brussels: Editions de la Connaissance, 1957. Brussels, Palais des Beaux-Arts, 11 Oct.–10 Dec. 1957; Delft, Museum Prinsenhof, 21 Dec. 1957–March 1958.

Buffalo 1901
Pan-American Exposition: Catalogue of the Exhibition of Fine Arts. Exh. checklist. Buffalo, 1 May–1 Nov. 1901.

Buffalo 1944
Charles Burchfield: A Retrospective Exhibition of Water Colors and Oils, 1916–1943. Exh. cat. Buffalo, Albright Art Gallery, Buffalo Fine Arts Academy, 14 April–15 May 1944.

Burlington 1959
Students' Art Festival. No cat. Burlington, Vermont, Robert Hull Fleming Museum, University of Vermont, April 1959.

Cambridge (Engl.) 1984
Prints and Drawings by Adolph Menzel: A Selection from the Collections of the Museums of West Berlin. Exh. cat. by Lucius Grisebach et al. Berlin: Staatliche Museen Preussischer Kulturbesitz, 1984. Cambridge, Engl., Fitzwilliam Museum, 16 Jan.–4 March 1984.

Cambridge 1941
Netherlandish Art. No cat. Cambridge, Mass., Fogg Art Museum, Harvard University, 1–26 Dec. 1941.

Cambridge 1948–49
Seventy Master Drawings: A Loan Exhibition Arranged in Honor of Professor Paul J. Sachs on the Occasion of His Seventieth Birthday. Exh. cat. Cambridge, Mass., Fogg Art Museum, Harvard University, 27 Nov. 1948–6 Jan. 1949.

Cambridge 1960
One Hundred Years of English Landscape Drawing, 1750–1850. Exh. cat. Exh. organized by David Brooke, Edith Kramer, and Gay van der Hoeven. Cambridge, Mass., Busch-Reisinger Museum, Harvard University, 13 May–8 June 1960.

Cambridge 1962
Anxiety and Elegance: The Human Figure in Italian Art, 1520–1580. Exh. cat. by students in the museum course, Mary Lee Bennett, Dr. Wolfgang Fischer, Marcia Brown Hall, Gyde Vanier Shepherd, and Franca Trinchieri. Cambridge, Mass., Fogg Art Museum, Harvard University, 1–25 May 1962.

Cambridge 1964
Studies and Study Sheets: Master Drawings from Five Centuries. Exh. cat. by Eunice Williams, Joseph Gluhman, Roland Hadley, and Michael Wentworth. Cambridge, Mass., Fogg Art Museum, Harvard University, 26 March–18 April 1964.

Cambridge 1966
Christmas Show. No cat. Cambridge, Mass., Gropper Art Gallery, Dec. 1966.

Cambridge 1967a
Ingres Centennial Exhibition, 1867–1967: Drawings, Watercolors, and Oil Sketches from American Collections. Exh. cat., introduction by Agnes Mongan; cat. by Agnes Mongan and Hans Naef; technical appendix by Majorie B. Cohn. Greenwich, Conn.: President and Fellows of Harvard College; distributed by New York Graphic Society, 1967. Cambridge, Mass., Fogg Art Museum, Harvard University, 12 Feb.–9 April 1967.

Cambridge 1967b
Art of the Northern Renaissance. No cat. Exh. organized by Charles L. Kuhn. Cambridge, Mass., Busch-Reisinger Museum, Harvard University, 13 Feb.–1 April 1967.

Cambridge 1970
Tiepolo: A Bicentenary Exhibition, 1770–1970. Drawings, Mainly from American Collections, by Giambattista Tiepolo and the Members of His Circle. Exh. cat. by George Knox, foreword by Agnes Mongan. Cambridge, Mass., Fogg Art Museum, Harvard University, 14 March–3 May 1970.

Cambridge 1991–92
Seventeenth-Century Dutch Drawings: A Selection from the Maida and George Abrams Collection. Exh. cat. by William W. Robinson, introduction by Peter Schatborn. Lynn, Mass.: H. O. Zimman, 1991. Amsterdam, Rijksmuseum, Rijksprentenkabinet, 23 Feb.–28 April 1991; Vienna, Graphische Sammlung Albertina, 16 May–30 June 1991; New York, The Pierpont Morgan Library, 22 Jan.–22 April 1992; Cambridge, Mass., Fogg Art Museum, Harvard University, 10 Oct.–6 Dec. 1992.

Cambridge 1998–2000
Mastery and Elegance: Two Centuries of French Drawings from the Collection of Jeffrey E. Horvitz. Exh. cat. edited by Alvin L. Clark, Jr., with Margaret Morgan Grasselli, Jean-François Méjanès, and William W. Robinson; foreword by Pierre Rosenberg; essays by Alain Mérot and Sophie Raux-Carpentier, Marianne Roland Michel; interview with the collector. Cambridge, Mass.: Harvard University Press, 1998. Harvard University Art Museums,

5 Dec. 1998–31 Jan. 1999; Toronto, Art Gallery of Ontario, 20 Feb.–18 April 1999; Paris, Musée Jacquemart-André, 1 May–25 June 1999; Edinburgh, National Gallery of Scotland, 9 July–5 Sept. 1999; New York, National Academy Museum and School of Fine Arts, 8 Oct.–12 Dec. 1999; Los Angeles County Museum of Art, 24 Feb.–24 April 2000.

Cambridge / New York 1996–97
Tiepolo and His Circle: Drawings in American Collections. Exh. cat. by Bernard Aikema. Translated by Andrew McCormick; appendix by Peter Dreyer. New York: The Pierpont Morgan Library; Cambridge, Mass.: Harvard University Art Museums, 1996. Cambridge, Mass., Harvard University Art Museums, 12 Oct.–15 Dec. 1996; New York, The Pierpont Morgan Library, 17 Jan.–13 April 1997.

Chapel Hill 1958
Paintings, Drawings, Prints, and Sculpture from American College and University Collections. Exh. checklist. Chapel Hill, N.C., William Hayes Ackland Memorial Art Center, University of North Carolina, 20 Sept.–20 Oct. 1958.

Charleston 1901–2
South Carolina Inter-State and West Indian Exposition. Exh. cat. Charleston, S.C., 1901–2.

Chicago 1935
Twenty-four Paintings and Drawings by Georges-Pierre Seurat: Studies for "La Grand Jatte" and Other Pictures. Exh. cat. by Daniel Catton Rich et al. The Renaissance Society of the University of Chicago, 5–25 Feb. 1935.

Chicago 1955
Mark Tobey. No cat. The Art Institute of Chicago, 15 Jan.–15 March 1955.

Chicago 1958
Seurat: Paintings and Drawings. Exh. cat. edited by Daniel Catton Rich and Robert L. Herbert. Chicago: University of Chicago Press, 1958. The Art Institute of Chicago, 16 Jan.–7 March 1958; New York, The Museum of Modern Art, 24 March–11 May 1958.

Chicago 1961
Smith College Loan Exhibition. Exh. cat., introduction by Thomas C. Mendenhall. The Arts Club of Chicago, 10 Jan.–15 Feb. 1961.

Chicago / Amsterdam / London 1994–95
Odilon Redon: Prince of Dreams, 1840–1916. Exh. cat. by Douglas W. Druick, Gloria Groom, Fred Leeman, Kevin Sharp, MaryAnne Stevens, Harriet K. Stratis, and Peter Kort Zegers. Chicago: The Art Institute of Chicago in association with Harry N. Abrams, 1994. The Art Institute of Chicago, 2 July–18 Sept. 1994; Amsterdam, Van Gogh Museum, 20 Oct. 1994–15 Jan. 1995; London, Royal Academy of Arts, 16 Feb.–21 May 1995.

Chicago / New York 1952
Cézanne, Paintings, Watercolors, and Drawings. Exh. cat. by Daniel Catton Rich and P. T. Malone. Chicago: The Art Institute of Chicago, 1952. The Art Institute of Chicago, 7 Feb.–16 March 1952; New York, The Metropolitan Museum of Art, 1 April–16 May 1952.

Cleveland / New Haven 1978
The Graphic Art of Federico Barocci: Selected Drawings and Prints. Exh. cat. by Edmund P. Pillsbury and Louise S. Richards. New Haven: Yale University Art Gallery, 1978. The Cleveland Museum of Art, 15 Feb.–26 March 1978; Yale University Art Gallery, 11 April–4 June 1978.

College Park 1976–77

Maurice Prendergast: Art of Impulse and Color. Exh. cat. by Eleanor Green, Ellen Glavin, and Jeffrey R. Hayes. College Park: University of Maryland Art Gallery, 1976. University of Maryland Art Gallery, 1 Sept.–6 Oct. 1976; Austin, University Art Museum, University of Texas, 17 Oct.–21 Nov. 1976; Des Moines Art Center, 1 Dec. 1976–2 Jan. 1977; Columbus, Ohio, Columbus Gallery of Fine Arts, 14 Jan.–20 Feb. 1977; Ithaca, N.Y., Herbert F. Johnson Museum of Art, Cornell University, 1 March–15 Apr. 1977.

College Park 1977–78

From Delacroix to Cézanne: French Watercolor Landscapes of the Nineteenth Century. Exh. cat. by Alain de Leiris and Carol Hynning Smith. College Park, University of Maryland Art Gallery, 26 Oct.–4 Dec. 1977; Louisville, Ky., J. B. Speed Art Museum, 9 Jan.–19 Feb. 1978; Ann Arbor, University of Michigan Museum of Art, 1 April–14 May 1978.

Columbus 1939–40

Watercolors by Paul Cézanne. Exh. checklist in Columbus Gallery of Fine Arts monthly *Bulletin* 10, no. 3 (Dec. 1939). Columbus, Ohio, The Columbus Gallery of Fine Arts, 19 Dec. 1939–8 Jan. 1940.

Columbus 1997–98

The Paintings of Charles Burchfield: North by Midwest. Exh. cat. by Nannette V. Maciejunes and Michael D. Hall, with contributions by Henry Adams, Kenneth L. Ames, Michael Kammen, M. Sue Kendall, Donald Kuspit, Roald Nasgaard, William H. Robinson, and Richard Wootten. New York: Harry N. Abrams in association with the Columbus Museum of Art. Columbus, Ohio, Columbus Museum of Art, 23 March–18 May 1997; Buffalo, Burchfield-Penney Art Center, 15 June–17 Aug. 1997; Washington, D.C., National Museum of American Art, Smithsonian Institution, 26 Sept. 1997–25 Jan. 1998.

Deerfield 1944

Commencement Exhibition. No cat. Deerfield, Mass., Deerfield Academy, 29 May–24 June 1944.

Deerfield 1956

[Exhibition title not known]. No cat. Deerfield, Mass., Hilson Gallery, Deerfield Academy, June–Sept. 1956.

Detroit 1983

The Quest for Unity: American Art between World's Fairs 1876–1893. Exh. cat., essay by David C. Huntington; cat. by Michele Bogart, David Hanks, David C. Huntington, Nancy Rivard Shaw, Deborah Fenton Shepherd, and Kathleen Pyne. The Detroit Institute of Arts, 22 Aug.–30 Oct. 1983.

Durham 1978

Contemporary Drawings from University Collections. No cat. Durham, N.H., University Art Galleries, University of New Hampshire, 6 Sept.–26 Oct. 1978.

Evanston 1985–88

Monotypes by Maurice Prendergast in the Terra Museum of American Art. Exh. cat. by Cecily Langdale, foreword by John Wilmerding. Chicago: Terra Museum of American Art, 1984. Washington, D.C., National Gallery of Art, 27 Jan.–14 April 1985; Evanston, Ill., Terra Museum of American Art, 27 April–30 June 1985; Fort Worth, Amon Carter Museum, 12 July–8 Sept. 1985; Williamstown, Mass., Williams College Museum of Art, 20 Sept.–17 Nov. 1985; Flint, Mich., Flint Institute of Arts, 24 Nov. 1985–19 Jan. 1986; Oklahoma City, Oklahoma Arts

Center, 28 Jan.–24 Feb. 1986; Syracuse, N.Y., Everson Museum of Art, 13 May–15 June 1986; Chicago, Terra Museum of American Art, 23 June–24 Aug. 1986; Montgomery, Ala., Museum of Fine Arts, 2 Sept.–26 Oct. 1986; Youngstown, Ohio, The Butler Institute of American Art, 2–30 Nov. 1986; The Minneapolis Institute of Arts, 13 Dec. 1986–15 Feb. 1987; New York, Whitney Museum of American Art at Philip Morris, 21 Feb.–12 April 1987; Miami Beach, Bass Museum of Art, 21 June–31 July 1987; Columbus Museum of Art, 8 Aug.–27 Sept. 1987; Utica, N.Y., Munson-Williams-Proctor Institute, 4 Oct.–5 Nov. 1987; Philadelphia, Pennsylvania Academy of the Fine Arts, 15 Nov. 1987–7 Jan. 1988; Los Angeles County Museum of Art, 20 Jan.–22 March 1988; Pittsburgh, Museum of Art, Carnegie Institute, 9 April–29 May 1988.

Florence 1975

Disegni di Federico Barocci. Exh. cat. by Giovanna Gaeta Bertelà. Gabinetto dei Disegni e Stampe degli Uffizi XLIII. Florence: Leo S. Olschki Editore, 1975. Florence, Gabinetto dei Disegni e Stampe, 27 Sept.–Nov. 1975.

Florence 1986–87

Disegni di Fra Bartolommeo e della sua scuola. Exh. cat. by Chris Fischer, translated by Stefano Baldi Lanfranchi. Gabinetto dei Disegni e Stampe degli Uffizi LXVI. Florence: Leo S. Olschki Editore, 1986. Florence, Gabinetto dei Disegni e Stampe, 25 Oct. 1986–Feb. 1987.

Florence 1992

Disegni di Lodovico Cigoli (1559–1613). Exh. cat. by Miles L. Chappell. Gabinetto dei Disegni e Stampe degli Uffizi LXXIV. Florence: Leo S. Olschki Editore, 1992. Florence, Gabinetto dei Disegni e Stampe, 23 July–Oct. 1992.

Florence / Paris 1976

Omaggio a Tiziano: Mostra di disegni, lettere e stampe di Tiziano e artisti nordici. Exh. cat. by Bert W. Meijer. Istituto Universitario Olandese di Storia dell'Arte VI. Florence: Istituto Universitario Olandese di Storia dell'Arte, 1976. Florence, Istituto Universitario Olandese, 16 Oct.–7 Nov. 1976; Paris, Institut Néerlandais, 2–30 Dec. 1976.

Florence / Paris 1980–81

L'Epoque de Lucas de Leyde et de Pierre Bruegel: Dessins des anciens Pays-Bas, Collection Frits Lugt. Exh. cat. by Karel G. Boon. Paris: Fondation Custodia, 1981. Florence, Istituto Universitario Olandese, 25 Oct.–30 Nov. 1980; Paris, Institut Néerlandais, 26 Feb.–12 April 1981.

Fort Worth 1996–97

The Shores of a Dream: Yasuo Kuniyoshi's Early Work in America. Cat. by Jane Myers and Tom Wolf for the exhibition *The Shores of a Dream: The Early Work of Yasuo Kuniyoshi.* Fort Worth, Tex.: Amon Carter Museum, 1996. Fort Worth, Amon Carter Museum, 7 Sept.–17 Nov. 1996; Portland, Maine, Portland Museum of Art, 1 Feb.–30 March 1997.

Frankfurt 1970

Vincent van Gogh Zeichnungen und Aquarelle. Exh. cat. Frankfurt, Frankfurter Kunstverein, 30 April–21 June 1970.

Frankfurt 1991

Marc Chagall: The Russian Years 1906–1922. Exh. cat. edited by Christoph Vitali. Frankfurt, Schirn Kunsthalle Frankfurt, 16 June–8 Sept. 1991.

Gorizia / Venice 1983

Da Carlevarijs al Tiepolo: Incisori veneti e friuliani del Settecento. Exh. cat. by Dario Succi; introduction by Giuseppe Maria Pilo; foreword by Giandomenico Romanelli; essays by Beatrice di Colloredo Toppani, Marino De Grassi, Annalia Delneri, Maddalena Malni Pascoletti, and Dario Succi. Venice: Albrizzi Editore, 1983. Gorizia, Musei Provinciali, Palazzo Attems; Venice, Museo Correr.

The Hague 1989

Jan Toorop, 1858–1928. Exh. cat., essay by Victorine Hefting. The Hague, Haags Gemeentemuseum, 18 Feb.–9 Apr. 1989.

The Hague / San Francisco 1990–91

In *Great Dutch Paintings from America.* Exh. organized by Hans R. Hoetink. Exh. cat. by Ben Broos with contributions by Edwin Buijsen, Susan Donahue Kuretsky, Walter Liedtke, Lynn Federle Orr, Juliette Roding, and Peter C. Sutton. The Hague and Zwolle: Mauritshuis / Wanders Publishers, 1990. The Hague, Mauritshuis, 28 Sept. 1990–13. Jan 1991; The Fine Arts Museums of San Francisco, 16 Feb.–5 May 1991.

Hamburg 1982

Menzel — der Beobachter. Exh. cat. edited by Werner Hofmann; cat. by Gisela Hopp and Eckhard Schaar; essays by Werner Hofmann, Elke von Radziewsky, and Eckhard Schaar. Munich: Prestel, 1982. Hamburger Kunsthalle, 22 May–25 July 1982.

Hanover 1966

The Sculptor Draws. Exh. cat. by members of the Museum Studies Seminar, essay by J. E. G. [John E. Glarskey?]. Hanover, N.H., Jacob H. Strauss Gallery, Dartmouth College, 10–30 March 1966.

Hanover 1973–74

One Hundred Master Drawings from New England Collections. Exh. cat. by Franklin Robinson. Hanover, N.H.: Dartmouth College, 1973. Hartford, Conn., Wadsworth Atheneum, 5 Sept.–14 Oct. 1973; Hanover, N.H., Hopkins Art Center Art Galleries, Dartmouth College, 26 Oct.–3 Dec. 1973; Boston, Museum of Fine Arts, 14 Dec. 1973–25 Jan. 1974.

Hartford 1957

Connecticut Collects: An Exhibition of Privately Owned Works of Art in Connecticut. Exh. cat., introduction by Charles C. Cunningham. Hartford, Conn., Wadsworth Atheneum, 4 Oct.–3 Nov. 1957.

Hartford 1975

Drawings: A Reinvestigation. Exh. brochure by Bernard Hanson. West Hartford, Conn., Joseloff Gallery, Hartford Art School, University of Hartford, 16 Feb.–3 March 1975.

Holyoke 1982–83

Sun, Sand, and Wild Uproar: American Seascapes. No cat. Holyoke, Mass., Holyoke Museum at the Holyoke Public Library, 14 Nov. 1982–27 Jan. 1983.

Høvikodden / Paris 1985–86

Klee og musikken. Exh. cat. by Jürgen Glaesemer, Thomas Adank, Christian Geelhaar, et al. Høvikodden, Norway: Sonja Henie-Niels Onstad Foundation, 1985. Cat. by Ole Henrik Moe et al. for Paris venue, *Klee et la musique.* Paris: Musée National d'Art Moderne, Centre Georges Pompidou, 1985. Høvikodden, Norway, Henie-Onstad Kunstsenter, 23 June–15 Sept. 1985; Paris, Musée National d'Art Moderne, Centre Georges Pompidou, 10 Oct. 1985–1 Jan. 1986.

Huntington 1990

Illuminations: Images of Landscape in France, 1855–1885. Exh. cat. by Carol Forman Tabler. Huntington, N.Y.: Heckscher Museum, 1990. Heckscher Museum, 10 March–29 April 1990; Baltimore, The Walters Art Gallery, 13 May–29 July 1990; Memphis, Tenn., The Dixon Gallery and Gardens, 9 Sept.–4 Nov. 1990.

IC MoMA 1958–59

French Drawings from American Collections: Clouet to Matisse. Exh. cat. edited by Helen M. Franc, introduction by Agnes Mongan. Exh. organized by the Committee for the Exhibition of French Drawings, under the auspices of the International Council of the Museum of Modern Art, New York, 1959. New York: International Council at The Museum of Modern Art, 1959. Rotterdam, Museum Boymans, 31 July–28 Sept. 1958 (Dutch ed., *Van Clouet tot Matisse: Tentoonstelling van Franse tekiningen uit Amerikaanse collecties,* Rotterdam, 1958); Paris, Musée de l'Orangerie, 24 Oct. 1958–2 Jan. 1959 (French ed., *De Clouet à Matisse: Dessins français des collections américains,* Paris, 1958); New York, The Metropolitan Museum of Art, 3 Feb.–15 March 1959.

IEF 1983–84

Gainsborough Drawings. Exh. cat. by John Hayes and Lindsay Stainton. Exh. organized and circulated by the International Exhibitions Foundation. Washington, D.C.: International Exhibitions Foundation, 1983. Washington, D.C., National Gallery of Art, 2 Oct.–4 Dec. 1983; Fort Worth, Kimbell Art Museum, 17 Dec. 1983–12 Feb. 1984; New Haven: Yale Center for British Art, 25 Feb.–22 April 1984.

IEF 1984–85a

The Grand Prix de Rome: Paintings from the Ecole des Beaux-Arts, 1797–1863. Exh. cat. by Philippe Grunchec, introduction by Jacques Thullier. Exh. organized and circulated by the International Exhibitions Foundation. Washington, D.C.: International Exhibitions Foundation, 1984. New York, National Academy of Design, 10 Jan.–3 March 1984; Richmond, Virginia Museum of Fine Arts, 3 April–27 May 1984; Indianapolis Museum of Art, 24 June–20 Aug. 1984; Baltimore, The Walters Art Gallery, 9 Sept.–4 Nov. 1984; Phoenix Art Museum, 18 Nov. 1984–13 Jan. 1985; Palm Beach, Fla., Society of the Four Arts, 9 Feb.–10 March 1985; San Antonio Museum of Art, 21 April–16 June 1985; New Orleans Museum of Art, 20 July–15 Sept. 1985.

IEF 1984–85b

Old Master Drawings from the Albertina. Exh. cat. by Veronika Birke, Marian Bisanz-Prakken, Christine Ekelhart, Ekhart Knab, Fritz Koreny, Walter Koshatzky, Erwin Mitsch, and Alice Strobl. Exh. organized and circulated by the International Exhibitions Foundation. Washington, D.C.: International Exhibitions Foundation, 1984. Washington, D.C., National Gallery of Art, 28 Oct. 1984–13 Jan. 1985; New York, The Pierpont Morgan Library, 8 March–26 May 1985.

IEF 1985–86

Master Drawings by Gericault. Exh. cat. by Philippe Grunchec. Exh. organized and circulated by the International Exhibitions Foundation. Washington, D.C.: International Exhibitions Foundation, 1985. New York, The Pierpont Morgan Library, 7 June–31 July 1985; San Diego Museum of Art, 31 Aug.–20 Oct. 1985; The Museum of Fine Arts, Houston, 9 Nov. 1985–5 Jan. 1986.

Ipswich (Engl.) 1927

Bicentenary Memorial Exhibition of Thomas Gainsborough, R.A. Exh. cat. Ispwich Museum, 7 Oct.–5 Nov. 1927.

Ithaca 1978
The Linear Tradition: Selected Drawings from the Eighteenth to the Twentieth Century. Exh. checklist and essay by Harriet Fowler Mullaney. Ithaca, N.Y., Herbert F. Johnson Museum of Art, Cornell University, 14 Feb.–3 April 1978.

Kassel 1930–31
Meisterliche Handzeichnungen aus Privatbesitz. Sammlung Deiker. Kasseler Museumsverein. Der Veröffentlichungen IV Heft. Exh. cat., introduction by Walter Kramm Luthmer. Kassel: Bärenreiterdruck, 1930. Kassel, Hessischen Landesmuseum, winter 1930–31.

Kyoto 1989–90
Yasuo Kuniyoshi. Exh. cat. by Takeo Uchiyama, Susan Lubowsky, and Alexandra Munroe. Kyoto: Nippon Television Network Corp., 1989. Tokyo Metropolitan Teien Art Museum, 1 Nov.–24 Dec. 1989; Okayama Prefectural Museum of Art, 5 Jan.–12 Feb. 1990; Kyoto, National Museum of Modern Art [organizer], 20 Feb.–1 April 1990.

Lawrence / Chapel Hill 1981–82
The Engravings of Marcantonio Raimondi. Exh. cat., essays by Innis H. Shoemaker and Elizabeth Broun, cat. by Innis H. Shoemaker. Lawrence, Kans.: The Spencer Museum of Art, 1981. Lawrence, The Spencer Museum of Art, The University of Kansas, 16 Nov. 1981–3 Jan. 1982; Chapel Hill, N.C., The Ackland Art Museum, University of North Carolina, 10 Feb.–28 March 1982; Wellesley, Mass., Wellesley College Art Museum, 15 April–15 June 1982.

Leiden 1996–97
Jan van Goyen. Exh. cat. by Christiaan Vogelaar, with foreword by H. Bolten-Rempt; essays by Sabine Giepmans, Christiaan Vogelaar, Edwin Buijsen, Eric J. Sluijter, R. L. Falkenburg, and E. Melanie Gifford. Zwolle: Waanders Uitgevers and Stedelijk Museum De Lakenhal, Leiden, 1996. Stedelijk Museum De Lakenhal, 12 Oct. 1996–13 Jan. 1997.

Leuven 1998
Dirk Bouts (ca. 1410–1475), een Vlaams primitief te Leuven. Exh. cat. edited by Maurits Smeyers with the collaboration of Katharina Smeyers. Leuven: Uitgeverij Peeters, 1998. Leuven, Sint-Pieterskerk en Predikherenkerk, 19 Sept.–6 Dec. 1998.

Lille 1988–89
Boilly 1761/1845: Un Grand Peintre français de La Révolution à la Restauration. Exh. cat. by Sylvain Laveissière and Annie Scottez-De Wambrechies. Lille: Musée des Beaux-Arts, 1988. Musée des Beaux-Arts, Oct. 1988–Jan. 1989.

London 1909
Catalogue of an Exhibition of Drawings by Aubrey Beardsley. Exh. cat. London: The Baillie Gallery, Aug.–Sept. 1909.

London 1920
Thirteenth Exhibition of the London Group. Typescript checklist. 18 Oct.–13 Nov. 1920.

London 1926
London, Burlington Fine Arts Club, summer 1926. No cat.

London 1927
Exhibition of Flemish and Belgian Art, 1300–1900. Exh. cat., introduction by Robert Witt. Exh. organized by the Anglo-Belgian Union. London, Royal Academy of Arts, Burlington House, 8 Jan.–5 March 1927.

London 1927 (Memorial)
Catalogue of the Loan Exhibition of Flemish and Belgian Art: A Memorial Volume. Exh. cat. edited by Sir Martin Conway; section on drawings and engravings by Campbell Dodgson. London: Country Life Ltd. and the Anglo-Belgian Union, 1927. London, Royal Academy of Arts, Burlington House, 8 Jan.–5 March 1927.

London 1930
Twenty-sixth Annual Exhibition of Early English Water-Colours. Exh. cat. London, Walker Galleries, Ltd., 30 June–autumn 1930.

London 1931
The Durrio Collection of Works by Gauguin. Exh. cat. London, Leicester Galleries, May–June 1931.

London 1934a
The Winter Exhibition of Early English Water Colour Drawings of the 18th and 19th Centuries. Exh. cat. London, Palser Gallery, Jan. 1934.

London 1934b
Early English Watercolour Drawings. Exh. cat. London, Palser Gallery, summer 1934.

London 1934c
Thirtieth Annual Exhibition of Early English Water-Colours. Exh. cat. London, Walker's Galleries, Ltd., 25 June–autumn 1934.

London 1952
Twentieth Annual Exhibition of Paintings, Drawings, and Sculpture by Artists of Fame and Promise. Part I. Exh. cat. London, Leicester Galleries, July 1952.

London 1957
XIX and XX Century French Paintings. Exh. cat. London, Alex. Reid & Lefevre, Ltd., March–April 1957.

London 1961
XIX and XX Century French Paintings and Drawings. Exh. cat. London, Lefevre Gallery, April 1961.

London 1962
Mark Tobey (modified version of Paris 1961). Exh. cat. translated from material in Paris 1961. London, Whitechapel Gallery, 31 Jan.–4 March 1962.

London 1964
Drawings and Watercolours, 1860 to 1960. Exh. cat. London, Thos. Agnew and Sons, 2–27 June 1964.

London 1965
Léon Reisener: From Romanticism to Impressionism. Exh. cat. London, Couper Gallery, 1965.

London 1975
Paul Nash: Paintings and Watercolours. Exh. cat. London, Tate Gallery, 12 Nov.–28 Dec. 1975.

London 1978–79
Sir Peter Lely, 1618–80. Exh. cat. by Sir Oliver Millar. London: National Portrait Gallery, 1978. London, National Portrait Gallery Exhibition Rooms, 15 Carlton House Terrace, 17 Nov. 1978–18 March 1979.

London 1981
Collecting in the Eighteenth Century: Paintings and Drawings, Works of Art. Exh. cat. London, Chaucer Fine Arts Inc., 19 Nov.–18 Dec. 1981.

London 1985
Chagall. Exh. cat. by Susan Compton, essay by Norbert Lynton.
London: Royal Academy of Arts; Philadelphia: Philadelphia
Museum of Art, 1985. London, Royal Academy of Arts, 11 Jan.–
31 March 1985; Philadelphia Museum of Art, 12 May–7 July 1985.

London 1987
Exhibition of Old Master Drawings. Exh. cat. London, Kate de
Rothschild and Didier Aaron, Ltd., 29 June–10 July 1987.

London 1989
Master Drawings and Sculpture. Exh. cat. London, Thos. Agnew
& Sons, 8 Nov.–8 Dec. 1989.

London 1991
French Drawings, XVI–XIX Centuries. Exh. cat. by Gillian Kennedy
and Anne Thackray. London, The Courtauld Institute Galleries,
University of London, 4 July–6 Oct. 1991.

London/Manchester/Paris 1984–85
James Tissot. Exh. cat. edited by Krystyna Matyjaszkiewicz.
Oxford: Phaidon Press; London: Barbican Art Gallery, 1984.
Barbican Art Gallery, 15 Nov. 1984–20 Jan. 1985; Manchester,
Whitworth Art Gallery, University of Manchester, 1 Feb.–
16 March 1985; Paris, Musée du Petit Palais, 5 April–30 June 1985.

London/New York 1984–85
The Drawings of Henry Matisse. Exh. cat. by John Elderfield and
Magdalena Dabrowski. London: Arts Council of Great Britain,
1984. London, Hayward Gallery, 4 Oct. 1984–6 Jan. 1985; New
York, The Museum of Modern Art, 27 Feb.–14 May 1985.

London/New York 1991
Louis Léopold Boilly's "L'Entrée au Jardin Turc." Exh. cat., essay by
Susan L. Siegfried. London and New York: Matthiesen Fine Art
and Stair Sainty Matthiesen, 1991. London, Matthiesen Fine Art,
and New York, Stair Sainty Matthiesen, autumn 1991.

London/Paris 1991–92
Toulouse-Lautrec. Exh. cat. by Richard Thomson, Anne
Roquebert, et al. English ed. New Haven and London: Yale
University Press, 1991. London, Hayward Gallery, 10 Oct. 1991–
19 Jan. 1992; Paris, Galeries Nationales du Grand Palais, 21 Feb.–
1 June 1992.

Los Angeles 1961
Prints and Drawings of Pieter Bruegel the Elder. Exh. cat. by Ebria
Feinblatt. Los Angeles County Museum of Art, 22 March–7 May
1961.

Los Angeles 1976
Old Master Drawings from American Collections. Exh. cat. by Ebria
Feinblatt. New York: Los Angeles County Museum of Art in
association with Allanheld & Schram, 1976. Los Angeles County
Museum of Art, 29 April–13 June 1976.

Los Angeles 1988–89
Mannerist Prints: International Style in the Sixteenth Century. Exh.
cat. by Bruce Davis. Los Angeles: Los Angeles County Museum
of Art, 1988. Los Angeles County Museum of Art, 28 July–
9 Oct. 1988; The Toledo Museum of Art, 26 Nov. 1988–29 Jan.
1989; Sarasota, Fla., John and Mable Ringling Museum of
Art, 23 Feb.–30 April 1989; Austin, Archer M. Huntington Art
Gallery, University of Texas, 1 June–6 Aug. 1989; The Baltimore
Museum of Art, 12 Sept.–5 Nov. 1989.

Melbourne 1990
The Enchanted Stone: The Graphic Worlds of Odilon Redon. Exh.
cat. by Ted Gott. Melbourne, National Gallery of Victoria,
7 July–2 Sept. 1990; Auckland City Art Gallery, 27 Oct.–
9 Dec. 1990.

Minneapolis 1962
The Nineteenth Century: One Hundred Twenty-five Master Drawings.
Exh. cat., introduction by Sidney Simon, essay and cat. by
Lorenz Eitner. Minneapolis, University Gallery, University of
Minnesota, 26 March–23 April 1962; New York, Solomon R.
Guggenheim Museum, 15 May–1 July 1962.

Minneapolis 1974–75
De Kooning: Drawings/Sculptures. Exh. cat. by Philip Larson
and Peter Schjeldahl. New York: E. P. Dutton & Co., 1974.
Minneapolis, Walker Art Center, 10 March–21 April 1974;
Ottawa, National Gallery of Canada, 7 June–21 July 1974;
Washington, D.C., The Phillips Collection, 14 Sept.–27 Oct.
1974; Buffalo, Albright-Knox Art Gallery, 3 Dec. 1974–19 Jan.
1975; The Museum of Fine Arts, Houston, 21 Feb.–6 April 1975.

Minneapolis/St. Louis/New York 1994
*The Sublime Is Now: The Early Work of Barnett Newman: Paintings
and Drawings, 1944–1949.* Exh. cat., essay by Jeremy Strick. New
York: Pace Wildenstein, 1994. Minneapolis, Walker Art Center,
20 March–29 May 1994; St. Louis Art Museum, 1 July–28 Aug.
1994; New York, Pace Gallery, 21 Oct.–26 Nov. 1994.

Montreal 1944
Loan Exhibition of Great Paintings: Five Centuries of Dutch Art. Exh.
cat. The Montreal Museum of Fine Arts, 9 March–9 April 1944.

Montreal 1953
Five Centuries of Drawings. Exh. cat. by Regina Shoolman. The
Montreal Museum of Fine Arts, 22 Oct.–22 Nov. 1953.

Montreal 1968
Toulouse-Lautrec. Exh. cat. by Jean Adhémar and Luc d'Iberville-
Moreau. The Montreal Museum of Fine Arts, 19 April–
2 June 1968.

Montreal 1995
Lost Paradise: Symbolist Europe. Exh. cat. by Jean Clair et al. The
Montreal Museum of Fine Arts, 8 June–15 Oct. 1995.

Munich 1906–7
L'Art Français. Munich Kunstverein, Sept. 1906; Frankfurt
Kunstverein, Oct. 1906; E. Arnold Gallery, Dresden, Nov. 1906;
Karlsruhe Kunstverein, Dec. 1906; Stuttgart Kunstverein, Jan.
1907.

Newark 1960
Old Master Drawings. Exh. cat. by William H. Gerdts and Elaine
Evans Gerdts. Newark, N.J., The Newark Museum, 17 March–
22 May 1960.

New Brunswick 1985–86
*The Circle of Toulouse-Lautrec: An Exhibition of the Work of the
Artist and of His Close Associates.* Exh. cat. by Phillip Dennis
Cate and Patricia Eckert Boyer. New Brunswick, N.J., Jane
Vorhees Zimmerli Art Museum, Rutgers, The State University
of New Jersey, 17 Nov. 1985–2 Feb. 1986.

New Haven 1953
Degas. No cat. New Haven, Yale University Art Gallery, 24 Feb.–
6 March 1953.

New Haven 1969–70
*Prints and Drawings of the Danube School. An Exhibition of South
German and Austrian Graphic Art of 1500 to 1560 Prepared by a
Graduate Seminar in the History of Art under the Direction of*

Charles Talbot and Alan Shestack. Exh. cat. by Joyce Bailey, Colles Baxter, John Clarke, Adrienne Gyongy, and Helen Manner. New Haven: Yale University Art Gallery, 1969. Yale University Art Gallery, 9 Oct.–16 Nov. 1969; City Art Museum of St. Louis, 11 Dec. 1969–25 Jan. 1970; Philadelphia Museum of Art, 10 Feb.– 24 March 1970.

New Haven 1974
Sixteenth-Century Italian Drawings: Form and Function. Exh. cat. by Edmund Pillsbury and John Caldwell. New Haven, Yale University Art Gallery, 7 May–30 June 1974.

New London 1950
From Delacroix to the Neo-Impressionists. No cat. New London, Conn., Lyman Allyn Museum, 12 Nov.–3 Dec. 1950.

New York 1912
Exhibition and Sale of Elihu Vedder's Work. Exh. cat. New York: Macbeth Gallery, 31 Jan.–13 Feb. 1912.

New York 1920
Cézanne Watercolors. No cat. New York, Montross Gallery, 10–21 Feb. 1920.

New York 1923
Recent Paintings and Drawings by Yasuo Kuniyoshi. New York, Charles Daniel Gallery, Jan. 1923.

New York 1929
First Loan Exhibition: Cézanne, Gauguin, Seurat, van Gogh. Exh. cat. by Alfred H. Barr, Jr. New York, The Museum of Modern Art, 8 Nov.–7 Dec. 1929.

New York 1929–30
Paintings by Nineteen Living Americans. Exh. cat., foreword by Alfred Barr, Jr. New York, The Museum of Modern Art, 13 Dec. 1929–12 Jan. 1930.

New York 1930
Paul Klee. Exh. cat., introduction by Alfred H. Barr, Jr. New York: Plandome Press, 1930. New York, The Museum of Modern Art, 13 March–2 April 1930.

New York 1931–32
Memorial Exhibition: The Collection of the Late Miss Lizzie P. Bliss. New York, The Museum of Modern Art, 17 May–27 Sept. 1931; *The Collection of Miss Lizzie P. Bliss,* Andover, Mass., Addison Gallery of American Art, Phillips Academy, 17 Oct.–15 Dec. 1931; *Modern Masters from the Collection of Miss Lizzie P. Bliss,* Indianapolis, Ind., John Herron Art Institute, 1–31 Jan. 1932.

New York 1933
Water Colors by Cézanne. New York, Jacques Seligmann Gallery, 16 Nov.–7 Dec. 1933.

New York 1934
The Lillie P. Bliss Collection. No cat. New York, The Museum of Modern Art, 14 May–12 Sept. 1934.

New York 1936
John Marin: Watercolors, Oil Paintings, Etchings. Exh. cat. by Henry McBride, Marsden Hartley, and E. M. Benson. New York, The Museum of Modern Art, 21 Oct.–22 Nov. 1936.

New York 1937
Cézanne Watercolors — Renoir Drawings. Exh. cat. New York, Valentine [Dudensing] Gallery, 4–30 Jan. 1937.

New York 1937–38
Exhibition of the Works of Elihu Vedder. Exh. cat., essay by John C. Van Dyke. New York, American Academy of Arts and Letters, 12 Nov. 1937–3 April 1938.

New York 1941
Master Drawings Fifteenth to the Nineteenth Century. No cat. New York, Schaeffer Galleries, 25 March–26 April 1941.

New York 1942–43
Animal Kingdom in Modern Art. No cat. Exh. organized by the Museum of Modern Art, New York. Poughkeepsie, N.Y., Vassar College, 1–22 Nov. 1942; Zanesville, Ohio, Art Institute of Zanesville, 1–22 Dec. 1942; Charlottesville, University of Virginia, 29 Jan.–19 Feb. 1943; Williamsburg, Va., College of William and Mary, 27 Feb.–12 March 1943; Chattanooga, Tenn., Chattanooga Art Association, 22 March–12 April 1943; University of Texas at Austin, 23 April–11 May 1943; Wilmington, Del., Wilmington Society of Fine Arts, 20 June–1 Aug. 1943.

New York 1946
10th Annual Exhibition of Old Master Drawings. New York, Durlacher Bros., 5–30 Nov. 1946.

New York 1947a
Seurat: His Drawings. Exh. cat. New York, Buchholz Gallery (Curt Valentin), 4–29 March 1947.

New York 1947b
Drawings by Contemporary Painters and Sculptors. Exh. cat. New York, Buchholz Gallery (Curt Valentin), 28 May–21 June 1947.

New York 1948a
Yasuo Kuniyoshi: Retrospective Exhibition. Exh. cat. by Lloyd Goodrich. New York, Whitney Museum of American Art, 27 March–9 May 1948.

New York 1948b
The Backus Collection. Exh. cat. in Schaeffer Galleries *Bulletin,* no. 6 (Nov. 1948). New York, Schaeffer Galleries, 23 Nov.–20 Dec. 1948.

New York 1949a
Seurat, 1859–1891: Paintings and Drawings. Exh. cat. New York, M. Knoedler & Co., 19 April–7 May 1949.

New York 1949b
Drawings through Four Centuries. Exh. cat. New York, Wildenstein, summer 1949.

New York 1953a
Paintings and Drawings from the Smith College Collection. Typescript checklist. New York, Knoedler Galleries, 30 March–11 April 1953.

New York 1953b
French Paintings. No cat. New York, Moser Gallery, Dec. 1953.

New York 1955
Timeless Master Drawings. Exh. cat. New York, Wildenstein & Co., Nov.–Dec. 1955.

New York 1956a
For the Connoisseur: Watercolors and Drawings through Five Centuries. Exh. cat. New York, Wildenstein & Co., 24 Sept.– 31 Oct. 1956.

New York 1956b
Drawings and Watercolors of Five Centuries. No cat. New York, Charles E. Slatkin Galleries, 1956.

New York 1958
Odilon Redon. Exh. cat. by Eugene Victor Thaw. New York, The New Gallery, 11–29 Nov. 1958.

New York 1959a
Great Master Drawings of Seven Centuries: A Benefit Exhibition of Columbia University for the Scholarship Fund of the Department of Fine Arts and Archaeology. Exh. cat. edited by Julius S. Held; entries by Winslow Ames et al. New York: Trustees of Columbia University, 1959. New York, Knoedler and Co., 13 Oct.–7 Nov. 1959; Oberlin, Ohio, Dudley Peter Allen Memorial Art Museum, 15 Nov.–15 Dec. 1959.

New York 1959b
Contrasts in Landscape: Nineteenth- and Twentieth-Century Paintings and Drawings. Exh. cat. New York, Wildenstein & Co., Oct. 1959.

New York 1960
Master Drawings. Exh. cat. presumably by Helene C. Seiferheld. New York, Helene C. Seiferheld Gallery, 2–30 April 1960.

New York 1961
The Mrs. Adele R. Levy Collection: A Memorial Exhibition. Exh. cat. by Blanchette Rockefeller, Alfred M. Frankfurter, and Alfred H. Barr, Jr. New York, The Museum of Modern Art, 9 June–16 July 1961.

New York 1963
Cézanne Watercolors. Exh. cat. edited by Theodore Reff. New York: Dept. of Art History and Archaeology, Columbia University, in collaboration with Chanticleer Press, 1963. New York, Knoedler and Co., 2–20 April 1963.

New York 1966
Prints and Drawings by the Great Masters of the Fifteenth to Twentieth Centuries from Private Collections in Impressions of the Highest Quality. Catalogue no. 40. New York, William H. Schab Gallery, 1966.

New York 1968–69a
Willem de Kooning. Exh. cat. by Thomas B. Hess. New York: The Museum of Modern Art, 1968. Amsterdam, Stedelijk Museum, 19 Sept.–17 Nov. 1968; London, The Tate Gallery, 5 Dec. 1968–26 Jan. 1969; New York, The Museum of Modern Art, 6 March–27 April 1969; The Art Institute of Chicago, 17 May–6 July 1969; Los Angeles County Museum of Art, 29 July–14 Sept. 1969.

New York 1968–69b
Gods and Heroes: Baroque Images of Antiquity. Exh. cat. by Eunice Williams, foreword by John Coolidge. Exh. organized by the Fogg Art Museum, Harvard University. New York: Wildenstein, 1968. New York: Wildenstein, 30 Oct. 1968–4 Jan. 1969.

New York 1975–76
Drawings from the Collection of Mr. and Mrs. Eugene V. Thaw. Exh. cat. by Felice Stampfle and Cara D. Denison, introduction by Eugene V. Thaw. New York: The Pierpont Morgan Library, 1975. The Pierpont Morgan Library, 10 Dec. 1975–15 Feb. 1976; The Cleveland Museum of Art, 16 March–2 May 1976; The Art Institute of Chicago, 28 May–5 July 1976; Ottawa, The National Gallery of Canada, 6 Aug.–17 Sept. 1976.

New York 1977
Paul Klee, 1879–1940, in the Collection of the Solomon R. Guggenheim Museum, New York. Exh. cat. by Louise Averill Svendsen. New York, Solomon R. Guggenheim Museum, 24 June–5 Sept. 1977.

New York 1977–78
Cézanne: The Late Work. Exh. cat. by Theodore Reff et al. New York: The Museum of Modern Art, 1977. The Museum of Modern Art, 7 Oct. 1977–3 Jan. 1978; The Museum of Fine Arts, Houston, 26 Jan.–19 March 1978.

New York 1979
The Monotypes of Maurice Prendergast: A Loan Exhibition. Exh. cat. by Cecily Langdale. New York, Davis and Long Co., 4–28 April 1979.

New York 1981
Master Drawings. New York, Spencer A. Samuels and Company, Ltd., 1981.

New York 1983
Henry Moore: Sixty Years of His Art. Cat. by William S. Lieberman for the exh. *The World of Henry Moore*. New York: Thames and Hudson and The Metropolitan Museum of Art, 1983. New York, The Metropolitan Museum of Art, 14 May–25 Sept. 1983.

New York 1985
Watercolors by Charles Burchfield and John Marin. Exh. cat. with essay by John I. H. Baur. New York, Kennedy Galleries, 27 March–20 April 1985.

New York 1985–86
Henri de Toulouse-Lautrec: Images of the 1890s. Exh. cat. edited by Riva Castleman and Wolfgang Wittrock. New York: The Museum of Modern Art and New York Graphic Society. The Museum of Modern Art, 16 Oct. 1985–26 Jan. 1986.

New York 1986–87
François Boucher, 1703–1770. Exh. cat. by Alastair Laing, S. Patrice Marandel, Pierre Rosenberg, Edith A. Standen, and Antoinette Fay-Hallé. New York: The Metropolitan Museum of Art, 1986. The Metropolitan Museum of Art, 17 Feb.–4 May 1986; The Detroit Institute of Arts, 27 May–17 Aug. 1986; Paris, Galeries Nationales du Grand Palais, 19 Sept. 1986–5 Jan. 1987.

New York 1987
French Nineteenth-Century Drawings, Watercolors, Paintings, and Sculpture. Exh. cat. by Martin L. H. Reymert, Elisabeth Kashey, and Robert Kashey. New York, Shepherd Gallery, spring 1987.

New York 1989–90
Canaletto. Exh. cat. by Katherine Baetjer and J. G. Links with essays by J. G. Links, Michael Levey, Francis Haskell, Alessandro Bettagno, and Viola Pemberton-Pigott. New York, The Metropolitan Museum of Art, 30 Oct. 1989–31 Jan. 1990.

New York 1990
Master Drawings, 1760–1880. Exh. cat. New York, W. M. Brady & Co., Inc., 2–22 May 1990.

New York 1992–93
Henri Matisse: A Retrospective. Exh. cat. by John Elderfield. New York, The Museum of Modern Art, 24 Sept. 1992–12 Jan. 1993.

New York 1994a
Sixteenth-Century Italian Drawings in New York Collections. Exh. cat. by William M. Griswold and Linda Wolk-Simon. New York, The Metropolitan Museum of Art, 11 Jan.–27 March 1994.

New York 1994b
European Master Drawings from the Collection of Peter Jay Sharp. Exh. cat. by William L. Barcham, George Knox, Alastair Laing, Suzanne Folds McCullagh, Marcel Roethlisberger, Werner

Schade, Janis Tomlinson, and Linda Wolk-Simon. New York, National Academy of Design, 25 May–28 Aug. 1994.

New York 1995
De Kooning: The Women, Works on Paper, 1947–1954. Exh. cat. New York, C & M Arts, 19 Sept.–18 Nov. 1995.

New York 1997–98
Objects of Desire: The Modern Still Life. Exh. cat. by Margit Rowell. New York: The Museum of Modern Art, 1997. The Museum of Modern Art, 25 May–26 Aug. 1997; London, Hayward Gallery, 9 Oct. 1997–4 Jan. 1998.

New York 1998
Nineteenth-Century Paintings and Works on Paper. New York, Artemis Fine Arts, Inc., 12 Oct.–20 Nov. 1998.

New York 1998–99
From Van Eyck to Bruegel: Early Netherlandish Painting in the Metropolitan Museum of Art. Exh. cat. edited by Maryan W. Ainsworth and Keith Christiansen, with contributions by Maryan W. Ainsworth, Julien Chapuis, Keith Christiansen, Everett Fahy, Nadine M. Orenstein, Véronique Sintobin, Della C. Sperling, and Mary Dprinson de Jesus. New York, The Metropolitan Museum of Art, 12 Sept. 1998–3 Jan. 1999.

New York 2000
Nineteenth- and Twentieth-Century Works on Paper. Exh. cat. by Bona Montagu. New York, Dickinson Roundell, 8–26 May 2000.

New York/Cleveland 1951–52
Odilon Redon, 1840–1916: Pastels and Drawings. Exh. cat., prefaces by Henry Sayles Francis and Ary Leblond; Leblond preface translated by Mrs. T. D. Parker. New York, Jacques Seligmann & Co., 22 Oct.–10 Nov. 1951; The Cleveland Museum of Art, 29 Nov. 1951–20 Jan. 1952; Minneapolis, Walker Art Center, 1 Feb.–1 March 1952.

New York/Cleveland/Chicago 1962–63
Mark Tobey. Exh. cat. by William C. Seitz. New York: The Museum of Modern Art in collaboration with The Cleveland Museum of Art and The Art Institute of Chicago, 1962. The Museum of Modern Art, 12 Sept.–4 Nov. 1962; The Cleveland Museum of Art, 11 Dec. 1962–13 Jan. 1963; The Art Institute of Chicago, 22 Feb.–24 March 1963.

New York/London 1986
The Northern Landscape: Flemish, Dutch, and British Drawings from the Courtauld Collections. Exh. cat. by Dennis Farr and William Bradford. London: Trefoil Books Ltd., 1986; paperback ed., New York: The Drawing Center, 1986. New York, The Drawing Center, 8 April–26 July 1986; London, The Courtauld Institute Galleries, 3 Sept.–30 Nov. 1986.

New York/London 1988
Master Drawings, 1550–1850. Exh. cat. by Kate de Rothschild and Didier Aaron. New York, Didier Aaron, 19 Oct.–5 Nov. 1988; London, Didier Aaron Ltd., 28 Nov.–8 Dec. 1988.

Northampton 1933
England, France, Germany: Watercolors. Exh. cat. SCMA, June 1933.

Northampton 1934
Five Americans. Exh. checklist. SCMA, 19 May–19 June 1934.

Northampton 1948
Some Paintings from Alumnae Collections. No cat. or checklist. SCMA, 10 June–3 July 1948.

Northampton 1950
Memorial to Alfred Vance Churchill, 1864–1949: Works of Art Belonging to Alumnae. Exh. cat. by Henry-Russell Hitchcock. SCMA, 22 May–7 June 1950.

Northampton 1953
Twenty-six English Watercolors and Drawings Given by the Children of Mrs. Thomas W. Lamont '93. Exh. checklist (unnumbered). SCMA, 2–10 June 1953.

Northampton 1956
Five Drawings by Jacques Louis David. Typescript checklist by Robert O. Parks. SCMA, 14 Sept.–5 Oct. 1956.

Northampton 1958a
European Drawings. Exh. organized by Robert O. Parks, typescript checklist by June-Marie Fink. SCMA, 11 April–7 May 1958.

Northampton 1958b
Kollwitz: Catalogue of the Exhibition and Collection of Thirty-four Prints and One Drawing. Exh. cat. by June-Marie Fink, with an essay by Leonard Baskin. SCMA, 1–30 Nov. 1958.

Northampton 1958c
British Drawings and Watercolors. Exh. organized by Robert O. Parks, typescript checklist by June-Marie Fink. SCMA and Lamont House (Smith College), 1–19 Dec. 1958.

Northampton 1959
Piranesi. Commemorative exh. cat. by Robert O. Parks; essays by Philip Hofer, Karl Lehmann, and Rudolf Wittkower. Northampton: SCMA, 1961. SCMA, 4 April–4 May 1959.

Northampton 1960
Recent Gifts, Purchases, and Loans. No cat. or checklist. SCMA, 20 May–30 June 1960.

Northampton 1963
Recent Accessions. SCMA, 4 Sept.–18 Oct. 1963. No cat. or checklist.

Northampton 1966
Henri Fantin-Latour, 1836–1904. Exh. cat. by Charles Chetham. SCMA, 28 April–6 June 1966.

Northampton 1967
The Class of 1927 Collects. Exh. cat. by Charles Chetham. SCMA, 27 April–5 June 1967.

Northampton 1968
An Exhibition in Honor of Henry-Russell Hitchcock. Exh. cat. edited by Alden Burray, essays by Phyllis Williams Lehmann, Mary Bartlett Cowdrey, and Robert Rosenblum. SCMA, 11–28 April 1968.

Northampton 1973–74
Selections from the Museum's Permanent Eighteenth-Century Collection. No cat. or checklist. SCMA, 11 Sept. 1973–17 Feb. 1974.

Northampton 1974a
Eighteenth- and Nineteenth-Century French Drawings. No cat. or checklist. SCMA, Print Room, 21 March–23 May 1974.

Northampton 1974b
A Selection of 17th-Century Prints and Drawings. No cat. or checklist. Exhibition to complement *Roman Baroque Sculpture* (SMCA's contribution to *The Five College Roman Baroque Festival*). SCMA, 4 April–4 May 1974.

Northampton 1974c
Selections from the Permanent Collection of American Drawings. No cat. Exh. organized by museum seminar students,

supervised by Elizabeth Mongan. SCMA, 16 May–2 June and 4–12 Sept. 1974.

Northampton 1975a
Prints and Drawings Acquired by the Smith College Museum of Art During the Curatorship of Elizabeth Mongan, 1966–1975. Typescript checklist. SCMA, Print Room, 24 April–21 Sept. 1975.

Northampton 1975b
One Hundred: An Exhibition to Celebrate the Centennial Year of Smith College. Exh. cat. by Betsy B. Jones. SCMA, 1 May–1 June 1975.

Northampton 1976
City Views: Prints, Drawings, and Photographs from the Museum's Collections. No cat. or checklist. Exh. organized by Colles Baxter and John Pinto. SCMA, Print Room, 28 Oct.–12 Dec. 1976.

Northampton 1977
French Master Drawings. No cat. or checklist. SCMA, Print Room, 15 Sept.–11 Dec. 1977.

Northampton 1978a
Antiquity in the Renaissance. Exh. cat. by Wendy Stedman Sheard. Northampton: SCMA, 1979. SCMA, 6 April–6 June 1978.

Northampton 1978b
A Selection of 18th-Century Drawings. No cat.or checklist. SCMA, 21 Sept.–13 Nov. 1978.

Northampton 1978–79
Piranesi's Carceri: Sources of Invention. Typescript checklist by Christine Swenson and William L. MacDonald. SCMA, 28 Nov. 1978–28 Jan. 1979.

Northampton 1979a
The Exhibition of the Century: 100 Years of Collecting at the Smith College Museum of Art, 1879–1979. Typescript checklist by Charles Chetham, Betsy B. Jones, Christine Swenson, Linda Muehlig, and Patricia Anderson. SCMA, 16 May–21 Dec. 1979.

Northampton 1979b
Prints, Drawings, and Books from the Permanent Collection. Typescript checklist by Colles Baxter and Christine Swenson (Spring 1979), in conjunction with *The Exhibition of the Century: 100 Years of Collecting at the Smith College Museum of Art, 1879–1979.* SCMA, 16 May–21 Dec. 1979.

Northampton 1980
American Drawing since World War II. Typescript checklist by Christine Swenson and Charles Chetham. SCMA, 30 Oct.–19 Dec. 1980.

Northampton 1982a
Bouts to de Kooning: Drawings from the Collection. No. cat. or checklist. Exh. organized by Christine Swenson. SCMA, Print Room, 26 Jan.–26 March 1982.

Northampton 1982b
Romanticism of the 1830s. No cat. or checklist. Exh. organized by Ann Sievers and J. Kenneth LeDoux. SCMA, 25 March–30 May 1982.

Northampton 1982c
Landscape Drawings from the Collection. No cat. or checklist. Exh. organized by Christine Swenson. SCMA, Print Room, 4 Nov.–19 Dec. 1982.

Northampton 1983a
In Memoriam: Jere Abbott (1897–1982). Checklist by Elizabeth Mongan. SCMA, 30 April–23 Oct. 1983.

Northampton 1983b
A Family of Friends: Gifts to the Collection from the Lamont and Cunningham Families, 1949–1983. Typescript checklist (unnumbered) by Christine Swenson. SCMA, 12 May–23 Oct. 1983.

Northampton 1984a
Twentieth-Century Art from the Collection. No cat. or checklist. Exh. organized by Charles Chetham. SCMA, 16 Feb.–22 April 1984.

Northampton 1984b
Master Prints and Drawings from the Museum's Collection. Typescript checklist by Christine Swenson. SCMA, 19 April–3 June 1984.

Northampton 1984c
Pissarro to Picasso: Drawings from the Selma Erving '27 Bequest to the Smith College Museum of Art. Typescript checklist by Christine Swenson. SCMA, 18 Oct.–2 Dec. 1984.

Northampton 1985a
Illustrating an Age of Elegance: French Prints and Drawings from Monarchy to Empire. No cat. or checklist. Exh. organized by Christine Swenson. SCMA, 29 Jan.–24 March 1985.

Northampton 1985b
Prints and Drawings in Honor of a Curator: Elizabeth Mongan. Typescript checklist by Christine Swenson. SCMA, Print Room, 11 April–14 June 1985.

Northampton 1985c
Dorothy C. Miller: With an Eye to American Art. Checklist by Betsy B. Jones with an appreciation by Robert Rosenblum. SCMA, 19 April–16 June 1985.

Northampton 1985d
Leaders: An Exhibition in Honor of the Inauguration of Mary Maples Dunn. No cat. or checklist. Exh. organized by Charles Chetham. SCMA, 27 Sept.–24 Nov. 1985.

Northampton 1985–86
Works on Paper Acquired during the Curatorship of Christine Swenson. No cat. or checklist. Exh. organized by Ann Sievers. SCMA, 5 Dec. 1985–23 March 1986.

Northampton 1986a
American Watercolors from the Museum's Collection. Typescript checklist by Ann Sievers. SCMA, Print Room, 6 Feb.–28 Mar. 1986.

Northampton 1986b
Images of Greek and Roman Mythology from the Smith College Museum of Art Collection. No cat. or checklist. Exh. organized by Lisa Vihos. SCMA, 1 May–30 Aug. 1986.

Northampton 1986c
Town and Country: Landscapes and Street Scenes from France and Northern Europe. No cat. or checklist. Exh. organized by Michael M. Floss. SCMA, *Landscapes,* 8 July–5 Oct. 1986, *Town: Street Scenes,* 5 Aug.–5 Oct. 1986.

Northampton 1986–87
The Book Beautifully Bound: Women Bookbinders of the Arts and Crafts Movement. No cat. or checklist. Exh. organized by Madeleine Watson with Ruth Mortimer. SCMA, 13 Nov. 1986–18 Jan. 1987.

Northampton 1987a
Twentieth-Century German Art from the Collection. No cat. or checklist. Exh. organized by museum seminar students, supervised by Charles Chetham. SCMA, 2 April–27 Sept. 1987.

Northampton 1987b
Italian Sixteenth-Century Drawings. Typescript checklist by Ann Sievers. SCMA, Print Room, 9 April–31 May 1987.

Northampton 1987c
Homage to Henry-Russell Hitchcock. No cat. or checklist. Exh. organized by Linda Muehlig. SCMA, 30 April–11 Aug. 1987.

Northampton 1987d
De Mortuis: Images of Death. Typescript checklist by Ann Sievers. SCMA, Print Room, 19 Sept.–22 Dec. 1987.

Northampton 1987–88
Georgia O'Keeffe and Artists from the Stieglitz Circle. No cat. or checklist. Exh. organized by Linda Muehlig and Joyce Hu. SCMA, 29 Oct. 1987–17 Jan. 1988.

Northampton 1988
France and Italy: Eighteenth-Century Prints and Drawings. Typescript checklist by Ann Sievers and Anne Havinga. SCMA, Print Room, 14 Jan.–20 April 1988.

Northampton 1988–89
From Ancien Régime to Revolution. No cat. or checklist. Exh. organized by Ann Sievers and Helen Searing. SCMA, 3 Nov. 1988–28 Jan. 1989.

Northampton 1989
Recent Accessions. Checklist by Edward Nygren, Linda Muehlig, and Ann Sievers. SCMA, 13 April–30 June 1989.

Northampton 1989–90
Italian Baroque Prints and Drawings. Typescript checklist by Ann Sievers. SCMA, Print Room, 17 Nov. 1989–18 Feb. 1990.

Northampton 1991
Portrait of the Artist. Typescript checklist by Ann Sievers. SCMA, Print Room, 10 Sept.–25 Oct. 1991.

Northampton 1992a
Acquisitions Made during the Directorship of Edward J. Nygren (1988–1991). Typescript checklist by Michael Goodison. SCMA, 2 April–31 May 1992.

Northampton 1992b
France in the Nineteenth Century: A Selection of Drawings from the Permanent Collection. Typescript checklist by Ann Sievers. SCMA, Print Room, 16 Sept.–30 Oct. 1992.

Northampton 1994
Antwerp: Prints, Drawings, and Books from the Sixteenth and Seventeenth Centuries. Typescript checklist by Ann Sievers. SCMA, Print Room, 8 Nov.–22 Dec. 1994.

Northampton 1995a
History and Technology of Papermaking. No cat. or checklist. Exh. organized by David Dempsey. SCMA, 23 Feb.–30 April 1995.

Northampton 1995b
Constructive Forms and Poetic Structure: Henry Moore and the British Avant-Garde. Checklist by Kristen Erickson. SCMA, Print Room, 11 April–28 May 1995.

Northampton 1997
Cigoli's "Dream of Jacob" and Drawing in Late-Sixteenth-Century Florence. No cat. Exh. organized by Ann Sievers. SCMA, 3 Oct.–14 Dec. 1997.

Ottawa 1997–98
Renoir's Portraits: Impressions of an Age. Exh. cat. by Colin B. Bailey, Linda Nochlin, and Anne Distel. New Haven and London: Yale University Press, 1997. Ottawa, National Gallery of Canada, 24 June–14 Sept. 1997; The Art Institute of Chicago, 17 Oct. 1997–4 Jan. 1998; Fort Worth, Kimbell Art Museum, 8 Feb.–26 April 1998.

Otterlo 1990
Vincent van Gogh Drawings. Exh. cat. by Johannes van der Wolk, Ronald Pickvance, and E. B. F. Prey. English ed. New York: Rizzoli, 1990. Otterlo, Rijksmuseum Kröller-Müller, 30 March–29 July 1990.

Oxford 1931
Retrospective Exhibition of Work by Paul Nash, 1910–1931. No cat. Oxford, Oxford Arts Club, Oct. 1931.

Paris 1900
Georges Seurat (1860 [sic]–1891): oeuvres peintes et dessinés. Exh. cat. Paris, La Revue Blanche, 19 March–5 April 1900.

Paris 1905
Exposition rétrospective Seurat. Exh. cat. Paris, Société des Artistes Indépendants, 24 March–30 April 1905.

Paris 1907
Les Aquarelles de Cézanne. Exh. cat. presumably by Josse and Gaston Bernheim-Jeune. Paris, Galerie Bernheim-Jeune, 17–29 June 1907.

Paris 1908–9
Exposition Georges Seurat. Exh. cat. Paris, Bernheim-Jeune et Cie, 14 Dec. 1908–9 Jan. 1909.

Paris 1920
Exposition Georges Seurat. Exh. cat. Paris, Galerie Bernheim-Jeune, 15–31 Jan. 1920.

Paris 1926
Les Dessins de Seurat. Exh. cat. Paris, Galerie Bernheim-Jeune, 29 Nov.–24 Dec. 1926.

Paris 1935
Aquarelles et baignades de Cézanne. No cat. Paris, Galerie Renou & Colle, 3–17 June 1935.

Paris 1936
Cézanne. Exh. cat. by J.-E. Blanche, Paul Jamot, and Charles Sterling. Paris, Musée de l'Orangerie, May–Oct. 1936.

Paris 1960
Vincent van Gogh, 1853–1890. Exh. cat. by Marc Edo Tralbaut. Paris, Musée Jacquemart-André, Feb.–March 1960.

Paris 1961
Mark Tobey. Exh. cat. edited by François Mathey. Paris, Musée des Arts Décoratifs, 18 Oct.–1 Dec. 1961.

Paris 1964
François Boucher, premier peintre du roi, 1703–1770. Exh. cat. by Jean Cailleux. Paris, Galerie Cailleux, May–June 1964.

Paris 1967–68
Ingres: Centenaire de la mort de Jean-Dominique Ingres. Exh. cat. by Lise Duclaux, Jacques Foucart, Hans Naef, Maurice Sérullaz,

and Daniel Ternois. Paris: Réunion des Musées Nationaux, 1967. Paris, Musée du Petit Palais, 27 Oct. 1967–29 Jan. 1968.

Paris 1971a
Dessins originaux, anciens et modernes; estampes anciennes du XVe au XVIIIe siècle; estampes originales de maîtres des XIXe et XXe siècles. Stock catalogue "Degas." Paris, Paul Prouté, 1971.

Paris 1971b
Dessins du XVIe et du XVIIe siècle dans les collections privées françaises. Exh. cat. Paris, Galerie Claude Aubry, Dec. 1971.

Paris 1975
L'Ancien Hôtel de Ville de Paris et la Place de Grève. Exh. cat. by Michel Gallet. Paris, Musée Carnavalet, June–Aug. 1975.

Paris 1977
Jan Toorop, 1858–1928: Impressioniste, symboliste, pointilliste. Exh. cat. by Victorine Hefting. Paris, Institut Néerlandais, 19 Oct.– 4 Dec. 1977.

Paris 1984a
Altdorfer and Fantastic Realism in German Art. Exh. cat. ed. by Jacqueline Guillard and Maurice Guillard. English ed. Paris: Guillard Editeurs, 1985. Paris, Centre Culturel du Marais, 3 April–15 July 1984.

Paris 1984b
Louis Boilly, 1761–1845. Exh. cat. by Marianne Delafond. Paris, Musée Marmottan, 3 May–30 June 1984.

Paris 1985
Graveurs français de la seconde moitié du XVIIIe siècle. XIIe exposition de la collection Edmond de Rothschild. Exh. cat. Paris: Editions de la Réunion des Musées Nationaux, 1985. Paris, Musée du Louvre, 14 Feb.–6 May 1985.

Paris 1986
De Rembrandt à Vermeer: Le Peinture hollandais au Mauritshuis de La Haye. Exh. cat by Ben Broos; essays by Hans Hoetink, Beatrijs Brenninkmeyer-de Rooij, and Jean Lacambre. The Hague: Editions de la Fondation Johan Maurits van Nassau, 1986. Paris, Galeries Nationales du Grand Palais, 19 Feb.–30 June 1986.

Paris 1987
Aspects de Fragonard: Peintures, dessins, estampes. Exh. cat. by Marianne Roland Michel. Paris, Galerie Cailleux, 23 Sept.– 7 Nov. 1987.

Paris 1991–92
Dessins de Dürer et de la Renaissance germanique dans les collections publiques parisiennes. Exh. cat., introduction by Emmanuel Starcky, cat. by Emmanuelle Brugerolles, François Fossier, D. Guillet, Pierette Jean-Richard, Gisèle Lambert, Myriam Magnon, Emmanuel Starcky, and Léna Widerkehr. Paris: Réunion des Musées Nationaux, 1991. Paris, Musée du Louvre, 98e exposition du Cabinet des Dessins, 22 Oct. 1991–20 Jan 1992.

Paris 1993
Le Siècle de Titien. L'Age d'or de la peinture à Venise. Exh. cat. by Michel Laclotte, Giovanna Nepi Scirè, Alessandro Ballarin, Konrad Oberhuber, Sylvie Béguin, Roger Rearick, and Francesco Valcanover. Paris: Réunion des Musées Nationaux, 1993. Paris, Galeries Nationales du Grand Palais, 9 March– 14 June 1993.

Paris 1995
Marc Chagall: Les Années russes, 1907–1922. Exh. cat. Paris: Paris Musées, 1995. Paris, Musée d'Art moderne de la Ville de Paris, 13 April–17 Sept. 1995.

Paris Salon
Catalogues of the Paris Salon, 1673 to 1881. 60 vols. [not numbered]. Compiled by H. W. Janson. New York and London: Garland Publishing, Inc., 1977–78.

Paris/Detroit/New York 1974–75
French Painting, 1774–1830: The Age of Revolution. Exh. cat., preface by Pierre Rosenberg; essays by Frederick J. Cummings, Antoine Schnapper, and Robert Rosenblum; cat. by Arnaud Brejon de Lavergnée et al. Detroit: The Detroit Institute of Arts and The Metropolitan Museum of Art, 1975. Paris, Galeries Nationales du Grand Palais, 16 Nov. 1974–3 Feb. 1975; The Detroit Institute of Arts, 5 March–4 May 1975; New York, The Metropolitan Museum of Art, 12 June–7 Sept. 1975.

Paris/London/Philadelphia 1995–96
Cézanne. Exh. cat. by Françoise Cachin et al. English ed., with translations by John Goodman. New York: Harry N. Abrams, in association with the Philadelphia Museum of Art, 1996. Paris, Galeries Nationales du Grand Palais, 25 Sept. 1995–7 Jan. 1996; London, Tate Gallery, 8 Feb.–28 April 1996; Philadelphia Museum of Art, 30 May–18 Aug. 1996.

Paris/New York 1987–88
Fragonard. Exh. cat. by Pierre Rosenberg. English ed. translated by Jean-Marie Clarke and Anthony Roberts. New York: The Metropolitan Museum of Art, 1987. Paris, Galeries Nationales du Grand Palais, 24 Sept. 1987–4 Jan. 1988; New York, The Metropolitan Museum of Art, 2 Feb.–8 May 1988.

Paris/New York 1991–92
Georges Seurat, 1859–1891. Exh. cat. by Robert L. Herbert, Françoise Cachin, et al. English ed. New York: The Metropolitan Museum of Art and Harry N. Abrams, 1991. Paris, Musée d'Orsay, 9 April–12 Aug. 1991; The Metropolitan Museum of Art, 9 Sept. 1991–12 Jan. 1992.

Paris/Ottawa/New York 1988–89
Degas. Exh. cat. by Jean Sutherland Boggs, Douglas W. Druick, Henri Loyrette, Michael Pantazzi, and Gary Tinterow. English ed. New York: The Metropolitan Museum of Art; Ottawa: National Gallery of Canada, 1988. Paris, Galeries Nationales du Grand Palais, 9 Feb.–16 May 1988; Ottawa, National Gallery of Canada, 16 June–28 Aug. 1988; New York, The Metropolitan Museum of Art, 27 Sept. 1988–8 Jan. 1989.

Paris/Ottawa/San Francisco 1982–83
Fantin-Latour. Exh. cat. by Douglas Druick and Michel Hoog. English ed. Ottawa: National Gallery of Canada, National Museums of Canada, 1983. Paris, Galeries Nationales du Grand Palais, 9 Nov. 1982–7 Feb. 1983; Ottawa, National Gallery of Canada, 17 March–22 May 1983; The Fine Arts Museums of San Francisco, 18 June–6 Sept. 1983.

Paris/Philadelphia/Fort Worth 1991–92
The Loves of the Gods: Mythological Painting from Watteau to David. Exh. cat. by Colin B. Bailey with the assistance of Carrie A. Hamilton; introduction by Pierre Rosenberg; essays by Philippe Le Leyzour, Steven Z. Levine, Donald Posner, and Katie Scott. New York: Rizzoli International Publications, Kimbell Art Museum, 1991. Paris, Galeries Nationales du Grand Palais, 15 Oct. 1991–6 Jan. 1992; Philadelphia Museum of Art, 23 Feb.–

26 April 1992; Fort Worth, Kimbell Art Museum, 23 May–2 Aug. 1992.

Paris/Versailles 1989–90
Jacques-Louis David, 1748–1825. Exh. cat. by Antoine Schnapper and Arlette Sérullaz, assisted by Elisabeth Agius-d'Yvoire. Paris: Editions de la Réunion des Musées Nationaux, 1989. Paris, Musée du Louvre, Département des Peintures; Versailles, Musée National du Château, 26 Oct. 1989–12 Feb. 1990.

Paris/Washington/Berlin 1996–97
Adolph Menzel (1815–1905): Between Romanticism and Impressionism. Exh. cat. edited by Claude Keisch and Marie-Ursula Riemann-Reyher; essays by Philip Conisbee, Marie-Ursula Riemann-Reyher, Peter Paret, Claude Keisch, Werner Hofmann, Françoise Forster-Hahn, Thomas W. Gaehtgens, and Peter-Kalus Schuster. Translated by Michael Cunningham, Judith Hayward, Simon Knight, and Elizabeth MacDonald. Exh. organized by the National Gallery of Art, Washington, D.C.; Stiftung Preussischer Kulturbesitz, Berlin; and Réunion des Musées Nationaux/Musée d'Orsay, Paris. New Haven and London: Yale University Press in association with the National Gallery of Art, Washington, 1996. Musée d'Orsay, 15 April–28 July 1996; National Gallery of Art, 15 Sept. 1996–5 Jan. 1997; Berlin, Alte Nationalgalerie, 7 Feb.–11 May 1997.

Pasadena 1967
Cézanne Watercolors. Exh. cat. by John Coplans. Los Angeles: Pasadena Art Museum and the Ward Ritchie Press, 1967. Pasadena Art Museum, 10 Nov.–10 Dec. 1967.

Pavia 1977–78
L'Opera incisa di Carlo Maratti. Exh. cat. by Paolo Bellini with an appendix by Luisa Erba. Pavia: Museo Civico, 1977. Pavia, Museo Civico, Nov.–Dec. 1977; Milan, Castello Sforzesco, April–May 1978; Rome, Gabinetto Nazionale delle Stampe, autumn 1978.

Philadelphia 1919
Original Drawings by Aubrey Beardsley from the Collection of Frederick Evans. Exh. cat. Philadelphia, The Rosenbach Galleries, 1–17 May 1919.

Philadelphia 1950–51
Masterpieces of Drawing: Diamond Jubilee Exhibition. Exh. cat. Philadelphia Museum of Art, 4 Nov. 1950–11 Feb. 1951.

Philadelphia 1968
Drawings by the Bibiena Family. Exh. cat. by Diane M. Kelder. Philadelphia Museum of Art, 10 Jan.–28 Feb. 1968; New York, Finch College Museum, 10 May–16 June 1968.

Philadelphia 1989
Masterpieces of Impressionism and Post-Impressionism: The Annenberg Collection. Exh. cat. by Colin B. Bailey, Joseph J. Rishel, and Mark Rosenthal. New York: Philadelphia Museum of Art in association with Harry N. Abrams, 1989. Philadelphia Museum of Art, 21 May–17 Sept. 1989.

Phoenix 1961–62
English Landscape Painters. No cat. Phoenix Art Museum, Dec. 1961–Jan. 1962.

Portland 1946
Old Master Drawings (from the collection of LeRoy Backus, Seattle). No cat. Portland, Oreg., Portland Art Museum, 16 Jan.–28 Feb. 1946.

Poughkeepsie 1970
Dutch Mannerism: Apogee and Epilogue. Exh. cat. Exh. organized by Thomas J. McCormick and Wolfgang Stechow. Poughkeepsie, N.Y., Vassar College Art Gallery, 15 April–7 June 1970.

Poughkeepsie 1976
Seventeenth-Century Dutch Landscape Drawings and Selected Prints from American Collections. Exh. cat. Exh. organized by Curtis O. Baer. Poughkeepsie, N.Y., Vassar College Art Gallery, 28 March–7 May 1976.

Princeton 1961
Tiepolo. No cat. Princeton, N.J., Princeton University Art Museum, 16–30 April 1961.

Princeton 1982
Drawings from the Holy Roman Empire, 1540–1680: A Selection from North American Collections. Exh. cat. by Thomas DaCosta Kaufmann. Princeton, N.J.: The Art Museum, Princeton University, 1982. The Art Museum, Princeton University, 3 Oct.–21 Nov. 1982; Washington, D.C., National Gallery of Art, 27 Jan.–11 April 1983; Pittsburgh, Museum of Art, Carnegie Institute, 23 April–19 June 1983.

Providence 1973
Drawings and Prints of the First Maniera, 1515–1535. Exh. cat. by the Department of Art, Brown University (Cathy Wilkinson, with Janetta Benton, Richard Campbell, George L. Grosz, John V. Quarrier, Michael Slavin, Susan E. Strauber, Christine I. Swartz, Claire F. Tyler, Anne Wagner). Providence: Department of Art, Brown University, 1973. Providence, Museum of Art, Rhode Island School of Design, 22 Feb.–25 March 1973.

Providence 1975a
Rubenism. Exh. cat. by the Department of Art, Brown University (Mary Crawford Volk with Roxane Landers Althouse, Diane Carole Bliss, Karen Towart Campbell, Gregory A. Dunn, Kresten Jespersen, Kathleen Ann Roy, Susan Danly Walther, and Simone Alaida Zurawski). Providence: Department of Art, Brown University and the Museum of Art, Rhode Island School of Design, 1975. Providence, Bell Gallery, List Art Building, Brown University, 30 Jan.–23 Feb. 1975.

Providence 1975b
Selection V: French Watercolors and Drawings from the Museum's Collection, ca. 1800–1910. Exh. cat. by Kermit Champa, Richard Campbell, Susan A. Denker, Joseph Jacobs, Deborah J. Johnson, Michael K. Komanecky, Robert Lobe, Ronald Onorato, Barbara Poore, Marcia R. Rickard, Michael Slavin, and Anne Wagner in *Bulletin of Rhode Island School of Design, Museum Notes* 61, no. 5 (April 1975). Providence, Museum of Art, Rhode Island School of Design, 1–25 May 1975.

Providence 1979
Festivities: Ceremonies and Celebrations in Western Europe, 1500–1790. Exh. cat., foreword by Winslow Ames, cat. by David Harvey Ball, Marianne Elizabeth Legg, Karen DiMartino Mensil, Joyce Elizabeth Nalewijk, and Christine Margit Sperling. Providence: Department of Art, Brown University, 1979. Providence, Bell Gallery, List Art Building, Brown University, 2–25 March 1979.

Providence/Toronto 1968
James Jacques Joseph Tissot, 1836–1902: A Retrospective Exhibition. Exh. cat. by Henri Zerner, David S. Brooke, and Michael Wentworth. Providence: Museum of Art, Rhode Island School of Design, 1968. Providence, Museum of Art, Rhode Island

School of Design, 28 Feb.–29 March 1968; Toronto, Art Gallery of Ontario, 6 April–5 May 1968.

Rome 1976–77
Immagini da Tiziano, Stampe dal sec. XVI al sec. XIX, dalle collezioni del Gabinetto Nazionale delle Stampe. Exh. cat. by Maria Catelli Isola. Rome: De Luca, 1976. Rome, Villa della Farnesina alla Lungara, 16 Dec. 1976–22 Jan. 1977.

Rome 1977
Disegni Fiorentini, 1560–1640, dalle collezioni del Gabinetto Nazionale delle Stampe. Exh. cat. by Simonetta Prosperi Valenti Rodinò. Rome: De Luca, 1979. Rome, Villa della Farnesina alla Lungara, 20 Oct.–20 Dec. 1977.

Rotterdam 1990–92
Fra Bartolommeo, Master Draughtsman of the High Renaissance: A Selection from the Rotterdam Albums and Landscape Drawings from Various Collections. Exh. cat. by Chris Fischer. Seattle and London: Museum Boymans-van Beuningen, Rotterdam, in association with University of Washington Press, 1990. Rotterdam, Museum Boymans-van Beuningen, 16 Dec. 1990–17 Feb. 1991; Boston, Museum of Fine Arts, 15 Jan.–12 April 1992; Fort Worth, Kimbell Art Museum, 9 May–2 Aug. 1992; New York, The Pierpont Morgan Library, 11 Sept.–29 Nov. 1992.

Rotterdam / Paris / Brussels 1948–49
Rotterdam: *Tekeningen van Jan van Eyck tot Rubens.* Exh. cat., introduction by J. C. Ebbinge Wubben. Rotterdam: Museum Boymans, 1949. Museum Boymans, 17 Dec. 1948–1 Feb. 1949. Paris: *De Van Eyck à Rubens: Les Maîtres flamands du dessin.* Exh. cat., introduction by Jean Vallery-Radot, essay by J. C. Ebbinge Wubben. Brussels: Editions de la Connaissance, 1949. Paris, Bibliothèque Nationale, 15 Feb.–12 March 1949. Brussels: *De Van Eyck à Rubens: Dessins de maîtres flamands.* Exh. cat., introduction by J. C. Ebbinge Wubben. Brussels: Editions de la Connaissance, 1949. Brussels, Palais des Beaux-Arts, 19 March–10 April 1949.

Rotterdam / Paris / New York 1958–59
Van Clouet tot Matisse: Tentoonstelling van franse tekeningen uit amerikaanse collecties. Exh. cat., introduction by Agnes Mongan. Rotterdam, Museum Boymans, 31 July–28 Sept. 1958; Paris, Musée de l'Orangerie (as *De Clouet à Matisse: Dessins français des collections américaines*), 24 Oct. 1958–2 Jan. 1959; New York, The Metropolitan Museum of Art (as *Exhibition of French Drawings from American Collections*), 2 Feb.–15 March 1959.

Salt Lake City 1976
Graphic Styles of the American Eight. Exh. cat. by Sheldon Reich. Salt Lake City: Utah Museum of Fine Arts, University of Utah, 29 Feb.–11 April 1976.

San Antonio 1995
Five Hundred Years of French Art. Exh. cat. by Douglas K. S. Hyland, Richard R. Brettell, James Clifton, and John Hutton. San Antonio: San Antonio Museum of Art, with the University of Texas Press, 1995. San Antonio Museum of Art, 8 April–20 Aug. 1995.

San Francisco 1937
Paul Cézanne: Exhibition of Paintings, Water-colors, Drawings, and Prints. Exh. cat., introduction by Gerstle Mack. San Francisco Museum of Art, 1 Sept.–4 Oct. 1937.

San Francisco 1940
Art. Official Catalogue. Golden Gate International Exposition, San Francisco. Exh. cat. *Old Master Drawings.* Division Head, Annemarie Henle. San Francisco: The Recorder Printing and Publishing Co.; H. S. Crocker Co., Inc.; Schwabacher-Frey Co., 1940. San Francisco, Palace of Fine Arts, 25 May–29 Sept. 1940.

San Francisco 1941
Golden Gate International Exposition. An Exhibition of Drawings from American Museums and Private Collections. Exh. cat. arranged by Annemarie Henle. San Francisco: The Recorder Printing and Publishing Co., 1941. San Francisco, Palace of Fine Arts, 25 May–29 Sept. 1941.

San Francisco 1947
Nineteenth-Century French Drawings. Exh. cat., foreword by Thomas Carr Howe, Jr., essay by John Rewald. (World's Fair Exhibition). San Francisco, 1947. San Francisco, California Palace of the Legion of Honor, 8 March–6 April 1947.

San Francisco 1974–76
Arthur Dove. Exh. cat. by Barbara Haskell. Boston: New York Graphic Society; San Francisco: San Francisco Museum of Modern Art, 1974. San Francisco Museum of Modern Art, 21 Nov. 1974–5 Jan. 1975; Buffalo, N.Y., Albright-Knox Art Gallery, 27 Jan.–2 March 1975; St. Louis Art Museum, 3 April–25 May 1975; The Art Institute of Chicago, 12 July–31 Aug. 1975; Des Moines Art Center, 22 Sept.–2 Nov. 1975; New York, Whitney Museum of American Art, 24 Nov. 1975–18 Jan. 1976.

San Miniato 1959
Mostra del Cigoli e del suo ambiente. Exh. cat. by Mario Bucci, Anna Forlani, Luciano Berti, and Mina Gregori; introduction by Giulia Sinibaldi. San Miniato: Cassa di Risparmio di San Miniato, 1959. San Miniato, Accademia degli Eutelati, Città di San Miniato, summer 1959.

Santa Barbara 1964
European Drawings, 1450–1900. Exh. cat. Santa Barbara Museum of Art, 25 Feb.–28 March 1964.

Sarasota 1967
Paintings and Drawings from American Public Collections. No cat. Sarasota, Fla., John and Mable Ringling Museum of Art, 16 Jan.–12 Feb. 1967.

Seattle 1970–71
Tobey's 80: A Retrospective. Exh. cat., foreword by Richard E. Fuller, introduction by Betty Bowen. Seattle: Seattle Art Museum and University of Washington Press, 1970. Seattle Art Museum, 3 Dec. 1970–31 Jan. 1971.

South Hadley 1955
The Eight: Bellows, Davies, Glackens, Henri, Lawson, Luks, Prendergast, Shinn, Sloan. Checklist. South Hadley, Mass., Mount Holyoke College, 11 April–3 May 1955.

South Hadley 1966
The Legacy of David and Ingres to Nineteenth-Century Art. Exh. cat., exh. organized by the Mount Holyoke Friends of Art to honor the inauguration of the Amy M. Sacker Memorial Lectureship. South Hadley, Mass.: Mount Holyoke Friends of Art, 1966. South Hadley, Dwight Art Memorial, 12 Oct.–13 Nov. 1966.

South Hadley 1968
Masterpieces of Modern Drawing. No cat. South Hadley, Mass., Mount Holyoke College Art Museum, 4–21 Feb. 1968.

Springfield 1933
Opening Exhibition in Honor of James Philip and Julia Emma Gray. Exh. cat. by Roger Fry et al. Springfield, Mass., Museum of Fine Arts, 7 Oct.–2 Nov. 1933.

Springfield 1939–40
David and Ingres: Paintings and Drawings. Exh. cat., foreword by John Lee Clarke, Jr. Springfield, Mass., Museum of Fine Arts, 20 Nov.–17 Dec. 1939; New York, M. Knoedler & Co., 8–27 Jan. 1940; Cincinnati Art Museum (as *The Place of David and Ingres in a Century of French Painting),* 7 Feb.–3 March 1940; Rochester, N.Y., Memorial Art Gallery of the University of Rochester, March–1 April 1940.

Springfield 1984
Masterpieces by François Boucher from New England Collections. No cat. Springfield, Mass., Museum of Fine Arts, 15 April– 3 June 1984.

Stanford 1990
Mark Tobey: Works on Paper from Northern California and Seattle Collections. Exh. organized by Betsy G. Fryberger, cat. introduction by Paul Cummings, essay by Judith S. Kays. Stanford, Calif.: Stanford University Museum of Art, 6 Nov.–23 Dec. 1990.

Stuttgart 1979–80
Zeichnung in Deutschland: Deutsche Zeichner, 1540–1640. Exh. cat. edited by Heinrich Geissler, cat. by Hans George Gmelin, Margaretha Krämer, Ilsa O'Dell-Franke, Klaus Pechstein, Hanna Peter, and Volkmar Schauz. 2 vols. Stuttgart: Staatsgalerie Stuttgart, 1979–80. Staatsgalerie Stuttgart, Graphische Sammlung, 1 Dec. 1979–17 Feb. 1980.

Stuttgart 1998
Paul Gauguin — Tahiti. Exh. cat. edited by Christoph Becker. English ed. Ostfildern-Ruit: G. Hatje, 1998. Staatsgalerie Stuttgart, 7 Feb.–1 June 1998.

Toronto 1972–73
French Master Drawings of the Seventeenth and Eighteenth Centuries in North American Collections (Dessins français du 17ème & du 18ème siècles des collections américaines). Exh. cat. by Pierre Rosenberg, translated by Catherine Johnston. London: Secker & Warburg, 1972. Toronto, Art Gallery of Ontario, 2 Sept.–15 Oct. 1972; Ottawa, National Gallery of Canada, 3 Nov.–17 Dec. 1972; San Francisco, California Palace of the Legion of Honor, 12 Jan.– 11 Mar. 1973; The New York Cultural Center in association with the Fairleigh Dickinson University of New Jersey, 4 April– 6 May 1973.

Toronto / London 1977–78
The Drawings of Henry Moore. Exh. cat. by Alan G. Wilkinson. London: The Tate Gallery, 1977. Toronto, Art Gallery of Ontario, 5 Nov.–31 Dec. 1977; Iwaki-Shi, Japan, Shimin Art Gallery Museum, 21 Jan.–12 Feb. 1978; Kanazawa, Japan, Prefectural Museum, 18 Feb.–26 March 1978; Kumamoto, Japan, Kumamoto Municipal Museum, 1–23 April 1978; Tokyo, Seibu Gallery, 28 April–31 May 1978; London, The Tate Gallery, 28 June–28 Aug. 1978.

Toulon 1985–86
La Peinture en Provence dans les collections du Musée de Toulon du XVIIe siècle au début du XXe siècle. Exh. cat. by Marie-Anne Dupuy and Pierre Rosenberg. Musée de Toulon, 26 Nov. 1985– 30 Jan. 1986.

Troy 1960
Emma Willard Alumnae Association Exhibition to Celebrate the Opening of the New Arts Center. No cat. Troy, N.Y., Emma Willard School, 26–30 Oct. 1960.

Troyes / Nîmes / Rome 1977
Charles-Joseph Natoire (Nîmes, 1700–Castel Gandolfo, 1777): peintures, dessins, estampes et tapisseries des collections publiques françaises. Exh. cat. by Isabelle Julia, Lise Duclaux, Pierre Rosenberg, Georges Brunet; chronology by Patrick Violette. Troyes, Musée des Beaux-Arts; Nîmes, Musée des Beaux-Arts; Rome, Villa Medici, March–June 1977.

Tübingen 1982
Paul Cézanne — Aquarelle. Exh. cat. by Götz Adriani. Cologne: DuMont, 1981. English ed. translated by Russell M. Stockman. New York: Harry N. Abrams, 1983. Kunsthalle Tübingen, 16 Jan.–21 March 1982; Kunsthalle Zürich, 4 April–31 May 1982.

Tucson 1965–66
CB: His Golden Year: A Retrospective Exhibition of Watercolors, Oils, and Graphics. Exh. cat., introduction by William E. Steadman, article by Charles E. Burchfield. Tucson: University of Arizona Press, 1965. Tucson, University of Arizona Art Gallery, 14 Nov. 1965–9 Jan. 1966.

Utica 1970
Charles Burchfield: Catalogue of Paintings in Public and Private Collections. Cat. edited by Joseph S. Trovato. Utica, N.Y.: Museum of Art, Munson-Williams-Proctor Institute, 1970. Published in conjunction with the exhibition *The Nature of Charles Burchfield: A Memorial Exhibition.* Utica, Museum of Art, Munson-Wiliams-Proctor Institute, 9 April–31 May 1970.

Venice 1947
Quattrocento pitture inedite. Prima mostra nazionale antiquaria. Exh. cat. by Alberto Riccoboni. Sponsored by Organizzazione Manifestazioni artistiche. Venice: Stamperia Editrice già Zanetti, 1947.

Venice 1962
Canaletto e Guardi. Exh. cat. by Karl T. Parker and James Byam Shaw, introduction by Giuseppe Fiocco. Translated by Lina Urban. Fondazione Giorgio Cini, Cataloghi di mostre 16. Venice: Neri Pozza Editore, 1962. Venice, Fondazione Giorgio Cini, Isola di San Giorgio Maggiore, 23 Aug.–15 Oct. 1962.

Venice 1970
Disegni teatrali dei Bibiena. Exh. cat. by Maria Teresa Muraro and Elena Povoledo, introduction by Gianfranco Folena. Fondazione Giorgio Cini, Cataloghi di mostre 31. Venice: Neri Pozza Editore, 1970. Venice, Fondazione Giorgio Cini, San Giorgio Maggiore, 22 Aug.–20 Oct. 1970.

Venice 1980
Disegni veneti di collezioni inglesi. Exh. cat. by Julian Stock, introduction by James Byam Shaw. Fondazione Giorgio Cini, Cataloghi di mostre 43. Vicenza: Neri Pozza Editore, 1980. Venice, Fondazione Giorgio Cini, Isola di San Giorgio Maggiore, 30 Aug.–15 Oct. 1980.

Venice 1982
Canaletto, Disegni — Dipinti — Incisioni. Exh. cat. edited by Alessandro Bettagno, with contributions by A. Bettagno, Ruth Bromberg, James Byam Shaw, Antonio Corboz, Jeffrey Daniels, Francis Haskell, Joseph G. Links, Oliver Millar, Charlotte Miller, Giovanna Nepi Sciré, Rodolfo Pallucchini, Terisio Pignatti, Lionello Puppi, Erich Schleier, Francesco Valcanover, and Pietro Zampetti; introduction by Bruno Visentini, selected cat. entries by Tessi Vecchi Doria. Grafica Veneta 3. Venice and Vicenza: Neri Pozza Editore, 1982. Venice, Fondazione Giorgio Cini, Isola di San Giorgio Maggiore, 25 July–17 Oct. 1982.

Venice 1993
Francesco Guardi: Vedute, Capricci, Feste. Exh. cat. by Alessandro Bettagno; essays by Eduard Huttinger, Francis Haskell, André Corboz, and Alessandro Bettagno; cat. by A. Bettagno (with Francesca del Torre, Marina Magrina, and Tessie Vecchi) and Margherita Azzi Visentini. Fondazione Giorgio Cini, Cataloghi di mostre 51. Milan: Electa, 1993. Venice, Fondazione Giorgio Cini, Isola di San Giorgio Maggiore, 28 Aug.–21 Nov. 1993.

Vlaardingen 1953
Vincent van Gogh. Exh. cat. Vlaardingen, the Netherlands, Visbank, 27 March–19 April 1953.

Volterra 1994
Il Rosso e Volterra. Exh. cat. by Roberto P. Ciardi and A. Mugnaini. Venice: Marsilio Editore and Giunta regionale toscana,1994. Volterra, Pinacoteca Communale, 15 July–20 Oct. 1994.

Washington 1956
Visionaries and Dreamers: An Exhibition Illustrating the Influence of the French Symbolist Artists on Succeeding Generations, Centered around a Group of Pictures in the W. A. Clark Collection of The Corcoran Gallery of Art. Exh. cat. Washington, D.C., The Corcoran Gallery of Art, 8 April–27 May 1956.

Washington 1973
Early Italian Engravings from the National Gallery of Art Collection. Cat. by Jay A. Levenson, Konrad Oberhuber, and Jacquelyn L. Sheehan published in conjunction with the exh. *Prints of the Italian Renaissance.* Washington, D.C.: National Gallery of Art, 1973.

Washington 1978
Master Drawings from the Collection of the National Gallery of Art and Promised Gifts. Exh. cat., preface by J. Carter Brown, introduction by Andrew Robison. Washington, D.C.: National Gallery of Art, 1978. National Gallery of Art, 1 June–1 Oct. 1978.

Washington 1978–79
Perceptions and Evocations: The Art of Elihu Vedder. Exh. cat. by Joshua C. Taylor, Jane Dillenberger, and Richard Murray; introduction by Regina Soria. Washington, D.C.: Smithsonian Institution Press, 1979. Washington, D.C., National Collection of Fine Arts, Smithsonian Institution, 13 Oct. 1978–4 Feb. 1979; Brooklyn, N.Y., The Brooklyn Museum, 28 April–9 July 1979.

Washington 1984a
Correggio and His Legacy: Sixteenth-Century Emilian Drawings. Exh. cat. by Diane De Grazia. Washington, D.C.: National Gallery of Art, 1984. National Gallery of Art, 11 March–13 May 1984; Parma, Galleria Nazionale, 3 June–15 July 1984.

Washington 1984b
Mark Tobey: City Paintings. Exh. cat. by Eliza E. Rathbone. Washington, D.C.: National Gallery of Art, 18 March–17 June 1984.

Washington 1984c
Marble and Bronze: One Hundred Years of American Sculpture, 1840–1940. Exh. cat. by Cheryl A. Cibulka. Washington, D.C., Adams Davidson Galleries, 9 Oct.–16 Nov. 1984.

Washington 1987–88
Rosso Fiorentino: Drawings, Prints, and Decorative Arts. Exh. cat. by Eugene A. Carroll. Washington, D.C., National Gallery of Art, 25 Oct. 1987–3 Jan. 1988.

Washington 1988–89
Places of Delight: The Pastoral Landscape. Cat. by Robert C. Cafritz, Lawrence Gowing, and David Rosand published in conjunction with the exh. *The Pastoral Landscape: The Legacy of Venice and the Modern Vision.* Washington, D.C.: The Philips Collection in association with the National Gallery of Art, 1988. National Gallery of Art and The Phillips Collection, 6 Nov. 1988–22 Jan. 1989.

Washington 1990
Selections and Transformations: The Art of John Marin. Cat. by Ruth E. Fine for the exh. *John Marin.* Washington, D.C.: National Gallery of Art; New York: Abbeville, 1990, Washington, D.C., National Gallery of Art, 28 Jan.–15 April 1990.

Washington 1990–91
Eva/Ave: Woman in Renaissance and Baroque Prints. Exh. cat. by H. Diane Russell, with Bernadine Barnes. Washington, D.C.: National Gallery of Art; New York: The Feminist Press at the City University of New York, 1990. National Gallery of Art, 25 Nov. 1990–29 April 1991.

Washington 1992
Käthe Kollwitz. Exh. cat. by Elizabeth Prelinger, essays by Alessandra Comini and Hildegard Bachert. New Haven and London: Yale University Press; Washington, D.C.: National Gallery of Art. National Gallery of Art, 3 May–16 Aug. 1992.

Washington / Cambridge 1978–79
Drawings by Fragonard in North American Collections. Exh. cat. by Eunice Williams. Washington, D.C.: National Gallery of Art, 1978. National Gallery of Art, 19 Nov. 1978–21 Jan. 1979; Cambridge, Mass., Fogg Art Museum, Harvard University, 16 Feb.–1 April 1979; New York, The Frick Collection, 20 April–3 June 1979.

Washington / Chicago / Paris 1988–89
The Art of Paul Gauguin. Exh. cat. by Richard Brettell et al. Washington, D.C.: National Gallery of Art, 1988. National Gallery of Art, 1 May–31 July 1988; The Art Institute of Chicago, 17 Sept.–11 Dec. 1988; Paris, Galeries Nationales du Grand Palais, 10 Jan.–20 April 1989.

Washington / New York 1986–87
The Age of Bruegel: Netherlandish Drawings of the Sixteenth Century. Exh. cat. by John Oliver Hand, J. Richard Judson, William W. Robinson, and Martha Wolff. Washington, D.C.: National Gallery of Art, and Cambridge University Press, 1986. National Gallery of Art, 7 Nov. 1986–18 Jan. 1987; New York, The Pierpont Morgan Library, 30 Jan.–5 April 1987.

Washington / New York / London 1994–95
Willem de Kooning Paintings. Exh. cat. with essays by David Sylvester and Richard Shiff; cat. by Marla Prather. New Haven: Yale University Press, 1994. Washington, D.C., National Gallery of Art, 8 May–5 Sept. 1994; New York, The Metropolitan Museum of Art, 11 Oct. 1994–8 Jan 1995; London, The Tate Gallery, 15 Feb.–7 May 1995.

Wellesley / New York 1960
Eighteenth-Century Italian Drawings: A Loan Exhibition. Exh. cat. by Janet Cox Rearick. New York: Bragaw-Hill, 1960. Wellesley, Mass., Jewett Arts Center, Wellesley College, 11 April–5 May 1960; New York, Charles E. Slatkin Galleries, 9–23 May 1960.

Wilkes–Barre 1981
Students of the Eight: American Masters, ca. 1910–ca. 1960. Exh. cat., introduction by Helen Farr Sloan, essay by William Sterling.

Wilkes-Barre, Pa., Sordoni Art Gallery, Wilkes College, 12 April–17 May 1981.

Williamstown 1978a

Tissot: Selected Paintings and Watercolors. No cat. Williamstown, Mass., Sterling and Francine Clark Art Institute, 5 Aug.–17 Sept. 1978.

Williamstown 1978b

Watercolors by Maurice Prendergast from New England Collections. Exh. cat. by Gwendolyn Owens. Williamstown, Mass., Sterling and Francine Clark Art Institute, 11 Nov.–17 Dec. 1978.

Williamstown 1979–80

Master Drawings from the Collection of Ingrid and Julius S. Held. Exh. cat. by Laura Giles, Elizabeth Milroy, and Gwendolyn Owens. Williamstown, Mass.: Trustees of Williams College and Trustees of the Sterling and Francine Clark Art Institute, 1979. Williamstown, Sterling and Francine Clark Art Institute, 5 May–10 June 1979; Hanover, N.H., The Dartmouth College Museum and Galleries, 12 Oct.–25 Nov. 1979; Brunswick, Maine, Bowdoin College Museum of Art, 14 Dec. 1979–20 Jan. 1980; Toronto, The Art Gallery of Ontario, 15 March–27 April 1980; Sarasota, Fla., The John and Mable Ringling Museum of Art, 15 May–29 June 1980.

Williamstown 1983

The New England Eye: Master American Paintings from New England School, College, and University Collections. Exh. cat., essay by S. Lane Faison, Jr. Williamstown, Mass., Williams College Museum of Art, 11 Sept.–6 Nov. 1983.

Williamstown 1984

Alexandre Gabriel Decamps, 1803–1860. Exh. cat. by David B. Cass and Michael M. Floss. Williamstown, Mass., Sterling and Francine Clark Art Institute, 2 March–29 April 1984.

Williamstown 1990

Maurice Prendergast in Context: Selections from Regional Museums. Checklist by Marion Goethals. Williamstown, Mass.: Williams College Museum of Art, 15 Sept.–25 Nov. 1990.

Williamstown 1990–91

Maurice Prendergast. Exh. cat. by Nancy Mowll Mathews. Munich: Prestel, in association with Williams College Museum of Art, 1990. New York, Whitney Museum of American Art, 31 May–2 Sept. 1990; Williamstown, Mass., Williams College Museum of Art, 6 Oct.–16 Dec. 1990; Los Angeles County Museum of Art, 21 Feb.–22 April 1991; Washington, D.C., The Phillips Collection, 18 May–25 Aug. 1991.

Winterthur (Switz.) 1953

Théodore Géricault, 1791–1824. Exh. cat. by Pierre Dubaut and Von Gotthard Jedlicka. Winterthur, Switzerland, Kunstverein Winterthur, 30 Aug.–8 Nov. 1953.

Worcester 1951–52

The Practice of Drawing. Exh. checklist in Worcester Art Museum *News Bulletin and Calendar* 17, no. 3 (Dec. 1951). Worcester, Mass., Worcester Art Museum, 17 Nov. 1951–6 Jan. 1952.

Worcester 1971

The Graphic Works of Toulouse-Lautrec. Exh. cat. by Richard Stuart Teitz. Worcester, Mass., Worcester Art Museum, 25 March–23 May 1971.

INDEX OF PREVIOUS OWNERS

References are to catalogue numbers. Names in quotation marks are those of buyers as recorded in sales catalogues. When a drawing was part of the artist's estate, the artist's name is listed. Sales at auction are not indexed, but galleries are included even in instances where they were acting as agents.

GENERAL INDEX

Entries in **boldface** refer to artists whose drawings are catalogued in this volume. Page numbers in *italics* refer to illustrations. Works of art other than drawings are identified in parentheses by type or medium used.

PHOTOGRAPH CREDITS